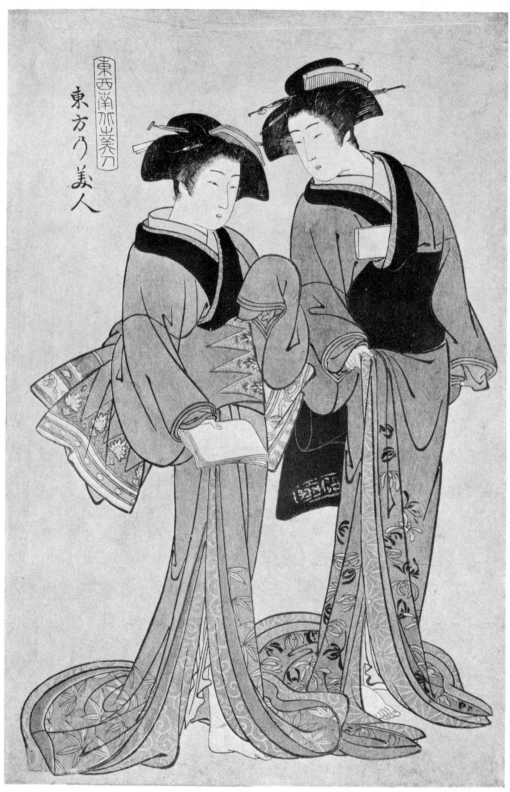

KITAO MASANOBU: "The Beauty of the East" (Yedo); one of a series
"Beautiful Women of the East, West, North, and South": *unsigned.*

PLATE A

A GUIDE TO JAPANESE PRINTS

AND THEIR SUBJECT MATTER

by
Basil Stewart

Dover Publications, Inc.
New York

This Dover edition, first published in 1979, is an unabridged republication of the work originally published by E. P. Dutton and Company, New York, in 1922, with the title *Subjects Portrayed in Japanese Colour-Prints* and the subtitle "A Collector's Guide to All the Subjects Illustrated Including an Exhaustive Account of the *Chushingura* and Other Famous Plays, Together with a *Causerie* on the Japanese Theatre." [Original British publisher: Kegan Paul, London, 1922.] In the present edition, most of the plates have been regrouped on two or more pages, and Plates A through H and 4A, originally in color, are here reproduced in black and white.

International Standard Book Number: 0-486-23809-1
Library of Congress Catalog Card Number: 79-50920

Manufactured in the United States of America
Dover Publications, Inc.
180 Varick Street
New York, N.Y. 10014

PREFACE

ADVANTAGE has been taken by the passing out of print of the author's *Japanese Colour-Prints and the Subjects they Illustrate*, published in 1920, to revise thoroughly the contents of that volume, rather than merely reprint it, and at the same time to add considerably to the existing matter therein and also to include much entirely fresh information, which it was intended originally to issue in a companion volume to it.

This volume, therefore, is much more than a second edition of the above book ; it is virtually a new work, dealing with Japanese Prints in the most comprehensive form possible within the limits of a single book, constituting a catalogue *raisonné* of all the most notable prints of *Ukiyoye* produced during the polychrome period.

The author has endeavoured to make the subject as interesting as possible, rather than write an academic monograph ; to produce a book which shall be useful to the requirements of the novice and amateur as well as to those of the advanced collector.

Many people collect these colour-prints for the attraction of their pure beauty, but have only a slight acquaintance with the scene or subject they illustrate, or the meaning which the artists desire to convey.

Japanese colour-prints should not be collected solely as works of art ; an intelligent study of the subjects and scenes they illustrate will tell us more of the life, history, and character of Japan in the days when it was a closed book to the rest of the world, than any number of pages of print.

To assist the collector in this respect and to increase the interest to him of his own and other collections is the main object of the writer. That collectors have desired a book of this nature rather than profound and ingenious theorizing is evinced by the warm reception of the author's previous volume, both in the United Kingdom and in America, and the marks of appreciation which he has received both personally and by correspondence, and for which he tenders his sincere thanks.

His thanks are due to Messrs. Sotheby for permission to use illustrations from their sale catalogues for reproduction in this volume ; to Mr. Henry Bergen for the loan of prints, and particularly to Mr. Shozo Kato, who throughout has shown great personal interest in the preparation of this volume, by the loan of prints and in other ways materially assisting the writer by placing at his service his intimate knowledge of the art, literature, and language of Japan.

PUBLISHER'S NOTE, 1979

In Chapter III, "On the Formation and Care of a Collection," and other places where prices are stated, the author's original text of 1922 has been left unaltered. Naturally, the availability and prices of Japanese prints mentioned herein have changed and are subject to constant variation.

ADDENDA

Page 153: "Six Tama Rivers" Series (early oblong set) by Hiroshige. With reference to the publisher of this series, described in Chapter XVII, page 153, in a footnote thereto it is stated that this was Tsuta-ya Kichizo, explaining at the same time the probable reason why the trade-mark of the other Tsuta-ya (Juzaburo) is often found in the margin. Further investigation, however, has since proved this explanation to be incorrect. It is true, as stated elsewhere, that Juzaburo had been dead several years by the date the above series was published, but his business was carried on, and trade-mark used, by his relations till 1840. These "Tama River" prints, therefore, were published by Juzaburo, and not Kichizo.

Page 206: Torii Kiyonobu. At the moment of publication, the author received a communication from a correspondent in Japan, who informed him that he had recently obtained a theatrical print, *printed* in two colours (green and red), signed in full *Torii Kiyonobu.* This proves that either (i) Kiyonobu II *did* use his house name, (ii) Kiyonobu I produced *block*-coloured prints, and, therefore, (iii) lived at least twelve years later than the date usually assigned to his death (1729): Fenollosa, indeed, puts it as late as "about 1755." The writer considers the third hypothesis the most likely explanation, and that the death of Kiyonobu should be assigned to about 1745.

CONTENTS

CONTENTS

PART IV

ACTOR-PORTRAITS AND THEATRICAL SUBJECTS

PART V

HISTORICAL SUBJECTS, LEGENDS AND STORIES

APPENDICES

LIST OF ILLUSTRATIONS

NOTE.—For convenience of reference the illustrations are listed alphabetically under artists' names instead of in the order in which the plates occur in the volume as is usually done.

All prints illustrated not otherwise acknowledged are from the author's collection.

[xi]

LIST OF ILLUSTRATIONS

LIST OF ILLUSTRATIONS

[xiii]

LIST OF ILLUSTRATIONS

GLOSSARY

Baren. The pad used by the printer when taking impressions from the wood-block.

Beni-ye. A print in which *beni* (or pink) predominates ; a term generally applied to the two-colour prints immediately preceding the polychrome period.

Chuban. A medium-size vertical print, measuring about 11 inches by 8 inches.

Daiban. The outline or key-block cut by the engraver from the artist's original drawing.

Diptych. A composition complete in two sheets, generally side by side, but an unusual form.

Gauffrage. " Blind " printing—that is, without the application of colour. In this process the print is laid on the block face *upwards* (thus reversing the process when a colour impression is taken), which has the effect, on pressure being applied, of giving the design an embossed appearance. Used frequently on *surimono*, but only to a slight extent (e.g. on parts of dresses, blossom of trees, and flowers) on full-size prints.

Harimazè. Sheets of two or more subjects or designs printed on the one sheet and intended to be cut afterwards ; very uncommon. [Example : Set of " Fifty-three Tokaido Stations," by Hiroshige, on fourteen sheets, arranged irregularly, three, four, or five views on one sheet. Title : *Go-ju-san Tsugi Harimazè.*]

Hashira-ye or *Hashira-kakè.* A long narrow print, about 27 inches by 5 inches wide, intended to hang from the pillars (*hashira*) of a Japanese house. Owing to the uses to which they were put, to adorn the living-rooms, few have survived to our day, and are consequently uncommon, and are nearly always discoloured by smoke. The origin of *hashira-ye* is not known, but they were designed by the Primitives, such as Okumura Masanobu and Torii Kiyoshige. The best ones were printed complete on one sheet, but late examples, such as those of the early nineteenth century by Shunsen, Yeizan, and Yeisen, are on two sheets joined together.

Hoso-ye. A small vertical print, 12 inches by 6 inches, often used for single actor-portraits (e.g. prints by Shunsho, Shunyei, Toyokuni, etc.). They were originally cut three on a block, and the print divided. It is very rare to find three such prints in an undivided state.

Ichimai-ye. A single-sheet print.

Kakemono-ye. Two full-size vertical sheets, one above the other, to form a complete picture when joined together.

Koban. A vertical print rather smaller than the *Chuban*, about 10 inches by 7 inches.

Mon. The crest worn by actors and others on the sleeve of their dress.

Nishiki-ye. Literally means " brocade picture," and was first used in the time of Harunobu, but afterwards applied to all polychrome prints.

GLOSSARY

Oban. A full-size vertical print, 15 inches by 10 inches.

Otsu-ye. A roughly painted sketch, the forerunner of the print ; first produced by Matabei at the village of Otsu on the Tokaido, hence their name. This Matabei (or Matahei [died *c.* 1720]) must not be confused with the better-known Iwasa Matabei.

Pentaptych. A composition consisting of five vertical sheets side by side.

Sumi-ye. A print in black and white only (*sumi* =black Chinese ink).

Surimono. A print issued for private circulation, like our Christmas, New Year, birthday, or invitation cards. They were lavishly embellished with gold, silver, bronze, and mother-of-pearl dust, and were printed on a thicker and softer paper than was usually employed for ordinary prints. They were almost square in shape, measuring 8 inches by 7 inches. (See Chapter IX.)

Tan-ye. A print in which *tan* (brick-red or orange colour) predominates ; a term applied to early hand-coloured prints. *Tan* turns black with exposure in course of time, an effect often noticed in the prints of Hokusai and Hiroshige, who used this colour in depicting sky and cloud effects.

Tanjaku (=*tan*, " short," and *shaku*, " a foot ") ; or *tanzaku* (= *tan*, " short," and *saku*, " a piece "). Narrow slips, like miniature *kakemono-ye*, on which poems were inscribed. Used by Hiroshige for thumb-nail sketches of birds and flowers, slight figure-studies, etc.

Triptych. A composition of three vertical prints side by side. Hiroshige has designed some very rare triptychs, composed of three *oblong* sheets.

Uchiwa-ye. A print intended for mounting as a fan. Fans were in two shapes, the *uchiwa*, a round non-folding fan, and the *ogi*, or folding fan. Prints designed for fans are not common owing to the uses to which they were put, but the *uchiwa* shape is the one most frequently met with.

Ukiyè. Prints designed after European canons of drawing, with perspective ; also means " bird's-eye view pictures."

Urushi-ye. Prints in which transparent lacquer is used to heighten the colour-effect, a process said to have been invented by Okumura Masanobu.

Yoko-ye. A full-size horizontal print, 15 inches by 10 inches, corresponding to the *oban*, often used for landscape designs.

PART I

THE COLLECTOR

CHAPTER I

INTRODUCTION

First Appearance of Japanese Prints in Europe—Captain Osborn's *Japanese Fragments*—French and American Collectors—Æsthetic Characteristics of Japanese Prints.

THE interest of European and American collectors in Japanese colour-prints is of comparatively modern origin, and dates approximately from the time when Japan was thrown open to the outside world, and her art products became accessible to the foreigner, a process accelerated, at the beginning, by the keenness of the natives to acquire in exchange European culture and manufactures to the disparagement of their own arts. True, they soon found out their mistake, but in the interval the eager dealer and collector from abroad had made good use of their opportunities, particularly where colour-prints were concerned.

These prints first made their appearance in France, via Holland, whence they came from the Dutch trading at Nagasaki, in the early part of last century, about 1815. They were, however, considered only as curiosities in those days, without any appreciation of their artistic merit. As it is said that they were merely used by the Dutch at Nagasaki as wrappings for parcels, when dispatching goods to Europe, or stuffed in bales, their condition on arrival would hardly conduce to a proper appreciation of their merit as works of art. The prints of Utamaro and Hokusai are supposed to have been the first to thus leave the land of their origin and be seen in Europe.

M. Isaac Titsingh, who died in Paris in 1812, was for many years an official of the Dutch company trading at Nagasaki, and amongst his collection of Japanese art objects, books, etc., were a few (less than a dozen) colour-prints, probably prints by Utamaro. As far as any definite records tell us, M. Titsingh's prints were, most probably, the first to find their way into Europe at the hands of a collector, apart from any which arrived as wrappings for merchandise.

The earliest mention of Japanese prints that the writer has been able to discover in any book published in this country is to be found in an interesting (but now rare) work of 139 pages, entitled *Japanese Fragments*, by Captain Sherard Osborn (London, 1861). This book contains six reproductions of prints by Hiroshige, coloured by hand, and various cuts in the text, mostly taken from Hokusai's book, *Hundred Views of Fuji*.

[3]

The author had been in command of the frigate which conveyed our ambassador, Lord Elgin, to Yedo Bay, on a mission which resulted in the signing of the treaty of 1858, based on the similar treaty just previously concluded between Japan and America. These treaties, by which certain ports were opened to foreign trade, and at which foreign settlements were established, marked the termination of Japan's two centuries of seclusion from the outer world.

Captain Osborn's prints, then, must have been amongst the earliest examples to be seen in this country, and he certainly, by his reference thereto, appreciated them as much for their artistic merit as for their (in those days) curiosity. He says in his Preface : " I have found much encouragement in being able to illustrate my fragmentary tale of the strange things of Japan with a series of beautiful illustrations, bought during my stay in the city of Yedo."

In allusion to one of the coloured illustrations, a reproduction of one of Hiroshige's scenes in his " Sixty Odd Provinces " series, he writes : " Even the humble artists of that land become votaries of the beautiful, and in such efforts as the one annexed, strive to do justice to the scenery. Their appreciation of the picturesque is far in advance, good souls, of their power of pencil, but our embryo Turner has striven hard to reproduce the combined effects of water, mountain, cloud, and spray."

Little did our author imagine, when he penned these words, that the day was not very far distant when " our embryo Turner " would be considered one of the two greatest landscape artists of his or any other country, and that one of his masterpieces would fetch from ninety to a hundred pounds in the auction room a bare fifty years later, and to-day is probably worth three times that sum.

Elsewhere Captain Osborn makes reference to the realism which these humble artists conveyed into their designs, in the following words : " These native illustrations bring before us in vivid relief the scenery, towns and villages, highways and byways of that strange land—the costumes, tastes, and I might also say, the feelings of the people—so skilful are Japanese artists in the Hogarth-like talent of transferring to their sketches the characteristics of passing scenes."

Coming from a writer who had visited Japan before it had adopted the notions of Western civilization, and while it yet remained the country of Hokusai and Hiroshige, who knew so well how to portray it, these appreciations of their pictorial art have an added interest at the present day.

Japanese colour-prints first attained more general recognition at the International Exhibition of 1862 in London, where the first public exhibition of them was given amongst the collection of Japanese Arts and Handicrafts

formed by the late Sir Rutherford Alcock, but they were the late and inferior specimens by contemporary artists then being sold in the streets of Yedo, Osaka, and Yokohama, as he states in his book, *Art and Art Industries in Japan*, that he made his collection in the markets of the latter town.

Paris appears to have been the centre in which Japanese print collecting was first seriously taken up in Europe, from about the year 1880 onwards, a movement that had its origin in the Paris Exhibition of 1867, which contained a display of Japanese colour-prints. though only by inferior artists. Amongst French collectors of this time M. de Goncourt stands out as one of the most important, and his volumes on *Utamaro* (1891) and *Hokusai* (1896) are standard works on these two masters of *Ukiyoye*. The dispersal of several important collections took place in Paris between the years 1890 and 1900, thus giving to Paris a pre-eminence amongst print collectors, and helping to extend a knowledge of the art to a larger circle, which had hitherto been confined to a few connoisseurs.

These sales included the following collections : Burty (March 16–20, 1891) ; an amateur (anonymous) (June 19–22, 1891) ; Duret (February, 1897) ; and Goncourt (March 8–13, 1897). The Hayashi sale, probably one of the largest private collections ever dispersed at auction, was held in Paris, June 2–6, 1902.[1]

American collectors, however, were the first in the field, or at least, if not earlier than the French, took up the serious study of this new art much in advance of amateurs in this country, while German collectors were the last to do so.

Americans, also, were much more fastidious in what examples they admitted into their collections, and insisted more on condition than collectors in this country were at first wont to do. Consequently French and American collections show a higher standard, and contain a larger proportion of fine examples of the work of artists whose designs are rare than is the case with other countries.

Prints, therefore, which are the pride of these collections rarely find their way to London, so that the English collector has a somewhat limited field wherein to acquire these art treasures, there being many of the rarer and more desirable prints he cannot hope to possess. Moreover, fine examples of almost any artist, and particularly of those in the first rank, are becoming more difficult to obtain as each year passes, owing to increasing competition, particularly from collectors in Japan itself, coupled with the fact that dispersals of large private collections in this country have been few and far between during recent years.

Owing to the immense production of Japanese colour-prints, as compared with the output of European wood-engravers, all of whose work is

[1] *Vide* Bibliography in Von Seidlitz's *History of Japanese Colour-Prints*.

known and has been catalogued, to acquire the complete work of any of the leading masters of *Ukiyoye* is probably an impossibility ; yet but a proportion of their original output has come down to us. Hence it is that in every collection, public or private, one meets with new examples, and no one collection, however large or varied, can hope to be complete.

In the province of collecting examples of graphic art, Japanese colour-prints may therefore be considered unique in this respect, and for this reason it is difficult, if not indeed invidious, to make comparisons between different collections. Amongst public collections that in the Museum of Boston, in America, is probably the largest, while that in the British Museum may also claim to be in the first rank, though perhaps somewhat defective in quality from a collector's standpoint.

The largest collections, however, are in private hands, the most notable in Europe being those of Parisian collectors, amongst whom M. Henri Vever is pre-eminent.[1] In America, which possesses many fine collections, that of the Spaulding brothers, of Boston, is the largest and best known, and early last year (i.e. 1920) the fine collection of Mr. Davison Ficke was sold by auction in New York, when some exceptionally high prices were realized. No collection of equal importance has appeared in the auction room in this country since the dispersal of the Swettenham and Danckwerts' collections in 1912 and 1914 respectively.

The charm which old Japanese colour-prints undoubtedly have for those who come under their spell, even when they cannot at first understand their language, lies in their pure beauty of decorative treatment combined with totally different canons of drawing. They are so different that they compel attention, so that, once their conventions are understood, one becomes fascinated by their beauty and simplicity of drawing. Western art distracts and irritates by its unnecessary, and often meaningless, detail in attempts at realism ; the Japanese colour-print designer wisely understood the limits of his art, and made no attempt to copy Nature, though, if he choose, he could—as in his drawings of flowers, birds, and insects— attain to a realism far beyond that reached by his Western confrères. He allows no extraneous details to divert attention from the subject of his picture, which he presents in such a fashion as shall hold the mind to the exclusion of all else.

Few of the many thousands who glance at the large pictorial advertisements on our street hoardings to-day realize to what extent the great improvement in their design, which has become evident within the last

[1] The whole collection of M. Vever was recently acquired by a Japanese collector and is now in Japan.

fifteen years or so, is due to the art of these Japanese craftsmen of the eighteenth and early nineteenth centuries. These prints, indeed, owe their origin to the large theatrical posters which were displayed outside the popular theatres of Yedo. To the modern designer of posters they offer superb examples of the correct use of bold outline in conjunction with large masses of colour, and of the most effective manner of grouping figures in a design. Their influence in many a pictorial advertisement, not only on street hoardings (an influence all to the good, as anyone who remembers the hideous posters of twenty to twenty-five years ago will admit), is at once apparent to all who have seen and admired the beautiful productions of the *Ukiyoye* school of Japan.

CHAPTER II

HOW COLOUR-PRINTS WERE PRODUCED

The Technique Employed—The *Ukiyoye* School and its Founders—The Ōsaka School—
Modern Colour-Prints—Decline and Fall of the *Ukiyoye* School.

OLD Japanese colour-prints are printed on a sheet of mulberry-bark paper, and are the product of three different craftsmen : the artist who drew the original design, the block-maker or engraver who transferred the design to the wood, and the printer. A block (generally cherry-wood) was cut for each colour, in addition to the outline or key-block.

These blocks were cut lengthwise, in the direction of the grain, like planks are sawn, and not across it as in Europe. One plank, therefore, would cut up into several blocks.

The drawing made by the artist, with whose name *alone* the print is generally associated, was done in Chinese or, as we erroneously call it, Indian ink, with a brush on very thin paper.

This was passed to the engraver, who pasted it, face downwards, on the wood-block and, cutting through the paper, transferred the outline to the block, afterwards removing the superfluous wood between the lines with chisels and gouges, similar to those used by European wood-engravers, and so producing an accurate negative in high relief.

The artist's design was therefore destroyed, a fact which should be borne in mind when offered as an original a drawing of which prints are known to exist, thus proving it to be a reproduction.

There is, of course, the converse of this, as there are in existence to-day original drawings which were never used for the production of prints therefrom, as, for example, certain designs drawn by Hokusai for the " Hundred Poets " series.

In the catalogue of the British Museum Collection of Colour-Prints, under Kiyonaga, are mentioned both a print and the original sketch for it, thus showing that the print itself was reproduced from a second drawing. Both the print and the sketch are illustrated at page 116 of the catalogue, the latter showing slight variations of detail over the final drawing as reproduced in the print. A preparatory design such as this must be extremely rare, and it is stated in a foot-note in the catalogue that " this example only escaped destruction through being used in the binding of an album." A very fine, full size, copy ($15\frac{1}{2} \times 10\frac{1}{8}$) of this same print is here illustrated at

Plate 33, page 192, with fuller margins and richer colouring than in the British Museum copy, as a comparison of the two illustrations will indicate.

To economize wood both sides of the block were engraved, the back being used either for another stage of the same print or for a different print altogether.

The writer here wishes to correct a statement made in the first edition of this volume concerning the printing, which he has since learnt to be erroneous, though it appears to be a view not uncommonly held.

The statement was to the effect that prints which are very early impressions from the blocks often show the marks of the cutting tools and the grain of the wood. While the marks of the tools might show at first on a newly-cut block, the appearance of the wood grain depends upon that particular block carrying a well-marked grain, and also upon the *amount of pressure used in taking an impression.* The tool marks being superficial would wear off in use, but the grain of the wood being continuous throughout the thickness of the block would show on the last pull as well as on the first, provided sufficient force was used in taking it.

The appearance of the wood grain on a print, therefore (often noticeable in prints by Hiroshige, and in others where a large surface is tinted in one colour), does not necessarily prove it to be an early impression.

From the outline or key-block (Japanese, *daiban*) a series of proofs were taken, on one of each of which was painted by the artist the part or parts of the print to appear in each separate colour ; from each proof so painted was cut an equivalent block, though if two colours were widely separated they might be put on one block. It is not, therefore, always the case that a print has been taken from as many blocks as it has colours. The printer could weaken his colour by rubbing off the pigment from one part of the block, or strengthen it in another, or he could gradually blend one colour into another on the same block.

When all the required blocks were cut they were then passed on to the printer, who painted the colours on the block with brushes, thus making possible that delightful gradation of colour which is one of the charms of these colour-prints. A sheet of damped paper was then laid on each block in turn, and the impression rubbed off by hand with a rubber or pad called a *baren.* Correct register was obtained by means of a right-angle cut at the lower right-hand corner of the original key-block, and a straight edge at the left (or " draw-close " line). These marks were repeated on each subsequent colour-block, and in taking impressions, the sheet was so imposed that its edges corresponded with these marks. So skilful were the old printers that faults in register are very rarely found, and when it is at all defective it is generally due to unequal shrinking of the blocks.

It will be noticed in these cases that the alignment is true on one edge of the print but gets out of register towards the other, even though it may have been pulled with the same amount of care as another perfect throughout.

A single complete print was not printed off at a time, but all the required number of impressions were taken off each block in succession. The blocks were re-charged with colour after *each* impression, as is the case with modern printing.

It will be noticed sometimes (particularly in the later prints of Hiroshige, which were produced in such large quantities) that the colours appear smudged, though not actually in bad register. This was no doubt due to the impression having been taken off worn blocks which, by reason of the wood becoming saturated with pigment through constant re-charging, absorbed less and less of it, leaving a superfluity which the paper, already damped, soaked up like a blotter, causing it to smudge on taking the impression.

The whole process, therefore, was hand-work in the fullest sense of the word, and was vastly superior, both artistically and technically, to any modern facsimile reproduction.

Various kinds of paper were used, as the printers often experimented in order to procure the best results, and the fine qualities of the colours are largely due to the tough and absorbent nature of the paper. The earlier prints, such as those of the middle and later eighteenth century, are generally on a thicker and softer paper than those of the time of Hokusai and Hiroshige, which are harder and thinner in texture.

Strictly speaking, these prints are not prints as understood in the modern sense, since no printing-press was used, and the colours are not from inks, but from paints mixed with rice-paste as a medium. The process was really a method of producing a painted drawing in large numbers from a hand-coloured block.

There is a certain amount of prejudice against Japanese colour-prints, on the ground that they are as mechanical as chromos. But since, as stated above, the whole process of production is hand-work in the fullest sense of the word, the Japanese print is a perfectly legitimate form of art, and it can in no way be compared with modern mechanical reproductions. True, the work of the engraver was purely mechanical in that his sole province was to reproduce, line for line and dot for dot, the design given him by the artist. But at the same time, it meant a manual dexterity which lifted his work far above the level of that produced by any machine, while no mechanical process could take the place of the printer's hands in the application of the colours and give such charming results.

These prints were produced almost entirely by the artists of one school,

the *Ukiyoye*, or " popular " school of painting. This school had its begin-
nings in a movement which arose in Yedo, in the seventeenth century,
for a pictorial art which, freed from the age-long traditions and conventions
of the classic Tosa and Kano schools of painting, should satisfy the artistic
longings of the masses, to whom these schools were closed and for whom
paintings were too expensive.

The Tosa school, founded early in the thirteenth century, formed the
courtly school patronized by the Mikado and his Court ; they depicted
mainly Court scenes and battle subjects. The Kano school, on the other
hand, founded in the second half of the fifteenth century, and upholding
the Chinese style of painting, was the special care of the *Shoguns*, the real
rulers of the country, the Mikado being the spiritual head, but devoid of
any power, and little better than a prisoner in his capital.

Both these schools, therefore, were in the nature of rivals, but both
gradually fell into a state of decay. Both followed certain fixed conven-
tions ; the realistic portrayal of contemporary life, such as the *Ukiyoye*
school depicted, they considered vulgar.

The artist who first broke away from these traditions to evolve a style
of his own was Iwasa MATABEI (1577–1650), an aristocrat by birth, who
studied first in the Tosa school, but later went over to the Kano school.
To him was first applied the epithet *Ukiyo* (" passing world "), a term
gradually extended to all the artists who followed his lead.

Matabei and his immediate followers worked only as painters, and it is
not unlikely that their abandonment of the ancient classic forms for popular
subjects would not in itself have been sufficient to popularize their work,
had it not been for its subsequent alliance with the hitherto little-developed
art of wood-engraving, which was used in a somewhat primitive style for
the illustration of books.

This Matabei must not be confused with another artist (died about
1725) of the same name (also called Mata*h*ei), that is sounded alike but
written in different characters, who lived at Otsu, on the Tokaido, near
Kyoto, and who produced rough sketches, known as " Otsu pictures," of
legendary scenes and demons, an effort on his part to supply the popular
demand for cheap pictures.

Through this conjunction of artist and wood-engraver in the time of
Hishikawa MORONOBU (*c.* 1638–1714), in the second half of the seventeenth
century, was found the means of producing designs in sufficiently large
numbers, and at a low enough cost, to enable even the poorly paid artisan
to satisfy his artistic cravings. The origin of the Japanese colour-print,
as we know it to-day, is another instance of the truism that necessity is the
mother of invention. The period of Moronobu's lifetime is uncertain.

" It must be granted that the colour-prints of this school constitute the

fullest and most characteristic expression ever given to the temper of the Japanese people. . . . The colour-print constitutes almost the only purely Japanese art, and the only graphic record of popular Japanese life. Therefore it may be regarded as the most definitely national of all the forms of expression used by the Japanese—an art which they alone in the history of the world have brought to perfection." (A. D. Ficke, in *Chats on Japanese Prints*. London, 1915.)

It is thanks, also, to this discovery of a means of rapid and cheap reproduction that so many prints have survived to delight the art-lovers of to-day. When we remember the frail nature of these prints, the numerous fires which constantly broke out in Japanese towns and villages, the uses to which they were often put, as decorations on paper partitions, screens, fans, kites, or otherwise treated as mere ephemera, their production must have been enormous for so many to have survived for our delectation. It is indeed surprising that any examples at all of the work of the early masters should have survived so long, from the days when the output was comparatively small. It probably reached a maximum during the closing years of the eighteenth and the first half of the nineteenth centuries.

With rare exceptions the artists of the *Ukiyoye* school were drawn from the artisan class, for whose delight they designed these prints, and were consequently ignored by the upper aristocratic class, the subjects they presented being beneath the dignity of a noble or *samurai*. As a consequence, the Japanese taste for prints was hardly existent when Europe and America first discovered them, until it was too late, and they woke up to find them carried off by the foreign dealer and collector.

At the present time, however, the Japanese are making great efforts to restore these artistic treasures to the land of their origin, and no country can produce keener collectors.

It was not until the time of HARUNOBU (*c.* 1725–1770), about the year 1760, that the multi-coloured *print*, in which several colours were impressed from blocks as distinct from one or two tints applied by hand to the print itself, came into being, thanks to improvements discovered by a certain printer and engraver in the art of colour-printing, chiefly in connection with the accurate register of the same sheet on several blocks. Previously the outline print had been sparingly coloured by hand or, as a development from this initial stage, at first one-colour and then two-colour blocks were introduced.

Harunobu, therefore, may be regarded as the originator of the polychrome print as we know it to-day, the forerunner of a long line of artists of varying ability, many, indeed, of those belonging to the period of the decline, towards the middle of last century, producing work of little or no

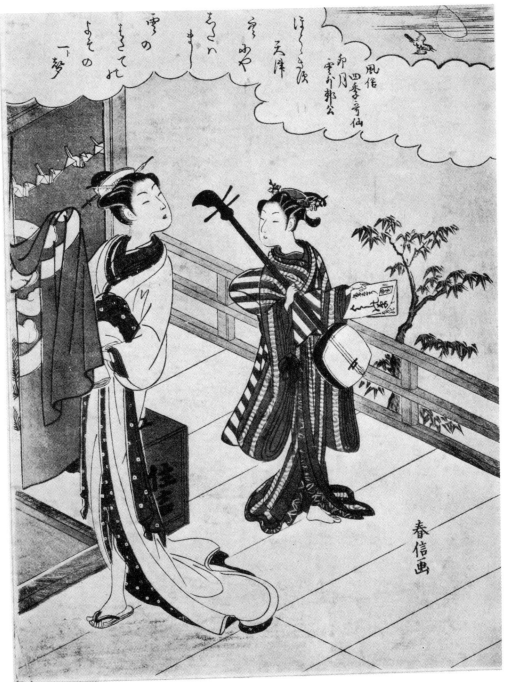

1. "Social Customs of the Four Seasons" : April. Two Girls on a balcony, one lifting a curtain to enter a room ; signed *Harunobu*.

(Reproduced from the Happer Catalogue by courtesy of Messrs. Sotheby.)

PLATE 1 (first part)

Suzuki HARUNOBU.

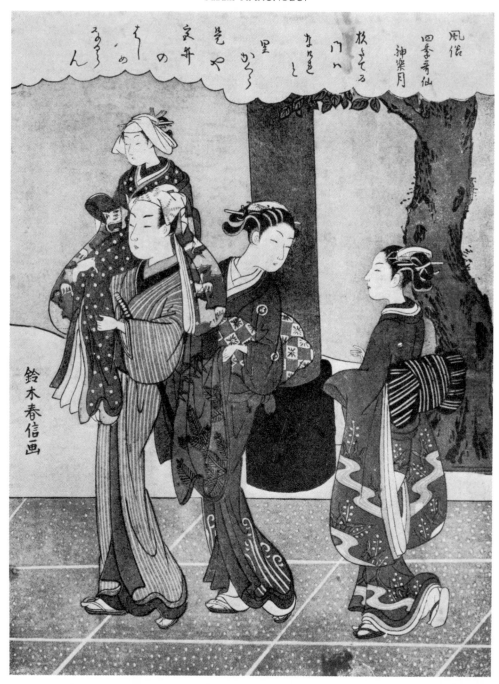

2. From the same series as No. 1. Taking a young girl to a Temple for the *Miyamairi* ceremony of naming; *Kagura* month. Signed *Suzuki Harunobu*.

(Reproduced from the Happer Catalogue by courtesy of Messrs. Sotheby.)

PLATE 1 (second part)

artistic merit. The best period lay between the years 1760 and 1825 ; after this, with the exception of the work of Hokusai and Hiroshige, it rapidly declined to extinction upon the death of the latter in 1858. An offshoot of the *Ukiyoye* school was formed by the Ōsaka school, founded about 1820 by the pupils of Hokusai and Kunisada. It produced actor-portraits, theatrical subjects, and landscapes, and also, more particularly, *surimono*.

Ōsaka prints may be recognized by a certain hardness of outline and cold brilliance of colouring, very different to the crude garishness of the productions of Yedo after 1860, combined with very careful printing. A print by an artist of this school, Utagawa Sadamasu (*w.* 1830–1845), a pupil of Kunisada, is illustrated at Plate 6, page 56, and shows clearly these characteristics. The outline is very hard and sharp, giving the effect of a picture in a vacuum, while even in a monochrome reproduction the cold brilliance of the colours is evident.

Another characteristic of the Ōsaka school is the employment of metallic lustres, and a liberal use of embossing, processes generally confined to the printing of *surimono*, but which artists of this school often adopted on ordinary full-size prints.

Their activity lasted from about 1820–1850 ; after this the school fell into disrepute, eventually equalling, even if it did not surpass, the late crudities of Yedo.

The art of the colour-print artist seems to us all the more wonderful when we remember that, at the time these prints were being produced in Japan, Europe had only the coarsest of picture books and the roughest of wood-cuts to show as an equivalent, while they were sold in the streets of Yedo for a few pence, though there is no doubt the finest cost more than the inferior ones. Could their artists have foreseen the prices which their work commands to-day they might well have dropped dead from astonishment.

Even at the present day no Western pictorial art can approach the artistic excellence, in composition, line, and colour, of these prints produced a hundred to a hundred and fifty years ago ; and it is to be regretted, from an artistic point of view, that the art has been so completely lost.

A new school of artists has, however, sprung up in recent years, but their work bears too much the obviousness of having been produced to satisfy the demand of the foreigner for Japanese pictures.

The best that can be said for this school is that it shows an improvement, at least in colour, over the very bad work of the opening years of the *Meiji* period (1868–1880), when the designs were the veriest travesties of the old work of *Ukiyoye*, though following, in a remote way, its

traditions. It has, also, improved upon the crude and glaring colours which marked the fall of *Ukiyoye*, but they do not compare with those of a hundred to a hundred and fifty years ago. The influence of European art is shown in the greater variety of subjects illustrated, and in the disappearance of the old conventions which have yielded to realism. The engraver shows the same skill in reproducing the artist's design, but there is not the same boldness of outline, nor are the blocks so deeply cut.

Landscape, as such, as Hokusai and Hiroshige depicted it, has disappeared, but at the same time it enters largely into other compositions. Perhaps the best colour-print artist of the modern school is Ogata Gekko.

Yoshitoshi, pupil of Kuniyoshi, was the last artist of the old school, and his life (1839–1892) embraced the period which saw the extinction of *Ukiyoye* and the establishment of the new. In his prime (*c.* 1875) he was easily the foremost artist, and enjoyed wide popularity.

His most celebrated work is his series entitled *Tsuki Hiak'ushi* (" The Hundred Moons "), which occupied him over five years to complete.

In the revival of colour-printing by the methods employed by the *Ukiyoye* school, the chief difficulty, even after the requisite skill in cutting the block has been acquired after years of patient labour, seems to be in the actual printing. Such European and American artists as have produced prints *more japanico* have generally been obliged to employ a Japanese printer to take the pulls.

It is interesting to note that a revival of the art of wood-engraving and printing *more japanico* is on foot in England at the School of Art, University College, Reading, where it is now being taught by Mr. Allen Seaby. The blocks are coloured by hand with water-colours, and the impression taken by hand-rubbing. The craft is still too much in its infancy to forecast its future, but if it revives in this country the (practically) lost art of wood-engraving, which has been killed by photography, it will serve a good purpose. If an exhibition of the craft of the School could be shown in the Department of Wood-Engraving and Illustration, at the Victoria and Albert Museum, South Kensington, it would be much appreciated by students and others interested in the process and would also help to revive the art.

No art has had such a meteoric career as that of the Japanese colour-printer. Taking 1745 as the earliest date of the true colour-*print*, in which the colour was impressed from blocks as distinct from colour applied by hand to the print itself, it reached its zenith during the period of Kiyonaga and his contemporaries down to the death of Utamaro in 1806.

It remained more or less at its high level of excellence till about 1825, after which date the decline set in surely and steadily, ever hastening with greater rapidity to its downfall as each year passed. For a brief period the

advent of Hiroshige arrested the decline, but his genius only threw into sharper relief the inferior work of his contemporaries, who almost without exception began to copy him, in compliance with the insistent public demand for prints *à la Hiroshigé*. It became practically, if not actually, extinct upon the death of Hiroshige in 1858, thus flourishing for a period of but a little more than a century.

The practical extinction of the art of colour-printing in Japan was due to various contributory causes : the decline in artistic taste of the common people, who were satisfied with coarse actor-portraits and shrieking colours ; the higher cost of living towards the middle of last century—low as it was according to European standards—so that the artisans could not produce them at the price people were accustomed to give for them ; a demand for things European, coupled with a neglect of their own arts ; these finally brought about the extinction of the *Ukiyoye* school. Also, the revolution of 1868, when the whole country was in a turmoil, gave the death-blow to the old Tokugawa feudalism, and under its ruins buried all art and humanity, inaugurating an era of gross materialism and one most inartistic. It is hardly surprising, therefore, that the artists, under such conditions, failed to obtain sufficient support, and were, in consequence, obliged to seek a livelihood elsewhere.

" Ancient culture and modern civilization are mutually exclusive notions ; Japan has chosen the latter path. . . . That choice, however, compelled her to renounce her past completely, more completely even than Europe, which has been spared such an abrupt transition." (Von Seidlitz, in *History of Japanese Colour-Prints*.)

While, no doubt, the technical skill has survived, it has been nullified by the use of imported European aniline colours, while the soft, fibrous, and silky nature of the paper has also gone. The beautiful and glowing colours in old Japanese colour-prints are largely due to the nature of the paper, and particularly to its highly absorbent character.

Such, in brief, was the career—short but glorious—of the school of artists which has given us the most beautiful pictorial art ever created, an art, too, evolved and perfected by a purely artisan class.

One may look in vain through an art gallery or an academy exhibition to find a single picture possessing even one of the first principles of true art. Any old Japanese colour-print, which originally sold for but a few pence, perhaps, in the streets of Yedo, will possess them all ; perfect in composition, line, form, and colour. (See foot-note on next page.)

" There are no coloured engravings in the world that may be compared with those of Japan in the long period from the coming of Torii Kiyonaga to the passing of Toyokuni ; the eye is beguiled by a brush-stroke of ineffable calligraphic beauty and by a tender harmony of colour that cheers

but never wearies the senses. In most of the popular broadsides of this time an almost feminine gentleness pervades the choice of motive and its treatment. . . . As schemes of dramatic decoration they are scarcely to be surpassed, and have rarely been equalled ; and the time is not far distant when the sheets which brought to artist and engraver the pittance of a mechanic, and were sold for a vile price in the streets of Yedo, Ōsaka, and Kyoto, will rank in the estimation of the collector with the master-pieces of the engraver's art." (W. Anderson, in *Japanese Wood-Engravings*. London, 1895.)

It is, perhaps, hardly necessary for us to add that the time has indeed come, and that each day adds another student to the ranks of those who can appreciate what true pictorial art is, thus confirming the judgment of one to whom collectors in this country are much indebted as a pioneer in the comprehensive study of the art of *Ukiyoye* as an element in our culture.

Note.—Colour-prints, actually, were only sold in the streets of Yedo in the early *Kioho* period (1716–1735) by hawkers called *Beniyè Uri* (" vendors of *beniye* "). These vendors are depicted in early illustrated books of this period. It was not till Harunobu's time that print-publishers' shops made their appearance, and from then onwards prints could only be bought in shops, though the common toy pictures continued to be sold in the streets. (*Vide* Kyoden's *Kottoshu*.) Another form of cheap print was the stencil-print, a method of printing borrowed from China, and used by the Japanese in imitation of painting. The process, however, was never used as an alternative to wood-engraving to any extent, and was chiefly confined to artists of Kyoto and Ōsaka, the last part of the eighteenth and early nineteenth centuries. They were often given away as advertisements, particularly by medicine vendors.

CHAPTER III

ON THE FORMATION AND CARE OF A COLLECTION

Growth of Interest in Japanese Prints—Cost of Forming a Collection—Chinese Colour-Prints—
The Landscape Prints of Hiroshige—How to Repair and Mount Prints—Their Value—
The Care of a Collection—Public v. Private Collections—Cataloguing a Collection.

THE collecting of old Japanese colour-prints, formerly the hobby of a select few, is to-day finding an ever-increasing number of votaries. As their beauty and charm become more widely appreciated, so do more art-lovers desire to possess them. The result is that prices, particularly for prints by the early masters—known as the Primitives—and for rare examples of later artists, have been greatly enhanced within recent years, so that to form a collection of the first rank nowadays would require very ample means. Added to this is the fact, already referred to in our introductory chapter, that collectors in this country, owing to the later period as compared with their French and American confrères at which the serious study of these prints was first taken up in England, have a more limited field of choice.

The would-be collector, however, whose means are limited, need not at once conclude that it is hopeless for him to gratify his desire to acquire these artistic treasures. Thanks to their enormous production originally, no pictorial art covers so wide a field as that of the Japanese colour-print, nor can any other offer such a varied choice, so that almost any taste and any purse can find material wherewith to form a collection.

By the exercise of care, and by seizing opportunities as they occur, a collection can be formed for a relatively modest outlay which will be a perpetual source of pleasure to its owner and his friends. The one point to bear in mind is that discrimination is the essence of all collecting ; aim at acquiring copies as near their pristine state as possible, unless a print is some great rarity, when a relatively inferior copy, that is somewhat faded or discoloured, may be preferable to none at all.

Collecting is an art in itself ; time and experience alone, aided by a certain amount of native intuition, will tell a collector what to acquire and what to reject. What constitutes collecting depends on the point of view from which it is regarded.

There is vicarious collecting in which people employ others to collect for them, a system of mere accumulating which anyone without any

knowledge of the subject, but with sufficient money, could follow. The true collector, on the other hand, is anything but an accumulator, but is one who makes his own purchases at first hand with the discretion which his knowledge and experience give him, and who has learnt to recognize opportunities when they occur and when, again, he can afford to wait.

Further, personal taste is of more moment than mere value. To some Sharaku's actor-prints, for example, which are extremely rare and cost anything over forty or fifty pounds apiece, will appear as masterpieces to be had at all costs ; others will think them merely ugly caricatures, and much prefer a good landscape by Hiroshige at as many shillings.

It is of course desirable, as far as one's means will allow, to have examples of all types and periods, even by relatively minor artists, for the sake of study and comparison. When one has acquired, as a foundation, a collection of, say, a hundred and fifty to two hundred prints of moderate price, up to five pounds each, one can then become more discriminating, and purchase only an occasional fine example by such artists as Kiyonaga, Shuncho, Koriusai, Harunobu, Yeishi, Shunsho, and so forth, and the rarer prints of Hokusai and Hiroshige. Many a collection has been improved by throwing out the inferior choices of early days.

A. Davison Ficke, in his *Chats on Japanese Prints*, gives the following advice to the collector. He gives a list of thirty-two artists as being amongst the most notable, and says : " Each one in the list is important, and a collection that contained even one fine example by each of these designers would represent very fairly the whole scope of the art. In fact, *the beginner will not go far astray if at the outset he confines his purchases to the work of the men here listed. . . .*"

While this advice is perfectly sound up to a certain point, we beg leave to criticize more particularly that statement in it which we have italicized, on the following grounds.

Of the thirty-two names in the list more than half are so rare that many a collector has had to wait several years before the opportunity has occurred to acquire even a single example of their work ; to others, perhaps, the opportunity may never come.

Also, to form a collection by only acquiring masterpieces presupposes a knowledge and discrimination which a novice cannot have, and which can only be acquired by experience. It also assumes that the beginner is not hampered in his choice by being obliged to restrict his expenditure, but is prepared to give fifty pounds or more for a single print, if necessary. Of the remaining names, four can be readily acquired by a beginner, viz. Hiroshige, Hokusai, Toyokuni, and Utamaro. Four others, Kiyonaga, Harunobu, Toyohiro, and Yeishi, require the exercise of patience and opportunity in varying degree for their acquisition.

We consider it more practicable advice for the amateur to start his collection with good examples of the lesser artists, and then later, with these as a basis, to become more discriminating, and restrict himself to the really important masters in Mr. Ficke's list, otherwise he will find it difficult to make a beginning.

It is but fair, however, to quote Mr. Ficke further, as he makes it clear that to obtain examples of the thirty-two artists he mentions is not an easy matter. He says : " A collection containing a really brilliant example by each of these thirty-two men would cost from three hundred to three thousand pounds to bring together, depending upon the quality and importance of the prints selected." At the same time, we still consider his advice more appropriate to the mature collector than to a novice. Mr. Ficke's book, which was published both in America and in this country, embodies the views and aims of American collectors, and is more particularly addressed to them. As we have stated in an earlier chapter, American collectors are more fastidious in what they admit to their collections, and have had better opportunities than their confrères in this country for the exercise of such discrimination.

The period at which the Japanese colour-print was at its best, the golden age of the art, lay between the years 1765 and 1825, that is, from the time of the invention of the true polychrome print, about 1765, under the sway of HARUNOBU, down to the death of TOYOKUNI I. This is, perhaps, extending the period to somewhat greater limits than is usually allowed, 1806, the year of Utamaro's death, being generally considered its end. While, however, it is true the art showed signs of decay as early in the century as this, particularly in the later work of Toyokuni, yet certain of Utamaro's pupils, and other artists, continued to do fine work even after the death of the latter, so that we have considered it legitimate to extend it to about 1820, taking the date of Toyokuni's death (the leading artist after Utamaro) as a definite landmark. After this event the decline of *Ukiyoye* became really pronounced.

Even this era of sixty years was not equally brilliant throughout. It rose to maturity, remained there for a few years and thence gradually declined. Its most notable epoch lay between the years 1785 and 1800, during which there existed a rivalry of all the greatest talents of *Ukiyoye*— Shunsho, Shuncho, Kiyonaga, Utamaro, Sharaku, Chōki, Yeishi, Toyokuni—to mention some of the chief.

Examples of the work of this half-century can still be obtained at quite reasonable prices, some of course more readily than others ; but a collector should have little difficulty in acquiring a fairly representative set of prints issued between these dates.

[19]

The varying degree of readiness with which prints by the foregoing artists may be obtained, and their approximate value, will be indicated later when dealing with them individually.

The writer's experience is that, amongst non-collectors, the impression prevails that the collecting of Japanese prints is an expensive hobby, and many would-be collectors are consequently afraid to indulge their artistic tastes therein. To remove this conception is one of the objects of this chapter.

While, speaking generally, the values of Japanese prints have, in common with other *articles de vertu*, risen considerably since the day when they could be had for as many shillings as they now fetch pounds, they are still, in proportion to their artistic merit and the pleasure they give to the collector and his friends, far cheaper than any other form of collecting wherein a person may indulge to satisfy his artistic tastes.

It has been stated to the writer that Japanese print-collecting has had its day, and its place is being taken by Chinese prints. Apart from the question whether Japanese prints are becoming less sought after or not, there is one fact which negatives this statement forthwith, and that is the extreme rarity of Chinese prints, which, apart from those in books, are almost unknown. The collection of these prints in the British Museum runs to but seventy examples, of which about half are in colours, and are mostly book-illustrations, yet it is probably the best collection of its kind in existence.

Of this collection Mr. Binyon, in his Introduction to the *Catalogue of Japanese and Chinese Woodcuts in the British Museum*, says : " The few specimens described in this catalogue were obviously cheap and ephemeral productions ; so cheap and common, in fact, that no one thought them worth collecting ; and for that reason, like old broadsides with us, they have become excessively rare. The popular theatre in China, as in Japan, created a demand for colour-prints illustrating or advertising favourite plays. . . .

" The finest known examples, however, of Chinese colour-printing are the woodcuts of flowers, fruit, birds, etc., described in this catalogue, which have been in the museum since its foundation. In these woodcuts, which are in a brilliant state of preservation, as many as twelve colours are used, and ten further tints obtained by super-imposition. *Gauffrage* is also employed with rich effect."

These prints, which are presumed to have been brought from Japan by Kaempfer in 1692–1693, originally belonged to the collection of Sir Hans Sloane, which formed the nucleus of the British Museum.

Chinese polychrome prints, therefore, were produced considerably earlier than their first appearance in Japan ; in fact the Japanese discovered

nothing in the process of the evolution of the colour-print which had not been known in China many years previous. There is, however, this great difference between Japanese and Chinese colour-prints. While the Chinese were first in point of time, they never brought to such a degree of excellence the combined art of designer, engraver, and printer which the Japanese did. The best Chinese colour-prints are simply reproductions of paintings ; in Japan, on the other hand, there arose a whole school of artists who designed expressly for the wood-engraver. It is this fact which raises the Japanese print to an altogether higher level than the Chinese, both from an artistic and technical point of view, and it is an additional reason, we think, even if that already given was insufficient, why we may doubt that it is likely to be supplanted in the estimation of art-lovers by the Chinese product.

As stated above, Japanese prints can be had at all prices, from a few shillings to many pounds.

While low-priced prints contain much worthless rubbish, excellent landscape subjects by Hiroshige can be obtained for two to five pounds, and sometimes less, provided discrimination is used, as there is much work (generally late reprints) bearing his signature on the market printed *after* his death, which is better avoided.

A comparatively cheap print, provided it is a genuine old one and in good condition, is preferable, from an artistic point of view, to a modern reproduction of a rarity.

It is difficult to give any general indications as to what should be paid for prints ; the amounts given here can only be taken as a rough guide. Much depends on circumstances, and everything on condition and quality of impression. According to its state, a print might be worth fifty pounds, five pounds, or only two pounds. Good first edition copies of prints by Hiroshige may sometimes be picked up for twenty-five to thirty shillings each, for which twice that sum might be given in the auction room under certain circumstances ; but the collector who obtains a really fine Hiroshige print from one of his rarer series in good condition for less than three or five pounds is lucky.

Prices obtained at auction sales are apt to be misleading unless the prints sold are seen, and other circumstances known ; at one sale competition might happen to be keen, at another the opposite might be the case.

There is an enormous number of inferior Hiroshige prints in existence which, from an artistic point of view, are of very little value. So great was the demand for his work as a landscape artist (due chiefly to the fact that,

for a certain period, from 1842 to 1853, prints of courtesans and actors were forbidden by law) that, in order to produce prints in sufficient quantities, the printing was hurried, so that the outline and colours did not register, neither were the colours well graded.

Again, many of his prints were reprinted in subsequent editions after his death, when the blocks had become worn through constant use, or were recut from an old print, and when European aniline colours were becoming much used in Japan. Such late editions and reprints can be readily detected by the coarse outlines and vicious, staring colours.

Prints of this nature will frequently be met with in his " One Hundred Views of Yedo " series, almost the last work he executed. Copies of the first edition, in fine state, are comparatively rare, and out of the total of 118 prints in the complete set only about a third of them can be described as masterpieces in which the design, printing, and colouring are excellent. Many, however, are inferior, notwithstanding the fact that Hiroshige himself regarded the series as a whole as the " masterpiece of his life," as he so states in the title-page, while certain plates, such as the inane " rear view of a horse " or the " boatman with the hairy legs," and a few others equally catastrophic, are evidently the work of his pupil, Shigenobu (afterwards Hiroshige II), whose aid he sometimes called in, as it seems impossible from their crudeness to imagine that they can be the work of the great master. These remarks also apply to certain views in his final series, " Thirty-six Views of Fuji," a series which he did not live to see completed, and also to his " Sixty Odd Provinces " (1856), and " Views on the Tokaido " (upright, 1855). This last-named series, however, is generally recognized nowadays as mainly the work of Hiroshige II, though the master signed it when completed. This fact accounts for the poor design of certain of the views in it ; well and carefully printed copies are rare, whereas poor ones, with crude colouring, are common. In fact, almost all the later work of Hiroshige bears evidence of the handiwork of his pupil, who seems to have been called upon from time to time to assist his master, owing, no doubt, to the very large number of plates contained in certain of the series, or perhaps from temporary incapacity through illness ; such work is known as *daihitsu* (" drawn for another ") or *hohitsu* (" assisted by pupils ").

Mr. Happer, of New York, was the first collector to investigate thoroughly, chiefly by the date-seal found on each print, the question of the authorship of the various upright series signed Hiroshige. Previously it was thought *all* vertical prints so signed were by Hiroshige II, but this view is now generally abandoned, at least in Europe, though judging from sale catalogues of auctions in New York which have been examined, many such series are still (though wrongly) attributed to the pupil in America.

HIROSHIGE (Ichiryūsai).

(1). Kanagawa on the Tokaido ; No. 4 of the "Fifty-three Stations" (*see page* 80).

PLATE B (first part)

HIROSHIGE (Ichiryūsai).

(3). "Theatres by Night, Young Monkey Street"; one of
the "Hundred Views in Yedo"; First Edition, 2nd State
(see page 173).

(2). The Chofu Tama River, Musashi; one of a "Tama
River" Series *(see page* 152).

PLATE B (second part)

Prints in which some large object, such as a tree-trunk, the mast of a ship, the body and legs of a horse, is thrust prominently into the foreground, blotting out the view, and thus spoiling the whole effect of the picture, may generally be ascribed to Hiroshige II ; the method of indicating the foliage of trees may also sometimes serve to distinguish between master and pupil. Prints of this nature often occur in the " Hundred Views of Yedo " series, which, being the most extensive, contains a larger proportion of the pupil's work. His best contribution to this set is Plate 48, *Akasaka Kiri bata*, which he supplied to later editions to take the place of the original block by Hiroshige, which was accidentally destroyed, probably by fire. It is signed " Hiroshige 2nd," and is considered amongst his best work. It may be distinguished from the first edition, which is very uncommon, by being a rain-scene.

In all the foregoing series first edition copies *only* are those worth collecting, later issues being of little value, either materially or artistically. First edition copies in perfect state are comparatively rare, whereas later and inferior impressions outnumber them at least fifty to one, perhaps a hundred to one. The former may be recognized by being carefully printed and the colours well graded. Later impressions often have an entirely different colour-scheme, while the repellent harshness of the colours, often from European aniline dyes, betrays them at once.

In the " Hundred Views of Yedo " series, the date-seals will be found on the margin of the print (see Plate 28A). Sometimes, as when prints of this series have been mounted in a book, the margins will be found to have been trimmed, thereby entirely or partly cutting off the seals ; an otherwise perfect impression may thus be spoilt.

And here let us add a note of warning : never cut or trim prints in any way. To cut down, or in any other way mutilate, a print or picture is one of those unforgivable offences which go to prove how easy it is for a vandal to spoil in a moment what may have been an inspiration of the artist, quite apart from the spoiling of the harmony of the design. It is bad enough to cut down a margin that is blank ; to do so when there is a design or mark on it is doubly so. Prints are so often found thus mutilated, that this warning seems very necessary.

Torn or rough edges may be covered by a mount ; holes in the print itself can be patched from the back, and for this purpose an old worthless print can be kept from which pieces of the right colour can be cut wherewith to make repairs. But beyond this a print should not be touched in any way, and if the collector confines himself to selecting only copies in a good state of preservation, there should be no necessity to do more.

Dirty or creased prints are improved by immersion in water, but they should only be left in long enough to become soaked right through. They

may also be damped and pressed between clean white blotting-paper, which should be changed several times until the prints are dry. Wet prints should be handled very carefully, else they are easily torn, particularly if they are very thin. They should then be allowed to drain, and afterwards spread out to dry on a flat surface, such as a clean sheet of white cardboard. When dry, it will be found all creases have disappeared. If pressed between two pieces of board, some of the colour will soak out. Most colours are fast, but the blue in the later prints of Hiroshige, and the purple often found in prints by Utamaro and Toyokuni, are liable to run, particularly the latter colour. *Surimono*, which contain colours from metals, and which sometimes have a very delicate blue tint, known as *surimono* blue, should not be wetted at all.

But the novice should not touch a print in any way nor attempt repairs unless he is quite sure beforehand what he is going to do and how he is going to do it. If at all uncertain of what the results may be, he should practise on an old worthless print kept for making repairs with. But if a print requires touching up in any way, it is best to leave it in the hands of some-one competent to handle it. Even the apparently easy process of mounting a thin print on another sheet of Japanese paper to strengthen it, is by no means as easy as it sounds if it is to be done smoothly.

In mounting prints, the print should be lightly pasted at the two top corners to a sheet of good drawing-paper, and a white board mount (size 22 in. by 15 in.) put over it with an opening to fit the print. This is the most effective method of mounting prints if they are to be framed ; but as a collection increases and the prints are kept in portfolios or cases, such mounting will make them very heavy, and necessitate several cases in which to keep them.

It is then better to put them between a folded sheet of thick drawing- or cartridge-paper, with an opening cut in the top sheet to show the print ; this will effect a great saving in bulk and weight.

It is a mistake to paste down each *edge* of a print to its mount, in order to keep it smooth and flat. This procedure, owing to the print and the mount being unequally affected by the dampness of the atmosphere, does not always have the desired effect ; while a future collector into whose hands the print might come might object to this treatment, and injure the edges in separating them from the mount. It is not unlikely that the cause of so many prints being found with the whole margins cut off is due to their having been at one time pasted down in this fashion, and were so cut to remove them.

But the chief objection to this practice is that it prevents an examina-tion of the back of the print, an important point when testing for genuine-ness. It is sufficient to very lightly paste down the two top corners only ;

the paper can then be turned over and properly examined, if necessary, and the print can be detached easily without injury.

The best method, and the one adopted by the writer, and which allows removal as often as necessary without any injury to the print, is to affix the two top corners to the mount by means of a thin paper hinge such as stamp-collectors use to mount stamps in albums.

Owing to their size when complete, triptychs are best kept separately like single prints, and so mounted that they can be put side by side to show the complete picture when being inspected.

Seals, and other marks on the margin of a print, outside the picture itself, should not be covered up, but the mount should be cut to show them.

In the " Sixty Odd Provinces " series the seals appear sometimes on the print itself, and sometimes on the margin (see Plate 26, page 158).

The vertical " Tokaido " set has the date-seal and publisher's seal on the print itself, as has also the " Thirty-six Views of Fuji " series.

While on the subject of date-seals, it should perhaps be pointed out that the seal *by itself* does not necessarily prove a print to be a first edition copy. Copies of many dated prints, particularly in the " Hundred Views " series, are met with which, by the poor printing and crude colours, cannot be first edition copies. As the date-seals were cut on the block at the time it was engraved, and not stamped on the finished print after being " pulled " from the block, the date thereon is no evidence as to the time of *printing*, which is the point of importance for the collector.

A dated print, therefore, should be judged by its condition to determine if it is a first edition or not ; that is to say, the printing should be well done, the register good, the colours carefully graded and not staring aniline dyes. At the same time, a collector who sets out to obtain a complete set of a series must not expect to find even all first edition copies of uniform excellence ; the masterpieces are, unfortunately, few. This may have been due to the artist superintending the printing of those views only which pleased him most, or which he thought would be more popular.

To revert to the question of prices, experience is the only real guide as to what should be paid for any particular print. Provided a print is in good condition, colours fresh, outline sharp, paper not discoloured nor worm-eaten, it is as a rule worth its price. Fresh colours, however, are not in themselves evidence of an early impression. As a block required recharging with fresh colour after each impression, a late impression might easily show good colour : one should look instead at the sharpness of the outline, though even this cannot always be taken as a sure guide owing to the practice of recutting old blocks (or revamping as Americans call it),

whereby the outline will appear as sharp as from a new block. In such cases comparison with an undoubted early impression is the best test, when small differences of detail will be noticed, coupled with a different colour-scheme. Thus sharp copies of Hiroshige's " Tokaido " views have proved on close inspection to be merely late reprints from revamped blocks which seemed at first sight to be early impressions. Reprints of this particular series are very common, and they may be detected readily by the very thick border line round them. Revamped prints are the bugbear of the collector till he has acquired sufficient experience to detect them.

Poor copies, in which colours are badly faded or the printing is faulty, or in which other defects are apparent, are best left alone, unless the print is some rarity, when moderate defects may be overlooked, though of course the reason for its rarity should be kept in mind.

Thus, Kunisada's portrait of Hiroshige is rare, not only because of its actual scarcity, but because such copies as are in existence are highly coveted by collectors by reason of the subject, and therefore rarely change hands. This particular print, therefore, is valued more by reason of the subject it portrays, than because of the fact that it is by Kunisada, whose prints are amongst the commonest.

A print by an artist not in the first rank, or by one of whom little or nothing is known, even though examples by him are very uncommon, is not necessarily of a high value. Thus, work by Yeishin, for example (a print by whom is illustrated in colours at Plate C, page 32),* a pupil of Yeishi, which is even rarer than that of his master, is not rated at as high a value as its scarcity and merit would lead one to expect.

In the same way, the collector may be fortunate to pick up an example by the artist Chōki for a sum very modest in comparison to the rarity of his work, notwithstanding the fact that he is a foremost artist. His very rare silver-prints, however (that is, prints with a silver background), are very highly treasured, and must be numbered amongst those desirable art objects which the average collector will probably never have the opportunity to acquire.

Fashion seems, in some degree, to determine the value of certain prints. There will, perhaps, be a boom in a particular artist at one time ; yet at another values will drop for the same examples. The rarer and really fine prints, however, will always fetch their price, and will always increase in value as time goes on. The writer, however, does not, on this assumption, advocate collecting as a source of investment. While, no doubt, a collection made with care and discrimination will also prove a good investment from a material point of view, if these prints are not acquired for the pure pleasure of their beauty and charm, they are better left alone. Otherwise the perception to sift the good from the bad will be lacking, and without such

*Reproduced in black and white in this edition.

discrimination no collection is likely to give any real pleasure to its owner or ever be worth much.

The two chief points to be considered in the value of a collection are (1) rarity of the specimens, and (2) their condition.

As to (1) rarity is not, as is often imagined, a question of age, but of quantity. Many people seem unable to grasp this simple fact, but think that because a print is old it must be rare, and therefore very valuable.

Rarity, however, in its turn, must not be confounded with value, a quality which often depends on the foibles of fashion, or because a particular artist happens to be in vogue at the time, quite apart from the rarity, or otherwise, of his work. It sometimes happens, therefore, that a relatively common print will fetch a higher price than another scarcer example.

And here again it should be pointed out that scarcity does not necessarily depend upon the number of copies originally printed, but upon the *number available in proportion to the demand* for that particular print. This fact—the *demand* for a print—accounts for the relatively low value of a print which is really rare by virtue of its actual scarcity (such as the example by Yeishin mentioned above) as compared with another of which many copies still exist but for which there is keener competition.

The collector should remember, however, that the second quality—condition—is the more important of the two, and he should aim rather at obtaining prints in as fine condition as possible in preference to mere rarities. Should he have the good fortune to procure a print combining both qualities, he will have attained the highest desideratum of every collector.

Though there are some people who prefer faded or discoloured prints, because of the mellowness thereby imparted to them, this point of view is, we think, a mistaken one. The chief object of a collector should be to obtain prints as near as possible in the pristine condition in which they left the printer's hands, so that we may see in them the artist's individuality. To prefer discoloured or badly faded prints (slight fading due to age is not detrimental, as the colours all tone in an equal degree) to fresh ones is akin to choosing a piece of cracked porcelain in preference to a perfect specimen.

Certain colours, however, particularly in prints by the earlier artists, undergo a complete transformation in course of time. Thus a certain blue may change to a light yellow ; pink, one of the most fugitive colours of any, fades altogether. White—but very rarely used—and a certain orange-red (*tan*), both made from lead oxide, turn black with exposure. A rose-red, used in the early two-colour prints, like that illustrated at Plate G,* may turn a yellowish tinge.

An instance of the rare use of white as a pigment is given in a well-

*Reproduced in black and white in this edition.

known snow scene by Hiroshige from the very rare series " Eight Views of
the Environs of Yedo " (*Yedo Kinko Hak'kei*), " Evening Snow, Asuka
Hill," in which, owing to decomposition, the flakes of snow, originally
white, have turned black.

Surimono, in which colours were employed made from metals, e.g.
silver, gold, and bronze, are even more susceptible to light, and extra care
should be taken to preserve them in all their original brilliance.

For this reason, therefore, it is best not to keep prints—and certainly
not the better examples in a collection—hanging on a wall for any length
of time, and under no circumstances to allow bright sunlight to fall on
them. If a collector wishes to decorate his walls with them, they should
be hung where no bright sun will fall on them, and they should consist of
comparatively cheap examples of which large numbers exist, so that
should they fade in course of time, no particular material or artistic loss is
occasioned.

The better and more valued treasures in a collection, particularly if
they are unusually good copies, should be kept out of the light in portfolios
or suitable cases. For the collector should remember that he is laying by
treasures for future generations ; that these prints represent what is a lost
art ; and that as time goes on they will become scarcer and scarcer. Upon
the care, therefore, expended upon their preservation to-day will depend
the enjoyment of art-lovers of future generations.

Japanese colour-prints are, by their peculiar nature, far better in the
hands of private collectors than in public museums and institutions where
they do not always receive the care which is their due, and it is, perhaps,
to be regretted that such a large proportion of the number of prints still
in existence are held in museums, and continue to find their last resting-
place therein, either by purchase or bequest.

If they are hung in galleries exposed to sunlight they fade and will in
time disappear altogether, while the general public will pass them by as
something they neither appreciate nor understand. They are, of course,
readily placed at the disposal of the interested enquirer, but the proportion
of collectors and students who are able to avail themselves of the oppor-
tunities they offer must be limited.

For their study and proper appreciation, Japanese prints require constant
examination and comparison at the hands of those who take a close interest
in them, and they can only receive such study in private collections ; in
museums they are lost as in a tomb as far as the collector is concerned,
while to the general public they are a matter of indifference.

This opinion (and one that was held by the late Edmond dè Goncourt),
that prints are better in a private collection than in a public museum, has
been criticized on the ground that there are many people of taste who

cannot afford to be collectors, and who manage to get much real pleasure out of a museum. The writer would be the last person to quarrel with this statement, but while museums are most appropriate for the display and study of art objects in general, they are not, for the reasons given above, a suitable repository for colour-prints, even when special precautions are taken for their preservation.

Mr. Ficke, already quoted above, expresses similar opinions as the writer as to the desirability of prints being in private collections rather than in a public museum. He says : " In public collections the prints are of service or pleasure to almost nobody ; while in the private collections their service and pleasure to the owner and his friends is great, and the same opportunities are easily opened to any one who is qualified to profit by them. Therefore it seems better that, upon the death of a collector, his prints should be sold ; in order that, as Edmond de Goncourt directed in the case of his collection, those treasures which have been so great and so personal a delight to the owner may pass on into the hands of such others as will find in them the same satisfaction." " ' My wish is,' he wrote in his will, ' that my prints, my curios, my books—in a word, those things of art which have been the joy of my life—shall not be consigned to the cold tomb of a museum ; . . . but I require that they shall all be dispersed under the hammer of the auctioneer, so that the pleasure which their acquisition has given me shall be given again . . . to some inheritor of my own taste.' "

It is interesting to note that this view of museums is also held by certain collectors of old books, which, like prints, they consider are better in private hands than in public institutions. Mr. Edward Newton, a distinguished American bibliophile, and author of *The Amenities of Book Collecting* (London, 1920), is another collector who is of the opinion that de Goncourt was right in instructing that his art treasures should be publicly dispersed.

Old books, like old prints, are of little interest to the public at large and even less understood, and their dispersal at auction is not only more in keeping with bibliophilism, but helps to extend a personal interest in old volumes, which results from change of ownership.

The same principle was adopted in the dispersal of the great Huth library, for while the British Museum was allowed to select fifty volumes (a mere fraction of the huge total) which should rightly be in their keeping, and so prevent their leaving this country for America or elsewhere for all time, the remainder of the collection was dispersed by auction amongst collectors and booksellers at large.

As to the best method of cataloguing a collection, particularly one

which is being added to from time to time, the writer, after trying various methods, has found a loose leaf book (size 4 in. by 7 in.) the best, in which each print has one page allotted to it, containing all information, such as title, when and where obtained, and so forth. Each print as acquired can then be entered in the catalogue in its proper place, under its particular artist, and in its correct series, if it belongs to a set such as Hiroshige's " Tokaido " views, or Hokusai's " Views of Fuji." Abbreviated particulars are also entered on the bottom of the mount under the mat, and prints are numbered consecutively as acquired.

CHAPTER IV

FORGERIES, IMITATIONS, AND REPRINTS

Modern Reproductions and their Detection—Crêpe Prints.

AS is the case with almost anything a person may collect as his fancy dictates, the collector of old Japanese colour-prints has to be on his guard against forgeries, reprints, and modern reproductions.

There is nothing to be said against reprints or reproductions which are honestly sold as such ; the danger is they may be used by the unscrupulous to deceive the unwary, and the object here is to show how they may be distinguished from the genuine article. Instances are not wanting where certain reproductions have been made with such skill that experts have been deceived by them, until an accidental comparison with an undoubted genuine copy has revealed the fraud.

But instances such as this are rare, and are confined to prints whose rarity (and consequently higher value) make it worth while to go to the considerable trouble and expense involved to produce a facsimile such as will deceive the cleverest. In such instances it will be noticed that great care has been taken to imitate the colours, not as they were when the genuine print was first issued, but as they should be to-day, faded and softened in the course of time, thus rendering their detection all the more difficult. The average reproduction, however, is generally so obvious once its defects have been learnt that no collector need be deceived by it. A golden rule is, if at any time suspicious of a print, yet unable to say exactly why, but feeling by intuition that there is something wrong with it, discard it.

Reproductions, then, are prints taken from a modern wood-block cut from an original print, or from a photographic process block. Generally the former process is the one employed.

Reprints are prints which have been taken from an *original* block, but so long after the block was cut that the outline is coarse and defective and the colouring poor, usually from modern aniline dyes. Sometimes, however, to remedy the defective outline, the block was recut as a facsimile of its original condition.

So long as any of the old blocks are in existence, such reprints are always possible, but comparatively few of the many thousands

which were engraved exist to-day for such use. It is simpler to make reproductions.

Reprints, however, are not a modern invention; it is known the Yedo publishers sometimes sold their discarded wood-blocks to publishers in another town, who skilfully recut them where badly worn, and sold prints from them. As such prints were naturally issued after the death of the artist who originally drew the design for them, they were often artificially aged by exposing to the fumes of charcoal, by means of tea-stains, and dirt. In the absence, therefore, of clear evidence (e.g. a Yedo publisher's mark) as to genuineness, discoloured and worm-eaten prints should be suspect.

Forgeries are, as the term implies, prints produced in the style and bearing the signature of some well-known artist, done either during his lifetime by a rival artist, or after his death.

Practically the only guard against forgeries, particularly against those done during an artist's lifetime, is a close study of his work in prints about which there is no question as to their genuineness, whereby the collector will discern at once, by the characteristics of the drawing, whether it is the work of the master or that of an imitator. Forgeries, however, are rare, and are confined to the work of comparatively few artists. Utamaro, owing to the great popularity he enjoyed, suffered considerably in this respect, so that he was obliged, for the sake of his reputation, to sometimes sign himself " the real Utamaro." However, he only used this signature on prints which had his especial approval, and consequently it is not often met with. One such print is here illustrated at Plate 30, page 182.

Another artist who was considerably forged during his lifetime is Harunobu, particularly by Shiba Kokan, the prince of contemporary forgers ; there are also *modern* forgeries of Harunobu, better, perhaps, described as imitations, while reprints from recut blocks are also in existence, which may generally be detected by the thick lines and inferior colours.

The old publishers did not hesitate to forge the signature of an artist whose prints were in great demand upon prints by another which did not sell so readily. This was accomplished by cutting out of the block the real artist's signature and letting in a fresh piece of wood in exactly the same place with the forged signature of another designer. So neatly was this done that the finished print showed no sign of the block having been tampered with.

To supply the demand for prints by Utamaro, publishers employed the pupils of his school who made use of his signature. But every artist has his own idiosyncrasies, as revealed in the pose of a head, the drawing of the features, the fold of a robe, or the curve of a finger, which cannot be

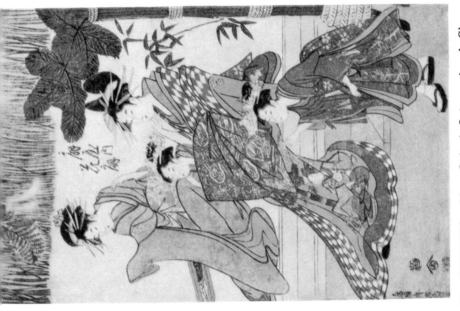

(2). YEISHIN: Hana-Ogi of Ogiya; signed *Choyensai Yeishin.*

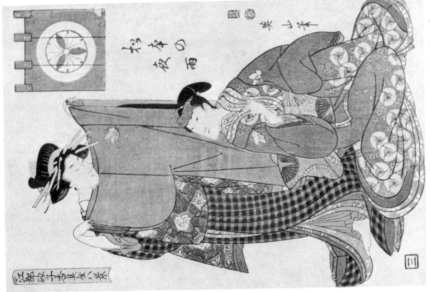

(1). YEIZAN: One of "Eight Views of the Incense Shops of Yedo"; "Evening rain at Matsumoto"; signed *Yeizan*; dated Tiger 8 = 8th month, 1806. Rare and early work.

PLATE C (first part)

Utagawa TOYOKUNI.

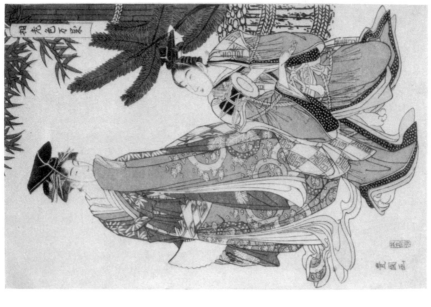

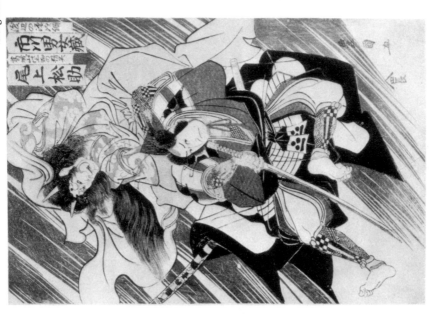

(3). The Actors Ichikawa Omezo and Onoyè Matsusukè in character; signed *Toyokuni* (*very fine work*). (*see page 223*).

(4). *Manzai*, (New Year) Dancers; signed *Toyokuni* (*very fine, early work*).

PLATE C (second part)

exactly copied, and which distinguishes his own work from that of his imitators.

In the same way the collector must learn to distinguish between the work of different artists who used the same artistic name, though not at the same time, as such would have been contrary to professional etiquette. Sometimes, when an artist assumed another artistic name, he bestowed his former name upon his chief pupil, as a recognition of merit ; or, as was more common, the leading pupil adopted the name of the master upon the death of the latter. Such, for example, is the case with Toyokuni, a name which was used by at least five different persons, thus carrying it down to quite recent times. With only three, however, are we concerned here, the distinguishing of whose work, one from the other, may be a source of difficulty to the novice.

Toyokuni I died in 1825 ; Kunisada, his pupil, adopted the name in 1844. There is, therefore, an interval of at least nineteen to twenty years between the prints of these two bearing the signature of Toyokuni, and during this interval prints underwent considerable change in drawing, and particularly in the colour-scheme employed. Toyokuni's colours are soft and pleasant compared to Kunisada's, which, by 1845, were becoming crude and harsh. Another distinguishing mark is that Kunisada's signature of Toyokuni is frequently enclosed in a cartouche, a device *never* employed by his master. It is not, however, so easy to distinguish at first between Toyokuni and his other pupil—and adopted son—Toyoshige, though close study will reveal their different characteristics. Toyoshige, on the death of his master, married his widow, and adopted his name, which he used for the remainder of his career.

The majority of his prints were produced within this period, and are signed either " Gosotei Toyokuni " (in which case no confusion is caused), or merely " Toyokuni." In this latter case, as his prints are much more akin to his master's both in style and colouring, it may sometimes be difficult for the beginner to distinguish between them.

The signature of Toyokuni I, however, is generally more carefully written and in smaller characters, and familiarity with their respective scripts and their individual brush-work, will enable the collector to decide between them fairly readily. Toyokuni's early form of signature is shown in the two coloured illustrations at Plate C,* while at Plate F is an example by Toyokuni II (Gosotei). Kunisada never recognized the claims of Toyoshige as Toyokuni II, as he frequently signed himself *the second Toyokuni.*

To revert to modern reproductions and their detection, both the paper

*Reproduced in black and white in this edition.

on which they are printed and the colours used form a fairly ready means by which they can be distinguished from the genuine old print. Old prints are upon a peculiar paper difficult to describe, but easily recognized with practice, while their soft, mellow colours are almost impossible to imitate. Thanks to modern processes of reproduction, the outline of an imitation can be, line for line, exactly like the original ; but even if the paper should be a close imitation, the colours at once proclaim its modernity and afford the safest guide to genuineness. They are generally flat and muddy in hue, and lack the soft brilliance of the old colours ; in fact, the difference is usually so marked that it seems hardly likely that anyone with an eye for colour and harmony would be deceived by them.

It is, however, a mistake to judge the age of a print solely by its appearance ; that is, if it appears fresh and clean to put it down at once as quite modern ; if faded and discoloured, as old. If there is one thing easier than another to imitate, it is age. Freshness, apart from any other evidence, should never be regarded as a sign of recent printing, any more than discoloured paper, faded colours, or damaged condition, such as worm-holes, are necessarily the adjuncts of an old print. Such, indeed, are the first devices the forger calls to his aid to deceive the unwary. Another source of error in judging the age of a print solely by its appearance lies in the water-lines, which appear in old prints in good, clean condition, and which can be seen in any " laid " paper of present-day manufacture. Prints as far back as 1700 have these water-lines in them. The water-lines in modern paper merely represent the attempt of the present-day manufacturer to copy the Japanese, because genuine Japanese paper is recognized as being the best in the world.

The freshness of a print is due to the fact that it has spent the greater part of its existence stored away with others as stock copies, that is, remainders of unsold editions, and has only been brought to light long after it was printed. The " remainders " of a modern book publisher is no new expedient for disposing of surplus stock. Also it should be remembered that, except for a few specially chosen prints, the Japanese did not expose their pictures, as we do, on the walls of their houses, but they spent the greater part of their existence stored away, and were only brought forth to be looked at on some very special occasion, or for the benefit of an honoured guest. The prints, however, of some special favourite, as Utamaro or Yeishi, were frequently used to decorate the paper screens and partitions which are such a feature of the Japanese home. They consequently suffered considerable wear and tear in course of time, and became discoloured by the fumes from the charcoal fires used for cooking and warming. The writer has seen more Utamaro prints damaged in this way than those of almost

any other artist; in some cases the outline and colour has disappeared altogether leaving only the black mass of a coiffure.

If an old print be held up to the light and looked at through the back, the whole picture will be seen as clearly as from the front, the colours, indeed, if faded on the surface, will appear brighter; in a modern one, only the patches of colour will appear. This is due to the fact that the old paper was absorbent.

The grace and beauty of composition, the excellence in the sweep of the lines, the rich and glowing, yet perfectly harmonious colours, which are characteristic of all old prints, are lacking in modern ones.

In this category (i.e. of modern work) should also be included prints issued between the years 1865 and 1880, in which the technique employed was the same as in genuine old prints. Such prints, by their crude and glaring colours made from aniline dyes, and often careless printing, which shock every artistic sense, may be at once dismissed as worthless. Sometimes, however, the actual printing is very good, the outline being sharp and the register perfect, showing that the technique employed could be as excellent as formerly, but was nullified by the bad colours used.

It was also about the year 1860 that the print on *crêpe* paper first made its appearance, a large number of the later prints of Kunisada, and of his innumerable pupils, being treated in this fashion. Doubtless the process was adopted in order to counteract in some degree the viciousness of the crude colours used from this date onwards, as it certainly has this effect. Modern reproductions are often treated in the same way.

The *crêping* process is carried out on the print itself, several being treated at the one time, and has the effect of reducing it in size by about one-fifth. If a print so treated is damped and then carefully rolled out, it will resume its original size, and the process is remarkable in that every detail of the design is preserved to an extraordinary degree, the reduction being carried out equally in every direction without the slightest distortion.

It is just the prints of the latter half of the nineteenth century of which there is such an abundance to-day, and against which the novice should be warned, as he is apt otherwise, in his newly formed enthusiasm, to imagine that such constitute the famous old colour-prints of Japan.

Such, also, are the prints that a collector who goes to Japan is likely to pick up, when he would do better to confine his activities to London. Japan itself has been ransacked long ago by collectors and art dealers from Europe and America, who have left behind only the late and worthless specimens. The Japanese did not realize, thirty to forty years ago, what art treasures they were allowing to leave the country for a mere song; and now, all too

late, they are regretting their loss, and are endeavouring to buy back at far higher prices, both for private and public collections, the prints they once sold for a few pence.

The result is that, on the average, prints fetch considerably higher prices in Japan to-day than they do in London, though the finer and rarer examples probably realize equally high values in any country where there are collectors.

CHAPTER V

SOME ACCOUNT OF THE ARTISTS OF THE "UKIYOYE" SCHOOL

Kiyonobu to Utamaro.

THE total number of known colour-print artists, from the commencement of the school down to the *Meiji* period (1867), lies between six and seven hundred names. This large number includes artists of varying degrees of ability and productivity, and, considering the relatively short life of the school, gives us an idea of its wide popularity; but the number with which the collector need concern himself is considerably less than this total—a collection which contained examples by half this number would be a very large one.

The art is generally divided into three or four periods: (i) the *Primitives*, from the foundation of the school by MATABEI to the invention of the true polychrome print in the time of HARUNOBU (*c.* 1765); (ii) the second period, from 1765 to the death of UTAMARO in 1806; (iii) the third period, 1806–1825; and the fourth, the decline from 1825–1860. A fifth period, known as the downfall, from 1860 onwards, might be added; but the work of this period is so inferior that it hardly merits attention except, perhaps, from the historical point of view.

Of the above periods, the second and third represent the colour-print at its best, the first being mainly one of development. The fourth period, indeed, witnessed the advent of Hokusai and Hiroshige, who brought new life into *Ukiyoye*, and arrested its decline for a time, but their genius only threw into sharper relief the inferior work of most of their contemporaries.

It is not proposed in these pages to do more than give a brief summary of the principal artists such as are familiar to collectors, and with whose work they are most likely to become acquainted in the process of forming a collection. Fuller and more detailed historical accounts of them and their work are left to other volumes on Japanese prints, which deal with the subject from that point of view, whereas we are more concerned with the subjects they portrayed. Additional facts regarding them will be given when considering their work under the various subject-headings of theatrical prints, landscape, and figure studies. Some names, however, cannot be omitted even in a brief survey such as this on historical grounds, even though their prints are to-day very scarce, and but rarely met with. Other

artists, again, confined themselves to illustrating books, a branch of print-designing somewhat outside our scope.

Amongst the Primitives, MATABEI and MORONOBU have already been mentioned. Then we come to Torii KIYONOBU (1664–1729), the founder of the Torii sub-school, a school which applied itself chiefly to theatrical subjects. He is said to have first been a designer of the large posters or signboards placed outside theatres, and also to have invented the style of scenery still in vogue on the Japanese stage.

KIYONOBU was followed by KIYOMASU (1679–1762), probably his younger brother, whose work to-day is rare.

The third head of the Torii school was KIYOMITSU (1735–1785), son of Kiyomasu. His work forms the connecting link between the two- and three-colour print; though he lived well into the polychrome period of Haru-nobu, practically all his work is of the former type, so that he must have ceased designing early in life. Like other Primitives, his prints are rare, and are in *hoso-ye* form, or as pillar-prints, of which latter he was one of the chief exponents. The beginner should perhaps be warned that Kiyomine, the fifth master of the Torii school, sometimes signed himself Kiyomitsu; but as he used the full palette of colours common at his time, and as his style is quite different, it is easy to distinguish his work from that of the original master.

A print by him, with this signature, is reproduced at Plate XXVIII in the handbook to the Victoria and Albert Museum collection, and the follow-ing plate shows a print by the first Kiyomitsu; these clearly show the different characteristics of these two artists.

Kiyomine's pupil and son, Kiyofusa, who died as recently as 1892, called himself the third Kiyomitsu on the death of his master in 1868; but no prints by him have come under observation, neither has the writer seen any mention of his work. The fourth of the name still lives at Tokyo.

Contemporary with the Torii school was the Okumura school, founded by Okumura MASANOBU (1685–1764), one of the most eminent of the early artists. He was at first a bookseller and publisher, and during his life as a colour-print artist used other names. Hogetsudo is, perhaps, the most frequent, in addition to that by which he is generally known. He is said to have invented the lacquer-print, in which lacquer is used to heighten the colours, and his prints are remarkable for the richness of effect pro-duced with only the use of two colours in addition to the black of the out-line block. These early two-colour prints are always in green and red, but the latter colour is liable to turn a yellowish tint in course of time. A two-colour print reproduced in Von Seidlitz's *History of Japanese Colour-Prints* at page 6 shows the effect produced by this change; while our Plate G, page 204, from a print by Kiyomasu (*c.* 1745), which has preserved its

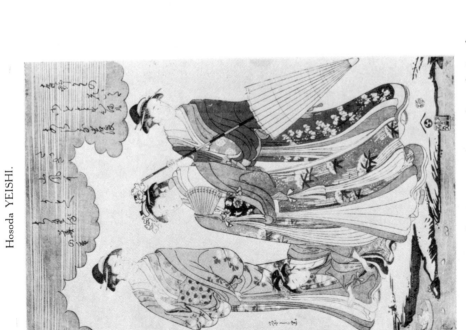

Hosoda GŌKYO.

Hosoda YEISHI.

2. Makinoya of Mitsu Kana-ya on parade; unsigned.

1. Floating cherry-blossom down a stream; centre sheet of triptych; signed *Yeishi*.

PLATE 2 (first part)

Yeishōsai CHOKI.

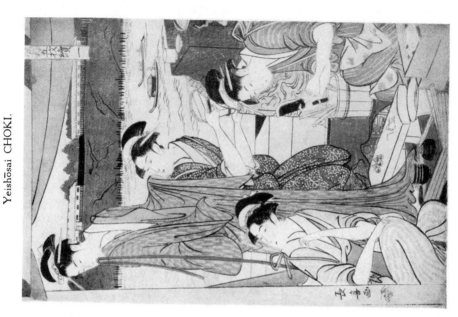

SHUNKO (or SHUNBENI).

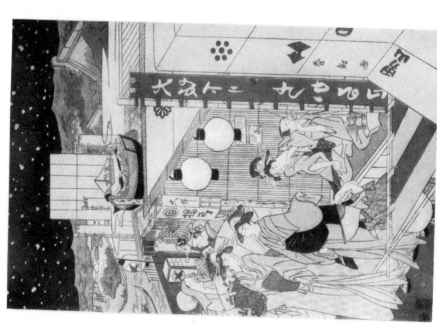

3. Street scene at night; one sheet of triptych; signed *Shunbeni*; dated 4th month, 1807.

4. Pleasure Barge on the Sumida River; one sheet of a pentaptych; signed *Choki*.

PLATE 2 (second part)

original tints to a remarkable degree,* gives an excellent idea of the beauty and richness of effect which these early artists were able to produce with such simple means. Prints by MASANOBU are very scarce.

Ishikawa TOYONOBU (1711–1785) was another important artist of this period, whose later work carries us into the second period. It should be noted that there were two artists of this name, the second being Utagawa Toyonobu, said to have been a pupil of the first. As he died very young, his prints are extremely rare. It was his brother, Toyoharu, who founded the Utagawa sub-school. Another pupil of Ishikawa Toyonobu is Ishikawa TOYOMASA (worked 1770–1780), with whom the representation of children was a favourite subject. Toyonobu was also called SHUHA.

We now come to Suzuki HARUNOBU (c. 1725–1770—the date of his birth being uncertain), pupil of the great Nishimura Shigenaga, who, by making full use of improvements at this time discovered in the art of colour-printing, brought into being the true polychrome print. He designed a few actor-prints in his youth, but shunned them as soon as he had reached his maturity, considering it a degradation of his art to apply it to the representation of a class which was held socially in such low esteem ; instead he turned his brush to the portrayal of dainty women. Most of his prints are a small, almost square, half-plate size, and are the earliest examples in which a background is introduced.

Harunobu's prints fetch very high prices, as they are valued not only for their great beauty and charm and rarity (most of the best examples being in the great private collections or in museums), but because Harunobu marks a most important epoch in the history of *Ukiyoye*. He created a style which influenced all his contemporaries, and for a time put actor-prints, such as were the special province of the Torii school, practically out of fashion.

He found himself, therefore, not only closely imitated, but also forged. Harunobu only worked as a colour-print artist about ten or twelve years. During the *Meiwa* period (1764–1771) there was a great demand by the public for his prints, and after his death Shiba KOKAN (1747–1818) was employed by his publisher to imitate them. This he did, usually not signing his productions, but sometimes signing them " Suzuki Harunobu." He also imitated Harunobu over the signature of Harushige, thus pretending, by using the prefix " Haru," to be his pupil. The avowed work of Kokan is very uncommon, and he is remarkable for his attempts at copper-plate engraving, which he learnt from the Dutch.

Shiba Kokan wrote his memoirs, which were published after his death, and he therein boldly states that he had forged many of the most popular prints signed " Harunobu." If Kokan could deceive the public of his day, it is hardly to be expected that we shall be any cleverer in the twentieth

*Reproduced in black and white in this edition.

century ; but the collector may rest satisfied with the thought that what was good enough to deceive the art-loving Japanese in 1765 is good enough for him, and that Kokan must have been a consummate artist.

What the collector, however, should be on his guard against are *modern* forgeries of Harunobu, who is one of the few artists who have been forged or reproduced during the last twenty years or so to any extent, very often extremely well, so that detection is difficult. The chief warning against them are the colours ; but in suspicious cases it is better, if possible, to compare them with undoubted genuine examples.

Another reason for the high value put upon Harunobu's prints is that, owing to the composition of the colours he used, they are very susceptible to the ravages of time and exposure, and are consequently rarely found in their original tints. Examples, therefore, in perfect condition are extremely valuable.

In examples by Harunobu, to a greater degree, perhaps, than is the case with other artists, perfect condition is of the utmost importance. His colours are so delicate, and applied with such refinement, that fading or changes of tint detract from their beauty to a more noticeable degree than is the case with artists who used the full-size sheet for their compositions, and who relied for effect upon colours laid on in broad masses more than upon subtle graduation of tints.

At Plate 1, page 12, are illustrated two fine examples of Harunobu's work, both originally in the Happer collection. They are from a set entitled " Social Customs (or Fashions) of the Four Seasons " with appropriate poem written on conventional clouds. Illustration 1, showing two girls on a balcony, one holding a *samisen* and a book, is for the " flower-month," i.e. April ; Illustration 2 represents a young girl being taken by her parents, accompanied by an elder daughter, to the temple for the *Miyamairi* ceremony of naming ; this being for the *kagura* month, *kagura* being the name given to a sacred dance enacted at the shrine of a local deity and takes place upon his death-day. A " great " *kagura* festival is one given in honour of the Sun-goddess, Amaterasu, and all local deities are considered to be under her sway.

Another copy of this print is in the British Museum collection, and the translation of the poem is given in the catalogue thereto as follows : " *Though there are no cedars in the gate, from the village comes the auspicious sound of the kagura music ; may this be of good augury for the child's first temple-visiting.*" This series consists of thirteen prints, one for each month of the year, which had, therefore, an intercalary month, the fourth being illustrated twice over ; this would fix the date at 1770.

Almost as famous as Harunobu is Isoda KORIUSAI, who worked from

about 1760–1780, and who is best known by his long, narrow pillar-prints (*hashira-ye*), measuring about 27 in. by 5 in. As these pillar-prints, unlike the ordinary full-size sheet, were intended for internal decoration and use, to hang on the pillars (*hashira*) of a house, far fewer in proportion have survived to our day than is the case with the ordinary full-size print.

Consequently these pillar-prints are very rare. Apart from their beauty, the wonderful talent displayed in the amount of composition, yet withal without crowding, portrayed on a sheet but five inches wide excites our admiration for the designers of these narrow prints. Koriusai was one of the few cases of an artist of the *Ukiyoye* school who was not of the artisan class. He was a *samurai*, or feudal retainer to a *daimyo*, and on the death of his master became a *ronin*, that is unattached, and took up the calling of an artist as a means of livelihood. In signing his prints, he sometimes dropped the final syllable of his name, putting only " Koriu."

Koriusai also designed prints of the same size and in a manner so closely akin to that of Harunobu that, when unsigned, it is often difficult to say to which of these two they should be ascribed. But unlike Harunobu (except for one or two very rare examples) Koriusai used the full-size sheet like the compositions of Kiyonaga, in addition to his pillar-prints, for figure-studies, a good example of which is illustrated at Plate 31, page 186.

Katsukawa SHUNSHO (1726–1793) is another important artist, whose work consists almost exclusively of actor-portraits in *hoso-ye* form, which are not very rare, thanks to his large output, but vary in quality. Two fine examples of his work in this form are shown at Plate 35, page 214. His prints are sometimes unsigned, when, in place of a signature, they are impressed with a seal in the form of a jar.

A distinguished follower of Shunsho's is Ippitsusai BUNCHO (*w.* 1764–1796), but his prints are exceedingly rare.

We now come to KIYONAGA (1742–1815), who became the fourth head of the Torii school, and in whom, and his immediate followers and contemporaries, the colour-print reached its highest excellence.

Though Kiyonaga was a pupil of Kiyomitsu, he very early in his artistic career abandoned the traditional actor-print of the Torii school, and only took to it again at the close before retiring altogether from the domain of print-designing. It is in Kiyonaga that we see the portraiture of women raised to its highest level, a level equalled only by Shuncho ; women at their daily occupations, promenading out of doors, or portraits of the most famous beauties of the " green-houses."

It was he, also, who first developed the three- and five-sheet print into a single design, though it is noticeable that frequently each sheet is complete in itself and can be shown as a separate unit, according to choice, yet

the full effect of the artist's intention is only apparent in the whole composition. Previous to the time of Kiyonaga, the *hoso-ye* prints of the Primitives were originally printed in sets of three and then divided, three being engraved on one block as a matter of convenience. Of course, a complete set of such *hoso-ye* prints in the form of an uncut triptych is extremely rare. Such a print, however, appeared in the Blondeau collection (sale April, 1910) in a *hoso-ye* triptych by Kiyomitsu, representing three pairs of lovers, each under an umbrella. In the Happer sale there also appeared three *hoso-ye* prints from the one block, but these had been divided.

Kiyonaga evidently developed the idea shown in the *hoso-ye* triptych to a triptych composed of three full-size sheets, each printed from their own set of blocks, and capable of being shown either singly or joined together to form a complete picture.

Like Koriusai, Kiyonaga was one of the chief exponents of the narrow pillar-print, and the average collector will find these less difficult of acquiring than his full-size sheets, though to obtain anything by him requires a considerable amount of patience.

Owing to the position he occupies amongst *Ukiyoye* artists, collectors are loth to part with such examples of his work as they may possess. Even a somewhat discoloured print by Kiyonaga will fetch £5 to £8 ; while a good, clean copy will be worth £15 to £20, up to more than double this sum, according to its importance ; a fine triptych will probably mean an expenditure of anything from £50 upwards, and for the average collector may be considered as practically unprocurable, so rarely do such come into the market.

Though SHUNCHO (Katsukawa) was a pupil of Shunsho, as is shown by the prefix " Shun " to his name, yet he would be more correctly described as a follower of Kiyonaga, as, like the latter, he portrays beautiful women. In fact, so akin is he to Kiyonaga that in the case of unsigned work it is sometimes difficult to say as to which of these two artists it should be assigned. A fine example of his work is illustrated in colours at Plate D, page 42.*

If anything, Shuncho's work is even rarer than Kiyonaga's ; he worked between the years 1770 and 1800, and is said to have lived to about 1820.

Another pupil of Shunsho's studio, who followed Kiyonaga rather than the style of his master, was Katsukawa SHUNZAN, who worked between 1776 and 1800 ; his prints also are very scarce.

The same may be said of SHUNKO, a late pupil of Shunyei, whose prints are very uncommon. He worked during the first quarter of the nineteenth century, and his signature must not be confused with the Shunko

*Reproduced in black and white in this edition.

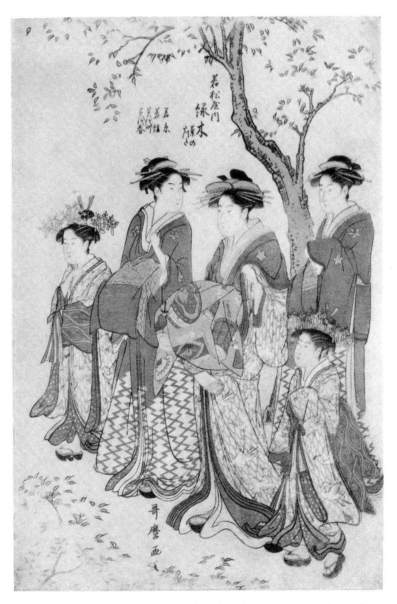

(1). UTAMARO: Midorigi of Waka-Matsu-ya on parade with two *shinzo* and two *kamuro*; signed *Utamaro*. (Early work in style of Kiyonaga).

PLATE D (first part)

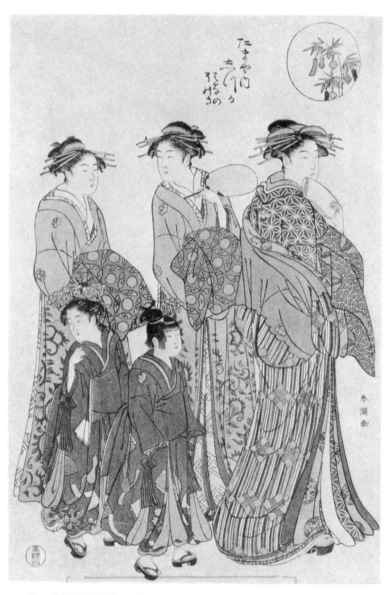

(2). SHUNCHO: Shizuka of Tamaya on parade with two *shinzo* and two *kamuro*; one of a series "Five Festivals," this for the "Weaver's Festival"; signed *Shuncho*. (*see page* 190).

PLATE D (second part)

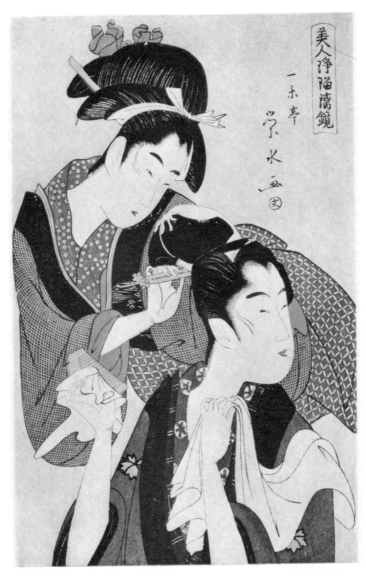

(3). YEISUI: A woman dressing a man's hair; one of a series "Beautiful Women compared to the Drama"; signed *Ichirakusai Yeisui.*

signature of Shunsen, nor with that of Shunko, pupil of Shunsho (see below), a designer of actor-prints, which are both written differently. To distinguish between them, this Shunko may also be read Shun*beni* (see Plate 2).

A fourth artist who followed the style of Kiyonaga, but who was trained in another studio, was Kubo SHUNMAN (*w.* 1780–1800), pupil of Shigemasa, a very rare artist, whose output was chiefly in the form of book-illustrations and *surimono*.

Von Seidlitz says Shunman was also a pupil of Shunsho, but it should be noted that his method of writing the character for " Shun " is quite different from the form in which Shunsho and all his recognized pupils wrote it. Shunman's prints are very rare, as he worked for but a short time as an artist, laying aside painting for literature during the latter part of his life.

Other pupils of Shunsho who carried on their master's traditions are (i) SHUNYEI (1762–1819), by some rated even higher than his master ; he is noted for his actor-portraits in *hoso-ye* form (see Plate 35), and also for his representations of wrestlers (see Plate 36), a subject very few artists attempted, and of which he and Shunsho were the chief exponents. (ii) Katsukawa SHUNKO (worked *c.* 1760–1790), who, like Shunsho, also used a jar-shaped seal in lieu of signature on some of his prints. The " ko " of this Shunko is written in a different character from that of the Shunko (or Shunbeni) mentioned above, who is sometimes described as Shunko II.

A pupil of Shunyei, with examples of whose work the collector is likely to meet, is Katsukawa SHUNSEN, who worked between the years 1790 and 1823. He designed both figure-studies and landscapes, employing a very pleasing colour-scheme of rose-pink, apple-green, and a slaty-blue. Another pupil was Katsukawa SHUNTEI (1770–1820), who produced actor-prints and wrestlers. (See Note, Appendix II).

Shunsen, as already mentioned, used the signature Shunkō on his later prints (*c.* 1820), and also added the name Kashōsai to that of Shunsen.

Utagawa TOYOHARU (1733–1814) chiefly claims attention as the founder of the Utagawa sub-school, and as the pioneer of purely landscape drawings in the *Ukiyoye*. It was one of his pupils, Toyohiro, who trained the great Hiroshige, with Hokusai the greatest landscape artist of Japan ; and another pupil, Toyokuni, had innumerable followers, so that the Utagawa school was the most numerous of any, and carried the art, though in a very debased form, down to modern times. Toyoharu's prints are very rare.

Upon the retirement of Kiyonaga from the field of colour-print designing, we enter upon the period of UTAMARO (1754–1806) and his contemporaries. Utamaro was the son and pupil of Toriyama Sekiyen, a painter

of the Chinese school, and was one of the most graceful and popular of *Ukiyoye* artists. He is among the best known to European collectors, his being the first colour-prints to be seen in Europe, and is famous for his beautiful figure-studies of women, which place him in almost the first rank of Japanese artists. At first Utamaro's work very closely followed that of Kiyonaga, and the example of this period here illustrated at Plate D shows clearly the influence of the latter artist.

Towards the end of his career, however, Utamaro's figures lose much of their grace by reason of the exaggerations he employs, drawn out as they are to an impossible length, till one expects to see them collapse altogether.

The Utamaro style is thus well described by Von Seidlitz in his *History of Japanese Colour-Prints* : " He created an absolutely new type of female beauty. At first he was content to draw the head in normal proportions and quite definitely round in shape ; only the neck on which this head was posed was already notably slender. . . . Towards the middle of the tenth decade these exaggerated proportions of the body had reached such an extreme that the heads were twice as long as they were broad, set upon slim long necks, which in turn swayed upon very narrow shoulders ; the upper coiffure bulged out to such a degree that it almost surpassed the head itself in extent ; the eyes were indicated by short slits, and were separated by an inordinately long nose from an infinitesimally small mouth ; the soft robes hung loosely about figures of an almost unearthly thinness."

About the year 1800 these exaggerations were still further increased, so that the head was three times as long as broad, and the figure more than eight times longer than the head. Most of his large head studies date at this period.

His triptychs, however, of which he produced a large number, do not show these exaggerations, except that the figures are very tall, and quite unlike any real Japanese woman. This trait, however, was common to practically all artists who portrayed the human figure, and was more or less an artistic convention as an expression of idealism.

Utamaro's signature is one of the first with which a collector will become acquainted, as it is one of the easiest to recognize. His early work can be distinguished from his later by the form of the signature, apart from the differences in the drawing of the figures already noted. In the former it is small, compact, and carefully written ; in the latter it tends to sprawl, is written larger, and the character for " Uta " is finished off with a long tail, which does not appear in his early work. The print reproduced in colours at Plate D*shows his early form of signature. It is his later straggling form which is found on prints done by his pupils and imitators, like that on the print by Utamaro II illustrated at Plate 3.

*Reproduced in black and white in this edition.

The outline block of this print may be seen in the Department of Illustration and Design at the Victoria and Albert Museum, South Kensington. On comparing it with this print, which is an early impression, it will be noticed that the original artist's signature has been erased and recut on the opposite edge, while the *kiwamè* and publisher's seals have been taken out altogether. The wistaria does not appear, and was probably cut on a separate block for use on other prints of the series, though only this one has come under observation. A set of modern colour-blocks, with proofs therefrom taken by a Japanese printer, have been cut from pulls taken from the outline block, in order to show the various stages in printing the colours.

Both Toyokuni and Yeizan are said to have forged some of Utamaro's prints, signature and all.

Owing to the manner in which his prints were forged by contemporaries, Utamaro sometimes signed himself *Shomei Utamaro*, that is, the " real Utamaro," thus signifying particular approval of his own work, but prints with this form of signature are very rare. A print so signed is illustrated at Plate 30, page 182.

Utamaro is best known by his figure-studies of women, but he also drew landscapes, bird, animal, and flower studies, and a large number of book-illustrations.

He had numerous pupils and followers, who may be classed as the Toriyama school, taking the name from Toriyama Sekiyen, the teacher of Utamaro.

At his death in 1806, his pupil, Koikawa Shuncho, married his widow, an apparently not uncommon proceeding with pupils—Gosotei Toyokuni, for example—and assumed the name of his great master till 1820, when he changed it to Tetsugoro, but no work over this signature has come under notice.

Many prints signed Utamaro are undoubtedly the work of this second Utamaro, and it is sometimes difficult to say which of them. Generally, however, the difference in the drawing of the figure and face affords the clue, and sometimes the prints are seal-dated, which determines their origin at once, though in this respect it should be noted that sometimes a print is met with, dated a few months *after* Utamaro's death, which, by its characteristics, would seem to be the work of the master rather than that of the pupil, so that it is not improbable that certain series contain prints which are by either, the pupil having been called upon to complete sets left unfinished by Utamaro himself, just as is found in the case of Hiroshige and Hiroshige II.

The best pupil of, and real successor to, Utamaro was Kitagawa KIKU-MARO (worked about 1790–1820), who about 1800 changed his name to

Tsukimaro. His early work over the former signature is very fine, and very closely resembles Utamaro's, as reference to the illustration of a rare large *hoso-ye* print (size 14 in. by 6 in.) by him at Plate 3 will show, while at Illustration 4, Plate 49 (page 280), is reproduced a scene from a rare " Chushingura " series, medium size, oblong, with his signature of Tsuki-maro (*c*. 1800).

At Plate 3, Illustration 2, is a fine figure-study showing the tea-house beauty, Tsukasa of Ogiya (House of the Fan), about to write on a fan, com-pared to a Chinese beauty inset on a Chinese mirror ; this example is signed *Kaimei Tsukimaro*, " changing (the name) to Tsukimaro." (Formerly in the Hayashi collection.)

Other pupils of Utamaro may be identified by the suffix " maro " to their names. Of these, SHIKIMARO (*w*. about 1790–1810) is perhaps the best after Kikumaro ; he was also a book-illustrator. HIDEMARO (*c*. 1800–1815) assisted Utamaro in his famous " Book of the Green Houses " (1804), as did also his pupils Kikumaro and Takimaro.

Besides the direct pupils of Utamaro, there were several artists who, while it is not known for certain that they learnt in his studio, evidently came under his influence, as their work follows his style very closely, but generally practically nothing is known of them except what we can gather from their prints, which are uncommon.

Two of the best of these little-known artists are Shunkyōsai RYUKŌKU (*c*. 1795) and Hiakūsai HISANOBU (*c*. 1800–1810). A very fine head-study by the former, not unlike those of Yeizan at his best, is illustrated at Plate 3 opposite, and another excellent one is reproduced, full page, at Plate XIX in the Catalogue of the Tuke sale (Sotheby's, April, 1911).

Other followers of Utamaro are BUNRO (*c*. 1790) and BANKI II (*c*. 1800). SEKIJO (*c*. 1800–1810), a pupil of Toriyama Sekiyen, produced a few prints after the Utamaro style, and also some good studies of birds, full size, upright. He was better known as a writer of stories than as a print designer ; as such his work is very uncommon.

As mentioned in a former chapter, forgeries, imitations, and modern reprints of Utamaro's work are rather common, particularly of some of his famous and rare triptychs. Thanks to his large output, genuine Utamaro prints are not very difficult to obtain, but of course examples of his earlier and better work are less readily procured than his later output. It is not easy, however, to find copies in first-class condition, the paper being often discoloured by exposure to the fumes of charcoal, which of course con-siderably reduces their value. This is due to their having been at one time used to decorate screens and paper partitions in Japanese houses.

Kitagawa KIKUMARO.

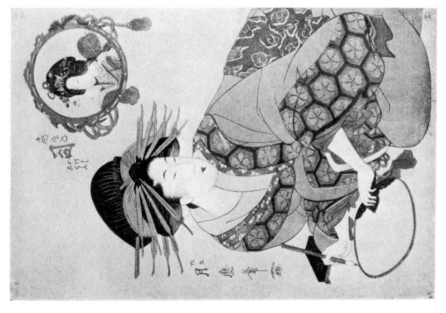

2. Tsukasa of Ogi-ya compared to a Chinese beauty;
 signed *Kaimei Tsukimaro*.

UTAMARO IInd.

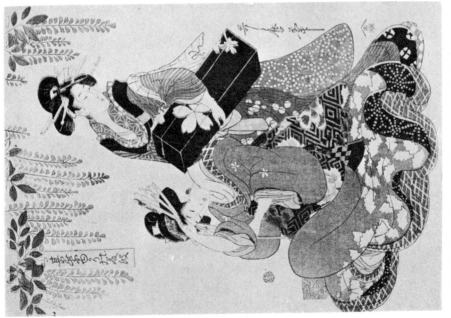

1. Geisha making her salutation; signed *Utamaro*.

PLATE 3 (first part)

Shunkyōsai RYUKOKU.

Kitagawa KIKUMARO.

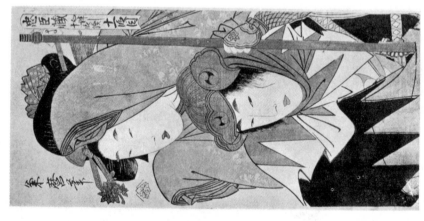

4. Motosuye of Daimoni-ya and a companion: signed *Ryukoku.*

3. *Chushingura,* Act II. Rikiya, followed by Konami, on the way to the attack; large *hoso-ye;* signed *Kikumaro.*

PLATE 3 (second part)

Utamaro prints are worth from three to five pounds upwards, according to their importance and condition, till we reach his fine triptychs at £30 or £40, up to £100 or £150 for a fine copy of a rare example, while £300 has been asked for a well-preserved set of his famous " silkworm " print, complete in twelve sheets. This print represents the whole process of the production of silk, from the raising of the silkworm to weaving the material, and is one of his prints which has been extensively forged or reproduced.

A very fine copy of one of Utamaro's rare prints with mica background realized $650 (£130 at normal exchange) at the Ficke sale, New York, February, 1920, to which we alluded in our first chapter.

Another famous and very rare print which has also been reproduced is his triptych showing women diving for shellfish ; this and several other triptychs are described in Appendix II.

Toriyama Sekiyen trained one other artist of the first rank, Yeishōsai Chōki (w. 1785–1805), also known as Shiko, a name which he adopted towards the end of his career. Opinions, however, on this point appear to differ, though the balance seems to be in favour of Chōki being his earlier name. This view is borne out by the fact that work so signed is more after the style of Kiyonaga, while that over the signature of Shiko more closely follows Utamaro, whose style did not come into vogue till after the retirement of Kiyonaga, about 1795, though the latter outlived Utamaro by nine years. Owing to this difference of style it was at one time thought that Chōki and Shiko were two different artists, though practically little is known of him but what we can gather from his prints, but these are very rare.

The signature Chōki may also be read Nagayoshi, but the former is the name by which he is more generally known, though continental collectors appear to prefer the latter transcription.

A print by him over the signature Chōki, forming one of a set of five, is here reproduced at Plate 2, showing ladies on a large pleasure boat on the Sumida River. On this sheet, No. 1 of the set, are depicted women preparing the evening meal.

Another example, later work in the style of Utamaro and his school, when working as Shiko, is illustrated at Plate 30, page 182.

There was also another artist who signed Shiko, known as Shiko II, who worked about 1810, and who was probably a pupil of Chōki. His signature differs slightly from the Shiko signature of Chōki.

CHAPTER VI

ARTISTS OF THE "UKIYOYE" SCHOOL—(*continued*)

Toyokuni to Kiōsai.

UTAMARO'S principal rival, particularly towards the end of his (Utamaro's) career, was TOYOKUNI (1769–1825), the chief pupil of Toyoharu. Toyokuni's early work consists mostly of studies of women, thus following the style of Utamaro, an example of which is illustrated at Plate 30, page 182. After the death of the latter he turned his attention to actors, and at one time was looked upon as *the* actor-painter of Japan. His best work is considered his series of actor-portraits in *hoso-ye* form, issued about 1800, but all his early work is good. After Utamaro's death, however, he confined himself to large actor-portraits almost entirely, and from this date his work began to deteriorate, his actors eventually becoming little better than caricatures, with their exaggerated features, squint-eyed, long-nosed, and wry-mouthed, exaggerations which were carried to repulsiveness by his pupil Kunisada.

Toyokuni's powers as the designer of actor-prints will be more fully considered in a later chapter dealing with actor-portraits in general as a subject of illustration.

Toyokuni's output was prolific ; but this designation chiefly applies to his later work, of which much survives to-day. His early work is comparatively rare, and may be distinguished, apart from the better quality of the work, both in drawing and colouring, by the signature being more carefully written, and in smaller characters. At Plate C, page 32, are reproduced examples of Toyokuni's work at his best, showing that it could be amongst the finest designed by the *Ukiyoye* school. Illustration No. 4 shows the small, carefully written script of his early signature, combined with graceful and natural figures.

Attention has already been drawn to the various artists following Toyokuni who adopted his name, and the way in which they may be distinguished both from one another and from Toyokuni himself.

Toyokuni's prints being fairly numerous, prices range from thirty or forty shillings or so for relatively unimportant single sheets, to £7 or £10 for good examples of his early work, up to £40 or £60 for particularly fine

triptychs. A rare pentaptych, or five-sheet print, will, perhaps, be worth £80 to £100.

TOYOHIRO (1763–1828) was a fellow-pupil of Toyokuni. His chief claim to fame lies in his having trained the great Hiroshige; as an artist he was far out-distanced in popularity by the much more productive Toyokuni. While the latter devoted himself to actors, Toyohiro followed his master's preference for landscapes; but owing to his comparatively small output, his prints are rare.

Toyohiro rarely, if ever, drew actors or courtesans; these he left to Toyokuni, a fact which may account for the latter's great popularity, and, in consequence, large output to meet it. Such figure-studies as Toyohiro drew are aristocratic ladies, and the scarcity of his prints is very likely due to his unwillingness to descend to depicting actors and courtesans, subjects he considered beneath him. His work is of a quality equal to, if it does not surpass, that of Toyokuni at his best, while at the same time he did not allow it to deteriorate in the manner that the latter did in his efforts to cope with the demand for his prints. Toyohiro was better satisfied to attain a high artistic level and keep it so, rather than lower it for the sake of gaining cheap popularity. The result is his figure-studies have a charm and gracefulness which put him almost, if not quite, on a level with Yeishi or Utamaro, while his colours are beautifully soft and harmonious.

In the early days of their career (c. 1800), Toyohiro and Toyokuni collaborated in certain series. Plate 33 (No. 3), page 192, is a sheet of a triptych showing two ladies and their children watching men at archery practice, from a rare set entitled "Twelve Months by Two Artists," this one being for the third month, by Toyohiro.

Another contemporary with Utamaro, and an artist whose work is of charming delicacy and refinement, was Hosoda YEISHI (also used the name Chobunsai), who worked between the years 1780 and 1800; died 1829. After 1800 he forsook print-designing and reverted to painting again. He is another of the few instances known of a print-designer not being of the artisan class, Yeishi being a *samurai* who first studied painting in the aristocratic Kano school, with the result that his prints are more delicate and refined than were those of most contemporary and later *Ukiyoye* artists. His figures, also, are more natural than those of Utamaro and do not exhibit the latter's exaggerations.

Many of his prints have a beautiful pale yellow background, and the collector is lucky who comes across one of these prints to-day in all its pristine loveliness. Unfortunately, this pale yellow is liable to fade with age, unless in the past it has been carefully kept from over-exposure to the light.

The subjects he portrayed are beautifully attired ladies, in various light occupations (see Plate 2, page 38).

He also did a series of small, almost square prints, about the same size as a *surimono*, also with a pale yellow background, depicting the popular courtesans of the day on parade with their attendants. He like-wise designed some remarkably fine triptychs, examples of which number amongst a collector's greatest print treasures, and in con-sequence are rarely in the market. Such, needless to say, fetch very high prices.

Lesser prints by Yeishi fetch about the same price as similar examples by Utamaro, but as his output was considerably less the average value of his better prints is higher. But even a relatively minor print by Yeishi has so much charm that an opportunity to obtain an example should not be missed.

Modern reproductions of prints by Yeishi are very common, particularly of one by him, full size, showing a tea-house beauty, Kisegawa of Matsuba-ya, seated, and facing to the right, looking at a partly unrolled *makimono ;* on the background is a small panel with flower decoration. The collector should carefully examine all prints signed Yeishi.

Yeishi was the founder of a sub-school, the Hosoda school, and had a large number of pupils, of whom the most important were YEISHO, YEISUI, YEISHIN, YEIRI, and GŌKYO, all of whose work is rarer, in some instances considerably rarer, than that of Yeishi himself.

Hosoda Yeiri must not be confused with Rekisentei Yeiri, pupil of Hasegawa Mitsunobu, who worked about 1800. The former often signed himself " Yeiri, pupil of Yeishi," to avoid this confusion, though Rekisentei Yeiri makes a further difference by using another character for writing the " Yei " of his name.

YEIZAN (Kikugawa) has already been referred to as a rival and imitator of Utamaro, after whose death he had practically a free field in his portraits of popular beauties, which had a great vogue, with the result that his prints are readily obtained and generally in good condition. He was a pupil at first of his father, Kikugawa Yeiji, a maker of artificial flowers, who painted in the Kano style. Yeizan worked as a colour-print artist between the years 1804 and 1829. His large heads, after the style of Utamaro, are fine, but his later work, when he took to copying Kunisada's full-length figures of courtesans, is not so good. They tend to become exaggerated as Kuni-sada's were, and overloaded with design, and are the work of an artist who became a pure copyist, without much originality of his own to work upon, one print being very like another. His early actor-prints are scarce.

Owing, however, to the fact that he ceased designing colour-prints about 1829, after which date he turned his attention to literature and the illustrating of books, his prints rarely exhibit the crude colouring of Kuni-sada's later work. Taken all round, Yeizan deserves a higher place amongst

Kikugawa YEIZAN.

Kikugawa YEIZAN.

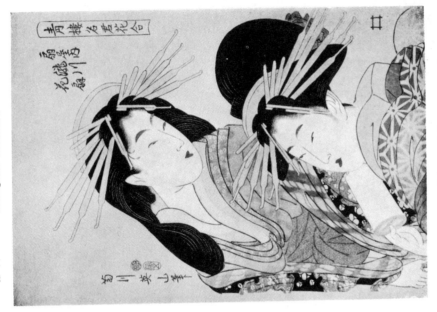

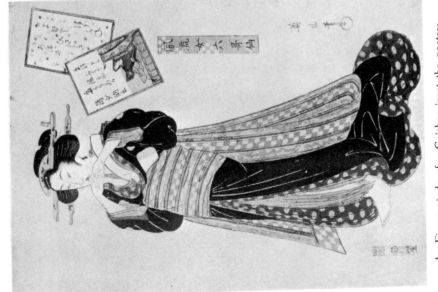

2. Hana-Ogi and Takikawa of Ogi-ya; one of a series "A Comparison of Tea House Beauties"; signed *Kikugawa Yeizan*; dated 5th month, 1808.

1. Figure study of a Geisha; inset the poetess Sei-sho-nagon; one of a series "Refined Six Poetesses"; signed *Kikugawa Yeizan*.

PLATE 4 (first part)

Torii KIYOMINE.

Torii KIYOMINE.

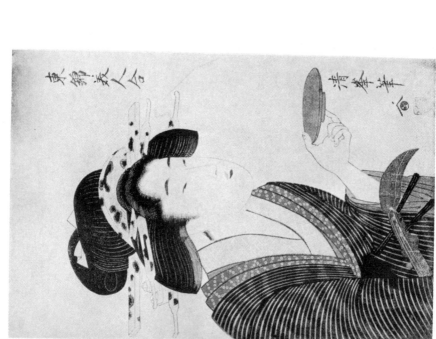

4. Aisome of Kado Ebi-ya on parade, with two shinzo and two kamuro; signed Kiyomine. (A fine example in very delicate and beautiful colouring.)

3. Woman holding out a saké cup; one of a series "Beautiful Women and Yedo Brocades Compared"; signed Kiyomine.

PLATE 4 (second part)

Ukiyoye artists than he is generally given. He may have followed other artists and had little originality of his own, but his early designs are boldly drawn, graceful, and his colours are good.

Many of Yeizan's prints are seal-dated, and any up to 1810 are good, but his late work (*c.* 1820–1829) follows too much the exaggerated and over-dressed figures of Kunisada.

The print by Yeizan here reproduced at Plate 4 (No. 1) is of particular interest, apart from being one of the earliest examples of his work, for the following reason.

Shojo KIŌSAI (1831–1889), the last artist of the old school of print-designers, has left a book, complete in four volumes, called *Kiosai Gwadan*, " Pictorial Life of Kiosai," which contains an index to all the principal artists of *Ukiyoye*, wherein are reproduced characteristic studies from their drawings, showing their particular style. The various scripts in which they wrote their signature at different periods of their career are also given, so that by comparing any print with the reproduction in this book, its approximate date can be fixed by the signature thereon. Yeizan is represented by the head and shoulders of the figure-study in this print, so that it must be considered a particularly good example of his work.

Another fine example, showing a *geisha* and her maid in a shower of rain, one of a series of fashion plates, is illustrated at Plate 33, page 192, while a good study in the style of Utamaro is reproduced at Plate 3, Illustration 2 ; this is dated 5th month, 1808.

Another artist of this period, somewhat similar in name, is Keisai YEISEN (1789–1851). Von Seidlitz wrongly states him to be a pupil of Yeizan, owing perhaps to the fact that he lived with Yeizan's father, Yeiji. Yeisen, however, was a pupil of Kano Hakukeisai, the last half of whose name he took for his first, Keisai. Also the styles, both in colour and design, of Yeizan and Yeisen differ too much for the latter to have been a pupil of the former. Again, Yeisen was a more original designer than Yeizan, and did both landscapes and figure studies, whereas Yeizan confined himself to the drawing of women, though he often used a landscape background in his triptychs. Yeisen's best work was done in landscape, both as single sheets, which, however, are rare, and as collaborator with Hiroshige in the series of " Sixty-nine Stations on the Kiso Road " ; one of his best contributions thereto is illustrated at Plate 13, page 100. (See Note 2, page 57.)

A fine snow scene by him is illustrated at Plate 8, No. 3, page 76, show-ing the Asakusa Temple, Yedo, under a fall of snow ; publisher's sign of *Moriji ;* signed *Yeisen.*

Yeisen's masterpieces are two very fine *kakemono-ye*, worthy to rank

with similar masterpieces of Hokusai and Hiroshige ; one a moonlight scene, with a bridge across a stream in the foreground, and behind high mountain peaks—a fit companion to Hiroshige's " Monkey Bridge " *kakemono-ye.* This print is exceedingly rare, a very fine copy changing hands in the Happer sale for £84, and would probably now fetch over £120. The other is a design of a carp, the Japanese emblem of perseverance, leaping up a waterfall, better known than the former as being less rare, and worth about £10 to £15, according to its condition. (See Note 1, page 57, and Plate 61, page 340.)

Other good prints by him in landscape are his series of waterfalls, in imitation of the set by Hokusai ; also single sheets of " Yedo Views " (oblong), like Hiroshige's similar views. All these are rare in varying degree. His figure-studies, which are fairly numerous and not difficult to obtain, are the output of his later years. The collector should not miss the opportunity of picking up good copies of his blue prints, in which the whole design is printed in varying shades of blue ; their effect is very pleasing, even though the actual drawing may not always be of a very high order. An unusually good example is illustrated at Plate 4A.*

Blue prints are not common ; besides Yeisen, they were designed by Kuniyoshi (rare), Kunisada, Kuniyasu, Yeizan, and Hiroshige II (landscape views).

Yeisen also designed some good *surimono.* He signs himself in full Keisai Yeisen, or Yeisen only, or Keisai only. In the latter case he should not be confused with Keis*u,* a designer of *surimono* and pupil of Hokkei, whose full name is Kiko Keisu. (See Note 2, page 57.)

KIYOMINE (1786–1868) was the fifth and practically the last master of the Torii school. He was a pupil of the great Kiyonaga ; his prints are rare and much prized for their gracefulness and pleasant colouring. (See Plate 4, Illustration 4.)

The print by him here reproduced at Plate 4 (No. 3) is remarkable in that the outlines of the face, hand, and wrist are printed in pink, the colour of the *saké* cup, and is called *nikuzuri,* meaning " flesh-colour." Another print from the same series is illustrated in Strange's *Japanese Illustration,* at page 28. Such printing is extremely rare, and is found only in a very few prints by Kiyomine and Utamaro.

We now come to the numerous pupils and followers of Toyokuni, forming the Utagawa school. Of this school, KUNISADA (1785–1865) is by far the best known, on account of his enormous productivity, his total output probably equalling, if it did not exceed, that of any two other figure-artists combined. It even probably exceeded the output of Hiroshige in the number of individual designs, prolific as was the latter. In fact, so prodigious was the number of his prints towards the end of his career, that

*Reproduced in black and white in this edition.

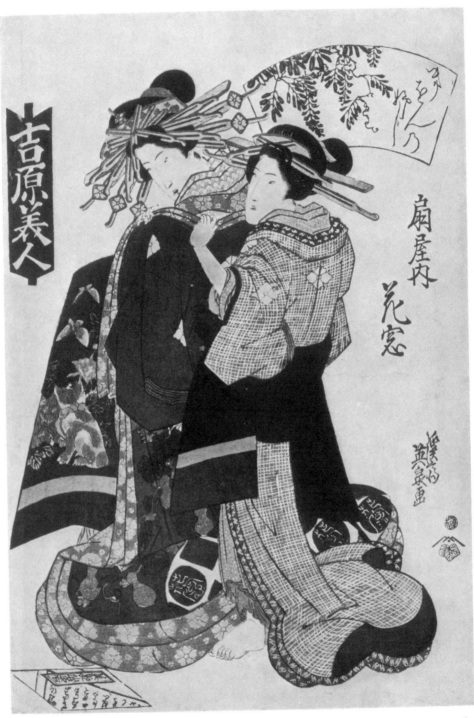

YEISEN: Blue Print; Hanamodo of Ogiya being assisted to dress by her maid; one of the series "Yoshiwara Beauties"; signed *Keisai Yeisen*; publisher *Tsutaya Kichizo*.

PLATE 4A

Kunisada did no more than the first outline drawing of a print, leaving his pupils to carry out the colour-scheme, and exercising no supervision over his printers. The result is seen in a complexity of design, meaningless elaboration of detail, crudeness of colouring, and often bad register in printing, which is so characteristic of a large number of prints bearing his signature, particularly in those signed with his later name of Toyokuni. In fact, the great majority of his innumerable actor-portraits of this period are little better than caricatures, with all the later eccentricities and exaggerations of his master, Toyokuni, magnified tenfold, though occasionally one may come across a really fine design like that illustrated at Plate 37, page 228.

His best prints are his early landscapes, but these are very rare. Two fine examples are here illustrated at Plate 5, both with his early signature of Kochoro Kunisada. Illustration No. 1 shows that in rendering atmospheric effect he could rival Hiroshige at his best. Illustration No. 2 is a design of combined landscape and figure-studies, the landscape being printed in shades of blue, the ripples of the water rendered in *gauffrage*, as is also the design on Narihira's dress. The scene is laid on part of the "Eight-parts" Bridge, Province of Mikawa (*vide* Hokusai's drawing of same bridge, Plate 18, page 122), which crosses an iris pond in a series of zigzag platforms. A lady is plucking the blooms while Narihira, the poet, accompanied by a lady sword-bearer, looks on.

Kunisada's early actor-portraits closely follow the style of Toyokuni, but the great bulk of his work in this direction is of little or no importance, and clearly reveals the decline into which the *Ukiyoye* school had fallen by this time.

His one really fine design in figure-studies is his portrait of Hiroshige, which we illustrate at Plate 5, Illustration 3, and which was done in the year of the latter's death (1858), and on it is a long and interesting inscription, in which occurs the following passage : " At the present time, Hiroshige, Kunisada, and Kuniyoshi are considered the three great masters of *Ukiyoye* ; no others equal them. Hiroshige was especially noted for landscape."

Hiroshige is represented seated, dressed in a *noshimè*, a robe worn only by *samurai* on special occasions, on which is his diamond monogram *Hiro*, often used by him on prints as a seal below his signature, or introduced into the design. (See Note 3, page 57.)

The complete inscription (written by Temmei Rojin, a famous poet and close friend of Hiroshige) is too long to give here, but a translation of it will be found in the B.M. Catalogue at page 499 ; the following passage therefrom states the actual date of his death : " *on the sixth day of Chrysanthemum* (i.e. September) *month* (9th) *having made a will disposing*

of all his affairs and written a farewell verse, he started on the mountain road of death, and retired into the forest of the cranes. It is a great loss." Above Kunisada's signature (*Toyokuni*) is the date-seal, *Horse* 9, corresponding to the date given in the inscription.

Near the lower left margin is the publisher's seal of *Uwoyei*, the publisher of the " Hundred Views of Yedo," and above it that of the engraver *Yokokawa Takè*. The large seal below Kunisada's signature reads *Chōen* (" Long Smoke ") *Ikkū* (" sky ") [not *Issō* as given in B.M. Catalogue], " A long trail of smoke towards the sky," in allusion to the cremation of Hiroshige's remains.

This print is very uncommon. As, however, it was issued by the same publisher as the " Hundred Views " series the same year the latter was completed, and was inserted in many of the *later* copies of the bound volumes of these views, it is difficult to say why it is so rare, unless time has been rather less kind to it than other prints. Copies with the edges cut down, thus obliterating the top line of the inscription, have probably been bound up with the " Hundred Views " series.

Kunisada often collaborated with Hiroshige in the design of triptychs, in which the landscape is done by the latter and the large figures by Kunisada. Or again, the left and right panels will be the work of one artist and the centre panel that of the other.

He also plagiarized Hiroshige's work in a set (rare) of half-block Tokaido views copied, in most cases, almost line for line from the former's early series published by Hoyeido, with a large figure, generally of a *geisha* or peasant woman in the foreground, separated from the main view by conventional clouds. Some of the plates are signed " To Order," as if to throw the blame for this plagiarism of Hiroshige's work upon his publisher, Sanoki (see Plate 12, page 96).

Kunisada, solely by reason of the quantity of his work, was considered the head of Toyokuni's school, as is shown by his eventually appropriating to himself that name ; but Utagawa KUNIYOSHI (1798–1861) was easily the better artist. He did some good landscapes, many deserving to rank with those of Hiroshige, particularly in a set of Tokaido views (see Plate 12), wherein several stations are shown on the one view, while his figure-studies are strongly drawn, often with a humorous touch. His colours are rarely the crude and hideous colours of Kunisada, while he frequently makes a very effective use of masses of black.

A fine, but at the same time rare, set of prints by Kuniyoshi depicts incidents from the life of the priest Nichiren (*vide* Chapter XXXV for details) in ten scenes. Von Seidlitz quotes one scene, *Nichiren on a Pilgrimage*

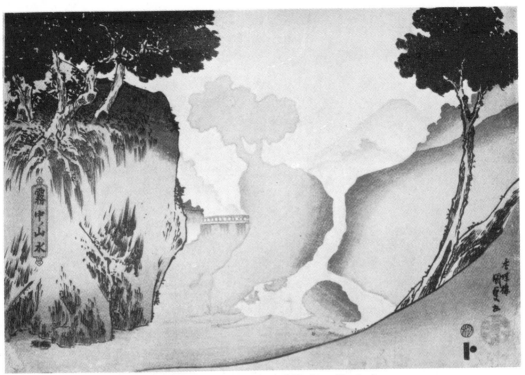

1. Landscape in Mist; signed *Kochoro Kunisada*.

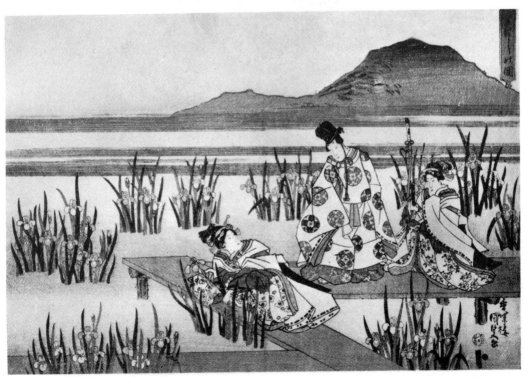

2. Blue Print: Narihira watching a lady gathering iris blooms; signed *Kochoro Kunisada*.

PLATE 5 (first part)

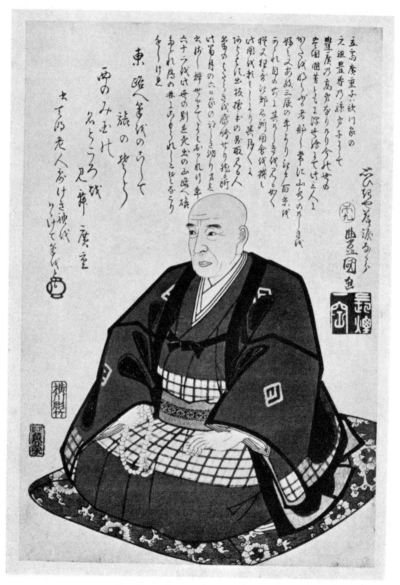

3. Portrait of Hiroshige; signed *Toyokuni*.
(From copy in British Museum.)

PLATE 5 (second part)

in the Snow, the best print of this series, as a single print, being apparently unaware that it forms one of a set; the set, at least, is not mentioned by him amongst the list of Kuniyoshi's works.

Another celebrated series is his set of scenes depicting the twenty-four paragons of filial piety, which are remarkable for their curious application of European pictorial ideas to a Chinese subject, but which detracts from them as works of art.

Neither of the above series are at all common, but examples of Kuniyoshi's prints are not difficult to pick up.

Kuniyoshi's most significant work, however, is his various series of prints illustrating heroic episodes in Japanese history, also legends, stories, and dramatic scenes; he was not very successful with actor-portraiture. It was the publication of his "Chinese Heroes" (*Suikoden*) series which first brought him fame in his lifetime.

Toyokuni's other pupils are mostly too unimportant to be mentioned individually. Five, however, who died before the art of the colour-printer was so far advanced towards decay, and before crude aniline colours became the custom, deserve mention, because their work is, for these reasons, superior to their contemporaries.

KUNIMASA I (1772–1810), whose portraits of actors are very good, and who had a reputation even higher than that of his master. His prints are very uncommon. An example of his work is reproduced at Plate 36, page 224.

KUNINAGA, who died about 1820; work uncommon.

KUNINAO (*w.* 1820), who first studied art in the Chinese school, afterwards becoming a pupil of Toyokuni. His prints are rare, and are at times notable for the grace and elegance of their figures.

KUNIMARU (1787–1817), whose figure-studies are of unusual merit, judging from the very few prints by him, which are rare, that have come under observation.

KUNIYASU (1800–1830), whose prints are also uncommon and are much above the average of his fellow-pupils, his colours being well chosen. He also designed *surimono*. His prints comprise both figure-studies, landscapes, and seascapes (see Plate 6).

The numerous followers of Kunisada and Kuniyoshi need not detain us long. Those of the former, together with pupils of Hokusai, formed what is known as the Ōsaka school, which came into existence at Ōsaka about 1825. Previous to this date, the art of the colour-printer was solely confined to Yedo, where it originated.

SADAHIDE (*c.* 1840), one of the best of Kunisada's pupils, designed landscapes in the style of Hiroshige, and also battle-scenes. His prints

are good of their kind, considering the lateness of the period at which he worked (see Plate H and Plates 54 and 55).

SADAMASU (*w.* 1830–1850) also worked in style of Hiroshige. His work is not common, and is distinctly above the average of the period. A good fan-print by him is reproduced at Plate 6.

Hasegawa SADANOBU (*c.* 1840) designed both actor-prints and landscapes, but in the case of the latter appears to have been not satisfied with merely following the style of Hiroshige, but needs must copy him line for line. Thus he copied Hiroshige's half-block set of " Views of Lake Biwa " practically line for line ; one scene of this set is illustrated in the handbook to the Japanese Print Collection in the Victoria and Albert Museum, South Kensington ; also his " Provinces " series, and others in half-block size.

Kuniyoshi's pupils continued to work at Yedo. Of these YOSHITORA (*w.* 1850) was, perhaps, one of the best, his colours being as a rule less offensive than is generally the case with prints of this date. He designed figure-studies, landscapes, and battle-scenes.

YOSHITOSHI (*w.* 1860–1890) was another pupil, already mentioned above, who was superior to the general run of contemporary artists.

The pupils of Kunisada may be recognized by the adoption of the second half of their master's name, " sada," as the first of their own, e.g. Sada-hide, Sada-nobu ; though some adopted the first part " Kuni," e.g. Kuni-chika, Kuni-hisa, Kuni-mori, and others. Kunimori also signed himself Horai (or Kochoyen) Harumasu ; his signature of Kunimori being a later one, adopted on his joining the school of Kunisada. In the same way Kuniyoshi's pupils all begin their names with the prefix " Yoshi," e.g. Yoshi-tora, Yoshi-kuni, Yoshi-kazu.

Two independent artists remain to be mentioned before turning to the landscape artists, Hokusai and Hiroshige, and their pupils. Shojo KIŌSAI (1831–1889), whose studies of crows are remarkable, and who may be reckoned as the last of the old school of print-designers of the first rank. Had he lived earlier, before the advent of aniline colours, his prints, which are not common, would have been esteemed even higher ; but his work, unfortunately, suffers from the inferior colours used.

The other artist is SUGAKUDO, who worked about 1858, and who has designed an excellent series of bird and flower studies, in forty-eight plates, twelve being allotted to each season of the year, which number amongst a collector's favourite examples in this subject. The best print in this series is No. 10, representing a large red parrot. The title of the series is *Sho Utsushi Shi-ju-hachi* (48) *Taka :* " Exact Representations of Forty-eight Hawks " (i.e. birds). (See Plate 6.)

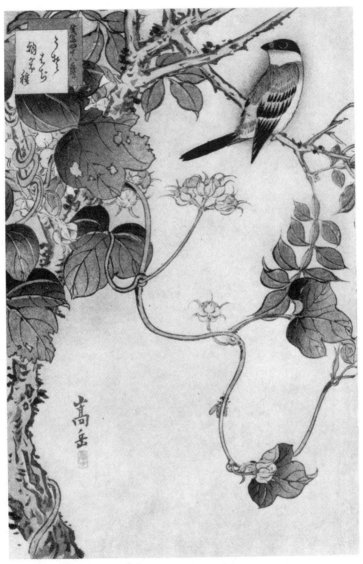

1. SUGAKUDO : Bull-finch and twining Convolvulus ; No. 29
of series of "Birds"; signed *Sugaku*.

PLATE 6 (first part)

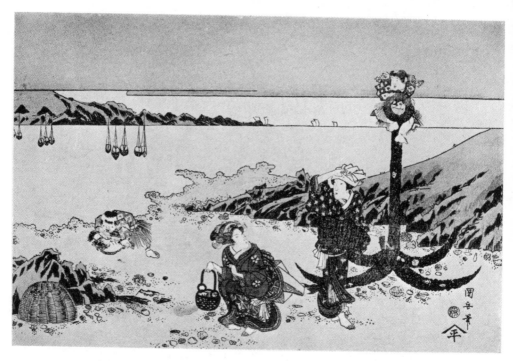

2. KUNIYASU: Gathering shells at low tide; signed *Kuniyasu*.

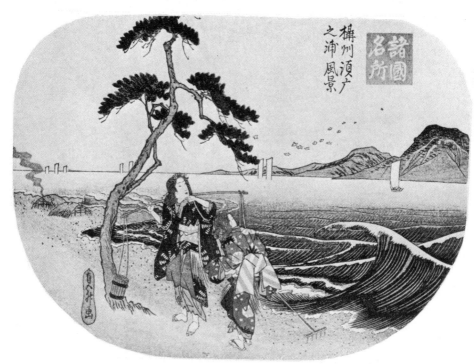

3. SADAMASU: View of Suma Beach; fanprint, signed *Sadamasu*.

PLATE 6 (second part)

Each plate is dated in the margin with the seal for the sheep year, equivalent to 1859, but the title-page is dated a year later, when the series was completed. Below the date-seal is the number of the plate in the series, and below that again the publisher's seal of *Kōyeido*, which will be found reproduced in the list of publisher's signs in Appendix IV. *Kōyeido* is also known as *Tsutaya Kichizo*, who must not be confused with *Tsutaya Juzaburo*. Both used the same seal, a leaf surmounted with a triple-peaked Fuji, but *Kichizo* inserts a small circle in the centre peak, which is not found in *Juzaburo's* seal. *Kichizo's* is the seal found on Hiroshige's prints (e.g. upright *Tokaido* series), which are almost invariably attributed to the wrong publisher. Juzaburo died 1797.

Note.—1. Gosotei Toyokuni has designed a very fine *kakemono-ye* also of a great carp leaping up a waterfall. It is very similar to Yeisen's and is considerably rarer ; a copy was on exhibition at the Fine Art Society's galleries, London, in 1910, and no other record of it has been noted by the writer. It is signed in full *Gosotei Toyokuni*, and bears the publisher's mark of *Yamamoto-Heikichi* (*Yamahei*).

2. We give on page 51 the year of Yeisen's death as 1851, instead of the generally accepted one of 1848, as he was at work on the illustrations of a book entitled *Shokoku Meisho Hokku* during the later year, signing them " *Old man* " *Yeisen*.

3. Kunisada's portrait of Hiroshige. In descriptions of this print Hiroshige is nearly always described as dressed in a *priest's* robe, doubtless because he is shown holding a rosary of beads in his hand, and with shaven pate—attributes of the priestly caste. The robe he is wearing, however, is a *noshimè*, usually worn only by *samurai* on ceremonial occasions.

Included in the inscription by Temmei Rojin is Hiroshige's *jisei*, or " farewell verse " : " I have laid down my brush in the East, and depart to view the wonderful scenery of the West." (*Azuma ji ni fude wo nokoshite taki no Sora, nishi no mikuni no Nadakoro-o-min* [not *Meisho-wo-miru* as often given.])

By " East " Hiroshige means the Eastern capital, Yedo, while " West " is the Buddhist Paradise.

CHAPTER VII

HOKUSAI AND HIROSHIGE, AND THEIR PUPILS

HOKUSAI (1760–1849) is generally classed as a landscape artist, as his chief work was done in this field, though he drew almost everything that could be drawn. He lived entirely for his work, and became the master-artist of Japan, dying at the age of eighty-nine, after a life of incessant work and almost continuous poverty, with the regret upon his lips that he had not been granted a longer spell of life to devote to his idol art.

No artist adopted so many artistic names with which to bewilder the collector of the present day as Hokusai.

As a pupil of Shunsho, at the age of nineteen, he used the name Shunro, but owing to a quarrel with his master, due, it is said, to his having taken lessons from a painter of the Kano school, he left Shunsho's studio in 1785, and started for himself as an independent artist.

Sori, Kakō, Taito, I-itsu, are some of the names he used in addition to that by which he is universally known, and as he often passed them on to a pupil when himself adopting a new name it is not always possible to say if a print signed Taito, for example, is by the master or the pupil of that name.

For instance, a well-known print, signed Katsushika Taito, representing a carp swimming in a whirlpool, is by some authorities attributed to Hokusai, and by others to the pupil, but the latter has the more numerous supporters. Many of Hokusai's prints are signed " Hokusai Mad-on-drawing " (*Gwakio jin Hokusai*), thus showing the fervour of his spirit. Other names he used are Shinsai and Manji.

A signature Hokusai sometimes used on *surimono* reads " Fusenkio " or " Furakkio," meaning " tired of living in same house," in allusion to his constant change of residence, as he is said to have altered his place of abode nearly a hundred times during his long lifetime.

Hokusai's masterpieces, by which we recognize him as one of the world's greatest artists, are the following series :

" The Imagery of the Poets," a series of ten large vertical prints, issued about 1830. This series is *very* rare, particularly in a complete set.

" The Thirty-six Views of Fuji " (*Fugaku San-ju Rok'kei*), with the ten additional views, really forty-six views, full size, oblong. Some prints in this series are much rarer than others, and really good copies of any are not easy to procure, though poor and faded copies are fairly common of some of them. The three rarest and most coveted by collectors are *The Great Wave ; Fuji in Calm Weather ;* and *Fuji in a Thunderstorm*, with lightning playing round its base. The first of these, *The Great Wave*, has been described, more particularly by American collectors, as one of the world's greatest pictures ; and certainly, even if this description is perhaps somewhat exaggerated, it is a wonderful composition, such as could only have emanated from the brain and hand of a great master. This series was issued between 1823 and 1829.

" The Hundred Poems explained by the Nurse " (1839). Of this series only twenty-seven prints are known to exist, and Hokusai never completed it. About fourteen original drawings, which were never used for producing prints from, are also known. Moderately rare as a whole, some plates being much rarer than others.

" Travelling around the Waterfall Country," a set of eight vertical prints, about 1825 ; rare.

" Views of the Bridges of various Provinces," a set of eleven oblong prints, similar to the " Views of Fuji " series, about 1828 ; rare.

Ryukyu Hak'kei, " Eight Views of the Loo-choo Islands " ; full size, oblong, *c.* 1820 ; very rare.

Modern reproductions and reprints of all the foregoing series are met with, particularly his " Imagery of the Poets," " Waterfalls," and " Views of Fuji " series.

The various prints comprising the foregoing series are described in detail elsewhere in this volume in the chapters dealing with landscape as a subject of illustration.

Besides landscape scenes and innumerable single prints, Hokusai designed some very fine—and very rare—bird and flower studies, of which modern reproductions exist, many *surimono*, and a very large number of book-illustrations. Amongst the latter may be mentioned his famous " Hundred Views of Fuji," and his *Mangwa* (sketches). It is computed that altogether he produced some thirty thousand drawings and illustrated about five hundred books (Von Seidlitz).

Of Hokusai's pupils, of whom about fifteen to twenty are known, Totoya HOKKEI (1780–1850) is considered the foremost, and excelled even his master in the design of *surimono*, a fine example of which is illustrated at Plate E, in colour, signed " copied by Hokkei," being taken from a painting of the Tosa school. *He also illustrated books.

Another pupil famous for his *surimono* is Yashima GAKUTEI (*w.* 1800–

*Reproduced in black and white in this edition.

1840), who also designed a set of very fine land and seascape drawings, full size, oblong, for a book, " Views of Tempozan " (*Tempozan Shokei Ichiran*, Osaka, 1838) (see Plate 19). A description of the prints comprised in this set will be found in Chapter XV.

A third good designer of *surimono* is Yanagawa SHIGENOBU (1782–1832), the scapegoat son-in-law of Hokusai, whose daughter, Omiyo, he married. This Shigenobu must not be confused with a later Ichiryusai Shigenobu, the pupil of Hiroshige, better known as the second Hiroshige, and a considerably less capable artist (see Plate 8.)

Shotei HOKUJIU (*w.* 1800–1830) is remarkable for his curious landscapes, done in a semi-European manner, known as *Rangwa* pictures, meaning literally " Dutch " pictures, as it was from the Dutch, the first Europeans allowed to trade with Japan (and then only under severe restrictions), that the idea of perspective, as we understand it, was learnt by Japanese artists.

His mountains are drawn in a very peculiar angular manner, almost cubist in effect, and his clouds are cleverly rendered by means of *gauffrage*. These characteristics are clearly shown in the print by him reproduced at Plate 19, page 132.

Shunkosai HOKUSHIU (*w.* 1808–1835) was another pupil of Hokusai, who designed figure-studies, in which the dress is sometimes rendered in *gauffrage*, a method of heightening the effect of colour-printing generally confined to *surimono*. Hokushiu, however, employed it largely in his ordinary full-sized prints.

Considering the very large number of landscape designs produced by Hokusai, one would have expected a corresponding activity on the part of his pupils in the same direction. As a matter of fact, but few of them seem to have turned their brush to this class of subject, and even then only to a limited extent, Hokujiu being almost the sole pupil who persevered in landscape design beyond an initial effort, and his prints are by no means common.

The others appear to have confined themselves almost entirely to the production of *surimono*, actor-portraits, and figure-studies, showing that, great as was the demand for the landscapes of Hokusai and Hiroshige, the populace still hankered after their favourite subjects from the theatre, street, and Yoshiwara. The names of several are given in Appendix III, and a fine *surimono* by SHINSAI illustrated at Plate 8.

Ichiryusai HIROSHIGE (1797–1858) shares with Hokusai the reputation of being the foremost landscape artist of Japan. He showed signs of the latent talent that was in him as a boy, and received his earliest tuition in painting in the studio of an artist, Rinsai by name, of the Kano school.

Katsushika HOKUSAI.

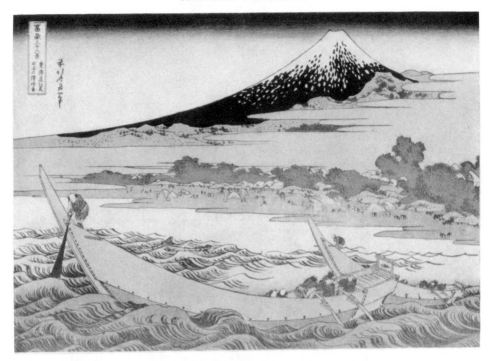

(1). No. 24 of the "Views of Fuji"; Fuji from Tago, Ejiri (*see page* 111).

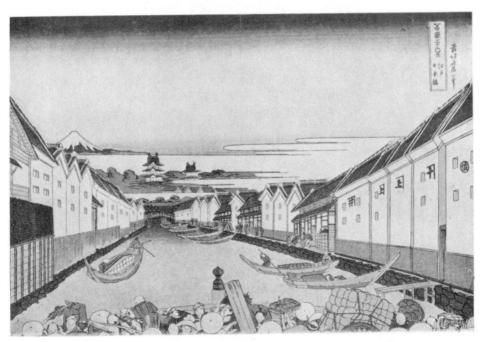

(2). No. 41 of the "Views of Fuji"; Fuji from the Nihon canal, Yedo (*see page* 112).

PLATE E (first part)

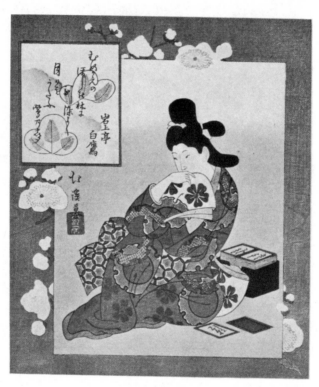

(3). HOKKEI: *Surimono*.

PLATE E (second part)

On the death of his parents, at the age of fourteen, he applied for admission to the school of Toyokuni, but there being no vacancy for him, he turned to Toyohiro, who accepted him as a pupil. This was in 1811 ; in the following year his master gave him the artist names of Ichiyusai Hiroshige, the first of which he changed, on the death of Toyohiro, in 1829, to Ichiryusai. This small change of but one letter in his first name is important, as by it we can distinguish between his early work, and that of his middle and later periods.

We now come to what was destined to be the great turning-point in his career. In 1830 he was commissioned by the Tokugawa Government, in whose service he was as a *doshin*, or official, to go to Kyoto and paint the ceremony of " presenting the horses," which it was the custom of the *Shogun* to send to the Emperor every year at Kyoto. It was not unusual for government officials in those days to eke out their slender salaries by adopting some other profession, such as painting, as well, hence Hiroshige's selection for this post.

Deeply impressed by the scenery of the Tokaido on his journey from Yedo to Kyoto in company with the party in charge of the horses, he made sketches on the way of each of the fifty-three relay stations along the road, resolving thenceforth to devote himself to landscape painting. To this end he spent three years travelling throughout Japan on a sketching tour after his return from Kyoto, his wife accompanying him on his journeyings and defraying all expenses, for which his official salary was quite inadequate.

On his return, in 1834, he completed his sketches of the Tokaido, which were then published in album form, and became an immediate success, landscape having never before, in the history of *Ukiyoye*, been so treated. Hiroshige himself took particular pains over their production, and supervised the engraving and printing. Hence it is that this " Great Tokaido " series, as it is known to distinguish it from other and later series, the *first edition* of which was produced under his supervision, constitutes, in the opinion of collectors, Hiroshige's most famous work as a whole.

There are, of course, other landscape series, some of which are rarer, certain of them much rarer, and which contain many masterpieces, besides his first Tokaido set, but the latter remains his *magnum opus*, as it was through this he made his fame as a landscape artist.

It is generally through his landscapes that the collector first becomes acquainted with Japanese colour-prints, and through which he is attracted to them. Hiroshige's prints more nearly approach our ideas of pictorial representation than those of any other artist of *Ukiyoye*, with the exception perhaps, though to a less extent, of Hokusai, yet at the same time he remains essentially Japanese.

Hiroshige gives us the effect of atmosphere and mist, sunrise and sunset, snow and rain, in his designs which Hokusai, with his sharper and more vigorous outline, does not. The latter's scenes are full of that restless activity which reflects his own untiring energy, an energy which nothing could damp, while misfortune merely spurred him to greater effort.

Hokusai, also, treats his subject from a different standpoint to Hiroshige ; the former depicts the relationship of man and nature to each other with a vividness not found in Hiroshige's compositions. Hiroshige shows us the real world as he saw it passing before him along the great highway he so realistically portrayed. Hokusai, on the other hand, puts before us his idea of it, as he saw it in his mind's eye, making the grandeur and force of nature his principal theme, and his humanity merely subordinate to it.

These divergent characteristics are well shown in Hokusai's *Great Wave*, a picture contrasting the all-devouring force of nature and the littleness of man, and Hiroshige's *Autumn Moon on the Tama River*, from his " Eight Environs of Yedo " series, considered one of his masterpieces in landscape, a scene of infinite peace and quietude (see Plate 22, page 144). Of like nature is his *Homing Geese at Katada*, from his " Eight Views of Lake Biwa " series, representing a flock of geese flying to rest at twilight.

To compare the work of these two masters is difficult, if not invidious ; their characteristics are so distinct one from the other, and their prints are admired for such different reasons. Much of Hiroshige's work is of a later period than that of Hokusai. Hiroshige's earliest work is assigned to about the year 1820 ; Hokusai had produced prints before 1800. The entirely different colour-schemes employed also render it difficult to make comparisons ; while the later and inferior impressions of many of Hiroshige's later series which are so relatively numerous, are a libel upon his powers as a colourist. His best work, namely his " Great Tokaido " series, is equal to anything Hokusai produced ; but on the whole it must be said that the latter's work shows a much higher average quality throughout, whereas that of Hiroshige varies to a considerable extent, many of his later series containing some inferior designs, apart from those obviously the work of his pupil.

Though this falling off was no doubt due to increasing age, yet in the case of Hokusai, who lived very nearly half as long again as Hiroshige, his work shows practically no traces of advancing years, in fact it improves. As he himself says, he did not expect to become a really great artist till he had reached the age of eighty, while he was dissatisfied with everything which he had produced prior to his seventieth year.

Fenollosa, one of the leading authorities on the artists of the *Ukiyoye*, while he classes Hokusai in the first rank, puts Hiroshige in the third only, though his classification refers to them as painters, while he does not specifically class them as colour-print designers.

There is, however, this great difference between Hokusai and Hiroshige. The latter was a great colourist ; Hokusai was both a draughtsman *and* colourist.

As an actual draughtsman Hiroshige is not eminent ; the beauty and charm of his prints lie almost solely in their colouring, and the atmospheric and other effects obtained thereby, which are due to the co-operation and skill of the engraver and, more particularly, the printer, who should receive the merit rather than the artist. In plain black and white outline, most of Hiroshige's prints would fail to arouse any particular enthusiasm, while, on the other hand, Hokusai's skill as a draughtsman is but enhanced by the colour-effects of his prints, so that his illustrations in black and white only and his designs for prints are as interesting as the colour-prints themselves.

We have seen the view put forward (and it is one which we consider very probable), that it was because the engraver and printer were often so much the better artists than the designer himself, that their seals, more particularly that of the engraver, are occasionally found on prints besides the artist's signature.

Where Hiroshige has turned his brush to the illustration of subjects outside the province of pure landscape, he has generally not been particularly successful (at times, indeed, very bad), unless the landscape element happens to predominate in the general composition. Even in purely landscape scenes, an otherwise effective composition is often spoilt by the crude drawing of the figures introduced, particularly if they are at all prominent in proportion to their setting.

The fact that the artist only supplied the design which was destroyed on cutting the outline or key-block, and gave instructions as to the colours to be employed, somewhat modifies the answer to the question, " Is the work of one artist better, or of greater value, than that of another ? " as the artist was almost entirely at the mercy of his engraver and printer, upon whose combined skill the excellence of the finished print depended. Added to this, there must be taken into account the fact that the same engraver and printer might be employed upon the designs of more than one artist, just in the same way that a printer does not confine himself to producing the books of only one writer. It is to be regretted that the engravers of these prints are almost totally lost in oblivion, and that

nothing is known of them, and only a comparatively few prints even bear their mark, as it is due to them that the most beautiful pictorial art in the world came into being, or at least in such a form that it could be enjoyed by thousands, where a single painting is but the delight of a select few.

A print is associated *only* with the artist whose signature it bears, or whose work it is known to be, or, in doubtful cases, to whom it is attributed. Yet the excellence of the print, and, in consequence, the reputation of the designer, rested with the engraver and printer. As pointed out above, the beauty of most of Hiroshige's work is due to the skilful co-operation of printer and engraver.

While Japanese literature tells us much about the artists, it is silent about the engravers, upon whom the former were so dependent for their reputation as designers. This lack of recognition was no doubt due to the fact that the engraver was looked upon as nothing more than a mere mechanic—albeit an extremely dexterous one—whose sole province was to reproduce, line for line and dot for dot, the design given him by the artist.

His work, therefore, was purely mechanical, and wonderful as it may appear to us from the point of view of manual skill, there was nothing original about it ; it was pure copying. Had the original drawing been preserved, and only a copy made for the engraver to work from, we should then have been able to compare his work with the original.

There is, however, in the Victoria and Albert Museum, a block which has been cut from a copy of the artist's drawing, in this case an illustration to a book of birds by Kono Bairei. The original drawing, the copy, the block, and a print therefrom, are shown together for sake of comparison ; notwithstanding the intervention of the copyist, it is very difficult to say which is the print and which is the original drawing, so skilfully has the engraver done his part.

Little as is our knowledge of the engraver, it is even less in the case of the printer. While a print occasionally bears the mark of the former, the writer can only recall a very few instances, from amongst many hundreds of prints examined, of sheets bearing the name or mark of the printer. Both, however, are often given on illustrated books.

In the writer's opinion, since these prints are (or should be) collected for their æsthetic charm, the standard to be aimed at is one in which subject and artistic merit come first.

The artist's signature is not, by itself, sufficient to satisfy the discriminating collector whose chief desire is to possess beautiful examples

HIROSHIGE.

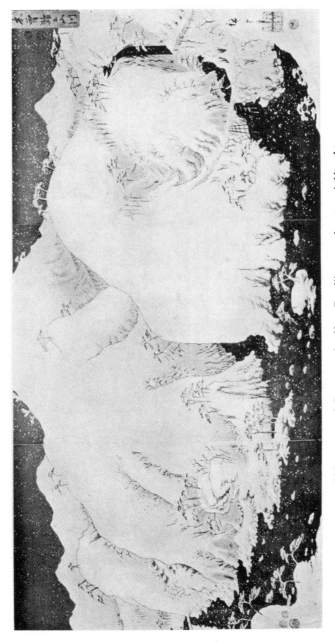

1. "Mountain and River on the Kiso Road"; triptych; signed *Hiroshige.*

(by courtesy of Messrs. Sotheby.)

PLATE 6A (first part)

HIROSHIGE.

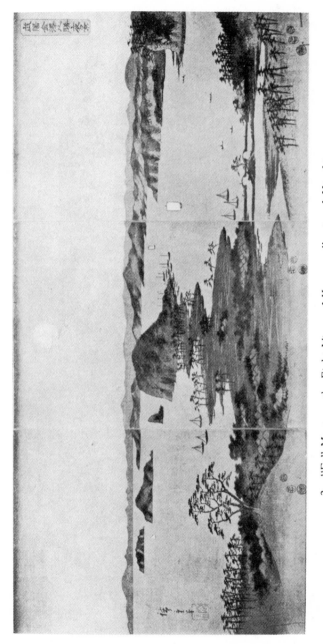

2. "Full Moon on the Eight Views of Kanazawa"; signed *Hiroshige*.
(by courtesy of Messrs. Sotheby.)

PLATE 6A (second part)

HIROSHIGE.

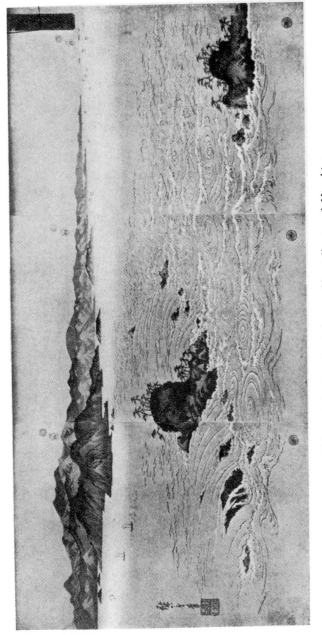

3. "View of the Rapids of Awa no Naruto"; signed *Hiroshige*.

(by courtesy of Messrs. Sotheby.)

PLATE 6A (third part)

of these prints. Beauty of drawing, harmony of colour-scheme, and all those qualities which appeal to his artistic sense, should form the chief consideration.

To the true collector a work of art is no better or no worse for being the product of one person rather than another. To pay a high price for a picture or print merely because it is—or is supposed to be—the work of a particular master, is a mistake, if the purchaser does not consider that, at the same time, it is worth that sum from an artistic point of view, and that its possession will bring him proportionate satisfaction.

Hiroshige's numerous landscape and other series are described in detail elsewhere, but certain single prints, which are reckoned his chief masterpieces as such, cannot be overlooked in any reference to him.

These are two large *kakemono-ye* and three very fine triptychs.

The former are the famous *Monkey Bridge by Moonlight* (date about 1840 ; publisher *Tsutaya ;* title *Koyo Saruhashi*), and *Snow Gorge of the Fuji River* (publisher *Sanoki ;* no title). Both these *kakemono-ye* (formed by joining two full-size vertical sheets together) are extremely rare ; a good copy of the *Monkey Bridge*, for example, is probably worth to-day from £250 to £300 (see Plate 61, page 340).

It is not unlikely that there was originally a third one, of Cherry Blossoms, making a *Settsu-Gekka* series of " Snow, Moon, and Flower," a favourite subject of illustration with artists, but no such print has ever been found (see Note, Appendix II).

There is also in existence a very rare small panel print measuring $8\frac{3}{4}$ in. by $4\frac{1}{2}$ in., under the same title, *Koyo Saruhashi*, showing the bridge between the tops of the tree-clad cliffs on either side of the gorge, and a solitary foot passenger crossing over to the right bank, and below the bridge a full moon across the face of which is a flight of wild geese. Signed *Hiroshige ;* no publisher's mark nor date-seal ; *kiwamè* seal next signature.

The following are Hiroshige's famous landscape triptychs :

1. *Kiso-ji no Yama Kawa*, " Mountain and River on the Kiso Road." A huge mass of snowy mountains fringed, here and there, with scattered pines, and broken into narrow ravines, down which pour torrents into the main river in the foreground. Title on narrow upright panel, and signature on right-hand sheet ; dated Snake 8 (1857) ; publisher, *Tsutaya (Kichizo)*.

2. *Kanazawa Ha'sshō Yakei*, " Full Moon on the Eight Views of Kanazawa." A magnificent land and seascape of the inlet of Kanazawa, looking across to a hilly coast-line opposite ; in the centre rises an island

[65]

at whose base shelters a fishing village, and connected by a level isthmus with the mainland ; overhead shines a full moon.

Title on narrow upright label on right-hand sheet ; signature on left sheet ; publisher, *Tsutaya* ; dated Snake 7 (1857).

3. *Awa no Naruto Fukei*, " View of the Rapids of Awa no Naruto." A wide view of the channel dividing the islands of Shikoku and Awaji, the sea foaming in whirlpools as it rushes over the sunken rocks ; in the foreground rise two small rocky islands. Across the channel rises a hilly coast. Title on label on right-hand sheet, signature on left ; publisher, *Tsutaya* ; dated Snake 4 (1857). (See Note, Appendix II.)

Modern reproductions of the foregoing *kakemono-ye* and triptychs are met with, sometimes so well produced as to be difficult of detection.

Amongst other famous single sheets by Hiroshige is a large vertical print, measuring 15 in. by 7 in., known as the " bow-moon," representing a crescent moon seen through a narrow gorge, behind cliffs spanned by a rustic bridge. This large panel forms one of a set entitled *Tsuki-niju-Hak'kei*, " Twenty-eight Views of the Moon," of which only this and another plate, a full moon rising behind a branch of a maple tree, are known. The series was, therefore, apparently not completed.

The bow-moon is illustrated in colours in the frontispiece to Mr. Ficke's book, and the original, in flawless condition, realized $475 (£95 at normal exchange) at the sale of his collection in New York, February, 1920.

Yet a third famous moonlight scene of Hiroshige's is another panel ($14\frac{1}{2} \times 5$), " Moonlight at Tsukuda-jima," showing a cluster of huts on an island, and junks moored in the foreground, the whole scene bathed in the light of a full moon, and a flight of birds across the sky. This print forms one of a panel series of *Toto Meisho* (Yedo Views).

Two other very fine snow scenes should also be recorded. One is a panel print (15×5), forming one of a series, *Shiki-no-Yedo Meisho*, " Famous Yedo Views at the Four Seasons," a man poling a raft along the Sumida River past a steep, snow-covered slope, at the foot of which are rows of piles ; a grey sky full of falling snow-flakes. Signed *Hiroshige*.

The second is a full-size, upright sheet from a *very* rare series, *Wakan Royei Shu*, " Poems from China and Japan " ; publisher *Jō-shū-ya* ; title on a red narrow upright label in white characters, and poem alongside on sky background. Peasants crossing a bridge over a stream running through a mountainous country ; in the background looms up a great white mountain ; signed *Hiroshige fudè*.

Hiroshige in his very early days, while still a pupil of Toyohiro, designed figure-studies, in response, we presume, to the insistent demand for this class of subject, before his genius for landscape diverted public taste into

another channel. Such designs are very rare, and are interesting both for comparison with the work of recognized figure-study designers and for the fact that they represent the skill of an artist in one direction who made his name by striking out in another. Plate 7 reproduces a figure-study by Hiroshige from a series entitled " A Mirror of Faithful Courtesans," this being a portrait of Umegawa of Tsuchiya. It shows, also, the earliest form of Hiroshige's signature. Another figure-study by Hiroshige is reproduced, full page, in the Happer Sale Catalogue.

Another (also very rare) set of figure-studies done between 1840 and 1850 is mentioned in Chapter XXXIV.

Of Hiroshige's pupil, Ichiyusai SHIGENOBU (w. 1840–1866), afterwards Hiroshige II, little need be said. As a rule his work, which closely follows that of his master, is very inferior, though at times it was of sufficient merit to compare very favourably with it, but he lacked originality and merely trod in the footsteps of his master.

As seems to have been a common habit with pupils, Shigenobu, on the death of his master, married his daughter, and at the same time assumed the great name. Six years later he divorced his wife, went to Yokohama, changed his name to Risshō, and died there in 1866.

Another pupil of Hiroshige, Shigemasa, married the divorced wife of Shigenobu and assumed the master's name as Hiroshige III. He is, however, a wholly commonplace and unimportant artist. He died as recently as 1894.

Reference has already been made to those landscape series which, while attributed as a whole to Hiroshige, yet contain certain views contributed by the pupil, and pointing out by certain characteristics how such may be distinguished from the work of the master. One series, at least, entirely by Hiroshige II, entitled " Thirty-six Views of Toto " (i.e. Yedo), contains some plates equal to any of the master's similar series, when carefully printed (see Plate 29, page 178).

Another series of Yedo views (oblong), printed almost entirely in blue, is also above his usual work, the purity of the blue atoning for the, at times, somewhat faulty drawing (see Plate 7).

This series was published by Senichi, and bears the date 1862. These blue prints owed their origin to an edict issued in 1842, and which was in force for nearly twelve years, limiting, amongst other restrictions, the number of blocks that might be used. It must be admitted that the printers overcame this restriction in a remarkably effective manner. It is not unlikely that this edict, which also prohibited the sale of prints depicting actors and courtesans, was one of the causes (perhaps, even, a very important

cause) that contributed to the decline and extinction of the art of the print-designer. Official interference and restrictions were bound to have an injurious effect upon an art which owed its existence to its ability to cater for the tastes of the multitude. Circumscribe and limit these tastes, and it is bound to suffer. It was from the date of this law that censor's and inspector's seals had to appear on all prints, a custom which was continued after the edict ceased to be in force. By prohibiting prints of actors and courtesans, by limiting the number of blocks which might be used, and the size of compound prints to triptychs, the law was aiming at raising the morals of the community and checking extravagance. This legal restriction of the subjects allowed to be portrayed naturally created a great demand for the landscape designs of Hiroshige, the result of which we see to-day in the great preponderance of his prints over those of any other individual artist, that is to say, in the number of copies still extant. It also caused other artists, who were hitherto figure-designers, to apply their brush in the same direction, or else cease work, and to this period belong the numerous prints depicting stories, folk-lore, and legend, such as the many series of this nature designed by Kuniyoshi.

Further consideration of the work of Hiroshige II in landscape will be found in a later chapter dealing with this subject.

Thanks to Mr. Happer's investigations in respect of the date-seals found on Hiroshige's prints after 1840, much confusion at one time existing between the two Hiroshiges has now been definitely cleared up, and prints formerly attributed to the pupil are now properly accorded to Hiroshige himself, though it is known he sometimes called in his pupil to assist him in completing some of his numerous series.

Owing to the difference in the signature Hiroshige appearing on the early oblong views (e.g. " Tokaido " series) as compared with that on the later vertical series (e.g. " Hundred Yedo Views "), it was at one time thought that the signature on the latter was the form in which the pupil wrote it, and consequently all vertical prints signed Hiroshige were formerly attributed to Hiroshige II. Von Seidlitz, however, points out that this difference in the form of signature is due to the change in the method of writing it, that is from the Japanese cursive to the Chinese square style, quite apart from the change naturally induced by increasing age. If the collector has opportunity of studying a number of Hiroshige's prints covering his whole career, he will notice that the change is not abrupt, as anyone comparing only early and late work, without any intermediate examples, might think, but is progressive.

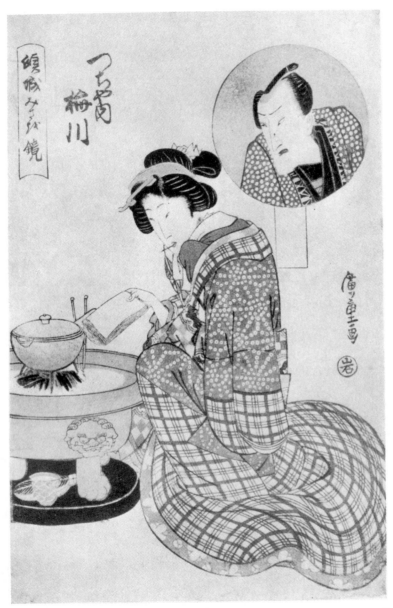

1. Umegawa of Tsuchi-ya; one of a series "A Mirror of Faithful Courtesans";
 signed *Hiroshige*.

PLATE 7 (first part)

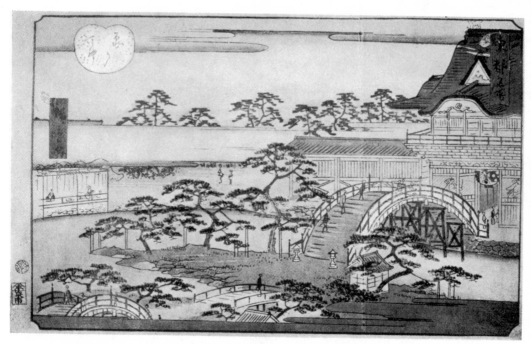

2. Blue Print ; Tenjin Temple and "Drum" Bridge ; one of a series of "Toto Meisho" ;
signed *Hiroshige* ; dated 3rd month, 1862 ; publisher *Senichi*.

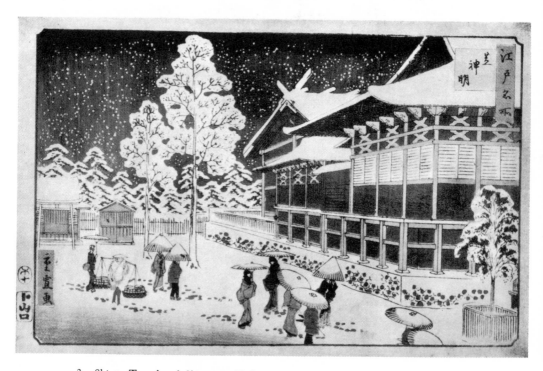

3. Shinto Temple of Shimmei, Yedo ; one of a series of "Yedo Views" ; signed
Shigenobu ; dated 10th month, 1858.

PLATE 7 (second part)

PART II

SUBJECTS OF ILLUSTRATION:
(1). LANDSCAPE

CHAPTER VIII

CHARACTERISTICS OF JAPANESE DRAWING

IN order to understand better Japanese pictorial art, it is necessary to approach it from a different standpoint to that adopted when criticizing Western art, and to make allowances for the limitations imposed upon it by their canons of drawing and the medium of expression employed. It should be recognized as a purely local product, unique in itself, and cannot fairly be judged by the highly cultivated and, it must be admitted, highly artificial work of European artists.

Thus Japanese painting, like its parent Chinese painting, when not showing traces of European influence, is in two dimensions only, that is, it confines itself to representation in one plane, the idea of space not being indicated by strict perspective, as with us, but if shown at all, by one scene behind or above the other.

Such perspective as the Japanese artist employs is quite sufficient for the purpose of the subjects he portrays, and it is not true to say, as has been said, that he knows nothing of the effect of distance. He is far more appreciative of, and more truthful to nature in his delineation of animate creation than any Western artist, while as a colourist he is unequalled. One has only to study his drawings of flowers, birds, and insects, to be convinced of the truth of this fact.

Even when European perspective is applied to a limited extent, as is the case with the landscape designs of Hiroshige, for example, the whole drawing remains essentially Japanese.

Then again, in the representation of figures, or other objects, these are not rounded and modelled to shape, nor do they cast shadows, shadows being considered, according to the Chinese doctrine, as something purely accidental, and therefore not worth delineating.

In addition, the proportions of figures are often purely arbitrary, both to one another and to the surroundings in which they may be placed, their size being governed by their importance in the general composition.

Whether this was the deliberate intention of the artist, or whether it was a point little considered—perhaps ignored altogether—cannot be stated for certain.

A fixed convention, too, is adopted in all portraits and figure-studies, and sometimes even in small figures introduced into a landscape, whereby

the face is invariably drawn half-way between full face and profile, a convention enabling the artist to portray all the topography of the features with more character than in a full face.

It also enabled him to draw his figures with less restriction as to their attitudes, or the occupations in which they could be represented.

It will further be noticed that, except in actor-portraits, where expression is everything, the features are almost expressionless, or at least immobile, due to the peculiar Japanese notion then current, whereby to betray one's feelings outwardly was considered a breach of good manners.

Another convention is that used to impart the sense of darkness at night-time by means of a black or grey sky, by introducing a moon or lanterns into the composition, a convention which well realizes the desired effect without causing a sense of incongruity, such as might be expected, while the picture remains as distinct as if the scene was in broad daylight.

The Japanese designer of colour-prints did not try to secure, by means of subtle graduations of light and darkness, the results attempted by European artists in producing a picture which should compete, in its reality and exactness to nature, with a photograph.

He understood the limitations imposed upon him by the methods and materials at his disposal ; to have attempted to secure effects beyond its capacity would have been to sacrifice the charming results of which the process was capable.

On the other hand his art is suggestive, and to it the observer must bring his own share of mind and thought if he would interpret clearly the artist's meaning.

That rare faculty which conceives or forms ideas of things which exist but are not perceptible to the senses is one which Westerners acknowledge only to be possessed by poets ; in Japan it is possessed by the artist, whose designs are not intended to be taken literally, but should be regarded in a metaphorical sense.

Thus these prints can never be appreciated by the dull, unimaginative mind, but on the other hand, those who can understand the principles upon which they are conceived, and who love art for its own sake, will find in them a source of the keenest delight in the realm of pure æsthetics as applied to painting, and will thereby rid his mind of much that passes for art in our Western world.

These colour-prints have not inaptly been compared to the art of the stained-glass designer. Both rely on firm outline and masses of colour for their effectiveness ; in other words their charm lies in their simplicity and absence of meaningless detail.

Thus Hiroshige's snow-scenes owe their wonderful effectiveness simply to the natural whiteness of the paper, and are far snowier than any amount

of paint could have made them. Their effectiveness is further enhanced by the most sparing use of colour, a blue strip of water or sky, or a few bright figures introduced into the landscape, supplying the necessary contrast.

Though these conventions were imposed upon the artist by the materials at his disposal, and by his training, the reader should not conclude that the resultant pictures are purely formal or unreal. No pictorial art has better expressed the life, habits, and customs of a people, while the scenery of Japan will live, as long as these prints exist, in the wonderful drawings of Hokusai and Hiroshige. They are indeed the pictures of a " passing world." It is their very realism, once their conventions have been mastered, which creates such an attraction for them, in addition to their pure beauty of line and colour.

Another remarkable feature of the designs of the *Ukiyoye* school is the extraordinary fertility of invention displayed by its artists, particularly those of the late eighteenth and early nineteenth centuries, not only in ideas for subjects, but in the arrangement of their colours and patterns.

One may look through thousands of prints in the course of forming a collection, yet it is very rare to come across any which closely resemble one another, unless one artist has deliberately copied another, as Utamaro has sometimes been copied. Even where more than one artist has taken the same subject for illustration, their respective designs will differ widely, yet convey the same lesson.

This talent of inventiveness is due, no doubt, to the Japanese love and close study of Nature, who never repeats herself.

It will be noticed also that, while their skill in drawing insects, birds, and flowers is such as to excite our admiration and the envy of artists of other nations, yet they do not seem to have mastered the drawing of animals. Their oxen are such as one never saw yoked to a plough, their horses never harnessed to a cart, nor would one expect to hear their dogs bark.

This does not of course mean that Japan produced no artists capable of correctly painting animals. Okio (1733–1795), Sosen (1746–1821), and Ganku (1749–1838), three artists of a naturalistic school of painting, of which the first-named was the founder, painted animals with extraordinary fidelity to Nature. Okio is famous for his dogs, Sosen for monkeys, and Ganku for tigers.

But speaking generally, Japanese artists' representations of animals are usually of the crudest description, and practically they confine themselves to drawing such purely domestic creatures as the horse, the ox, and the dog. Japan itself being devoid of large wild animals, such as the lion, tiger, or leopard, such attempts as are made to depict these

beasts have been taken from descriptions or rough drawings which have reached them from other countries, the opportunity of personal observation being lacking.

The *Ukiyoye* artists, also, did not apparently pay much heed to the drawing of hands and feet, which are generally ill-proportioned, notwithstanding the fact that, next to the face, these are the most easily observed parts of the human anatomy, while the figure itself is often drawn out to an impossible height, an exaggeration very noticeable, for example, in the later work of Utamaro. This fault, however, often appears greater than it really is, owing to the effect produced by the long flowing robes which completely hide the contour of the figure, and was doubtless intended as an expression of idealism.

In the period of the decline, from 1830 onwards, the drawing becomes very inferior, the hands and feet being little better than deformities, while effect is sought less by the outline than by complexity of design and vividness of colouring.

CHAPTER IX

CLASSIFICATION OF SUBJECTS

Surimono and Fan-Prints.

THE subjects illustrated in Japanese prints may be generally classified under the following heads : (i) Theatrical scenes and portraits of actors ; (ii) Portraits of *geisha* and courtesans, full-length figure and head studies ; (iii) Illustrations of historical and legendary stories, mythical heroes, and the like ; (iv) Landscape. A further division might be added under the heading of ghosts, a subject which certain artists, particularly Kuniyoshi, seem to have strongly favoured. *Surimono* form a class to themselves, and are of such a varied nature that it is impossible to group them under any particular heading.

What they were will be best indicated by saying that they were like nothing so much as our Christmas, New Year, Birthday, or other form of greeting card, while the designs on them were as diverse.

They were, as a rule, only printed on commission, and the regular designers of colour-prints were often requested by their patrons to supply the drawing for them ; many again were produced by those who used them, which accounts for the appearance on some *surimono* of unknown signatures, that is of people who were not professional artists.

Surimono are almost square in shape, measuring about 8 in. by 7 in., and sometimes they are made up of multiples of this size, in the form of triptychs or two vertical ones. Particular care was lavished both by the artist, the engraver, and the printer upon their production, the decorative effect being increased by the use of gold, silver, bronze, and mother-of-pearl, while relief-printing (*gauffrage*) was liberally employed. They were also, as a rule, printed on a much better quality paper, being thicker and softer than the ordinary prints sold in the street. Some collectors, indeed, reject *surimono* on the ground that they are not true examples of art, because artistic effect is produced by mere complication of technique, so that the medium employed, instead of the result, has become their sole object. Even so, fine *surimono* are very beautiful, while they show the skill of the engraver and the printer at its highest level.

Some of the finest *surimono* were produced by pupils of Hokusai, who

excelled even their master in this respect. Of these Hokkei, Gakutei, Shinsai, and Yanagawa Shigenobu were the chief.

Another special form of print was that intended for mounting on a fan. Fan-prints were in two shapes, the *uchiwa*, for the round, non-folding fan, and the *ogi*, or folding fan. Owing to the uses to which they were put, which of necessity condemned them to a relatively short existence, fan-prints are not common, but the *uchiwa* shape is the one most frequently met with (see Plate 6).

Most of those which have survived to our day are ones which have not been mounted on fans, but occasionally one finds a fan-print which has been so mounted, showing the marks of the ribs, but has been taken off and preserved.

To revert to our classification, prints combining both figure-studies and landscape are also found, where beautiful women are compared to beautiful scenery, though sometimes the connection between the two is not very apparent, or is too subtle for the European to detect. In such prints the landscape is often relegated to a small inset view, or it may occupy the whole of the upper half of the picture.

It is the common experience of many collectors that it is through the landscape designs of Hiroshige they are first attracted to these colour-prints. The reason for this is well put by E. F. Strange, in the Victoria and Albert Museum handbook on Japanese Colour-Prints [1] (p. 96), from which we take the liberty to quote as follows :

" Japanese colour-prints devoted to landscape form a class apart in the art of the world. There is nothing else like them ; neither in the highly idealistic and often lovely abstractions of the aristocratic painters of Japan nor in the more imitative and, it must be said, more meaningless transcripts from nature of European artists. The colour-print, as executed by the best men of the Japanese popular school, occupies an intermediate place ; perhaps thus furnishing a reason why we Westerns so easily appreciate it. Its imagery and sentiment are elementary in the eyes of the native critic of Japanese high art ; its attempts at realism are in his eyes mere evidence of vulgarity. On the other hand, these very qualities endear it to us. We can understand the first, without the long training in symbolism which is the essential of refinement to an educated man of the extreme East. And the other characteristic forms, in our eyes, a leading recommendation. In short, the landscapes of artists such as Hiroshige approach more nearly to our own standards, and are thus more easily

[1] *Japanese Colour-Prints*, by Edward F. Strange. Victoria and Albert Museum, London. 4th ed., 1913.

Yanagawa SHIGENOBU.

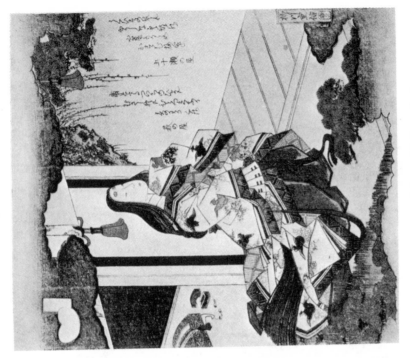

2. *Surimono*: A beautiful Court Lady; signed *Yanagawa Shigenobu.*

Riuriukio SHINSAI.

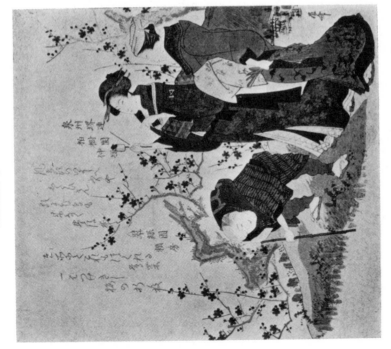

1. *Surimono*: Two women and a boy out in a garden viewing plum-blossom; signed *Shinsai.*

PLATE 8 (first part)

Keisai YEISEN.

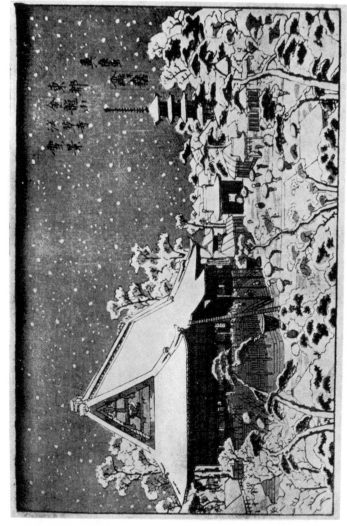

3. "Asakusa Temple, Kinryūsan, Yedo, under snow"; signed *Yeisen*; publisher *Mori-ji.*

PLATE 8 (second part)

acceptable to us than anything else in the pictorial arts of China and Japan ; while they have all the fascination of a strange technique, a bold and undaunted convention, and a superb excellence of composition not too remote in principle from our own."

It seems, therefore, convenient to deal with our last class of subject first, namely landscape, as constituting the most appropriate nucleus in the formation of a collection, though historically landscape marks the final years of the *Ukiyoye* school. Beginning, then, with the landscape designs of Hiroshige and Hokusai, we will afterwards pass on to the consideration of our other subjects, actor-portraits and theatrical scenes, portraits of women, and illustrations of stories and legends.

CHAPTER X

THE FIFTY-THREE STATIONS ON THE TOKAIDO

OF the numerous series of landscape scenes designed by Hiroshige, none is better known, or has brought him wider fame, than his celebrated early set of Views (oblong) on the Tokaido, the road running along the eastern coast between the two capitals Yedo (now Tokyo) and Kyoto, a distance of 323 miles, entitled the " Fifty-three Stations of the Eastern Road " (*Tokaido Go-ju-san-Tsugi*), issued jointly about the year 1834, by the publishers *Hoyeido* (seal *Takè-Uchi*) and *Senkakudo*.

So great was its popularity that this series ran through many editions, each one worse printed than its predecessor : copies from these inferior editions are numerous; fine impressions of the first edition are rare.

A certain number of the earliest impressions from the first edition of some three thousand copies were bound up complete in two volumes.

In volume form the full title is *Tōkaido Go-ju-san eki zuye tsuzuki yoko-ye* (" Continuous Oblong Views of the Fifty-three Stations of the Tokaido ") ; the abbreviated title as given above (*Tokaido Go-ju-san-Tsugi*) is that inscribed on each plate of the series.

These two volumes are generally taken as the standard for deciding which of the different states in which many of the plates are found constitutes the original one.

Fuji-yama alone has been depicted more frequently than this historic highway of Japan, and no artist has done fuller justice to it than Hiroshige, nor more vividly portrayed the characteristics of the people who thronged it. All classes of the population, from the *daimyo* travelling in his *norimonō*, surrounded by his escort, to the coolie and mendicant by the wayside, are depicted, often with a strong sense of humour.

Captain Osborn, to whom we referred in our opening chapter, and who travelled along part of this road about the year 1858, says of these stages on the Tokaido : " The lords of the various manors are compelled by the authorities to maintain these places of refreshment for travellers ; they are vastly superior to the caravanserais of the East, and relays of horses or porters are always ready at these post-houses, and must do all work at a regular fixed charge, ridiculously small according to English

notions. Another and still more onerous duty falls on these establishments, and that is the responsibility of forwarding all Imperial dispatches between the two capitals, or from Yedo to any part of the Empire. Runners are consequently ever ready to execute this task." We see such a runner depicted in the view for station No. 8, *Hiratsuka* (illustrated at Plate 9).

The social status of a person is indicated by the manner in which he travels. The *daimyo* and people of the upper class travel in *norimono*, which are roomy enough to allow of a fair amount of ease, and are comfortably furnished. The sides can be opened or closed at will, as a protection against the weather. The length of the pole proclaims the rank of the passenger ; if a nobleman, a long pole borne by five or six men at each end ; a person of lower rank, a shorter pole and only four carriers. If the occupant is a prince of the royal family, the pole rests on the palms of the hands, otherwise it is borne on the shoulders. Humble individuals have to be satisfied with a *kago* carried by two porters, which entails a very cramped position. In steep mountain regions everyone, whatever their rank, is obliged to use a *kago*.

The complete series of Tokaido views consists of fifty-five plates, views of the two capitals, Yedo and Kyoto, being added to those of the fifty-three stages on the road. In addition, six plates out of the first ten are found redrawn with variations, due perhaps to the originals having been lost in a fire, or to their becoming much worn through the large number of impressions taken from them, by reason of a greater demand for these particular views, thus necessitating a new key-block altogether from a fresh design.

Other plates will be found with variations in the colour-blocks, while the key-block remains the same, or the alteration will be confined to the omission in a later issue of certain lettering, as, for example, with Plate 36 (Goyu station) or Plate 46 (Shono station).

A complete set, therefore, showing all the known variations, will consist of some seventy prints.

The following are the plates comprising this series, with the variations where they occur :—

Plate 1. *Nihon Bashi.* View looking across the Nihon Bridge, Yedo, from whence all distances were measured—the " London Bridge " of Japan—with a *daimyo's* cortège coming into view over the summit. In the foreground a group of five fish-vendors (and a sixth partly hidden) getting out of the way, on the left, and two dogs on the right. Rosy sky on horizon, changing to blue across the top and blue clouds in left half of sky. Very uncommon in this earliest state.

1st variation. Blue clouds omitted in sky.

2nd variation. Clouds omitted, and foreground filled with many more figures ; dogs in centre, and drawn smaller.

Plate 2. *Shinagawa.* A street of houses backing on to the seashore, and the tail-end of a *daimyo's* procession passing along it ; behind the houses ships moored in the bay. A variation shows four more figures in the procession. (Publisher *Senkakudo,* 1st state.)

Plate 3. *Kawasaki.* A ferry-boat crossing the river, and passengers waiting on the further bank in front of a cluster of houses ; Fuji in the distance. Close to the further bank is a man on a raft.

Variation plate. The second issue shows both inferior drawing and inferior colour compared with the first state. The man is gone from the raft ; the boatman's head is turned the opposite way ; Fuji is indicated only by a white shape in a yellow sky, no outline block ; fewer trees and more roughly drawn, and fewer huts in the village in the background. The first issue carries the red seal of the publisher *Senkakudo,* the second a red gourd-shaped seal marked *kiwamè* and *Takè* (i.e. *Hoyeido*).

Plate 4. *Kanagawa.* View of a street along the top of a cliff overlooking Yedo Bay, and female touts trying to drag travellers into the rest-houses. Late issues show slight variations, the chief of which is a row of posts in the water, while the position of the blue cloud is altered to the right (see Plate B, page 22).

Plate 5. *Hodogaya.* A bridge over a stream, and across it two coolies are carrying a closed *kago* towards a village on the opposite bank ; behind the village rises a low wooded hill. (Publisher *Senkakudo.*)

Plate 6. *Totsuka.* A man dismounting from his horse in front of an open tea-house, while a waitress stands by to receive him.

Greater differences appear in the variation block of this view than in any other, as will be seen by the illustrations of them at Plate 9.

In the second edition the tea-house is boarded up, thus shutting out the view of the hill beyond, the man is mounting his horse, though the attitude of the waitress remains the same. Other minor differences will also be noticed, such as in the banks of the stream, and the trees.

Plate 7. *Fujisawa.* The village by the edge of a stream, and a bridge leading to it, over which people are passing. In background, overlooking the village on a wooded hill, above the mists, stands the temple Yugi-o-ji ; in the foreground a *torii,* and close to it four blind men following each other by the bank of the stream.

Plate 7a. *Katase, on the Enoshima Road.* Katase is a small village lying between stations Fujisawa and Hiratsuka, and though this plate appears to have been made for the Tokaido set, it is not included in the two volumes published on completion of the series, and it is, moreover, extremely

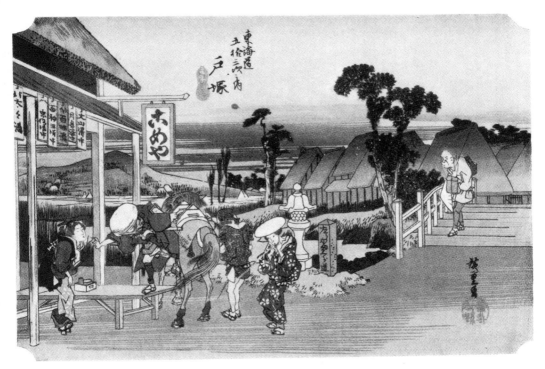

1. Station 6 : Totsuka (1st state).

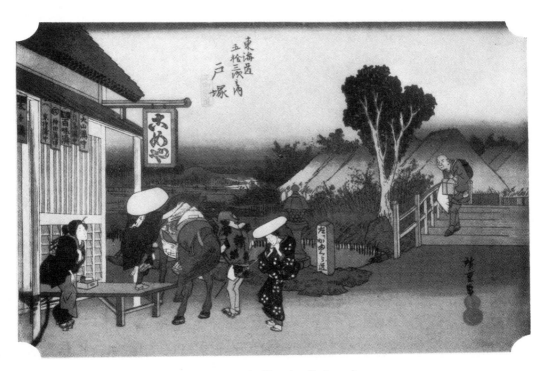

2. Station 6 : Totsuka (2nd state).

PLATE 9 (first part)

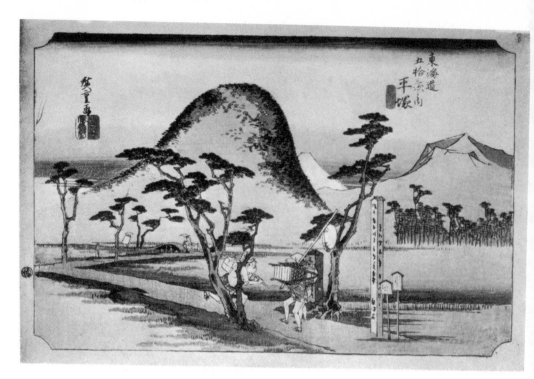

3. Station 8 : Hiratsuka.

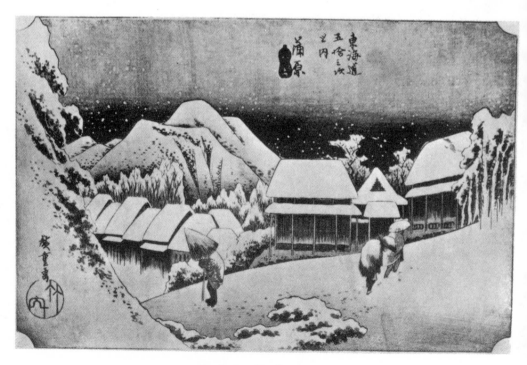

4. Station 16 : Kambara.

PLATE 9 (second part)

rare. Its rarity, and the fact that it does not appear in the bound book of Tokaido views, may very likely be due to the accidental destruction or loss of the block early in its career, when only very few impressions had been taken from it. The village is shown lying at the foot of a hill on the left, crowned with trees, and two men admiring the view from the summit ; in the distance the tree-covered island of Enoshima, towards which people are wending their way along the narrow sand-bank connecting it with the mainland. (Anonymous sale, June, 1913 ; illustrated at Plate VIII of Catalogue.)

Plate 8. *Hiratsuka.* A zigzag road, lined with a few trees, traversing fields, and a courier running along and passing two other travellers. In the background a dark, round-topped hill, behind which a white Fuji appears in the distance. In best impressions the fields are bluish-green, deep blue along the edges of the road ; deep blue sky behind hills, changing to red at top. (See Plate 9.)

Plate 9. *Oiso.* The approach through rice-fields along a narrow road lined with trees, to a curving street of huts, overlooking the sea, and travellers entering the village under a downpour of rain. First edition copies have a pale yellow sky changing to black at the top.

Plate 10. *Odawara.* A *daimyo's* cortège being carried across the River Sakawa ; the background a mass of high, jagged hills, the most distant printed from colour-blocks only. This plate is found in four different states ; the first may be recognized by there being only two figures on the near bank of the river. In the second and third states there are five, and in the fourth there are four, while in all states the outline of the distant hills varies. Each state is found with variations in the colour-scheme.

State 1. This is the view included in the bound two-volume edition which is generally taken as the standard in determining the first issue of plates found in different states. Two coolies on near shore ; mountains immediately behind village and castle on further shore higher than in other states, in each of which their outline is the same. Fields lying between river-bank and village dark green. Very high angular mountain, printed in blue from graded colour-block only, in background ; yellow sky on horizon, changing to black at top ; also found with crimson sky, changing to purple at top. Red *Hoyeido* seal below Hiroshige's signature.

State 2. Three coolies and two travellers on near shore ; sixteen figures on further shore against thirteen in the previous state. Fields a lighter shade of green, which is graded off into mist lying over the village, an effect not always found in the previous state. Deep blue mountains in background from colour-block only, with four sharp peaks ; blue sky on horizon, changing to crimson at the top. Red *Hoyeido* seal.

State 3. Practically the same as the foregoing, with three coolies and two travellers on near shore. Mountains in background more rounded in outline than in the last state, and rising rather higher ; sky crimson.

State 4. Two travellers and two coolies on near shore ; fields green ; yellow and orange mist lying over village ; smaller round-topped, blue mountain in background, and another printed in reddish tint in the further distance in centre of picture ; crimson sky on horizon, changing to purple at top. *Hoyeido* seal. The most interesting point about this state is the signature, which is written in a totally different script, and must be an early one either of Hiroshige II or some other pupil. This fact appears to have led Mr. Happer to consider this state (which he calls the second) really the earliest one of the four, but the full script, *Hiro shige gwa*, is quite unlike even the earliest form used by Hiroshige himself, such as appears on his figure-studies (*vide* our illustration at Plate 7).

Plate 11. *Hakonè.* A high peak, round the base of which, through a gorge, a *daimyo's* cortège is wending its way ; on the left the Hakonè Lake, with Fuji in the distance. The peak is drawn in a peculiar angular manner, almost cubist in effect, which detracts somewhat from this view.

Plate 12. *Mishima.* Travellers setting forth in the mists of early morning, one on horseback and the other in a *kago*. A charming mist effect, such as Hiroshige knew so well how to render.

The first issue of this plate may be distinguished from later issues by having the clump of trees, huts, etc., printed in graded *black* and grey ; in later issues they are blue. One of the favourite plates of the set.

Plate 13. *Numazu.* Travellers walking along the river bank, lined with trees, towards the village ahead, under a huge full moon in a deep blue sky, one of them carrying on his back a large *Tengu* mask, the mark of a pilgrim to the Shinto shrine of Kompira. Dark forest of trees on further shore of river. Another very effective print, landscape under a full moon being a favourite theme with Hiroshige.

Plate 14. *Hara.* Two women wayfarers, and a coolie carrying their boxes, passing along by rice-fields, overlooked by the huge snowy mass of Fuji. When the margins of this print have been trimmed, if formerly mounted in a book, the peak of Fuji is cut off. Uncut copies only of this print should, therefore, be selected.

Plate 15. *Yoshiwara.* A road lined with trees running through rice-fields, along which a man leads a horse carrying three women ; Fuji in the distance.

A variation of this plate shows a higher Fuji with the title written across it.

Plate 16. *Kambara.* A mountain village at nightfall under deep snow, through which three people are toiling, one with his head buried in a half-

open umbrella. A very fine snow scene, and one of the masterpieces of the series. (See Plate 9.)

This plate is found in variations in which the sky is sometimes darkest below, graded to lighter above, and in others blackest at the top. The former is, perhaps, the best, as the darker sky below throws into stronger contrast the whiteness of the snow-covered roofs and hills. The black sky is also found carried up higher in some copies than in others, level with the top of the rounded hill in left-centre.

Plate 17. *Yui.* A fine view of Fuji, snow-covered, from Satta-toge, overlooking Saruga Bay.

Plate 18. *Okitsu.* View near the mouth of the Okitsu River, looking out to sea, and two wrestlers being carried up-stream, one on a packhorse and the other in a *kago.* The somewhat grotesque coolies and fat wrestlers are a blot on an otherwise pleasing view of land and sea. All copies of this print which have come under observation have invariably been well printed, with sharp outline and good colours.

Plate 19. *Ejiri.* View over Mio-no-Matsu-bara, at the mouth of the Okitsu River (seen close to in previous plate), to a hilly coast-line beyond ; junks anchored in foreground in front of a fishing village, and others sailing in the bay.

Plate 20. *Fuchu.* A woman in a *kago* being carried across the Abe River ; others fording the stream from the opposite bank ; a range of mountains in the background.

Plate 21. *Mariko.* Two travellers having refreshment at a wayside tea-house, from which another traveller has just departed, and a woman with a child on her back waiting on them. Beside the tea-house grows a plum tree, just bursting into blossom against the rosy sky ; behind rises a grey hill tinted with brown. The earliest issue of this plate has the place-name mis-spelt Maru-ko, and was very soon withdrawn, consequently copies with this error are extremely rare. This print is one of the most charming of any in the whole series, thanks to the effect produced by the beautiful rosy-pink sky, which in some copies is much faded, and in late issues is often missing altogether.

Plate 22. *Okabe.* A mountain torrent rushing between steep banks and walled in on one side by a stone embankment, along which people are passing. High peaks in the background. In first edition copies the banks on either side of the stream are coloured green, in late issues they differ from one another, the left slope being a yellowish colour.

Plate 23. *Fuji-yeda.* Changing horses and coolies outside a rest-house. The first issue may be recognized by the very fine grading of the ground from wine-colour to yellow and then green in the background, an effect which redeems an otherwise rather coarse design.

Plate 24. *Shimada.* View looking down upon the wide bed of the Oi River, with people waiting on its sand-banks to be taken across. An uninteresting plate, being merely a bird's-eye view of a wide stretch of river and sand-banks, dotted about with small figures.

Plate 25. *Kanaya.* Beyond the wide sandy flats of the river, across which a *daimyo's* cortège is being carried, rises a jumble of foot-hills, in a crevice of which nestles a village. In the background a high range of curiously hump-shaped mountains, printed in graded black from colour-blocks only ; golden sky at top. This plate is similar to Plate No. 10, Odawara, showing the ford over the Sakawa River.

Plate 26. *Nissaka.* A very steep yellow road in a mountainous district, and at the foot of it people examining a large rock, marking the spot where a murder was committed. In later issues the road is *green.*

Plate 27. *Kakegawa.* Travellers crossing a high trestle-bridge over the Kakè River, two of them peering into the water below, and behind a small boy watching a kite up in the air, while beyond another, with broken string, flutters to earth. Peasants transplanting rice in the flooded fields, and in the distance Mount Akiba rising above the mists. (Illustrated at Plate 11 in our quarto edition, 1920.)

Plate 28. *Fukuroi.* Coolies resting by a wayside shelter, while a large kettle, hung from the branch of a tree, is boiling ; a woman stirs the fire, while a coolie lights his pipe at it. Close against the tree stands a road-direction post, and on the right is a bird perched upon a wayside notice-board ; behind are rice fields, at the edge of which stands the village.

Plate 29. *Mitsuke.* A large sand-bank in the centre of the " Heaven-dragon " River, and people crossing the further arm in boats ; two other boats in foreground, moored to the sand-bank, and the distant shore enveloped in mist.

Plate 30. *Hamamatsu in Winter-time.* A party of coolies warming themselves by a bonfire beside a large tree, a traveller, with pipe in hand, looking on, and a peasant woman carrying a child on her back, approaching from the right. Bare, flat rice-fields, across which stand the castle and village in the background. In the best impressions, the edge of the smoke should be tinted a reddish-brown at the base, and should be slightly *gauffraged ;* the grass in the foreground should be a light green, carefully graded to a slight tinge of brown at the edge on which grows the tree.

Plate 31. *Maisaka.* View of Imaki Point jutting out into the sea, and a white Fuji (without outline) in the distance. In some copies the sky is a deep pink, in others it is yellow on the horizon, fading to white and indigo at the top.

Plate 32. *Arai.* A large ferry-boat, with an awning round it, taking a *daimyo* across from Maisaka, followed by a smaller boat with his

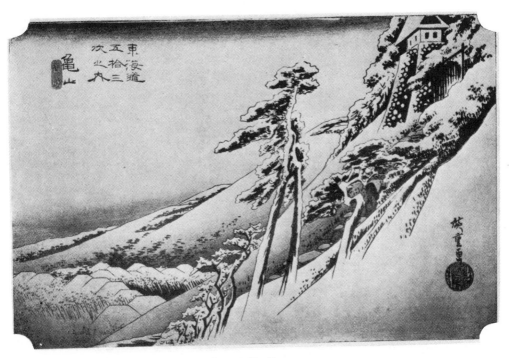

1. Station 46 : Shono (2nd state).

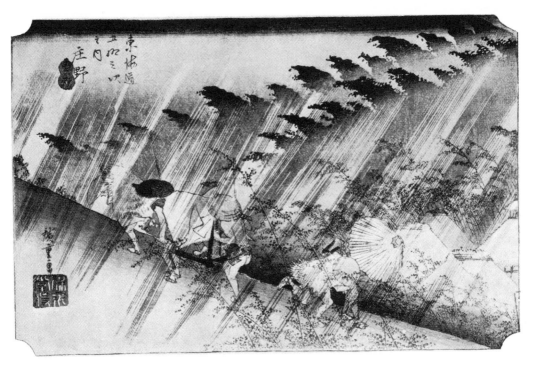

2. Station 47 : Kameyama.

PLATE 10 (first part)

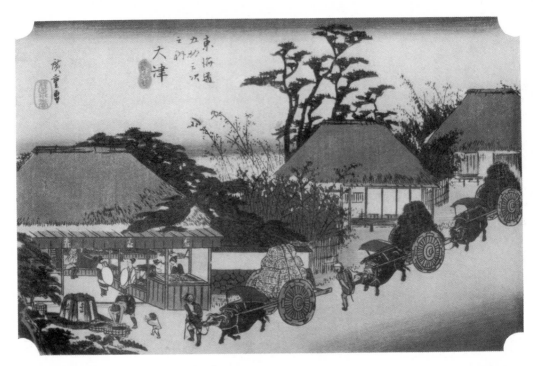

3. Station 54 : Otsu (usual state).

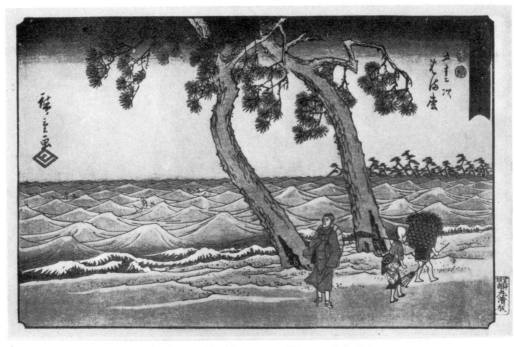

4. Station 30 : Hamamatsu (*Marusei Tokaido*).
(Reproduced from Happer Catalogue by courtesy of Messrs. Sotheby.)

PLATE 10 (second part)

retainers. A high range of hills behind the village on the further shore ; golden sky.

Plate 33. *Shirasuka*. View out to sea through a dip in the hill, at the foot of which a *daimyo's* procession is passing ; clumps of trees to right and left.

The slopes of the hill in the foreground, on either side, should be dark grey, graded almost to black at the edge ; the slope on other side of the procession green ; the sea deep blue at the edge of the shore, gradually shaded off to white on the horizon, where it meets an orange sky which is generally found in process of changing to black, owing to chemical change in the pigment, which gives the effect of storm-clouds arising.

Plate 34. *Futagawa*. A low hill, covered with small cider trees ; on the left a tea-house, at which a traveller is taking refreshment, and three others approaching it.

Plate 35. *Yoshida*. Bridge over the Toyo River, and in the right foreground workmen repairing the castle.

Plate 36. *Goyu*. Main street of the village at nightfall and female touts dragging travellers into the tea-house on the right, where one is already resting. The large circle on the wall bears the sign of the publisher of the series, *Takè-no-Uchi*, which is omitted in later issues. On the sign-boards inside are given the names of the engraver, *Jirobei ;* the printer, *Heibei ;* and the artist, *Ichiryusai*.

Plate 37. *Akasaka*. The courtyard of a rest-house, in the centre of which a sago-palm is growing ; on the left, guests being served with refreshments, and on the right, *geisha* dressing up for their performance.

Plate 38. *Fujikawa*. The head of a *daimyo's* procession at the entrance to a village, and three peasants making obeisance as it passes.

Plate 39. *Okazaki*. A *daimyo's* cortège crossing the bridge over the Yahagi River towards the village and castle on the further bank ; in the background a blue hill, printed from colour-blocks only.

Plate 40. *Chiryu*. A number of horses tethered near a tree in the fields, where a fair is held in the summer. An uninteresting print, the drawing of the horses being crude and the green of the fields harsh.

A variation plate shows a low whale-backed hill in the background. According to the bound volume issue the state *without* the hill is the earliest, thus reversing the usual practice, where the omission of some feature generally denotes a later state. Probably the hill was added as an after-thought in an attempt to retrieve, in some degree, the poorest plate in the series. As, however, it is very uncommon in this state, it is possible that the hill denotes a very early impression, of which only a very few copies were printed, like the rare state of Plate 21 with the place-name mis-spelt, the block for the hill being early destroyed and not recut.

Plate 41. *Narumi.* A woman carried in a *kago* and two others walking in front, followed by a man on horseback and two attendants, passing two large open shops in the main street, where dyed cloths are sold. On a blue fascia over the front of the nearer shop is the monogram *Hiro* in the centre, and that of the publisher, *Take-no-Uchi*, each side of it, omitted in later issues.

Plate 42. *Miya.* Two gangs of men and horses dragging a festival car (not shown) past the entrance to Miya Temple on a fête day.

Plate 43. *Kuwana.* Two large junks moored at the mouth of the Kiso River, and others sailing away to sea.

Early issues of this plate have the green and blue of the waves very carefully graded.

Plate 44. *Yokkaichi.* The hurricane. A man racing after his hat, bowled along by the wind, and another crossing a small bridge over a stream, his coat blown about him. Considered one of the masterpieces of the series. In first edition copies the man's coat is shaded in colour.

Plate 45. *Ishiyakushi.* A temple in a grove of trees on the left and the village on the right ; behind, a high range of hills, printed from colour-blocks. In late issues the blue hill in the background, from graded colour-block, is sometimes omitted.

Plate 46. *Shono.* Rain-storm in the mountains ; coolies carrying a *kago*, with a straw coat thrown over it, up the hill, and two others, one with an umbrella, rushing down. In the first edition the title, *Go-ju-san-Tsugi*, and the publisher's name, *Take-no-Uchi*, are inscribed on the umbrella, but are left out in subsequent issues, an omission which is considered an improvement. The rain is also more strongly printed, the sky darker, and the roofs of the huts stand out sharper. In general effect the later issue is the best when well printed, like the copy here reproduced at Plate 10. This plate is considered the masterpiece of the whole Tokaido series.

Plate 47. *Kameyama.* A celebrated snow scene of Hiroshige's. Travellers ascending a steep hill-side, under deep snow, to the entrance to the castle of Kameyama. Considered the second masterpiece of the series.

In the best impressions the slopes of the hill beyond the village should be tinted grey to almost black at the base against the white roofs. The nearer slopes should also be graded a slight grey tint. The sky on the horizon should be flushed crimson, gradually shaded off, changing to blue at the top. (See Plate 10.)

Plate 48. *Seki.* View outside a rest-house in the early morning, where a *daimyo* is stopping, the retainers preparing, by the aid of lanterns, to proceed on the journey.

Plate 49. *Saka-no-shita*. Travellers resting at an open tea-house, looking across a ravine to the rocky heights opposite ; blue hills beyond, in colour-blocks only.

Plate 50. *Tsuchi-yama*. The head of a *daimyo's* procession crossing a torrent by a bridge towards the village, hidden in a grove of trees, under a heavy downpour of rain.

Plate 51. *Minakuchi*. A solitary traveller walking through the village, where women are peeling and drying gourds ; in the background a range of hills, printed from colour-block only.

Plate 52. *Ishibe*. View of a tea-house on left, under a large tree, and travellers watching a man dancing ; hills in background from graded colour-block, the lower part in mist.

Plate 53. *Kusatsu*. View of a rest-house for coolies, and horses on the road ; coolies passing in the foreground with a *kago* and a covered palanquin.

Plate 54. *Otsu*. Three bullock-carts passing down the main street of the village, and an open tea-house on the left ; in the background a green hill, faintly printed from colour-blocks, is found in some copies. (See Plate 10.)

As this state is *very* rare, it probably denotes a very early issue of which only a few copies were taken, after which the hill block got damaged or destroyed, and this feature was left out in subsequent impressions. This view is borne out by the fact that copies without the hill carry the *kiwamè* seal, usually the mark of first edition copies, though not invariably so.

Plate 55. *Kyoto*. In the foreground the " long " bridge over the Kamo River, and people crossing over, with the town beyond, behind which rise hills overlooking it, the most distant printed from graded colour-block only, in a reddish-brown tint. The bridge and figures crossing it should stand out well-defined against the white mists lying over the river beyond.

CHAPTER XI

THE STATIONS OF THE TOKAIDO—(*continued*)

IN addition to the foregoing Tokaido series, generally known for purposes of distinction as the "Great" Tokaido, Hiroshige issued two other oblong sets, one through the publisher Yetatsu (or Yesaki), about 1840, somewhat smaller than the first series, and the other through the publisher Marusei, during the prohibition period (1842–1853), as each plate carries two censors' seals.

This Marusei edition is also called the *Reisho* series, because the title, *Tokaido*, on a red label, is written in *reisho* or formal script (i.e. in capitals) ; while the Yetatsu edition is also known as the *Gyosho* series, the title, also on a label, being written in *gyosho*, or informal script.

In the Marusei set the title and number of the plate is on the label, the station name and censors' seals outside it ; also the script " Fifty-three Stations." Hiroshige's signature occurs sometimes on a red label (as in Plates 13 and 14), at other times without it ; the publisher's mark is on the margin, but does not occur on all the plates.

The Yetatsu set has the title " Tokaido, Fifty-three Stations " on a red label and the place-name alongside.

Both these sets are rare, the Marusei one particularly so, owing to the fact that all the blocks for it were destroyed by fire when only a few impressions had been taken from them. Considered as a whole, this set is the best after the Hoyeido, or " Great " Tokaido series.

A later edition of the Yetatsu issue was published by Yamada-ya, in which the blocks for stations Nihon-bashi, Totsuka, Fukuroi, and Goyu were re-drawn ; these plates carry Yamada-ya's stamp in black. In the Yetatsu edition, the publisher's mark (reproduced in Appendix) occurs sometimes in the margin, sometimes on the face of the print.

Owing to the rarity of these two oblong series, particularly of the Marusei issue, we cannot give a description of all the plates in each, as only an occasional print from them has come under observation ; neither is such description necessary, as for this very reason (their rarity) the average collector will be unlikely to acquire but a few of the plates, if any.

Also, considered as a whole, they do not constitute a work of any par-

ticular importance, though certain of the plates are amongst Hiroshige's best work in this form; we give sufficient particulars to identify any of the views which may come under the reader's observation.

From the MARUSEI edition the following plates are notable :—

No. 13. *Numazu.* A great white-crested Fuji, its sides streaked with white, towers up, on the left, above a long line of dark foothills, into a yellow sunset sky, changing to black at the top. At the base of the hills lie bands of mist over a wide plain across which moves a man leading a horse; in a grove of trees on the right are seen the towers of a castle.

No. 14. *Hara.* A huge grey-white Fuji fills the whole of the background, towering up into a blue sky above the foothills and plain in the foreground.

No. 15. *Yoshiwara.* Along a road bordered with trees pass a group of travellers, a woman on horseback in front, led by a coolie, and another woman walking alongside; in the distance rises the white mass of Fuji streaked with grey.

No. 21. *Mariko.* A very fine snow scene. Snow falling from a dark sky over a wide valley, buried deep in its white mantle.

No. 23. *Fuji-yeda.* Rain scene. Under a downpour of rain from a black sky, three travellers on foot and another on horseback plod along the road, at either side of which grow two great trees; rice-fields on either side of the road and in the foreground a stook of straw.

No. 30. *Hamamatsu.* A choppy sea breaks into foam on the shore close under two pine trees, and stretches away to a dark horizon betokening storm. In foreground three people pass along the shore, one half-hidden by a large basket he is carrying. One of the masterpieces of the set in the expression of approaching storm. (See Plate 10, Illustration 4, page 84.)

No. 48. *Seki.* Another masterpiece. Against a black wintry sky is outlined a rounded hill, pure white under its mantle of snow; in foreground runs the road uphill, by a *torii*, under which porters and a traveller are passing; by the side a shrine, overlooked by a tree, on the top of a mound. Over the whole scene falls the silent snow.

From the YETATSU issue we take the following :—

No. 14. *Hara.* A great grey Fuji towers up over the river and wide plain.

No. 19. *Ejiri.* A fine snow scene. In the left foreground passes the road, bordered on one side by snow-laden trees, to the village behind; along it pass porters and wayfarers. From the edge of the road stretch flat fields towards the horizon, glowing with a red sunset.

No. 29. *Mitsuke*. Two ferry-boats pass one another in mid-stream ; wooded shore beyond, and in the background a range of hills is seen. On the prow of one boat appears the publisher's mark.

No. 45. *Ishiya-kushi*. Another fine snow scene. Three travellers, one on a pack-horse, make their way through the deep snow down a steep slope, at the foot of which lies the village, and meeting another way-farer coming up. On their left grows a clump of trees overhanging the road ; snow falls steadily from a grey sky, blackest at the top and again on the horizon, thus throwing the white foreground into greater contrast.

No. 50. *Tsuchi-yama*. Under heavy rain the head of a *daimyo's* pro-cession is seen fording a stream running between steep green banks ; from the right bank project the branches of a tree. Against the grey sky is silhouetted a still darker mountain ; in the background stretches the road leading to the ford, and three figures approaching along it.

This plate is also found without the rain-block.

Owing to the great popularity of Tokaido views, they were repeated in various editions, in different forms, in sets rather smaller than the regula-tion full-size plate, in half-plate, or as a miniature set in quarter-plate, that is four views to a block. All these, however, are uncommon, particularly the last-named.

Two half-plate series were issued, one by the publisher Sanoki and the other by Tsuta-ya.

In order to obtain an even number of full-size blocks for printing from, the former series is increased to fifty-six plates, an extra view being allotted to Kyoto, while the Tsuta-ya set is reduced to fifty-four by putting stations 24 and 25, Shimada and Kanaya, on opposite banks of the Oi River, into one view.

A miniature series of four-on-a-block size was issued by the publisher Arita-ya, and consists of fifty-six views, that is fourteen to a block, with a second view allotted to Kyoto.

In 1855, when Hiroshige had virtually abandoned the oblong form of print for the upright, which was now his favourite form of composition, he issued a Tokaido series, his first and only attempt of this subject in this shape, with the publisher *Koyeido ;* each plate dated Hare 7 = 7th month, 1855. Like almost all Hiroshige's upright series, late issues and poor impressions of this Tokaido set are numerous, while those of fine quality are rare. Many of the designs are excellent, and when early, impressions from the first edition are amongst the best of his work at this period. The series is notable for the great number of river and sea-views contained in it. (See Note, page 97.)

As pointed out in a previous chapter, it is not unlikely that this Tokaido set was largely the work of Hiroshige II working under his master's instructions, who signed the drawing when completed. Late issues may be identified by the harsh colours, particularly in the use of aniline red and a very offensive purple.

<center>Title : Go-ju-san Tsugi Meisho Zuye.</center>

As this series, next to the " Great " Tokaido set, is the one most likely to come under the observation of the average collector, we select the following plates from it as being amongst the best. Only first edition copies should, of course, be collected ; a plate here described as good might, in a late impression, be worthless.

Plate 4. *Kanagawa.* Moonlight scene over Yedo Bay. A man and two women on the balcony of a tea-house on the cliff, admiring the view. Junks at anchor and others sailing along the coast. Dark, grey-blue sky on horizon, deep blue at top. Sea tinted in blue in fore and background, white in centre.

Printed almost entirely in different shades of grey and blue, this is one of the best plates in the set. (See Plate 11.)

Plate 6. *Totsuka.* In foreground peasants planting out rice in a hollow surrounded by yellow and green slopes, beyond which runs a grey road lined with tall firs and pines. Through them appears the grey mass of Fuji in the distance, its peak white with snow, white clouds floating round its base, rising up into a brownish-tinted sky, graded to white and then deep blue above. To the left of Fuji appears another round-topped hill through white mists. A very fine plate, beautifully coloured. (See Plate 11.)

Plate 8. *Hiratsuka.* Beyond a wide river, flowing past low banks, rises a dark green hill above the low-lying mist ; towering above it, on the left, rises a grey Fuji, its peak white with snow, into an orange-tinted sky, changing to deep blue above. Ferry-boats crossing the river to a village on further bank at the edge of a clump of trees ; flat sandy shore in foreground and three small pines.

Plate 11. *Hakonè.* Porters preceded by torch-bearers mounting a steep road which overlooks the river below, and great grey hills, shaded to deep black at the summit, rising up from the river-bed into a grey sky, changing to black above. Three large pines grow at the extreme edge of the road, overhanging the river.

The deepening shadows of nightfall are very well indicated in this view.

Plate 12. *Mishima.* Street scene at nightfall. A row of shops and tea-houses seen in perspective on the right before a large *torii*, by the side of which grows a fir tree. Late reprints of this view are in existence in

which a priest and three figures in semi-European dress have been added in the foreground, close to the *torii*. (Reproduced in Captain Osborn's book.)

Plate 13. *Numazu*. Snow scene : one of the two best plates in the set. In foreground two figures are crossing a bridge over a blue stream, to a hut on the further bank ; another bridge beyond. In background the peak of Fuji rises up into a blue sky, over a nearer range of hills outlined against a pale yellow sky. The snow should be tinted with grey to heighten the effect in the best impressions.

Plate 14. *Hara*. A great grey Fuji rises above the foothills against a pale rosy sky.

Plate 15. *Yoshiwara*. Against a blue sky, a huge grey Fuji, with white cap, streaked with grey, rises above white clouds and mist lying over the marshes ; above the reeds appear the yellow roofs of six huts and two clumps of trees. Men fishing in the river in the foreground ; across the view, with the mountain as a background, a flight of *chidori* rise up from the marshes.

Plate 16. *Kambara*. View from high ground leading steeply down to the river-bed, to a round-topped green hill on further shore, with white mist lying at its base. Above a dip on the right appears the white cone of Fuji against a red sky. In foreground, at each side of the road, two booths and people sitting in them ; others climbing up the steep slope from the sandy river-bed below. The foreground should be coloured yellow, over-printed with black at the foot of the picture.

Plate 17. *Yui*. A precipitous green cliff faces the sea ; in the back-ground rises Fuji above dark foothills against a glowing sunset sky.

Plate 19. *Ejiri*. View of a wide bend of the Okitsu River, and a junk in full sail in the foreground ; two anchored in mid-stream at the angle of the bend, and others sailing in the distance. In the background rises the mass of Fuji, its slopes and base wreathed in brilliant sunset clouds. Two small boats and two fishing nets on the sandy shore in close fore-ground.

Plate 22. *Okabe*. A fine plate, printed in various shades of grey. View of the road from above passing through a deep cutting in the rock, with a great mountain beyond in front rising above blue and white mist. At a corner of the road, on left, a small straw-thatched booth. A pilgrim passes along the road carrying on his back a *tengu* mask ; in front of him a priest and other wayfarers.

Plate 23. *Fuji-yeda*. A winding stream with willows and other trees growing at the water's edge ; people fording the river, some on the backs of coolies, and a woman in a *kago*.

Plate 25. *Kanaya*. View of the wide bed of the Oi River and its sand-

HIROSHIGE : Tokaido Views (upright).

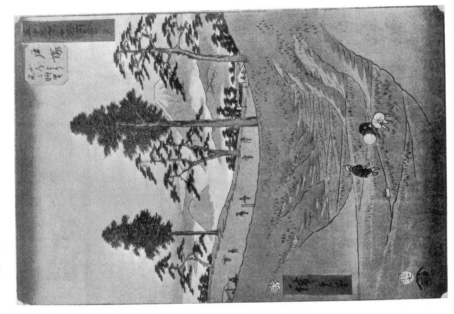

2. Station 6 : Totsuka.

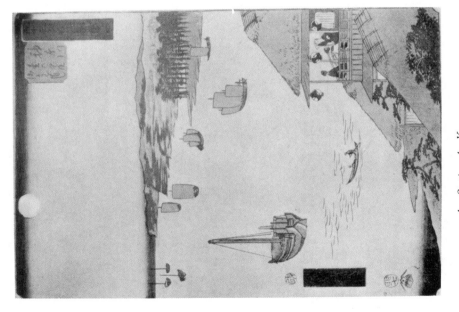

1. Station 4 : Kanagawa.

PLATE 11 (first part)

HIROSHIGE : Tokaido Views (upright).

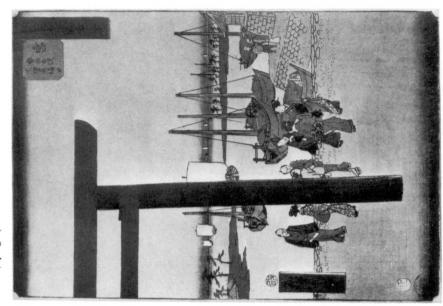

4. Station 42 : Miya.

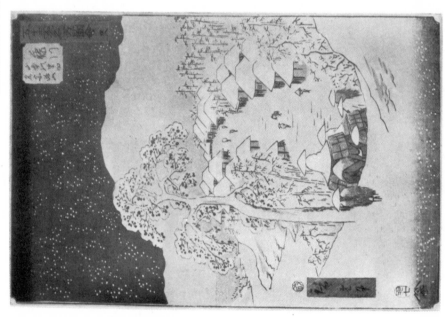

3. Station 38 : Fuji-kawa.

PLATE 11 (second part)

banks from high ground, and people making their way across. In the distance rises the white cone of Fuji above the dark foothills in a crimson sky, changing to deep blue above. In the foreground a traveller on a pack-horse led by a coolie, and others coming up from the village below.

Plate 27. *Kakegawa.* On the left the river runs by high, steep cliffs crowned with trees ; in the background a high hill, grey, graded to black at the top. In the foreground another bend of the river, flowing by a grassy mound on which a cluster of trees is growing ; people fording the stream.

Plate 28. *Fukuroi.* The road stretching across flat green fields in which peasants are working transplanting rice. In the centre grows a large fir by the roadside, and along the road boys are flying kites.

A somewhat uninteresting plate, but the rather featureless design is retrieved by good colour and careful graduation of the sky in early impressions, giving a fine atmospheric effect. The sky should be a deep rosy red on the horizon, well graduated into blue, and deep blue above ; the fields should be a light shade of blue-green, and the trees a *dark*, deep green.

No. 30. *Hamamatsu.* View of the sea-beach with three ancient, gnarled and twisted pines growing close to the water's edge, one of them being admired by a nobleman and his attendants ; beyond, three junks sailing close in-shore, and a dark coast-line studded with trees stretching away in the distance.

No. 31. *Maisaka.* A great headland runs out into a blue sea, against a crimson sunset sky ; four junks with sails set in foreground, and in the lower corner a row of posts. A fine sea-view ; practically the same as the view in the oblong issue (*Hoyeido*) adapted to the upright form.

No. 35. *Yoshida.* In foreground part of the bridge over the Toyo River, and two peasants making obeisance as a *daimyo's* procession passes. Beyond rise the towers of the castle above white mists, and the shore lined with trees ; in the background rises a grey mountain ; laden barges on the river.

No. 36. *Goyu.* Scene by the river bank at edge of which grow willows, the stream winding from fore to background. Behind rise black hills, beyond which is seen a grey Fuji, its peak streaked with snow, rising into a blue sky from above white mists.

No. 38. *Fujikawa. The* masterpiece of the series ; a famous snow scene. Travellers entering the village down a steep slope, at the foot of which stretch the houses overlooking the river. In the background a range of snow-covered mountains.

Found in two states, the sky being much darker in one than in the other. Our illustration at Plate 11 is from a copy in the former state ; at

Plate 54 in Mr. Ficke's *Chats on Japanese Prints* is shown the state with the less dense sky. Which is the best is a matter of personal taste ; the writer prefers the darker sky as thus affording greater contrast.

No. 39. *Okazaki.* View from underneath the bridge over the Yahagi River, across which a *daimyo's* procession is passing. On further bank appear the castle towers rising above the trees ; lumber-rafts on the river, and close in-shore a man washing a horse.

No. 40. *Chiryu.* People resting under an old pine tree by the edge of the road running across flat fields ; in foreground another dwarfed pine tree overhangs a lake or pond. Range of hills in distance against a crimson sunset sky changing to blue above. Another plate which owes its effectiveness to the colour-scheme and atmospheric effect rather than to the design. (Reproduced at Plate 5 in the author's *On Collecting Japanese Colour-Prints*, 1917.)

No. 41. *Narumi.* View of the main street through the village with shops selling dyed cloth, a product of the locality ; on the left by a grassy mound, close to a pine tree, a high wooden staging from which are hung strips of red and blue-patterned cloth to dry. A fine plate when well printed, the golden-hued sky making an effective background.

No. 42. *Miya.* A group of seven people standing near a large red-brown *torii* built on the quay-side overlooking the harbour, which is protected by a spit of land running out from either side ; junks sailing in and others at anchor by the quay-side. Deep indigo sky on the horizon betokening nightfall, graded to white and then dark blue at the top. One of the best plates. (See plate 11.)

No. 47. *Kameyama.* Rain scene. From a black and yellow sky streaked with flashes of red lightning which are reflected in the wet road, a heavy rain pours down on four travellers. On the left a green mound with three large and other smaller trees growing from it ; further along, on the right, a line of trees bordering the road which leads up to the entrance of Kameyama Castle.

The road in the close foreground should be a deep grey, almost dead black, shaded off to a lighter tint.

No. 48. *Seki.* At the top of a flight of steps leading down to the valley below, and overlooked by a green hill on which grow two trees, stands a *torii* flanked by lanterns on either side ; in front of it passes a broad road along which approaches a traveller in a *kago*. Behind him stand buildings under the shelter of a large tree overlooking the valley and hill opposite ; in the background rising out of a white mist is a *deep* blue mountain, printed from colour-block only, towering into a paler blue sky. A very fine plate when well printed, with beautiful mist effect. Flight of birds above mountain top.

In late issues the mountain is a *pale* blue, the same colour as the sky, which is streaked with white clouds, and below the white mist lying across the side of the mountain is a streak of raucous purple mist, which ruins the whole effect.

No. 51. *Minakuchi*. The road, along which two faggot-gatherers and other wayfarers are passing, runs past a grove of maple trees, brown with autumn tints; behind are high green hills, and still higher mountains beyond.

Hiroshige's success with his Tokaido views naturally led other artists to copy him, particularly during the Prohibition period, when prints of actors and courtesans were forbidden by law.

Kuniyoshi contributed a series of Tokaido views, full size, oblong, complete in twelve plates, which place him at least on a level with, and, in the estimation of some collectors, above Hiroshige in the domain of landscape design. One view from this series (*c.* 1840), which is rare, is here illustrated at Plate 12, representing stations Akasaka (37), Fujikawa (38), Okazaki (39), Chiryu (40), and, on the near side of the river, Narumi (41). On the scaffolding on the right are hung strips of dyed cloth, a product for which the locality was noted.

This series by Kuniyoshi gives an excellent idea of the relative position of the stations to one another. Across the water we see the long bridge at Okazaki, over the Yahagi River, and its fifteenth-century castle, which form the subject for Hiroshige's view of this station (i.e. Okazaki).

The full title of this series is *Tokaido Go-ju-san Yeki; Go-shuku Meisho* (" Fifty-three Tokaido Stations; Views of Five Stations ").

In some plates, however, only four stations are shown, when the subtitle is altered accordingly. One such is reproduced at Plate 12 in our first edition (1920). Each print of the series is signed in the margin (not reproduced in illustration) *Ichiyusai Kuniyoshi, Shuku-zu* (" sketches by contract "); while over the signature are the publishers' marks of *Tsuta-ya* and *Tsuru-ya*, thus showing the series to have been a joint production.

It was left, however, to Kunisada to flatter Hiroshige to the extent of copying his early Tokaido series in a half-block set, in many views practically line for line. The majority are signed *Kochoro Kunisada*; others *To order, Kunisada*, as if in apology for plagiarizing the work of his fellow-artist, and to make it appear his publisher, Sanoki, was really responsible.

Stations 1 (Nihon Bashi) and 3 (Kawasaki) are signed in full " *To*

order," Kochoro Kunisada ; about four or five views are signed *Gototei Kunisada.*

In the foreground of each view is a large figure of a woman, separated from the landscape view by a conventional cloud effect. This series is very uncommon ; the writer has only once found a complete set of fifty-six views mentioned,[1] and only twenty-seven of the set figured in the Happer collection, but being virtually only a plagiarism of the work of another artist, it is not particularly important. Two views from it, Stations Kakegawa and Otsu, are here illustrated at Plate 12 for purposes of identification of the series ; in the view of Otsu, showing the shop where " Otsu " pictures were sold, Kunisada has followed his own design, it being quite different to Hiroshige's, which is shown at Plate 10, page 84.

In the complete set two views are allotted to Kyoto, to make an even number (56) of plates.

Plates 1 to 41 follow, mostly with but slight variation of detail, Hiroshige's first Tokaido views, but from Plate 42 onwards Kunisada appears to have made his own designs, as they differ entirely from Hiroshige's, though for No. 42, Miya, he seems to have taken the latter's station 43, Kuwana, for his model, as in the foreground are two large junks, like Hiroshige's Kuwana view.

This apparent inversion is due to the fact that Miya (Station 42) and Kuwana (Station 43) lie on opposite sides of Kuwana Bay, the distance across being seven *ri* (a *ri* = about $2\frac{1}{2}$ miles), hence the name " The Seven *Ri* Ferry," the coast-road round the bay being three or four times the distance by water.

Kunisada, therefore, has shown one end of the ferry and Hiroshige the other.

All the remaining stations by Kunisada are entirely different.

As if in compliment to this attention on the part of Kunisada, Hiroshige designed a vertical series, entitled *Tokaido Go-ju-san Tsugi Zuye* (" Exact Views of the Fifty-three Tokaido Stations "), in which oblong landscape views occupy the upper third of the sheet, while the lower part is taken up with large figures, drawn after the style of Kunisada.

Again, in another, and very uncommon series, we find these two artists in collaboration, a series entitled *So-hitsu Go-ju-san Tsugi* (" Fifty-three Stations by Two Brushes "), and dated between the years 1854 and 1857, in which the upper part consists of a Tokaido view by Hiroshige, and the lower part large figures, illustrative of legends, by Kunisada, over the signature of Toyokuni. Owing to the size of the figures they encroach somewhat upon the landscape above.

Hokusai has designed a small quarter-block series of the Tokaido

[1] Orange and Thornicraft sale, March, 1912.

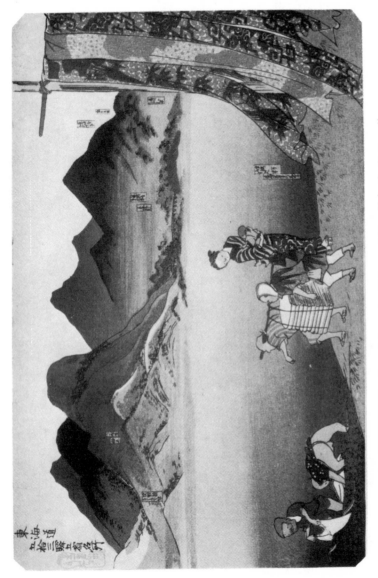

1. KUNIYOSHI : One of the series "Views of Five Tokaido Stations."

PLATE 12 (first part)

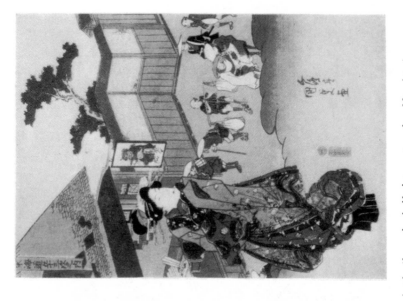

2. KUNISADA : Kakegawa and Otsu on the Tokaido (from the half-plate series after Hiroshige).

PLATE 12 (second part)

stations, showing people engaged at various occupations, sometimes an industry for which the particular place is renowned; for example, making sheets of seaweed by hand at Shinagawa on the same principle as paper-making, or the cultivation of silkworms, as at Kusatsu.

They are found in two issues, either of which are very uncommon, particularly the first, which may be distinguished by having a short poem or verse inscribed on each view above the picture, which is removed in the later issue.

Each view is signed *Gwakio Jin Hokusai*, meaning " Hokusai Mad-on-Drawing."

Note to page 90.—Hiroshige's upright Tokaido series. The publisher of this series is *Tsutaya Kichizo*, the same as *Koyeido*, publisher of Sugakudo's " Birds and Flowers " series (*vide* page 57), and must be distinguished from the other *Tsutaya*, known as *Juzaburo*. Owing to the similarity of their seals (reproduced in Appendix IV) Kichizo is almost invariably confused with Juzaburo, and Hiroshige's prints so marked attributed to the latter publisher in error.

CHAPTER XII

THE SIXTY-NINE STATIONS OF THE KISOKAIDO

THE alternative route between Yedo and Kyoto, known as the Kisokaido or mountain road, which ran inland, was also the subject of illustration by Hiroshige in a series of seventy plates, in which he had the collaboration of Keisai Yeisen, who contributed twenty-three of them.

While this series contains about fifteen masterpieces, worthy to rank with the best views in the first Tokaido set, the majority of the plates are uninteresting, some of them indeed very inferior, and the series as a whole has suffered in the estimation of collectors by reason of the numerous poor copies of late issues which are in existence.

While good and even brilliant impressions of the Tokaido series may be acquired fairly readily, with the exercise of patience, such has not been the writer's experience with the Kisokaido views, which more often than not are badly discoloured and faded copies of late editions, whereas copies of the first edition in brilliant condition are most rare.

Apart generally from poor colouring, late issues may also be detected, particularly in the views contributed by Yeisen, by the absence of the artist's signature. It is suggested that the absence of Yeisen's signature on late issues was due to the fact that, as his reputation as a landscape artist was not the equal of Hiroshige's, his views did not sell so readily, so they were issued again without any signature, in the hope that they would be bought as Hiroshige's work.

When the signature on a print became badly worn, by reason of the large number of impressions taken off the block, it was sometimes erased altogether, but in this case this would apply equally to the inscription of the title of the series and the place-name, so that the above supposition to account for unsigned prints in this series seems a sound one.

Views by Yeisen, when unsigned, may be further identified by the different script in which the title *Kisokaido Roku-ju-ku-Tsugi* (" Sixty-nine Stations of the Kiso Road ") is written, though this evidence does not hold good in all cases, as one or two unsigned views have the title in the script of Hiroshige, yet by reason of the style of drawing they are generally attributed to Yeisen.

By reason of the large number of plates comprising this series, the set

was divided between two publishers, Hoyeido, the publisher of the early Tokaido set, issuing Yeisen's contributions and a few of Hiroshige's, and Ise-Iri the remainder. *Second* editions of Yeisen's views, however, generally bear the trade-mark of Ise-Iri. Their trade-marks, particularly that of Ise-Iri, are frequently introduced into the picture itself, as upon a horse-cloth, a banner, the shutter or screen of a house, and so forth.

This series was commenced about 1835, and took many years to complete, probably not before the death of Yeisen in 1851, Station 55, Kodo, being the last one contributed by him. Only the first edition was issued jointly by the two above-named publishers ; Ise-Iri taking over the whole publication afterwards, when Yeisen's name was suppressed on his plates. Finally, the now worn-out blocks were made over to a third publisher, Yamada-ya.

Station 1. NIHON BASHI : Nihon Bridge. Sunrise over Yedo. View of the canal, with the sun, cut by streaks of mist, rising behind the houses, crowds by the bridge, and coolies pushing a cart laden with bales over it.

As on the Tokaido, the Nihon Bridge, Yedo, formed the starting-point of the Kisokaido, which rejoins the former highway again at Station 69, Kusatsu (No. 53 on the Tokaido), this, and the final station, Otsu, being common to both. In the Kisokaido series, no view is allotted to the terminus Kyoto, that belonging to the Tokaido set doing duty for both.

Station 2. ITABASHI. A man shoeing a horse by a roadside hut ; on the left, the first houses of the village.

Station 3. WARABI. Ferry over the Toda River. A large ferry-boat laden with passengers and a horse being poled across the river, travellers and horses waiting on the further bank ; two herons flying over the boat.

Station 4. URAWA. In the distance, Mount Asama in eruption ; in the foreground, a coolie leading a packhorse.

Station 5. OMI-YA. A traveller carried in a *kago* along the road on a high bank bordering rice-fields ; Fuji in the distance, snow-capped.

Station 6. AGEO. The Shinto temple of Kamo, with a rest-house outside the grounds, and peasants winnowing rice in front of it. A rather poor plate.

Station 7. OKEGAWA. View of the common ; a woman stripping rice outside a thatched hut, and a traveller speaking to her.

Station 8. KONOSU. A distant view of Fuji seen across fields, and porters passing along ; on the left a pilgrim in a large basket-hat.

Station 9. KUMAGAÈ and the " eight-*cho* " (about ⅞ths of a mile)

embankment. A traveller arriving at the cross-roads, at the entrance to the village, in a *kago*, and another, on foot, chatting to him ; on the left, a woman serving two coolies at a wayside tea-house, and behind a horse feeding with his nose in a bucket. On the extreme right a road-direction post, and behind it a shrine, with a stone figure inside and a candle burning in front of it ; the embankment stretching away behind in the distance uphill. (Illustrated at Plate 13 in our quarto edition, 1920.)

Station 10. FUKAYA. A group of women, guided by one leading with a lantern, passing along the street. One of the figures, turning to speak to another, is drawn with the face in profile, an unusual position, but the picture as a whole is uninteresting, and the large figures crude and clumsily drawn.

Station 11. HONJO. Ferry over the Kanryu River, crossed partly by bridge and partly by boat, and a *daimyo's* cortège passing over.

All the above plates are by Yeisen ; with the next commences Hiroshige's contributions to the series in one of the most beautiful views of the whole set, here reproduced at Plate 13, which, unfortunately, cannot give any impression of the exquisite colouring of this print in all its pristine freshness. The dark fir trees by the river bank are silhouetted against a pure golden sky, over a distant range of deep blue mountains, while above it gradually melts into beautiful wine-coloured clouds. For beauty of atmospheric effect this print is equalled by few and surpassed by none, even amongst those by Hiroshige himself.

Station 12. SHIMMACHI. Travellers crossing a bridge over a stream to a village beyond, and others walking along the river-bank ; in the distance, a mountain range, printed from colour-block only.

Station 13. KURAGANO, by Yeisen. View of the Karasu River at Kuragano. Children playing about in the water by a weir in an irrigation canal ; on the right, a woman seated in an open tea-house looking at another cleaning a tub or cooking pot. A crude design.

Station 14. TAKASAKI, by Hiroshige. A peasant (or perhaps hotel-tout) bowing to a man and a woman, and another, with a fan, running up to them ; behind them a tea-house, built out over the river, and a man seated in it admiring the view. Beyond, the village by the river on the left bank, and in the background a blue mountain range, printed from colour-block only.

Station 15. ITAHANA, by Yeisen. Travellers on foot passing along the hummocky bank of a stream, lined with very meagre trees, in the depth of winter. In the background, over a bridge, appear the first houses of the village, and a man on horseback approaching it. A very fine snow scene, and one of the masterpieces of the set, showing that Yeisen could, when so minded, equal Hiroshige in producing an effective design. This plate,

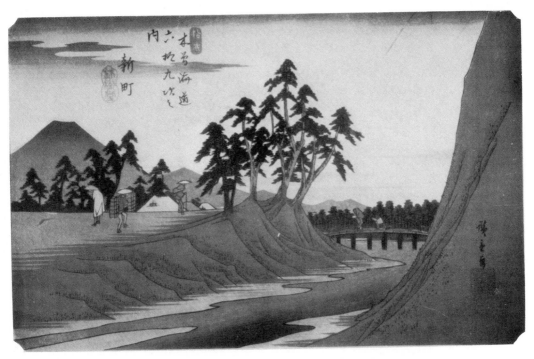

1. HIROSHIGE : Station Shimmachi (No. 12). Kisokaido.

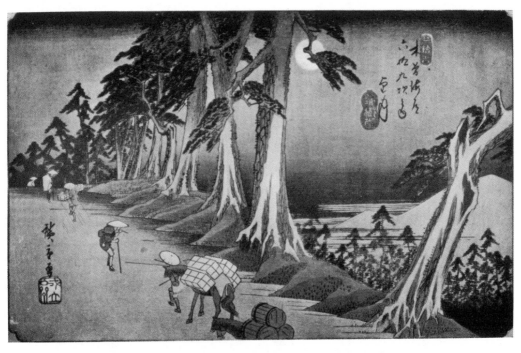

2. HIROSHIGE : Station 26, Mochi-zuki, Kisokaido.
(Reproduced by courtesy of Messrs. Sotheby.)

PLATE 13 (first part)

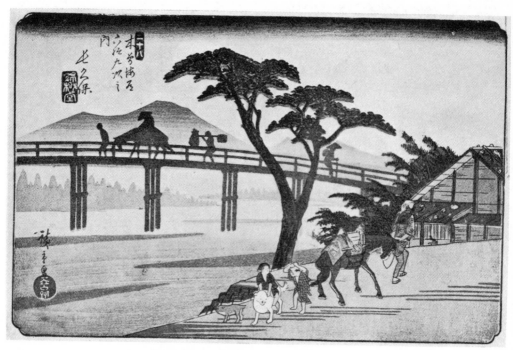

3. HIROSHIGE : Station 28, Nagakubo, Kisokaido.
(By courtesy of Messrs. Sotheby.)

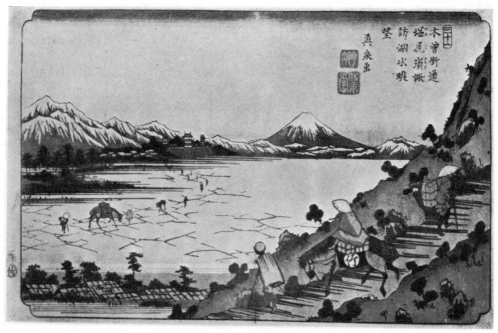

4. YEISEN : Station 31, Shio-jiri and Lake Suwa in winter.

PLATE 13 (second part)

even in first edition copies, carries no signature, but from the style of the drawing is generally attributed to Yeisen, though the title is written in the script employed on Hiroshige's views. The supposition given above, therefore, to account for the omission of Yeisen's signature from certain views is hardly sufficient in this instance. Mr. Happer suggests as a reason that it was due to Yeisen's careless habits, brought on by his over-indulgence in *saké*.

Station 16. (From here onwards all plates are by Hiroshige, except where otherwise stated.) ANNAKA. A *daimyo's* procession seen from above, passing along a narrow road by a few huts at the foot of a steep hill on the left.

Station 17. MATSUIDA. Travellers with packhorses on the road on a hillside passing a large tree, under the shade of which stands a small wayside shrine.

Station 18. SAKAMOTO. Another unsigned plate, but generally ascribed to Yeisen, though the title is in Hiroshige's script, for which reason Mr. Happer attributes it to the latter, but with reserve. A village street with a narrow stream, crossed at intervals by planks, running down the centre between the houses ; a high green hill in background.

Station 19. KARUI-ZAWA. Another masterpiece of the series by Hiroshige. A scene at night outside a village ; a coolie lighting his pipe at a bonfire close to a large tree, while another lights his from the pipe of a man on horseback ; in the distance is another bonfire. The effect of the light cast by the fire on the tree, and from the lantern hung at the horse's saddle on to the faces of the two men lighting their pipes from one another, is wonderful, considering the simple means by which it is produced. In poor and faded copies and in late issues the contrast between the light from the fires and the lantern and the darkness of the surrounding night is very weak.

Station 20. KATSU-KAKE, by YEISEN. Rain on Hiratsuka Moor. Coolies and two laden oxen caught in a heavy downpour of rain and gale of wind. One of Yeisen's best contributions to the series, the rain and wind being very cleverly indicated.

Station 21. OIWAKE, also by YEISEN, but not signed. Distant view of Mount Asawa from Oiwakè. Another rain scene by Yeisen. (In some issues the rain block is omitted.)

Coolies carrying loads, and one behind leading a packhorse, under a straight downpour of rain, hurrying along the road round the base of the mountain.

In the catalogue of the print collection in the British Museum this print is described as being in the *first* state when printed *without* the rain block, which Mr. Binyon considers was added as an afterthought, to give the idea of distance to

the mountain, remarking also that the figures are not drawn as if drenched by a storm. Though, as a rule, the omission of some feature in a design, such as a rain-storm or range of mountains, generally connotes a late edition, the reverse might well be the case in this instance for the reasons Mr. Binyon gives.

Station 22. ODAII. Four pilgrims at the edge of a brook running through a moor covered with grass ; hill in background.

Station 23. IWAMURATA, by YEISEN. A very crude scene of blind men fighting amongst themselves, and a dog barking at them ; one of the poorest views of the series.

Station 24. SHIONADA. Coolies resting in a wayside tea-house under a large tree by the bank of a river ; drawing of figures crude.

Station 25. YAWATA. Peasants crossing by a plank bridge a stream flowing past a high bank covered with bamboos ; blue hills in the background, printed from colour-blocks only.

Station 26. MOCHI-ZUKI. A wide road in perspective lined with giant firs overlooking a valley below covered with trees, and hills beyond ; travellers and laden packhorses passing along, the whole scene under a full moon in a deep blue sky. A very fine moonlight view. (See Plate 13.)

Station 27. ASHIDA. The road with travellers passing seen through a dip of a green hill with trees on it, and reappearing at the top on the right.

Station 28. NAGAKUBO. Perhaps *the* masterpiece of the whole series. A very fine moonlight and mist effect with figures, one on horseback, crossing a bridge over a river ; in the foreground, a tree growing by the edge of the river, a man leading a horse, and two children playing with dogs. In the background are mountains printed from colour-blocks (graded black) only, omitted in late issues, in which also the colour is much weaker. The bridge, the figures crossing it, and the tree, are all printed in dead black, the whole forming a very fine composition and relying for its effectiveness upon the use of black graded to various tones, and the deep blue of the river in the foreground shading off to a misty grey in the dim distance. This view is very uncommon, particularly fine copies of the first issue, and has been much reproduced. (See Plate 13.)

Station 29. WADA, the highest station on the road, over 5000 feet above sea-level. A snow scene, with a view of the road running between steep slopes, and in front a high peak covered in snow.

Station 30. SHINO NO SUWA, by Lake Suwa, famous for its hot baths. Front view of an inn, with travellers refreshing themselves inside, and a man in a tub in the bath-house at the side.

Station 31. SHIO-JIRI. The frozen Lake Suwa seen from Shio-jiri

Pass. Another masterpiece by YEISEN, showing Fuji in the distance under its mantle of snow, and travellers picking their way across the cracks in the ice of Lake Suwa ; in the foreground, travellers, one on horseback, on the steep road leading down to the lake. (See Plate 13.)

In late issues Yeisen's signature is omitted, the monogram *Takè* on horse-cloth altered to Ise-Iri, and no seal in left margin.

Station 32. SEMA. River scene under a full moon slightly obscured by clouds, with a man poling a laden punt along, and another behind on a raft ; on the bank willow trees bending before the wind. One of the best plates in the series. (See Plate 14.)

Our illustration of this plate is taken from a fine copy of the later issue, in which the slight cloud over the face of the moon is omitted ; the whole effect, also, is somewhat lighter in colour. This view is considered one of the masterpieces of the series, a worthy companion to the wind-storm scene (Yokkaichi) in the first Tokaido set.

Station 33. MOTOYAMA. A large pine tree blown across the road by the gale, propped up on a trestle, and two wood-sawyers sitting under it by a fire, the smoke from which goes up across a blue sky. Drawing crude.

Station 34. NIEGAWA. Front view of a large inn, with travellers resting inside and a waitress bringing tea to one ; a man leaning over the balcony above and looking at a coolie unloading his horse ; on the left an empty *kago*. Like Station 36 (Goyu) on the Tokaido, this view is interesting for the information given on the signboards in the inn, on which are inscribed the names of the engraver *Fusajiro*, and the printers *Yasu-goro* and *Ichitaro*.

Station 35. NARAI, by YEISEN, but not signed. " View of the shop (for the sale of) the famous products (combs) of Narai." At the top of a steep road a coolie putting down his load, and two travellers going off down the hill ; snow-covered peaks rise from the mist in the valley below.

Station 36. YABUHARA, also by YEISEN. Travellers sitting by the way-side, and two women, carrying faggots, standing under a pine tree and admiring the view from the top of the Torii Pass.

Station 37. MIYA-NO-KOSHI. Another very fine moonlight and mist effect. It is an open question as to which of the two views, Nagakubo or this one, is the finest. Mr. Happer appears to favour Miya-no-koshi. Three people, one a man carrying a child, are crossing a plank bridge over the Kiso River under a misty full moon. Through the mist loom up trees like ghosts, and in the distance the dim figure of a man wending his way to his hut along the river's bank. (See Plate 14.)

Station 38. FUKUSHIMA. The guard-house at the entrance to the village, and a high gate across the road, with people passing through.

Station 39. UEMATSU. A traveller and his coolie standing on a bridge

over a torrent and gazing at the Ono Waterfall ; a peasant, carrying faggots, crossing the bridge.

Station 40. Suwara. Another of Hiroshige's famous rain scenes. A small tea-house, built under the shelter of an enormous pine tree, to which two coolies rush for shelter from the torrential downpour ; in the background, two travellers, one on horseback, throwing on their straw coats for protection as they plod along through the storm.

This plate is found in two states ; in one the background is very much blacker than in the other, and the whole effect is much darker.

Station 41. Nojiri, by Yeisen. View of the Inagawa Bridge spanning a rocky gorge, through which a mountain torrent rushes ; high up, on the left, on a steep mountain-side, stands a shrine, dimly seen through the mist, while through the bridge appears the faint outline of a mountain far off ; the arch of the bridge itself taking the form of the cone of Fuji.

Station 42. Mitono. Two peasants at work in a field and a woman leading a child towards a hill up which the path leads, under two *torii*, to a shrine beyond ; roofs of huts in the background. A poor design ; figures crudely drawn.

Station 43. Tsumagomè. A pilgrim, a wayfarer, and a porter passing along the road cut through the hills, and trees overlooking it ; beyond, two other travellers appearing over a dip in the road, and on the hill to the right a faggot-gatherer passes with his load.

Station 44. Magome, by Yeisen, but not signed. Another view of the road cut out of the side of the mountain, with a peasant riding his ox along it ; beyond, the roofs of the village in the valley below, overlooked by high mountains, printed from graded colour-blocks. One of the best plates by Yeisen when well printed.

Station 45. Ochiai. On the right, the village on the side of the hill, and the road through it, along which travellers and porters are passing downhill and crossing a small bridge over a stream on the left. In the background, a range of blue hills printed from colour-blocks only, and in front of them the forest, overlooking the road.

Station 46. Nakatsu-gawa. This plate was issued in two totally different states, of which the first is extremely rare,[1] very few impressions having been taken from it, probably because the block got burnt in a fire. The first state is a near view of the.village, and three travellers approaching it in a downpour of rain ; behind the village rises a high hill.

The second state (known as the " willow tree " version) is a distant view of the village nestling at the foot of the hill, across flat rice-fields, and the road winding to it in a series of zigzags ; in the foreground,

[1] Anonymous sale (Sotheby), June, 1913, item 210 ; reproduced in Catalogue at Plate VIII.

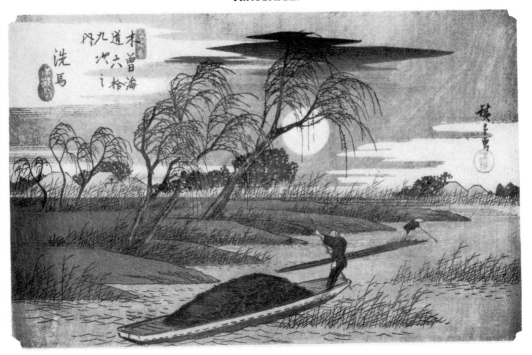

1. Station 32 : Sema (2nd state).

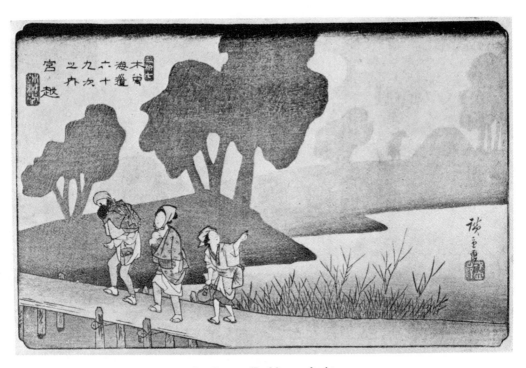

2. Station 37 : Miya-no-koshi.
(By courtesy of Messrs. Sotheby.)

PLATE 14 (first part)

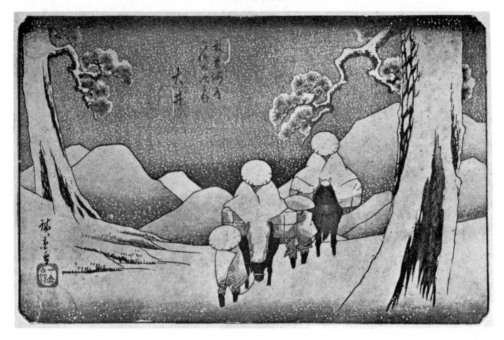

3. Station 47 : OI.
(By courtesy of Messrs. Sotheby.)

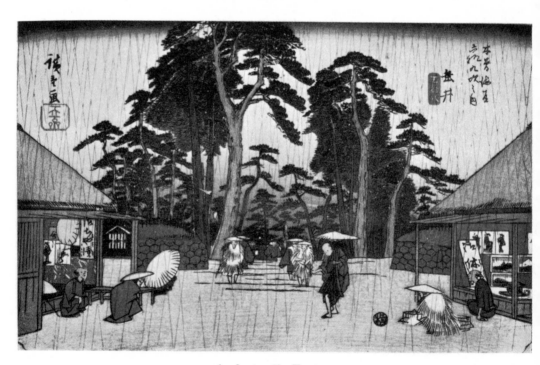

4. Station 58 : Tarui.

PLATE 14 (second part)

people crossing a small bridge over a stream, and a willow tree growing close by.

Station 47. OI. Perhaps one of the finest snow scenes designed by Hiroshige, the representation of the falling snow-flakes being extraordinary in its realism. Two travellers, mounted on packhorses led by coolies on foot, all thickly covered with the heavily falling snow ; to right and left two large pine trees, and a background of irregular hills. (See Plate 14.)

Station 48. OKUTÈ. The road across a bleak moorland over the Biwa Pass, and two peasants toiling along uphill with a load of faggots on their backs. An uninteresting design, but often retrieved by good printing.

Station 49. HOSOKUTÈ. The village lying in a plain surrounded by hills, seen through the arch formed by two pine trees leaning across the road to one another, and people passing under them.

Station 50. MITAKÈ. An open tea-house, at which travellers are taking refreshment, while outside a man washes a tub at a small stream ; mountains in the background, faintly printed from colour-block, in a dark sky. Drawing crude.

Station 51. FUSHIMI. Travellers resting under a large tree by the edge of the road, and others passing by.

Station 52. OTA. Travellers waiting for the ferry by the bank overlooking the river, down which a raft is passing ; blue hill beyond further bank and a pink sky ; three trees by edge of river on left.

Station 53. UNUMA, by YEISEN, but not signed, and one of his best views. On the right stands the Castle of Inuyama, overlooking the Kiso River ; rice-fields and village in the distance beyond the river, backed by hills.

Station 54. KANO. Peasants making obeisance at the approach of a *daimyo's* procession along a road lined with trees ; across the fields is seen his castle.

Station 55. KODO, by YEISEN ; considered one of his masterpieces. View of the Nagara River, and men fishing at night with cormorants, the fish being attracted by flares hung over the punt from a pole. The last of the views contributed by Yeisen.

Station 56. MEIJI. On a green slope, between two camellias in flower and tall bamboos, a peasant inquiring the way of another, who points behind him towards the village across the fields in the distance.

Station 57. AKASAKA. A man and a woman crossing a small bridge over a stream in opposite directions ; on the further side stands the village surrounded by trees not yet in leaf.

Station 58. TARUI. The head of a *daimyo's* procession entering the

town from under an avenue of trees in a downpour of rain, and the natives making obeisance. This plate (reproduced at Plate 14) is interesting from the views of the two print shops on either side of the street, while on the shutter of the one on the left appears the trade-mark of Ise-Iri.

Station 59. SEKIGA-HARA. A woman serving two travellers at a tea-house, while a coolie stands idly by holding his horse and staring at them ; in the background, another tea-house.

Station 60. IMAZU. On the left, a line of shops ; on right, a large tree ; a porter and another traveller passing down the centre of the street which looks out across green fields to hills beyond. Sitting outside one shop is a man lighting his pipe from another man's.

Station 61. KASHIWARA. Front view of the large Kome-ya tea-house, and shops adjoining it, and people having refreshment while their *kago* carriers wait outside.

Station 62. SAMEGAI. View of the village in a hollow and mountains beyond, and a large tree in the centre ; porters passing on one side, and on the other an old peasant sitting resting.

Station 63. BAMBA. The village street, with horses and coolies waiting about ; on the right, a tea-shop, and a range of mountains behind the village.

Station 64. TORII-MOTO. A tea-house on the steep side of a mountain and travellers resting therein, and admiring the view over the valley, river, and lake below.

(This plate is wrongly numbered 63.)

Station 65. TAKAMI-YA. Two women with large straw bales on their backs and a coolie passing behind them in foreground; behind them the dry bed of a wide river in which stand the trestles of a washed-away bridge. On the further bank lies the village amongst trees, and hills rising in the background. Two large tree-trunks frame the view in foreground.

Station 66. ECHIGAWA. People crossing the Echi River by a low plank bridge ; a woman leading a laden ox in the foreground and passing two pilgrims, whose heads are hidden in large basket-hats. In the distance hills, printed from colour-blocks, rising above the mists.

Station 67. MUSA. Travellers crossing a small stream by two punts moored end on to one another.

Station 68. MORIYAMA. A street of houses along the highway on one side and a stream on the other ; cherry trees in bloom on hill behind the houses, and in the background a green hill, printed from colour-block only.

Station 69. KUSATSU. Here the Kisokaido joins the Tokaido. People walking along the dry bed of the Kusatsu River.

Station 70. OTSU. View looking down a broad street over Lake Biwa, on which appear the white sails of junks. Travellers and bullock-carts passing along the street. Publisher's and artist's seals appear on various shop-signs.

Otsu station is the last of the Kisokaido series, there being no plate for Kyoto, the view in the Tokaido set doing duty for both.

CHAPTER XIII

THE THIRTY-SIX VIEWS OF FUJI

EVEN as Fuji is the dominating feature in the landscape of southern Japan, so is it also the ever-recurring theme in Japanese pictorial art.

If Hiroshige made his name amongst the artists of *Ukiyoye* by his scenes on the Tokaido, Hokusai, his fellow-artist in the realm of landscape, is entitled to an equal, if not a higher place, even if he had done nothing beyond his incomparable views of Fuji.

The series of " Thirty-six Views of Fuji " (with its ten supplementary views really forty-six) by Hokusai constitutes one of his two greatest works, the other being the extremely rare series of ten very large upright prints, entitled " The Imagery of the Poets." The rarity of this latter series may be gauged from the fact that a complete set, in exceptionally fine condition, fetched £340 in the Happer sale as far back as 1909, and would realize considerably more to-day. Each print of the series is illustrated in the catalogue of this sale.

In looking over Hokusai's designs one is at once struck by their infinite variety. Fuji is depicted in calm and storm, in mist and bright sunlight ; sometimes dominating the whole scene, at others receding to a mere speck in the distance. Plates Nos. 4 and 18 of the series give a good idea of such contrasts. In the former it is dwarfed by distance to a speck on the horizon; in the latter it towers up into the sky, filling the background, the monarch of all it surveys. Plates Nos. 11 and 24 (here illustrated) also show Hokusai's contrasting treatment of his subject.

Another point one will notice is the simplicity of the colour-scheme employed, green, blue, yellow, and brown, laid on in large masses. Sometimes all four colours are used, sometimes only three of them. The result is very bold and effective.

Impressions of this series vary very considerably, the colour-scheme being quite different in different copies ; some are in blue outline, some in black, while copies of the same print will be found in both variations.

The following are the views constituting this series, and the order given is that universally accepted nowadays, corresponding with that given by M. de Goncourt in his work on *Hokusai*. In the British Museum catalogue they are arranged according to locality.

Publisher YEIJUDO, whose seal in red occurs on the face of the print, but while its presence generally denotes a first edition, its absence does not of necessity imply a late issue.

No. 1. Fuji seen from Ejiri, Province of Suruga, across rice-fields, on a windy day, and travellers struggling against the gale.

No. 2. Fuji seen from Ono Shinden, Province of Suruga, across the water, its base enveloped in mist ; in the foreground coolies leading oxen laden with bundles of straw.

No. 3. Fuji seen from the tea-fields of Katakura, Province of Suruga, where women are picking tea and coolies carrying it into the store sheds ; beyond rises Fuji, snow-covered from base to summit, into a deep blue sky. This view exhibits a different colour-scheme to the usual prevailing tints, yellow and a light brick-red predominating.

No. 4. Fuji seen through the circle of a large tub, the seams of which a man is caulking, from Fujimigahara, Province of Owari. (Reproduced in *On Collecting Japanese Colour-Prints*, 1917.)

No. 5. Fuji seen from Ko-ishi-kawa, Province of Yedo, in the depth of winter, across a landscape covered in snow, and people in a tea-house admiring it.

No. 6. Fuji seen at a great distance from the beach at Todo through one of two *torii* standing in the water, and people gathering shellfish.

No. 7. Fuji seen from the banks of the Minobu River, along which coolies and horses are passing. On the further side rugged crags tower up from the mist, showing between them a glimpse of the white crest of Fuji.

No. 8. Fine weather on the slopes of Fuji, which raises its red, snow-streaked peak into a blue sky flecked with white fleecy clouds, gradually melting towards its base into the green of the forest below. Considered one of the three masterpieces of the whole series, which are most sought after by collectors, the other two being the *Great Wave*, No. 20, and the following plate (No. 9).

There is in existence a very rare variant of this plate in which the chief differences are fewer white clouds, and the lower slopes of the mountain strong blue instead of green.

No. 9. Fuji in a thunderstorm, with lightning playing round its base.

There is also a very rare second state of this plate in which tops of trees appear on the lower slopes of Fuji, thereby somewhat spoiling the effect of a design notable for its simplicity and grandeur.

No. 10. Pilgrims making an ascent of the mountain and others assembled in prayer in a cave above. In foreground a man mounts a steep place by means of a ladder.

No. 11. Fuji seen from Narumi, in Province of Kazusa, on the horizon, and two junks in full sail, one filling the whole foreground of the view. (See Plate 15.)

No. 12. Fuji seen from Ushibori, Province of Hitachi, over a large junk moored against the bank in the foreground, rising above the water reeds into a deep blue sky shading off into white at the top. Printed almost entirely in blue, in various tints, this plate is one of the best in the series. (See Plate 15.)

No. 13. Fuji seen from Lake Suwa, Province of Shinano; a thatched hut under two pine trees, on a rocky promontory, in foreground. Another fine plate. Printed in blue.

No. 14. A print in blue and grey. Fuji seen from the Totomi Mountains, through a trestle supporting a huge square log which men are sawing into planks, one kneeling below and the other standing on top of it; on left, a third man sharpening a saw, and underneath the log a fourth sitting by a fire, the smoke of which trails upwards to the right. Another very favourite view.

In early impressions the log is tinted a slight pink colour, in later ones it is white.

No. 15. Fuji from the Onden water-wheel, which projects from a thatched shed on the left.

No. 16. Fuji seen from Inume Pass, Kai Province, a long green ridge sloping up towards the right with travellers, followed some distance behind by two packhorses, making their way up it. Across the valley filled with white mist rises a brown and blue Fuji, its summit white with snow and its sides snow-flecked. Sky streaked with orange-coloured cloud.

No. 17. Fuji reflected in Lake Misaka, Province of Kai. Green indented shores of a calm lake with yellow thatched roofs amongst the trees, and Fuji rising beyond, reflected in the water. Blue outline.

No. 18. Fuji seen from the Pass of Mishima, in the Province of Kahi, with its crest wreathed in a light cloud, and clouds rising behind its base, while in the foreground, as if challenging comparison with the peerless mountain, stands a huge tree, the giant of the forest, and three men, like pigmies, are endeavouring, with outstretched arms, to encircle its girth. Another magnificent plate. (See Plate 15.)

No. 19. Fuji seen from Isawa, Kai Province, at daybreak, rising out of the mists; in the foreground, a street between two rows of houses still closed, and travellers setting forth.

No. 20. Fuji seen across the inlet of Kanagawa, and a huge wave about to envelop three boats and their helpless crews. Reprints and reproductions of this plate are common. Good impressions of original

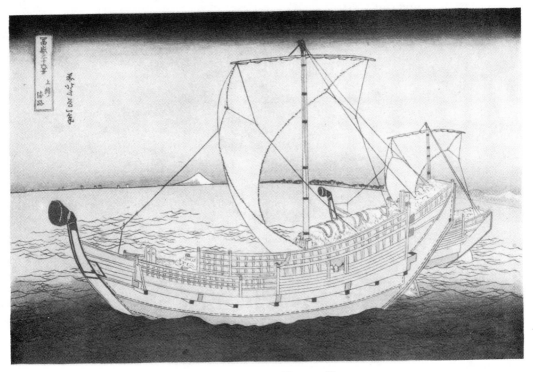

1. No. 11.—Fuji from Narumi, Kazusa.

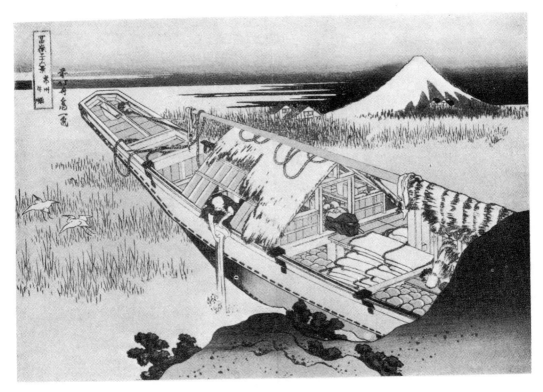

2. No. 12.—Fuji from Ushibori, Hitachi.

PLATE 15 (first part)

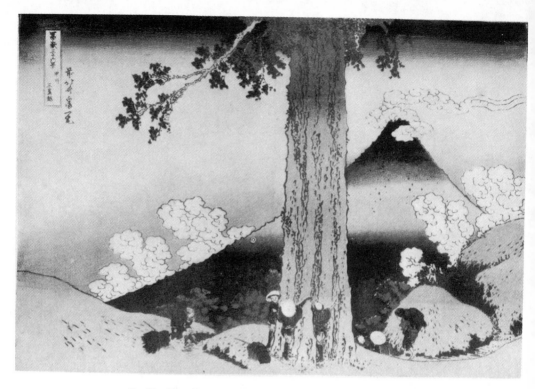

3. No. 18.—Fuji from Pass of Mishima, Kahi Province.

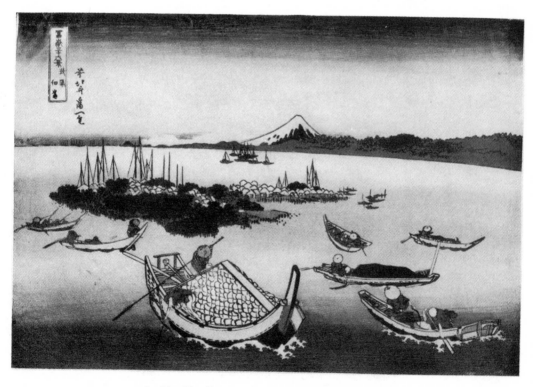

4. No. 38.—Fuji from Tsukuda-jima, Sumida River.

PLATE 15 (second part)

copies should show some slightly tinted clouds in the upper part of the sky, which do not appear in late impressions nor in reprints.

No. 21. Fuji, its crest white with snow, seen through a row of pines by the edge of the road, from Hodogaya on the Tokaido, and travellers, one on horseback, passing along the highway.

No. 22. Fuji seen from a tea-house at Yoshida on the Tokaido, and a waitress pointing it out to two ladies who have been brought thither in a *kago*. This plate is hardly up to the standard of the other views in the series.

No. 23. Fuji seen from the ford over the Oi River at Kanaya on the Tokaido, with people being carried across on the backs of coolies, and gangs of men carrying *norimon*.

No. 24. A blue Fuji with its crest in white towering up behind green hills shrouded in yellow mists, overlooking the shore at Tago, near Ejiri ; while in the foreground two large junks, and others beyond, are being beached stern foremost. Prevailing colours of yellow, blue, and green. One of the best plates in the series. (See Plate E, page 60.)

No. 25. Fuji seen in the distance from Enoshima, and a cluster of houses in green woods with the pagoda of the shrine of Benten rising above the foliage and people wending their way to it. Blue outline.

No. 26. Fuji from Nakabara, Province of Soshu. Coolies passing across a low plank bridge by a small stone wayside shrine on the edge of a stream, and a man fishing with a net close by.

No. 27. Fuji from Shichiri-ga-hama (" The Seven *Ri* Coast "), Province of Soshu. A print in dark bluish-green, with a snow-capped Fuji showing on right of clump of trees, and curious white clouds on the horizon on left. Blue outline.

No. 28. Fuji from Hakone Lake, Province of Sagami. Rounded green hills rise up from the tree-fringed shores of Hakone Lake, between which, in the distance, rises the cone of Fuji.

No. 29. Fuji from Umesawa, Province of Sagami. A deep blue mountain, graded lighter towards the crater, green forests at its base ; cranes in the foreground, and two flying towards the crater. Dense clouds encroaching from either side upon the mountain. A somewhat uninteresting plate in prevailing green and blue.

No. 30. Fuji seen from the timber-yard at Honjo, Yedo ; in foreground a man sawing a log, and on the left another throwing up billets to a third standing on the top of a pile of logs for stacking.

No. 31. Fuji seen through the piers of the Mannen Bridge over the Fuka River ; people passing over the bridge, a laden barge on the water, and a man fishing.

No. 32. Fuji from the pagoda of the " Five-Hundred Rakan " at Yedo ;

people admiring the view from a balcony adjoining the temple, and a man pointing the mountain out to them.

No. 33. Fuji seen across the ancient pine of Aoyama, whose trailing branches are supported on trestles ; low-lying mists intervening, and a party picnicking on the hill-side.

No. 34. A solitary fisherman at Kajikasawa, Kai Province, standing on a rock jutting out over the waves and hauling in his lines, the outline of the peak of Fuji appearing beyond above the mist. One of the favourite views of the series. Blue outline.

No. 35. Fuji just visible from Shimo Meguro, a small village in the hills near Yedo. This view having no strongly marked features is difficult to describe in words.

No. 36. Fuji seen from Senju, a suburb of Yedo, and two men fishing at a weir, another leading a horse.

No. 37. Another view of Fuji from Senju, looking across the Yoshiwara ; two women watching a *daimyo's* procession passing.

No. 38. Fuji seen from Tsukuda-jima, an island at the mouth of the Sumida River, rising above green hills on the further bank, and white clouds, printed in *gauffrage*, rolling along the horizon. Another very fine view. (See Plate 15.)

No. 39. Fuji seen across the Tama River, in the Province of Musashi, with a wide band of mist stretching across from side to side below the snow-capped crater ; a laden boat crossing the stream, and on the near bank a man leading a horse with faggots on its back. A favourite plate.

No. 40. A distant view of Fuji from Gotenyama, at Shinagawa on the Tokaido ; in the foreground, cherry trees in blossom and people admiring them.

No. 41. Fuji appearing over the roofs of warehouses along the banks of a canal, at the end of which rise, above the mists and trees, the towers of the Uyeno Temple ; in the foreground, the Nihon Bridge crowded with coolies and porters. A fine plate. Blue outline. (See Plate E, page 60.)

No. 42. Fuji seen from Suruga Street, Yedo, between the tops of roofs, on one of which on the right are workmen making repairs ; kites flying.

A view of the celebrated drapery shop of Mitsui, whose trade-mark, *Mi-tsui* (" three wells "), appears on signboards.

No. 43. Fuji seen across the house-tops in the distance from Suruga-dai, a hill in the centre of Yedo ; coolies and others passing in the foreground. A composition mainly in green and brown.

No. 44. Fuji seen from the Buddhist Temple of Hong-wan-ji at Asakusa,

Yedo. The roof of the temple on right, clouds over the roofs of the city below, kites flying, and a high trestle fire-outlook tower rising through the clouds on the left. Blue outline.

No. 45. Fuji at evening beyond the Ryogoku Bridge, Yedo; in the foreground a large ferry-boat, and beyond it the long line of the bridge stretching across from bank to bank and Fuji terminating it in the distance.

No. 46. A distant view of Fuji, red with the rays of the setting sun, from the village of Seki-ya, on the Sumida River, rising above the mists over a flat landscape; in the foreground, three horsemen riding along a curved embankment against a gale of wind. Blue outline.

The foregoing series was issued between the years 1823 and 1829; Hiroshige designed a series of " Thirty-six Views of Fuji," upright, which was issued in 1859 by the publisher *Kōyeido*. On the title-page, published on completion of the series, is a list of contents giving the order of the various plates, and a preface, written by Santei Shumba. In this preface occurs the following interesting passage : " One day Hiroshige came to the publisher with ' Thirty-six Views of Fuji,' which he said was his last work, and asked him to engrave them. It was the beginning of last autumn (i.e. 1858), and at the close of the autumn he died, aged 62." Hiroshige's words had an unforeseen prophetic truth, as he did not like to see them completed, some of the views, by reason of the crudeness of their design, being obviously the work of his pupil, Hiroshige II.

The first edition, which is rare—late, poorly printed copies largely outnumbering the good ones—was very carefully printed " in respectful commemoration of the artist," and as such takes high place amongst the various upright series designed by Hiroshige. (See foot-note at page 97.)

The views constituting this series are as follows :—

No. 1. Fuji seen across the town from the Ichikoku Bridge, Yedo.

No. 2. Fuji seen from Suruga Street, Yedo. The corner of the street occupied by a drapery store ; Manzai dancers passing, and two girls playing *samisen*.

No. 3. Fuji from the moat round Yedo Castle in the depth of winter. A very good snow scene.

On the right an angle of the moat-wall, grey and white, rises out of the blue water ; beyond, a low stone causeway leading to a cluster of houses, and people crossing it. In the distance rises a pure white Fuji against a faint rosy sky, changing to blue above.

No. 4. Distant view of Fuji from Tsukuda-Oki, Yedo, with junks moored in the bay, and one in the foreground, close to a bank of reeds. Fuji

should be slightly tinted grey in best impressions. A good plate. (See Plate 16.)

No. 5. View of Fuji from the Tea-water Canal, Yedo, with an enclosed water-conduit carried across it like a bridge.

No. 6. Fuji seen across Yedo from the Ryogoku Bridge ; a woman in a boat alongside a landing stage talking to another standing on it under a willow tree.

A fine plate. Fuji should be slightly grey below and white above, rising out of purple mists above dark foothills into a graded blue sky above.

No. 7. A grey Fuji seen from the embankment of the Sumida River, along which two girls are walking under cherry trees.

No. 8. Fuji from Asuka-yama ; view from a green field with cherry trees, and people walking about.

No. 9. View of Fuji from the " Fuji View " tea-house, Zoshiga-ya, on high ground overlooking a stream running through rice-fields, and two women admiring the view. Perhaps a plate by Hiroshige II.

No. 10. Fuji seen from Meguro Yukiga-oka, between two red maples on the high bank of a stream.

No. 11. Fuji rising through a crimson sky above low-lying mists and yellow plains with the winding Tonè River in the foreground, and sailing junks on it. People standing under the trees on a high cliff, below which runs a path, overlooking the river.

No. 12. The cone of Fuji seen through the cleft in a tree-trunk beside a stream, from Kokanei, Province of Musashi.

No. 13. Considered one of the masterpieces of the series. Fuji seen from the Tama River, Province of Musashi. Fuji rises through purple mists and cloud above deep green hills, slightly touched with blue ; in the foreground, two people crossing a low bridge over the shallow river by a willow tree, and in the distance people fishing from the bank. (See Plate 16.)

No. 14. Fuji from Koshiga-ya, Province of Musashi, rising above the surrounding hills, across the intervening river and fields ; in the foreground, two cherry trees with red blossom just coming into leaf. A man in a punt on the river, and four people walking along the bank.

No. 15. A snow-white Fuji towering up into the sky and a cloud hanging on its slopes seen from Nogè, Yokohama, lying at the head of an inlet up which junks are sailing, past a flat promontory covered with trees.

No. 16. Fuji seen from the sea at Honmaki, Musashi, and a perpendicular yellow and green cliff in the foreground, with trees on its summit, and a boat sailing past it.

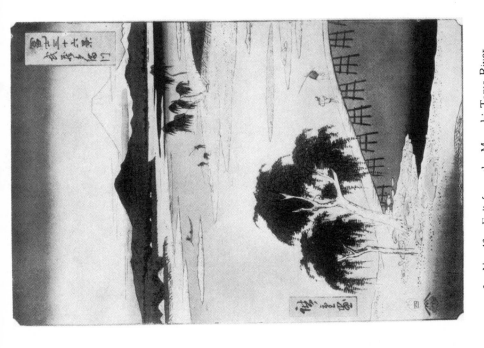

2. No. 13.—Fuji from the Musashi Tama River.

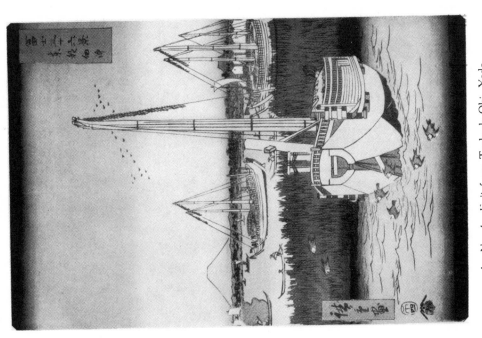

1. No. 4.—Fuji from Tsukuda-Oki, Yedo.

PLATE 16 (first part)

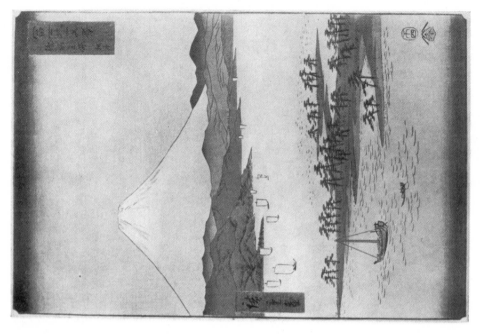

4. No. 24.—Fuji from Miho-no-Matsubara.

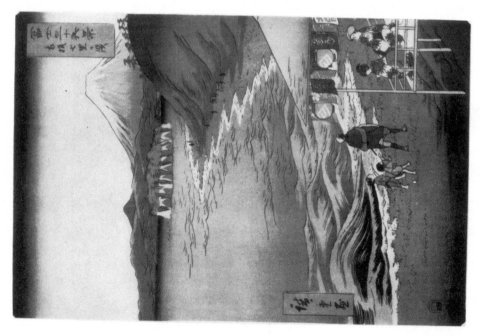

3. No. 19.—Fuji from the "Seven Ri" Beach. Shoshu Province.

PLATE 16 (second part)

No. 17. Similar to the last view. Fuji from the Sea of Miura, Province of Shoshu, its base wreathed in red clouds ; in the foreground, cliffs crowned with trees.

No. 18. A grey Fuji with snowy cone seen above a green hill from the Sagami River, Province of Shoshu, and two men on rafts, the one in the foreground with a fire burning ; herons flying above, and one alighting on the water by a clump of reeds.

No. 19. A grey Fuji, its upper slopes and summit snow-covered, from the seashore known as the " Seven *Ri* " (about eighteen miles) beach, Shoshu Province, and a man, followed by two children, passing a tea-house on the beach in which two women are sitting. On the lanterns hung from the roof of the tea-house appear Hiroshige's diamond seal, " Hiro." In the bay appears the island of Enoshima ; behind it rise dark grey foothills against a yellow sky, changing to blue above. (See Plate 16.)

No. 20. Fuji seen across Enoshima Bay through a large dark grey *torii* erected on the beach close to a tea-house which three women are approaching.

Across the deep blue water (graded lighter in the centre) is a coast-line of low green hills backed by a higher dark grey range behind, above which towers Fuji, grey below, white above ; purple sky on horizon, blue above. A very fine plate.

No. 21. Fuji from Lake Hakonè, Soshu Province. Two arms of the lake with a promontory between them ; yellow cliffs along the shore.

No. 22. Fuji, rising above white and purple mists, seen in the heart of the Izu Mountains, and a great waterfall in the foreground.

No. 23. Fuji seen from the coast at Satta Point, and a great wave breaking in on the shore. Considered the masterpiece of the whole series. (Reproduced in colours at Plate F, page 156.) *

No. 24. A great grey-white Fuji rises up into a golden sky, seen from the promontory Miho-no-Matsubara, one of the stations of the Tokaido ; ships sailing in the bay. Another masterpiece. (See Plate 16.)

No. 25. Fuji seen across rice-fields from the edge of a road lined with great pine trees, along which a woman and a priest, with shaven head, are passing, at Yoshiwara, on the Tokaido.

No. 26. Fuji seen in the distance from the ford over the Oi River, and women being carried across in *kagos* by coolies. A poor plate by Hiroshige II.

No. 27. Fuji seen across a wide expanse of calm sea from the beach at Futami, Ise Province, with the " husband and wife " rocks in fore-ground.

*Reproduced in black and white in this edition.

No. 28. Fuji seen at the far end of Lake Suwa, Shinano Province, sur-
rounded by mountains, and boats on it.

No. 29. Another, more distant, view of Fuji at the head of Suwa Lake,
with the narrow road between steep hills leading down to it.

No. 30. A near view of Fuji across the Motosu Lake from Misaka Pass,
Kai Province. A fine view.

Two travellers at the top of the pass in foreground, and another
approaching from the lake beyond.

No. 31. Fuji rising above grey hills seen from a field, in which wild
flowers and tall *suzuki* grass are growing, in the Plain of Otsuki, Kai
Province.

No. 32. Fuji, from the Inume Pass, Kai Province, rising above other
mountains overlooking a ravine through which the River Fuefuki
flows, and clouds hanging over it. A plate probably by Hiroshige II ;
colouring crude.

No. 33. A distant view of Fuji seen across a flat plain with a small stream
meandering through it, and two horses grazing, the one in the fore-
ground blocking out half the view. A wretched plate, obviously the
work of the second Hiroshige.

No. 34. Fuji, rising above dark foothills against a crimson sunset sky,
changing to deep blue above, seen across the Bay of Kuroda, Province
of Kazusa, with junks at anchor, and others sailing across.

Green shore in near foreground with a few small pine trees growing
close to the water's edge. The sea should be deep blue at the edges of
the coastline, only slightly tinted to white in centre.

No. 35. Fuji across Yedo Bay, seen from Rokusozan, Kazusa ; a large
tree in the foreground by the edge of the road, along which a woman
on a led horse is passing under a *torii*. Probably by Hiroshige II.

No. 36. Fuji from the seashore at Hota, Boshu, showing the path running
round a projecting headland and waves breaking on the shore ; in
foreground a bare-headed priest gazing across the bay at Fuji rising
above purple mists. A good plate.

CHAPTER XIV

FAMOUS SERIES OF PRINTS BY HOKUSAI

" The Imagery of the Poets "—" Waterfalls " Series—" Bridges " Series—" Eight Views of the Loo-choo Islands "—" Snow, Moon, and Flowers " Series.

BEFORE dealing with the remaining series of landscape views by Hiroshige, we will now pass in review other great sets of prints by Hokusai, including certain landscape views by his pupils.

For the sake of uniformity and convenience of reference we include here his two series of " Poets " which, while they are mainly illustrations of (or allusions to) the poems, are chiefly landscape views, and fit this description, perhaps, better than any other.

Shika Sha-Shin-kyo, " The Imagery of the Poets " (literally " Poems of China and Japan mirrored to life "). A series of ten large, upright prints, measuring 20¼ in. by 9 in. ; each signed *Zen Hokusai I-itsu ;* publisher *Moriji ;* attributed to the year 1830.

Though this series is extremely rare, some prints in it even more so than others, so that it is unlikely the average collector will ever have an opportunity of acquiring original copies, to say nothing of the high price they command, yet their importance warrants a fairly detailed description of them. Modern reproductions of this series have been very skilfully made. Seven of the set are in the B.M. collection ; all are illustrated in the Happer catalogue.

No. 1. The poet HARUMICHI NO TSURAKI (*d.* A.D. 864). (No. 32 of the " Hundred Poets " Anthology.) The poet is shown crossing a small bridge over a rushing stream, gazing at the water and followed by two retainers ; on his right, close against the bridge rises a steep cliff, with bushes growing from it. On the further bank stands a cluster of houses and in the background a great mountain rears its summit into the sky in the glow of sunset.

This illustrates the poet's verse which tells how the mountain stream became choked with the maple leaves brought down by the gale of yesterday.

No. 2. ABE NO NAKAMARO (*d.* A.D. 780). (No. 7 of the Anthology).

The poet is seated on a high balcony under the shelter of a tall pine, over-looking the sea, gazing out upon the moonlit waters, upon which float fishing boats in the distance; round him stand four Chinese servants respectfully offering him food. (See Plate 17.)

Nakamaro, while but a youth of sixteen summers, was sent in company with two others to China to discover the secrets of the Chinese calendar, and on the night before returning to Japan he was given a farewell banquet. Another version is that, suspecting his motives, the Chinese Emperor banqueted him on the palace roof, and while he slept, overcome with wine, had the stairs removed, in order that he might be left to die of hunger. Awaking suddenly in the moonlight, Nakamaro bit his thumb, and wrote the following poem in blood upon his sleeve :—

> While gazing up into the sky,
> My thoughts have wandered far ;
> Methinks I see the rising moon
> Above Mount Mikasa,
> At far-off Kasuga. (Porter's translation.)

Kasuga being the name of a famous temple at the foot of Mount Mikasa near the poet's home.

Nakamaro afterwards effected his escape and fled to Annam.

No. 3. ARIWARA NO NARIHIRA (A.D. 825–880). (No. 17 of the Antho-logy.) This scene, which carries the name of the poet Ariwara on its title, is more appropriate to one of the " Six Tama Rivers," as it does not appar-ently illustrate Ariwara's verse, which compares the music of running water to some sweet song.

Beside the water's edge, under the light of a full moon, across the face of which fly a flock of wild geese, a woman and a boy kneel facing one another, pounding cloth ; behind them a man is engaged in carrying baskets into a thatched hut partly seen in right foreground. In the back-ground rises the tower and roofs of a pavilion above mist ; a tall pine tree grows on the bank above the water, and a flock of geese wade out into the stream.

No. 4. TORU DAIJIN, the Minister Toru. A Court Poet, holding a closed fan over his shoulder, stands with two retainers, one his sword-bearer, by the edge of a narrow strait, contemplating the crescent moon on the third day, a lucky observance. On the further shore of the strait are a few huts under the shelter of two great pine trees ; three boats moored in mid-channel.

No. 5. TOKUSA KARI, " Gathering Rushes." An old peasant, carrying a pole across his shoulder on which two bundles of rushes are slung, crosses a small bridge over a foaming torrent, towards a calm lake whereon two ducks are asleep. In the background rises a full moon behind a clump

Katsushika HOKUSAI.

1. ABE-NO-NAKAMARO gazing over the moon-lit sea.

2. Illustration to the Poetess SEI-SHO-NAGON.

(*Reproduced by courtesy of Messrs. Sotheby.*)

PLATE 17 (first part)

Katsushika HOKUSAI.

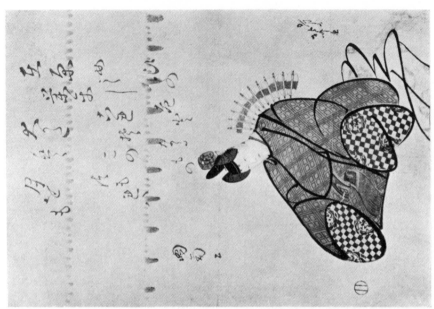

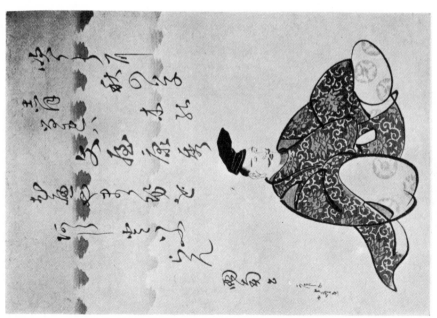

3. The Poet Bunya-no-Yasuhide; "Six Famous Poets" series. 4. The Poet Ariwara-no-Narihira; "Six Famous Poets" series.
(Reproduced by courtesy of Mr. Shozo Kato.)

PLATE 17 (second part)

of trees and rushes which grow down to the water's edge, and mist lying on them.

No. 6. SHONENKO. The Japanese title of a Chinese Poem upon the pleasures of travelling.

Along a winding road by the shores of a lake a rider urges his steed ; beyond a bend in the road is his servant riding ahead ; by the shore of the lake sits a fisherman dozing.

No. 7. HAKURAKUTEN (the title of a Nō drama). Hakuraku is the Japanese name for the Chinese poet Po Chū-I. He is here shown standing on a ledge of rock above the sea, with three retainers, listening to the counsel of the Chinese sage, Kiang Tsze-Ya, who sits on a rock in the foreground fishing. Behind the poet appears the mast and prow of a ship, and in the background, wreathed about with cloud, rise three needle-like pinnacles of rock.

This is presumably the same Hakuraku who was sent by the Emperor of China all over the world in quest of the perfect horse, and he is here shown seeking the sage's advice before setting out on his quest.

No. 8. RIHAKU (Chinese Li Peh), the most famous of the Chinese poets (A.D. 699–762). He is depicted gazing in lost admiration at the cascade of Luh, while two youthful attendants clasp hands round him to prevent him, in a sudden emotion of ecstasy, from losing his balance and falling headlong over the edge of the precipice.

No. 9. SEI-SHŌ-NAGON. (The Poetess Lady Sei, Shō-nagon being a title only, a famous Japanese writer, lived early in the eleventh century ; No. 62 of the " Hundred Poets " Anthology.) (See Plate 17.)

This scene illustrates her poem which is based on the Chinese story of Prince Tan Chu who, fleeing from his enemies, was shut up with his retainers in the town of Kankokkan, the gates of which were closed from sunset to cock-crow. A quick-witted retainer, however, climbed a tree and so successfully imitated the crowing of a cock that he started all the cocks in the neighbourhood, whereat the guards, thinking daybreak had come, opened the gates and the Prince and his followers escaped under cover of darkness.

The guards are shown opening the gates, while above is the man in the tree, whose crowing is answered by a cock perched on the roof of the prince's travelling palanquin.

Lady Sei's poem is as follows :—

> Too long to-night you've lingered here,
> And, though you imitate
> The crowing of a cock, 'twill not
> Unlock the tollbar gate ;
> Till daylight must you wait. (Porter.)

No. 10. Tōba (Chinese Su-she, 1036–1101), a celebrated Chinese official and caligraphist who, after rising to high rank was, owing to intrigues against him, deposed and banished to the island of Hainan.

He is here shown on horseback on a rocky crag overhanging the sea, contemplating a pine tree laden with snow, and seagulls floating on the water, while the snow falls silently down. Behind his horse stands an attendant.

Shokoku Takimeguri, " The Waterfalls of Various Provinces " (literally " Going the Round of the Waterfalls of the Country "), a series of eight, full-size, upright views, published about 1827 by Yeijudo ; rare.

No. 1. *The Kiri-guri* (" falling mist ") *Fall, Province of Shimotsuke.* Three men look up at the torrent as it pours in several streams down the rocks ; two others high up on the slope on the right.

No. 2. *The Ono Fall on the Kisokaido.* Five coolies on a small wooden bridge stand admiring the fall as it plunges sheer down into a stream which foams away beneath them ; beyond the bridge is a small shrine on an overhanging rock and, above, a crag towers up through the mist.

No. 3. *The Kiyo* (" pure water ") *Fall at the Kwannon Shrine at Saka-no-shita, Tokaido ;* a narrow stream down a hill-side. In front, partly screening the fall, rises a cliff ; tea-houses below and steep steps leading to the shrine above towards which two men are mounting, while a third is already praying before it.

No. 4. *The Yoshitsune Horse-washing Fall, Yoshino, Province of Izumi,* so called in allusion to the warrior Yoshitsune having washed his horse in it. A great torrent plunges in curves past overhanging rocks at the foot of which are two coolies grooming a horse in mid-stream. (See Plate 18.)

No. 5. *The Amida* (*Buddha*) *Fall, Kiso Province.* From a round hollow in the top of the cliff, supposed to resemble the head of Buddha, a torrent falls sheer down into a deep gulf. On each side are overhanging crags, and up on a ledge on the left are three men preparing to picnic.

No. 6. *The Aoiga Fall, Province of Yedo.* A wide fall pours over a stone wall from a calm lake with lotus leaves on it, into a broad stream below. In foreground a coolie, with buckets of shellfish suspended from a yoke, is resting, wiping the perspiration from his head, while others are ascending a hill to a house above on the left.

No. 7. *The Roben Fall, Province of Soshu.* From a wooded height the fall pours into a pool below where several men are bathing ; on each side are guest houses for the convenience of bathers.

No. 8. *The Yoro Fall, Province of Mino.* A wide torrent of water plunges sheer down over a ridge of rocks into a stream in the centre of

which rises a jagged rock at the foot of the fall ; in the foreground a rudely-thatched hut in which people are resting, and two others outside gazing up at the fall.

Each print in the above series carries the red seal of the publisher and a red *kiwamè* seal, when first edition copies, and the outline is printed in blue.

KEISAI YEISEN designed a series of Waterfalls (publisher *Yamamoto* ; censor's seal of *Wataru*), full size, upright, in close imitation of Hokusai's " Waterfalls," entitled " Famous Views in the Nikko Mountains." This series is very rare, and is presumed to consist of eight views, as in Hokusai's set, the only reference to it the writer has found being in the Miller sale (May, 1911), at which five views appeared, two of them being illustrated.

SHO-KOKU MEIKIO KIRAN : " Views of Bridges in Various Provinces " ; a series of eleven, full-size, oblong prints ; publisher Yeijudo, *c.* 1827–30. Rare.

Signature on each plate *Zen Hokusai I-itsu*. The order is that given by De Goncourt.

No. 1. *Yamashiro, Arashiyama, Togetsu Kyo ;* " The ' Reflected-Moon ' Bridge at Arashiyama, Province of Yamashiro." A wooden bridge on trestles crossing a wide blue river, on which floats a raft ; on the further shore, on the banks of which grow cherry and pine trees, rises Arashiyama, with red mists across it.

No. 2. *Kozuke, Sano, Funa Bashi Fuyu ;* " The Bridge of Boats at Sano, Province of Kozuke." Snow scene. A pontoon bridge, held by cables on either bank, is bent in a sharp curve by the swift current of the Tonè River. On either bank at each end of the bridge is a small hut ; near the one in the right foreground grows a slender pine tree. Three travellers on the bridge, one on horseback led by a coolie. Behind a screen of trees on the further bank rises a hill above low-lying mist. River deep blue in foreground, graded lighter towards the centre. Perhaps the masterpiece of the set.

No. 3. *Gyodosan, Kume-no-kake bashi ;* " The ' Hanging-Cloud ' Bridge at Gyodosan," Province of Shimotsuke. A light bridge, like a spider's-web, joining an isolated crag and a rocky cliff. White mist floating about, a coil of which trails up into the blue sky above.

No. 4. *Hida, Etchu, Tsuru Bashi ;* " The Suspension Bridge between (the Provinces of) Hida and Etchu." A swinging suspension bridge made of cordage and bamboo, and a man and a woman, both laden, in the centre of it. Below it the tops of pine trees emerge above the mist ; in background rises up a deep blue pinnacle of rock.

No. 5. *Suwo, Kintai Bashi ;* " Kintai Bridge, Province of Suwo." Rain scene. A wooden bridge of five arched spans supported on four stone piers ; through the rain appears a high mountain peak in the background.

No. 6. *Tokaido, Okazaki, Yahagi no bashi ;* " The Yahagi (Archers) Bridge at Okazaki, on the Tokaido." A high-arched bridge on wooden piers stretches in one fine sweep from bank to bank, across an almost dried-up river bed. Through the centre piers of the bridge is seen an awning in front of which is a party of archers practising at a target ; crowds watching them from the bridge. In the foreground are strips of cloth hung up on a staging in the sand of the river-bed to dry ; and great hats stuck up on sticks. On one of them appears the publisher's mark, repeated round the awning behind the archers. In the background the peak of a hill rises through the clouds. (See Plate 18.)

No. 7. *Kameido, Tenjin Taiko Bashi ;* " The Drum Bridge at the Tenjin Temple, Kameido." A semi-circular wooden arch, supported by two wooden piers, leading to a smaller bridge beyond, in the temple grounds. (See Plate 18.)

No. 8. *Ajikawa Guchi, Tempozan ;* " Mouth of the Aji River, Tempozan." On the right rises a promontory connected by bridges with a small island, and bright with cherry blossom. Alongside the signature is added, *Oju Naniwa* (i.e. Ōsaka) *nozu O-nisu,* " *copied by request from an Ōsaka picture.*"

No. 9. *Settsu, Temma Bashi ;* " Temma Bridge (Ōsaka), Province of Settsu." Scene at night during the Festival of Lanterns, with a view of the great bridge over the river at Ōsaka, crowded with people ; lanterns across the bridge, and on the boats below.

No. 10. *Echizen, Fukui Bashi ;* " Fukui Bridge, Province of Echizen." A bridge joining two different districts of the same province, half being of stone (built by a wealthy *daimyo*), and half of wood (built by a poor *daimyo*). Coolies passing over the bridge, one leading a packhorse ; on the sandy shore beyond are strips of cloth drying in front of a cluster of huts. On the bundles carried by the coolies occurs the mark of the publisher, *Yeijudo.* Background of low wooded hills shrouded in mist.

No. 11. *Mikawa, Yatsu Hashi ;* " The ' Eight-parts ' Bridge, Province of Mikawa." A number of zigzag platforms on trestles across an iris swamp, the two middle ones raised higher like an arch ; people crossing or stopping to admire the iris blossoms growing in the marsh around. In the background rises a hill-top above the mist. (See Plate 18 ; also Plate 5 illustrating the same bridge by Kunisada.)

RYUKYU HAK'KEI ; " Eight Views of the Loo-choo Islands " ; a set of

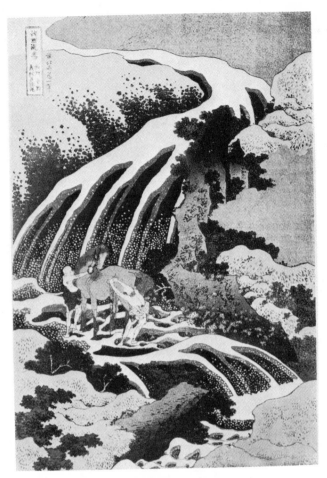

1. The Yoshitsune "Horse-Washing" Fall;
No. 4 of the "Falls" series.

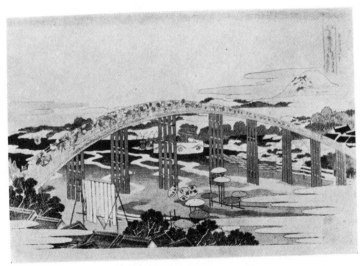

2. The Yahagi Bridge, Okazaki, Tokaido;
No. 6 of the "Bridges" series.

PLATE 18 (first part)

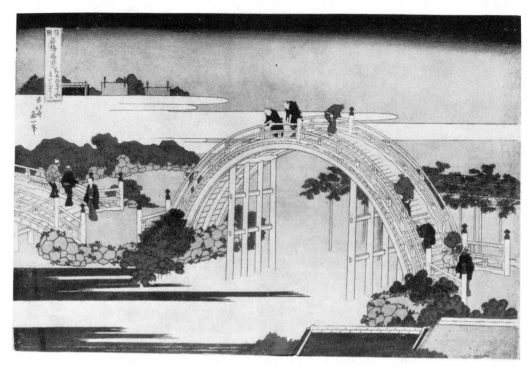

3. The "Drum" Bridge, Kameido; No. 7 of "Bridges" series.

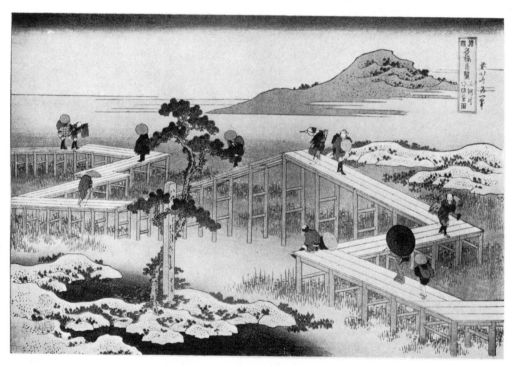

4. The "Eight-Parts" Bridge, Mikawa; No. 11 of "Bridges" series.

PLATE 18 (second part)

eight, full-size, oblong prints; each signed *Zen Hokusai aratamè I-itsu* (formerly Hokusai, changing to "I-itsu"); publisher *Moriji, c.* 1820. Very rare.

1. *Rinkai Kosei;* "The Sound of the Lake at Rinkai" (a poetical allusion). Lake scene. From the right foreground a winding stone causeway connects two small islands forming a peninsula jutting into the sea. Behind a walled enclosure on one island are blue-roofed houses.

2. *Riuto Shoto;* "Pines and Waves at Riuto." Snow scene. View of an indented sea coast, fringed with small islands, thinly covered with pines. In the middle distance tops of trees show through the mist like in-rolling waves, hence the allusion in the title.

3. *Senki, Yagetsu;* "Moonlight at Senki." In the foreground a stone bridge of three arches spans a river or inlet of the sea; on the right bank stands a cluster of houses. In the background a nearly full moon appears above the dark blue mass of a mountain rising out of mist.

4. *Kigaku Unsen;* "The Sacred Fountain at Kigaku." In the centre a waterfall pouring into a pool, and two men lying on the grass admiring it; mist floats about the hilly landscape and in the distance rises the red peak of the Loo-choo Fuji.

5. *Jungai Sekisho;* "Sunset at Jungai." A high wooded hill juts out into a lake, whereon are two sailing junks passing to the left. At the foot of the hill stands a *torii* marking a shrine.

6. *Sanson Chikuri;* "The Bamboo Grove of Sanson." In the foreground an embankment by the edge of calm water; and a row of houses along the front of which are clumps of bamboo; in the background a high hill.

7. *Choko Shusei;* "Autumn Light at Choko." A calm and misty sea and green hills showing through the haze; Chinese junk on left. From the right foreground runs a stone causeway, with small bridges at intervals, and two people crossing it.

8. *Chūto Shoyen;* "Banana Groves at Chūto." Near view of the village of Naka-jima from the sea; above their blue roofs can be seen the leaves of the banana trees; round-topped hills rise above the mist which lies low over the house-tops.

The foregoing series of "Eight Views" does not follow the theme usually associated with this title, and so is here given separately.

SETTSU GEKKA, "Snow, Moon, and Flowers." A set of three full-size, oblong prints; signed *Zen Hokusai I-itsu;* publisher *Yeijudo; c.* 1830. Very rare.

1. *Snow on the Sumida River.* View across the water to a cluster of buildings and trees on the opposite shore ; on the right are two men walking across the snowy fields ; fishing boat on the river.

2. *Moon on the Yodo River.* View looking down upon the river, with the ramparts and towers of Ōsaka Castle on the right ; on the further bank men are towing laden boats up-stream.

3. *Flowers at Yoshino.* Travellers and coolies, one leading a horse, traversing a hill road above a valley filled with a mass of cherry blossom ; top of a *torii* and roofs of houses beyond.

CHAPTER XV

FURTHER SERIES BY HOKUSAI AND HIS PUPILS

The " Hundred Poets "—" Six Famous Poets "—" Views of Tempozan," by Gakutei—Land-
scapes by Hokujiu and Hokkei.

WE now come to Hokusai's well-known set of illustrations
to the famous anthology, *Hiaku-nin-isshiu* (" Single Songs
of a Hundred Poets "), entitled *Hiaku-nin-isshiu Ubaga
Yetoki* (" The Hundred Poets illustrated by the Nurse "),
of which twenty-seven are known, together with
fourteen original drawings which were never used for reproducing as
prints.

The " Hundred Poets " is an anthology collected in A.D. 1235 by Fuji-
wara-no-Sudaiye, himself one of the hundred, and ranges from A.D. 670
to the year of compilation. The best English translation of this anthology,
and one which preserves very well the spirit and intention of the original,
is that by William N. Porter.[1] On one page is the original, below which
is a wood-cut taken from a native edition of about 1790 ; on the opposite
page is the translation.

" Perhaps what strikes one most in connection with the *Hyaku-nin-
isshiu* (' Single Songs of a Hundred Poets ') is the date when the verses
were written ; most of them were produced before the time of the Norman
Conquest, and one cannot but be struck with the advanced state of art
and culture in Japan at a time when England was still in a very elementary
stage of civilization." (Porter.)

Hokusai's illustrations are full size, oblong ; each signed *Zen Hokusai
Manji* (" Old Man Hokusai ") ; red seal of publisher *Yeijudo* and red
kiwamè seal. On a narrow upright label is the title of the series, and on a
square one, partly overlapping it, is the name of the poet illustrated and
his poem. Some plates are much rarer than others ; fine copies of any
are not at all easy to procure, while the series as a whole may be described
as moderately rare. The scene portrayed generally illustrates the poem
or the circumstances under which it was written, but sometimes there

[1] *A Hundred Verses from Old Japan.* Clarendon Press.

appears to be little or no connection between them, or else it is too subtly veiled for our understanding.

The following constitute the poets illustrated :—

No. 1. The Emperor Tenchi (reigned, A.D. 668–671). The poem tells how, while watching harvesters at work, the Emperor took shelter from a shower of rain in a neighbouring hut, which afforded only slight protection.

> The scene shows us labourers at work in the rice-fields and travellers passing along a narrow path, and in the right foreground another peasant and his wife, preceded by a boy crossing a small bridge over a stream. In the background a few rude huts showing amongst trees, behind which rise hills above the mist. In the centre three tall but slender trees stand out against a sunset sky.

No. 2. The Empress Jito (reigned 690–696), daughter of the Emperor Tenchi. Poem on the coming of summer. Two women carrying linen on a pole which they have just washed in the stream, one going up from the river, which coolies are fording. On the right cloth is hung out to dry, in allusion to the poetess's reference to the angels of the sky who, on the coming of summer, spread their white robes to dry on the peak of the " Hill of Heaven."

No. 3. The Nobleman Kaki-no-moto (died A.D. 737). After death he was deified as the God of Poetry. There is no apparent connection in this case between the poem and the illustration, which shows us fishermen dragging a net up a stream ; across the scene trails the smoke of a fire. In the poem the nobleman laments his loneliness.

No. 4. Yamabe-no-Akahito (A.D. 700), also deified as a God of Poetry ; one of the most celebrated of the poets. His poem is on the beauty of the view of Fuji from Tago Bay, and the illustration depicts Fuji seen from Tago, with people climbing the hillside overlooking the bay.

No. 5. Sarumaru Taiyu (c. 800). Poem on hearing the cry of a stag wandering in the mountains in the autumn-time. Women listening to the stag's call as they travel through the mountains.

No. 6. Chunagon Yaka-mochi. Two men on a junk watching a flight of magpies, in allusion to the " Magpies' Bridge," mentioned in the poem (vide Tanabata festival, at page 325, for meaning of the Magpies' Bridge). Three other junks moored near by, and on the right appears a distant coast.

No. 7. Abe-no-Nakamaro, who was sent to China to discover the secret of the Chinese Calendar, and when about to return home was starved to death by the Emperor's orders. The illustration depicts him

admiring the rising moon reflected in the calm sea below him, the subject of his poem, which he composed the eve before his return to Japan (*vide* previous chapter).

No. 9. Ono-no-Komachi, a famous poetess (A.D. 834–880), noted for her great beauty in her youth, followed by a most decrepit and penurious old age, a fact which she bewails in her poem. The scene shows us peasants outside a house engaged in various daily tasks, the drudgery of their work, and the man sweeping up the fallen blossom, illustrating the mood of the poem which has a double meaning running through it. (See page 321.)

No. 11. Sangi Takamura (*d*. 852). He composed his poem while being deported across the water in a small boat to Yasoshima, on the west coast of Japan, whither he was banished. Illustration : women diving for shells, and a boat putting out to sea, in allusion to the boat which rowed him away.

No. 12. Sojo Henjo, who took holy orders and was made a bishop ; he died in the year 890. His poem is an invocation to the winds of heaven to arise and bring up the clouds and bar the passage of the fair ladies who, he fears, will otherwise assume the form of angels and fly away ; the ladies being a nobleman's daughters performing the *Nii-name Matsuri*, a sacred dance, at a Court festival at which Sojo Henjo was present before he entered the priesthood. The illustration, therefore, depicts the scene which inspired the poem. (See Plate 19.)

No. 17. Ariwara-no-Narihira (A.D. 825–880). Poem on the music of the Tatsuta stream as it flows by, red with fallen maple leaves. Peasants crossing a high-arched bridge, supported on trestles, over the Tatsuta stream, along whose waters are borne fallen maple leaves.

No. 18. Fuji-wara-no-Toshiyuki (A.D. 880–907). A large junk sailing slowly across the Bay of Suminoye, Settsu Province.

His poem is an invitation to his lady-love to meet him on Sumi-no-ye Beach, where they will be safe from prying eyes.

No. 19. The Princess Ise. A woman and her daughter in the upper part of a house, with men working on the roof.

No. 20. Motoyoshi Shinno (*d*. 943). In foreground, a coolie dragging along a laden ox, and two women behind large umbrellas looking out over Ōsaka Bay ; behind them a small boy carrying a load on his back. Mist lying over the water, and hills appearing above it, on the left.

Jutting out from the shore, below the road, is a small promontory round which are set up stakes for measuring the height of the tides.

In the poem there is a play on certain words which may mean either to do one's utmost or die in the attempt ; or they may refer to the graduated sticks set up at Naniwa (i.e. Ōsaka) to measure the tides.

The poet, who was notorious for his love affairs, threatens to drown himself by the tide-gauge at Naniwa if he cannot again see his lady-love.

The two meanings of the words are alluded to in the illustration by the coolie struggling his utmost to drag along his refractory beast, and the tide-gauges set up by the water's edge.

No. 24. Michi-zane Suga-wara (Kwan-ke), (*d.* 903), a learned scholar, deified as the God of Caligraphy, and a favourite with schoolboys. The poet visiting the temple on Mount Tamuké, Nara, the scene of his poem.

The temple of Hachiman, on Tamuké Mountain, is famous for its maple leaves, which are shown strewn on the ground, and the poet says he can make no finer offering to its shrine than its own maple leaves.

No. 26. Prince Tei-shin (Tadahira Fuji-wara) (died about 936). Scene on Mount Ogura, with the Emperor Uda, after his abdication, being received by the monks of the temple. The poem is an invitation to his son, the Emperor Daigo, to visit Ogura-yama, famous for its maples.

No. 28. Minamoto-no-Mune-yuki (*d.* 940). Men outside a hut surrounded with a bamboo fence and covered with snow, warming themselves at a fire, the smoke of which trails upwards across the scene, in allusion to the poem on the dreariness and loneliness of winter-time.

No. 32. Harumichi-no-Tsuraki (died 864). Two men sawing up a large log, and a woman and child crossing a stream covered with maple leaves which a man is clearing out. The poem alludes to the stream choked up with fallen leaves so that it cannot flow on. (See also " Imagery of the Poets " series in previous chapter.)

No. 36. Kiyowara-no-Fukayabu. The forepart of a large pleasure boat, lit by lanterns, on the river at night, sailing between two smaller boats. Poem on the summer night.

No. 37. Bunya-no-Asa-yasu (lived end of ninth century). Five women in a boat, close to the shore, gathering lilies ; one of the rarest prints of the set. Poem on the dew glistening in the grass like sparkling jewels.

No. 39. Sangi Hitoshi (lived during tenth century). A *daimyo* with two retainers on a wild moor on which bamboo reeds are growing. Probably meant to be the poet himself, who alludes to reeds growing on a wild moor as easier to hide than his passion for his lady-love.

No. 49. Ona-Katomi Yoshinobu (lived end of tenth century). The poet is seated on a hill overlooking a plain, and below are men around the

warder's fire at the palace gateway, the subject of his poem, in which he compares the constancy of his love to the watchfulness of the palace warders.

No. 50. Fuji-wara-no-Yoshitaka (d. 974). A bath-house by the edge of a misty lake, over which people are looking from the balcony. From the bath below, in which two men are immersed, steam rises up past the balcony and is lost over the lake in which two cormorants are disporting themselves.

The illustration appears to have no connection with the poem.

No. 52. Fuji-wara-no-Michinobu (tenth century). Daybreak over a grey plain, with trees on the horizon silhouetted against the sky, and coolies bearing three kago, and other travellers, who are setting forth with lanterns along the winding roads across it. In the foreground other coolies hurry along the steep village street with two kago, a companion running beside them. The scene typifies daybreak and the discomforts of turning out in the cold of early morning, such as, no doubt, the coolies feel; discomforts which the poet gives expression to in his verse.

No. 68. The Emperor Sanjo (reigned A.D. 1012–1015). He was obliged to abdicate in 1015, and composed this poem in his exile, saying that now the moon is the only friend left to him.

The illustration is a temple ceremony in honour of the full moon which shines down upon the scene from a dark sky.

No. 71. Dai-nagon-Tsune-nobu (d. 1096). Road on a hillside overlooking rice-fields, and women filling buckets at a stream, two coolies passing along carrying two baskets on a pole between them.

No. 97. Fuji-wara-no-Sada-iye (known in the anthology as Gon-Chu-Nagon-sada-iye, his official title), the compiler of this anthology, who died 1242. This plate is one of the rarest of the series.

In his poem he sighs for his lady-love, and complains that, though the evening is cool, yet the salt pans drying on the shore are not more parched with thirst than he is. Here again there is a play upon the meaning of words, that translated " scorching " or " evaporating " (like the sea-water in the salt pans) also meaning " to love ardently." The illustration shows a salt kiln, the fire from which is throwing out a great volume of smoke.

The following are the fourteen original drawings for the key-blocks, which, left by Hokusai at his death, were never used.[1]

14. Kawara-no-Sada-ijin.

[1] Amateur collection sale (anonymous), March, 1910. It is stated in the catalogue thereto that these drawings were originally bought in Japan by the late Dr. Ernest Hart.

21. The Priest Sosei.
25. Sanjo-no-Udaijin (Sadakata Fuji-wara).
34. Fuji-wara-no-Oki-kaze.
43. Chu-nagon Yatsu-tada.
53. Udaisho Michi-Tsuna-no-Haha, a poetess famous for her beauty.
57. Murasaki Shiki-bu, another poetess, famous in Japanese literature as the authoress of the historical romance *Genji Monogatari* (" Tales of Prince Genji ").
70. The Priest Riyo-zen.
72. Yushi-Naishinno-ke-kii, a Court lady.
73. Gon-Chu-nagon-Masafusa.
74. Minamoto-no-Toshi-yori-Ason.
75. Fuji-wara-no-Moto-toshi.
76. Hosho-ji Nyudo-Sakino-Kwambaku-Daijo-daijin (Tada michi Fuji-wara).
83. Kwo-Tai-Kogu-no-Tayu-Toshinari.

In addition to the Hundred Poets there are also the Thirty-six Poets, and the still more select *Rok'kasen*, or " Six Famous Poets," five of whom also appear amongst the hundred.

These six select poets are Kizen Hoshi, represented in priest's robes with a fan ; Ariwara-no-Narihira, with a sheaf of arrows at his back ; Sojo Henjo, in priest's robes ; Otomo-no-Kuronushi, in Court dress ; Bunya-no-Yasuhide, also in Court dress ; and the poetess Ono-no-Komachi.

These six poets are represented in a very rare set by Hokusai, full size, upright ; each signed *Katsushika Hokusai* ; publisher *Yezaki-ya* ; c. 1810, according to De Goncourt. Each print is a large figure of the poet in which the outlines are formed by the characters for their names.

Except for Kizen Hoshi and Yasuhide, the poems are different from those which appear in the above anthology. The upper half of each print has the poem written in large characters, the caligraphy of which is evidently supplied by another hand, as this is signed *Tonan*. Two prints from this set are here reproduced at Plate 17, showing the poets Ariwara-no-Narihira and Bunya-no-Yasuhide. (See page 118.)

1. KIZEN HOSHI. Seated, dressed in priest's robes of dark grey, green and yellow, holding an open fan, and with a smiling countenance. Poem (as in the " Hundred Poets " Anthology) No. 8 :

> My home is near the Capital,
> My humble cottage bare
> Lies south-east on Mount Uji ; so
> The people all declare
> My life's a " Hill of Care." (Porter.)

The smiling countenance in which Hokusai has depicted him hardly

bears out the tenor of the poem bewailing his hard lot, unless, as a philosopher, he hid his sorrows behind a smiling exterior.

The play on the words is contained in the word *Uji*, which means " sorrow " or "care."

2. ONO-NO-KOMACHI. Seated, half hidden by a screen, her back turned, but looking over her shoulder, and holding a yellow fan. Poem : " The colour whose charm is enduring is the colour that flowers pure in the heart " (Binyon).

3. OTOMO-NO-KURONUSHI. Seated, facing right, in *daimyo's* dress of mauve and purple. Poem : " I feel that old age comes over me ; therefore I will go to see the Mirror on the Mountain " (Binyon). This poet is not one of the Hundred.

4. BUNYA-NO-YASUHIDE. Seated, facing right, in Court dress with tall *yeboshi* hat. Poem from the " Hundred Poets " Anthology, No. 22.

> The mountain wind in autumn time
> Is well called " hurricane " ;
> It *hurries canes* and twigs along,
> And whirls them o'er the plain
> To scatter them again. (Porter.)

5. ARIWARA-NO-NARIHIRA. Seated, facing left, with a quiver of arrows at his back. Dress of blue, with diamond pattern of a darker blue on it, lined with a brown and white pattern (also found in another state with dress of blue and white, lined with orange). Poem : " Gazing year after year at the fulness of the perfect moon, I noted not how the years heaped themselves one on another ; and lo ! I am grown old " (Binyon).

6. SOJO HENJO. Seated, full face, in red robes. Poem : " O for a heart like the lotus that springs from the mud stainless, and the dew on its leaves is as precious gems " (Binyon).

Hokusai also designed a set of " Six Poets " (*c.* 1800), quarter-plate size, with the title *Rok'kasen* on a bean-shaped panel, a figure of the poet, and on a larger panel, variously shaped square, fan-shaped, or bean-shaped, a small illustration to the poem which is written round the figure. Signed *Hokusai ;* publisher *Ise-Iri ;* very rare.

YEISHI has also left a set (full size) of the " Six Poets " very similar to Hokusai's large set described above.

Amongst Hokusai's pupils, practically three only have left landscape designs and these are very uncommon, as their principal work lay in the production of *surimono*, as was the case with most of his pupils.

These three were Shotei HOKUJIU (*w. c.* 1810–30); Totoya HOKKEI (*b.* 1780 ; *d.* 1850) ; and Yashima GAKUTEI (*w. c.* 1810–40).

This latter designed a fine series of land and seascapes, entitled *Tem-*

pozan Shokei Ichiran, " Views of Tempozan," Ōsaka, intended as illus-
trations for a guide to Ōsaka, published in the year 1838 ; signed *Go-gaku*.
These views are the full-size, oblong shape, known as *yoko-ye*, an unusual
size for book illustrations. The complete book, text and illustrations, is
extremely rare, while the illustrations, singly in sheets, are almost as rare.

1. A sailing junk in the trough of a huge wave making for harbour in a
 heavy rainstorm. The masterpiece of the series.
2. A fleet of junks entering Tempozan Harbour, under a burst of sunlight
 against blue clouds, and cranes flying overhead. Another very fine
 plate. (See Plate 19.)
3. " Escaping the Rain." People amusing themselves crawling through
 square holes in the two pillars at the entrance to a temple, for luck.
4. Moonlight, Suyehiro Bridge. A large boat, with people looking out from
 the cabin windows, passing under the bridge, which intersects a great
 moon hanging low in a dark blue sky.
5. Ōsaka Stone Bridge over the Agi River ; view looking out to sea.
6. " Eight Views into the Mountains." The stone embankment at the
 mouth of the Agi River, three junks moored by it, and another sailing
 past. Clouds lying over the bank, which is lined with trees, and
 people ascending a three-peaked hill overlooking the river. (Illus-
 trated in our quarto edition at Plate 23.)

TOTOYA HOKKEI has left a series of thirteen prints entitled *Shokoku
Meisho*, " Famous Views of Various Provinces," remarkable for their very
unusual shape, which is a long, narrow, oblong form, measuring 7 in. by
15¼ in. The title of the series and the sub-title of the plate is on a square
label divided into three panels, the signature, *Kiko Hokkei*, being in the
left-hand compartment ; publisher *Yeijudo of Yedo*. (See Plate 19.)

These prints are very rare indeed, but a set of eleven sheets appeared
in the Miller sale, 1911, one of them being illustrated in the catalogue
thereto, entitled *The Village of Musashi*, showing a winding road through
rice-fields, along which three men on horseback are passing, and a great
half-moon resting on the horizon and geese flying across it. Another view
of this series, but not included in the Miller set, is here illustrated at Plate 19,
Illustration 3, representing a three-masted European ship of the period of
the Armada saluting as she passes Mount Inasa, at the entrance to Nagasaki
Harbour. The masterpiece of the set is a view entitled " Sumida River,
Musashi," showing a ferry-boat in a downpour of rain, which has recently
been noted by the writer from an American collection. (See Note, Appen-
dix II, for titles of plates.)

SHOTEI HOKUJIU designed several landscapes and views of sea and coast
scenery. His prints are remarkable for their evidence of European in-

1. HOKUSAI : Illustration to poem by Sojo Henjo.

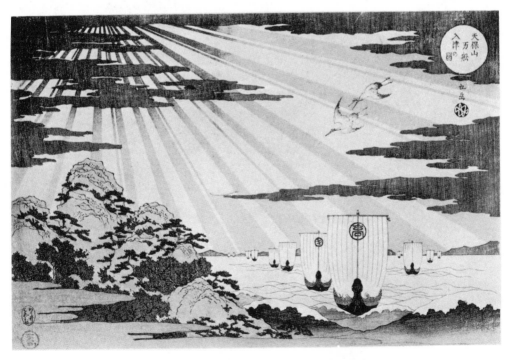

2. GAKUTEI : Ships entering Tempozan Harbour.

PLATE 19 (first part)

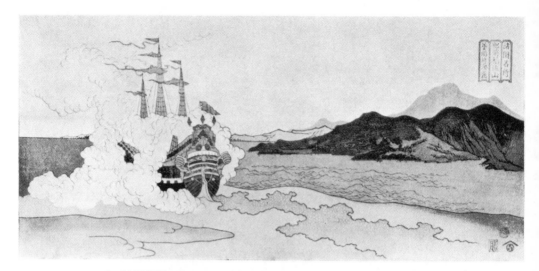

3. HOKKEI : European ship saluting at entrance to Nagasaki Harbour.
(Reproduced by courtesy of Messrs. Sotheby.)

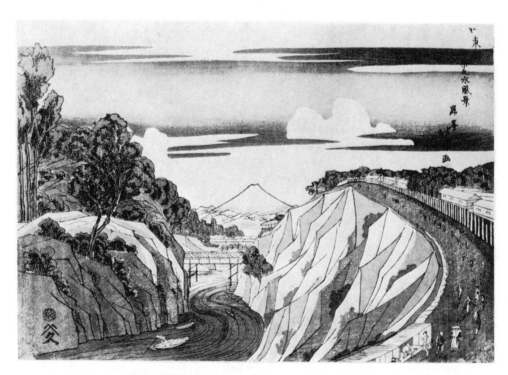

4. HOKUJIU : The "Tea-Water" Canal, Yedo.

PLATE 19 (second part)

fluence, in the drawing of clouds and shadows cast by figures, while his mountains are drawn in a very curious angular manner, quite cubist in effect. All these characteristics are well shown in his view of the Tea-water Canal, Yedo (here illustrated at Plate 19), where the figures on the bank cast shadows and the clouds are strongly indicated by *gauffrage*. He uses a curious, though very striking, colour-scheme of deep blue, brown, and green. His pictures are called *Rangwa*, or " Dutch " pictures, as it was from the Dutch at Nagasaki that he learnt his ideas of European perspective and the delineation of clouds.

A well-known print by him in the same style as that here illustrated and issued through the same publisher, *Heikichi*, is his view of the famous Monkey Bridge (*Saru-bashi*) in Kōshū Province. The view is taken on a level with the bridge which stretches across the picture from cliff to cliff, over a precipitous gorge ; half-way across is a traveller on horseback. In this case his signature is on a narrow upright panel, in the bottom left-hand corner.

Other landscapes by Hokujiu that have come under observation are the following :—

Takanawa, Okido. " The Barrier, Takanawa," Yedo. A wide view of Yedo Bay, and junks moored out in the centre, casting shadows on the water ; Fuji appearing over low foothills on the right, and in the foreground people passing along the shore, on which are built two stone mounds forming the barrier, or gate. On the left appear two rest-houses, and along the water's edge are small booths at intervals. Publisher *Yeijudo*.

Enoshima, Shichi Ri-ga Hama. " The Seven *Ri* Beach at Enoshima," showing Enoshima Island on the left and Fuji in distance.

Shimosa ; Choshi no ura Katsuo Tsuribune ; " Bonito Fishing-boats at Choshi Bay, Province of Shimosa." View of a rocky coast-line with a curious arched rock and a tunnel running through it ; in foreground a boat is being beached stern foremost, and others out in the bay fishing with rods and lines. Publisher *Heikichi*.

Seishu, Futamá ga Ura. " Coast of Futami, Province of Seishu," showing the famous " Husband and Wife Rocks " joined together with a straw rope.

The reader will, no doubt, come across other landscapes by Hokuju, though these are not at all common, but the above should be sufficient to enable him to recognize their peculiar characteristics, and to identify further examples.

CHAPTER XVI

MISCELLANEOUS LANDSCAPE SERIES (OBLONG) BY HIROSHIGE

IN this chapter we will describe various miscellaneous oblong series of views by Hiroshige, dealing with Yedo, Kyoto, and other districts of Japan ; his different " *Hak'kei,*" or " Eight Views," and " Six Tama Rivers " are dealt with elsewhere under their particular titles in company with series by other artists illustrating the same subject.

Under the title of " Yedo Views," Hiroshige issued a large number of series with different publishers. Mr. Happer states that nearly fifty different series of indefinite number, in various sizes and shapes, are known, thus giving some idea of the popularity of this subject.

The earliest known series (very uncommon) is a set complete, according to Mr. Happer, in ten views, each full size, oblong, issued by the publisher KAWA-SHO, and may be recognized by the narrow decorative border (omitted in late editions) in varied patterns with round corners, each signed in full *Ichi-yusai Hiroshige*. It is also characterized by the red clouds in the sky. The title and sub-title are written on the print itself, inside the margin ; outside is the name and address of the publisher, *Kawaguchi Shozo* (usually in other series shortened to *Kawa Sho—vide* Appendix).

The different plates in this series are :—

1. *Evening Cherries at Goten-yama.*

2. *Evening Moon at Ryogoku Bridge*, a view looking through and under the bridge, past one of the wooden piles, behind which appears the moon partly hidden by cloud.

3. *Masaka, end of Spring.*

4. *First Cuckoo of the year, Tsukudashima*, a crescent moon over the island, across which flies the cuckoo.

5. *The Sumida River* at the time of " leaf-cherry," that is, early summer ; a river view with two sailing barges and a raft on it.

6. *Cherry-blossom* in the early morning at Yoshiwara.

7. *Ebb Tide at Shiba-ura*, and people in the distance gathering shell-fish.

8. *Susaki, New Year Sunrise.* A very fine snow scene, considered the masterpiece of the set. On the horizon the deep red orb of the sun is just

emerging above the ocean ; in the foreground, close to the water's edge, a cluster of houses, and a shore line, edged with trees which are bent with the weight of snow, trails off towards the horizon.

9. *Full Moon at Takanawa.* View of the sweep of the shore of Yedo Bay, and wild geese flying across the face of the moon.

10. *The Lotus Pond, Shinobazu*, Uyeno Park. View of the pond and, on the left, a *torii* at the end of the causeway, in centre of which is a small " drum " bridge, leading to the shrine.

The series of most uniform excellence is probably that entitled " Toto Meisho," " Celebrated (Views of) Toto " (Toto or Yeto being alternative names for Yedo), the next earliest issue to the above, published by SANOKI, whose mark of KIKA-KUDO is stamped on the margin in red with the *kiwamè* (" perfect ") seal above it. The title is in a yellow, oblong label outside the margin, and projects somewhat above the top border. A view from this series of the Yoshiwara at night, under a full moon, is given at Plate 20.

Owing to an error, the margin showing the position of the labels has not been reproduced, but both the SANOKI and KIKA-KUDO seals are reproduced in the Appendix.

Another series, also issued by Sanoki, may be distinguished from the foregoing by having the title, which is also in a frame on the margin of the print, placed a trifle lower down, while the shape of the frame is slightly different. The publisher's stamp in the margin is that of SANOKI, in red, instead of Kika-kudo, and the border is shaped slightly differently at the corners. Hiroshige's signature, too, is written in his middle period form ; in the previous Sanoki issue it is in an earlier script.

One of the best views in this series (reproduced at Plate 22 in the Happer catalogue) is that of the yearly festival at Asakusa Temple, showing the crowds of people thronging up the temple steps under their umbrellas, during a heavy snow-storm. Except for slight touches of yellow and green, this is a print in one colour only, effect being produced by the contrast between the brilliant red of the temple and the snow.

Yet a third series by Sanoki is one with the title " Yeto (instead of " Toto ") Meisho." The date of this series is, perhaps, intermediate between the last two. The title is in a frame similar in shape and position to the previous series, to which Asakusa Temple under snow belongs, but the publisher's seal is that of KIKA-KUDO (in red), and is placed higher up in the margin.

The view of the Yoshiwara under snow, in early morning, reproduced at Plate 20, is an example from a *Toto Meisho* series issued about 1846, during the Prohibition period, as it carries two inspectors' seals, those of Watanabe and Kinugasa, alongside Hiroshige's signature. The title is on a

yellow label, outside the right-hand margin as in the previous series, but the publisher's mark is that of SANOKI *printed* in black (instead of stamped) at the foot.

Before proceeding to other *Yedo Meisho* series in which the titles are on the face of the print itself, we will indicate certain views which occur in one or other of the foregoing sets, and which are particularly notable.

White Rain on Nihon Bridge. In the foreground is a view of part of the bridge, with people hurrying across, and " white rain " (a sudden shower lit up by sunlight) falling against a pale sky, while on the horizon looms up a grey Fuji (printed from colour-block only). Red seal of *Kika-kudo* in margin.

Snow at Shiba Akabane. View looking straight down a deep-cut canal to a small bridge, beyond which rises a red pagoda, half-hidden in the snow-covered woods. On the right of the canal runs a broad road, along which pass a few wayfarers, and on the further side is the long wall of a *daimyo's* palace or barracks, above which rises a high wooden tower through trees. A very fine snow scene. *Sanoki* seal in red.

Falling Snow in the Gardens of Kameido Temple. Another famous snow scene. A series of small bridges, joining islets across a lake, lead up to the temple entrance on the right. Round the edge of the lake are deserted booths and shelters ; red seal of *Kika-kudo.*

Twilight at Takanawa. Three large junks with immense square sails are coming to anchor off the wharf crowded with carts and travellers ; behind their masts blue clouds in a sunset sky and birds flying to rest. *Kika-kudo* seal. (See Plate 20, Illustration 3.)

Atago Hill, Shiba. View from the hill looking out over the roofs of the city towards the bay ; on the left, partly hidden by a tree, a rainbow arches across the sky. Only two other rainbow scenes are known to the writer, one a view in the " Hundred Views of Yedo " series (upright), and the other in the " Sixty Odd Provinces."

At Illustration 4, Plate 20, is an excellent snow scene showing the Benkei Canal in winter-time, in the Sakurada district of Yedo, from a series of YEDO MEISHO published by *Arita-ya*, whose seal is in the bottom corner. Alongside Hiroshige's signature is the *aratamè* seal (" examined "), and below that a date-seal which reads Tiger *uru* 7, that is, intercalary 7th month, Tiger year = 1854.

Through the publisher Yamada-ya Hiroshige issued a set of Yedo Views known as the *Yamada-ya figure set,* so called from the prominence of the figures introduced into the composition.

The set is supposed to be complete in forty plates, which were issued between the years 1853 and 1858, though there are none for the year 1855

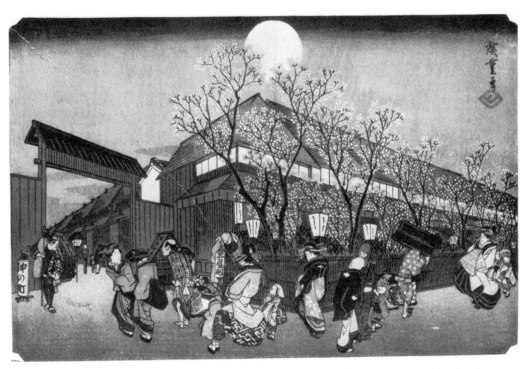

1. Yoshiwara by night under a full moon; "TOTO MEISHO" series published by *Sanoki*
(*Kika-kudo* seal in red).

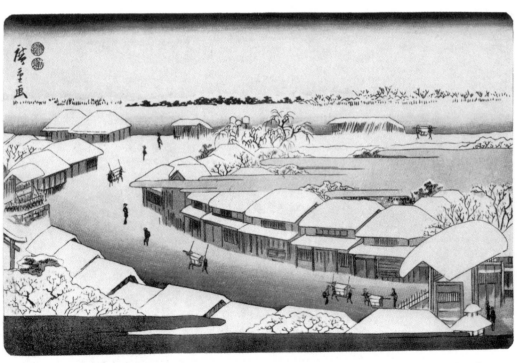

2. Yoshiwara under early morning snow; "TOTO MEISHO" series, published by *Sanoki*
(prohibition period).

PLATE 20 (first part)

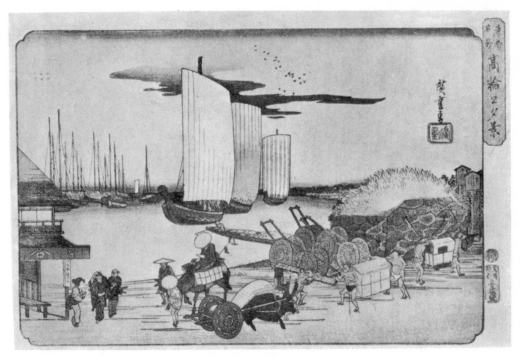

3. Twilight at Takawana; "TOTO MEISHO" series by *Sanoki* (*Kika-kudo* seal).

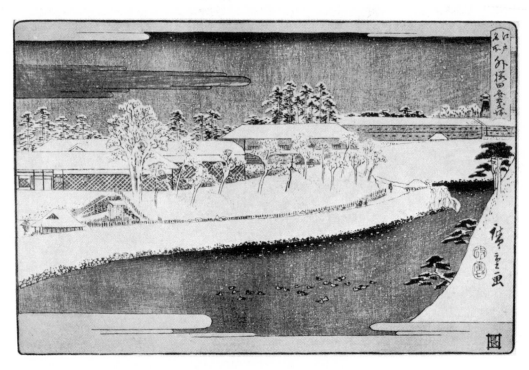

4. Benkei Canal under snow; "Yedo Meisho" series by *Arita-ya*; dated 1854.

PLATE 20 (second part)

and only one for 1856. Those dated *after* the last year of the Prohibition period (i.e. 1854) do not carry inspectors' seals, but are marked with the *aratamè* (" examined ") seal instead.

This set may be identified by having the series title on a narrow vertical label, and the sub-title on a square one projecting from it, in the top right-hand corner, very similar to the two labels on the well-known upright set, " Hundred Famous Views in Yedo."

The views comprising this set vary in quality, and owing to the late date at which some were issued the colouring is at times crude and harsh. The best plate is that of the Tea-water Canal, Yedo, in a heavy snowstorm, the deep blue water of the canal flowing between high banks, crowned on one side with trees, all under a thick mantle of snow, falling from a black sky, making a picture of wonderful contrasts. Two women under umbrellas mount the road overlooking the canal, followed by a man.

Another plate rather better than most is that entitled *Nihon-bashi, Yedo-bashi*, showing two women and a girl crossing Nihon Bridge, followed by two fishmongers, the girl pointing to Yedo Bridge in the distance. Mists lie over the distant roofs and on the horizon Fuji rises above its foothills. Dated Ox 11 (11th month, 1853).

Other good plates are : *Akabane Sui Tengu*, " Water Birds at Akabane," a facetious reference to two women crossing a bridge over a canal in a heavy downpour of rain from a dark sky ; in the background is seen a long row of barracks and a watch-tower above them. The date-seal (Hare 3 = 1855) is printed over the water of the canal. No censors' seals.

Matsuchi-yama, Saruwaka cho. Three girls standing under some trees by a railed-in walk overlooking Young Monkey Street (i.e. Theatre Street) ; in the distance appears the pagoda of *Kinryusan Temple*. Dated Ox 11 = 1853.

The foregoing series is interesting from the fact that at this date Hiroshige had practically abandoned the oblong form of print for the vertical ; in this set, however, he reverts to his former shape.

The above constitute some of the principal " Yedo Meisho " series in oblong shape, prints of which the collector is most likely to come across. As already stated, about fifty different series, in various shapes and sizes, issued by various publishers, are known, but as many are now represented by only an occasional print, little purpose would be served by giving up space to them.

Under the title *Koto Shokei*, " Particular Views of Yedo," Hiroshige issued a set of eight, full-size, oblong views, through the publisher Kawasho. This series is very uncommon. Title in white on a red label.

With the title *Yedo Kōmyo Kaiseki Tsukushi*, " Famous Resorts (i.e.

Tea-houses) of Yedo," Hiroshige issued through the publisher *Fuji-Hiko*, about the year 1840, a series of which twenty-nine plates are known, showing the principal tea-houses in and around Yedo. Like the Yamada-ya " Toto Meisho " series, they vary in merit considerably, some being much better than others. The colours at times are somewhat crude, and certain views are put out of balance by the too prominent figures in the foreground, which distract the attention from the subject of the picture and tend to blot it out.

The view from this series here illustrated at Plate 21, showing the Teahouse by the Imado Bridge, does not exhibit these defects, the colours being well-blended, and the figures in the boat well-proportioned to the rest of the design. This series is very uncommon. The publisher's mark is often introduced into the picture itself ; in the example here illustrated it will be found on the awning of the boat just over the head of the woman with the *samisen*, with the *kiwamè* seal above it.

Of " Yedo Views " (oblong) by Hiroshige II we have already mentioned in an earlier chapter his set printed in blue, issued through the publisher *Senichi*, and dated 1862. A view from this set is illustrated at Plate 7, page 68.

At the same plate we reproduce an excellent snow scene from an earlier set over the signature *Shigenobu*, and dated Horse 10 (10th month, 1858), one month after the death of Hiroshige ; publisher *Yamaguchi-ya (Tōbei)*. Another plate from the same series is illustrated at Plate XXVIII in the Happer catalogue.

Yet a third series is one with the title " Yedo Meisho " on a narrow vertical label and signed Hiroshige II ; and dated Sheep 2 (2nd month, 1859) ; publisher *Fuji-Hiko*. In this case the date is incorporated with the *aratamè* seal in one round seal, 1859 being the first year in which such incorporation is found.

In the Happer catalogue a view from this set is illustrated at Plate XXIX, signed in full, *Shigenobu changing to the second Hiroshige*, and with the note " the only print thus signed that could be found, although hundreds of prints were examined."

We will now pass in review Hiroshige's views illustrating places outside the capital of Japan ; as a rule these are rare, some of them very rare.

KYOTO MEISHO, " Famous Views in Kyoto." A set of ten full-size, oblong prints, early work ; publisher *Kawaguchi ;* very rare. This series, which contains many masterpieces, may be recognized by having a narrow double-line frame round each view. (See Plate 21, Illustrations 1 and 2.)

The title, *Kyoto Meisho no uchi*, and sub-title are on the face of each print ; publisher's seal of *Yeisendo* or *Kawaguchi* on the different plates.

The following are the plates comprised in this series :—

1. The gold-plated Kinkakuji Temple at Kyoto, by the shores of a lake, surmounted with a large bird with its wings outstretched ; behind it a hill rises out of the mist.

2. Tsuten Bridge spanning a gorge, through which rushes a torrent, with red maples on either bank, and people picnicking.

3. View of Arashi-yama, famous for its cherry trees. A hill-side covered with pines and blossoming fruit trees ; at the foot runs the Oi River along which two men are poling a raft.

4. " The Village of Yase " ; a path through fields, along which women with loads on their heads are walking.

5. A large boat being poled along the Yodo River with a company o people under a straw awning having refreshment, served from a small boat tied alongside ; above shines a full moon with a light cloud across it.

6. Gion Temple under snow. The *torii*, railings, and stone lanterns at the entrance to the temple grounds, and three women just outside, and a fourth, all with umbrellas, coming out. In the background, the roofs of the temple buildings covered with snow falling from a dark sky. The masterpiece of the set, frequently illustrated.

7. Shimbara, one of the gates of the Yoshiwara quarter of Kyoto, and a reveller being escorted out in the early dawn ; overhead a crescent moon. Another fine plate. (See Plate 21.)

8. Storm on the banks of the Tadasu River. Tea-houses by the river-side under a heavy downpour of rain, and people rushing for shelter. In the foreground, two people hurrying across a plank bridge ; in the background, a forest of trees rendered misty through the downpour. In best impressions sky should be black at top, and trees stand out distinct against a graded grey background. Another masterpiece. (See Plate 21.)

9. View of the Kiyomidsu Temple standing on the hill-side amongst cherry trees in bloom ; tea-house on left.

10. People taking " evening cooling " in the dry bed of the Kamo River at Kyoto. Another fine plate, the deepening shadows of nightfall producing a wonderful atmospheric effect.

HONCHO MEISHO, " Celebrated Views of the Main Island." A set of which fourteen prints are known (Happer collection) ; full size, oblong ; publisher *Fujihiko* (*Matsubarado*) ; *very* rare.

According to the Happer catalogue the following are the titles to the fourteen plates :—

1. The Seven *Ri* Beach, Enoshima.
2. Cave of Enoshima, Province of Soshu, with a great wave breaking on shore.
3. Approach to Akiwa Temple.
4. Ferry over the Fuji River, with a view of Fuji.
5. View of Tempozan, Ōsaka.
6. Ascent of Horaiji.
7. Reflected Moon, Sarashina.
8. Kanazawa.
9. Kyomi Beach, Suruga.
10. Fuji from Satta Point.
11. Hot Springs at Hakone.
12. The *Nuno-biki* Waterfall, Sesshu Province.
13. Beach at Maiko on the Inland Sea.
14. Ama-no-hashi-date, one of the three celebrated views of Japan.

Nihon Minato Tsu-kushi, " The Harbours of Japan " ; ten full-size, oblong views, published by MARUSEI ; rare.

The harbours are Yedo ; Nakasu, in Yedo Bay ; Shinagawa ; Tepposu ; the Agi River at Ōsaka ; Marugame, Province of Sanuki ; Muronotsu, Harima Province ; Uraga ; Shimi-zu, Suruga Province ; and Shimonoseki.

Naniwa Meisho, " Famous Views of Naniwa " (i.e. Ōsaka) ; a series of ten oblong views, published by KAWAGUCHI, *c.* 1828 ; *very* rare.

Sankai Mitate Sumo, " Mountain and Sea compared like Wrestlers," the title written in the top corner on a fan such as is used by the umpire at a wrestling match. An uncommon set of twenty views, oblong, published by YAMADA-YA, whose seal is on each print, ten being of coast and sea scenery and ten of mountains. Some views are dated Horse 7 and others Horse 8, that is the 7th and 8th months of the year 1858. This series, therefore, must have been the last one Hiroshige saw completed, as he died in the autumn of 1858 ; his " Thirty-six Views of Fuji " he did not live to see as prints. It is curious to see Hiroshige reverting once more to his original oblong shape the last year of his life.

His signature is on a red label, like on his various upright series, a device employed from 1850 onwards.

As examples from this series we quote the following views :—

1. *Echigo, Kamewari Tōge.* Kamewari Hill, Echigo Province. Considered one of the best plates in the series. View of a winding road round a narrow inlet, leading up through the mountains, which rise sheer up

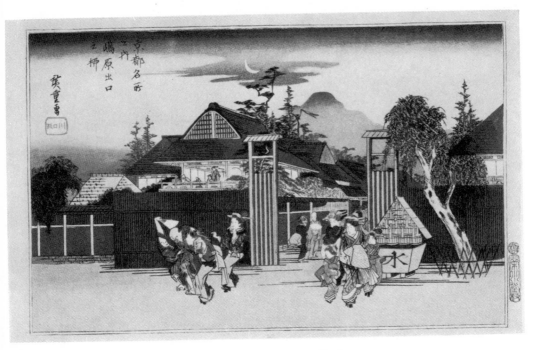

1. Shimbara; No. 7 of the *Kyoto Meisho* series.

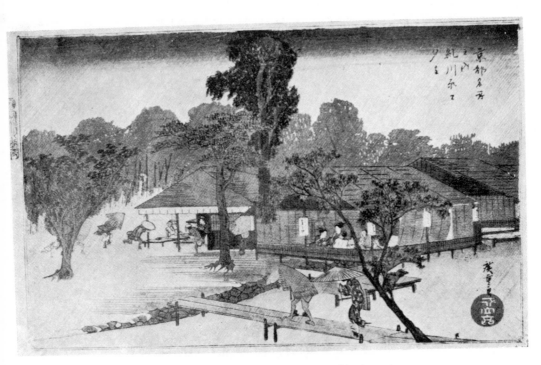

2. Tadasugawa; No. 8 of the *Kyoto Meisho* series.

PLATE 21 (first part)

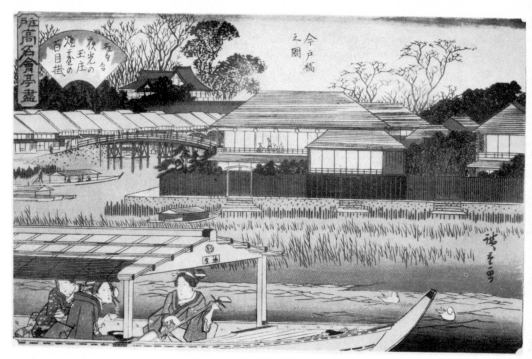

3. Tea-house by Imado Bridge; "Restaurant" series.

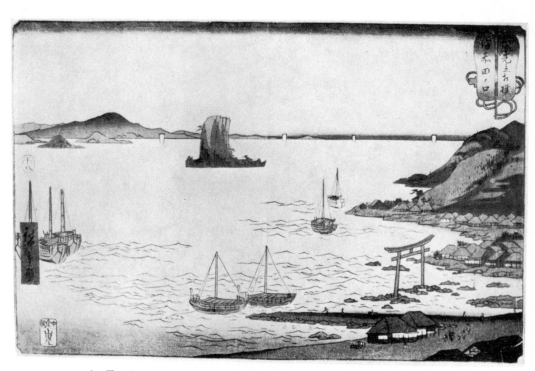

4. Tanokuchi, Bizen Province; "Mountain and Sea like Wrestlers" series.

PLATE 21 (second part)

from the water ; a rest-house at a bend in the road along which travellers are passing. Dated Horse 8.

2. *Marunami, Sanuki.* Marunami, Province of Sanuki. View from above the harbour looking across the sea to islands in the distance ; on the left, overlooking the harbour, stands a castle amid trees. Dated Horse 8.

3. *Echizen, Mikuni.* Mikuni, Province of Echizen. View from the sea-shore, off which several junks are at anchor, and parties of people sitting by the water's edge, or strolling about. Dated Horse 8.

4. *Uraga no ura, Sagami.* Uraga Bay, Sagami Province. View of a narrow, enclosed harbour with several junks at anchor, two lowering sails ; a headland juts out from the right, with a beacon at its point. Dated Horse 7.

5. *Tanokuchi, Province of Bizen.* View over a bay in centre of which stands a great rock shaped like a ship in full sail ; hilly coast beyond. In right foreground a village lying on the shores of an inlet in a semicircle, and a *torii* erected on a reef of rocks in the water close in shore ; junks at anchor. Dated Horse 8. (See Plate 21, Illustration 4.)

With reference to the dating of the foregoing series, the oval form of the seal, and the fact that there are no inspectors' or *aratamè* seals, fix the date as for the year 1858 ; the previous Horse year (1846) fell within the Prohibition period (1842–1853).

SETTSU GEKKA, " Snow, Moon, and Flowers." A set of three full-size, oblong prints ; publisher *Maru-ya Jimpachi.* Very rare.

1. " Snow at Benten Shrine." View of the shrine on its island in the Shinobazu Lake at Uyeno, and snow falling.

2. " Catching Fish by Moonlight on the Tama River." A group of men and a boy under a willow tree, and two women with nets under another tree ; in the middle distance a bridge, and a full moon shining above. A beautiful moonlight scene.

3. " Cherry-blossom Season on Koganei Bank." A river lined with cherry trees in blossom on both banks, and in the foreground a bridge over it ; Fuji in the distance.

HAKONE SHICHI-TŌ, " The Seven Hot Springs of Hakone " ; a series of seven full-size, oblong plates ; publisher *Sanoki ;* dated Rat 12 = 12th month, 1852 ; very rare. The seven springs illustrated are : Yumoto, Ashinoyu, Kiga, Miyanoshita, Sokokura, Dogashima, and Tonosawa.

CHAPTER XVII

VARIOUS SERIES OF *HAK'KEI*, OR "EIGHT VIEWS," AND "SIX TAMA RIVERS"

THE "EIGHT VIEWS" was a theme borrowed from Chinese Poetry and adapted to various scenes in Japan, the subject for each scene being the same, with its attendant poem, whatever the locality.

The eight subjects were : (1) Snow ; (2) Evening Rain ; (3) Autumn Moon ; (4) Vesper Bells ; (5) Boats Returning at Evening ; (6) Geese Flying to Rest ; (7) Sunset ; and (8) Clearing Weather after Rain.

Of the various localities to which these " Eight Views " were adapted, Lake Biwa, in the Province of Omi, was the most popular and is the best known.[1] These series are known as the " Omi Hak'kei," and the finest of them is the early oblong set by Hiroshige, any one of which is a masterpiece. A companion set, also by Hiroshige, of Eight Views in the Environs of Yedo, is perhaps the only other series which, as a whole, is equally as fine. Both series are rare, particularly the latter.

The following comprise the views in the " Omi " series ; publishers' seals of KAWASHO (*Yeisendo*) and HOYEIDO (*Takeuchi*).

Title of series on a narrow red label, and the sub-title and poem on an adjoining square label.

It will, we think, give an added interest if we quote Mr. Binyon's translations to each verse (taken from the British Museum catalogue), which will show how well Hiroshige has conveyed the spirit of the poem into his drawings. The fame, indeed, of this series rests upon the extraordinary poetic quality infused into the composition.

1. *Evening Snow on Mount Hira.* " He who would see the beauty of the evening on the peaks of Hira must behold it after the snows have fallen, and before the flowers are fully blown."

In the foreground a snow-covered village and clumps of bamboo by an inlet of the lake ; behind rises the snowy mass of Mount Hira beyond hills. Seal *Yeisendo*.

[1] According to Japanese legend, in the year 286 B.C. (by our chronology) the earth opened out in the Province of Omi, near Kyoto, and Lake Biwa, sixty miles long and nearly twenty broad, was formed in the shape of a *biwa*, or four-stringed lute, from which it takes its name. At the same time, to compensate for this depression in the earth, Fujiyama was thrown up, the word " erupted " being an epithet applied to it for this reason (see Plate 8 in the " Kisokaido " series).

2. *Night Rain on Karasaki.* "Elsewhere will they talk of the music of the evening breeze that has made the pine of Karasaki famous ; the voice of the wind is not heard through the sound of the rain in the night."

View of the great pine almost blotted out by the downpour of rain. Seal *Yeisendo.*

This plate is also found in a *very* rare state printed in blue.

3. *Autumn Moon on Ishiyama.* "O Hill of Stone, the image of the moon that thou seest appear on Niwo Sea, is it not more beautiful than even the moonlit Akashi, or Suma ? "

On the left rises a steep rocky cliff, on the summit of which stands Ishiyama Temple, overlooking the lake. In the distance appears the long Seta Bridge, while still further, on the horizon, a mountain shows through the mist, its peak emerging above the moonlit haze. Seal *Hoyeido.*

4. *Vesper Bell, Mii Temple.* "At the sound of the bell beginning from Mii-dera, Hark ! says the traveller, I am one step nearer the twilight."

In the foreground flat fields, and trees bordering a road ; beyond lie the temple buildings on the wooded hill-side which is overlooked by yet higher mountains behind ; yellow mists on the hills and sky a deep orange. Seal *Takè.* Found in two states ; in the later one the foreground is green and the upper part of the hills is reddish in colour.

5. *Boats Returning to Yabase.* "The boats that come with swelling sails to Yabase have been chased by the wind along the coasts of Uchide."

Some are out in the centre of the lake, others in-shore, or coming to anchor. Behind the opposite coast-line a mountain raises its peak above the mist ; in the distance, on the right, a cluster of sails loom through the evening haze. Seal *Hoyeido.*

(This view is illustrated in the Handbook to the Print Collection in the Victoria and Albert Museum, at Plate XI, but over the incorrect title of *Autumn Moon on Ishiyama.*)

6. *Geese Flying to Rest at Katata.* "After crossing many a mountain range, the wild geese alight at Katata for a while, soon to continue their flight to northern Koshiji."

In the foreground a fishing-boat with nets hanging up to dry, and other boats on the lake ; flights of wild geese descending from the sky ; a background of high hills, their peaks rising clear above low-lying mist. Seal *Yeisendo.*

7. *Sunset at Seta.* Perhaps the chief masterpiece of a set in which all are masterpieces. "Soft and fitful rain passes far away over the mountains ; the evening light streams along the Bridge of Seta."

View of the long Seta Bridge running right across the lake from the village at the foot of Ishiyama ; in the background rises the peak of the lesser Fuji (not *the* Fuji as sometimes erroneously described) into a beautiful orange sky. Seal *Hoyeido*. (See Plate 22.)

8. *Clearing Weather at Awadzu.* "White as when the wind clears away the cloud and scatters it, the sails of a hundred boats come flying to Awadzu."

View of the road along the shore of the lake lined with trees, and boats on the water ; background of hills behind which rises a higher mountain, its peak clear of the low-lying mist. Seal *Hoyeido*.

As with other series, Hiroshige issued these Lake Biwa views in other forms, as a full-size, vertical set (dated Snake 3 = 1857), through the publisher Uwo-yei ; in a half-plate set, through Tsuta-ya (rare), which another artist, Utagawa Sadanobu, has copied practically line for line ; and various miniature quarter-plate sets.

At Plate 25, page 152, we reproduce one view from his full-size upright set, *Homing Geese at Katada*, for purposes of identification. The poem is written in a conventional illuminated cloud across the top ; the title on a narrow, oblong label and sub-title alongside it. Date-seal, publisher's seal, and *aratamè* seal in margin. This is a good and uncommon set, which is sometimes attributed (though wrongly) to Hiroshige II, though possibly he may have assisted his master in this as in other upright series.

Hiroshige II has left a set of " Omi Hak'kei " views (upright), but these are dated 1862, while his master's set is dated 1857. (See Note, page 153.)

Hiroshige's half-plate *Omi Hak'kei* set is perhaps his finest work in small size, and is wholly different in conception to his full-size, oblong set described above. As a rule his small series are more or less reduced copies or adaptations of the full-size ones.

Hokusai has designed a half-plate set of *Omi Hak'kei* views, entitled *Shimpan* (" New Edition ") *Omi Hak'kei* (the only set of this subject by him which has been noted), in prevailing tints of green and yellow, with bands of pink and purple cloud drawn across the view ; signed *Hokusai ;* very early work with this signature, c. 1800 ; no poem.

Utagawa Sadahide has concentrated all eight views into one large view in a triptych (illustrated in Orange and Thornicraft Sale Catalogue, March, 1912) which shows Seta Bridge in the foreground, Mount Ishiyama in the left panel, and Mount Hira under snow in the distance on the right.

The " Eight Views of Lake Biwa " was a subject portrayed by several artists besides Hiroshige, though his series are the best known.

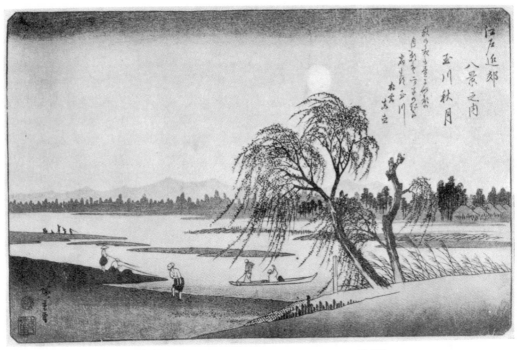

1. Autumn Moon on the Tama River; *Yedo Kinko Hak'kei* series.

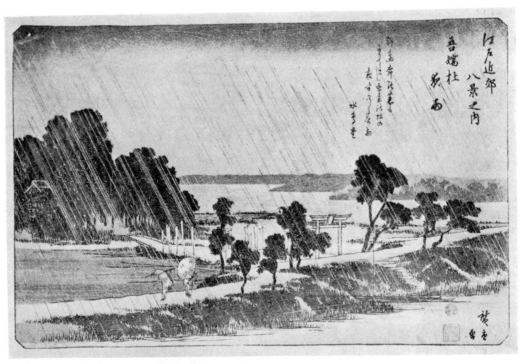

2. Night Rain at Azumasha; *Yedo Kinko Hak'kei* series.

PLATE 22 (first part)

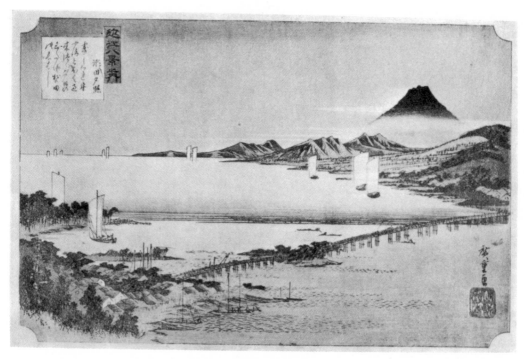

3. Sunset at Seta; *Omi Hak'kei* series.
(Nos. 1, 2 and 3 reproduced from Happer Catalogue by courtesy of Messrs. Sotheby.)

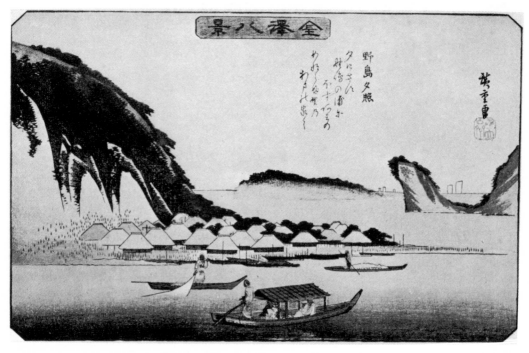

4. Sunset at No-jima; *Kanazawa Hak'kei* series.

PLATE 22 (second part)

Toyohiro, for example, his master, has designed a set, almost square, in which the views are in a circle.

The next *Hak'kei* series by Hiroshige which we will now describe contains what are considered his chief masterpieces in landscape design in the full-size, oblong format, namely his *Autumn Moon on the Tama River*, and *Night Rain at Azumasha ;* views of which we here reproduce at Plate 22 from the Happer catalogue, by courtesy of Messrs. Sotheby.

YEDO KINKO HAK'KEI, " Eight Views of the Environs of Yedo." A series of full-size, oblong prints ; published by SANOKI, whose seal of *Kikakudo* is stamped in red on each print. *Very* rare. The title, sub-title, and poem are written on the face of each plate. A series of master-pieces.

1. *Asukayama, Bosetsu,* " Evening Snow at Asuka Hill." View of a sloping hill-side dotted with cherry trees ; at the bottom of the slope runs a road leading to a village street ahead, along it plod wayfarers, one leading a packhorse, through the deep snow.

This is the only snow scene known to the writer (but he believes there are others) in which the falling flakes of snow are indicated with a pigment (made from white-lead), instead of the natural white of the paper itself, with the result that they are now black owing to chemical decomposition.

2. *Azumasha, Yoru Amè,* " Night Rain at Azumasha." A road along the top of a low embankment, with a *torii* at the side marking another road leading to a temple in a grove of trees, all under a heavy downpour of rain.

One of the two rarest plates in the set, and one of the chief master-pieces.

3. *Tamagawa, Akinotsuki,* " Autumn Moon on the Tama River." In the foreground a willow tree grows by the river bank, just over it a misty full moon shines down on the scene ; people fishing from the bank.

The masterpiece of the set, and considered Hiroshige's finest design in landscape scenery in this form. (See Plate 22.)

4. *Ikegami, Bansho,* " Evening Bell at Ikegami." View of the steep flight of steps leading to the Temple of Hommonji, which stands high up in a thick wood nearly concealing it ; below, tea-houses and people grouped about them.

5. *Gyotoku, Kihan,* " Boats Returning to Gyotoku." Two great junks sail up-stream past a low marshy shore silhouetted against a red sunset sky ; in foreground a ferry-boat.

6. *Haneda, Rakugan,* " Homing Geese at Haneda." Two flights of wild geese fly down towards the green rushes in the water ; in distance sails outlined against a golden sky.

7. *Koganei, Sekisho*, " Sunset at Koganei." Blossoming cherry trees line the banks of a narrow stream, spanned by small bridge in the foreground ; Fuji in distance.

8. *Shibaura, Seiran*, " Clearing Weather at Shiba-ura." In the foreground are two large junks at anchor ; two other boats out in the stream, the sky brightening after a storm.

KANAZAWA HAK'KEI, " Eight Views of Kanazawa." Full-size, oblong prints ; publisher KOSHIMURA-YE (*Heisuké*), whose seal (*Koshi-hei*) is stamped in margin. *Very* rare.

1. *Uchikawa, Bosetsu*, " Evening Snow at Uchikawa." In the foreground three peasants trudging along the road by the edge of which grows a tall tree ; snow-covered shores of an inlet of the sea, and a raft on it ; hills in the distance.

2. *Koidzumi, Yoruamè*, " Night Rain at Koidzumi." On a narrow road across fields two peasants meet in a downpour of rain ; a misty landscape scene, with straw stacks in the fields, and trees dotted about.

3. *Seto, Akinotsukè*, " Autumn Moon at Seto." In the right foreground stands a tea-house, and two small bridges spanning the water in the middle distance ; a rounded hill in the background.

4. *Shomyo, Bansho*, " Vesper Bell at Shomyo." View of a village on the flat bank of a river or lake, in front of a wood, over which lies evening mist. Above the mist rises a hill on which can be seen the temple buildings, their roofs peeping through the dense woods ; out in the stream two boats, in one of which a woman bends in prayer at the sound of the temple bell.

5. *Otomi, Kihan*, " Returning Boats at Otomi." View of a road fringed with trees with flat fields on one side and the broad stream of a river or inlet, flowing into a wide bay, on the other. On the road two peasants stop for a chat, while a junk with big square sail drifts slowly by ; out in the bay are other boats in full sail.

There is in existence an extremely rare state of this print printed almost entirely in *blue*.

6. *Hirakata, Rakugan*, " Homing Geese at Hirakata." A long pine-covered strip of land dividing the bay from an inlet ; in the foreground people gathering shellfish ; overhead a flight of wild geese.

7. *Nojima, Sekisho*, " Sunset at Nojima." View of Nojima village lying by the edge of the sea at the foot of Nojima-yama, with the island of Natsu-shima in the distance. (See Plate 22.)

8. *Suzaki, Seiran*, " Clearing Weather at Suzaki." A man poling along a timber raft on a river in foreground ; on the bank behind an overhanging willow tree growing in front of a cluster of huts, and two fishing nets put

up to dry alongside. Beyond, a row of trees stretch across green fields away to the right, and in the background rise grey hills against an orange sky.

Hiroshige has also left a very rare series of eight half-block size trip-tychs entitled *Meisho Yedo Hak'kei*, " Famous Eight Views of Yedo " ; publisher *Jō-kin ;* not mentioned by Happer. (Private sale, June, 1912, six plates of the set.) They are mainly large figure-studies *à la* Kunisada with a landscape background. These follow the usual *Hak'kei* theme, the six views in the above sale being " Autumn Moon at Takanawa " ; " Even-ing Snow at Asakusa " ; " Sunset at Ryogoku Bridge " ; " Evening Bell at Uyeno " ; " Returning Boats at Tsukuda-jima " ; and " Rain at Mimiguri."

MEISHO HAK'KEI (" Famous Eight Views ") series by Gosotei TOYO-KUNI.

A set of eight full-size, oblong views ; published by ISE-IRI (*Ise-ya Rihei*), whose seal is in the margin (not reproduced in the illustrations, but see Appendix), and also at end of large horizontal label, which carries the title and sub-title in large white characters, the sub-title being also on the face of each plate. Underneath Toyokuni's signature is a red seal, *Utagawa*. Very rare.

In addition to their rarity, the views in this set are interesting from the fact that Gosotei Toyokuni was, with practically this one exception, a designer of theatrical prints and actor-portraits ; in this instance he has clearly come under the influence of Hiroshige.

The plates here reproduced show clearly the peculiar characteristics of this set of *Hak'kei* views ; the title written in white characters on a large horizontal label, sometimes violet or a deep purple, or gold, as in Illustra-tion No. 4 ; the hard but very sharp outline and cold brilliance of colour-ing, characteristics very noticeable in the prints of the Ōsaka school of artists.

As is the case with the majority of uncommon series, this set is particu-larly difficult to find in really fine state.

1. " Autumn Moon on the Tama River." Men fishing by moonlight in the Tama River, and two others wading in the stream ; on the shore, in front of a straw-roofed hut, two women pounding cloth in a mortar (the attribute of the Chofu Tama River, Province of Musashi). In the distance a blue Fuji rises above a purple band of mist, its snowy peak lit up by a full moon, across the face of which passes a light cloud. Round the prow of one boat is the smoke from a flare lit to attract the fish. Perhaps the masterpiece of the set. (See Plate F, page 156, for reproduction in colours.)*

*Reproduced in black and white in this edition.

2. " Evening Glow (Sunset) at Atami." A semicircular bay with steep coast-line on two sides, and three large junks at anchor close to the shore, others sailing further out, and islands in the distance ; from the summit of one rises the smoke of the volcano of Oshima.

In the foreground a cluster of straw-roofed huts, and on the beach two gangs of men hauling in a large net. (See Plate 23.)

3. " Returning Boats at Kanazawa." Boats entering the almost land-locked inlet of Kanazawa, the rays of the setting sun cutting across a deep rose-pink sky. The hilly shores of the inlet are faintly reflected in the deep blue of the water ; in the foreground are two small foot-bridges connecting a little island with two promontories, on one of which is a tea-house, which two women, followed by their porter, are approaching ; in the opposite direction passes a peasant. (See Plate 23.)

4. " Homing Geese at Miho." View from the mouth of the Okitsu River looking across the Miho no Matsubara peninsula and bay to the mountainous coast-line beyond, behind which rises a great Fuji, its peak white with snow, faintly printed from grey colour-block only, and white mist rising from its base.

On a rocky cliff on left, overlooking the river, stands Kiyomi Temple ; below it on the beach is a village, off which junks are anchored. Across the sky, flying towards the temple, is a long flight of wild geese. Another very fine plate.

5. " Evening Rain at Oyama." Partly obscured by a heavy slanting downpour of rain rises the wooded hill of Oyama, on the summit of which stands the temple of Fudo, approached by steep steps, and pilgrims ascending. On the left rises the brown peak of Fuji through the rain. A wonderful rain scene.

6. " Vesper Bell, Kamakura." View of Boshu Mountains in the distance across the sea from the courtyard of the Temple on Tsurugaoka Hill.

7. " Clearing Weather at Enoshima." In the centre the rocky, wooded island of Enoshima, and big waves breaking on shore in the foreground ; on left an overhanging cliff crowned with trees, and in the distance (right) a grey Fuji rises into the sky, its summit white with snow.

8. " Evening Snow on Fuji." View of the great mountain towering up into the sky, looking across a temple, fresh snow on the peak of Fuji.

YEDO HAK'KEI, by Keisai YEISEN. This is an uncommon series (also difficult to find in fine state) of Eight Views of Yedo, full-size, oblong, issued by the publisher YAMAMOTO-HEIKICHI (*Yamakiu* or *Yamahei*), (seal in margin) ; censor's seal of *Wataru*, which places the date of publication about 1846 ; signed *Keisai Yeisen*.

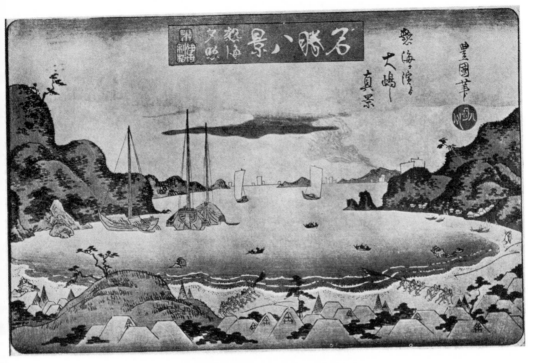

1.　Sunset at Atami; *Meisho Hak'kei* series.

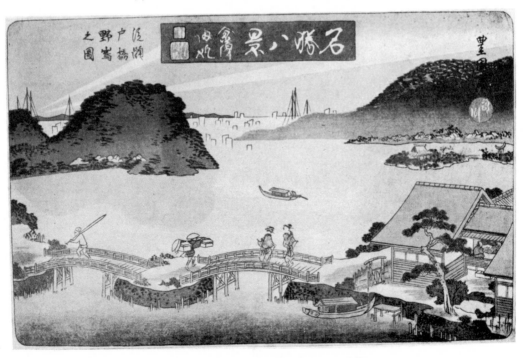

2.　Returning Boats at Kanazawa; *Meisho Hak'kei* series.

PLATE 23 (first part)

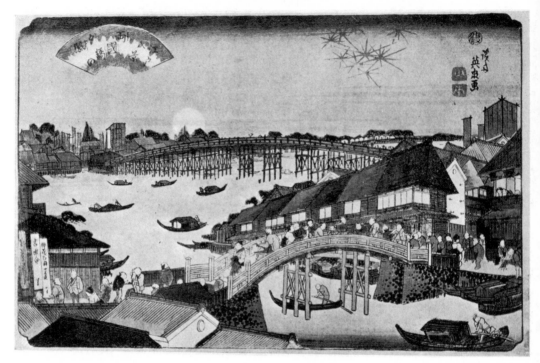

3. Sunset at Ryogoku; *Yedo Hak'kei* series.

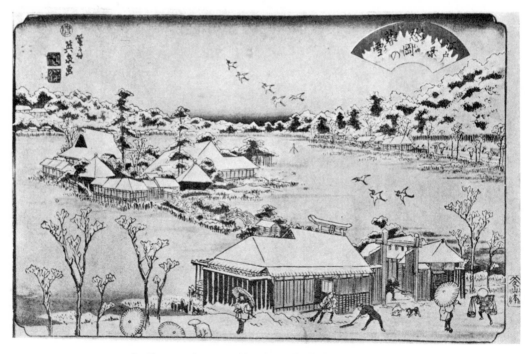

4. Evening Snow on Shinobu Hill; *Yedo Hak'kei* series.

PLATE 23 (second part)

1. " Autumn Moon, Atago Hill." On the right a corner of the Temple at Shiba overlooking Yedo Bay, lit by a large full moon in the centre ; in foreground a pine tree.

2. " Sunset at Ryogoku." The big Ryogoku Bridge spanning the Sumida River and fireworks bursting in the air above it ; in the foreground the Asakusa Bridge over the canal which here joins the river. In the distance a rising moon and light blue clouds across its face.

One of the best plates in the series. (See Plate 23.)

3. " Returning Boats, Shiba." In foreground a big junk and others round it sailing into harbour ; in background a large Fuji overlooking the bay, snow on its peak, and clouds resting on the side of the mountain.

4. " Homing Geese, Sumida River." View up the river from Mukojima ; in foreground a road along which coolies and pack-horses are passing, part of a *torii* of a temple showing. In the distance the blue peak of Fuji.

5. " Evening Rain at Yoshiwara." People under umbrellas passing along the Nihon Embankment in a downpour of rain.

6. " Evening Snow on Shinobu Hill." The masterpiece of the set. View of the island in the Shinobazu Lake on which stands the temple or Benten, seen from Shinobu Hill in mid-winter. (See Plate 23.)

7. " Clearing Weather at Nihon Bridge," and two cranes flying over the river.

8. " Vesper Bells, Uyeno Temple." View of the temple surrounded by pines and cherry trees in blossom.

Another rare series of YEDO VIEWS, eight in number, by YEISEN, but without title, and not following the *Hak'kei* theme, has been noted. (Set in Swettenham sale, May, 1912.)

This set is full size, upright, and each view is enclosed in a black frame, with white letters in curious European characters, forming the word Holland.

SUMIDAGAWA HAK'KEI series, by HIROSHIGE II. Very rare, particularly well-printed first edition copies ; even late impressions printed in (generally) aniline colours are by no means common. Publisher HIRANOYA ; each view dated Cock 11 = 11th month, 1861. This series constitutes Hiroshige II's best work in this form, and most of the views in it are worthy to be placed alongside any of those by Hiroshige himself of the same nature. The best plate is the snow scene, reproduced in the Happer sale catalogue at Plate XXX, closely followed by that for the " Autumn Moon " and " Evening Rain," which two we here illustrate at Plate 24.

1. " Autumn Moon at Makuchiyama Temple." On the right a corner

of the temple standing on a mound in the shadow of a big tree, overlooking the Imado Bridge and Sumida River, the whole scene under a large full moon, and a flight of geese across its face.

2. " Sunset at Mimeguri Embankment." View from the river embankment looking across to the city on the opposite bank and Fuji in the distance (printed from grey colour-block only) ; in foreground a woman passing along and another standing in a boat below looking at her. Trees growing along the edge of the bank, and on the left the corner of a teahouse with a paper lantern hung from the roof. At the foot of the picture appears the top of a stone *torii*.

3. " Returning Boats at Azuma Bridge." In the foreground the large sail of a boat partly hiding the bridge, which is seen from a point above ; on the further side of it are two laden barges lowering sails and coming to anchor. On the further shore appear the roofs and pagoda of a temple rising above the trees ; across the view, hiding the buildings by the river's edge, is a band of pink mist, floating over the bridge. In the distance the yellow glow of sunset.

4. " Geese Flying to Rest at Shirahigè." A flock of geese flying down from the sky and alighting on the yellow shore by the edge of the river. In the distance a range of blue hills printed from colour-block only.

5. " Evening Rain at Makurabashi." One of the masterpieces of the set. In background a thickly wooded island approached by two small bridges ; across one passes a peasant in straw raincoat, and behind him, going in the opposite direction, a woman with her head buried in an umbrella and carrying a lantern. The rain block, printed in *blue*, is often missing except in the earliest impressions.

6. " Evening Snow at Hashiba." A ferry-boat with passengers crossing the river in a heavy snowfall ; the landscape white with snow, and on the left, by the edge of the river, temple buildings appear in a grove of trees. The snow on the ground should be slightly tinted in grey to throw the snow-laden trees into greater relief.

7. " Clearing Weather at Sekiya Village." A woman and a child crossing a small bridge over a stream, watching a *chidori* flying towards them ; in the centre of the view a large pine tree, beyond which is the river and sails on it.

The sky a pale yellow on the horizon graded to white and then blue at the top, an effect which well reproduces the idea of clearing weather after rain.

8. " Vesper Bells at Mii Temple." A woman walking along the Nihon Embankment, looking over her left shoulder ; on the right a big tree and opposite it a cherry tree in blossom. Behind two other figures on

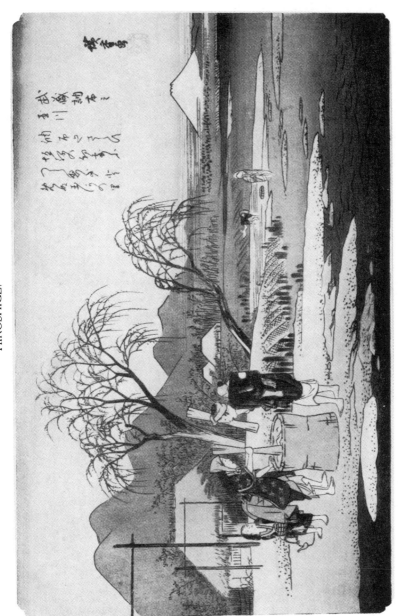

HIROSHIGE.

1. Chofu Tama River; "Six Tama Rivers" series.

PLATE 24 (first part)

HIROSHIGE II.

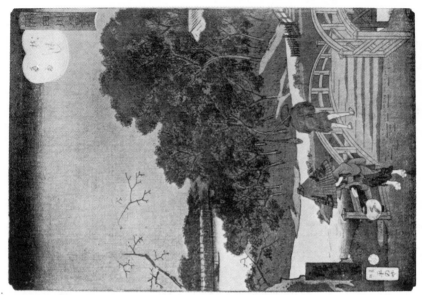

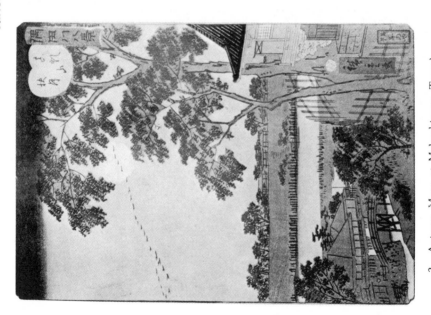

2. Autumn Moon at Makuchiyama Temple. 3. Evening Rain at Makurabashi.

Both from *Sumidagawa Hak'kei* series.

(By courtesy of Mr. Henry Bergen.)

PLATE 24 (second part)

the bank close to another cherry tree ; the river winding away in the distance towards a range of blue hills, from colour-block only.

MUTSU TAMAGAWA—SIX TAMA RIVERS

The six rivers of the same name in various provinces furnished another favourite theme for landscape designs. As in the *Hak'kei* views, each river had its one particular theme for treatment.

Hiroshige designed two full-size series, oblong and upright, of this subject, besides some in a panel shape. The most important are the two full-size series, the early oblong set issued by TSUTA-YA (a view from which, showing the Musashi Tama River, is here reproduced at Plate 24), and the later vertical set issued by MARU KYU, each print of which is dated Snake 11 = 11th month, 1857. Although this vertical series was issued barely a year before Hiroshige's death, it is, in the writer's opinion, perhaps his masterpiece in this form, while the colouring is exceptionally good for so late a date. The view of the two women beating cloth by moonlight, by the Kimuta Tama River, is a masterpiece in the art of producing the greatest effect with the simplest means, and of his many moonlight scenes this one is amongst the finest. (See Plate 25.) (See note, page 153.)

Both these sets are rare, particularly fine copies of them.

In the oblong series the title *Sho-koku Mutsu Tamagawa* (" Six Tama (Crystal) Rivers of Various Provinces ") is on a red label in the right-hand margin, and below it is the publisher's seal.

Before describing each plate in these series, we may explain that they are called *Mutsu* Tamagawa instead of *Roku* (the usual word for six in Japanese), by saying that the former (sometimes written " Mu ") is an alternative for six, and is used in this particular case because Mutsu is also the name of one of the Tama River provinces, likewise known as Michinoku ; a designation, however, only used in literature.

The different scenes for each river are as follows :—

1. The Kimuta Tama River, Province of Settsu. Two women pounding cloth by the edge of a stream in the light of a full moon. The masterpiece of the set. (See Plate 25.)

Poem by Toshiyori : " The sighing of the pine branches sharpens the autumn loneliness, where they beat the cloth by the banks of Tama River."

2. The Noji Tama River, Province of Yamato. A nobleman (or poet), attended by two retainers, looking at the moon's reflection in the stream, whose banks are fringed with flowering bush-clover.

Poem by Toshiyori : " We shall come again to Tama River by the meadow-path, where the bush-clover grows, and it may be we shall see the moon's image lying among the ripples."

3. The Ide Tama River, Province of Yamashiro. The poet, Ariwara-no-Narihira, crossing the river on horseback, with two attendants ; on the banks yellow roses in bloom.

Poem by Toshinari : " We stop our horse and give him refreshing water from Tama River in Idé, where the yellow roses blow."

4. The Chofu Tama River, Province of Musashi. Two women pounding cloth in a mortar, another rinsing it in the river, and some distance behind a fourth spreading it out on the ground to dry. Fuji in the background. Another very fine plate. (Reproduced in colours at Plate B, page 22.)* (See also Plate 24 for illustration of this view in the oblong set.)

Poem by Sada-iye : " In the vale of Tama River the cloth which is hung on the high leaves of the hedges shakes off the morning dew."

5. The Koya Tama River, Kii Province. Two pilgrims standing by the edge of the stream (in the oblong series three are shown resting by the bank) gazing at the water, said to be poisoned. In the background a high mountain, and on the right a waterfall. (Illustrated in Happer's *Heritage of Hiroshige*.)

Poem by Kubo-Daishi : " The traveller may forget everything ; he might forget to beware of fetching water from the Tama River in Koya."

6. The Noda Tama River, Mutsu Province. A Court lady or poetess (in the oblong series two ladies) and her attendant watching a flight of sanderlings across the water.

Poem by No-in : " When evening comes the wind blows salt in Mutsu, and the plovers of the river cry over the wide fields."

(The above translations of the poems are taken from the set catalogued in the British Museum collection.)

Of the various forms in which the above series is found, the writer considers the vertical one the more appropriate, to which the treatment of the subject better lends itself, while it is particularly pleasing in the panel shape.

At Plate 25, Illustration 4, is reproduced a view from an extremely rare " Tama Rivers " series by Hiroshige, entitled KOKA MUTAMAGAWA, " Six Tama Rivers with Ancient Poem," this being for the Chōfu River, Musashi Province ; size $9\frac{3}{4} \times 7\frac{1}{4}$; publisher's sign of *Mura-Ichi* (= Murata-ya) ; censor's seal of *Muramatsu*. This is the only plate of this set which has come under notice, and is apparently from the first edition of a series mentioned by Mr. Happer as published by *O-Hira*, who issued a later edition of it. This series is a combination of figure-studies and landscape, and was issued during the Prohibition period.

In the panel form (measuring $14\frac{1}{2}$ in. by 5 in.) there are two editions,

*Reproduced in black and white in this edition.

HIROSHIGE (Ichiryusai).

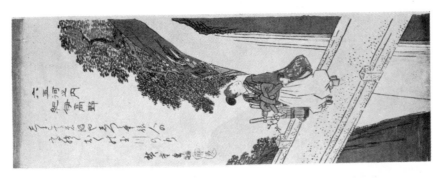

3. Koya Tama River;
 panel series.

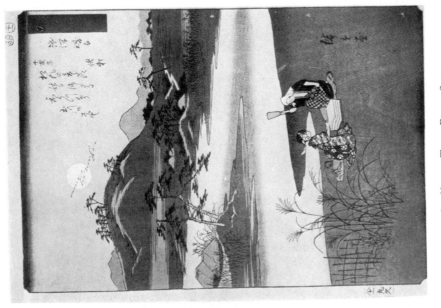

1. Kinuta Tama River, Settsu.

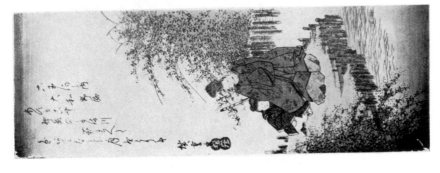

2. Noji Tama River;
 panel series.

PLATE 25 (first part)

HIROSHIGE (Ichiryusai).

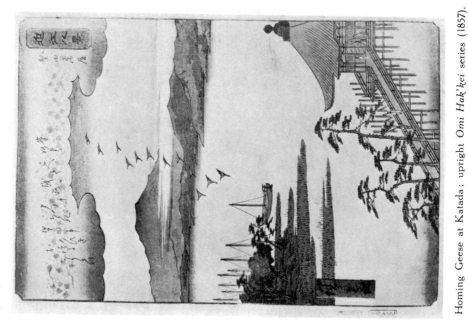

5. Homing Geese at Katada; upright *Omi Hak'kei* series (1857).

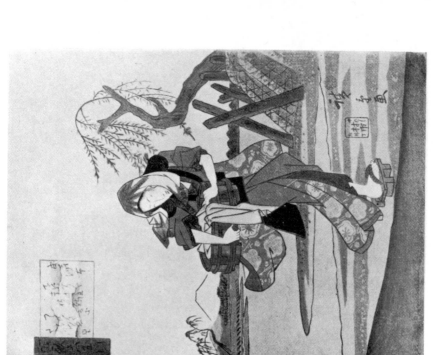

4. Chofu Tama River, Musashi; *Koka Mu Tamagawa* series (very rare).

PLATE 25 (second part)

one issued by the publisher KAWASHO, and the other by FUJI-HIKO. They follow the large series in treatment sufficiently for them to be identified from the foregoing description of the vertical and oblong views. The plate for the Koya Tama River, however, shows, instead of two pilgrims standing by the edge of the river, a temple boy standing on a bridge gazing at the waterfall as it dashes over the face of the rocks ; and that for the Chofu Tama River, Musashi, a woman treading on linen in the water. (See Plate 25 for reproductions of the views for the Noji Tama River and Koya Tama River.)

Note to page 144.—A very rare *Omi Hak'kei* series, full size, *oblong*, by Hiroshige II, has recently been noted (Sale, Sotheby's, April, 1921) ; publisher *Fuji-kei ;* signed " *The Second Hiroshige*," and dated Goat 2 = 2nd month, 1859. The title is on an oblong red label, sub-title in square one alongside ; Hiroshige's signature on red label, and engraver's seal (*Take*) below it ; publisher's seal in margin.

Note to page 151.—Hiroshige's " Six Tama Rivers " series (oblong). The publisher of this series is Tsuta-ya *Kichizo.* Copies of these prints, however, which have had the original margins cut off (on which appear the title and publisher's mark), are often met with repaired with a new margin, on which the seal of Juzaburo (instead of Kichizo) occurs in error. Juzaburo, of course, died before the advent of Hiroshige's prints. Besides the distinction already noted, Juzaburo's ivy-leaf is often drawn with sharply-pointed edges, while Kichizo's has a more rounded outline. (*Tsuta-ya* = " ivy-house.") *See Addenda on page viii.*

CHAPTER XVIII

FAMOUS VIEWS IN THE SIXTY ODD PROVINCES, BY HIROSHIGE ; HUNDRED VIEWS IN VARIOUS PROVINCES, BY HIROSHIGE II

WE will now turn our attention to the remaining upright landscape series by Hiroshige and certain views by his pupil, which will complete our section dealing with this subject of illustration.

Hiroshige's very ambitious set of " Views in different Provinces," being exceeded in number only by his " Hundred Famous Views in Yedo," is entitled *Roku-ju-yo Shio Meisho Dzu-ye* (literally " Views of the more-than-sixty Provinces "), and consists of sixty-nine plates and a title-page with list of contents.

The seal-dates on the prints range from 1853 to 1856, the majority (42) being for the first year, one only for 1854, seventeen for 1855, and nine for 1856 ; publisher *Koshimura-ye Heisuké*, whose seal is on each print, sometimes on margin, sometimes on print itself.

Besides the publisher's seal, other seals occur on the prints : (i) the engraver *Hori Takè* or *Soji*, but only on some of them ; (ii) date-seal, either on margin or on face of print ; (iii) two small inspectors' seals, or, in lieu of them, the *aratamè* (" examined ") seal ; making five seals in all.

The title of the series is on a narrow, upright, red label, and the sub-title on a similar one alongside, variously coloured. Hiroshige's signature is on the red label usual to his upright prints, and that of the engraver *Takè*, where it occurs, generally on a smaller red label next it.

Owing partly to the large number of plates comprised in this series, they are of very varying quality. Another, and probably the main reason, is because Hiroshige did not actually visit many of the provinces, but based his designs on the drawings of other artists, altering them to his fancy ; thus his drawings of Matsushima (No. 28), Hashidate (38), and Itsuku-shima (50), places which are called the " Three most famous Views in Japan," are in this set amongst the least interesting.

On the other hand, some views are amongst Hiroshige's master-pieces. Speaking generally the views of coast, lake, and river scenery are the best, while those of inland scenery are inferior. The series as a whole, however, is notable for the careful gradation and shading

of different tints, one into the other, particularly in the views of rock and mountain scenery, which go far to retrieve what, as a drawing, is often crude and unskilful.

This, of course, only applies to good impressions from the first edition, this careful grading of colour being omitted from late issues. Even copies from the first edition vary considerably in this respect; in fact it is unusual to find two copies of the same plate exactly alike; with the same colour-scheme, or same differences of tints, or even same depth of colour, apart, of course, from loss due to fading. For this reason it is impossible in the following description of the various plates to give more than an idea as to what condition or state any particular view is most desirable; the collector must judge for himself which he considers the best. There is, of course, such considerable differences between early and late issues, that anyone with any experience at all can soon detect them. It is evident, therefore, that the printer did not adhere to one particular colour-scheme even for the first edition, but tried variations to discover which gave the most pleasing effect.

Owing to the large number of views in this series, to give a description of all the sixty-nine plates would take up more space than their importance warrants, apart from the fact that some of them are of too poor a quality to be worth inclusion; such, therefore, have been omitted. A complete set is given in the catalogue to the British Museum collection.

As impressions from this series are frequently found with the margins cut, owing to having been bound up in book form at one time, it has not always been possible to give the dates of those plates wherein the date-seal so occurs.

No. 1. YAMASHIRO PROVINCE, *Togetsu Bridge, Arashiyama.* View of a hill-side on which grow flowering cherry trees, and crimson cloud floating about it; a waterfall plunges into the river below in the centre of which is a flat island connected to either bank by a long low bridge.

Engraver *Take ;* censors' seals, date-seal (Ox 7 = 1853), and publisher's seal on face of print.

No. 2. YAMATO PROVINCE, *Tatsuta River and Hills.* A blue river flows past steep banks on which grow maple trees; hills rise above mist beyond further shore; raft in foreground. Five seals as in No. 1.

No. 3. KAWA-CHI PROVINCE, *Otokoyama in Hirakata.* View of the bend of a wide river flowing past villages on either bank, that on the further side lying at foot of brown mountains rising above crimson and purple clouds floating about their base. Seals as in foregoing.

No. 4. IDZUMI PROVINCE, *Takashi Coast.* View from a pine-dotted

slope on which stands a small *torii* and shrine commanding a wide prospect of sea and hilly coast-line on right. A good plate.

The sea should be a *deep* blue in foreground, lighter towards horizon, where it merges into a crimson sky, changing to orange and then greyish-purple above. Seals and date as in foregoing.

No. 5. SETTSU PROVINCE, *Demi Beach and Lighthouse, Sumiyoshi.* A cluster of houses by the edge of a stream overlooking the shore and bay, and a small bridge, close to which, surrounded by pines, is a stone light-house. Boats moored close to the shore and others sailing out in the bay ; coast-line on horizon. Date and other seals as in the foregoing. A good plate.

In best impressions the upper part of the lighthouse should be graded to a deeper shade than the lower part.

No. 7. ISE PROVINCE, *Asama Hills.* View from the terrace of a tea-house looking down the pass across a wilderness of conical hills to the sea beyond ; tea-houses on either side of the road as it mounts the steep incline up to the terrace. Date-seal on face of print, Ox 7. No engraver. A good plate when carefully printed.

In best impressions the foreground should be a light colour, the hills green, and not a blue-green, in greater contrast to the blue of the sea.

No. 8. SHIMA PROVINCE, *Toba Harbour and Hiyori Hill.* View looking down to the harbour, and a green hill on the right ; islands and sails on a *dark* blue sea. Dated Ox 7. No engraver.

No. 9. OWARI PROVINCE, *Festival of Tenno Shrine at Tsu-shima.* In centre a procession of festival boats decorated with great clusters of red lanterns ; dark sky indicating nightfall. Dated Ox 7. *Takè* engraver.

The sea should be *deep* blue by the boats and at edge of shore, lighter between.

No. 10. MIKAWA PROVINCE, *Horai-ji Temple.* A path by the edge of a torrent past a shrine in a grove of trees, leading to a long flight of steps up a precipitous green mountain-side ; clouds across landscape. Engraver *Takè.* Date-seal in margin (cut).

No. 11. TOTOMI PROVINCE, *Lake Hama-na and Kanzanji Temple.* A broad winding belt of deep blue water between yellow and grey hills ; in foreground a narrow sand-spit leading to the shrine amidst trees, standing on a green hill overlooking the lake ; yellow glow on horizon. A beautifully coloured plate.

Engraver's seal (*Takè*) and censors' seals on print ; date and publisher's seals in left margin (cut).

No. 13. KAI PROVINCE, *The Monkey Bridge.* A well-known plate, strongly reminiscent of Hiroshige's famous *kakemono-ye* of the same subject.

Gosotei TOYOKUNI.

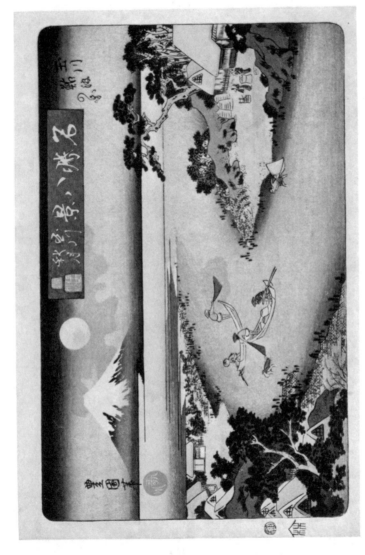

(1). Autumn Moon on the Tama River; one of a series *Meisho Hakkei*; signed *Toyokuni* (*see page 147*).

HIROSHIGE.

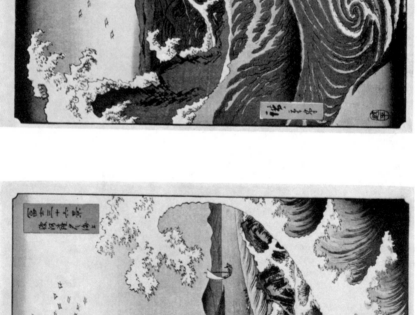

(3). Wave and Whirlpool at Awa; from the "Sixty-odd
Provinces" series.

(2). Wave at Satta Point; from the "Thirty-six Views of
Fuji" series.

PLATE F (second part)

Below a bridge, springing from high cliffs, half hidden by red maples, foams a torrent in a narrow gorge, which just beyond changes to open country with low-lying banks ; mountains in distant background. Seals in margin (cut).

No. 14. IZU PROVINCE, *Hot Springs at Shuzenji*. View looking up a stream from below a waterfall with numerous inns on either bank, connected by a bridge, just above which is an island whereon stands a large stone lantern. Background of green hills. Engraver *Takè ;* date in margin (cut).

No. 15. SAGAMI PROVINCE, *Caves at Enoshima*. On the right the sea-washed caves and wooded heights of Enoshima, with waves foaming about their base ; on the left Fuji partly visible across the bay. Engraver *Takè ;* date in margin (1853).

No. 16. MUSASHI PROVINCE, *Morning Snow, Sumida River*. In the foreground, on the right, stands the Makuchiyama Temple amongst trees, on a hill overlooking the Imado Bridge, which crosses a stream flowing into the Sumida River. Snow-covered islands out in the river, and in the distance a solitary timber-raft ; red mist lying over further bank. One of the best plates in the series. Seals in margin (cut).

No. 17. MUSASHI PROVINCE, *Yedo, Asakusa Temple*. View of the Temple grounds at night, under a starry sky, during a fair, thronged with crowds coming out of the Temple. Seals in margin (cut) ; no engraver's seal. Another fine print.

The roofs of the temple buildings and pagoda, the trees, and sky should be strongly printed in a *deep* blue-grey to grey tint ; in most impressions they are in too light a colour, thus losing much of the effectiveness of this plate. (See Plate 26, Illustration 1.)

No. 18. AWA PROVINCE, *Kominato Bay*. View from a pass between green hills at foot of which lies a village, looking out across the bay, whereon float five junks, to cliffs and hills opposite, at foot of which is the town by the edge of the bay ; orange sky on horizon.

Inspectors' seals and date-seal (Ox 8 = 1853), also publisher's seal on face of print ; engraver's seal of *Takè*.

No. 19. KAZUSA PROVINCE, *Yazashi-ga-ura and the Ninety-nine " Ri "
Coast*. Two gangs of men hauling in a seine net (not shown), and a boat being rowed ashore ; men and women on beach gathering clams.

Engraver *Takè ;* date-seal (Ox 8 = 1853), and publisher's seal in left margin, censors' seals top margin.

No. 20. SHIMOSA PROVINCE, *Choshi Bay*. A rocky point juts out on the left into a narrow channel through which three boats are sailing ; beyond, a wide expanse of bay commanding a fine view of Fuji on the horizon. Seals in margin (cut), no engraver.

No. 21. Hitachi Province, *Daijingu Temple, Kashima*. Houses and street leading down to the beach close to which is built a *torii* in the water ; behind rises a green, pine-clad hill, shaded to blue at the summit. Three boats sailing in middle distance, and another in foreground. Engraver *Takè*. Publisher's seal right margin ; date-seal in left (cut).

No. 22. Omi Province, *Ishiyama Temple and Lake Biwa*. The masterpiece of the series. Only finest impressions have the light cloud across the face of the moon. (See Plate 26, Illustration 2.)

Censors' seals, date-seal (Ox 7 = 1853), engraver's seal (*Takè*), and publisher's seal on face of print.

No. 24. Hida Province, *Kago-watashi* (" Basket-ferry "). Travellers crossing the gorge of a river in baskets from one platform to another ; steep crags dotted with pines and other trees on either side, and a mountain rising up in background. One of the best plates of inland rock and cliff scenery in the series. Engraver *Takè ;* other seals in left margin (cut).

In best impressions the river should be a *deep* blue, the foam of the torrent indicated by patches of lighter blue (missing in later copies) ; the rocks in foreground graded reddish-orange at bottom to green, edged with brown tints above. The mountain in background *grey* (not brown) graded to black or deep blue at the summit ; orange or crimson sky behind changing to blue above.

No. 25. Shinano Province, *The Reflected Moon, Sarashina*. A well-known view in this set. On a steep hill-side the full moon is reflected in the watery rice-plots, planted in terraces. Below, on the left, runs a stream in a valley, and grey mountain beyond. Engraver *Takè*. Seals in margin (cut).

No. 26. Kotsuke Province, *Mount Haruna under Snow*. A small red bridge joins two snowy cliffs across a blue stream, the fantastic crags of Mount Haruna under a thick blanket of snow, all white against a dark wintry sky. Engraver *Takè*.

No. 29. Dewa Province, *Mogami River and Tsukiyama* (Mountain of the Moon) in the distance, rising above bands of grey cloud ; sailing barges, rafts, and smaller boats on the river, which here flows in a double bend. (Seals in margin cut, *Takè* engraver.)

No. 31. Echizen Province, *Tsuruga*. A land-locked bay connected with the sea by a narrow channel, and a fleet of junks anchored at the foot of a steep hill, and two others sailing close in-shore in foreground. (Seals in margin cut, no engraver.)

No. 32. Kaga Province, *The Lotus Lake, Kanazawa*. Numerous boats fishing on the lake with flares, by night ; two islands, dotted with houses, joined by two bridges. Green hilly shore and mountain in background ; dark night sky. (Seals in margin cut.)

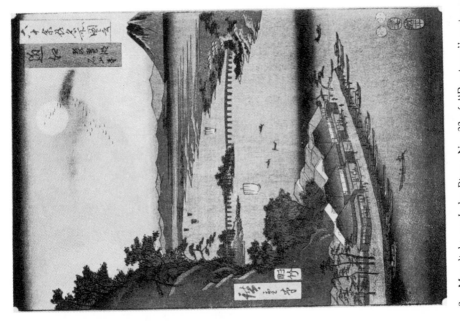

2. Moonlight on Lake Biwa; No. 22 of "Provinces" series.

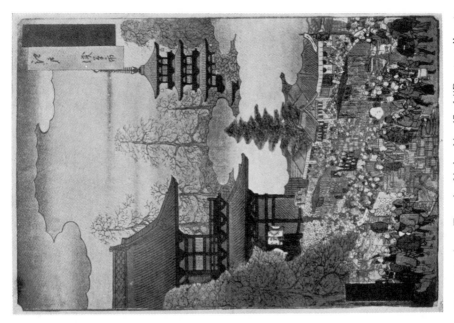

1. Fair at Asakusa Temple, Yedo; No. 17 of "Provinces" series.

PLATE 26 (first part)

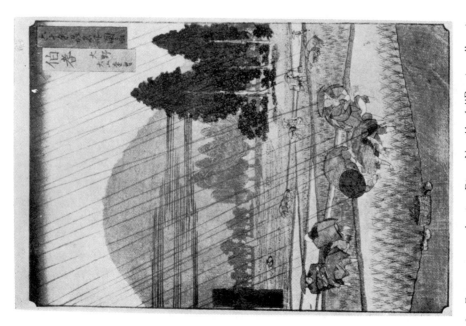

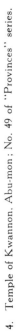

4. Temple of Kwannon, Abu-mon; No. 49 of "Provinces" series.

3. Peasants transplanting Rice; No. 41 of "Provinces" series.

PLATE 26 (second part)

No. 33. NOTO PROVINCE, *Coast of Taki*. Yellow and green cliffs on which grow cherry trees in blossom, of fantastic shape, pierced by a row of natural arches ; on right a torrent runs down over the cliffs into the sea, and at the foot a small *torii*. Engraver *Takè*.

No. 34. ETCHU PROVINCE, *Bridge of Boats*. A long curving bridge of boats across a wide river ; cluster of huts on opposite shore amongst bamboo and pine trees ; green slopes behind. Engraver *Takè*.

No. 35. ECHIGO PROVINCE, *Oyashirazu*. A narrow beach running round a rocky promontory, honeycombed with caves, viewed from the sea. Brown cliffs, green above, with scattered pines growing on them ; *deep* blue sea. (No engraver ; date 1855.)

No. 36. SADO PROVINCE, *Kanayama*. Three streams issuing at the base of yellow cliffs from the entrances to the mines ; bushes overhang the cliffs which are green above. (No engraver ; dated 1855.)

No. 39. TAJIMA PROVINCE, *Temple of Kwannon, Iwaidani*. On the left a great cliff towers up, overhanging the path leading to the temple standing amidst trees ; on the right, a torrent leaps in cascades down the mountain-side ; pink clouds floating over landscape. (Dated 1855.)

No. 41. HOKI PROVINCE, *Distant View of O-yama*. Peasants transplanting rice in a rain-storm, through which appears the form of the mountain in the distance. *Aratamè* seal in top margin ; engraver's seal (*Takè*), date-seal (1853), and publisher's seal in left-hand margin. One of the best plates in the series.

In late impressions the trees in middle distance (right) are printed too bright a green, and the mountain and trees behind not sufficiently strongly, nor the *black* streaks of cloud. (See Plate 26, Illustration 3.)

No. 42. IZUMO PROVINCE, *Taisha*. One of the masterpieces of the series. In foreground a giant cryptomeria stands out *strongly* against a misty background, through which appears the dim outline of a *torii*, and two figures retreating towards the distance ; passing by the cryptomeria are a man and two women taking offerings to the shrine. (*Aratamè* seal in top margin ; date-seal cut.)

Late impressions are lacking in contrasts, the background being too dark.

No. 43. IWAMI PROVINCE, *Salt Beaches at Takatsu*. Salt-makers on a flat beach overlooked by the green slope of a promontory with pines growing on it. *Aratamè* seal in top margin ; date-seal Ox 12 (1853) ; engraver's seal (Sōji), and publisher's seal left-hand margin.

No. 45. HARIMA PROVINCE, *Coast of Maiko*. A row of ancient pines growing on a sandy beach, close to the water's edge. A well-known plate. (Date in margin 1853.)

No. 46. MIMASAKA PROVINCE, *Yamabushi* ("travelling priest's") *Valley*. A famous rain scene.

On the near bank of a stream, on which is a solitary timber raft, two travellers pass ; one has his hat carried away by the wind. On the further shore rises a great rock seen through the curving streams of sabre-like rain.

No. 47. BIZEN PROVINCE, *Coast of Tanokuchi, Yukayama*. A great grey *torii* stands on a reef of low rocks close to the shore in front of a cluster of huts lying at the foot of a low green hill ; junk anchored off shore, and beyond a reef another sailing towards harbour. Crimson sky on horizon, blue above. (Seals in margin cut.)

No. 48. BITCHU PROVINCE, *Go Waterfall*. A mountain torrent rushes foaming along past two towering pinnacles of rock on either bank ; round the base of one runs a green path on an overhanging ledge. In background rises a green hill (blue at base), against a yellow sky. Bold drawing.

(*Aratamè* seal top margin ; date-seal (Ox 12), and publisher's seal left margin.)

No. 49. BINGO PROVINCE, *Temple of Kwannon, Abu-mon*. Another well-known plate of this series. (See Plate 26, Illustration 4.) View of the temple perched high on the summit of a precipitous cliff, over which shines a dim full moon through the mist.

In best impressions the sea is a deep green, edged with blue round the foot of the cliff, gradually merging into a greyish-blue mist in background ; in the background the *black* summits of a range of mountains against a deep grey-blue sky appear above the mist. The cliff itself should be a deep grey (almost black), overprinted at the base with dark green, and here and there shaded with patches of lighter grey ; the detached rocks at the base should be a dark brown tint.

(*Aratamè* seal, date-seal (1853), engraver's seal (? *Sōji* [partly cut]), and publisher's seal in left margin.)

No. 51. SUWO PROVINCE, *Kintai Bridge, Iwakuni*. A wooden bridge on four massive stone piers ; village and high hills beyond over which lie mists.

No. 52. NAGATO PROVINCE, *Shimonoseki*. Two women in a ferryboat passing the stern of a big junk at anchor, and others moored near by.

No. 53. KII PROVINCE, *Coast of Waka*. Five cranes flying inland over the sea ; below them a shrine on a small wooded island joined to the shore by a series of small bridges. Dark grey mountains rise above purple mists in the background against a crimson sky, changing to blue above. A good plate.

(*Aratamè* seal and date-seal (Hare 9 = 1855) in top margin ; publisher's seal on face of print.)

In best impressions the sea should be *deep* blue in foreground and tops of waves a lighter blue ; the two large cranes in upper foreground should have their wings, one with them picked out in blue, and the other in *gauffrage*.

No. 54. AWA-JI PROVINCE, *Go-shiki-ga-hama* ("The Coast of Five Colours"). Fishermen in boats hauling in a large seine net; sandy beach between brown rocks, green hills behind, touched with brown at top; golden sky on horizon.

No. 55. AWA PROVINCE, *Naruto Rapids.* A masterpiece. A whirling eddy and waves breaking into foam over projecting rocks. (See Plate F, page 156, for reproduction in colours of an exceptionally fine copy of this masterpiece.)*

Aratamè seal and date-seal (Hare 9 = 1855) in top margin.

The sea should be a *deep blue*, not green as is generally found.

No. 56. SANUKI PROVINCE, "*The Elephant-headed*" *Mountain, Zozusan.* The mountain rises up in the background, purple clouds floating at its base, seen across a plain dotted with trees and straw-roofed huts. In foreground a party of travellers coming up from the plain below, by a road in a cutting; bushes of red camellia on either side. (Engraver *Soji*; dated 1855.)

No. 59. CHIKUZEN PROVINCE, *Hakozaki.* A narrow zigzag strip of land runs through the sea across the foreground, covered with pines; on right a red *torii* and stone lanterns round it. Beyond, appear a few yellow huts on a grey shore at the foot of a green hill (summit graded to a red-brown), off which lies a small island. In the distance stretches a grey coast with pines growing along the water's edge. Two boats sailing along the coast, and others at anchor off the village.

The sea should be a *deep* blue along the edge of the land and in bottom foreground, lighter elsewhere.

(*Aratamè* seal and date-seal (1855) in top margin; engraver's seal (*Soji*) and publisher's seal below artist's signature.)

No. 61. BUZEN PROVINCE, *Rakan Temple.* A curving blue river flowing past red-brown cliffs pierced with caves and galleries leading underground to the temple. (Dated on face of print Tiger 11 (1854); *aratamè* seal above signature; no engraver.)

The cliffs should be red-brown at base, then yellow, changing to green, and finally edged with brown above. A fine, bold drawing.

No. 64. HIGO PROVINCE, *Go-kanosho.* Across a fallen tree-trunk which forms a bridge across a misty abyss, goes a peasant carrying faggots; beyond rises a great *blue* peak wreathed in fleecy clouds against a blue sky. A fine plate.

(Also found with mountain in grey and sky touched with yellow.)

No. 65. HIUGA PROVINCE, *Yuzu-no-Minato Harbour.* View of a landlocked harbour looking out to sea, past a narrow mouth, with steep wooded height on left; four junks anchored off shore in foreground, and corner of a tea-house overlooking the harbour on the right.

*Reproduced in black and white in this edition.

No. 66. OSUMI PROVINCE, *Sakura-jima* (" Cherry Island "). A green island with flowering cherries on its lower slopes, rises up into a steep red-brown, flat-topped cone ; junks sailing by and others at anchor in foreground.

(*Aratamè* seal and engraver's seal (*Takè*) on face of print.)

No. 67. SATSUMA PROVINCE, *The Sword Rocks, Bo-no-ura*. Two great needle-like rocks stand in the water close to the shore, two people in a boat looking at them ; other rocks beyond and sails in the distance. Engraver *Takè*.

No. 68. IKI PROVINCE, *Shisaku*. Snow falling from a black sky over a blue sea ; in foreground a steep conical hill, with a few small pines on it. In middle distance a headland juts out into the sea, joined to the mainland by a low narrow neck ; hilly coast-line in background, all white with snow. A masterpiece.

(Publisher's seal in bottom right-hand corner ; date-seal (Dragon 3 = 1856) and *aratamè* seal in top margin.)

The hill in foreground should be tinted grey at base, white to summit ; sky blackest at top, then deep grey down to the horizon ; sea deep blue at edges of shore, lighter in centre.

No. 69. TSUSHIMA PROVINCE. Clearing weather after rain ; a rainbow arches over a bay and distant coasts. Boats in a small harbour.

(Only two other rainbow scenes by Hiroshige are known.)

HIROSHIGE II designed a series in close imitation of the foregoing entitled SHOKOKU MEISHO HYAK'KEI, " A Hundred Views of Various Provinces," published by *Uwo-yei* (*Uwo-ya Yeikichi*), and variously dated for the years 1859 to 1861. Mr. Happer states that about eighty plates have been noted.

While the majority of them are inferior and crude in colour and execution, a few compare very favourably with the best in the " Sixty Odd Provinces " set.

At Plate 27, Illustration 1, page 162, we illustrate an excellent snow-scene from this series, entitled " Snow at Kiso, Province of Shinano," a nearer view of the right-hand sheet of Hiroshige's famous triptych of the Kiso Gorge under snow ; and at Illustration 2 on the same plate is another good view which is much above the average of the series, entitled " Nagoya, Province of Bishu." Moonlight scene over the sea and town of Nagoya lying along the shore. In the foreground a great golden dolphin forming a terminal to the roof of Nagoya Castle. Flight of geese across the sky and face of the moon. Dated Sheep year (1859).

Another very good plate is that showing the Kintai Bridge, Province of Suwo, on its four massive stone piers, in a heavy snowfall, a raft in the

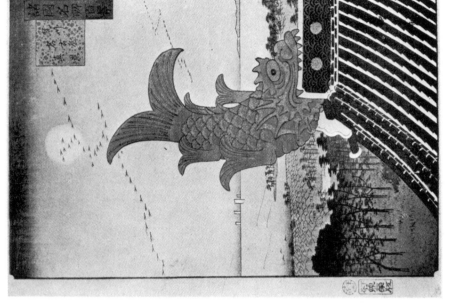

2. Nagoya; Province of Bishu.

1. Snow at Kiso; Shinano Province.

PLATE 27 (first part)

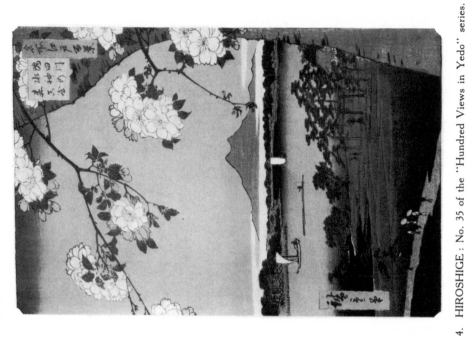

4. HIROSHIGE: No. 35 of the "Hundred Views in Yedo" series.

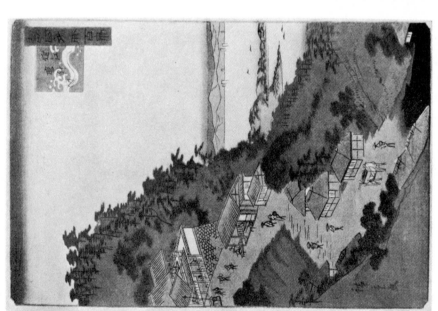

3. Pass of Mashin; Omi Province.

PLATE 27 (second part)

stream in the distance. The water should be a *deep* blue where it flows under the bridge, and along the shore in foreground, and again where it disappears in the distance, lighter elsewhere. Dated 1859.

Also the following :—

" Pass of Mashin, Province of Omi." A rest-house built out on the steep side of a hill commanding a fine view of Lake Biwa and the opposite shore, and the road lined with booths leading up to it. Dated Cock year (1861). (See Plate 27, Illustration 3.)

Beach near Enoshima, with a high wave breaking in, dated 1859, not unlike Hiroshige's " Wave at Satta Point " in the " Thirty-six Views of Fuji." Dated 1859.

" Evening Cooling at Kyoto," similar to Hiroshige's scene in his " Kyoto Meisho " set. Dated 1859.

" Beach at Maiko " (dated 1859); compare with same scene in " Sixty Odd Provinces."

" Tatsukuchi-yama." A very fine rain and wind scene. The great rock cavern known as the " Dragon's Mouth," Province of Bizen, and a peasant hurrying along against the storm by the edge of the river under trees which bend before the gale.

Hiroshige II also designed a half-plate set entitled *Sho-koku Rokuju Hak'kei*, " Sixty-eight Views of Various Provinces," each plate numbered ; two views on one sheet ; dated 1862.

Both the foregoing series by Hiroshige and Hiroshige II have been copied, practically line for line, by Hasegawa Sadanobu in a quarter-plate set entitled *Shokoku Meisho Hyak'kei* (" A Hundred Famous Views in Various Provinces ").

CHAPTER XIX

"THE HUNDRED FAMOUS VIEWS OF YEDO"

IN this enormous series of 119 prints (118 views and title-page) Hiroshige displays his powers at his best and also at his worst, if, that is to say, the inferior plates are really his handiwork and not that of his pupil called in to assist.

Hiroshige, indeed, himself considered the set his masterpiece and so inscribed the title-page, but many of the views in it, such as the inane *Boatman with the Hairy Legs* and the *Rear View of a Horse*, which almost blots out the whole picture, like an equally inane print in his "Thirty-six Views of Fuji," and certain others almost as catastrophic, can only be attributed to premature senile decay; Hiroshige was only sixty-one at his death. All such worthless prints, and others of inferior quality, are here omitted, and the following list only gives those plates really worth the collector's attention. A nearly complete set will be found in the British Museum collection, to which the reader is referred for further information.

Each print has the date-seal, the *aratamè* seal, and the publisher's seal (*Uwo-yei*) in the margin, the dates varying from 1856 to 1858.

The plate numbers are those given in the index on the title-page, published on completion of the series, and it will be noticed that the order does not follow the date at which the blocks were engraved, the date-seal being cut in the block and not stamped on the print afterwards. The reason of this apparent irregularity between the plate numbers and the date is that, when the series was finally completed, it was arranged according to the seasons, Plates 1 to 42 representing spring; 43 to 72, summer; 73 to 98, autumn; and 99 to 118, winter.

Owing to the margins of some copies which have come under observation being cut, we have not been able to give the date thereon in every instance.

Owing to the enormous demand for these views they were reprinted in subsequent editions many times over, and it is copies from these late, crudely printed editions that are so abundant at the present day, and against which the collector should be warned.

Early copies may be distinguished by the good printing, in which the colours are carefully graduated and the different tints in the sky melt im-

perceptibly one into the other. In strongly-printed impressions the grain of the wood-block will be clearly seen.

Late issues also often show an entirely different, and frequently raucous, colour-scheme.

As the author has already pointed out, the date-seal on each print is no guide, *by itself*, as to what edition a print belongs. One must judge by the quality of the printing and of the colours employed.

No. 1. *Nihon-bashi, Yuki-hare*, "Snowy Morning at Nihon Bridge." A very good snow-scene when well printed. View of the river and the Nihon Bridge, towards which three barges are being rowed; other boats moored in mid-stream, and alongside the bank, lined with fish shops. Warehouses on opposite bank upon which lie pink and red mists; through the mist appears Yedo Castle in the background, with Fuji on the left rising above the foothills, white with freshly fallen snow. Blue sky above. (Dated Dragon 5 = 1856.)

Note.—Plate No. 1 is incorrectly given in the B.M. catalogue owing to there being *two* views of Nihon-bashi, the other being entitled *Nihon Bashi, Yedo Bashi* (an uninteresting plate), which is properly No. 43 of the series, forming the first of the summer views.

No. 2. *Kasumi-ga-seki*, "The Kasumi Guard-house." View from the summit of the hill looking out to the bay of Yedo, across the city roofs below, and a procession coming into view up the slope. On the right stands the guard-house, a big *daimyo's* palace, and in the corner a large *kadomatsu*; kites flying. (Dated Snake (?) = 1857.)

Crimson sky on horizon, changing to blue above. Trees should be *strongly* printed, and shaded to a darker green at their edge.

No. 3. *Yamashita cho, Hibiya no Sakurada*, "Outside Hibeya Gate, Yamashita Street, Sakurada District." View of the moat outside Yedo Castle, the wall of which appears on the right; ducks on the water, kites flying, and two battledores projecting into the picture from either side, that on the left partly hidden by a young pine. Fuji in the distance above the roofs of the city. (Dated Snake 12 = 1857.)

No. 4. *Yeitai Bashi, Tsukuda-jima*, "Yeitai Bridge and Tsukuda Island." Fishing boats with flares seen just beyond a pier of the bridge; on the right a cluster of junks at anchor under a black sky with a half-moon and stars shining. (Dated Snake 2 = 1857.)

Found in two states, one with the dark sky brought down to the horizon, and in the other stopped just above it (this state illustrated in Happer Catalogue); in late issues the stars are omitted.

No. 5. *Ryogoku sumo Eko-in*, "The Eko-in Temple, Ryogoku, by the Wrestling Ground." Fuji under a mantle of snow seen across the Sumida River, down which two junks are sailing, and in the left foreground a high

wooden tower with white paper flags hung out to denote a wrestling match is in progress. Dated 5th month, 1857.

No. 6. *Hatsune no Baba, Bakuro Cho,* " First Race-Course, Horse-dealer's Street." Strips of blue and brown cloth hung out between willow trees to dry, and in the background a fire-outlook tower. Dated 9th month, 1857. One of the best plates of the series when well printed, the sunset sky producing a beautiful atmospheric effect. (Illustrated at Plate 21 in our quarto edition.)

No. 8. *Suruga Cho,* " Suruga Street." Street scene in perspective looking straight down towards Fuji in the distance, whose cone rises above brightly tinted mists lying over the roofs, right across the view ; many groups of people walking about. (Date cut.)

No. 9. *Yatsukoji, Sujikai uchi,* " Broad Avenue, Yatsukoji." Bird's-eye view of the broad space outside the Shogun's Palace, with a *daimyo's* procession in foreground. (Dated Snake 11 = 1857.)

No. 10. *Kanda Mio-jin,* " Kanda, Miojin Shrine." Three Temple attendants, a woman and two men, one carrying a water-bucket, standing under a trellis on a high terrace looking out over the roofs of the city below at the reddening sky of dawn. In foreground the trunk of a tall crypto-meria and two other trees partly seen on either side. The foreground should be well graded from green in front to yellow in centre and then grey under the trellis. (Dated Snake 9 = 1857.)

No. 14. *Nippori,* " Nippori Temple Garden." Two flowering weeping cherry trees in foreground at edge of wide path (grey-green), and people promenading. On further side green slopes, trees, and clipped shrubs, one on the right cut like a boat in full sail. A good plate when well printed. (Dated Snake 2 = 1857).

Also found with *yellow* path in foreground.

No. 15. *Nippori, Suwa-no-dai,* " Suwano dai, Nippori." People seated on low benches, taking refreshment, on a high terrace by two tall cryptomerias and cherry trees, and admiring the view across a wide plain to Mount Tsukuba in the distance. At foot of the terrace a cluster of houses surrounded with blossoming cherry trees, and people mounting up from them to the terrace. Crimson sky on horizon, purple at top. (Date cut.)

No. 16. *Sendagi, Dango-saka hana,* " Cherry gardens at Dangosaka, Sendagi." In foreground people sitting out by the edge of a lake under blossoming cherry trees, over which lies a cloud edged with pink and green. Behind, steps lead up to a tea-house set amongst trees on a hill overlooking the lake. (Dated Dragon 5 = 1856.)

No. 17. *Asukayama,* " View from Asukayama." People picnicking under pine and cherry trees on a grassy terrace, overlooking the wide

plain of Hitachi below to Mount Tsukuba in the distance rising above purple mists. A fine plate when well printed. (Dragon 5 = 1856.)

No. 18. *Oji, Inari no Jinga*, " Inari Shrine, Oji." Under the shadow of tall cryptomerias stands a corner of the temple on a terrace commanding a fine view across the wide plain to Mount Tsukuba in the distance. People mounting to the terrace up steps at foot of which stands a *torii*. Crimson sky on horizon, changing to blue at top. (Date cut.)

No. 19. *Oji, Otonashigawa*, " Otonashi River and Waterfall." Three men bathing in the fall (white), and others in the river itself (blue) ; steep green banks either side on which grow cherry trees in blossom and other trees. (Date cut.)

No. 20. *Kawaguchi no Watashi*, " Ferry at Kawaguchi," and Zenkoji Temple. Three lumber-rafts on river, and ferry-boat on right in mid-stream. On further bank a blue and red temple in a dark grove of trees ; pine and willow overhang the water on near bank. (Snake 2 = 1857.)

In early impressions there appears a band of dark blue across the middle of the river.

No. 21. *Shiba, Atagoyama*, " Atago Hill, Shiba." A " messenger to Bishamon " coming up the steps of the temple. He carries a huge rice-ladle in one hand and a pestle in the other ; on his head he wears a basket and other fanciful decorations, fern leaves, etc. In the distance, across the roofs of the city below, a view of Shinagawa Bay, and sails on it.

Above Hiroshige's signature, on a yellow label, is written " third day, first month, Bishamon's Messenger," and in the top left-hand corner, the date Ansei 4 (= 1857), which verifies the seal-date in the upper margin, Snake 8 (= 8th month, 1857).

This print is solely interesting from the evidence it gives of the correctness of the seal-dates on other prints, but as a picture it is not a success, the drawing being crude and the colours invariably harsh and staring in any copies which have come under observation.

No. 23. *Meguro Chiyo-ga-ike*, " Chiyoga Pond, Meguro." Chiyoga pond and a cascade flowing into it down a steep slope on which grow cherry trees in blossom, and bands of mist lying over them. Two girls standing at the foot of the fall admiring it. (Dated Dragon 7 = 1856.)

Notable for the reflection of the trees in the pond, one of the few known examples.

No. 24. *Meguro, Shin Fuji*, " The ' New ' (or Imitation) Fuji, Meguro." An artificial mound formed to resemble the real Fuji which is seen in the distance, and people ascending it up a zigzag path to view the latter. (Date cut.)

No. 25. *Megura, Moto Fuji,* " The ' Original ' Fuji from Meguro," seen in the distance, on the left, from an artificial mound (see preceding plate), half-way up which are two people ; out of its side grows a spreading pine tree, and at the foot, under blossoming fruit trees, are people seated on low benches admiring the view. (Date cut.)

Though these two plates are hardly worth inclusion, they are given here to assist the reader to identify one from the other, owing to their similarity.

No. 27. *Kabata, Ume Yashiki,* " Plum Gardens at Kabata." Small tea-houses amongst the trees, and an empty *kago* in right foreground. (Dated Snake 2 = 1857.)

One of the most beautifully coloured prints of any in the series. Found in two states : (1) strong green in foreground ; pink sky behind trees graded to beautiful rosy flush, changing to deep blue at top. (2) Foreground much lighter green ; sky much paler pink and no blue at top. Either is first edition ; perhaps the first state is the more beautiful colour-effect.

No. 28. *Shinagawa, Gotenyama.* People crossing the almost dry bed of the Shinagawa, now shrunk to a narrow brook, towards a path up steep yellow cliffs to a plateau beyond on which are planted cherry trees and a few large pines. (Dated Dragon 4 = 1856.) Also found with *grey* cliffs.

No. 29. *Sunamura, Moto Hachiman,* " The ' Original ' Hachiman Shrine, Sunamura." In foreground stands the blue-grey *torii* of the shrine by blossoming cherry trees, at the edge of a winding causeway leading out to marshes which melt into the sea beyond, on which are five sails ; hilly coast-line on horizon against a crimson sky. (Dated Dragon 4 = 1856.)

No. 30. *Kameido, Ume Yashiki,* " Plum Garden, Kameido," seen through the branches of a plum tree in blossom, and people sitting or walking about. Sky deep blue at top, changing to crimson, and then white below ; a plate which owes its effectiveness to the beautiful colour-effect of the sky ; very similar to Plate No. 27. (Dated Snake 11 = 1857.)

No. 31. *Azuma no Mori,* " Azuma Woods." By the edge of the water runs a winding yellow path on a raised embankment, lined with flags, leading to Azuma Shrine ; cherry trees in blossom along the bank. (Dated Dragon 7 = 1856.)

No. 32. *Yanagi shima,* " Yanagi (" Willow ") Island," standing at the confluence of a stream with the Sumida River, and a bridge leading to it ; in a grove of trees stands a temple and other buildings. On the further side of the river stretches a dark plain with scattered villages on it, to Mount Tsukuba in the distance, on the left, rising above white mists. A good colour-effect when well printed. (Dated Snake 4 = 1857.)

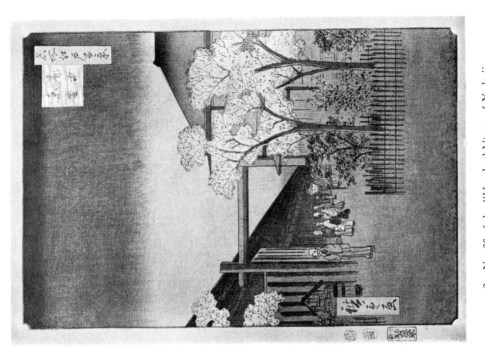

2. No. 38 of the "Hundred Views of Yedo."

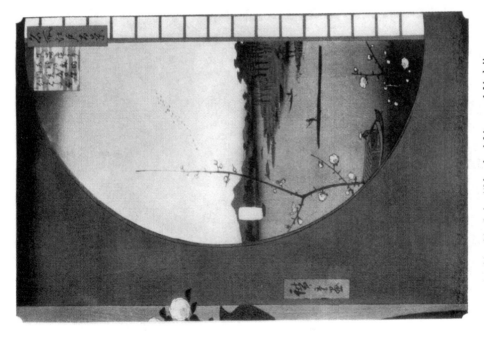

1. No. 36 of the "Hundred Views of Yedo."

PLATE 28 (first part)

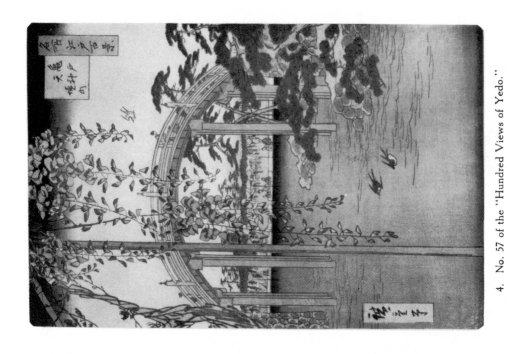

4. No. 57 of the "Hundred Views of Yedo."

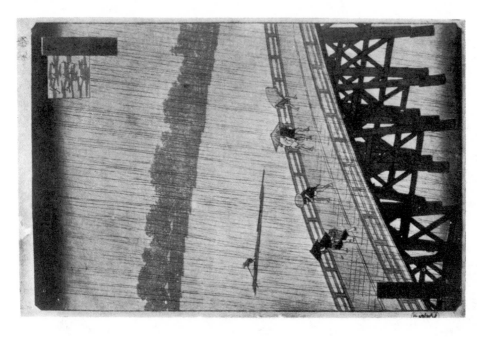

3. No. 52 of the "Hundred Views of Yedo."

PLATE 28 (second part)

No. 34. *Matsuchi-yama, Yoru no kei,* "Night Scene at Matsuchiyama." A *geisha* going home at night after an engagement, along the river bank ; the lantern carried by her guide just showing on the left. On the far bank across the water houses lighted up, and stars shining which are reflected in the water. (Dated Snake 8 = 1857.) No stars in late issues.

No. 35. *Sumida gawa, Suijin-no-Mori,* "The Woods of Sui-jin by the Sumida River," and Mount Tsukuba rising above the mists beyond into a blue sky. One of the masterpieces of the series. (Dated Dragon 8 = 1856.) (See Plate 27, Illustration 4.)

No. 36. *Masaki no hotori yori Suijin-no-Mori, Uchi-kawa Sekiya-no-Sato,* "Masaki, the village of Sekiya, the Uchi River, and the woods of Sui-jin." View through a half-open circular window looking up the river to Mount Tsukuba in the distance. (Dated Snake 8 = 1857.) Another masterpiece. (See Plate 28.)

No. 38. *Yoshiwara yo-ake,* "Dawn, Yoshiwara," and revellers coming out of the Great Gate of the Yoshiwara on their way home in the early morning. One of Hiroshige's most famous renderings of early dawn, the full effect of which is only found in the earliest impressions. (Dated Snake 4 = 1857.) (See Plate 28.)

No. 39. *Ryogoku Bashi, Okawabata,* "Okawa Bank, Ryogoku Bridge." In foreground a row of yellow-roofed shops backing on to the river where the Ryogoku Bridge crosses it ; three sailing barges on the water, one furling its sails. Pink bands of mist lie across the further bank. (Date cut.)

Not a very interesting plate, but included here as it is not given in the B.M catalogue.

No. 40. *Sekiguchi.* People walking by the river side, a steep wooded slope on the right overlooking the path and flat fields beyond. (Dated Snake 4 = 1857.)

No. 41. *Ichiga-ya Hachiman,* "Hachiman Shrine, Ichiga-ya." The temple standing high on a wooded slope, at foot of which are tea-houses and shops, and in the foreground the water of the moat. Bands of mist cut across the centre of the picture. (Dated Horse 10 = 1858.)

No. 44. *Nihon bashi Itchome,* "First Avenue, Nihonbashi." A crowded street scene, and in the centre a group of five people under one large umbrella, followed by a woman with a *samisen.* (Date cut.)

No. 46. *Shohei Bashi, Kandagawa,* "Shohei Bridge, Kanda River." Rain scene. Between steep green banks flows the river ; rain beating down from a black sky. On the further side a road uphill, people walking along it ; in bottom corner appears the rail of the bridge and boats passing below. (Dated Snake 9 = 1857.) A good plate.

No. 47. *Oji, Fudo-no-Taki,* " The Fudo Waterfall, Oji." A column of intensely blue water plunges sheer down into a pool enclosed on three sides by precipitous cliffs, their bases yellow and sides green ; behind the fall black rock. A man entering the pool to bathe, and two women looking on ; another man seated on a bench and a woman bringing him refreshment. (Dated Snake 9 = 1857.)

Across the chasm, between two trees, is stretched a rope hung with yellow paper streamers. The fall should be strong blue in centre, graded lighter to the edges.

No. 48. *Akasaka, Kiri-bata.* Found in two states, but the first, by Hiroshige, is very uncommon, and represents a village at the foot of a tree-covered slope, by the edge of the further bank of a river, seen past two paulownia trees in the foreground on the near side. Dated 4th month, 1856. The block for this view having been damaged or lost in a fire early in its career, Hiroshige II was called upon to supply a new design. This second edition represents the woods in the background in a mist and rain falling, with a cluster of trees close to the river in the foreground and people passing them. This plate, dated 6th month, 1859, is signed " the second Hiroshige," and is considered his best print so signed.

No. 50. *Tsukuda-jima,* " Festival of the Sumiyoshi Temple, Tsukuda Island." A tall white banner in centre of picture bearing down the centre large black characters, and the date Ansei 4 (1857) in small script at the edge ; on the left a procession with festival car passing along a marshy piece of land by the water's edge ; on right a junk at anchor and others in middle distance. Two ships out in the bay and hilly coast on horizon in red glow of sunset. (Dated in margin Snake 7 = 1857.) (Another print confirming the date-seal.)

No. 51. *Fuka-gawa, Mannen Bashi.* A large paper turtle, emblem of age, hung in an opening of the Mannen (" ancient ") Bridge over the Fuka River, commanding a fine view of Fuji, and sailing junks on the water. Dated 11th month, 1857.

No. 52. *O-Hashi no Yudachi,* " Storm on the Great Bridge " over the Sumida River, and people rushing for shelter ; out in mid-stream is a man poling along a raft. Considered *the* masterpiece of the series, and one of Hiroshige's most famous rain scenes. Dated 9th month, 1857. (See Plate 28.)

Sky should be black at top graded to dark grey and shore opposite should show strongly through rain against grey sky ; piers of bridge black. Late issues have *blue* sky, opposite shore almost obliterated, and piers grey. Illustration shows correct state from a very fine copy.

No. 54. *Asakusa-gawa, Shubi-no-Matsu, Omma-ya-gashi,* " Horse-ford, Shubi pine tree, Asakusa River." A night scene on the Asakusa River,

with stars in the sky ; a covered boat passing under the branches of an overhanging pine tree, and the shadow of a woman inside faintly showing on the green blind (omitted in late and inferior copies). Dated 8th month, 1856.

No. 55. *Komagata Do, Azuma Bashi*, "Komagata Shrine and Azuma Bridge." Cuckoo flying against a stormy sky and rain setting in ; behind the bird a wisp of black cloud. Below, the blue river with boats and rafts on it ; on the left a corner of the temple with bridge beyond. In foreground a red banner on a high mast ; buildings seen on opposite bank backed by woods in leaf. Sky should be black at top just above the cuckoo, then a deep slaty-blue-grey, and finally grey above tree tops in background. (Date cut.)

In later impressions the wisp of black cloud is omitted, but instead two small *blue* clouds project on to the darker sky from either side ; also found in very late issues without any cloud at all.

No. 56. *Horikiri*, " Iris Garden, Horikiri." Tall iris flowers against a blue sky, growing by the edge of a pond, and people on the opposite bank admiring the blooms. (Dated Snake 5 = 1857.)

No. 57. *Kameido Tenjin*, "Wistaria at Kameido Temple." The famous " drum " bridge spanning the lake, and people crossing over it, seen through blooms of wistaria hanging over the water in the foreground. (Dated Dragon 7 = 1856.)

A very charming view. (See Plate 28, Illustration 4.)

No. 58. *Sakai no Watashi*, " Sakai Ferry." Three white herons standing amidst the reeds in the river, and two others flying down to them ; higher up stream two ferry-boats crossing opposite a cluster of houses ; white mist in background, above which appear tree-tops and hills (grey) in the distance. Pink sky at top, grey in later issues. (Dated Snake 2 = 1857.)

No. 63. *Suido Bashi, Surugadai*, " Suruga-dai (a suburb of Yedo) from Suido Bridge," on the Boys' Festival (May 5th), and a great paper carp floating from a pole in foreground. Below is the river and bridge, and the roofs of Suruga-dai ; Fuji (grey with streaks of snow on its cone) rising in distance against a crimson sky, changing to pale blue-grey and purple at top. Over the distant roofs float other paper carps and various banners. (Dated " Snake ' intercalary ' five " = intercalary fifth month (i.e. May), 1857.)

No. 64. *Kumano Juni Sha*, " The Twelve Shrines of Kumano," Tsunabazu. A large sheet of water with green banks and small resting-places built by its edge, lined with trees ; beyond them a range of mountains (printed from graded black) rise above a finely graded mist. A good plate when well printed. (Dated Dragon 7 = 1856.)

No. 66. *Soto Sakurada, Benkei Bori,* " Benkei Moat outside the Saku-
rada Gate, Kojimachi." View of the moat and buildings surrounded by
trees on the left bank ; in foreground five figures walking along the bank
towards the gate. (Dated Dragon 4 = 1856.)

No. 67. *Mitsumata wakare-no-fuchi,* " The separating bank at the three
branches of the river." Fuji rising up beyond the city, with its ware-
houses on the banks of the river, and in the foreground a laden sailing junk,
and two other laden barges being poled along, and behind them a bank of
reeds in the centre of the stream. (Date cut.)

No. 68. *Azuma Bashi, Kinryusan Okawa,* " Kinryusan Temple and
Azuma Bridge from Okawa on the Sumida River." In foreground
the prow of a covered boat stretches across the view, and a girl
sitting in it partly seen on left. Beyond appears the temple roof
and its five-storied pagoda ; in distance the Azuma Bridge, and a
blue Fuji with white crest. Cherry blossom falling on the water.
(Date cut.)

In best impressions the water should be graded deep blue round sides of boat
to lighter beyond and deep again at bottom edge of picture. A good plate.

No. 69. *Ayase-gawa, Kane-ga-guchi,* " The Pool of the Bell, Ayase
River." A man on a raft on the Ayase River ; overhead a branch of the
Icho tree in blossom. Dated 7th month, 1857.

No. 73. *Shichu Tanabata,* " Tanabata Festival." In foreground
bamboo poles with streamers and paper decorations flying above the house-
tops ; a grey Fuji rises in the distance above pink mist, changing to blue
above. (Dated Snake 7 = 1857.)

No. 75. *Kanda, Konyama-cho,* " Dyer's Street, Kanda." A grey
Fuji with snow-capped peak seen from Kanda between two tall wooden
stagings, on which are hung to dry long strips of blue and white material.
On the white strips appear, in blue, the monogram of the publisher, and
Hiroshige's diamond seal *Hiro.* In best impressions the strips of cloth
should be *gauffraged* with a minute diaper pattern.

Crimson sky on horizon, blue above. (Dated Snake 11 = 1857.)

No. 76. *Kyobashi, Takegashi.* " Bamboo Bank, Kyo Bridge." Against
a deep blue sky, in which shines a full moon, rises a long row of bamboo
stacks ; across the foreground stretches part of the bridge over a deep
blue canal, a man in a punt passing underneath. A fine plate. (Dated
Snake 12 = 1857.) (See Plate 28A.)

No. 77. *Tepposu, Inari bashi, Minato Jin-sha,* " Minato Shrine and
Inari (" Fox ") Bridge, Tepposu." The bridge over the canal seen be-
tween two masts of a boat (one yellow, the other grey-brown), and roofs of
city beyond ; a corner of the temple appears on the left at the edge of
the water and two laden barges in foreground. Fuji, its peak streaked

with grey, rises in the distance above a crimson sky, changing to blue above. (Dated Snake 2 = 1857.)

No. 78. *Tepposu Tsukiji Monseki*, "The Buddhist Temple Tsukiji, at Tepposu," seen across the river, with its roof rising above the mists ; in the foreground, the tops of two sails, and other boats. (Dated Horse 7 = 7th month, 1858.)

No. 81. *Takanawa, Ushi Machi*, "Ox Road, Takanawa." A rainbow crosses a grey sky above a harbour dotted with sailing-boats and others at anchor, its colours duplicated in two half-eaten slices of melon lying on the shore by the wheel and shafts of an upturned cart, beneath which two puppies are playing. (Dated Snake 4 = 1857.)

Water should be a deep blue in foreground, graded lighter towards horizon, on which lies a crimson sky changing to grey and then deep indigo at top.

No. 82. *Tsuki no Misaki*, "Moon-viewing Cape." An open tea-house with a fine view over the sea, dotted with junks at anchor, and birds flying across the face of a full moon. On the paper screen on the left appears the shadow of a waitress. Dated 8th month, 1857.

No. 83. *Shinagawa, Susaki*, "Susaki in Shinagawa." Benten Shrine in a grove of trees on a small island connected by a bridge to the mainland ; beyond, a wide expanse of sea dotted with sails. (Dated Dragon 4 = 1856.)

No. 84. *Meguro, Jiji ga cha-ya*, "Old Man's Tea-house, Meguro." On the left, a grassy slope with three large trees on it and a man gazing at Fuji in the distance ; below, a small tea-house by the edge of the path overlooking a wide plain, across which a solitary man and horse are wending their way. Dated 4th month, 1857.

No. 87. *Ino-Kashira no Ike Benten*, "Benten Pond at Ino-Kashira." View of the lake and shrine on a small island on the left lying in a grove of trees ; wooded green shores line the lake, and in the distance rise dark hills against a crimson sky above yellow mist. (Date cut.)

Good colour-effect when well printed.

No. 88. *Oji, Takinogawa*, "Takino River, Oji." People bathing in the "Waterfall" River which flows past steep, rocky banks ; on the right a man standing under the straight fall of water issuing from the cliff above, and two others under a shelter built on a flat rock in mid-stream. Bridge in middle distance ; cliffs crowned with clumps of trees, some in brown tints of autumn. Path round cliff on which stands a small red *torii*. The cliff should be yellow, then green, and darker green at top ; water deep blue in foreground. Yellow mist in sky behind trees, blue at top. (Dated Dragon 4 = 1857.)

No. 90. *Saruwaka cho, Yoru Shibai*, "Theatres by Night, Young

Monkey Street." One of the best-known plates of the series. A full moon shining down upon the street, seen in perspective, lined with buildings on each side, and crowds of people promenading. This print is remarkable for the shadows cast by the moon, thus showing European influence in its design. (See page 22.)

Found in two states, the earliest (and very uncommon) has a slight cloud across the face of the moon, omitted in the second state ; either of these, with *large* moon (as in the fine copy here reproduced at Plate B), is the first edition ; in late issues (a third state) the position of the moon is altered and it is smaller. The upper windows on the right, from which three figures look down upon the crowds below, should be brightly lit up (an effect lost in many copies); also the whole row of windows opposite. (Dated 9th month, 1856.)

No. 91. *Ukiji, Akiba no keidai,* " Akiba Temple Garden, Ukiji." In the lower left-hand corner is seen a small booth in which is seated an old man sketching (said to be Hiroshige himself), and a woman and girl standing close by, looking across to the trees on the opposite bank, the lake filling most of the view. European influence is again seen here in the reflection of the trees in the water. (Dated 8th month, 1857.)

No. 92. *Mokuboji, Gozen no niwa.* Another beautiful lake and park scene. View of the lake in the Park of Gozen, Mokuboji, and two women landing from a boat and going up to a tea-house, and beyond it a bridge over the lake with people crossing. (Date cut.)

No. 94. *Mama no Momiji, Tekona no Yashiro,* " Maples of Mama at Tekona Shrine." View through the overhanging branch of a maple tree from an elevated point across the Mama-no-Iri-ye Swamp and its temple to the Oyama Hills in the distance rising above the low-lying mists. One of the masterpieces of the series, when well printed. (Date cut.)

No. 95. *Konodai, Tonè River.* People standing on a high bluff overhanging the river, and admiring the distant view of Fuji across the Plain of Yedo ; junks sailing on the river. (Dated Dragon 5 = 1856.)

The overhanging cliff should be overprinted in brown at the edge and the effect heightened with mica. Fuji *white*, not blue, which denotes a late issue.

(Compare with same view in Hiroshige's " Views of Fuji " series, Plate 11.)

No. 96. *Horikiri Yokozane.* A river flowing past a village of yellow-roofed houses built on both banks ; on the right a small temple in grove of trees. In foreground two people snaring wild birds on the mud-bank of the river. In background rises a great white Fuji above a horizon streaked with mist. A good colour and atmospheric effect when well printed. (Dated Dragon 2 = 1856.)

No. 98. *Ryogoku, Hanabi.* Fireworks at Ryogoku Bridge, Yedo, with

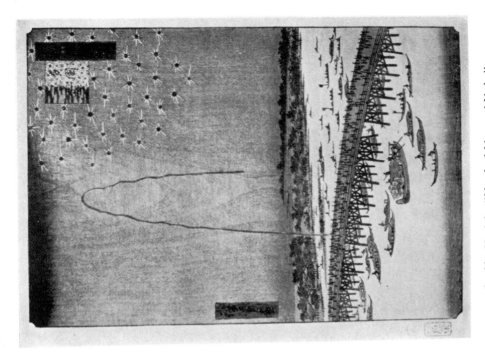

2. No. 98 of the "Hundred Views of Yedo."

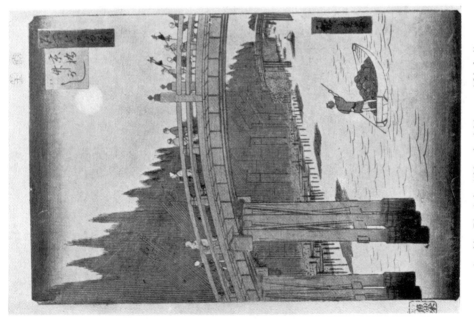

1. No. 76 of the "Hundred Views of Yedo."

PLATE 28A (first part)

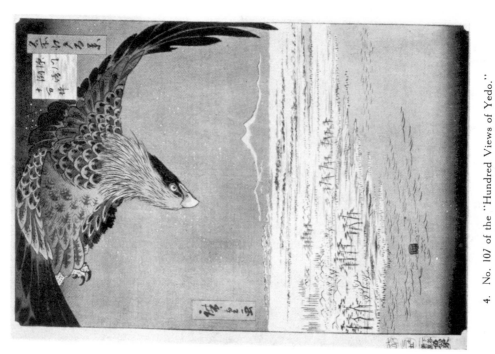

4. No. 107 of the "Hundred Views of Yedo."

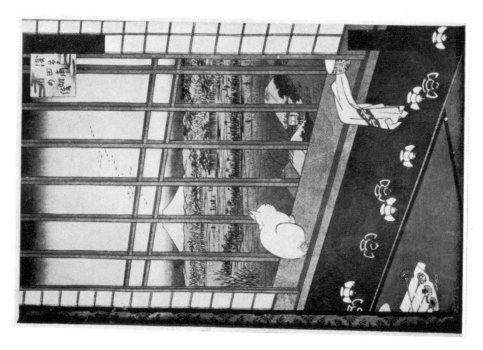

3. No. 101 of the "Hundred Views of Yedo."

PLATE 28A (second part)

a great rocket bursting in the sky in a shower of falling stars, and crowds on the bridge and in boats watching. (Dated Horse 8 = 8th month, 1858.)

In the best and finest impressions (but *very* rare in this state), there should be a bright haze of light round the bursting rocket, and the sky *black*, such as the copy illustrated at page 462 in the B.M. catalogue ; an even finer impression appeared in the Ficke sale, New York. In ordinary impressions the sky is *blue* instead of black and there is no bright haze round the rocket, which greatly enhances the whole effect of the picture. The fine copy here illustrated at Plate 28A appears to be an intermediate state between the above very rare one and the ordinary impression. The sky is a deep indigo, almost black, with a black strip at the top stretching as far as the stars, while the markings of the grain of the wood-block are very sharply defined. The rocket and stars, originally orange-red (*tan*), have decomposed to almost black in course of time.

No. 99. (From this plate to the end are comprised the winter scenes, which contain many fine snow views.) *Asakusa, Kinryusan.* An avenue under deep snow leading up to the Asakusa Temple, and people wending their way thither, viewed through a gateway in which hangs a great circular paper lantern. A well-known plate. (Dated Dragon 7 = 7th month, 1856.)

No. 100. *Yoshiwara, Nihon Tsutsumi,* "The Nihon Embankment leading to Yoshiwara." A half-moon lights up the causeway leading to the Yoshiwara across the rush-swamps, yellow booths at each side and crowds passing. Roofs appear in the distance through the grey and purple mists in the deepening shadows of nightfall ; flight of geese across the sky and moon. (Dated Snake 4 = 1857.) A very fine moonlight effect.

No. 101. *Asakusa Tampo Tori-no-Machi,* "Festival of the Cock, Asakusa Rice-fields." A white cat sitting at the bars of a window watching a procession in the distance wending its way to the Asakusa Temple, a snowy Fuji in the distance. In first edition copies Fuji is tinted grey, an effect missing in later issues. Dated 11th month, 1857. A famous print. (See Plate 28A.)

No. 103. *Senju, O-Hashi,* "The Great Bridge at Senju," with people crossing on foot, a man on horseback, and a passenger in a *kago.* Three sailing junks on the river, which stretches away in the distance behind till lost in the mists, above which rise grey mountains. (Dated Dragon 2 = 2nd month, 1856.)

No. 105. *Ommaya Gashi, Sumidagawa,* "The Ommaya Embankment, Sumida River." Two women standing in the bow of a ferry-boat crossing the Sumidà River at Asakusa, and just reaching the bank close to a mound out of which two willow trees are growing. In first edition copies the trees stand out in sharp contrast against the sky, an effect much minimized in late issues. Dated 12th month, 1857.

No. 106. *Kiba, Fukagawa*, " Timber Yard, Fuka River." Snow scene on the Fuka River, in the timber district ; logs floating in the water and stacked on shore, the whole scene under heavy snow falling from an almost black sky. In foreground the top of a yellow umbrella. The density of the sky varies in different impressions from almost deep black to grey. (Dated 8th month, 1856.)

No. 107. *Fukagawa Susaki, Juman Tsubo*, " The Juman (10,000 acres) Plain, Susaki, Fukagawa." A large eagle hovering in a dark grey-blue sky over a light blue sea in which a tub is floating ; the adjoining plain and the twin peaks of Mount Tsukuba in the distance under snow ; light snow-flakes falling. (Dated Snake intercalary 5 = intercalary 5th month, 1857.) (See Plate 28A.)

One of *the* masterpieces of the series, and one of Hiroshige's most famous prints. While European collectors appear to consider Plate No. 52 (*Storm on the Great Bridge*) as the finest print in this series, American collectors seem to prefer this one. A very fine copy realized $180 (£36) in the Ficke sale, a price unheard-of for any print in this or any other upright series by Hiroshige in this country. This series is, as a whole, more highly valued by American collectors than by their British and European confrères ; in fact, this applies to almost all prints by Hiroshige, particularly the better-known views. They are particularly keen on his snow scenes.

No. 108. *Shiba-no-ura no kei*, " View of the Coast at Shiba." View of coast-line and sea ; flight of *chidori* across the scene ; junks sailing or at anchor. On the right an embankment covered with small pines ; on the left, posts marking the tideway. (Dated Dragon 2 = 1856.)

In best impressions the sea should be *deep* blue in foreground, graded lighter towards the horizon, where it meets a crimson sky ; *deep* blue at top. In late issues the sea is one tint of greeny-blue all through and the sky purple instead of blue.

No. 110. *Senzaku-no-ike, Kesa kake matsu*, " The ' Scarf-hanging Pine,' Senzaku Pond." An old pine tree, protected by a railing, standing on a peninsula jutting out into the lake, so-called from Nichiren having, so it was said, hung his scarf (*kesa*) upon it. In foreground a tea-house with yellow roof and lanterns hung outside. Background of dark hills rising above yellow mists against a crimson sky, changing to deep blue above. (Dated Dragon 2 = 1856.) A good colour-effect when well printed.

No. 111. *Meguro, Taiko bashi, Yuki-no-oka*, " Snow Hill and Drum Bridge at Meguro." One of the best snow scenes in the series. People crossing the bridge over the Furu River in foreground, towards the hill on the left and the Meguro Temple ; snow falling against an indigo sky. All is white and grey except the deep blue river and the figures on the bridge. (Dated Snake 4 = 1857.)

(In best impressions the bridge is *grey*, not brown.) (See Plate 29.)

No. 112. *Atagoshita, Yabu Koji* (name of a street in the Shiba district). Another very good snow scene. People plodding along under heavy snow past some buildings on the left, and the canal on the right with overhanging bamboos and sparrows flying about. (Dated 12th month, 1857.)

No. 113. *Toro no mon, Soto Awoizaka,* " Outside ' Tiger ' Gate, Awoizaka." A very fine night and moon scene. A crescent moon and stars in a dark sky, with flight of birds across the moon and sky. View of a weir (graded blue water) and moat with a broad road alongside. In foreground two almost naked apprentices going from shrine to shrine with bell and lanterns, and beyond an insect-seller carrying his stall of cages, and part of another one standing on the ground on the right. (Dated Snake 11 = 1857.)

(Between January 10 and February 1 in each year, " first pilgrims " used to go from one icy bath to another at the various Fudo shrines to procure the recovery of sick relations and friends.)

In later issues no stars are shown, and the crescent moon is turned the opposite way, with its horns to the right.

No. 114. *Bikuni Bashi, Setchu,* " Bikuni Bridge in Snow." View looking across the bridge which a laden porter is approaching, to street beyond at end of which rises a fire-tower. Snow falling from deep indigo sky. On further side of bridge is a man with his head buried in his umbrella.

On the left is a notice-board stating that " mountain-whale " (really wild boar, so-called to disguise it as a fish !) is for sale. (Dated Horse 10 = 1858.) A fine snow scene.

No. 115. *Takata-no-Baba,* " Takata Race-course " in the Ushigome district. In foreground the white disc of an archery target placed close against a pine tree, and in the distance archers practising at it. Alongside the ground runs the race-course, round which two men are galloping horses in opposite directions ; in the distance a greyish-white Fuji (printed without outline) rises up into a delicate pink sky, changing to blue above. (Dated Snake 1 = 1st month, 1857.)

In best impressions the target and trunk of tree is sprinkled with mica dust ; the grass in bottom foreground should be printed in *deep* green, graded to lighter shade, Fuji delicately tinted in grey.

No. 117. *Yushima, Tenjin Sama,* " Tenjin Shrine, Yushima." Snow scene. View from the summit on which the temple stands looking out across the Shinobazu Pond, in the centre of which stands the shrine of Benten on an island. At the left, part of a *torii* appears (*grey* in early im-

pressions, blue in later ones) ; close by stands a woman with closed umbrella admiring the view, and two other people coming up the steps to the temple from the houses below. (Dated Dragon 4 = 1856.) Very fine plate when well printed.

No. 118. *Oji, Shozoku Enoki Omisoka Kitsune-bi*, " Fire-breathing foxes under Enoki trees at Shozoku, Oji." A number of foxes breathing fire, assembling round a tree at night ; stars in the sky. (Dated Snake 9 = 1857.)

(On the last day of the year foxes were supposed to breathe out fire.)

In imitation of the foregoing, Hiroshige II designed a series, full size, upright, entitled *Toto San-ju Rok'kei*, " Thirty-six Views of Toto " (i.e. Yedo) ; publisher *Aëto* of Yedo, and variously dated between the years 1859 and 1862. The series title is on a narrow upright red label, and the sub-title of the plate itself on an adjoining fan-shaped panel ; date and publisher's seals in margin.

The series as a whole suffers from the crude aniline colours in which many of the plates are printed, but the following are selected as being amongst the best work of Hiroshige II, well drawn and not suffering (except in late impressions) from the above defects.

1. *Ryogoku Bridge, Yedo*. View from a balcony overlooking the Sumida River and the Ryogoku Bridge ; a woman standing and a man squatting on the balcony watching a laden sailing barge pass downstream. On a screen half hiding the figure of the woman is a hanging *kakemono* decorated with an eagle perched on a rock, and on it the signature *Shogetsu ;* sealed *Sho*. (Dated Dog 3 = 3rd month, 1862.)

2. *Makuchiyama Temple by the Imado Bridge*. A very good snow scene. The temple standing in a grove of trees on a hill overlooking the houses by the river bank ; in foreground an island in the centre of the river, and a covered boat passing. Snow falling from a sky black at top carefully graded to grey below ; flakes over the water. (Dated Cock 8 = 8th month, 1861.)

3. *Tenjin Temple at Yushima*. Another very fine snow scene. People walking about the grounds in front of the main gate of the temple during a heavy snowfall ; on paper flags hung round the booth in the centre are written the monograms of artist and publisher. Sky black at top and on horizon, indigo between. (Dated Goat 9 = 9th month, 1859.) (See Plate 29, Illustration 2.)

4. *Tsukuda Island at the Mouth of the Sumida River*. The masterpiece of the set.

Boats fishing by night with flares off the island of Tsukuda, and two

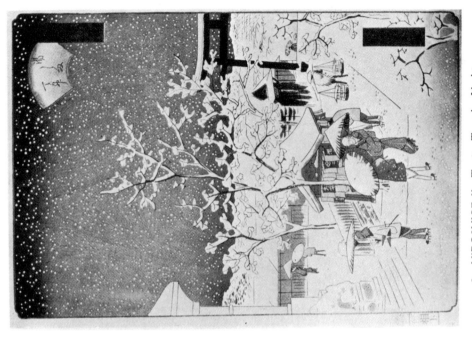

2. HIROSHIGE II : Tenjin Temple, Yushima.

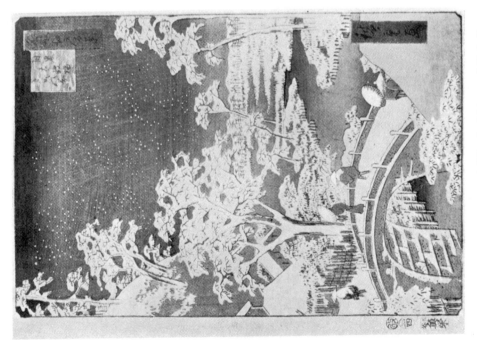

1. HIROSHIGE : No. 111 of "Hundred Views of Yedo."

PLATE 29 (first part)

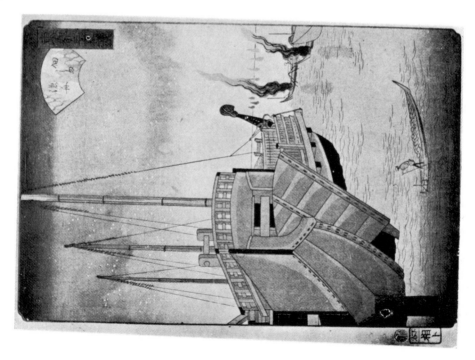

4. HIROSHIGE II : Morning mist at Zojoji Temple.

3. HIROSHIGE II : Fishing off Tsukuda Island.

PLATE 29 (second part)

large junks moored in mid-stream. (Dated Dog 8 = 8th month, 1862.) (See Plate 29.)

Early impressions should show the sea well graded from dark green in foreground to pale blue-green on the horizon, with carefully graded black sky into which mingles the smoke from the flares, an effect missing in late issues, while the flares are also graded from deep red to pink.

5. *Morning Mist at Zojoji Temple.* Another unusually good plate. Early morning scene in the open space in front of the main entrance to the Temple which shows up through the mist ; two lady pilgrims, followed by their porter, looking at a passing fish-vendor. (Dated Cock year = 1861.) (See Plate 29.)

6. *Atago Temple.* View from the terrace overlooking city below to Yedo Bay in distance ; at edge of the broad walk stand two shelters hung round with red and white lanterns ; kites flying over city roofs below and people walking about. (Date cut.)

7. *Mimeguri.* A woman and two men standing under a blossoming cherry tree in the light of a full moon, near Mimeguri Temple ; the top of a *torii* seen below them on the left. One of the best plates of the set. (Date cut.)

PART III

SUBJECTS OF ILLUSTRATION:
(2). FIGURE STUDIES

CHAPTER XX

FIGURE STUDIES: COURTESANS AND *GEISHA*

The Yoshiwara—Utamaro as the Painter of Women—Famous Figure-painters of *Ukiyoye*.

THE majority of designs in figure-studies, either full-length or head and shoulders, are portraits of the inmates of the licensed quarter of Yedo, called the Yoshiwara, a name also applied to the similar districts of other large towns, such as Kyoto and Ōsaka.

The gorgeous apparel and elaborate coiffure adopted by the beauty of the " green-houses " appealed strongly to the colour-print artist in search of material for his brushes.

Apart from such purely artistic reasons, there was also a personal motive to account for the popularity of the courtesan. To understand the cause of this, we must first put behind us all preconceived ideas as to what the term courtesan usually implies.

The late Lord Redesdale, in his *Tales*, says, in a foot-note on the courtesans of Yedo, that, in his opinion, in no country is the public courtesan more looked down upon than in Japan. Doubtless contact with the outer world, and all that such conveys, did not tend to improve matters in this particular respect, but such can hardly have been the attitude adopted towards the courtesan in the days when Japan was a hermit empire.

Considering that all the great masters of *Ukiyoye* lavished their highest skill upon her portrayal, she must have been a very different person from the moralless creature of the streets of our cities.

She was, on the contrary, a woman who had received the highest education, spoke a peculiar, old-fashioned language, and was remarkable for her intellectual refinement.

There were, of course, varying degrees of courtesans, and, as a rule, it is only those of the highest class, called *oirans*, that are represented in prints.

Neither was her position in society considered degrading ; in many instances it was due to filial piety, a daughter selling herself for a term of years to a keeper of a tea-house in the Yoshiwara to rescue her parents from the consequences of debt. On the expiration of the term on attaining the

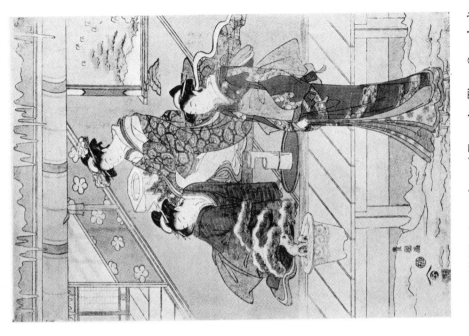

2. TOYOKUNI: Centre sheet of Triptych: Three Court Ladies on the *engawa* in winter time; *fine early work*.

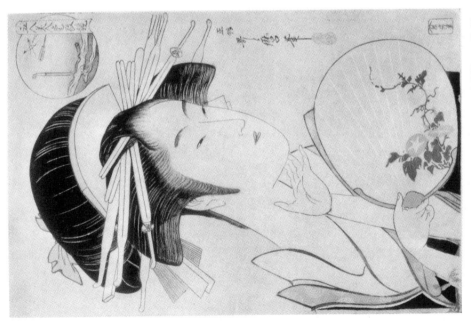

1. UTAMARO: Kisegawa of Matsuba-ya; signed *"Shomei" Utamaro*.

PLATE 30 (first part)

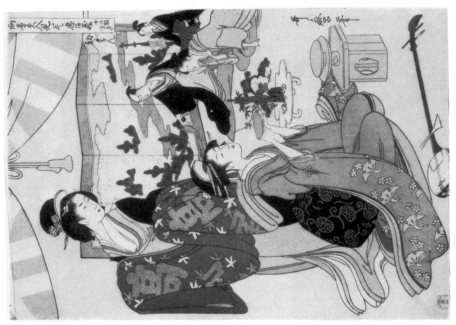

4. UTAMARO : Ladies imitating the First Act of the *Chushingura* ; signed *Utamaro*.

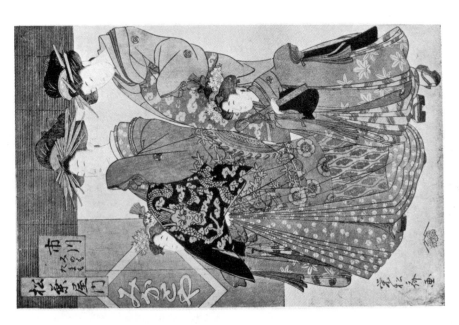

3. CHOKI : Ichikawa of Matsuba-ya on parade ; signed *Yeishosai*. (Late work as Shiko.)

PLATE 30 (second part)

age of twenty-seven, she was still considered a virtuous and marriageable woman. Her state, indeed, was not unlike that of a princess. Each *oiran* had two young girls attendant on her, called *kamuro*, who, on reaching a certain age, were themselves promoted to the rank of their mistress. These *kamuro* were children bought by the *yoro-ya* keepers, at the age of five or six years, for the purposes of prostitution, and during their novitiate were employed to wait upon the fashionable *oiran* like female pages. Like the *oiran* they were generally sold to the Yoshiwara to relieve the poverty of their parents, or they were unfortunate orphans whose unfeeling relatives would thus dispose of, rather than be at the expense of maintaining them. Sometimes an *oiran* is represented with one or more attendants, in addition to her *kamuro ;* these elder attendants were in the nature of maids-of-honour, called *shinzo*, and ranked next to an *oiran*.

The dress of all courtesans, particularly of the *oiran*, was of a splendour wholly different from the costume of the ordinary woman, and their coiffure also was of a very elaborate nature, which was built up upon a light frame and kept in position by a regular forest of light metal or wooden pins, which framed the head like the halo of a saint in a stained-glass window.

They were further distinguished by wearing the sash (*obi*) tied in front, whereas all other women, including *geisha* (dancing and singing girls), tied them with the bow behind. It is often in the decoration of the *obi* that we find the most elaborate and brilliant designs, even in a costume which is gorgeous throughout.

The *Yoshiwara*, euphemistically termed " Flower District," the name given to the courtesan quarter of Yedo, and afterwards applied to the similar districts of Kyoto, Ōsaka, Nagasaki, and other towns, was founded in 1612 by Shoji Jinyemon, and was so called from its being built on the site of a rush-moor (*Yoshiwara*). The name is also said to have been derived from the town Yoshiwara, because the majority of the women in the Yedo Yoshiwara were supposed to have come from that place, but the derivation from the site of its location is generally considered the more correct of the two. Previous to the year 1612, courtesans were scattered throughout the city of Yedo in different quarters, according to the town from which they came. This arrangement being distasteful to the reforming mind of Shoji Jinyemon, he petitioned the Government in 1612 that all courtesans should be made to live in one " Flower District," which petition was granted five years later.

After a great fire in 1657 it was moved to its present site on the north side of the city, not far from the great Asakusa Temple, and enclosed by a wall. Entrance to it was gained by a single great gate, which gave access

to the main thoroughfare in which the tea-houses (or " green-houses " as they were called) were situated. The fronts of these " green-houses " were barred like cages on the street level, and behind these bars sat the gorgeously arrayed *oirans*.

Prints show also the interiors of these houses. Thus, in an unusually large size, oblong print,[1] 12¾ in. by 18¼ in., by Kiyonaga, is depicted the interior of the " House of the Clove," showing the inmates entertaining their guests and others walking about, and behind, on one side, a small army of cooks and servants preparing the viands.

Again, in a triptych by Toyokuni,[2] we are shown the upper floor of the same house, the foreground filled with courtesans and their *kamuro*, and in the centre one with her guest.

The *geisha*, however, fulfils a totally different rôle in Japanese society. Since actresses were forbidden on the stage, the *geisha* was called upon to take her place as an entertainer, and no banquet would be considered complete without her.

Japanese wives were not expected to have accomplishments, such as dancing and singing, so if the husband desired this form of entertainment for himself and his guests he would send to an establishment and hire *geisha* to come and perform at his house. A *geisha* was trained to dance or sing from the age of seven, and retired from the profession while still young, when, if not married, she would keep a school for the training of others.

Apart from being able to dance, sing, and play, the well-trained *geisha* was expected to know all the latest jokes and stories, to be quick at repartee, and an accomplished conversationist.

Her dress was as beautiful as that of the courtesan, but she wore her *obi* tied behind, while her head was not adorned with the enormous hair-pins of the latter.

While courtesans and *geisha* were generally painted for the sake of their portraits (though not, of course, in the strict sense of portraiture as under-stood in European art), we also find them represented engaged in all sorts of occupations, such as in practice are only carried on by artisans and peasants; in processions of nobles, with their retinue of *samurai;* as warriors or poets, and in comparison with beautiful scenery.

Again, the portraits of tea-house beauties are often nothing more than fashion plates, and the most celebrated series of this nature is that to which both Kiyonaga and Koriusai contributed, entitled " First Dyed Designs for Spring Grasses." Examples from this set, both by Kiyonaga and Koriusai, are reproduced at Plate 31, page 186.

[1] Anonymous sale, June, 1913. [2] Satow sale, November, 1911.

A print from a similar series of fashion plates by Yeizan is here illustrated at Plate 33, entitled " Present Day Patterns of Dyes," and shows a *geisha* accompanied by her maid holding an umbrella over her in a heavy shower, the rain indicated by *gauffrage* on a wash background.

Of the many artists who devoted their brushes to the portraiture of women, it is, perhaps, Utamaro who has gained the highest reputation in this branch of design, and become noted as *the* painter of women.

His type is purely his own, and quite unlike that of any other artist, but it was closely followed by his numerous pupils and imitators, while that of Kiyonaga and Shuncho, the two other great artists in feminine portraiture, may be termed the classic type of beauty.

Yeishi, the fourth great figure-artist, combined the gracefulness of Utamaro at his best with the more natural style of Kiyonaga.

A short acquaintance with examples by Utamaro is sufficient to enable the collector to quickly recognize his work from amongst that of other figure-artists, quite apart from the signature on them, so marked is his individuality.

Mr. A. D. Ficke,[1] in the following well-chosen words, thus sums up Utamaro's characteristic type : " Her strange and languid beauty, the drooping lines of her robes, her unnatural slenderness and willowiness, are the emanations of Utamaro's feverish mind ; as her creator he ranks as the most brilliant, the most sophisticated, and the most poetical designer of his time. His life was spent in alternation between his workshop and the haunts of the Yoshiwara, whose beautiful inhabitants he immortalized in prints that are the ultimate expression of the mortal body's longing for a more than mortal perfection of happiness. Wearied of every common pleasure, he created these visions in whose disembodied, morbid loveliness his over-wrought desires found consolation."

In similar language Von Seidlitz says of him : " Utamaro has glorified the Japanese woman with an enthusiasm unexcelled in any other age or nation. It is true that he consecrated his worship to a class of woman that stands outside the pale of society and, in spite of the splendour that surrounds her, is one of the most unfortunate of all creatures ; but he did not depict her as she appears in reality, but formed of her an ideal of nobility and loveliness that stamps her as a goddess."

It would require a whole chapter almost to give merely the titles of the innumerable series designed by Utamaro in which courtesans, *geisha*, or ladies are portrayed, though now many are represented only by one or two prints.

[1] *Chats on Japanese Prints.* London, 1915.

We have referred to the representation of women engaged in various occupations. Utamaro's most famous series of prints of this nature is his set of twelve sheets, intended as illustrations to a book, showing " Women's Work in the Cultivation of Silk-worms."

A reproduction, in colours, of the second sheet of this set is given in Seidlitz's *History of Japanese Colour-Prints*, at page 126, from a copy in the British Museum. Descriptive sub-titles are given on all the sheets except the first two and the last two, written on conventional clouds ; the set can be put together complete as one picture of twelve sheets, which are numbered, or they may be kept separate. (See Note, Appendix II.)

Another well-known large print by Utamaro, in seven sheets, represents the procession of the Corean Ambassador parodied by *geisha* wearing peaked hats, on the day of the Niwaka Festival, a subject parodied by other artists in the same way, and also with children in place of *geisha*.

Yet another well-known, but very rare, print, entitled " The Chief Product of Yedo : making Brocade Pictures," or rather series of prints, complete in two triptychs, shows women engaged in making colour-prints, cutting the block, preparing the paper, taking prints, etc., another instance of the representation of women at occupations in practice followed by men. One print of this series, showing one woman at a low bench with a chisel and mallet cutting out the superfluous wood between the outlines of a design, another at a second bench engraving the block from the artist's drawing, while a third is sharpening a knife on a stone, is illustrated at Plate LXXVII in the Victoria and Albert Museum Handbook. This print has been closely imitated by Kunisada, over the name of Toyokuni, in a single triptych which may be seen at the Victoria and Albert Museum. (See Note, Appendix II.)

Representations of theatrical characters, the six famous poets, the seven gods of good fortune, historical events, legends, and so forth, all furnished themes for the portraiture of Yoshiwara beauties and *geisha*.

Perhaps the most graceful series of figure-studies by Utamaro is that entitled *Seiro Ju-ni-toki*, " Twelve Hours of the Tea-Houses," the title written on a Japanese clock, represented by figures, full-length or seated, beguiled by light occupations.

To give an idea of the estimation in which this series is held, apart from its rarity, it is known that the sum of £275 was asked for a complete set several years ago, while to-day probably well over £300 would be suggested.

Owing to Utamaro's widespread popularity as a designer of portraits and figure-studies of women, he was extensively copied by contemporary artists, even to the point of forging his signature, so that he was obliged in some prints to add the word *shomei* (" the real ") before his signature.

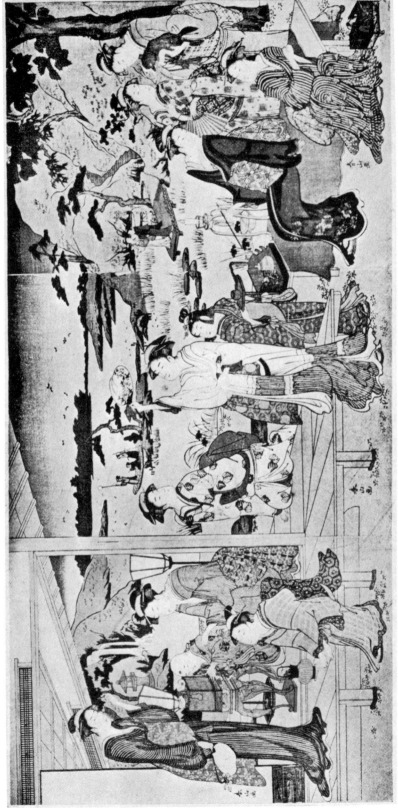

1. SHUNZAN: Catching insects at night-fall; each sheet signed *Shunzan*.
(Reproduced by courtesy of Messrs. Sotheby.)

PLATE 31 (first part)

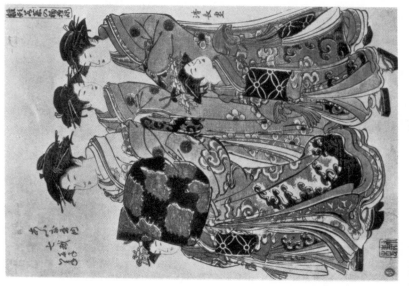

2. KORIUSAI: Kayo-iji of Echizen-ya on parade; signed *Buko Yagenbori no Inshi Koriusai* ("Koriusai, the retired man of Yagenbori").

(Author's Collection.)

3. KIYONAGA: Nanakoshi of Ogi-ya on parade; signed *Kiyonaga*.

(By courtesy of Messrs. Sotheby.)

Both from the series *Hinagata Wakana no Hatsumoyo*, "New Designs for Spring Grasses."

PLATE 31 (second part)

One series of portraits with this addition to his name is a set in which the name of the tea-house beauty is given in a rebus, or picture-puzzle.

Plate 30, Illustration 1, is from a print in this series, a portrait of Kise-gawa of Matsuba-ya. In a circle in the top right-hand corner is the rebus giving her name : A tobacco pipe (*Kise-ru*, shortened into *Kise*) ; below the pipe a representation of a stream or river (*gawa*) ; at the top of the circle, pine-needles (*Matsu*), and below them an arrow (*ya*, also means a house). Therefore we have " Kise-gawa of the House of the Pine." Over one edge of the circle, in a frame, is the title *Gonin Bijin Aikyo Kisoi*, " A Competition of Five Lovely Women." Publisher, OMI-YA. Below Utamaro's signature is a red seal, *Honké*, meaning " the main house."

Other prints of this series which have come under observation are : Sakura-matsu of Choji-ya reading a scroll of poems ; the rebus in the top left-hand corner reads : Cherry-blossom flower = *Sakura ;* pine twig = *matsu ;* coiffure in form of a butterfly = *Choji ;* an arrow = *ya*, also means house.

Matsu-yama of Wan-ya, looking to the left, holding a pipe ; the rebus in top left-hand corner reads : Pine = *Matsu ;* hills (in top of circle) = *yama ;* a cup or bowl = *Wan ;* arrow = *ya* (also " house ").

Another series with the signature " Shomei " Utamaro is one entitled *Seiro Nana Komachi*, " Tea-house (Beauties) as the Seven Komachi." This series is considered one of the earliest by Utamaro in the form of large head studies, of which the following have come under observation : Kisegawa of Matsuba-ya ; Akashi of Tama-ya ; and Hanamurasaki of Tama-ya. (See Note, Appendix II.)

Another series in which the name of the beauty is given in a rebus is a set entitled *Komei Bijin Rok'kasen*, " Celebrated Beauties as the Six (Famous) Poetesses " ; signed simply Utamaro.

A series in which Utamaro also uses an unusual signature is one entitled *Fujin Ninso Ju-bin*, " Ten Physiognomies of Women," and is signed *Somi Utamaro ko gwa*, " carefully drawn by Utamaro the Physiognomist." (See Note, Appendix II.)

In the comparison of beautiful women with scenery, Von Seidlitz mentions a series by Utamaro in which the Fifty-three Stations of the Tokaido are represented by women, half-length figures, each station being indicated in a small circular landscape in the upper right-hand corner. This was a theme followed by other artists, particularly by Yeizan and Yeisen.

To turn to the other great masters of *Ukiyoye* who devoted their brushes to the portraiture of feminine beauty, Harunobu is of great importance in that he was the first artist to introduce the true multi-coloured *print*, and

also the first to popularize this form of subject, though he sought his figures in the domestic scene rather than from the haunts of the Yoshiwara.

His prints, which are of small size, lack the stately magnificence of the imposing figures of Kiyonaga or Shuncho ; they are, nevertheless, prints of great beauty and charm, and his style influenced all his contemporaries and created a furore by their novelty.

At Plate 31 is reproduced a fine full-size print by Koriusai from a famous series of fashion plates, to which Kiyonaga and Shunzan also contributed, entitled *Hinagata Wakana no Hatsumoyo*, " New Designs for Spring Grasses " (i.e. Dresses), in which famous Yoshiwara beauties are arrayed in the latest spring creations. Publisher *Yeijudo*.

In the contributions by Koriusai one drawing is made to do duty for two plates, with the name of the beauty altered. One represents *Tomioka of Ogiya* (House of the Fan) leaving the house on parade with two *kamuro* and an attendant carrying a large lantern on which is the house sign ; the other is *Meizan of Choji-ya* (House of the Clove). In this plate the series title is omitted from the top right-hand corner as is also the name of the beauty, that of Meizan being put instead on the blind of the house behind her, while the house sign on the lantern is also changed.

This series is rare, and Shunzan's contributions to it particularly so. (See Note, Appendix II.)

It is in KIYONAGA and his immediate contemporaries that we find the portraiture of women raised to its highest level ; the period of *Ukiyoye*, in fact, which marks the culmination of its art. It is this period, too, which saw the production of the magnificent triptychs and five-sheet prints of Kiyonaga, Shuncho, Shunzan, Yeishi, and Yeisho.

Probably Kiyonaga's finest and most famous masterpiece is his triptych of Yoshitsune serenading Joruri-hime, showing him playing his flute outside the gate (left panel), and one of Joruri's attendants holding up a lantern to see who the visitor might be, Joruri herself listening inside (right panel), and two other ladies-in-waiting listening at a half-open window (centre panel). A copy of this triptych described as in flawless condition, as published, realized $1700 (say £350) at the Ficke sale (New York, February, 1920).

Another very rare and famous print by Kiyonaga, in flawless condition, also fetched a very large sum ($1375) at the same sale. This was his print (full size, upright) showing two girls walking, hand in hand, along the bank of the Sumida River at dusk, turning to look at another woman following behind, carrying a fan in her right hand. Grey sky suggesting nightfall. This print forms the right-hand sheet of a diptych, or two-sheet print, the left-hand sheet showing two women standing by a low bench, on

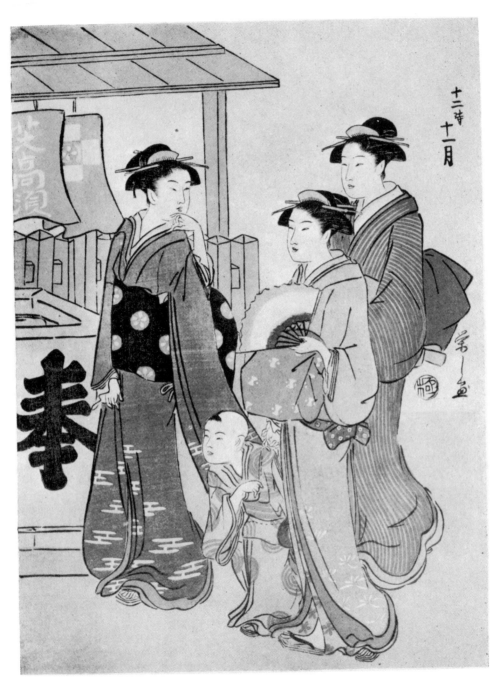

1. YEISHI : A Lady, followed by her maid, turns to look at another woman passing
 with a little boy; one of a series of "Twelve Months," this for the eleventh;
 signed *Yeishi.*

PLATE 32 (first part)

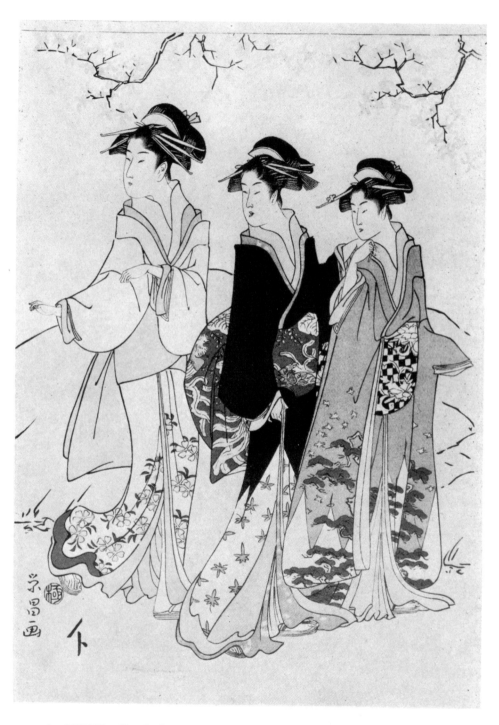

2. YEISHO: Two Ladies, followed by their maid, out walking, passing under a maple tree; signed *Yeisho*.

PLATE 32 (second part)

which a third is seated. The complete diptych is illustrated at page 126 in the B.M. Catalogue.

A third famous print by Kiyonaga is that of which we reproduce an exceptionally fine copy at Plate 31, and to which we referred in Chapter II (illustrated in colours in R. Koechlin's " *Kiyonaga, Buncho, Sharaku* " (Plate XII) (Paris, 1911), and also in monochrome at page 116 in the B.M. Catalogue).

It is apparently one sheet of a triptych (possibly a diptych), with the title (in seal characters) *Fuzoku Adzuma no Nishiki*, " Fashionable Eastern Brocades " (i.e. " Yedo Fashions "), and represents the two sisters Murasame and Matsukaze (the subjects of a *Nō* drama) carrying salt water in buckets from yokes.

Murasame (" Little Shower ") and Matsukaze (" Wind in the Pines ") were two country girls who became the lovers of Ariwara no Yukihira, a nobleman exiled to the small fishing village of Suma. Their daily task was to fetch water from the sea for the making of salt.

Another important print from this series, which contains many of Kiyonaga's masterpieces, is one showing a girl dressed in a black robe walking to the left, accompanied by a boy with shaven pate, and two women, one of them, who talks to her, wearing a black hood. (Illustrated in the Ficke Sale Catalogue, No. 232.) (See Note, Appendix II.)

SHUNCHO, though originally a pupil of Shunsho, a designer of actor-prints, became the most notable disciple of Kiyonaga, following his style with extraordinary closeness.

Shuncho's prints are notable for the extreme delicacy of their drawing, their gently flowing lines, and the subdued, but perfect, harmonies of his colours.

In historical importance Shuncho is second only to Kiyonaga ; in absolute beauty he is at least his equal ; in the estimation of some he is the greater of the two.

Shuncho's prints are very rare, but they are always printed with the utmost sharpness and refinement ; well-preserved copies are even rarer than work by Kiyonaga.

Perhaps Shuncho's most beautiful set of figure-studies is his series of " Five Festivals," consisting of five superb prints of Yoshiwara beauties on parade, in costumes emblematic of the Festivals ; in the top corner a small circle with an emblem of the fête.

For richness of colour and perfection of harmony these prints are equalled by few and surpassed by none, while the goddesses who majestically move across the scene are like creatures from another world.

" Shuncho leads us into a secret heaven where the loveliest and most

flower-like of the gods have remained behind. . . . No women in the whole range of Japanese art so haunt one's memory as do his. . . ." (A. D. Ficke.)

The following are the prints comprised in the above series :—

1. THE FIRST DAY OF THE FIRST MONTH (*Shōgatsu*). Nanakoshi of Ogiya walking to the left, with a *kamuro* on either side, one on her left carrying a large battledore, followed by two *shinzo*; in circle New Year decoration of pine and bamboo.

2. THE THIRD DAY OF THE THIRD MONTH (*Hina Matsuri*; the Girls' Doll Festival.) Makinoto of Choji-ya passing to the right, with two *kamuro* on one side and her *shinzo* on the other, and another companion following. In circle two dolls.

(A copy of this print is in the British Museum, but is wrongly described in catalogue as being part of a triptych; perhaps an error for pentaptych.)

3. THE FIFTH DAY OF THE FIFTH MONTH (*Tango*; the Boys' Festival). Seyama of Matsubaya passing to the right, followed by two little *kamuro*, behind them her *shinzo*, to whom Seyama turns her head to address. In circle two flags.

4. THE SEVENTH DAY OF THE SEVENTH MONTH (*Tanabata*; the Weavers' Festival). Shizuka of Tama-ya holding her paper handkerchiefs up to her chin, followed by two *kamuro* and two *shinzo*, one of whom carries a fan. In circle branch of bamboo hung with small coloured paper streamers and flags. (See Plate D, page 42, for reproduction in colours.)*

5. THE NINTH DAY OF THE NINTH MONTH (*Choyo*; Chrysanthemum Festival). Katano of Ogiya walking to the right followed by two *kamuro*, and behind them two *shinzo*, one of whom holds her sleeve up to her mouth. In circle chrysanthemum flowers.

Another fine set of figure-studies, emblematic of the five festivals, is a series by Utamaro entitled " MUTUAL LOVE AS THE FIVE FESTIVALS," full size, upright; publisher *Wakasa-ya*. Each print shows a pair of lovers in various occupations connected with each festival.

1. *Shogatsu*. A man and a woman beside a *kadomatsu* (the New Year pine and bamboo decoration), she trying to recover a shuttle-cock which he has hit up into its branches.

2. *Hina Matsuri*. A young man presenting a girl with a doll playing the *tsuzumi*, in a box, and she clapping her hands with delight.

3. *Tango*. A youth painting a huge kite with a figure of Shoki, the demon-queller, and a girl watching him.

4. *Tanabata*. A girl seated at a table writing poems and other inscriptions on the pieces of coloured paper which are hung up on bamboo

*Reproduced in black and white in this edition.

branches on the Weavers' Festival, and her lover standing behind her reading one of them.

5. *Choyo.* A young man standing behind a girl, and holding a vase of chrysanthemums, while she rolls up rice-cakes between the palms of her hands, which she packs into a box alongside her.

Next to Shuncho, the chief exponent of the classic type of beauty in figure-studies is YEISHI, followed by his pupils YEISHO, YEISUI, YEIRI, and GŌKYO.

Yeishi is particularly noted for his extremely fine pentaptychs and triptychs ; one of the most famous of the latter is his " Treasure Ship," showing nine noble ladies afloat in a barge the prow of which is shaped like the mythical *ho-ho* kind. They are engaged in the refined entertainments of painting or composing poetry ; in the centre, behind two of the figures, is a tray on which are several picture rolls tied up in a bundle.

This triptych should not be confused with another very similar one (a copy of which is in the B.M.) showing *seven* women in a large barge, as the Seven Gods of Good Fortune in their treasure ship (the *takarabune*), playing various instruments.

Other famous triptychs by Yeishi are those which form a series called *Furyu Yatsushi Genji*, or " Popular Stories of Prince Genji," which illustrate in popular form scenes from the well-known tenth-century romance of Prince Genji, the figures being in the costumes of Yeishi's time. The treatment of the subject is also changed to suit the period. (See Plate 63.)

Thus, in the triptych which illustrates the reconciliation of Prince Genji with a nobleman from whom he had become estranged, instead of the latter, a princess is shown attended by an umbrella bearer and two ladies-in-waiting, preceded by another woman who offers him a branch of wistaria as a peace-offering.

At Plate 2, Illustration 1, is reproduced the centre sheet of a triptych composed of five full-length figure-studies by Yeishi ; subject, " Floating Cherry-blossoms down a Stream on Paper Boats." The right-hand sheet shows a Court lady seated, facing to the left ; the left-hand sheet another standing holding a Corean hat in her left hand, and a fan in her right, each lady with attendants. The background is a very pale yellow wash, and poems written on a dark green cloud above.

Of Yeishi's pupils, YEISHO (see Plate 32), who followed his teacher's style very closely, is the most important ; he produced full-length figures, large bust-portraits, pillar-prints, and triptychs.

Other pupils are YEIRI, YEISUI, YEISHIN, and GŌKYO. The two last-

named are extremely rare indeed ; there are probably less than a dozen prints between them in existence. Yeisui is also very rare.

Gōkyo is notable for the soft and subdued colour-scheme he employed ; greys, browns, and low-toned greens, in conjunction with deep black. A fine example by him (unsigned) is illustrated at Plate 2. Only three other prints (one a diptych) by him, each signed " Yeishi's pupil, Gōkyo," are known to the writer. An example by Yeishin is illustrated in colours at Plate C, page 32,* and also one by Yeisui at Plate D, page 42,* both in fine state.

Further artists in the Kiyonaga manner are SHUNZAN and Kubo SHUN-MAN ; of the latter it may be said that his full-size sheets are so rare as to be beyond the reach of the ordinary collector. His most famous series of full-size prints is his set of " Six Tama Rivers " ; three sheets (from the Salting collection) are in the British Museum, and one of them (that for the Koya Tama River) is illustrated in the B.M. Catalogue at p. 144.

Shunman's smaller book-illustrations and his *surimono*, which are excellent and fairly numerous, are more readily procurable by the average collector.

Shunzan's prints are also rare, and amongst them are some beautiful triptychs ; a fine example is illustrated at Plate 31, showing ladies catching fire-flies at nightfall. The right-hand sheet was illustrated in our first edition ; here we are able to give the complete triptych.

No reference to figure-studies can omit mention of the two most beautiful picture-books of *Ukiyoye*, and therefore, one may add, in the world. One is by Kitao MASANOBU, a set of seven double-sheet prints from his most famous work entitled " Beautiful Women of the Yoshiwara and their Autographs," showing magnificently attired women with attendants dress-ing, reading, writing, promenading, and so forth.

The other is " A Mirror of the Beauties of the Green-houses," by Shunsho and Shigemasa. Single sheets from these books are sometimes met with as separate prints.

Six out of the seven double-page sheets from Masanobu's book are in the B.M. His full-size, single sheet, prints are very rare. (See *Frontispiece*.)

Shunsho and Shigemasa also collaborated in another celebrated work illustrating the cultivation of silk-worms, in twelve sheets (each $9\frac{3}{4} \times 7\frac{1}{4}$), each artist doing six plates, similar to Utamaro's famous set mentioned earlier in this chapter.

(For further notes on figure-study prints see Appendix II.)

*Reproduced in black and white in this edition.

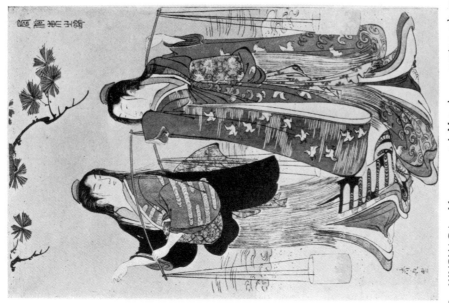

2. KIYONAGA: Murasame and Matsukaze carrying salt water on Suma Beach; signed *Kiyonaga*.
(By courtesy of Mr. Shozo Kato.)

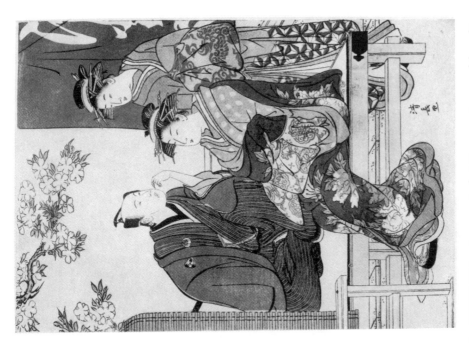

1. KIYONAGA: A *samurai* admiring a courtesan and her *shinzo*; signed *Kiyonaga*.

PLATE 33 (first part)

4. YEIZAN : A *Geisha* and her maid in a shower of rain; signed *Yeizan*;
dated Hare 6=6th month. 1807.

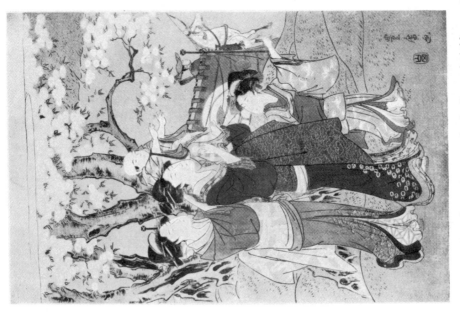

3. TOYOHIRO : One sheet of a triptych; Ladies and children watching
archers at practice; signed *Toyohiro*.

PLATE 33 (second part)

ACTOR-PORTRAITS AND THEATRICAL SUBJECTS (WITH A *CAUSERIE* ON THE JAPANESE THEATRE AND ITS DRAMA)

CHAPTER XXI

ORIGIN AND DEVELOPMENT OF THE JAPANESE THEATRE AND ITS PLAYS

Conservatism of the Native Theatre—Close Association of Art and Drama—The Nō and Kyōgen Dramas—The Joruri, or Popular Drama—The Marionette and Kabuki Theatres.

WHEN Japan, by the revolution of 1868, adopted *in toto* the civilization and methods of Western Europe, discarding in one night, as it were, its age-long feudal system, and burying in its ruins all their ancient art and culture which, in their new-found enthusiasm, they even for a time affected to despise, their dramatic art almost alone escaped the general so-called movement of reform and enlightenment, which has, unfortunately, so largely tended to deprive ancient Japan of its unique local colouring. The native theatre, even at the present day, in its manner of acting, modes of expression, and in the costumes worn, differs but little from the customs and forms that have always been in vogue. The student therefore, of local colour, who finds himself in Japan, cannot do better than seek it in the theatre.

To those unable to visit Japan, the pictorial art of the *Ukiyoye* school, which was so closely allied to the theatre, will prove a no mean alternative, thanks to the skill with which its artists wielded the brush.

" Since the eighteenth century it may be said, without injustice, that the *kabuki-shibai* (popular theatre) has remained stationary. Certain improvements in histrionic and scenic matters have been introduced, but no development in construction and character-drawing, as we understand these terms, no change in the peculiar ethical and feudal teachings of the Yedo period, has supervened. Enter a Tokyo theatre to-day, and you will find yourself in Old Japan, amongst resplendent monsters, whose actions violate our moral sense, yet exhibit a high and stern morality by no means out-moded through the advent of modern ideas.

" Beauty and duty are the hall-marks that stamp as authentic the plays which delight and instruct the Japanese. A race of artists, they expect and obtain such stage-pictures as no other stage affords. To watch act after act of their spectacular tragedies is like looking through a portfolio of

their best colour-prints " (*Japanese Plays and Playfellows*, by Osman Edwards).

The student or collector of Japanese colour-prints cannot but have noticed, from the first, the great preponderance of actors and dramatic subjects in their designs. The landscapes of Hokusai and Hiroshige are, at the present day, more, or at least equally as numerous ; that is to say, an average collection will probably contain as many of these as all others combined, but this circumstance is due to the fact that, by reason of the great demand for them at the time of their first publication, and their consequent large production, more copies of individual landscape drawings have survived to our day than those of other subjects. The production, however, of actor and theatrical prints, chiefly by the later artists of the Utagawa sub-school, again greatly increased on removal of the prohibition against them after 1853, showing that, however strongly landscape may have appealed to the art-loving masses by reason, no doubt, of its novelty, they still hankered after portraits of their stage favourites and their souvenirs of the theatre. Unfortunately the art of the *Ukiyoye* school had, at this late date, become so debased, that its productions have practically little or no artistic value, so that, from this point of view, they need hardly be taken into account.

While certain artists drew their inspiration from landscape, or from natural objects such as birds and flowers, the great majority took the popular theatre for their province ; also, landscape as a subject of illustration only made its appearance during the closing years of *Ukiyoye*, so that popular art and popular drama were in the closest relationship for nearly the whole period of the former's existence.

This close affinity was due to the fact that both arts appealed solely to the masses, and both came into existence within about fifteen years of one another during the first half of the seventeenth century.

Another point they held in common was that, while both owed their origin to China, when once transplanted, they attained a perfection far in advance of that country, so that at their full development, they may be considered more purely native to Japan than the other arts.

The *Ukiyoye* school produced the only purely Japanese pictorial art, and the only graphic record of contemporary Japanese life and customs, while the stage presented scenes from the lives of national heroes and historical events, thus proving an all-important element in the social education of the masses at a time when education for the people at large was of a very primitive nature. As any education beyond the most elementary was practically restricted to the priests and the aristocracy, the popular theatre must, by the nature of its performances, have been largely instrumental in instilling into the masses those sentiments of patriotism

and filial piety which have always been such a strong point in the Japanese character.

In fact, almost the sole aim of the popular theatre, as expressed in innumerable plays, was to impress upon the masses the duty of obedience and self-sacrifice at all costs. This was the theme of all the most popular dramas from the earliest days of the *kabuki-shibai*, and these same dramas are applauded to-day as they were two hundred and fifty years ago. Such are the *Chushingura* and the *Pine Tree, or the Suga-wara Tragedy*, to mention but two of the most famous, both written by Takeda Izumo originally for the marionette theatre, the former in collaboration with Chikamatsu Monzayemon (1653–1734), Japan's two most celebrated playwrights.

Another famous play dealing with the Battle of Ichi-no-tani and called *Ichi-no-tani Futaba Gunki* (" The Story of the Sapling of Ichi-no-tani ") is a further typical instance of the teaching of the popular stage. Like the drama of the *Pine Tree*, it deals with the substitution and sacrifice of an only son in order to save the life of a lord and master. The story of this drama, written by Namiki Sosuki (1694–1750), is given in outline in a later chapter of this volume, where a scene from it is illustrated and described.

The two aristocratic schools of painting, the *Tosa* and *Kano*, were founded in the thirteenth and fifteenth centuries respectively, the former which mainly depicted battle scenes and life at the Court, being patronized by the Mikado and his entourage, while the latter which upheld the Chinese style of painting, was under the special care of the *Shōgun*. These schools had nothing to do with the popular theatre which they, in common with their patrons, looked down upon as something vulgar.

Their entertainment was represented by the *Nō* or lyrical drama, founded on the legends and folklore of Japan and China, and which was originally devised and produced for the benefit of the nobles and *samurai* class, some time during the Muromachi period (1392–1603).

The recitation of these dramas is still in vogue at the present day amongst the aristocracy of Japan. No doubt our readers are familiar with the performances of old Greek plays which are occasionally given in this country at Bradfield College, Berkshire, and University College, London. These *Nō* dramas of old Japan are similar to these Greek plays in that both are recited or chanted, and a chorus takes up the action from the point where the dialogue ends.

Another point of similarity exists in the wearing of masks by certain of the characters ; but beyond this the similarity ends. While the old Greek plays are dramas which reached a high degree of development, the Japanese *Nō* was a very simple and primitive affair. It is sometimes termed a dance, but this is perhaps somewhat misleading in that it only partly describes the performance, which centres on a definite story, and is accompanied by

a chorus whose object is to stimulate the attention of the audience, and intensify the various emotions of the actors. The nearest parallel to the *Nō* drama which Europe affords lies in the passion play, both being of a religious nature, or at least religious in origin.

Together with the *Nō*, and on the same stage, was performed the *kyōgen*, or light farce, which was intended as a foil to the classical severity of the former, and which was a simpler and even more primitive affair than the *Nō*. Like it, the *kyōgen* had a religious motive ; but was played without masks and without any musical accompaniment.

These two forms of drama provided entertainment solely for the *daimyos* and nobles, and were beyond the comprehension of the common people. The actors who took part in them were in the pay of the *daimyos* and never mixed, unless surreptitiously, with the actors of the common theatre.

The author has seen it stated, on the authority of a French writer, that these dramas, although *organized* by the nobility, were nevertheless often given in huge circuses for the benefit of the people at large.

Japanese authorities, however, whom we prefer to follow rather than European, do not appear to take this view, which seems to arise from a confusion of the *Nō dances* with the *Dengaku* and *Sarugaku plays*, which latter were of a comic nature, and were essentially suited to the intelligence of the masses. *Dengaku* is made up of *den*, a " field " or " plot," and *gaku*, a " play," from being acted in fields or on grass plots for the entertainment of the country people.

It is true the *Nō* dance had its *origin* in the *Sarugaku* (c. 1390), but it was not so-called till later.

The above writer appears to base his contention upon the authority of a book (from which he quotes) written by Seami, a famous actor who, writing of his father, Kwanami, says that he could make his art intelligible " even in the depths of the country, or in remote country villages," a description which might well apply to *Sarugaku* or *Dengaku* actors. Both Seami and his father, Kwanami, were famous Sarugaku actors of the late fourteenth century, not *Nō* dancers ; the *Nō* being a later development of the fifteenth century and which took many years to attain to its perfect classical form.

The *Dengaku*, or bucolic mime, may be described as acrobatic, and the *Sarugaku*, or monkey mime, as purely comic, as its name would suggest ; the latter is supposed to date back as far as the sixth century, but its origin is uncertain.

The *Nō* dramas, on the other hand, are amongst the masterpieces of Japanese literature, but, like all great works of art, they were not popular, being read and patronized by the cultured aristocracy, who alone could

appreciate the subtle and beautiful metaphors and similes in which they are cloaked.

The form of drama acted in the popular theatre was the *joruri*, or epic drama, written during the Yedo period (seventeenth century), originally for the marionette theatre, but later adapted to the theatre proper.

The *joruri*, unlike the primitive *Nō* performance, is a drama with a well-defined plot running through it, while it abounds in dramatic situations and owes much to spectacular effect. And this constitutes one point wherein the stage in Japan is widely different to that of Western Europe. The development of a play on the Japanese stage will often unfold itself through entire scenes in pantomime only ; throughout several acts the actors may utter but a few words. Instead, the action of the piece is explained by the chorus who adapts his voice to the needs of the moment. This method of conducting a drama has made Japanese actors the best mimics in the world, and explains much which may otherwise seem grotesque or even absurd in the representation of actors in colour-prints.

With us mere spectacular effect is often introduced to make up for the deficiency of our actors. In staging, let us say, a play by Shakespeare, the European actor is at a disadvantage by reason of his inability to wear the dress and adopt the manners of a more ceremonious and courtly age. The Japanese actor, on the other hand, has never lost, and therefore has not been obliged to assume, the dignity consonant with the garb and habits of a bygone time.

A Japanese drama, therefore, relying as it does on action rather than speech can be interesting even to the stranger totally ignorant of the language, a statement which few would claim for our stage.

The *joruri* being written in simple language, is easily understood by the poorest peasant or artisan. The narrative of the play is chanted to music by a chorus who also, in the case of the marionette theatre, declaims the speeches of the actors. In the theatre proper, the actors themselves carry on the dialogue, and act and dance to the recitation by the chorus of the narrative, which supplies the thread of the story, and also aids the imagination of the audience by describing the actions and facial expressions of the actors.

The name *joruri*, as applied to popular drama, owes its origin to a story, written towards the end of the sixteenth century, called the " Story of the Lady Joruri," which was much in vogue amongst the chanters or public reciters of stories and popular history. It relates how a certain *samurai* prayed to the god Joruri-Kō to bless him with a child, and in response to his prayers he becomes the father of a beautiful girl whom he names after

the god. Owing to the popularity of this story, the theme of which is the tragic love of Joruri for the hero Yoshitsune, amongst the chanters all compositions recited by them came to be known as *joruri*, and themselves as *joruri*-chanters, the term being extended to include the acted play, whether given by marionettes or by real actors.

Some time later, towards the end of the seventeenth or early in the eighteenth century, the name *gidayū* was substituted for *joruri*, after a certain Takemoto Gidayū, who established a marionette theatre in Ōsaka, where he instituted a new style of recitation, which became so popular that his methods superseded those of other contemporary chanters.

The marionette theatre was a development from the simple *joruri*-chanter, and originated some time between the years 1596 and 1615 through the combination of a *samisen*-player of Kyoto, named Chozaburo, with a certain marionette showman. These two joined forces and originated the art of manipulating puppets to the accompaniment of chanting and music. This novelty rapidly caught the popular fancy, so much so that its fame reached the ears of the Emperor in the seclusion of his palace, who accordingly summoned them to give a performance before him. Unlike the theatre proper at which actors performed, the marionette theatre appears to have been frequently patronized by *daimyos* and others of the aristocracy.

The theatre proper was known as *kabuki-shibai*, *shibai* meaning " lawns " or " turf-places," from the fact that the earliest theatrical performances were given on a grass plot, while *kabuki* is made up of the three words or characters, *ka* (song), *bu* (dance), and *ki* (performance). They originated about the same time as the marionette theatre (though the first regular theatre was not opened in Yedo till 1634, a few years after the first of the marionette theatres was established), and are attributed to a certain priestess or dancer, named Okuni, who visited Kyoto about the year 1603, and with Nagoya Sanzaburo (or Sanzayemon), superintendent of Court festivities at Kyoto, erected a primitive stage in the dry bed of the Kamo River, on which she performed dances.

The success which greeted these performances led women-dancers to repeat them in other cities, so that actresses increased in number and theatre-going became a most popular form of entertainment, so much so that, as it developed, it began to affect public morals injuriously with the result that, in 1643, a law was passed forbidding actresses from giving performances. This law remained in force till the middle of last century, and even at the present time, now that women may act on the stage, actresses are considered inferior to the actors of the old schools who used to take women's parts.

In order to render them more efficient in this respect boys intended to become actors of women's parts (or *onna-gata*) were brought up from

youth as women, and wore women's clothes both on and off the stage. Apart also from this legal prohibition against women acting, the physical strain due to the long period of twelve hours (a period which it required a law to reduce even to nine hours) which a play lasted, coupled with the strenuous form of acting, would have been sufficient in itself to preclude their taking part therein except to a limited degree.

Speaking of the Women's Theatre in Kyoto, where all parts are taken by women, Mr. Osman Edwards says : " In fact, however, though the women are exceedingly clever in simulating the gait and gestures of men— if I had not been taken behind the scenes, I should have believed myself in the wrong theatre—they are hopelessly handicapped by physical weakness. The stage is so enormous, and the performance so long, that an artist may reckon on walking ten miles in the course of the day, while the voice is severely taxed by the prolonged stridency of declamation."

Owing, no doubt, to the low moral tone with which the theatre became tainted, actors came to be considered outcasts, so that they could no longer obtain permission to act on the public lawns or gardens, but were obliged to give their performances in the (in summer) dried-up river-beds ; whence they got the appellation of " river-bed folk " (kawa-a-mono).

As the kabuki-shibai gained in popularity, so did the marionette theatre find itself gradually deprived of its patrons, though at the beginning this state of affairs was reversed, owing to the fact that, in the early days of the former, the playwrights were obliged to conform to the individual idiosyncrasies of the actors, who considered themselves of more importance than the play. The natural result was that the kabuki-shibai only attracted second and third-rate playwrights, while in some instances the plays were written by the actors themselves, thereby failing to attract good audiences. In course of time, however, and under the stress of competition with the marionette theatres, the kabuki-shibai put their house in order and staged really popular plays, so that they eventually turned the tables upon their rivals, and almost succeeded in driving them out of the field altogether.

The first regular theatre in Yedo was built by Saruwaka Kanzaburo in the year 1634, and was situated in *Naka-bashi* (Middle-Bridge) Street where it stood for eight years, after which period it was moved elsewhere. Ten years later a rival theatre was opened, and in 1651 all theatres were ordered to be moved to one particular street, just as the various courtesan districts which were originally scattered over Yedo according to the different towns from which their inmates came, were, in 1617, removed to the one district of Asakusa in the northern part of the city. This street was called *Saruwaka* (Young Monkey) Street, from the name of the founder of the first theatre in Yedo.

It is interesting to note that the popular theatre came into existence

both in England and in Japan at about the same date. While Okuni, the ex-priestess, and her lover, Sanzaburo, were giving their performances on a primitive stage, the forerunner of the theatre, in the dry bed of the Kamo River, the first theatre was being erected by the actor Burbage in Shoreditch, London. Also, up to the year 1660, women's parts were taken by men on the English stage, as was the case in Japan up to quite recent times. Another coincidence between the birth of the stage in England and Japan lies in the fact that both countries were passing through periods of warlike excitement at the same time ; England met and defeated the Spanish Armada in 1588, while three years later Hideyoshi subjugated Corea. No doubt these events stirred the minds of the populace of both countries to demand something more vigorous than morality plays and *Nō* performances.

CHAPTER XXII

THEATRICAL PRINTS AND THEIR DESIGNERS

Close Association of Actors and Artists—Their Position in Society—Memorial Portraits—The *Torii* School—Okumura Masanobu and his School—The Nishimura School—Prints depicting Theatre Interiors.

WE have already alluded to the close affinity that existed between popular art and popular drama in Japan. So much so was this the case that artists and actors often worked together in collaboration, the latter seeking advice in the matter of correct design in their costumes, such advice being treated as law. This was particularly the case from the year 1800 onwards, and this intimacy between actor and artist became closer as time went on, lasting right up to the extinction of the *Ukiyoye* school with the death of Yoshitoshi in 1892.

As an illustration of this close collaboration we need only refer to the well-known story of the actor Baiko who visited Hokusai in order to persuade him to accept a commission for the design of a ghost picture, the impersonation of ghosts being Baiko's particular *forte*.

This story, which is too well known to make it necessary to repeat it, also serves to illustrate the low social position in which actors as a class were held even in the estimation of the artists, who were themselves, by reason of their association with the theatre, considered almost at the lowest rung of the social ladder.

Shunsho, indeed, the leading actor-painter of his day, and one of the best-known artists of *Ukiyoye*, states in the preface to a book of actor-portraits that, though he loved the theatre and enjoyed being a spectator thereof, he would have no intercourse with the actors themselves and declined to make their acquaintance.

Even until the beginning of this century actors were still regarded as, on the whole, outside the pale of decent society, even if they were no longer considered rogues and vagabonds, and it is only during quite recent times that this prejudice against them has been overcome, due largely, no doubt, to contact with the outer world.

On the stage, however, the chief actors, such as those who bore the names of Danjuro, Hanshiro, Kikugoro, or other famous actor-clans, were

idolized by the populace, while their portraits, in their favourite characters, sold by thousands, and were in as much demand as those of the accomplished beauties of the Yoshiwara. The stage and the " green-houses " in fact practically monopolized between them the activities of the artists of *Ukiyoye* till the advent of Hiroshige's landscapes.

On the death of a favourite actor his memorial portrait was published, representing him in the attitude of a Buddha, with his head shaved, and clad in the pale blue robe of a priest. A short biography is generally added, giving his age, date of his death, his private and posthumous names, the chief parts in which he acted, and so forth. It is probable, however, that these memorial prints were issued only for private circulation amongst his more personal friends and acquaintances, as they are not at all common, particularly when compared with portraits of actors in character which were bought by the public at large ; such examples of memorial prints as have come under notice have been few in number, and generally of a date after 1820. They were called *Shi-ni-ye* (" death-pictures ").

A good example of a memorial portrait is illustrated at Plate 37, page 228, showing the actor Nakamura Utayemon dressed as a priest and holding a rosary in his hand. Under the outer pale blue robe he wears a purple garment. The inscription states that he died on the seventeenth day of the second month, in the fifth year of the *Kayei* period, that is 1852.

Memorial portraits do not always represent an actor dressed as a priest as in the example here illustrated ; sometimes he is shown in the character in which he made his name on the stage, or which he made famous by his impersonation. Again, more than one actor will sometimes be shown on the same memorial print, or the same actor in different characters.

An unusual kind of actor-memorial print is one in the British Museum collection in the form of a large *surimono* by Kiyomine. It represents Danjuro the first in the character of a warrior, and the text thereon states that it is published by Danjuro the seventh and his son, Danjuro the eighth, to celebrate the one hundred and eighty-second year of the continuance of the Danjuro clan. It is dated the third month of the year 1832, and a list of eighteen plays with which the Danjuros were specially associated is also given.

In the same way we find memorial prints of artists sometimes issued, designed either by one of their pupils or by a fellow-artist from the same studio. One of the best known of these is Kunisada's portrait of Hiroshige, and is undoubtedly Kunisada's best work in figure-studies, and would be a notable example in portraiture by any artist. (See pages 53, 54.)

Kuniyoshi's portrait was drawn by two of his pupils, Yoshi-iku and Yoshitomi ; Kunisada's by Kunichika (diptych) ; and Toyokuni's by Kunisada.

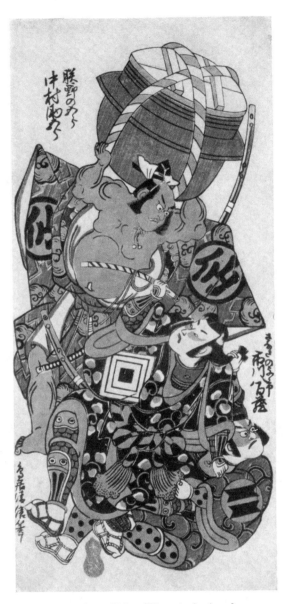

(1). KIYOMASU : Theatrical trio ; *hosoye ;*
signed *Torii Kiyomasu.*

PLATE G (first part)

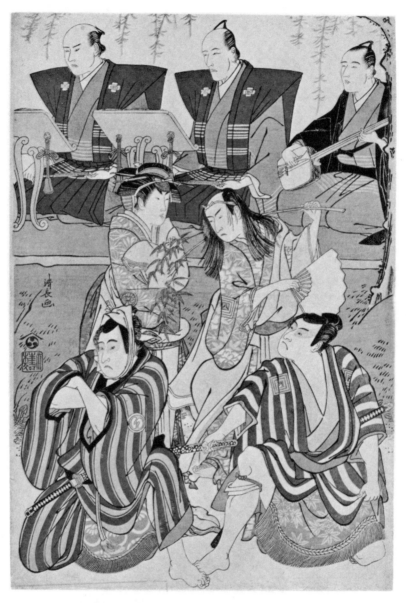

(2). KIYONAGA: Theatrical Scene with musicians;
signed *Kiyonaga*.

At Plate 34, page 210, is illustrated a rare memorial print (*c.* 1790) of the publisher YEIJUDO (Nishimura Yohachi), by TOYOKUNI, issued for private circulation amongst his friends, and therefore limited in the number of copies printed. He is shown seated on his bed in green and wine-coloured robes on which is embroidered his monogram JU, reading an open book on a stand. Round the bed is a two-fold screen on which is painted a falcon, Mount Fuji, and a red sun, and in the left-hand corner an egg-plant bearing fruit. Above the plant is written " First Fuji, second a falcon, third an egg-plant fruit," three lucky dream emblems.

In the bottom left-hand corner of the print is the inscription *Shichi-ju-ichi-ō-kina* ("the 71 years old man") *Yeijudo Hibino* (the latter his family name.)

Yeijudo was the leading print-publisher of his day, the bulk of the work by all the most famous artists of *Ukiyoye* being issued by him.

Three schools are prominent in *Ukiyoye* as exponents of the theatrical print, the Torii, Katsukawa, and Utagawa. Certain artists of other sub-schools and independent artists portrayed scenes from the drama, but eschewed actor-portraiture as such.

The theatrical print had its origin in the large posters displayed outside the theatres as advertisements of the play, and their first appearance in Yedo is attributed to Torii Kiyomoto, said to have been both an actor and designer of posters and play-bills, who came thither from Ōsaka at the close of the seventeenth century. No prints by him, however, are in existence to-day.

Kiyomoto, therefore, may be regarded as the virtual founder of the Torii school, while his son KIYONOBU (1664–1729) was the actual founder. His were the first of the immense number of theatrical prints which were to exercise the talent of so many successive artists, and which raised the level of actor-portraiture to the position of a permanent subject for the wood-engraver, an art which came to be looked upon as the special prerogative of the Torii school throughout the whole of its career.

The second master of the Torii school was KIYOMASU (*c.* 1679–1762). The date of his birth is uncertain, some authorities putting it at 1702, others earlier at 1679. He was therefore either the son or the younger brother of the first Torii, according as to which of these two dates is accepted. Von Seidlitz mentions a play-bill of the Nakamura theatre by him, dated 1693, and also that he produced illustrated books in 1703 and 1712.

This evidence supports the theory that the first two Torii were brothers,

unless Kiyomasu was unusually precocious, though as far as the evidence of the play-bill goes, it is possible that this was only a commemorative advertisement of the theatre as it appeared at its opening in 1693, but published several years later.

The probability, however, is that Kiyomasu was a brother, as much of their work was contemporaneous, and bears such resemblance that without the clue of signature its origin would often be difficult to determine.

On the death of Kiyonobu, Kiyomasu became head of the Torii school and carried on its traditions.

In Kiyomasu and Kiyonobu II the two-colour *print* (in rose-red and green) reached its zenith, and a particularly fine example by the former is illustrated in colours at Plate G, page 204.* As its date can be fixed through the characters represented at about 1745, it must be an unusually early example coloured wholly from blocks, 1743 being the earliest date generally assigned to the invention of this process of colouring.

Next we come to Kiyonobu II (*w.* 1740–1755), who worked contemporaneously with Kiyomasu, and was therefore not one of the heads of the Torii school. He consequently signs himself Kiyonobu only, in distinction to the founder who signed in full *Torii Kiyonobu.* Kiyomasu and Kiyonobu worked during the best period of the two-colour print, and all such prints signed Kiyonobu are by the second of this name, as the first died some twelve years before the process was invented. Mr. Laurence Binyon devotes an article in his introduction to the catalogue of the collection of Japanese and Chinese Woodcuts in the British Museum in discussing the question, " Was there a second Kiyonobu ? " and presents the reader with five different hypotheses as possible answers thereto. The position of Kiyonobu II in the Torii school is certainly not at all clear, but we may set out the following facts about him as fairly well established :

I. He designed *both* hand-coloured and block-coloured prints.

II. He took up print-designing where the first Kiyonobu left off, though there is a gap of a few years between them, and is identical with him in style, a style, however, which undergoes changes in course of time, as does the work of practically all *Ukiyoye* artists.

III. He signs himself *Kiyonobu* only.

What does, however, appear uncertain about Kiyonobu II is his relationship to Kiyonobu and Kiyomasu, as different authorities state him either to be the third son of the former, or a son of Kiyomasu, which would make him a nephew of Kiyonobu. **

*Reproduced in black and white in this edition. **See Addenda on page viii.

The third head of the Torii school was KIYOMITSU (1735–1785), son of Kiyomasu. His work forms the connecting link between the two and three-colour print, and he is credited with having been the first artist to add a third colour-block (greyish-blue) to the original two. He also introduced the practice of overprinting one colour on to another; thus his green is often the result of printing blue over yellow, and purple from blue over red.

Kiyomitsu lived well into the polychrome period of Harunobu, but he appears to have retired from active work on the appearance of the latter; perhaps popularity forsook him under the ascendency of Harunobu's dainty women. Though Kiyomitsu carried on the traditions of the Torii school in its connection with the theatre, we find him also designing figure-studies of women, but his actors predominate.

KIYOHIRO (w. 1750–1766) was another pupil of Kiyomasu—possibly a son according to some authorities—but little is known about him. Practically all his known prints are in two colours only.

We now come to Torii KIYONAGA (1742–1815), the fourth and greatest master of his line, a pupil of Kiyomitsu, though not of the Torii family. While a pupil he worked in the manner of his master in the accepted Torii tradition, but early in his career he broke away entirely from actor-portraiture, and made his fame in the representation of beautiful women, changing thereby the whole face of *Ukiyoye* by the influence of his powerful drawing, and bringing under his spell every contemporary artist to a greater or less degree, an influence which lasted until his retirement about 1790, when Utamaro rose into ascendency. Towards the close of his career, however, he reverted to the Torii tradition with a series of theatrical scenes of actors in character and musicians seated behind. These prints have been very closely imitated by Shuncho.

A good example from this series is here illustrated in colours at Plate G, page 204,*and represents scenes from two different plays. The two standing figures are characters from *Ashia-doman Ōuchi Kagami Abe-no-Yusuna* (a fanciful title, difficult of translation), the one with the fan and branch of bamboo over his shoulder being the actor Ichikawa Yaozo as Abe-no-Yasuna Kioran, or the " dancing-mad " Yasuna ; the other his wife, Kuzunoha, represented by Segawa Kikunojo. The two figures in foreground are Ichikawa Monnosuke (right) and Sawamura Sōjuro (left) as the two wrestlers Nuregami Chogoro and Hanaregoma Chokichi.

KIYOMINE (1796–1868), grandson of Kiyomitsu and pupil of Kiyonaga, was the fifth and practically the last head of the Torii school. Like those of Kiyonaga, however, his prints, which are uncommon, are mostly representations of women, though he produced copies of theatrical prints by Kiyonobu and Kiyomasu. Towards the end of his career he signed Kiyomitsu.

*Reproduced in black and white in this edition.

Other artists of the Torii school who followed its traditions in actor-portraiture are the following :—

KIYOTSUNE (w. 1764–1770), pupil of Kiyomitsu ;

KIYOTADA (c. 1715–1740), pupil of Kiyonobu ; and

KIYOSHIGE (c. 1720–1760), another pupil of Kiyonobu.

The work of all these artists is very rare.

Before turning our attention to the next great school of actor-portraiture —the Katsukawa—we should here mention an independent artist, Okumura MASANOBU (c. 1685–1768), who founded the Okumura school which existed alongside the Torii school.

Though such of his work as has survived to our day—his prints being very scarce—is largely composed of studies of women engaged in various occupations or pastimes, and popular beauties, he did not shun the theatre altogether as did some artists, like Harunobu (in his maturity) and Utamaro for example, who preferred to devote their energies solely to the portrayal of feminine beauty.

In addition to a few actor-portraits, Masanobu has left us interesting prints showing the internal arrangements of a theatre with a play in progress. Two such pⅰints are in the British Museum collection, both hand-coloured.

One shows a scene from the play " Dojoji," in which appears the actor Segawa Kikunojo in the character of Kiyohime, the heroine of the play, approaching the stage along the *hana-michi*, or " flower-walk." On the stage itself are two other actors as monks, sitting under the great bell of the temple. Behind them is the entrance to the temple represented by a gate in bamboo wicker-work. On the margin of the print is an inscription which reads, " Original publisher of perspective theatre-pictures," which may refer either to Masanobu's claim to be the first artist to introduce the ideas of European perspective into Japanese pictures, or it may mean " original " in the sense of " genuine," as his work, which was very success-ful in its day, was forged and copied by others.

The play of " Dojoji " here represented was a very favourite one with the *kabuki-shibai*. It is founded on the story of Kiyohime, the beautiful daugh-ter of a tea-house proprietor. This tea-house stood on the bank of the Hidaka River ; on the opposite bank was the Dojoji Temple. A certain monk, Anchin, on his return to the temple from a pilgrimage to the shrine of Kumano, stopped at the tea-house, contrary to the rules of his monastery which forbade its priests from drinking *saké* or visiting tea-houses. Anchin, however, became infatuated with the charms of Kiyohime, and crossed the river from the monastery to visit the tea-house several nights in succession. She returned his love with even greater passion, but the monk at last,

remembering his priestly calling, succeeded in smothering his unholy desires, at the same time exhorting Kiyohime to do likewise. Her passion, however, only increased the more as that of the priest's waned, until his continued refusals to reciprocate her love changed it into an equally fierce hatred. Kiyohime thereupon called in the aid of the infernal deities against Anchin, but his fervent prayers to Buddha preserved him from harm, though they did not prevent the enraged woman from pursuing him right into the sacred precincts of the temple itself where, in order to escape her, Anchin hid himself in the great bell, which weighed many tons. At the same moment, Kiyohime, by the power of the infernal magic which she had invoked in her passion for revenge, suddenly changed into the form of a dragon-serpent, and threw herself on to the belfry which crashed down under her weight, imprisoning the wretched priest inside the bell. Kiyohime embraced the bell in her serpent's coils ; tighter and tighter grew her embrace, till the metal became red-hot. In vain were the prayers of Anchin and his fellow-monks who stood round horrified at the spectacle ; the bell finally became white-hot and ran down in a pool of molten metal, destroying together both Anchin and the serpent that once had been the beautiful Kiyohime.

The other print by Masanobu of the interior of a theatre is a very large one measuring $17\frac{1}{4} \times 25\frac{1}{4}$ in., or a little larger than the very similar print by Toyoharu which is $15 \times 20\frac{1}{2}$, and which we illustrate at Plate 34. The subject also is the same, a scene from the play of the " Revenge of the Soga Brothers." In the print by Masanobu the principal actor is Ichikawa Yebizo, in the character of Soga-no-Goro, sharpening an arrow, doubtless intended for his enemy Suketsune. At the left is shown the *joruri*-chanter accompanied by a *samisen* player, and on one of the pillars is an interesting notice setting forth the price of admission, 16 *mon* (about 4d.).

The " Soga Brothers' Revenge " was another very popular drama. Two brothers, Juro Sukenari and Goro Tokimune, sought to avenge the murder of their father, Kawazu Sukeyasu, by Kudo Suketsune, when they were but children of five and three years of age. Their opportunity came when Suketsune accompanied Yoritomo on a hunting expedition to Mount Fuji. Entering the camp at night while a fierce storm was raging, they found their way to Suketsune's tent, and killed their man. Instead of making good their escape, they proclaimed their deed aloud and fought Suketsune's retainers. Sukenari was killed, but his brother Goro fought his way to Yoritomo's tent, when he was tripped up from behind (an incident often illustrated in prints) by Goromaru, a retainer disguised as a woman. Goro was taken before Yoritomo who, on account of his youth, would have spared his life, but he could not refuse justice to Suketsune's son, and Goro was executed.

[209]

There is another dramatized story dealing with these two brothers, called the " Reprieve of the Soga Children." Some years after the murder of their father, Suketsune appealed to Yoritomo, on the pretence that the two brothers would one day try and murder the *Shōgun*, who had killed their grandfather. Yoritomo believed this story, and ordered them to be executed on the beach at Yuigahama. However, at the last minute they were reprieved on account of their tender years. This incident has been illustrated by Hiroshige amongst other artists.

The best of Masanobu's pupils was his son TOSHINOBU (*c.* 1750), who is said to have died young. His prints are very rare ; two examples appear in the British Museum collection, both hand-coloured, one of them being representations of actors. Von Seidlitz illustrates a print by him from the Bing collection, Paris, showing the actor Segawa Kikunojo as a woman-dancer in a shower of gold coins.

Another small but important school of artists was the Nishimura, founded by Nishimura SHIGENOBU (*w.* 1728–1740), who produced some actor-prints in the Torii manner. Very little of his work exists to-day ; he is represented in the British Museum collection by a hand-coloured print of two actors as *samurai*.

He was followed by his pupil (perhaps also his son) SHINEGAGA (1647–1756), who designed studies of women as well as actors. The same can be said of Ishikawa TOYONOBU (1711–1785), pupil of Shinegaga. Other artists of this school, such as the famous Harunobu and Koriusai, both pupils of Shinegaga, eschewed actor-prints.

Shinegaga also designed prints showing the interior of a theatre, similar to that by Masanobu described above. One such is before us as we write ; unfortunately its condition is too worn to reproduce well as an illustration. It shows the interior of the Ichimura Theatre, with a scene from the play " Miss Shichi, the Greengrocer's Daughter."

Occupying the stage, on which is set out a vegetable stall, is O-Shichi ; in front of her kneels her lover who turns his head in the direction of the " flower-walk," along which another actor, in the character of an *eta* woman (or wandering minstrel called *tori-oi*), is approaching, his entry being announced by the *kojo* (an official of the theatre for which we have no proper equivalent) on the left of the stage, who holds up a fan.

The play of Miss Shichi, written in 1704 by the playwright Ki-no-Kaion (1663–1723), was another favourite in the *kabuki-shibai*, and was first staged in Yedo in 1707. Yawo-ya O-Shichi was the daughter of a greengrocer whose house was accidentally burnt down. Being thus deprived of a home until it should be rebuilt, she was sent as a dancer to the

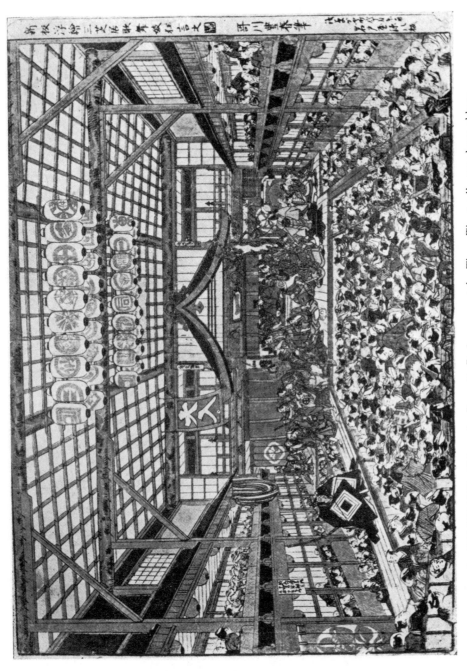

1. TOYOHARU: "View of a Dramatic Performance at the Three Theatres"; very large oblong print on one sheet; signed *Utagawa Toyoharu*.

PLATE 34 (first part)

Utagawa TOYOKUNI.

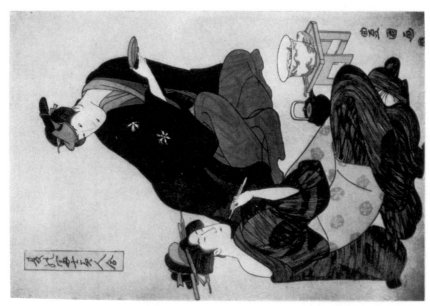

3. Iwai Kiyotaro in private life, being entertained by a lady; one of a rare series "A Comparison of Beautiful Women and Fuji in Summer"; signed *Toyokuni*.

2. Memorial Portrait of the Publisher Yeijudo; signed *Toyokuni*.

PLATE 34 (second part)

Kichi-join Temple, where she fell in love with one of the acolytes. In despair at being parted from her lover when her new home was ready to receive her, she purposely set fire to it, hoping thereby she would be sent back to the temple again. She was, however, detected in the act, and was publicly condemned to death by burning.

The three examples of hand-coloured prints depicting the interior of the *kabuki-shibai* which we have mentioned above, are interesting not only from the subject illustrated, but because they must be amongst the earliest of this type of print, as the artists of the Primitive period (so-called) did not, as a rule, go beyond actor-portraiture for their subjects. The character of the theatrical print did not alter much until the arrival of the Katsukawa and Utagawa schools, when their scope was considerably enlarged.

We reproduce at Plate 34 a particularly fine print (size 20½ × 15 on one sheet) of a theatre interior, by Utagawa TOYOHARU (1733–1814), founder of the Utagawa school. This is printed in green and two shades of *tan*, and shows the whole building from pit to roof and practically its whole length ; the prints described above show only the stage and immediate surroundings.

The play being acted is a scene from the " Soga Brothers' Revenge," an account of which we have already given. In the centre of the " flower-walk " is the principal actor, Ichikawa Danjuro in the character of Soga-no-Goro, while seated in the centre of the stage is Yoritomo. From the roof hang lanterns on which appear the crests of all the leading actors, some of whom we can identify (besides the central figure of Danjuro) amongst the crowd on the stage ; for example, Nakamura Sukegoro, Sakata Hangoro, Iwai Hanshiro and Segawa Kikunojo (both in female character), Ichikawa Yaozo as Yoritomo, and others. Evidently the management had succeeded in procuring all the leading " stars " in the theatrical firmament for the production of this play. The title on the right-hand margin reads " Perspective View of a Dramatic Performance at the Three Theatres," signed Utagawa Toyoharu. On a large banner hung from the roof over the stage are the characters " Great Success." On one side is the curtain which is drawn across the front of the stage at the end of an act.

At Plate 37, page 228, we reproduce a theatre interior by Hiroshige (very rare, early work), ordinary full-size sheet, showing a scene from the same play. On the " flower-walk " (left) are the two Soga Brothers conferring together. Sitting on the stage on a yellow stand (right) is Kudo Suketsune, and opposite, second from left, is Asahina Saburo, famous for his feats of strength.

The scene is apparently laid at the house of Oiso-no-Tora (figure in

centre of stage holding a wooden stand on which is a cup), who was mistress of Soga-no-Juro. Juro is feasting at her house in company with Saburo and Hatakeyama Shigetada, the latter being the highest personage present. Tora, however, hands the loving-cup to her lover first, instead of to Shigetada, who is incensed at this lack of courtesy and vows vengeance. Goro, however, who is close at hand, is suddenly apprehensive that his brother is being attacked, and rushes to his assistance. As he opens the door, Asahina seizes him and tries to drag him in forcibly, but Goro stands his ground, and in the struggle Asahina wrenches off part of the armour he is wearing, an incident often portrayed in prints.

The three large characters on the curtain above the stage (*hi-i-ki*) signify " favour," showing that it is a benefit performance in favour of the principal actor.

CHAPTER XXIII

THE KATSUKAWA SCHOOL

Katsukawa SHUNSHO and his Pupils—SHARAKU.

ON the advent of the polychrome period, theatrical prints such as Harunobu and his school rejected with scorn became the special province of the Katsukawa school virtually founded by Katsukawa SHUNSHO (1726–1793), himself a pupil of a painter Miyagawa Shunsui, who changed his artistic name from Miyagawa to Katsukawa.

In Shunsho and his pupils the representation of actors and theatrical subjects reached its highest level in the polychrome print, a level only maintained for a short period by the Utagawa school in the early work of Toyokuni and his pupil Kunimasa.

Shunsho abandoned the traditions of his master and invaded what had till then been the special province of the Torii school, a subject but little allied to the school in which he received his training, whose *forte* was the portrayal of elaborately-attired women.

Shunsho thus revived the theatrical print, which the popular innovations of Harunobu and his followers had caused to fall out of fashion almost to the point of extinction. Even the Torii school at this period had dropped actor-portraiture to a considerable extent, while its greatest master, Kiyonaga, was almost exclusively a painter of women.

As proof of the hold which the fashion set by Harunobu and continued by Kiyonaga had on the popular taste, we find certain pupils of Shunsho's school, such as Shuncho and Shunzan, to mention two of the best known, following in the steps of Kiyonaga rather than in those of their instructor.

In his particular subject of actor-portraiture, Shunsho became supreme amongst his contemporaries. Almost all of his prints are in *hoso-ye* form, which were originally printed three-on-a-block and afterwards divided. An undivided *hoso-ye* print is a great rarity, while complete, though cut, they are almost as rare. Full-size prints by Shunsho are very uncommon.

His designs are remarkable for their admirable decorative effect, through which they appeal to those who would otherwise see little beauty in

his ferocious faces and tense attitudes, and particularly in his use of masses of black as a contrast. Coupled with an admirable colour-scheme is an intense rendering of dramatic emotion, though in dignified repose his figures are equally as effective.

In his treatment of actors in women's parts Shunsho is particularly happy; their grace and stateliness is unmatched, and to find their equal one must go back to the queens of Greek tragedy.

These characteristics of Shunsho are well indicated in the illustrations at Plate 35 of two fine examples of his work. Illustration No. 1 is the actor Ichikawa Danjuro in character (perhaps that of Soga-no-Goro), and the other is that of an actor (unidentified) as a woman carrying a spear in a procession with its tufted covering over the blade. This print is signed with Shunsho's well-known " jar " seal, a device which he used on his early work when he lived with his publisher, Hayashi (or Iseri), whose monogram appears on it. It is said that during the early days of his struggle on the road to fame, he was too poor to have a seal of his own, and being desirous of remaining anonymous till such time as he was sure of success, borrowed that of his publisher.

In Shunsho and his pupils we find the theatrical and actor-print at its highest level during the polychrome period, a level which Toyokuni might have maintained had he not frittered away his undoubted talent in pandering to a public taste, which, after the death of Utamaro, was rapidly becoming decadent.

About the year 1785 Shunsho gave up print-designing and reverted to his original work of painting, which he continued till his death in 1793.

A distinguished follower of Shunsho, but originally trained in the aristocratic Kano school of painting, is Ippitsusai BUNCHO (w. 1765–1775), an artist of the *samurai* class. This fact accounts for a certain delicacy and refinement in his prints such as we see in those of Yeishi, another *samurai* turned print-designer. Buncho's prints are very uncommon, and are practically all in *hoso-ye* form. He particularly affected actors in the rôle of women, one of his best-known prints being a portrait of the actor Segawa Kikunojo, the foremost woman impersonator of the day.

Buncho collaborated with Shunsho in the production of a book, *Fan-Portraits of Actors*, which is considered one of the three most beautiful picture-books of *Ukiyoye*, the other two being *A Mirror of the Beauties of the Green-Houses*, by Shunsho and Shigemasa, and *Beautiful Women of the Yoshiwara*, by Kitao Masanobu, to which we have already referred. Single sheets from all these books are sometimes met with as separate prints.

Buncho only worked for about ten years which accounts for the scarcity

3. SHUNYEI: Ichikawa Danjuro in character; signed *Shunyei.*

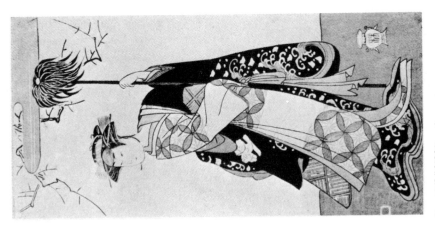

2. SHUNSHO: An actor as a woman in a procession; unsigned, but with "jar" seal.

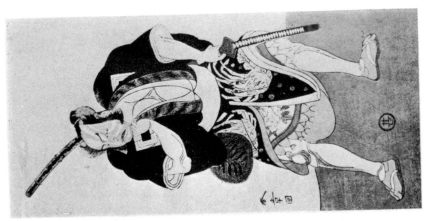

1. SHUNSHO: Ichikawa Danjuro as Soga-no-Goro; signed *Shunsho.*

PLATE 35 (first part)

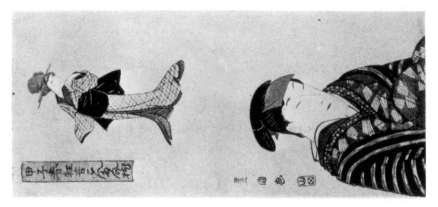

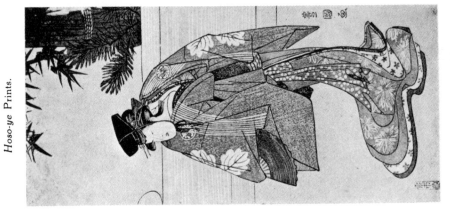

6. An actor dreaming of success in a female character; signed *Toyokuni*.

5. TOYOKUNI: Segawa Kikunojo as a woman "New-Year" dancer; signed *Toyokuni*.

4. SHUNKO: Ichikawa Danjuro in character; signed *Shunko*.

PLATE 35 (second part)

of his prints to-day, coupled with the fact that much of this short period was spent in dissipation, until he was induced by his fellow-*samurai* to mend his ways and abjure his connection with the common theatre.

SHUNYEI (1768–1819) was, perhaps, the leading pupil of Shunsho's studio who carried on the traditions of the Katsukawa school, and on the retirement of the latter, became one of the most prominent artists of *Ukiyoye*. He entered Shunsho's studio while still a boy, and himself became eventually the master of a large and flourishing school. Besides his actor-portraits he is noted for his representations of wrestlers, a subject few artists attempted, and of which he and Shunsho were the chief exponents. A fine wrestler-print by Shunyei is illustrated at Plate 36.

Shunyei was the equal of, and in the estimation of some, superior to his master by reason of his fine, but very uncommon, large size, full-length portraits and head-studies after the style of Sharaku, who is generally credited with being the originator of this type of portrait, though Shunyei has his supporters to this claim.

The great majority of Shunyei's prints, however, are in the *hoso-ye* shape with which the Katsukawa school is particularly associated ; a fine example by Shunyei is here illustrated at Plate 35 (No. 3), showing the actor Ichikawa Danjuro in character, holding up one end of a long paper banner on which is inscribed the crest of the Prince of Soma. Comparing his work with that of Shunsho, Shunyei's actors are more restrained and individualistic. Shunsho portrays the character in the which the actor plays his part ; Shunyei gives us the individual himself. The Danjuro here portrayed was one of the line famous for a well-developed nose.

Equal with Shunyei amongst the pupils of Shunsho is Katsukawa SHUNKO (*c.* 1760–1827), who should not be confused with the other artist of this name, but written differently, a late pupil of Shunyei, who is known as Shunbeni, or Shunko II, *beni* being an alternative reading of the character for " ko." Work by Shunbeni, however, is very rare. The very few prints by him that have come under observation have mostly been a combination of landscape or outdoor scenes and figure-studies like the example illustrated at Plate 2, page 38, though one actor-print by him has been noted. He worked during the first quarter of the nineteenth century.

Katsukawa Shunko also used a jar seal like that of his master, Shunsho, but smaller, from which he was nicknamed *Ko-tsubo*, or " little-jar." A fine *hoso-ye* print by him is illustrated at Plate 35 (No. 4).

Though Shunko lived well into the nineteenth century, he ceased work

after about 1785 owing, it is said, to his becoming paralysed in his right hand when about forty-five years old.

Pupils of Shunyei are Katsukawa SHUNTEI (1770–1820) and Katsukawa SHUNSEN (*c.* 1780–1830). The former was noted, like Utagawa Kuniyoshi, for his prints illustrative of history and legend, and for battle-scenes. He also designed actor-prints and portraits of wrestlers. He ceased work early in his career, however, owing it is said to ill-health, and his prints are in consequence not common.

Katsukawa SHUNSEN (*w.* 1800–1823) designed mostly figure-studies of women and landscapes, and was very fond of a pleasing colour-scheme of pale blue, apple-green, and rose-red. He appears to have designed very few actor-portraits ; out of twenty-one examples by him catalogued in the British Museum collection only two, both triptychs, are representations of actors. In a later chapter, however, will be found described and illustrated a good series of " Chushingura " scenes by him. During his lifetime he was better known for his book-illustrations than for his full-size prints. Towards the end of his career, about the year 1820, Shunsen changed his name to Shunko, being thus the third artist to use this signature. He, however, wrote the character for " ko " differently to the form used by either Katsukawa Shunko, pupil of Shunsho, or by the Shunko known also as Shunbeni. A print signed " Shunsen changing to Shunko " has been noted by the writer, a very uncommon signature.

At this period, the closing years of the eighteenth century, there came on the scene an artist who was destined to create a stir in the artistic and theatrical world of Yedo. This individual was none other than the great SHARAKU (*w.* 1790–1795), himself an actor of the aristocratic *Nō* drama in the service of the *daimyo* of Awa, turned print-designer. No other artist, not even Shunsho nor Toyokuni, took greater advantage of the characteristics of Japanese acting, nor portrayed dramatic emotion with such vehemence as did Sharaku. This vehemence brought down upon him the indignation of the theatre-loving population of Yedo, angry at seeing their favourites treated with so much malignity, so that he was obliged to cease work after but a very few years. His prints are consequently very rare, though considering his short working period, they are more numerous than might have been expected ; the total number known to exist is about a hundred and twenty, of which the Paris Exhibition catalogue of 1910 enumerates 105 examples.

Sharaku seems to have found more favour with contemporary artists than with the public ; both Shunyei and Toyokuni, for example, not to mention others, show his influence in their actor-portraits. He is also credited with the invention of the mica print in which powdered mica is applied to a coloured as distinct from a plain background. A fine series

of Sharaku prints (twenty-seven in all, from the Satow collection) will be found in the British Museum collection.

Sharaku was a realist—too much so in the estimation of the public of Yedo—who drew without regard to anything but the truth and intensity of effect. The outlines of his drawings are exceedingly delicate, and his colour-schemes unique.

Besides the full-size bust portraits which brought him such notoriety, Sharaku has left some full-length studies in *hoso-ye* form which are even rarer than the former. A full triptych in this form, though divided, appeared at an exhibition of Japanese Prints in London in 1910, a particular rarity amongst the rare productions of Sharaku.

His two most famous prints are his portrait of the actor Matsumoto Koshiro with a pipe in one hand and a bandage round his head, facing to the right, in the character of Banzuin Chobei, the chief of the Otokodate who befriended Gompachi (*vide* Lord Redesdale's *Tales* for the story of Chobei). This print is generally known as the " Man with a Pipe." The other companion print is known as the " Man with a Fan," a portrait of the actor Onoye Matsusuke as a *ronin*, holding a closed fan in his right hand (illustrated at page 150, B.M. catalogue). The former of these two prints was reproduced by the artist Chōki (Shiko) in a *hashira-kake* print of a tea-house girl holding a fan on which appears the " Man with a Pipe," a remarkable tribute, probably unique, of the appreciation of one artist for the work of another. This print by Chōki is illustrated at Plate XXIII of the Happer collection sale catalogue (Sotheby). Chōki, however, repeats this compliment in another *hashira-kake* belonging to the same set by similarly reproducing a print by Toyokuni.

This is a full-length portrait of the tea-house waitress of Hira-no-ya, holding a cup and stand in her left hand, and in the other a split-bamboo fan on which is a portrait of the actor Ichikawa Danjuro ; *unsigned*.

The above instance is further proof that the powers of Sharaku were more appreciated by his fellow-artists, notwithstanding the fact that he was not of their class, than they were by the public.

There is also another " Man with a Fan " print by Sharaku besides that mentioned above, a bust portrait of the actor Sawamura Sojuro, looking to the left, and holding in his right hand a large open fan.

CHAPTER XXIV

THE UTAGAWA SCHOOL

Toyokuni and his Pupils—Utagawa Kunisada—The Ōsaka School—Representation of Wrestlers.

IN the Utagawa school, founded by Utagawa TOYOHARU (1733–1814), do we find the greatest number of artists who strove to satisfy the ceaseless demand for theatrical prints and actor-portraits.

Toyoharu himself, whose prints are rare, was mainly a designer of figure-studies and landscape, though he painted theatre posters. He produced hardly any prints after 1775, when he reverted instead to painting. He was the first *Ukiyoye* artist to treat landscape as a subject in itself, and not as a mere setting for figures, and he is particularly noted for his successful employment of European perspective, especially in the representation of buildings, such as the theatre interior illustrated at Plate 34. He evidently learnt perspective from a study of Dutch pictures. His landscapes have aptly been described as the grandparents of those of Hiroshige, whose instructor was a pupil of Toyoharu. It is curious that the two chief pupils of Toyoharu should have taken such widely-divergent paths ; Toyohiro followed in his master's footsteps ; Toyokuni set a fashion in theatrical and actor-prints which dominated the Utagawa school throughout its career to the almost total neglect of the teachings of its original founder.

After the death of Toyokuni, however, the art of the print-designer fell into such a rapid and steadily-maintained decline that, notwithstanding its size, the *Utagawa* school, considered as a whole is, from an artistic point of view, the least important.

From the point of view, however, of the popular theatre and its connection therewith, it was, in its day, the leading school of artists, having gradually taken the place of the Katsukawa, even as the latter in its turn had displaced the Torii.

Utagawa TOYOKUNI (1769–1825), the leader of this numerous body of print-designers, by reason of his prolific output and the number of pupils which he trained, is one of the best-known artists of *Ukiyoye*.

He was the son of a wood-carver, specially of figures of actors, and this fact may have influenced the young Toyokuni in his choice of subjects for his brush, whereby he later became the leading exponent of actor-

portraiture at the close of the eighteenth and the opening of the nineteenth centuries.

Toyokuni's best work is amongst the finest produced by any artist of *Ukiyoye* in actor-portraiture. Up to 1790 he was exclusively a painter of feminine beauty, following in the wake of Kiyonaga, Yeishi, Chōki, and later Utamaro, but on the advent of Sharaku he discarded these and turned his brush to actor-portraiture, though when Sharaku retired from the field with such suddenness in 1795, Toyokuni reverted for a time to studies of women, and became a distinct rival to Utamaro. After the latter's death, however, he abandoned this subject for the second time, thenceforth producing only actor-prints in ever-increasing numbers, but of a steadily deteriorating quality, until his latest efforts were but a parody of his former self. This deterioration, no doubt, was due to an over-hasty production in obedience to a popular clamour for his work, coupled with a coarsening of public taste in matters artistic. His best series in the full-size, upright sheet is one entitled *Yakusha Butai no Sugata-ye*, "Portraits of Actors on the Stage" (rare).

With the advent of Toyokuni, we come to the actor-print wherein actors are depicted otherwise than in character on the stage; in picnics, or in the company of beautiful women taking their pleasure on the waters of the Sumida River, surrounded by their eager admirers.

Toyokuni, also, is noted for his large scenes in triptych form showing the interior of a theatre during a performance, similar to those already described, but on a larger scale. One such triptych we have before us as we write, and another very similar is in the British Museum.

In the centre sheet is a near view of the stage which is occupied by four actors, one of whom is a woman endeavouring to separate two others who have been violently quarrelling, while the fourth waits, squatting motionless behind, for his turn to take part in the scene.

On a level with the stage and somewhat behind it, on the right as viewed by the spectator, is the orchestra, in front of whom kneels the leader, with two blocks of wood in his hands, which he bangs violently on the floor when additional noise is required to emphasize the scene that is being enacted on the stage. In front of him again, with a book in his hand, is the prompter.

Behind a black screen which partly hides the orchestra is the chorus, whose functions have already been described; opposite the orchestra, on the other side of the stage, is a crowd of coolies who are almost invading the stage itself, so intense is their excitement, while an attendant squats in front of them to keep them back.

Above them in a gallery is another crowd of women and coolies. At the sides are boxes filled with women of a superior class and of a more serious turn of mind, while the uppermost tiers are occupied by inmates of the Yoshiwara. Immediately round the stage itself is a miscellaneous

crowd penned in small compartments, three or four in each, whose heads are on a level with the stage. All are not equally engrossed with the scene being enacted in front of them ; one coolie pours himself out a drink of *saké*, while in the next compartment another is enjoying an easy shave.

Three young women, arriving late, are making a somewhat hazardous passage to their places under the guidance of an attendant, along the very narrow ledge which divides the different compartments, to the evident amusement of the occupants thereof.

At the left corner of the stage is shown the end of the principal " flower-walk " (there is another on the other side of the auditorium, but only half the width) which runs thence to the back of the auditorium, and which gives access to the pit, besides being used by the actors for their exits and their entrances, specially when illusion requires them to come from a distance, or walk in processions.

This custom led actors to commence their dialogue as soon as ever they set foot inside the auditorium, and behind their audience, long before they reached the stage. The " flower-walks " thus became adjuncts to the stage, while the action of the play could be transferred from one to the other as circumstances required ; the audience thereby were literally in the thick of the plot and become, as it were, part and parcel of the drama being enacted in their very midst, and not, as with us, something apart.

The print by Toyoharu illustrated at Plate 34 shows how the action of a play was thus transferred from the stage to the " flower-walk," whereon Danjuro holds forth to the pittites, apparently oblivious to the invasion from the stage of Suketsune's retainers to attack him.

Toyokuni's triptych gives a very realistic representation of the interior of the *kabuki-shibai*, the arrangement of the stage and scenery, position of the orchestra and chorus, to say nothing of the types of audience which patronize it, and the evident gusto with which they enjoy it. Which theatre is represented is not stated, nor are the names of the actors given ; the title simply reads " Great success at the Theatre ! " Neither can the play being acted be identified from the scene depicted.

Kunisada has copied the right and left-hand sheets of this triptych practically line for line, but the scene on the stage in the centre sheet is different.

Another similar triptych by Toyokuni is in the British Museum collection, and represents a scene which is supposed to take place outside a house, in winter. Two women from inside look out at Ichikawa Komazo on the left, who, with drawn sword, defies three men advancing from the right from behind the house. Behind Komazo stands Ichikawa Danjuro. The proceedings are enlivened by a free fight amongst certain of the

spectators on the left, evidently caused by the strong objections of a coolie to being thrown out, in which the immediate audience are more concerned than in the fight about to open on the stage.

Sometimes a section of the stage was made to revolve, so that while one scene was being enacted another was being prepared behind, and on a given signal the turn-table was revolved bringing to the front fresh scenery and new actors. Or the first act of an entirely new play could thus be presented.

Revolving stages, trap-doors, and such-like accessories are not inventions of the modern European stage, as is probably generally imagined. They existed in Japan at least in the early eighteenth century, if not in the seventeenth, though the methods of working were, of course, primitive. The trap, for instance, was operated by a man hauling on a rope passing over a pulley, and fastened to the lower end of an upright in the centre of the trap, like a centre-leg table.

In certain respects, however, in connection with stage scenery and stage management, the Japanese theatre may seem to us too complaisant. For example, the leader of the orchestra (the man with the two blocks of wood), the prompter, and the stage attendants who remove " properties " or otherwise assist and attend on the actors, are dressed in black or a neutral colour because they are thereby supposed to be invisible, whereas, as a matter of fact, these functionaries are very much in evidence. A Japanese audience, however, is far too polite to notice them when custom demands they should be considered invisible.

Though the actors of the popular theatre wore no masks, they frequently painted their faces with red streaks as a substitute, as shown in the prints here reproduced, in order to enhance the effect of facial expression, while their elaborate and strikingly designed costumes afforded excellent material for colour-print artists, an advantage none made better use of than Toyokuni.

In fact it is often the magnificent costumes, so peculiarly adapted to the technique of the colour-print, that form the chief attraction of actor-prints for many who find the portrayal of the features and the modes of expression employed difficult to appreciate.

Actor-portraits are found full and three-quarter length in character, or as head-studies only ; singly and in pairs.

Generally the name of the actor is given, and the character in which he is represented ; at other times the only identification is by the *mon*, or crest, on his sleeve.

Toyokuni's best actor-prints were produced between the years 1790

and 1800, both full-size and in *hoso-ye* shape ; the former often have a grey-wash background evidently in imitation of the coloured mica background used by Sharaku, or the silver-prints of Utamaro.

While, perhaps, Toyokuni's reputation as an actor-painter was at one time held too high, there seems a tendency at the present day, particularly with American collectors, if we may judge by the criticisms of Mr. A. D. Ficke, one of the most recent writers on the subject, to unduly discredit him, in proportion as the estimation of other artists in this respect has risen.

Doubtless this lower estimation of Toyokuni is primarily due to the relative abundance of his late work, which is of a poor quality, and which we see perpetuated in an even worse form by his numerous pupils, particularly by Kunisada.

As an actor-painter, however, he should be judged by his early work, which is of a high order of merit. On this point we take leave to quote from Mr. Strange's Handbook to the Victoria and Albert Museum, which contains a very complete collection of Toyokuni's large early actor-prints.

With a collection such as this before one, it is possible to arrive at a better judgment with regard to Toyokuni's powers as the designer of actor-prints.

" These portraits of actors," writes Mr. Strange, " are the work of a master of the highest artistic rank, whatever be his social position. They have not the prettiness of the graceful but, truth to tell, somewhat inane females of Toyokuni's predecessors and contemporaries. The face and pose are often hard and angular ; but, as anyone will admit who has ever seen a Japanese play, these qualities are absolutely inherent in the Japanese actor at work. Indeed the face was as a mask, and the Japanese stage of old times held nothing like the human restlessness of a European actor. Thereon movement was slow, studiously controlled, and worked into what was really nothing more than a series of *tableaux ;* exactly such as Toyokuni, in fact, represents over and over again with perfect realism. His rendering of dramatic emotion is intense ; but it is that of the Japanese, and not of the European actor.

" And the simplicity of his convention, the unerring lines of his composition, and the inimitable dignity of his subjects, when such is required of them, are all evidences of great and personal skill. His colour is always good and generally in a somewhat subdued key . . . a notable characteristic is the fine use he made of black in solid mass. Probably no other artist of his class has excelled him in this respect—few have, even occasionally, equalled him."

The above constitutes, in the writer's opinion, a much fairer estimate

of the power of Toyokuni as a designer of actor-prints than what most collectors and writers on the subject seem disposed to concede to him.

Toyokuni's powerful rendering of dramatic scenes is well shown in the example by him reproduced in colours at Plate C.* This print, which by itself would entitle him to rank amongst the greatest of dramatic artists, depicts the actors Ichikawa Omezo and Onoye Matsusuké in the characters of Watanabe-no-Tsuna and the *Oni* of Rashomon. There are two versions of this legend, one in which Watanabe is attacked by an *Oni* during a rain-storm at the gate of Rashomon, when he cut off its arm. He hid this arm in a box, refusing to show it to anyone, but was at length prevailed upon to do so by an old woman. As he opened the box, the woman assumed the form of a witch with the horned face of Hannya, and pouncing upon the arm, carried it away. (See page 32.)

The other version is as follows : A beautiful woman asked Watanabe to escort her to Gojo, as she was afraid to travel alone. He helped her on his horse, but during the journey she changed into a demon, and seized him by his hair ; whereupon he drew his sword and cut off her arm. The remainder of the story is the same as the first version.

Another very striking theatrical *duo* by Toyokuni, and one which clearly shows the influence of Sharaku, is reproduced at Plate 36, page 224. This represents the actors Ichikawa Danjuro as Matsumaye Tetsunosuké (or Arajishi Otokonusuké), and Ichikawa Komazō in the character of Nikki Danjo, in a scene from a popular play called " Sendai Hagi."

Nikki Danjo was a retainer in the service of the Lord of Sendai, and headed a conspiracy to rob the latter's child of his inheritance on his father's death. By the devotion of the child's nurse and her husband, Otokonu-suké, they sacrifice the life of their own son whom they allow to be poisoned by the conspirators in the place of their young lord. The scroll which the rat is carrying in its mouth contains the will of the Lord of Sendai giving the title of succession to his son. This Danjo contrives to steal, and to effect his purpose assumes the form of a rat by magic incantation the moment Otokonusuké attempts to catch him, and so escapes. Otokonusuké, however, manages to hit the rat with his fan, when Danjo immediately changes back into himself again, but with a wound in his head. (In the play this transformation is effected on the disappearance of the rat by Danjo rising up through the trap-door in the ' flower-walk,' holding the *makimono* in his mouth.)

Danjo is seized and tried for theft and witchcraft, and punished by imprisonment.

After serving his term he goes to the judge who sentenced him, and expresses sorrow for his deed. The judge receives him graciously, but the treacherous Danjo contrives to get close up to him and stabs him.

*Reproduced in black and white in this edition.

Retainers rush to the help of the murdered man, but Danjo expires by his own hand at the fall of the curtain.

The above scene, Otokonusuké attacking the rat, forms the sixth act of the play, and is illustrated in a print by Kiyonaga in the British Museum collection.

Another well-known scene from this play is that known as the " *Sage-giri* " or " hanging by the crown of the head " scene, in which Yorikuni, Lord of Sendai, hangs the courtesan Takao over the side of a boat by her hair, and lets her fall into the waves by cutting it through with his sword. This scene is also often found illustrated in prints.

Takao was a very famous Yoshiwara beauty who persistently refused the advances of her admirer, Daté Tsuna-mune, Lord of Sendai. He, however, bought her for her actual weight in gold from the *joro-ya*, and ordered her to his castle. Still refusing to become his mistress, she rather chose death by drowning in the Sumida River.

The play, *Sendai Hagi*, is founded on an actual historical event, the characters being taken from an earlier period and the names altered, in the same way that the famous " Chushingura " drama was adapted for the stage from history.

Thus Otokonusuké is the same as Matsumai Tetsunosuké, another retainer in the employ of the Lord of Sendai, who caught Danjo in the act of stealing a valuable book from his master's room.

As examples of Toyokuni's work in *hoso-ye* form (*c.* 1800), we reproduce at Plate 35, Illustrations 5 and 6, and at Plate 36, three fine examples ; one (No. 5) a portrait of the actor Segawa Kikunojo as a woman *Manzai* or ' New Year ' dancer, with a grey-wash background across which is a band of pink mist, and behind that a *kadomatsu*, after the style of Shunsho and his school.

At Plate 36, No. 3, is a full-length figure of the actor Ichikawa Danza-buro, also as a woman dancer, holding a fan in one hand and a rattle in the other. This is in a style more purely that of Toyokuni himself, without a background. In one case the actor's name can be identified from the *mon* or crest on his dress ; in the other his name is written in characters.

As a large number of actor-prints only give the actor's name by the crest he wears, we reproduce in an appendix various actors' crests with their clan names, which we have been able to identify.

Illustration 6, Plate 35, shows an entirely different treatment. The title reads " Secret thoughts of the Pillow, a Spring Phantasy for the Rat Year " (i.e. 1804), and the subject is an actor dreaming of his success in a woman's part, probably in allusion to Rosei's dream, a story taken from the Chinese.

2. KUNIMASA I: Sawamura Sojuro (standing) and Segawa Kikunojo in character; signed *Kunimasa*.

1. TOYOKUNI: Ichikawa Komazo and Ichikawa Danjuro in the play *Sendai Hagai*; signed *Toyokuni*.

PLATE 36 (first part)

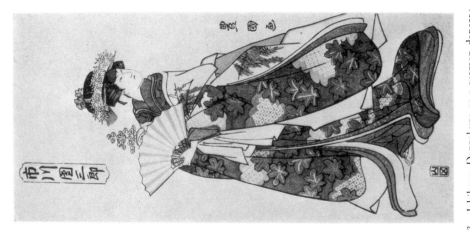

3. Ichikawa Danzaburo as a woman dancer; hosoye; signed *Toyokuni*.

4. SHUNYEI: The wrestlers Shachihoko and Nishikigi at grips; signed *Shunyei*.

PLATE 36 (second part)

Rosei (Chinese, Chao Lu Sheng), hearing that the Emperor was in need of councillors, set out for Canton to offer his services, and on the way met a *Rishi* or *Sennin* (immortal) who gave him a magic pillow. While waiting for his evening meal to cook, he rested his head on the pillow and fell asleep, dreaming that the Emperor becomes so pleased with his administration that, in gratitude for his services, he gives him one of his daughters in marriage.

Waking up, however, to find his meal still uncooked, he realized that his dream was a warning of the transitory nature of all earthly greatness, and instead of pursuing his way onwards, returned home to meditate thereon.

This print shows also the piece of purple silk which actors wore at this time on their foreheads, in virtue of a decree which ordered them to shave off their front hair, as the Government considered their good looks were too liable to play havoc with the hearts of the gentler sex. To replace their shorn locks, actors substituted this piece of silk, which, if anything, enhanced their personal appearance, and had an effect opposite to what the law had intended.

Following even closer the style of Sharaku are Toyokuni's large heads on a grey background in emulation of the former's large bust portraits published in 1794.

Like Sharaku's portraits they are notable for the very fine outline drawing, refinement of colour-scheme, and careful printing. Three such head-studies are in the British Museum collection, one of them, a portrait of an actor as Yuranosukè, the leader of the forty-seven *ronin*, being reproduced in the catalogue thereto.

None of Toyokuni's early actor-prints, such as described above, are at all common, particularly really fine copies of them, and this especially applies to his large heads.

The only other artist of the Utagawa school whose actor-prints are of a high order of merit—by some esteemed even above those of Toyokuni—and which were very popular in his lifetime, is Utagawa KUNIMASA (*w.* 1772–1810), an early pupil of Toyokuni. Owing to the fact that he worked for a short time only, his output was small, and his prints to-day are consequently very rare. They show almost a closer resemblance to the style of Sharaku than to that of his teacher, though doubtless the fact that, at this period, Toyokuni himself was largely influenced by this same great personality, reflected itself to an even greater degree in the pupil. A fine example by Kunimasa, showing clearly the influence of Sharaku, is illustrated at Plate 36. Besides full-length figures, Kunimasa also designed large head-studies.

Another, even rarer pupil of Toyokuni is KUNIHISA, said to have been a female pupil. If this surmise is correct, this must be an unique case in *Ukiyoye* of a woman print-designer. A print by her of the actor Segawa Ronosukè as an *oiran* is reproduced in the sale catalogue of the Tuke collection (Sotheby, April, 1911), and is signed " Kunihisa, pupil of Toyokuni." As the latter died in 1825 we should be inclined to date Kunihisa somewhat earlier than the period attributed to her in the above catalogue (1840–1860). The quality and style of drawing, also, suggests an earlier date, rather 1815–1830. If working as late as 1840, she would have been a pupil of Kunisada, who was then the master of the Utagawa school. The writer, however, considers her more likely to have been pupil of Gosotei Toyokuni.

After Toyokuni's death, in 1825, actor-portraiture fell into a rapid decline, and in the hands of his followers, led by Kunisada, eventually degenerated into pure caricature, squint-eyed, long-nosed, and wry-mouthed, defects enhanced tenfold by the shrieking colours.

Amongst other pupils of Toyokuni who died young or ceased work early in their career, before the art had so far advanced towards decay, and whose prints therefore are often above the level of their longer-lived contemporaries, may be mentioned the following : —

Utagawa KUNIYASU (*c.* 1800–1830), who designed actor-prints amongst other subjects, and whose drawing and colour is often good. His prints are not common, and were produced between the years 1805 and 1820.

Other pupils, such as Kunimaru, Kuninao, and Kuninaga, all of whose work is uncommon, appear to have designed studies of Yoshiwara beauties rather than actors, judging from such prints by them as have come under observation. All these worked only during Toyokuni's lifetime.

A very rare contemporary of Toyokuni, and fellow-pupil of Toyoharu's, is Utagawa TOYOMARU (*c.* 1785–1815), who designed actor-prints. The only example by him that has come under observation is a print in the British Museum collection. Von Seidlitz mentions him as an actor-painter, quoting examples from the Bing and Hayashi collections. He was also a pupil of Shunsho under the name of Kasumura Shunro.

The artist who dominated the Utagawa school after the death of Toyokuni is his chief pupil Utagawa KUNISADA (1786–1865), whose production of actor-prints was even greater than that of his master.

His first prints of this nature appeared about 1810, closely following the style of his teacher, and he is said to have achieved fame at the very beginning of his career by his portrait of a celebrated actor.

As an example of his productivity, he issued, in collaboration with Toyokuni, a series of some hundred and fifty sheets of one actor alone in his different parts.

His early work, which carries the signature Gototei (" Fifth ferry-house ") Kunisada, is good ; this name signified his ownership of a ferry of which he held the license. About 1834 he changed this to Kochoro ; and ten years later assumed the name of his master as Toyokuni the second, thus ignoring the prior claim of Gosotei Toyokuni (originally Toyoshige), an adopted son and pupil of Toyokuni, whose name he used after his death, and was the real second Toyokuni.

It is from this date (viz. 1844) that we see most marked evidence of the rapid decline in Kunisada's work, and in that of his contemporaries and pupils. The drawing becomes rougher and cruder, the designs needlessly intricate and filled with a mass of bewildering detail of composition, which is reluctant to leave even the smallest space unoccupied, while the colouring becomes much stronger and garish.

" If we shut our eyes to all the clumsiness, crudeness, and exaggeration in his (Kunisada's) work, there still shine through it glimpses of the old grand style ; . . . but the falling-off is nevertheless so great that we can only call this new tendency, which entirely dominated Kunisada, the evidence of a rapid and uncontrollable decay " (Von Seidlitz).

The very fine, large head-study of the actor Seki Sanjuro (private name Kazan) in the character of Kiogoku Takumi, which we illustrate at Plate 37, shows more than a glimpse of the old grand style ; it is a really fine piece of work, while at the same time it proves that as far as the technical skill was concerned, there was no falling-off on the part of the engraver and printer, even as late as the middle of the nineteenth century. The engraving is remarkably delicate, and the printing extremely accurate, while *gauffrage* (or " blind-printing ") is freely employed both in the elaborate coiffure and on the dress. This print is on remarkably thick, soft paper, even superior to that usually employed for *surimono*. Alongside Kunisada's signature of Toyokuni is the printer's signature, *Rinzo*, a hall-mark of very fine printing. The publisher's mark in the margin (not reproduced) is that of *Kishodo*, and above Kunisada's signature is the seal-date Monkey 3 = 3rd month, 1860. As the other Monkey year, 1848, falls within the so-called Prohibition period, when actor-prints were banned by law, it must be the later of these two dates, which would give Kunisada's age as seventy-five, and shows that he had maintained his skill to the last, a skill which he too often sacrificed to mere hastiness of production.

Further evidence on the date is given by the form of the date-seal which incorporates the year and the *aratamè* (" examined ") seal in one, a device adopted in 1859 and subsequently.

Kunisada was the master of a large school of pupils who carried on the traditions of the Utagawa school in a very decadent and debased manner, till its practical extinction in 1870–1875. Their work calls for no comment.

The other leader of the Utagawa school after the death of Toyokuni was KUNIYOSHI (1797–1861), a much less prolific artist than Kunisada, but on the whole a more competent one. Like the latter he had a large following of pupils, but Kuniyoshi himself did few actor-prints, a subject with which he was not successful. He is better known for his numerous illustrations to heroic episodes in Japanese and Chinese literature, and kindred subjects.

We may, therefore, here dismiss Kuniyoshi without further comment.

THE ŌSAKA GROUP OF ARTISTS

The various sub-schools of *Ukiyoye* which we have now passed in review all worked in Yedo, the city where the art of the colour-print designer first came into existence. About 1820, however, there arose a new school of designers in Ōsaka, formed largely by pupils and followers of Hokusai and Kunisada. The former visited Ōsaka in 1818, and probably his influence started the idea of forming a school of print-designers there. An interesting piece of evidence, however, of Kunisada's connection with Ōsaka is in existence in the form of a triptych, a copy of which is in the Victoria and Albert Museum, South Kensington, giving a representation of the Dotombori Theatre, Ōsaka, showing its general internal arrangements, actors learning their parts, making-up, gossiping with one another, and so forth. The publisher of this triptych, Nishimura, states that it is being issued as a memorial of Kunisada's visit to Ōsaka, but unfortunately it is not dated, but it is probably about 1820–1825.

The Ōsaka artists devoted themselves mostly to actor-portraits and theatrical subjects. The memorial portrait which we reproduce at Plate 37 of the actor Nakamura Utayemon, is probably by an Ōsaka artist, and is signed *Suiho Sanjin ;* Utayemon was a favourite in the theatrical world both in Yedo and Ōsaka.

The particular characteristics of Ōsaka prints have already been noted in Chapter II.

Next to the actor, the wrestler was the most popular public entertainer, yet few artists turned their attention to him as a subject for their brushes. Shunko, Shunjo, and Shunyei, pupils of Shunsho, were almost the only artists of importance who did so, and of these only the last-named to any extent, as has already been noted. Kunisada and his pupils, and Kuniyoshi, drew wrestlers to some extent, but like their actor-prints they were generally crude in drawing and worse in the colours employed.

The late Dr. W. Anderson, in his *Japanese Wood Engravings*, accounts

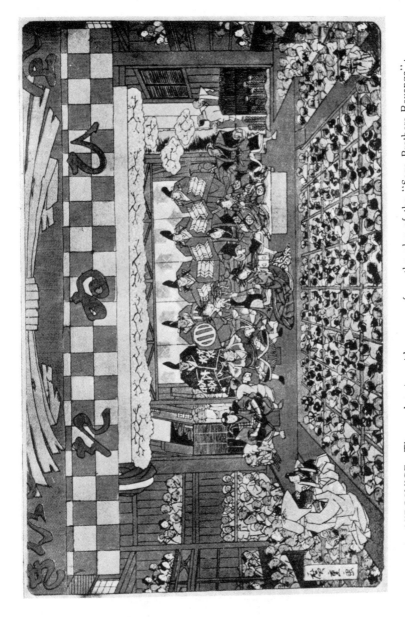

1. HIROSHIGE : Theatre Interior with a scene from the play of the "Soga Brothers Revenge" : signed *Hiroshige*.

PLATE 37 (first part)

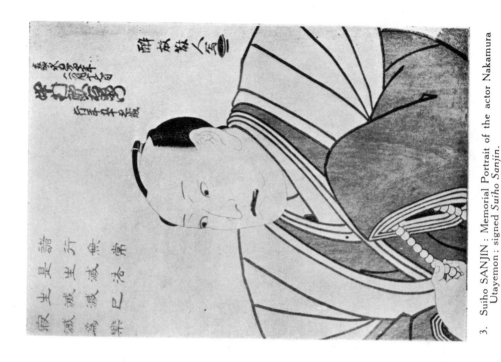

3. Suiho SANJIN: Memorial Portrait of the actor Nakamura Utayemon; signed *Suiho Sanjin*.

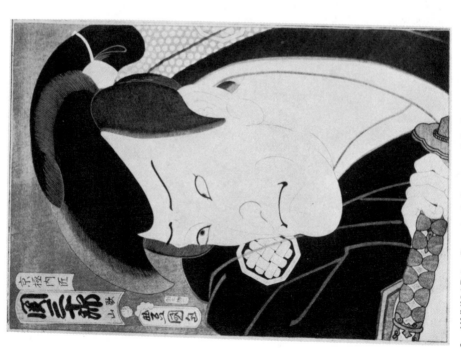

2. KUNISADA: Portrait of the actor Seki Sanjuro as Kiogōku Takumi; signed *Toyokuni*; dated 3rd month. 1860.

PLATE 37 (second part)

for this apparent neglect of a popular subject by the nature of an artist's training. He says : " Their training in the traditional art canons had rendered them unfit to appreciate the grand display of muscular force that often revealed itself beneath the hide of the athlete, and, as they could make nothing of the heavy features and elephantine limbs of their model the few studies of the wrestling arena that have reached us have little attraction for the art collector. This failure on the part of the artist to render a subject that might have appealed strongly to his European confrère is an interesting contradiction of the theory that the magnificent creations of the sculptors of ancient Greece were inspired by the opportunities that those great artists had of studying the nude form. The Japanese artist had at least equal facilities, and many worthy subjects, but not one of the men who in certain directions showed so perfect and instructive an appreciation for beauty of line has ever made a serious effort to do justice to the matchless curves of the human figure."

We have, when dealing earlier in these pages with the characteristics of Japanese drawing, commented on the fact that the *Ukiyoye* artists paid little or no attention to the drawing of the human figure, even in respect of the hands and feet, the most easily noted parts besides the face, but followed a pure convention in this respect.

Then, again, the fact that they did not model their figures to shape, would render the wrestler, with his heavy paunch and unwieldy, puffy limbs unsuitable in their eyes as a subject for delineation, developments unnaturally exaggerated in drawings of wrestlers, save when intended as caricatures.

The Japanese wrestler, however much he may be admired in his own country, forms a striking contrast to our notions of how a wrestler should be trained.

Like the actor he was considered a low, vulgar fellow, but enjoyed a certain amount of familiarity with his patrons like jockeys and prize-fighters in our own country. Champion wrestlers were allowed the privilege of wearing a rope girdle, and also of giving exhibitions of their prowess before the *Shōgun*.

Wrestling was a very old institution in Japan, the first historical record of a match occurring 24 B.C. In the eighth century (A.D.), when Nara was the capital of Japan, the Emperor Shōmu instituted wrestling as part of a religious ceremony, a custom not discontinued till 1606. Later, about 1640, was instituted the custom of having public wrestling matches in the streets of Yedo, for the purpose of raising funds for the building or repair of temples, a custom still in force in the nineteenth century.

CHAPTER XXV

JAPANESE PLAYS : "THE CHUSHINGURA"

OF the numerous dramas performed in the *kabuki-shibai*, or in the marionette theatre, by far the most popular as a subject for colour-prints was the " Chushingura," or the " Loyal League of Forty-seven Ronin."

While we find actors innumerable in characters from scores of plays, in the " Chushingura " almost alone, with an exception of an odd scene or two, like the examples cited in a previous chapter, from other dramas, do we find the complete play illustrated in an entire series of *tableaux*, generally eleven or twelve in number.

This will give some idea of its immense popularity, a popularity which it has retained to the present day, so much so that any theatre which finds itself losing patronage has only to stage the " Chushingura " to regain its audience.

Originally written for the marionette theatre by Chikamatsu Monza-yemon (1653–1734) and Takeda Izumo (1688–1756), Japan's two most celebrated playwrights, the " Chushingura " was first performed in Yedo in 1748.

In 1706, however, Chikamatsu Monza-yemon had produced a play called " Goban Taiheiki," which was based on the story of the Forty-seven Ronin, and it was just before his death in 1734 that he proposed to Takeda Izumo, his successor, that they should collaborate together in writing a play for marionettes dealing with the events of the " Chushingura " itself.

In the same way, the story of the Forty-seven Ronin was introduced into an historical drama called " Kokyo-no-Nishi-ki," written in 1734, and staged in 1747, with the actor Sawamura Sojoro in the part of Yuranosukè, and it was his success therein which induced Takeda Izumo to produce the " Chushingura " in the *kabuki-shibai* with real actors in place of marionettes.

The " Chushingura " is founded on an historical event which took place in the fourteenth year of the *Genroku* period, that is A.D. 1701, and relates how a certain noble, Asano Takumi-no-Kami, was so persistently insulted by another noble, Kira Kotsukè-no-Sukè, his instructor in Court etiquette, that he was at last compelled to draw his sword upon his tormentor in the

latter's palace, though he only managed to inflict a slight wound, owing to the timely (or untimely, according to the point of view) interference of a certain officer, Kajikawa Yosobei, thanks to whom Kotsukè escaped an attack which otherwise would certainly have ended fatally for him.

Such an offence (drawing his weapon within the Court-precincts) was punishable by death, and Takumi-no-Kami was condemned to commit *seppuku*, or self-immolation.

Briefly, the story of the Forty-seven Ronin upon which the play is based is as follows :—

At the time when these incidents occurred, the *Shōgun* at Yedo, Tsuna-yoshi, the fifth of the Tokugawa line, was the real, or temporal, ruler of the country, the Emperor, the hereditary and spiritual ruler, being but little more than a figure-head, and practically a royal prisoner with his Court at Kyoto. When therefore the latter wished to make known his will to the *Shōgun*, communication was made through an envoy, who was received with royal honours, and the duty of entertaining him was en-trusted to nobles of high rank. The two officers appointed on this occasion to receive the Emperor's envoy were Asano Takumi-no-Kami, Lord of Akō, and Kamei Oki-no-Kami, Lord of Tsuwano. For brevity's sake we shall refer to these two by the names given them in the play, Takumi-no-Kami being called Yenya, and Oki-no-Kami, Wakasa. The councillor, also of high rank, appointed to teach these two the proper ceremonies to be employed in discharge of their duties towards the envoy was Kira Kotsukè-no-Sukè, otherwise called Moronao in the play.

Now this Moronao was of an avaricious nature, and not deeming the presents which Yenya and Wakasa gave him, according to time-honoured custom, in return for his instruction, sufficient, took no trouble to instruct them, but on the contrary not only insulted them, but also taught them wrongly, so that they made mistakes.

Yenya at first bore his insults patiently, but Wakasa determined to rid the world of so pestilent a fellow, though well knowing that if he attacked Moronao within the precincts of the castle, his own life would be forfeit, and his family and retainers ruined. So calling together his councillors in secret, he advised them of his purpose to kill Moronao on the morrow, to which they were, perforce, obliged to concur, seeing remonstrance was use-less.

His chief councillor, however, a man of much wisdom, knowing Moronao's greedy nature, determined to buy off his hostility towards Wakasa, and during the night collected all the money he could, and early in the morning, before the latter arrived at Moronao's castle, presented it, together with a sum for his retainers.

This had the desired effect, and Wakasa was agreeably surprised by the changed demeanour of Moronao towards him.

Not so, however, was it with Yenya, towards whom Moronao was, if possible, more insulting. Unfortunately Yenya's own chief councillor, Yuranosukè, was not with him at the time, and the councillor in attendance in his place was not quick-witted enough to propitiate Moronao as Wakasa's had done. Had Yuranosukè been with his lord, the drama of the " Chushingura " might never have been written.

As a crowning insult, Moronao ordered Yenya to tie up the ribbon of his sock, which the latter felt in duty bound to do. When he had done so, Moronao, affecting to be displeased with the way he had tied it, called him a clumsy boor.

This proved the last straw, and Yenya no longer able to contain himself, rushed at Moronao with his dirk, but the blow was only a partial one, inflicting a slight wound. Yenya essayed another blow at his enemy, but again missed his aim. At this point a retainer (Honzo in the play) rushed up and held back Yenya, thus allowing Moronao to make good his escape.

Yenya was arrested, disarmed, and kept in custody till sentence was pronounced upon him to the effect that, for drawing his sword in the castle-precincts, even under great provocation, he must commit *seppuku*, or self-immolation, his castle of Akō and other property be confiscate, and his retainers to become *ronin*, that is leaderless men.

Some of these attached themselves to other *daimyos*, while others turned merchants, but forty-six of them banded together under Yuranosukè, the chief, to avenge the death of their lord.

Such is the historical episode which furnished the theme for the play. During the Tokugawa regime (*c.* 1600–1868), however, it was forbidden, when dramatizing history, to use the real names of persons of high rank, or to publish current or recent events of a public character. As this episode occurred during the Tokugawa period, the principal characters were taken from the time of the first Ashikaga *Shōgun*, Takauji (*c.* 1330), and the scene is laid at Kamakura instead of Yedo.

By comparing the foregoing historical account with the description herein given of each scene, it will be seen how the two versions differ.

Additional facts will be given where necessary, when describing the various scenes, respecting the different characters introduced, some of whom occur only in the drama, and showing also how the authors, while disguising the reality by diluting it with a certain amount of fiction and transferring the actors to an earlier period, have dovetailed the two versions together into a consecutive whole.

For this purpose we have taken the well-known set by Hokusai, complete in eleven scenes, *yoko-ye* shape. This is the largest and finest " Chush-

ingura " set designed by him, and is found in two issues, one by the publisher TSURUYA (dated Tiger 4), and the other by SENICHI which is dated Tiger 6 = 6th month, 1806.

Having thus given an account of the play generally as dramatized in its eleven scenes, we will devote the following chapters to various series of " Chushingura " prints, representative as far as possible of the whole school of *Ukiyoye*. We shall thus endeavour to present it in as varied a form as possible, so that in the end practically every episode and incident which finds a place in the story will have been illustrated.

In order to render the play more intelligible we give below a list of the characters in it, with their names as they occur in the story and in the dramatized version of it.

REAL NAME.	DRAMATIZED NAME.
Asano Takumi-no-Kami, Lord of Akō, in the Province of Harima.	*Yenya Hangwan*, a *Kōké* (noble) under the *Shōgun*, Ashikaga Takauji.
Kamei Oki-no-Kami, Lord of Tsuwano, in Province of Iwami.	*Momonoi Wakasa-no-suké*, another noble.
Kira Kotsukè-no-Suké, expert in Court ceremonial.	*Ko-no-Moronao*, a noble.
Ōishi Kuranosukè, chief councillor to Lord of Akō, and Prime Minister of Akō.	*Ōboshi Yuranosuké*, leader of the forty-seven *ronin*.
Ōishi Chikara, his son.	*Rikiya.*
Kajikawa Yosobei, retainer to the *Shōgun*.	*Kakogawa Honzo.*[1]
Ohotaka Gengo, retainer of Asano.	*Ohowashi Bungo.*
Kayano Sampei, retainer of Asano.	*Hayano Kampei.*
Terasaka Kichiyemon, a low-class *ronin*, or common soldier.	*Tera-oka Heiyemon*, retainer to *Yenya* and brother to *Ōkaru* (see below).
Ono Kurobei.	*Ono Kudayū*, a former retainer to *Yenya*, turned spy.
Ono Gunyemon, son of Kurobei.	*Ono Sadakuro*, a robber.
Amanoya Rihei, a loyal merchant, and contractor to Lord Asano Takumi.	*Amakawa-ya Gihei.*

The following characters also occur in the play :—

Tadayoshi, brother of the *Shōgun*, acting as his deputy.
Lady *Kawoyo*, wife of *Yenya*.
Umanojo (Ishido) } Commissioners at *Yenya's seppuku*.
Jirozayemon (Yakushiji) }
Tonasé (*Honzo's* wife).
Konami (" Little Wave ") (his daughter).
O-kaya (*Yoichibei's* wife).

[1] *Honzo* in the play is really chief councillor to Wakasa, and it is only in Act III that he is made to appropriate the part of Kajikawa Yosobei, when the latter frustrates Asano's attack on Kotsukè.

Takemori Kitahachi
Senzaki Yagoro
Yazama Jiutaro (real name Hazama Jujiro) } Retainers to *Yenya.*
Hara Goyemon
Sagisaka Bannai, retainer to *Moronao* (appears in Acts III and VII).
O-Sono, wife of *Gihei*.
Ō-ishi, wife of *Yuranosukè*.
Ōkaru (betrothed to *Kampei*), maid to *Lady Kawoyo* and sister of *Heiyemon*.
Yoichibei (a farmer, *Ōkaru's* father).

ACT I. *Kabuto Aratamè* : "Examination of the Helmets." Scene in the grounds of the Hachiman Temple of Kamakura. Moronao offers his verses to the Lady Kawoyo, wife of Yenya, Wakasa standing behind him. (See Plate 38.)

Lady Kawoyo has been brought to the Hachiman Temple to identify the helmet of Nitta Yoshisada, a rival to the *Shōgun* Takauji, from amongst forty-six others, the spoils of war. Yoshisada was the famous Minamoto warrior, who, in 1333, became an adherent of the Emperor Go-Daigo-Tenno, and attacked the Hōjō clan, at this time the real rulers of Japan, at their Castle of Kamakura.

In return for his services the Emperor presented him with this helmet. Now before Kawoyo married Yenya she had been in service at the Castle of Nitta Yoshisada, and was the only person who knew which one it was out of the forty-seven. In the presence of Moronao, Yenya, Wakasa, and other nobles, she at last picks out the helmet and hands it to Ashikaga Tadayoshi, brother to the *Shōgun* Takauji.

After the examination of the helmets, Moronao secretly hands a love-letter to the Lady Kawoyo, with a request for a sympathetic answer, at the same time making himself agreeable to Yenya, but insulting towards Wakasa, because the latter upbraided him for making advances towards another man's wife.

ACT II. Scene in the grounds of the Castle of Wakasa-no-sukè. On the veranda is seated Wakasa, and in front of him is Honzo cutting off the branch of a pine tree ; behind, love scene between Kōnami and Rikiya.

Wakasa, his patience exhausted by the insults of Moronao, has decided to kill him on the morrow, and takes his councillor, Honzo, into his confidence. The latter, however, knowing that such a deed would ruin the family of Wakasa, and all dependent on him, is determined to prevent it. So taking his (i.e. Wakasa's) sword he cuts off the branch of a pine tree, saying, " You cut off Moronao's head like that," at the same time putting back his sword in its sheath *without first wiping it*. Owing to the great amount of wax in the Japanese pine, this would have the effect of causing the sword to stick fast in the sheath when the wax dried, so that the blade could not be drawn.

ACT III. The scene now changes to the Castle of Kamakura, outside the walls, and we are shown Kampei being attacked by Bannai and his men, and Ōkaru assisting by entangling them in her scarf.

To connect this with the last act we must retrace our steps, and pick up the thread of the narrative.

During the night Honzo propitiates Moronao with suitable gifts, so that when Wakasa appears early at Kamakura Castle the next morning, prepared to carry out his threat against Moronao, the latter flatters him and apologizes for his former insults. This abrupt change of behaviour throws Wakasa off his guard, so that he loses his chance of killing Moronao, and goes off.

Yenya then appears on the scene, and hands Moronao an answer from the Lady Kawoyo to his love-letter (Act I). Moronao is at first very gracious to Yenya, but when he reads the answer, rejecting his overtures with scorn, he completely changes his attitude, and deeply insults him.

Yenya, unable at last to keep his temper any longer, rushes at Moronao with his short sword, or dirk, to kill him, but at this moment Honzo seizes him from behind and allows Moronao to escape with nothing worse than a slight wound.

While these scenes were being enacted inside the castle grounds, Kampei remained outside with the rest of Yenya's body-guard, and spent his time chatting with Ōkaru, who had arrived very early in the morning with Lady Kawoyo's answer for Moronao which she (Ōkaru) gives to Kampei to take to Yenya. While thus engaged Bannai and his men approach, and the former, being in love with Ōkaru, tries to arrest Kampei, and run off with her, but the attempt fails.

During this scrimmage between Kampei and Bannai outside the castle grounds, Yenya is made prisoner, and handed over to the safe custody of another noble, till sentence should be passed on him. On learning the fate of his lord, Kampei is so mortified that he decides to commit *seppuku* on the spot, but Ōkaru persuades him to flee with her to her father's home at Yamazaki, near Kyoto, over three hundred miles from Kamakura.

ACT IV. Interior of Yenya's castle at Ogigayatsu (Yedo). Rikiya receiving the commissioners who have brought sentence of death on Yenya; the Lady Kawoyo seated with attendants, and surrounded with branches of the rare eight-fold cherry-blossom, and other presents, brought to console her for the loss of her husband.

ACT V. View on the road to the village of Yamazaki. The murder and robbery of Yoichibei, father of Ōkaru, by Sadakuro, for the sake of the money he obtained from a *joro-ya* keeper by the sale of his daughter, to help Kampei.

Sadakuro is himself accidentally killed by Kampei, while stepping aside to avoid the charge of a wild boar the latter is hunting. Kampei then helps himself to the money stolen from Yoichibei. In the background, the meeting of Kampei and Senzaki Yagoro, one of the *ronin*. This scene is generally represented as taking place in a rain-storm, hence the umbrella carried by Yoichibei which Sadakuro is cutting through with his sword, but Hokusai here only indicates rain by a black sky.

We now take up the story from the end of Act III, when Kampei decides to go with Ōkaru to her father's house at Yamazaki. They are now married, and live together as husband and wife. Kampei is anxious to be one of the band of forty-seven *ronin*, and learns that Yuranosukè is collecting money to pay for a monument over Yenya's tomb. (See Note, page 244).

But, unfortunately, neither he nor his wife, nor her father, Yoichibei, have any money, all being very poor, so Ōkaru decides to sell herself as a courtesan to the tea-house Ichiriki, in Kyoto, with her father's consent, but does not tell Kampei.

Yoichibei goes to the tea-house and receives payment in advance, to the amount of 50 *Ryo* (about £50 to £60 present rate). Just as he nears home he is attacked by Sadakuro, who was lying in wait behind a stack of rice-straw for any traveller who happened to pass. At the same moment a boar rushes by which Kampei was hunting, and Sadakuro, starting aside, receives the shot intended for the animal.

While out hunting Kampei meets Senzaki Yagoro and tells him where he (Kampei) is living. From him he learns that Yuranosukè wants money, and that if he (Kampei) wishes to join them, he must subscribe his share. With this they part.

Kampei having fired his shot at the boar goes up to it, and to make sure of its being dead beats it violently with the butt of his gun, and then touches the body, when to his horror he finds that, in the darkness, he has been beating a man (Sadakuro). At first he is inclined to run away, but thinking perhaps the man had been lying there ill, he searches his pockets for medicine and finds the purse of money stolen from Yoichibei.

Though not intending to steal the money, yet knowing how urgently he wants it to help on the revenge of his lord and join the *ronin*, he takes it and, running after Yagoro, hands it to him.

ACT VI. Yoichibei's house, the scene of Kampei's *seppuku*. Ōkaru being taken away in a *kago* to the tea-house Ichiriki, at Kyoto.

Kampei is now returned to Yoichibei's house, and at the same time Yoichibei's corpse is found by two hunters, and brought home to his wife O-kaya, who suspects Kampei as the murderer, and reviles him.

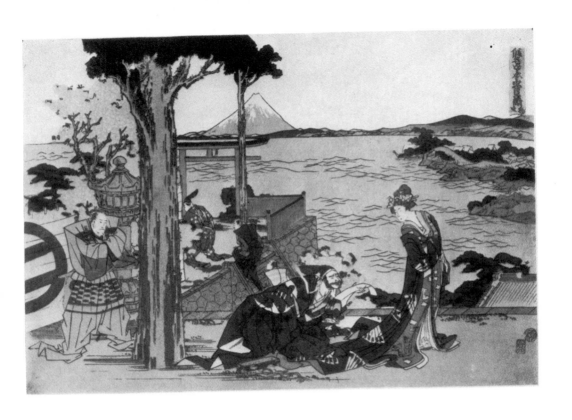

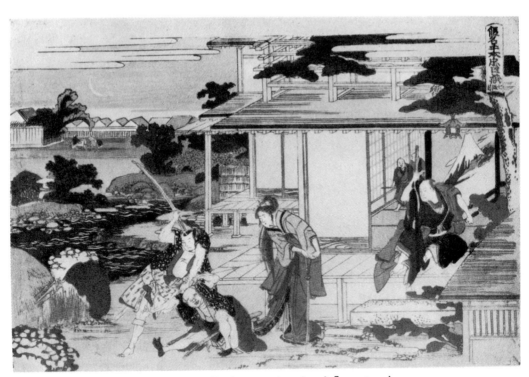

HOKUSAI : *Chushingura*, Acts 1 and 7 ; unsigned.

PLATE 38 (first part)

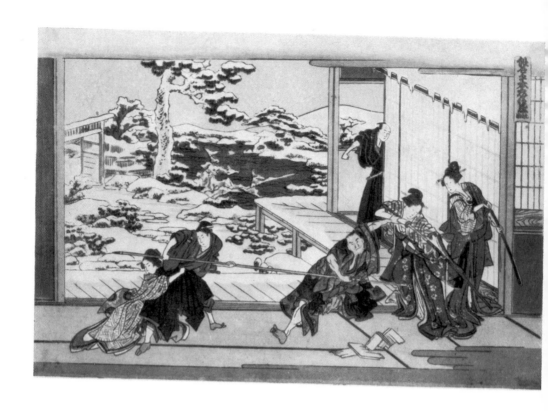

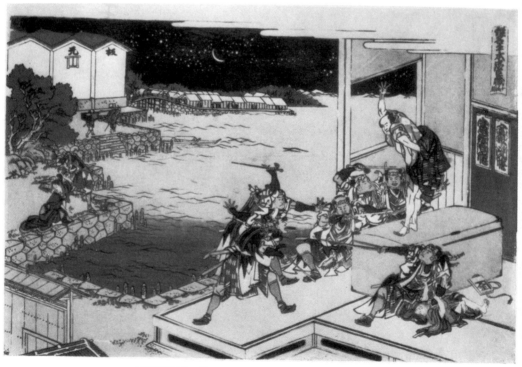

HOKUSAI: *Chushingura*, Acts 9 and 10; unsigned.

PLATE 38 (second part)

Two of the *ronin*, Hara Goyemon and Senzaki Yagoro, then come to the house, and join in the accusation, at the same time returning Kampei his money, saying Yuranosukè does not want money obtained by murder.

As they turn to go Kampei calls on them to wait and hear his explanation.

He then tells them how, after Yagoro had left him last night, he saw a boar and shot at it, but found he had killed a man instead. While searching the body for medicine he found money, which he gave to Yagoro. On his return home he hears how the money was what Yoichibei had got for the sale of Ōkaru, and that he must have killed his father-in-law by mistake. Owing to the darkness he could not see at the time whether it was Yoichibei or Sadakuro he had shot.

While telling this to the two *ronin*, he attempts to commit *seppuku* on himself. The two *ronin* then say, " We will examine Yoichibei's body to see if he is killed with a gun-shot or by a sword-thrust." Finding it is by a sword, this is proof Sadakuro killed him and not Kampei. Therefore Kampei was quite right in killing Sadakuro, a murderer, in revenge for the death of his father-in-law.

Being thus satisfied of Kampei's innocence, he is asked to sign the roll of the *ronin*, and the scene shows him holding it out. Kampei willingly signs it, but dies soon afterwards, and the *ronin* hand back his money for his funeral and leave.

The true account of how Kayano Sampei (Kampei in the play) came to his death is as follows :—

After Yenya's death, Sampei returns home to his village, and finds his mother dead. His father begs him to stay with him, pleading his loneliness and old age. As all the *ronin* have strictly promised to keep their revenge secret, and to tell no one, his father is in ignorance of the fact that Sampei is one of them, and refuses permission to him to leave home when attacking time approaches. In his dilemma, being unwilling to disobey his father by going away without leave, and unable to join the *ronin*, he commits *seppuku*.

Kuranosukè, in honour of Sampei's loyalty, when making the attack on Moronao's castle, carried a spear with a paper attached, on which was written " Kayano Sampei," and with it killed an enemy on Sampei's behalf.

ACT VII. Scene at the tea-house Ichiriki, Kyoto. Heiyemon dragging out the spy Kudayū from under the *engawa*, and raising his sword to kill him ; Ōkaru standing by. Yuranosukè squatting on the *engawa* looking on, and two other *ronin* inside the tea-house. (See Plate 38.)

On the death of Yenya, Moronao, expecting that the former's retainers

would seek one day to be revenged on him, had spies set to watch their movements.

Yuranosukè, however, in order to throw these spies off the scent, ordered the *ronin* to scatter, while he and his son went to live at Yamashima, near Kyoto, Yuranosukè himself appearing to lead a dissolute life with wine-bibbers and spending his time in the courtesan quarter, having also just divorced his wife. Every night Yuranosukè would come from Yamashima to Kyoto and spend his time in the Ichiriki tea-house, and often give supper-parties. During such a party, three of the *ronin* enter with Heiyemon, brother to Ōkaru, and ask when Yuranosukè intends going to Kamakura, that is to attack Moronao. Knowing there are spies about, he replies that he has no intention of taking any revenge ; it is Yenya's fault they are now all *ronin*. Such a reply creates consternation amongst Heiyemon and the other *ronin*, and they leave the tea-house, thinking Yuranosukè must be mad, or at least drunk with *saké*. At this point there enter the two spies, Kudayū and Bannai, who join Yuranosukè's party. Kudayū, in order to test Yuranosukè, offers him a piece of fish. As he was on the point of taking it, the former reminds him that it is the anniversary of the death of Yenya, but Yuranosukè eats it all the same, thus showing he troubled himself little about his late lord. To show respect to the departed, Buddhist families never eat fish or meat on the anniversary of the day on which their parents or, in the case of a *ronin*, their lord died.

These tactics on the part of Yuranosukè, which were all duly reported by spies to his enemy, entirely threw Moronao off his guard, who thought little was to be feared from a man who appeared not to trouble himself in the slightest about the fate of his lord, nor show any intention of avenging him, so that he gradually relaxed his precautions.

In the meantime, other *ronin*, disguised as pedlars or workmen, contrived to gain entrance to Moronao's castle, and thus made themselves familiar with the plan of the building, and also ascertained the character of the inmates, all of which matters they make known to Yuranosukè.

Other versions of this act show Yuranosukè playing blindman's-buff with the tea-house girls, or reading a letter which Rikiya has brought him from the Lady Kawoyo, while the spy Kudayū, hiding under the *engawa*, reads it from below, Ōkaru also reading it by the aid of a mirror from the balcony above.

This refers to the scene which takes place after Yuranosukè has eaten the fish Kudayū offered him, when the former goes out, and is handed a letter by his son Rikiya about Moronao from the Lady Kawoyo. He sits down on the balcony outside to read it, while the spy Kudayū hides underneath and reads from below as Yuranosukè unrolls it, while Ōkaru, who has gone up into the balcony of the floor above, also reads it by the aid of a

mirror. Suddenly Yuranosukè becomes suspicious that others are reading his letter, and, looking up and seeing Ōkaru, calls to her to come down. He then tells her he proposes to pay her debt and free her from the *joro-ya* keeper, but wants her to be with him for three days, not knowing she is already Kampei's wife.

At this point her brother Heiyemon enters, and having seen her reading Yuranosukè's letter from the balcony threatens to kill her as a spy, but Yuranosukè intervenes and says she is no spy, and commands him to drag out Kudayū from under the balcony, whom he (Yuranosukè) had stuck through with his sword, and throw him into the river.

ACT VIII. Tonasé and her daughter Konami walking along the sea-shore at Tago while on their way to Yamashima, near Kyoto, to find Rikiya, to whom Konami is betrothed, and who had gone to live there with his father, Yuranosukè.

This scene introduces characters which only occur in the play, and have no part in the actual story, so calls for no detailed description. In the play this is a gay scene of dancing and singing, and is introduced as an antidote to the others, which are too full of murder and sudden death.

ACT IX. The house of Yuranosukè at Yamashima. Rikiya attacking Honzo, who is also defending himself from Ō-ishi, wife of Yuranosukè, and Konami holding him back. Yuranosukè appearing from behind a screen in the background; beside Ō-ishi stands Tonasé sheathing the sword with which she was going to kill Konami, an act Honzo arrives just in time to frustrate. (See Plate 38.)

Ever since Yenya's death, there has been bad blood between Honzo and Yuranosukè because the former stopped Yenya from killing his enemy, Moronao, by holding him back. Honzo, in this scene, comes to Yuranosukè's house disguised as a *ronin* beggar with the bamboo flute and basket hat of the *komuso*, to apologize and make amends, bringing with him a plan of Moronao's castle.

We now take up the story from Act VIII, showing Tonasé and Konami journeying to Yamashima. In Act IX they have arrived at Yuranosukè's house, and Tonasé, wife of Honzo, says to Ō-ishi, wife of Yuranosukè, " I have brought my daughter to marry your son, Rikiya, as you have promised." Ō-ishi flatly refuses to sanction the marriage, saying, " Your husband, Honzo, interfered and prevented my lord, Yenya, from killing his enemy, Moronao, at Kamakura Palace; I refuse to allow my son to marry the daughter of such an unchivalrous man."

Tonasé and Ō-ishi then start quarrelling, and Konami, to settle matters, and knowing that if she married Rikiya without consent, she would be divorced, consents to sacrifice herself, and to this her mother agrees, and

takes up a sword to kill her. At this moment she is interrupted by Honzo's piping who enters and stops her. He then insults Ō-ishi, who thereupon snatches up a spear to stab him, but he is too quick for her, and overcomes her. Rikiya then suddenly appears and attacks Honzo with a spear, which the latter seizes by the shaft and guides into his own body. The dying Honzo then confesses his fault in holding back Yenya when he attacked Moronao, and appeals to Konami, his daughter, to marry Rikiya, at the same time producing a plan of Moronao's castle which he explains to Yuranosukè, who has just appeared on the scene. Yuranosukè consents to the marriage of Rikiya and Konami, and Honzo expires. Yuranosukè then takes the dress of Honzo and, disguised as a *komuso*, starts on his journey to Kamakura to fulfil his revenge on Moronao.

ACT X. Scene at the house of Amakawa-ya Gihei at Sakai. (See Plate 38.)

Gihei was a contractor to Lord Yenya, and Yuranosukè entrusted him with the making of the arms and armour to be used by the *ronin* in their night attack on Moronao.

Yuranosukè, however, was very anxious as to what might happen supposing the authorities were to raid Gihei's house and, finding a store of arms and armour there, accuse the latter of being in a conspiracy against the Government. Gihei himself was prepared for this eventuality, and knowing he would be executed if discovered, divorced his wife in order to avoid trouble.

Yuranosukè, therefore, sent some of the *ronin* to Gihei's house, disguised as police, in order to see if he would disclose the arms he had or confess for what purpose he had made them.

The *ronin*, therefore, raid his house, and finding the arms, threaten him with arrest, on the ground that he is plotting against the Government. Gihei, however, is true to his salt, denies the charge, and says they may kill him if they don't believe him. (This is the incident portrayed in Act X, in Hokusai's set, which we are here describing.) This proof of loyalty satisfying the *ronin*, they reveal their true identity to Gihei, saying they are not police, but *ronin* formerly in the service of Lord Yenya, and go off.

True Story of Gihei (Amanoya Rihei).

Amanoya Rihei was a native of Ōsaka, and business took him, one day in summer, to the Castle of Akō, Lord Asano's residence. It so happened that this was a "spring cleaning" day, and all the treasures of the house were placed in one or two rooms while their proper resting-place was being cleaned and renovated. Rihei asked permission to examine them, which he was allowed to do. When the cleaning was over, and everything was being put back, it was discovered by the servants that a small, but valuable cup was missing.

As no one but Rihei had had access to the collections, suspicion naturally fell upon him, and on being questioned by Kuranosukè he confessed that he had stolen it, and would willingly abide by the consequences.

This candour on his part proved to Kuranosukè that Rihei was no ordinary man, so not knowing what he should do under the circumstances, he referred the matter to Lord Asano for decision, who said there was no necessity to make a fuss as he himself had just found the cup, at the same time showing it to Kuranosukè.

When Kuranosukè, after his lord's death, began to make his plans to take revenge on Moronao, he remembered how Rihei had proved his honesty on an earlier occasion, and decided to make use of his services by entrusting him with the fitting out of the *ronin* with arms and armour.

Rihei secretly made them, having first sent away his wife and children, and as secretly forwarded them in readiness for the attack to Yedo.

But after they had been delivered in Yedo, one of his workmen reported the matter to the authorities, because the arms were of a very unusual kind.

Rihei is arrested and put on trial, but though questioned many times, never reveals the true purpose for which the arms were made. Eventually he is submitted to torture to make him confess, but he remains firm in his trust.

At last he pleads his memory has gone, owing to the trials and torture he has endured, and asks to be set free till next spring, so that he may recover, when he will explain everything. The authorities accede to his wish, but before the time comes for his re-trial the *ronin* attack Moronao and attain their revenge. Rihei, thus released from secrecy, then confesses, and the authorities, in consideration of his fidelity to his trust, set him free.

Rihei then returns home and retires from his business, which is carried on in his stead by one of his sons. He died at Ōsaka in January, 1727, aged 66.

Act XI. The *ronins'* attack on Moronao's castle.

Yuranosukè, at last satisfied by the reports he received that Moronao was now thoroughly off his guard, and quite certain no attack was to be feared from Yenya's retainers, appointed a secret meeting-place for the *ronin*, and decided to make the attack at midnight, in the season of midwinter, when the whole country was deep under snow.

The *ronin*, to the number of forty-seven, including their leader, dressed in a black uniform with a white diamond pattern, and on the sleeve the " *kana* " character (one for each man; the Japanese alphabet, *hirakana*, consists of forty-seven characters), attack the principal gate and break it open, the actual forcing of the door being done by one of the younger

ronin, Ohowashi Bungo (real name Ohotaka Gengo), who may be identified in the scene of this act by his carrying an enormous wooden mallet.

After a severe fight with the defenders of the castle the latter are overcome, and Moronao is eventually found by Yazama Jiutaro, hiding in an outhouse used as a coal-cellar. He is dragged forth and, in consideration of his rank, given the option of dispatching himself by *seppuku*, as Yenya was obliged to do. As Moronao declined to die the death of a nobleman, Yuranosukè was obliged to dispatch him himself, cutting off his head with Yenya's dirk.

Thus did the forty-seven *ronin* avenge the insult and death of their lord, and then set out on the return to Yedo, to lay the head of their enemy as an offering before the grave of Lord Asano, at the Temple of Sengakuji.

In some " Chushingura " sets this last episode, the journey to Sengakuji, completes the series, though the play itself always ends with the attack on Moronao's castle.

True story of the attack on Moronao.

On the 14th day of December, the anniversary of the death of Yenya, in the 14th year of *Genroku* (1702), the *ronin* assembled at the house of one of them, O-no-dera Junai, under the command of Kuranosukè, and started near midnight, under heavy snow, for Moronao's castle.

Moronao who was now expecting an attack by Yenya's *ronin* about this time, was on this night entertaining his friends at a farewell dinner, preparatory to departing next morning for Yonezawa, in the Province of Dewa, the territory of the *daimyo* Uesugi, whose daughter was married to his (Moronao's) son.

The *ronin*, arrived at the castle, divided into two forces ; half under Kuranosukè attacked the main gate, while the remainder under Ōishi Chikara, his son who, though only sixteen years old, was a giant in size and strength, attacked the back gate.

One of the party at the front gate gained entrance over the wall by means of a rope ladder, and all the guard being asleep, opened the gate from inside.

Kuranosukè and the rest immediately dash in, while at the same time his son forces the back gate. Most of the defenders run away, but some put up a strong fight against the *ronin*. They are, however, all finally overpowered ; and then begins a hunt to find their enemy Moronao. He cannot be found, and the *ronin* in despair resolve to commit *seppuku*. At last, however, one of them, Yazama Jiutaro, goes to the coal cellar, where bags of charcoal are stored, and thrusts his spear well into them in case anyone is hiding behind. Drawing out his spear he finds it blood-stained, so immediately removes the bags of charcoal to find Moronao crouching

behind them. He is immediately dragged out and the signal, a whistle, given that he has been found.

Kuranosukè runs up and identifies Moronao by the wound on his forehead, inflicted by Yenya when he attacked him a year ago. Moronao is invited to die the death of a nobleman by committing *seppuku*, Kuranosukè offering to act as his second. But being a coward he steadfastly refuses, so Kuranosukè has no option but to dispatch him himself, and completes the revenge by cutting off his head.

In spite of the severe fighting with the defenders of Moronao's castle, none of the *ronin* were killed, and only some were even wounded.

Having achieved their purpose the *ronin* are reassembled and leave the castle, with Moronao's head, to make their way to Sengakuji Temple, about seven miles distant, at Takawana, a suburb of Yedo, where Yenya is buried.

Before they arrived at Sengakuji the day broke, and everyone came out to watch the procession. On reaching the temple, they washed the head of Moronao in a well in the grounds and laid it as an offering before their lord's tomb, while the abbot read prayers and they each burnt incense.

Having done this they departed, and awaited the sentence of the Government. They were divided into four parties, and sent to four different *daimyos* in Yedo, till sentence should be passed upon them, namely Lords Hosokawa, Matsudaira, Mōri, and Mizuno.

They were kept in custody till the following spring, when, on the 4th day of the second month in the 16th year of *Genroku* (1703), the Tokugawa Government ordered that all the *ronin*, except Terasaka Kichiyemon (who was of too low a rank), should commit honorary execution by *seppuku* for the murder of Moronao.

Knowing this would be their fate they were prepared for it, and met their death bravely. The priests of Sengakuji Temple prayed that they might be allowed to have the bodies, which, on their request being granted, they reverently buried round the grave of Lord Asano. Kichiyemon was also buried there when he died later. Owing to his low rank, he was not allowed to die by *seppuku*, an honour only for nobles and *samurai*.

The fame and loyalty of the *ronin* caused crowds to flock to their burial-ground to pray there, and at the present day it is still a place of pious pilgrimage.

Actually there are forty-eight graves besides the larger one of Lord Asano. The history of the forty-eighth grave is as follows :—

When Kuranosukè was living at Yamashima, in order to deceive Moronao's spies, he frequently pretended to be drunk, and used to fall

asleep in the road. One day a *samurai* of the Satsuma clan came across him lying thus in the middle of the road, and reviled him, saying he was a disgrace to the rank of *samurai*, at the same time kicking and otherwise insulting him.

When, after the death of the *ronin* the story of their loyalty to their chief and how they plotted to avenge him became known, the Satsuma man was so ashamed of his behaviour towards Kuranosukè at Yamashima, that, in atonement for his insult, he came to their burial-place at Sengakuji, and there committed *seppuku*, and was buried alongside the graves of the *ronin* by the priests of the temple.

Such is the story which inspired the most famous drama on the Japanese stage, a story of loyalty and heroism one cannot but admire.

Note to page 236.—Act V. The meeting of Kampei and Yagoro. The story of a monument over Yenya's tomb was, of course, a fiction ; Yagoro was merely hinting to Kampei what Yuranosukè's real plans were, the money being actually required to pay for the *ronins'* armour and equipment, which was to be of a special kind to be made secretly.

CHAPTER XXVI

THE DRAMA OF THE "CHUSHINGURA"—*(continued)*

The Eleven Scenes portrayed by Masayoshi and Hokusai (Kako).

ONE of the earliest complete sets illustrating the *Chushingura*, a record of which has been noted, is a large oblong series by Kitao MASAYOSHI (1761–1824), about 1790, with the title *Ukiye Kanadehon Chushingura*, which may be translated "A Perspective Copy of the Loyal Retainers," *Kanadehon* meaning "copy," such as is given to school-children as an exercise in copying.

Chushingura is made up of three words, or characters, signifying "Treasury (of) Loyal Retainers."

This series by Masayoshi consists of eleven scenes, each showing two or more episodes in one scene, and is very rare. Act VII of it is represented in the British Museum collection. The following acts have come under observation :—

Act IV. Lady Kawoyo seated receiving the commissioners who have brought sentence of death on her husband ; outside Yuranosukè showing Yenya's retainers the dirk with which their lord committed *seppuku*, as they pass out across the moat of the castle.

Act V. Rain scene. The murder of Yoichibei by Sadakuro, and Kampei hunting the wild boar.

Act VII. The tea-house Ichiriki, at Kyoto. In the centre, Yuranosukè, blind-folded, plays with the tea-house girls, three *ronin*, Yazama Jiutaro, Takemori Kitahachi, and Senzaki Yagoro, looking on. On the right, in another room, the letter-reading scene with Kudayū hiding under the balcony ; in a room behind, on the left, Yuranosukè and Kudayū eating together.

In the open garden behind, on the right, is the litter which brought Kudayū to the tea-house, with the big stone inside ; on the left the dead Kudayū being dragged out by Heiyemon, and Yuranosukè squatting on the veranda spurning him with his foot.

Act IX. Honzo arriving outside Yuranosukè's house ; inside, Tonasé about to take her daughter's life, is interrupted by Ō-ishi. In another part of the house Rikiya attacking Honzo with a spear ; and in yet another

part, Yuranosukè with Honzo's plan of Moronao's castle explaining how he proposes to make the attack.

Act X. In the centre, the *ronins'* attack on Gihei, who is seated on the chest, defying them ; in the distance through an open screen is seen a vista of buildings by the canal-side, and Gihei's wife, O-Sono, being set upon by other *ronin*, while on the left she is shown trying to gain admission to the house.

The term *Ukiyè*, applied to this and other *Chushingura* series, means " perspective " or " bird's-eye view " pictures, that is, pictures drawn after European canons with deep and elaborate perspective. Other conventions traditional to *Ukiyè* pictures are the red clouds framing the picture above, and the long descriptive label at the right-hand side. These characteristics are well shown in the early *Chushingura* set by Hokusai (about 1798) which we describe next, and they are also found in sets designed later by other artists, such as that by Shunsen described in Chapter XXIX, who have evidently modelled their scenes upon this set of Hokusai's.

It is characterized by the relatively small size of the figures, which are unusually tall in proportion, and by the very deep perspective in which the scene is set. This early set is uncommon, and it is rarely met with in good condition ; the outline, particularly of the figures, is slight, and it relies for effect more upon the colour-scheme than upon the drawing. The predominating colours are red and pink opposed to yellow, greyish-blue, and green.

The following are the scenes comprised in this series issued by Hokusai through the publisher *Iseya Rihei* (*Iseri*) over the signature *Kako*. It is not dated, but is generally attributed to about the year 1798.

The actual size of each print is $12\frac{1}{4}$ in. by 8 in. (engraved area), compared to $15\frac{1}{4}$ by $10\frac{1}{4}$ in. in the large *yoko-ye* sets described in our previous chapter.

Title : *Shimpan Ukiye Chushingura* (" New edition Perspective Chushingura Pictures ").

Act I. In the grounds of the Hachiman Temple, Tsuruga-oka (Kamakura), looking out across the Bay of Yedo. (See Plate 39.)

In the earliest impressions (*vide* set in the British Museum collection) Fuji is shown in the distance across the bay, but in the majority it is omitted. The *kiwamè* (" perfect ") seal appears on copies both with and without Fuji. On the right the temple buildings ; in the centre the tall figure of Lady Kawoyo, at whose feet kneels Yenya, Moronao on the right, and Wakasa, behind a tall pine tree, on the left ; retainers squatting in the background.

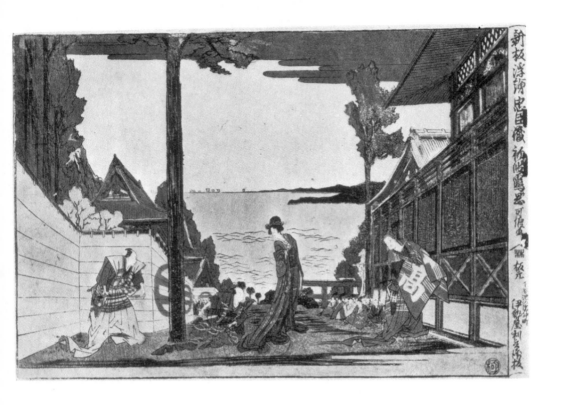

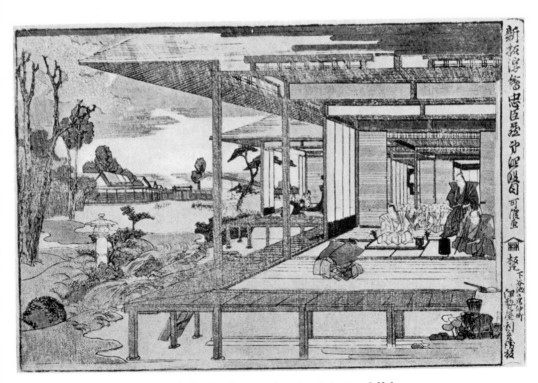

HOKUSAI : *Chushingura*, Acts 1 and 4 ; signed *Kako*.

PLATE 39 (first part)

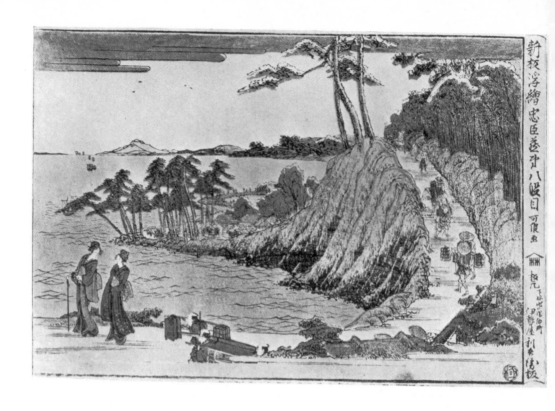

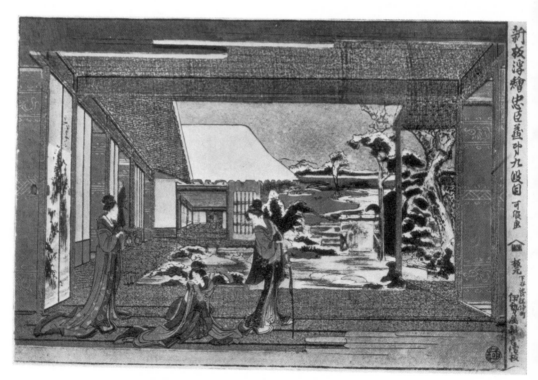

HOKUSAI: *Chushingura*, Acts 8 and 9; signed *Kako*.

PLATE 39 (second part)

Act II. In front of a pine tree, on the left, stands Wakasa on the veranda of his house, looking at Honzo who has just cut off a branch of the tree, saying, " So let the enemies of my lord perish by his hand."

In the background, on the veranda, overlooking the garden and lake, Konami receiving Rikiya, while her mother Tonasé and another woman watch proceedings from behind the partition.

Act III. Scene in the grounds outside the Castle of Kamakura. Kampei, behind whom stands Ōkaru restraining him, threatening to kill the prostrate Bannai, whose followers are either running away or else throwing themselves into the moat. On the further side of the moat, Yenya is being taken to his castle in a *norimono*, under an escort, a prisoner.

Act IV. In a large room of his house, overlooking gardens through which flows a stream, Yenya is seated on a mat prepared for *seppuku*, while Rikiya prostrates himself before him, in response to his lord's question whether his chief councillor, Yuranosukè, who was away in Harima while these events took place, has yet arrived. " He is not yet come, your lordship," replies Rikiya.

" Alas ! and yet I wished so greatly to see him once more in life ; there is so much to be arranged—but now——"

And with these last words the unfortunate Yenya gives himself the fatal stroke, when at this moment Yuranosukè, followed by a crowd of other retainers, bursts into the room, starts when he sees his lord's plight, then duly makes his obeisance. With his last breath, Yenya exchanges a few hurried words with his councillor, adding this final exhortation : " Yuranosukè—this sword—my dying gift to you—you will do what is best."

With a last effort he throws aside the weapon, and expires.

On Yenya's left are the two commissioners, Ishido Umanojo and Yakushiji Jirozayemon. During the fulfilment of their duties, the latter behaves very truculently and callously towards the condemned man, a behaviour which the other commissioner, Ishido, tries his best to counteract by being as considerate as possible. Yakushiji, however, meets his due reward at the hands of Rikiya in the final act. (See Note, page 249.)

Act V. Scene at nightfall during a thunderstorm, on the road between Kyoto and the village of Yamazaki. Yoichibei, father-in-law of Kampei, being murdered by Sadakuro, a reprobate son of Kudayū, both disloyal retainers of Yenya. Down a steep slope on the left rushes the wild boar, Kampei's shot at which finds its mark in Sadakuro as the latter jumps aside to escape its onset.

In the background the meeting of Kampei and Yagoro.

(In some very early copies a flash of lightning is indicated as well as rain in the black sky, but it is generally omitted.)

Act VI. The house of Yoichibei, father of Ōkaru, at Yamazaki. Ōkaru

standing in an outer room weeping at having to leave her husband and parents, while behind is seated Kampei with his musket on the floor in front of him. On the left squatting on the floor are the two *kago*-bearers, while Ōkaru's mother looks out from an inner room. Outside Yagoro and Goyemon, disguised with the basket hats worn by *komuso*, approach along a path, and further off again are huntsmen bringing home the dead body of Yoichibei on a stretcher.

Act VII. The Ichiriki tea-house at Kyoto. On the veranda stands Yuranosukè intervening to save Ōkaru from the zeal of her brother Heiyemon, who, having seen her reading the letter which the former had just received from Lady Kawoyo concerning Moronao, was about to kill her for fear of her divulging its contents.

Under the veranda-floor crouches the spy Kudayū, and on the left Bannai opens the *kago*, in which the former has placed a huge stone to deceive the bearers when they take it away.

(At this point Kudayū, pretending that nothing is to be got out of Yuranosukè, makes as though to leave the tea-house in company with his bosom friend Bannai, and calling up his *kago*-bearers, invites the latter to enter it. Bannai declines on the ground that Kudayū is the older man and therefore better entitled to it.

Kudayū, thereupon, enters the *kago*, but deftly gets out on the other side and creeps under the veranda. Bannai, thinking he has taken his seat in the *kago*, continues to carry on the conversation, but receiving no reply, draws back the blind to find only a huge stone inside. Giving vent to his astonishment, he looks round perplexed, and suddenly hears himself addressed from under the veranda by Kudayū, who explains his trick and the reasons for it, adding, " Meanwhile, accompany the *kago* as if I were in it." " I understand," answers Bannai, who, giving the word to the *kago*-bearers, goes off.)

Act VIII. Scene on the coast road from Yedo to Kyoto, at Tago. The Bridal Journey of Tonasé and her daughter Konami to Yamashima to find Rikiya.

On the right, the road, crowded with travellers and coolies, passes over a steep eminence from a village beyond lying at the water's edge. (See Plate 39.)

Act IX. Yuranosukè's house at Yamashima in winter-time. In the centre Tonasé about to draw a sword and kill her daughter and then herself, is interrupted by Ō-ishi, wife of Yuranosukè, who approaches with a wooden stand in her hand. Behind Ō-ishi appears Yuranosukè, looking out from an inner room. In the background is Honzo, disguised as a *komuso*, coming in at the open gate. (See Plate 39.)

(Ō-ishi, indignant at Honzo's conduct in his stooping to bribe Moronao in order to buy off the latter's hostility towards Wakasa, while Yuranosukè refused to lend himself to such practices in the case of Yenya, though urged to do so by Ohowashi Bungo, one of Yenya's retainers, declines to allow the proposed marriage of her son, Rikiya, to Honzo's daughter, Konami. This refusal so mortifies the mother and

daughter, that Konami begs Tonasé to take her life, rather than suffer the indignity of divorce. To this Tonasé (really her stepmother) agrees, adding she will follow her daughter's fate at the same time.

At the moment when she is about to give the fatal stroke with the sword, the shrill notes of Honzo's pipe arrest her hand. A second time she raises her arm, but ere the blow descends, a voice calls out loudly, " No more ! "

Irresolute, she looks round for the source of this second interruption, and relaxes the grasp of the sword. Seeing nothing, and Honzo's piping ceasing, she concludes it is addressed to the *komuso* to bid him depart.

A third time she essays the fatal stroke ; again a voice calls out, " No more ! "

" What can this mean ? " exclaims the perplexed Tonasé. " Is it to send away the *komuso* with his dole, or is it to stay my hand ? "

" It is to stay your hand," cries Ō-ishi, entering at this moment, carrying a small white-wood stand ; " my son Rikiya shall marry your daughter, whose behaviour has called forth my admiration as much as her unfortunate position has aroused my compassion.

" This marriage, distasteful though it is to me, shall take place ; but in return I must ask as a bridal gift the head of Kakogawa Honzo placed upon this stand "—at the same time setting the stand down on the matting before Tonasé, who expresses astonishment at such a request.

At this moment Honzo, who has overheard everything, enters, throwing off his disguise, and smashes the stool by stamping on it.)

Act X. The house of Amakawa-ya Gihei at the seaport of Sakai. An analogue of the scene in which Gihei, standing on the chest concealing Yuranosukè, defies the *ronin*, sent to test him, to make him reveal the whereabouts of the armour. Here Gihei, in the porch of his house, has leapt on to a wooden stand, and is attacked in play by a party of children. In the distance are seen the *ronin* approaching along the quayside, while at the gate of the house is O-Sono, Gihei's wife, seeking admission.

Act XI. The attack on Moronao's castle. On the right Moronao discovered in his hiding-place, who defends himself with the bundles of firewood against attack ; on the left one of the *ronin* stands on the roof and shoots an arrow at one of Moronao's retainers, who is attacked by another *ronin*.

Note to page 247.—Yenya's dying injunctions to Yuranosukè. In Dickins' translation of the *Chushingura*, Yenya is made to say, " you will exact vengeance." He could not, however, in the presence of the two commissioners, compromise his chief councillor by uttering the word vengeance in their hearing ; he could only hint as much to Yuranosukè, trusting to the latter's native wit and loyalty to guess his real meaning.

CHAPTER XXVII

THE DRAMA OF THE " CHUSHINGURA "—*(continued)*

Hiroshige's Illustrations to the Play.

WE now come to one of the most famous and best-known series of illustrations to the "Chushingura," namely Hiroshige's set complete in sixteen plates, the eleventh act containing six different episodes ; publisher *Senichi*. Round the border is the double *tomo-ye* crest of Yurano-sukè ; copies of prints from this set are often found mutilated by having this decorative border cut off.

This *Chushingura* set is not at all common, especially the extra scenes to Act XI, and it is rarely found in really fine impressions, with the result that it usually conveys a somewhat poor impression of Hiroshige's powers as an artist.

The first episode of the eleventh act, the *ronin* crossing the bridge on their way to the attack, is so far and away the best plate in the series, that it is a real masterpiece. We here reproduce at Plate 40 an exceptionally brilliant impression of this scene and also of Act V, such as are rarely met with.

As an example of the estimation in which this particular *Chushingura* series is held by collectors, a complete set of the sixteen scenes, in only moderate condition, changed hands at auction early last year (1920) for nearly forty pounds, a sum which, in the opinion of the writer, seemed high considering its state. But prints, particularly complete sets, by Hiroshige have been fetching very high prices in the auction room ; competition is especially keen on the part of American and Japanese collectors.

The writer recently made an interesting find in the shape of a set of quarter-plate scenes, four acts on one sheet, of this series, finishing with the second episode of Act XI. Whether there should be a fourth sheet with the other four episodes of Act XI to complete it, it is impossible to say. The artist's signature which appears on each scene is difficult to decipher, but seems to be Yukinobu, a name not previously met with, and one which does not appear to be mentioned in any book dealing with this subject.

With the exception of slight alterations here and there in parts of the

colour-scheme, Hiroshige's set is copied exactly, and this fact led the writer to at once attribute it to Hasegawa Sadanobu, an Ōsaka artist, copies of whose set of small *Omi Hak'kei* views in exact imitation of Hiroshige's same series in half-plate size is in the Victoria and Albert Museum collection, South Kensington, and who was known to be an arrant imitator of the latter. It is possible this *Chushingura* set is by him, but comparing the signature thereon with that on the above-mentioned *Omi Hak'kei* set, it does not appear the same.

Each scene of this set has a border of a white fret pattern on a blue ground, but without the *tomo-ye* crest on it.

The following constitute the scenes in the *Chushingura* set published by Senichi.

Act I. Examination of the Helmets at the Hachiman Temple, Kamakura.

Lady Kawoyo, followed by two men carrying the box of helmets, mounts the temple steps (blue and grey) towards the council of nobles seated at the top.

On the uppermost step is Tadayoshi, acting as deputy for the *Shōgun* Takauji, at the inauguration of the temple; below him on his left is Moronao, and on his right, another commissioner, Ishido.

On a lower step again is Yenya (below Moronao), and Wakasa opposite him. (See Plate 40.)

(Yoshisada had been defeated and slain in battle by the Ashikaga *Shōgun*, Takauji, who caused this shrine to be erected to the war-god, Hachiman, at Kamakura (Tsurugaoka) in commemoration of his success. He commanded that the helmet worn by Yoshisada should be placed in the treasury of the temple as a trophy of war, but as forty-seven helmets had been picked up on the ground round the spot where Yoshisada and his defenders fell, none of the councillors knew for certain which was the one he had worn.

Lady Kawoyo, who had been one of the twelve *naishi* ("inner attendants") in the service of Yoshisada, is thereupon, on the suggestion of Tadayoshi, sent for to solve the difficulty; she immediately picks out the helmet in question, which had been presented to Yoshisada by the Emperor Go-daigo as a reward for his services.

The helmet is then delivered over to Yenya and Wakasa for safe keeping, to see that it is duly placed in the temple treasury; they then retire in company with Tadayoshi, leaving Moronao alone with Lady Kawoyo, when he presents her with his love-verses which she scornfully rejects.

Before the episode closes, however, Wakasa opportunely returns, and seeing that some insult had been offered to Lady Kawoyo, cleverly interposes by reminding her that, her duties being now done, Tadayoshi had given her permission to retire.

Moronao, hot-tempered and suspicious that Wakasa guessed what had passed between him and Lady Kawoyo, insults Wakasa who, exasperated by Moronao's conduct, coming on top of a previous insult earlier in the day, grasps his sword, then and there, to make an end of his tormentor, when, fortunately for Moronao, at that moment Tadayoshi's escort comes running up, clearing a way, and in the stir and confusion thus occasioned Wakasa is obliged to defer his vengeance.)

Act II. From behind a yellow screen, on which is a painting of a bamboo, signed *Joko-an*, Tonasé watches her daughter as she diffidently approaches *Rikiya* to receive his message ; through the open side of the room is seen Wakasa standing on the veranda and before him Honzo cutting off the pine branch.

A plate above the average of the set ; the bright yellow screen against the blue and green of the room and the gay colour of Konami's dress make a very effective colour-scheme.

(Rikiya comes to Wakasa's castle to deliver a message from his lord Yenya, to the effect that Tadayoshi commands they both be present at Kamakura on the morrow at the seventh hour (4 a.m.) for instruction at the hands of Moronao.

Honzo, Wakasa's chief steward, deputes his wife Tonasé to receive Rikiya's message and transmit it to Wakasa, adding, " And stay, Rikiya and Konami are betrothed, so treat him civilly. I must away to your mistress."

Under the circumstances, Tonasé considers it would be more fitting if Konami received the visitor, but her daughter hesitating to reply, the mother feigns indisposition, saying it will be impossible for her to receive Rikiya, and hobbles off as though to retire to an inner room, but really conceals herself behind a screen to watch Konami's behaviour.)

Act III. Scene outside the Castle of Kamakura at early dawn. Sagisaka Bannai, chief retainer to Moronao, reading the list of presents which Honzo has brought to appease the hostility of Moronao against Wakasa. Behind Bannai stand two of his followers, grasping the handles of their swords ; on the left kneels Honzo and a servant.

On one of the wooden stands in front of Bannai are the picture-rolls, and on the other the *ogon* (oval gold or silver-gilt money-pieces), which constituted the presents.

(The threatening attitude of Bannai's two retainers is explained by their suspicions of any possible foul play on the part of Honzo, such as a dagger hidden in the roll of paper containing the list of presents, which he might snatch up and try to plunge into Moronao, who, in the actual story, is present when Honzo brings his gifts.

Moronao was fully prepared, after the previous day's scene with Wakasa, for an attempt on his life, and his chief retainer, Bannai, was at first suspicious that the offer of these presents was a mere blind to attack him, and that Wakasa had deputed Honzo to do, or attempt to do, the deed.)

(In the previous act, while Konami is receiving Rikiya, Wakasa explains to his councillor Honzo the insults to which Moronao had treated him at Kamakura, and that he intended, on the morrow, to wipe out his score against him, and so rid the country of a pestilential fellow. Appearing to approve of his lord's decision, but secretly knowing it would mean death to him and disaster to his family if he succeeded in carrying it out, Honzo strikes off a pine branch with his short sword, exclaiming, " *Sah !* So let the enemies of my lord perish by his hand."

Wakasa then retires to rest, it being now midnight. Honzo, however, immediately sets about in the short time available to devise means of preventing the threatened calamity, and knowing Moronao's miserly disposition, collects all the money and presents he can and rides off during the night with it to Kamakura. He arrives just

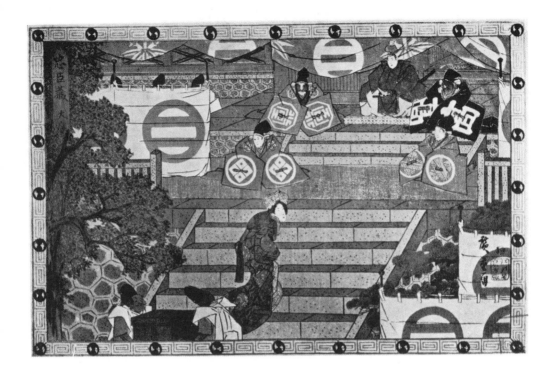

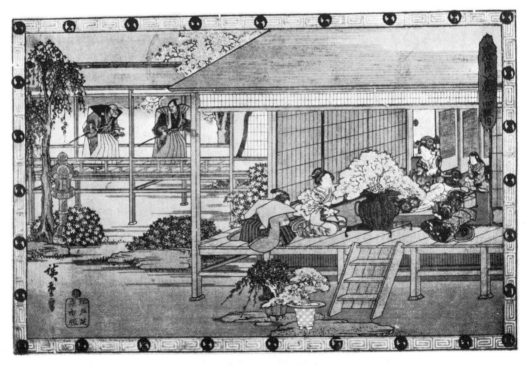

HIROSHIGE : *Chushingura (Senichi* issue). Acts 1 and 4.

PLATE 40 (first part)

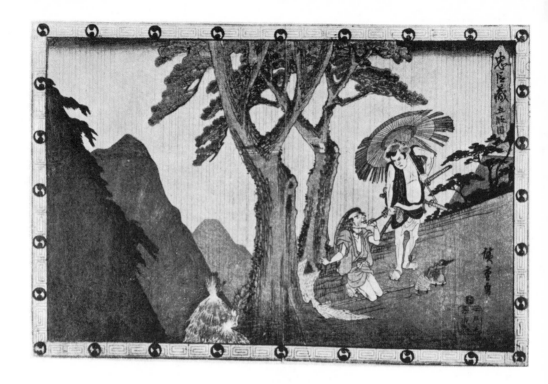

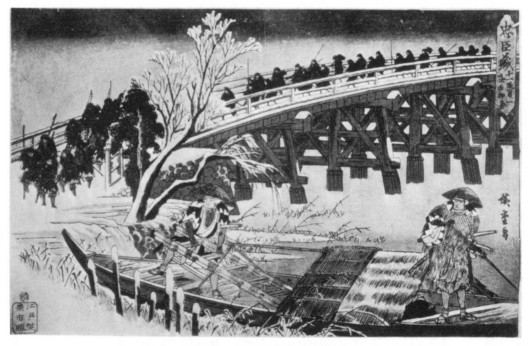

HIROSHIGE : *Chushingura* (*Senichi* issue). Acts 5 and 11 (1st episode).

PLATE 40 (second part)

in time to present his gifts to Moronao and his retainers as coming from Wakasa and his household before Wakasa comes on the scene, fully prepared to have it out with Moronao.

Moronao, however, is now completely changed in his manner to him, and apologizes profusely for his conduct of the previous day, whereupon Wakasa is so taken aback that his former anger is changed to amazement, and he feels himself unable to draw his sword, but is obliged instead to hold it in the reverse attitude to that of fighting. Honzo meanwhile secretly congratulates himself on the success of his bribe to Moronao, a success, however, for which he pays the price of his own life, as we shall see in a later act.)

Act IV. Yenya's castle at Yedo. In a large open room overlooking the garden is seated Lady Kawoyo and her attendants, accompanied by Rikiya, before a large bowl of rare cherry-blossoms, which she had caused to be brought to afford some distraction to her lord in his unfortunate condition.

Along a covered veranda, on the left, Hara Goyemon, the chief of Yenya's retainers (ranking next to Yuranosukè, his councillor) is approaching, followed by Kudayū. (See Plate 40.)

Act V. Scene at nightfall in the mountains, on the hill-road between Kyoto and the village of Yamazaki, during a heavy rain-storm.

(Only copies of very early impressions are printed with the rain-block, as in that here reproduced at Plate 40 ; such copies are very uncommon.)

Between two large pine trees kneels the old peasant Yoichibei, imploring mercy, while the robber Sadakuro snatches at his purse, hung from his neck by a cord.

Steep, black mountains rise up from a deep gorge on the left, while in the distance appears another mountain through the rain. Sky graded from black at top to grey, and then grey-blue.

(Yoichibei, father of Ōkaru, was returning home from Kyoto bringing half the money received from the tea-house proprietor there by the sale of his daughter, who had, unknown to Kampei, adopted this means to raise money for him to enable him to join the *ronin* ; the rest of the money to be handed over when the proprietor came next day to claim her and take her to Kyoto.)

Act VI. Along a yellow road, over a bridge, three huntsmen who have found Yoichibei's dead body and brought it to his cottage, are returning.

In the story of the " Chushingura " their names are given as Meppo Yahachi, Tanegashima no Roku, and Tanuki no Kakubei.

Behind, Kampei receiving Yagoro and Goyemon at the door of the hut. Background of hills. A rather poor plate, the figures of the huntsmen are crudely drawn, and the colouring is not happy.

Act VII. The Ichiriki tea-house, Gion Street, Kyoto. Yuranosukè supping with the spy Kudayū, surrounded by tea-house girls ; on the left two *geisha* playing *samisen*.

In the centre of the group are two of the *ronin*, Yazama Jiutaro and Senzaki Yagoro, dressed in black, one of them pointing his fan at Yurano-sukè, who have come to question him as to his plans against Moronao. Kudayū being present, Yuranosukè feigns drunkenness and talks stupidly to them, whereupon they retire, rather ashamed at their chief's conduct, not realizing at the time his reasons for it.

Act VIII. The journey of Tonasé and her daughter Konami from Yedo to Yamashima to find Rikiya.

Behind them, by the roadside, stands the trunk of a huge pine tree, wreathed with an autumn-tinted creeper ; a woman stoops to tie up Konami's sandal. Behind Konami follows their porter, and behind him again is another traveller mounted on a pack-horse, led by a coolie. In the background, over a wooded hill, appears the cone of Fuji, white against a blue sky.

An unusual treatment of the Bridal Journey scene, which is generally depicted by the seashore at Tago.

Act IX. One of the best plates of the set. Yuranosukè's house at Yamashima under snow.

In an open room, overlooking the garden, Honzo, in the presence of his weeping wife and daughter, commits *seppuku* in atonement for his conduct in stooping to bribe Moronao in favour of his lord, Wakasa, and for interfering when Yenya attacked his enemy, thus indirectly being the cause of reducing his retainers to the status of *ronin*, while outside, Yurano-sukè, who has now adopted Honzo's disguise, goes off to Sakai where he makes his final preparations to attack Moronao. Behind him kneels his wife, bidding a tearful farewell, and his son Rikiya.

Act X. Scene outside the house of Amakawa-ya Gihei, at Sakai, at night.

A party of nine *ronin*, who have been sent to test Gihei's loyalty to their cause, two of them carrying a large basket which conceals Yuranosukè, knocking at the door of Gihei's house. In the background Gihei's wife approaches ; three street dogs and coolies right.

Act XI. First Episode. The *ronin* crossing the bridge at night on their way to the attack on Moronao's castle. In the foreground is a boat, in which are two *ronin*, close in to the shore.

In the event of their being attacked on their return by Moronao's re-tainers, or by those of his son's father-in-law, who lived in the neighbourhood, this boat was kept in readiness to enable one of them to escape with their enemy's head by water. The masterpiece of the set. (See Plate 40.)

Act XI. Second Episode. The party in charge of Rikiya breaking an entrance into the inner building by forcing out the shutters with bent bamboos inserted under the upper and lower grooves, thereby prising open the framework.

One *ronin*, Ohowashi Bungo, carries a huge wooden mallet to batter down the gate, while another is armed with an enormous battle-axe.

Act XI. Third Episode. The finding of Moronao, who has been dragged out of his hiding-place, and is struggling to free himself from the grip of two of the *ronin*, while Yuranosukè shows him the dirk with which Yenya committed self-dispatch, and invites him to do likewise, an invitation which Moronao declines, so that Yuranosukè himself is obliged to give him the *coup de grâce*.

Act XI. Fourth Episode (really the fifth). The *ronin*, on their way to Sengakuji Temple, are halted in the snow-covered street outside the Palace of Matsudaira-no-Kami, Prince of Sendai, by three of his foot-soldiers. (See Plate 41.)

We here give this episode in the order in which the plate is numbered, but correctly speaking this and the next should change places to be in the proper sequence of events. It is probably owing to this error that this plate is often found incorrectly described in order to make it fit in the place assigned to it by the plate number.

In this scene the *ronin* are now quite close to Sengakuji Temple, near which the Prince of Sendai's castle is situate. Having heard of their valorous deed in avenging their lord, he sends out some foot-soldiers to stop them and bring them to his palace for rest and refreshment, an act of kindness which they gratefully accept.

Identification of the scene is further afforded by the five sparrows fluttering above their heads, a sparrow being the badge of the Lord of Sendai.

Act XI. Fifth Episode (really the fourth). The *ronin*, as they are about to cross the Sumida River by the great Ryogoku Bridge, are challenged by a mounted *hatamoto*, armed with a lance, who forbids their crossing.

(The Sumida River, at the time these events took place, divided two different provinces at this point, access between which was given by the Ryōkoku (=two provinces ; *pronounce* Ryōgoku) Bridge. By the time the *ronin* had reached Yedo their deed had become noised abroad, and the *daimyo* in whose jurisdiction the province lay forbade them to enter it, being apprehensive of thus harbouring forty-seven murderers, as legally speaking they were. He therefore sent out a *hatamoto* with orders to turn them back should they attempt to enter his province, so they were obliged to cross by the Yeitai Bridge to avoid it.

The *hatamotos* were feudatories who flocked to the standard of the *Shōgun* (the word means " under the flag ") in war-time. In rank they came between the *daimyos* and the *samurai*.)

Act XI. Sixth Episode. Scene at sunrise.

The *ronin* entering the precincts of Sengakuji Temple. On the right is a snowy cliff, wonderfully graded. A very fine print.

After a short rest at the Palace of Sendai the *ronin* take their departure with many thanks for the hospitality shown them, and continue their way to the temple, where they are received at the entrance by the abbot, and conducted to the resting-place of their lord, before which they each burn incense in turn as the priests of the monastery read prayers.

Hiroshige issued through the publisher *Arita-ya* another series illustrating the " Chushingura," complete in twelve scenes. This set is very uncommon, even more so than the foregoing *Senichi* issue, and contains several plates which compare very favourably with the best in the latter. This set has the customary *tomo-ye* border, and is notable for the unusual treatment of several of the scenes.

Act I. Wakasa defending Lady Kawoyo from Moronao's insults.

Scene in the grounds of the Hachiman Temple ; a large *torii* in the centre, through which can be seen steps leading up to the main gate, and in the distance a range of hills.

Act II. Konami shyly bringing tea to Rikiya, who is seated in a room in Wakasa's castle, while in another room, on the left, Wakasa watches Honzo as he cuts off a pine branch. One of the best plates in the series.

Konami's brightly-patterned dress showing up against the white paper screen as she passes along the veranda is an effective contrast to the dark shades of night over the landscape.

Act III. Bannai and his followers stampeding before Kampei's assault ; behind him stands Ōkaru by the bridge over the moat, across which rise the walls and towers of Kamakura Castle. The sky is still dark with the shadows of night.

Act IV. Nightfall : Yuranosukè by the moat in the grounds of the castle after Yenya's *seppuku*, leaving to prepare his plans for vengeance and so carry out his dying lord's last injunctions. A very unusual treatment of this act. (See Plate 41.)

Act V. By a huge solitary pine tree stands the robber Sadakuro, counting the money he has just stolen from Yoichibei, whose hat and sandals lie on the ground beside him, and whose body he has thrown to the bottom of the ravine on the left. Sky indicating nightfall, but no rain. While the landscape element in this scene is almost identical with that in the same act of the *Senichi* set, the general treatment in showing only Sadakuro is unusual.

Act VI. Kampei, with musket on shoulder, returning home, passes Ōkaru on a bridge over a stream as she is being taken away in a *kago* to the tea-house at Kyoto, followed by the tea-house proprietor looking very pleased with his new acquisition.

In the background, behind a large willow tree, stands Ōkaru's mother at the door of her cottage, waving a farewell to her daughter.

Like the same act in the *Senichi* issue, this plate is one of the least satisfactory.

Act VII. Yuranosukè playing blind-man's buff with the girls of the Ichiriki tea-house, and three of the *ronin*, Yazama Jiutaro, Senzaki Yagoro, and Takemori Kitahachi, followed by Heiyemon, watching him in disgust.

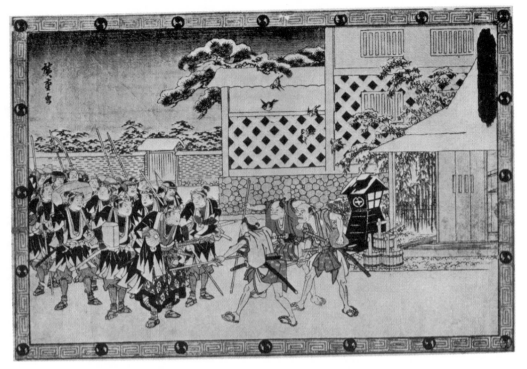

1. Act 11 (4th episode) (*Senichi* issue).

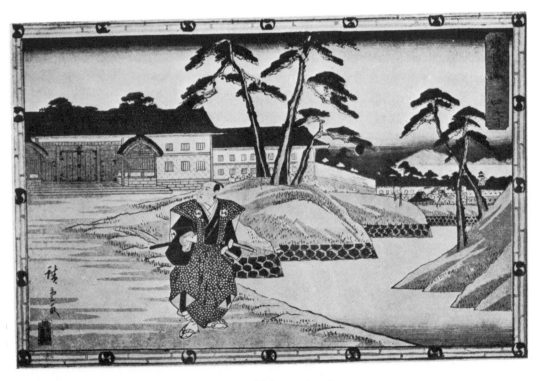

2. Act 4 (*Arita-ya* issue).

PLATE 41 (first part)

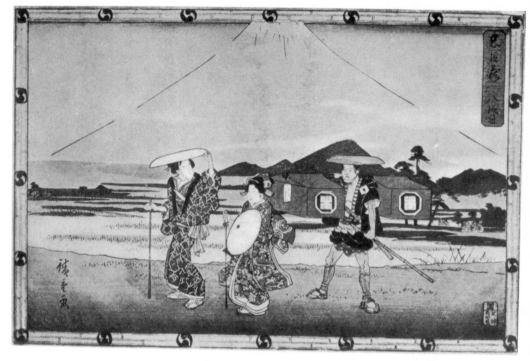

3. Act 8 (*Arita-ya* issue).

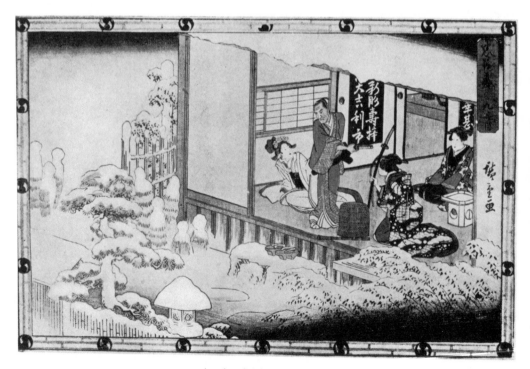

4. Act 9 (*Arita-ya* issue).

PLATE 41 (second part)

Yuranosukè in running after one of the girls has, instead, seized hold of Yazama, much to the latter's surprise at his chief's conduct.

"Yuranosukè," cries Yazama, disengaging himself; "I am Yazama Jiutaro, don't you know me? What does all this nonsense mean?"

"*Namusambo*," mutters Yuranosukè; "I have done, the game is all up now."

Yazama thereupon dismisses the girls, and he and his companions try, but in vain, to find out from their chief what his intentions are, and when he proposes to start for Kamakura. Yuranosukè, however, knowing Moronao's spies are lurking in the tea-house, feigns drunkenness and stupidity, so that Yazama and his companions lose patience with him as a worthless fellow, and are on the point of falling upon him with their swords, when Heiyemon prevails on them to desist, and in an earnest speech begs Yuranosukè to allow him, though only a common soldier (*Ashigaru*, a low-class *Samurai*), to join the others in their conspiracy to avenge Yenya's death.

In the course of this appeal on the part of Heiyemon, Yuranosukè falls asleep, and the three *ronin*, in utter disgust, again draw their swords to make an end of him, but Heiyemon, more quick-witted than the others, interposes a second time, divining that Yuranosukè's conduct had reasons in it.

Yielding to Heiyemon's explanation of their chief's conduct, the three *ronin* then withdraw, leaving Yuranosukè asleep.

Act VIII. The Bridal Journey. One of the best plates in the set, beautifully coloured. In the background rises a great white-coned Fuji, its lower part streaked with grey, and white clouds floating round it. (See Plate 41.)

Act IX. Honzo arrives at Yuranosukè's house at Yamashima just in time to prevent Tonasé taking her daughter's life and her own. On the floor at his feet are his *komuso's* hat and bamboo flute; behind sits Ō-ishi with the white-wood stand in front of her on which she demanded Honzo's head as a price of the marriage of her son Rikiya with Konami.

Another very fine plate. (See Plate 41.)

Act X. Scene outside Gihei's house at night; one of the *ronin* about to set on O-Sono and cut off her hair. A very fine plate, the masterpiece of this set, and most effectively coloured. (See Plate 42.)

(O-Sono, wife of Gihei, has been temporarily divorced by him to ensure her ignorance of the plot against Moronao. On the night that the *ronin* pay their surprise visit to Gihei, O-Sono comes to seek re-admission to the house, and to plead with her husband to take her back, otherwise her father, Ryochiko, would compel her to re-marry against her will. But Gihei refuses to allow her back until the spring, when the necessity for secrecy will no longer be paramount, and pushes her outside the house.

While she lingers, two of the *ronin*, Ohowashi Bungo and Yazama Jiutaro, their

[257]

faces concealed all but the eyes, seize O-Sono and cut off her hair, so as to make her like a nun and prevent her father compelling her to re-marry.

This they do by order of Yuranosukè who thus explains the matter to Gihei : " Ere her hair grows again, I hope we shall have attained the object of our enterprise, and after our vengeance shall have been fully accomplished, you will be reunited— may you live long and happily together ! "

" And," added Yuranosukè, " however long it may be ere she be reunited to you, Gihei, we are all sureties for her that she shall divulge nothing, and I myself, from the dark path, will act as intermediary in effecting your reunion."

The foregoing representation of this act is a most uncommon one, which renders this set more than usually interesting.)

Act XI. First Episode. Snow scene at night in the grounds of Moronao's castle. Moronao discovered in his hiding-place in an outhouse used to store wood and charcoal, one of the *ronin* blows a whistle, a pre-arranged signal that their enemy had been found.

Corresponds to the third episode of Act XI in the *Senichi* set.

Act XI. Second Episode. The *ronin*, headed by Yuranosukè and Rikiya, in the sunrise of early morning making their way to the Temple of Sengakuji with the head of their enemy, which one of the *ronin* carries in a kind of urn. A fine plate. (See Plate 42.)

(By the bank is the boat with three other *ronin* in it, one of whom carries another casket with which to convey the head by water to Sengakuji in case they were attacked by Moronao's retainers or his friends on the road.

Just as they were, however, on the point of leaving Moronao's castle, on the fulfilment of their mission, Yakushiji Jirozayemon, the commissioner who carries out his duties towards Yenya, in Act IV, so callously and brutally, and Bannai Sagisaka, Moronao's chief retainer, whom we last heard of at the Ichiriki tea-house, suddenly rush out from their hiding-place in one of the rooms of the castle, and attack Yurano-sukè.

Rikiya, however, immediately rushes to his father's assistance, and cuts both of them down, a fit ending to their villainy.)

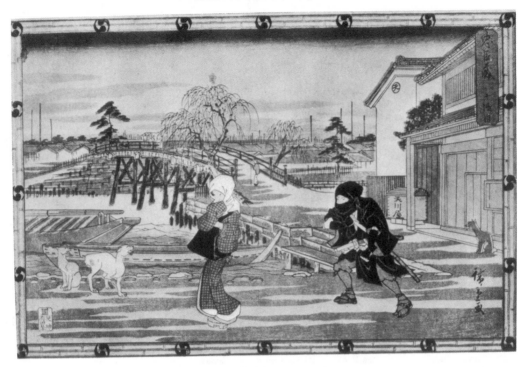

1. Act 10 (*Arita-ya* issue).

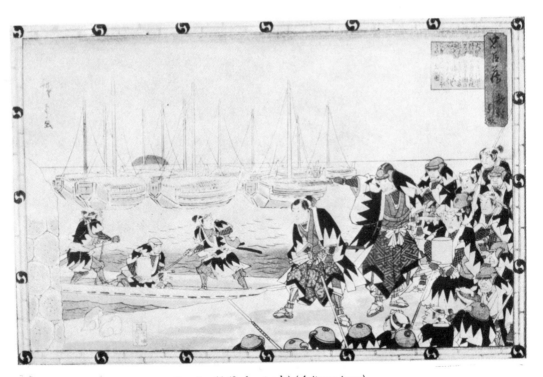

2. Act 11 (2nd episode) (*Arita-ya* issue).

PLATE 42 (first part)

3. Act 5 (*Marusei* issue).

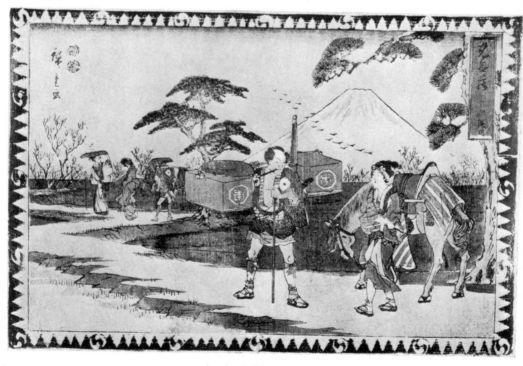

4. Act 8 (*Marusei* issue).

PLATE 42 (second part)

CHAPTER XXVIII

HIROSHIGE'S ILLUSTRATIONS TO THE "CHUSHINGURA"—*(continued)*

BESIDES the two foregoing series, Hiroshige issued yet a third full-size, oblong set, through the publisher *Marusei*, which appears to be the least common of any by him in this form. The latest Japanese work on Hiroshige, which professes to catalogue all the known series by him, makes no mention of this *Chushingura* set, while it gives both the *Senichi* and *Arita-ya* sets.

The *Marusei* set may be distinguished by the following characteristics from the other two oblong sets.

It has a black and white indented border on which appears the *tomo-ye* crest at intervals, while in several of the scenes the principal figures are drawn on a larger scale. On each plate are two round censor's seals, those of Kinugasa and Watanabe, showing that this set was issued during the Prohibition period, 1842–1853. The publisher's seal of *Marusei* occurs only on the first act. The title, "Chushingura," followed by the number of the act portrayed, is on a red label in the top right-hand corner.

Act I. In the grounds of the Hachiman Temple looking out over the Bay of Yedo. Moronao, in high dudgeon, turning his back on Wakasa and Yenya, and walking away; Lady Kawoyo behind them looking at the retreating Moronao. Behind Wakasa grows a big tree. The sky a beautiful rosy pink, which makes this scene one of the best in the set, and counteracts the somewhat crude drawing of the figures.

Act II. Honzo drawing his sword preparatory to cutting off the branch of a big pine tree, while Wakasa, seated by the veranda, watches him. Behind, in another room, on the left, Konami receiving Rikiya.

Act III. Scene by the moat of Kamakura Castle in the early morning. Kampei defending Ōkaru from Bannai and his men.

Act IV. Like the same act in the *Arita-ya* set described above, this is a very unusual treatment of this scene, and is almost identical with the former, except that it is reversed, that is to say, the moat is shown on the left of the picture, and the building behind on the right, while a large round paper lantern stands on the ground beside Yuranosukè, who faces right instead of left. (See Plate 41 for the illustration of this act in the *Arita-ya* set.)

Act V. The best plate in this set. Sadakuro, with Yoichibei's bag of money firmly held in his mouth, wipes his sword and at the same time kicks over the dead body of the old man down the slope. On the other side, at the foot of a tree-clad hill, the meeting of Yagoro and Kampei. (See Plate 42.)

There is no separate rain-block to this plate, rain being indicated by the streaky appearance of the dark background.

Act VI. Kampei receiving Yagoro and Goyemon at the door of Yoichibei's hut. A flat landscape with low hills in the distance, and in the foreground a stream by the side of which grows a clump of bamboos, and beyond the further bank a solitary tree.

Act VII. The tea-house scene. Yuranosukè reading the letter from Lady Kawoyo in the light of a full moon, while Ōkaru reads it from above by the aid of a mirror concealed in a book, and Kudayū under the veranda reading it with the aid of a large pair of spectacles.

Act VIII. The Bridal Journey. An unusual treatment of this scene. In the right foreground a porter turns to address a girl close behind him leading a horse ; further along the winding road are Tonasé and Konami, followed by another porter, turning to look at the great white cone of Fuji. (See Plate 42.)

Act IX. Honzo in disguise arrives at the gate of Yuranosukè's house just as Tonasé prepares to take her daughter's life. A good snow scene.

Act X. Gihei seated on the basket in which Yuranosukè is concealed defying a party of six *ronin* to dislodge him.

Sometimes Gihei is shown seated on the chest containing the armour, and sometimes on the basket in which Yuranosukè is concealed ; strictly speaking, according to the story, the latter is the more correct version.

Act XI. First Episode. Snow scene in the grounds of Moronao's castle. The fight between the *ronin* and Moronao's retainers.

Act XI. Second Episode. Snowy sunrise over Yedo Bay. The forty-seven *ronin*, headed by Yuranosukè and Rikiya, arrive up a steep slope before Yenya's tomb at Sengakuji Temple, where they are received by two priests, one of them bearing an incense burner. One of the best plates in the set.

The last *Chushingura* series by Hiroshige which we have space to mention in detail is a very rare half-plate set issued during the Prohibition period, about 1845, through the publisher *Fuji-kei*, whose sign occurs on Acts II, X, and the Second Episode of Act XI. The censor's seal of *Muramatsu* occurs on Acts III, IV, VI, IX, X, and XI. Each scene has a black border on which is repeated the *tomo-ye* crest. Both in colour and drawing it is a great improvement on the full-size *Marusei* set, issued about the

same time, and in this respect follows fairly closely the *Arita-ya* edition. The set from which the illustrations at Plate 43 are taken is in unusually good condition and colouring.

Act I. Lady Kawoyo, summoned before the council of nobles at the Hachiman Temple, makes her obeisance at the foot of the steps at the top of which they are seated ; before her is the box of helmets.

Act II. Love scene between Konami and Rikiya, her mother listening from behind a screen. (See Plate 43.) Reproduced to show publisher's mark.

Act III. An unusual treatment of this scene. Ōkaru, escorted by one of Yenya's servants with a lantern, whom she is dismissing, arrives at the bridge over the moat, carrying a letter-box containing her mistress's answer to Moronao, and which she wishes to give to Kampei to convey to Yenya with a request to hand it to Moronao. While Kampei is carrying out his instructions, Bannai approaches and attempts to make Ōkaru run off with him, but he is interrupted by two men (bribed by Kampei) calling out that his master wants him (a trick previously played upon Kampei by Bannai), and he returns into the palace and at the same moment Kampei comes out again to Ōkaru. Later, after Yenya's attack on Moronao, Bannai comes out a second time and attempts to arrest Kampei. (See Plate 43.)

Act IV. Yuranosukè leaving Ogigayatsu Castle after his lord's *seppuku*. Almost a reproduction of the same scene in the *Arita-ya* set, except that the moat is not shown.

Act V. Sadakuro robbing Yoichibei of his money ; scene in the mountains, with a great pine tree in foreground. Dark blue sky changing to black at top indicating nightfall, but no rain-block.

Act VI. Kampei, with gun on shoulder, stands on a small plank bridge over a stream, gazing abstractedly at the landscape, while from the further side approaches the *kago* containing Ōkaru and the tea-house proprietor. In background the straw-thatched roofs of cottages, and a willow tree overhanging the stream.

Act VII. Yuranosukè, blindfolded, coming down the steps from the veranda of the tea-house, after the tea-house girls ; overhead a full moon.

Act VIII. Tonasé and Konami resting under the shade of a large tree overlooking the seashore, and admiring the fine view of Fuji. (See Plate 43.)

Act IX. Tonasé preparing to take her daughter's life is arrested by hearing Honzo's pipe outside the gate of Yuranosukè's house.

Act X. Gihei, on his knees, being threatened by a patrol of *ronin ;* behind him is the large basket concealing Yuranosukè.

Act XI. First Episode. The attack on Moronao's castle ; snow scene

under a full moon. Ohowashi Bungo attacking the main door with his huge mallet, while behind others are effecting an entrance over the roof by scaling ladders.

Act XI. Second Episode. The *ronin*, headed by Yuranosukè and Rikiya, climbing up the snow-clad slope leading to their lord's tomb at Sengakuji Temple, and a priest squatting at the entrance. (See Plate 43.)

In instances such as those given above in this chapter where the last act is portrayed in two or more episodes, these really form illustrations to the story only, as in the dramatized version as acted on the stage, the play always ends with the attack on Moronao's castle and the death of their enemy, the subsequent incidents while on their way to Sengakuji not being given.

At Plate 43 we also illustrate three acts, the first, second, and third, from a very rare panel series, complete in four plates, printed three-on-a-block, issued by Hiroshige through the publisher *Yamaguchi-ya* (*Tōbei*), with the title *Chushingura*.

The different acts follow the usual treatment sufficiently to be easily identified. In Act III Ōkaru is shown giving the letter-box to Kampei to take to Yenya, containing Lady Kawoyo's answer to Moronao.

Act VII. Ōkaru coming down the ladder from the upper balcony at the tea-house in Kyoto.

Act X. O-Sono seeking admission to Gihei's house.

Act XI. First Episode. The *ronin* crossing the bridge ; below, the waiting boat. Snow scene.

Second Episode. Yuranosukè and Rikiya at Yenya's tomb.

Hiroshige II has designed a *Chushingura* set, full size, oblong, complete in twelve scenes, with the usual *tomo-ye* border ; publisher *Fuji-kei ;* seal-dated for the year 1855 ; signed *Ichiyusai Shigenobu.*

HIROSHIGE (Ichiryūsai).

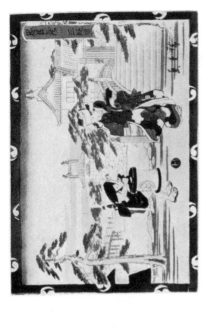

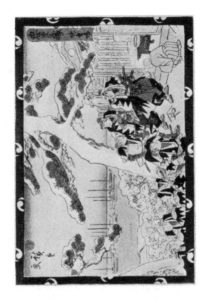

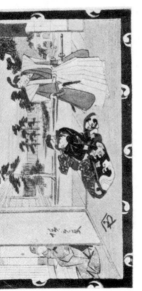

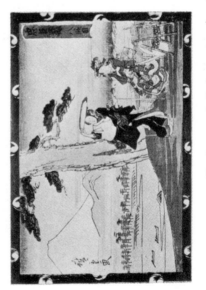

1. *Chushingura*, half-plate series. Acts 2, 3, 8 and 11 (2nd episode); publisher *Fuji-Kei*.
(Very rare.)

(Author's Collection.)

PLATE 43 (first part)

HIROSHIGE (Ichiryūsai).

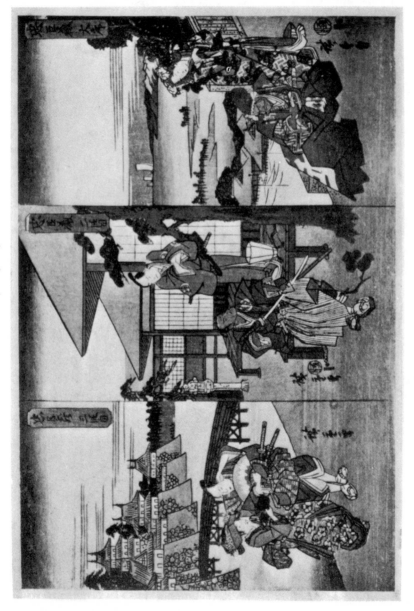

2. *Chushingura*, panel series, Acts 1, 2 and 3; publisher *Tobei*.
(Very rare.)

(*By courtesy of Messrs. Sotheby.*)

PLATE 43 (second part)

CHAPTER XXIX

ILLUSTRATIONS TO THE "CHUSHINGURA" BY ARTISTS OF THE KATSUKAWA AND UTAGAWA SCHOOLS

EXAMPLES of *Chushingura* prints by artists of the above sub-schools which have come under observation, have generally been various single sheets only from different sets ; complete sets appear difficult to find. A good, and almost complete set (one act only missing) by Katsukawa Shunsen (pupil of Shunyei) is described later in this chapter, and we are able to mention scenes from two different and interesting series by Shunyei.

An occasional *Chushingura* print by Shunsho has been noted, usually in his familiar *hoso-ye* form, but do not require particular mention.

The *Chushingura* scenes by Katsukawa SHUNYEI, here illustrated at Plate 44, Illustrations 2–5, are from a very rare series, medium size, upright, complete in eleven scenes, which are seldom seen. Many of the plates are distinguished compositions, and are interesting in that they are of a different type to any yet described. The figures are unusually large in proportion to their setting, and constitute the chief element in the design, whereas in all the various series hitherto described and illustrated the figures are set in surroundings such as the scene portrayed might be enacted in, the landscape being as important in the composition (in some instances the best part of the design) as the characters of the play.

Here these characteristics are reversed, the setting being merely intended to help out the scene, the characters themselves partaking more of the nature of figure-studies. From the point of view of drawing, these are far in advance of Hiroshige's illustrations to the *Chushingura*, which rely on the landscape element and the generally good colour-scheme to counteract the sometimes crudely-drawn figures.

These examples by Shunyei, on the other hand, are more akin to the graceful and reposeful figures of Kiyonaga, Shuncho, or Utamaro, than to the emotional and restless characters usually associated with dramatic representations.

Illustration 1, Plate 44, shows Act IV from a set complete in twelve plates, two episodes being given of Act XI, with the title *Chushingura ;* signed *Shunyei ;* publisher *Yeijudo.*

This is a very unusual representation of this act, and depicts Yurano-sukè before the two commissioners, Ishido Umanojo (left), and Yaku-shiji Jirozayemon (right), after Yenya's *seppuku*.

He is here supplicating the two commissioners to spare, if possible, the family and clan of Asano, and to leave them the Castle of Akō. Ishido replies that he will endeavour to influence the authorities at Yedo to do so if possible, but he is overruled by Yakushiji who, throughout the whole proceedings, behaves very truculently and boorishly towards the unfortunate Yenya and his dependants.

Hardly was the last breath out of Yenya's body, than Yakushiji springs to his feet, as if exulting in his death and the misfortune that had thereby fallen upon his family and retainers, and at once orders them out of the castle, bidding the latter turn themselves into *ronin* without more ado. Ishido, on the other hand, reproves his colleague for his too-hasty words and informs Yuranosukè that there is no intention of driving them at once out of the castle, at the same time adding that his services are gladly put at his disposal should he require any assistance.

Shunyei has cleverly delineated in their features the very different characters of the two commissioners.

In the drama, the *ronin* band together to avenge Yenya's death, in obedience to his dying injunction to Yuranosukè; actually Asano's chief steward was not present at any time during his lord's *seppuku*. He took upon himself to avenge his death, owing to his failure to influence the Government at Yedo to cancel their orders that unless Asano's castle and lands were surrendered, the whole clan and family would be exterminated.

Kuranosukè, thereupon, seeing it would be impossible for their small numbers to defend their lord's castle and possessions against his enemies, banded his retainers together to seek death by their own hands, after slaying their enemy Kira Kozuké. Originally sixty-three signified their willingness to " follow their lord upon the dark path " (an euphemism for death), giving their assent thereto in the most solemn manner by smearing the document with their own blood, but during the interval of a year which elapsed before they could put their resolve into execution, their number had dwindled down to forty-seven.

The late Lord Redesdale in his *Tales* gives a translation of a document, a copy of which was found upon each of the forty-seven *ronin*, explanatory of their conduct and the reasons therefor. This is not the same document as that referred to above, as it was drawn up only on the day they made their attack on Kira Kozuké and signed by Kuranosukè and the other forty-six. Its object, of course, was to clear their character after death, and to show the world at large that they were no common murderers.

SHUNYEI : *Chushingura.*

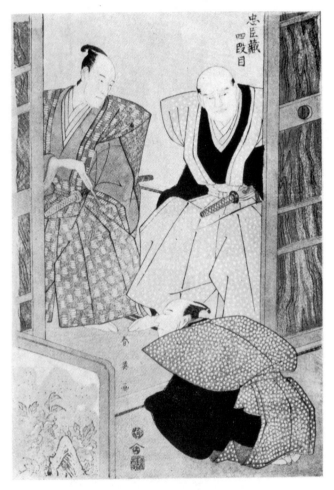

1. Act 4. Yuranosukè before the Commissioners.

PLATE 44 (first part)

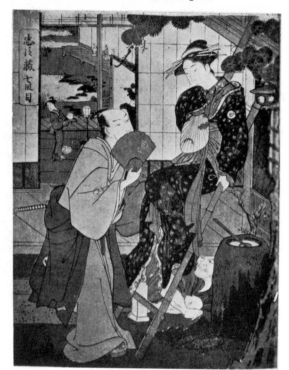

2. Act 7.

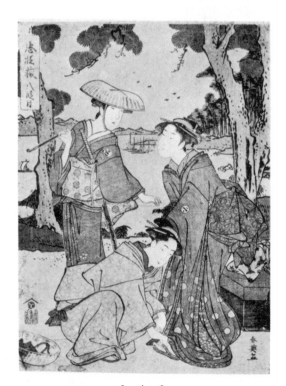

3. Act 8.

PLATE 44 (second part)

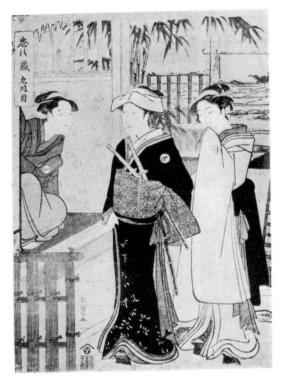

4. Act 9.

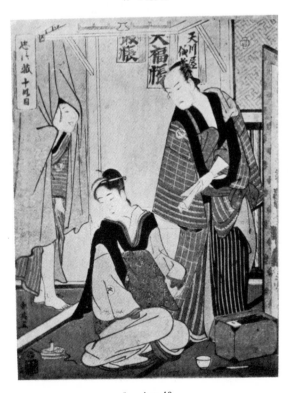

5. Act 10.

PLATE 44 (third part)

The following six plates from the medium-size, upright set by Shunyei (size $10\frac{1}{4} \times 7\frac{3}{4}$ in.), mentioned above, have come under observation ; publisher *Yeijudo*.

The predominating colours are subdued tints of *tan* and olive-green, while masses of black are introduced with very effective results.

Act III. Kampei threatening the prostrate Bannai with his sword, while Ōkaru revenges herself upon him by pinching his cheek. In the background the moat round the Castle and a corner of the battlements.

Act IV. Rikiya offering his condolences to Lady Kawoyo, who is attended by a maid-of-honour. (Reproduced at Plate 7 of sale catalogue, Sotheby, May 31, 1920.)

Act VII. Scene at the Ichiriki tea-house, Kyoto. Yuranosukè standing at the foot of the ladder, while Ōkaru descends it from the balcony above, after he had detected her reading the letter he had just received from Lady Kawoyo. Underneath the veranda is the spy Kudayū watching him.

The *crêpe*-like effect (found also on prints by Shunzan and Utamaro) given to Ōkaru's dress should be noted in this print.

Act VIII. The Bridal Journey along the seashore at Tago. A woman stoops to fasten Konami's sandal, while Tonasé turns to speak to her daughter. A very graceful composition.

Act IX. Tonasé and Konami arrive at Yuranosukè's house at Yamashima, and are received by one of the servants. A charming plate. Tonasé's black dress and Konami's black *obi* form an effective contrast to the snowy landscape in the background.

Act X. Gihei handing back to his wife, O-Sono, who kneels at his feet, the letter of divorce which she had brought back to him, when entreating that she might be allowed to return. On the left, a boy-servant, Igo by name, who had admitted her to the house, pokes his head through the curtain and makes fun at her.

With regard to *Chushingura* sets by Toyokuni, much the same applies to him as the remarks above concerning Shunsho. Judging from the various odd single sheets that have been noted, Toyokuni appears to have designed several *Chushingura* sets at different periods of his career, including a very uncommon pentaptych which depicts all the eleven acts in one picture, but complete sets are rare.

At Plate 45 we reproduce this pentaptych, some of the scenes in which are treated in an unusual manner.

Title on large, upright yellow label on right-hand sheet, "*Shimpan* ('New Edition') *Chushingura, Eleven Scenes*" ; each sheet full size, upright ; signed on large yellow label on bottom corner, left-hand sheet, *Toyokuni fudè* ; name and address of the publisher, *Yeijudo*.

Sheet 1 (right hand).

Acts I and II. The quarrel between Wakasa and Moronao, Yenya intervening, and Lady Kawoyo standing behind.

Below (II) : Honzo riding off at midnight, after hearing from Wakasa of his intention to kill Moronao on the morrow, to bribe Moronao and so avert the quarrel. An unusual treatment of this scene.

(Bidding Honzo good night Wakasa then withdrew. For a few moments Honzo gazed after his lord wistfully ; then rousing himself, he bent his steps hastily in the direction of the servants' quarters.

" Ho, there," he cried in a loud voice, " saddle a horse for me, quick."

The order was obeyed without delay, and Honzo at once swung himself into the saddle.

" Follow me, I go to the mansion of Moronao."

As he spoke, Tonasé and Konami came out of an apartment, and hurrying up to him, hung upon his bridle, exclaiming, " Where are you going ? We have overheard everything. How, Honzo ! You an old man, and yet you do not endeavour to moderate our lord's anger by your wisdom—what can this mean ? Stay, stay ! "

" Silence, both of you," cried Honzo, angrily. " Our lord's life—the existence of his house—are at stake. Mind you do not utter a word about my departure to your master. If you betray me, you, daughter, shall be turned out of my family, and you, Tonasé, shall be divorced. Ho, there ! (to the servants) I will give you your orders on the way."

Tonasé and Konami uttered an exclamation of alarm.

" You are too importunate," repeated Honzo, sharply. " Delay not (to the servants), but follow me." So saying, he hastily rode off. . . . Tonasé and her daughter immediately afterwards betook themselves with heavy hearts to the inner apartments.)[1]

The above is the episode here illustrated.

Sheet 2. Acts III and IV.

Below (III) : The discomfiture of Bannai by Kampei.

Above (IV) : Yenya before the two commissioners, one of whom reads out the sentence of the court against him. An unusual treatment of this act.

Sheet 3. Acts V and VII.

Below (V) : The robber Sadakuro, with Yoichibei's purse in his mouth, wiping his sword on the palm of his hand after murdering the old man, whose lantern and hat lie on the ground.

Above (VII) : Heiyemon dragging out the spy Kudayū from under the *engawa* at the Ichiriki tea-house ; Yuranosukè and Ōkaru looking on.

Sheet 4. Acts VI, VIII, and IX.

Below (VI) : Kampei being upbraided by his wife's mother for the death of Yoichibei, while Goyemon and Yagoro join in the accusation.

Centre (VIII) : The Bridal Journey.

[1] Taken from Dickins' translation of the *Chushingura*.

Above (IX) : The death of Honzo who holds in his right hand the plan of Moronao's castle ; behind him is Konami, and squatting on the ground Rikiya.

At the top corner of the adjoining sheet (No. 3) is Ō-Ishi carrying the white-wood stand on which she demands Honzo's head of Tonasé.

Sheet 5. Acts X and XI.

Above (X) : Gihei's house. Outside is his wife, O-Sono, seeking admission, while inside Gihei politely intimates in a forcible manner that the presence of Ryochiku is very distasteful to him. An unusual treatment of this act.

Below (XI) : Yuranosukè, with Rikiya and the other *ronin*, arrives outside the gate of Moronao's castle, prepared to exact vengeance.

One of the best series of *Chushingura* scenes by Toyokuni in the usual oblong form, which have come under observation, is an early set (*c.* 1790), which is represented in the British Museum collection by Act IX.

The title *Ukiyè Chushingura* (" Perspective Chushingura Pictures ") is on a panel at the side (like Hokusai's early set, signed *Kako*), and has a broad band of pink cloud across the picture above. Publisher *Idzumi-ya Ichibei (Senichi)*. Both in drawing and colouring this set is distinctly superior to many of his later series, which are at times somewhat crude in both respects.

Acts II, IV, V, VI, and IX of this set have been noted, which follow the usual treatment of these scenes, two episodes being sometimes shown in the one act.

Thus in Act IV, Lady Kawoyo is receiving the two commissioners, while in another part Yuranosukè is showing Yenya's dirk to his retainers.

Act V. Sadakuro about to attack Yoichibei, and in the centre he is shown trying to escape the charge of the wild boar, hunted by Kampei, by seeking refuge up a pine tree.

Act IX. Honzo appears at the gate of Yuranosukè's house just as Tonasé in one room, is about to take her daughter's life ; in another is Rikiya and Ō-ishi, who carries a wooden stand upon which she demands Honzo's head ; and in yet another part of the building Honzo shows his plan of Moronao's castle to Yuranosukè.

All the full-size plates illustrating the *Chushingura* which we have hitherto described have been of oblong shape ; as an example of the treatment in the less common full-size, *upright* form, we will here mention a series by Toyokuni, complete in six plates, two scenes in one illustration ; publisher *Moriji*.

Plate 1. Act I (above) : Moronao giving his love-verses to Lady Kawoyo.

Act II. Wakasa watching Honzo cutting off the pine branch.

Plate 2. Act III (above) : Bannai Sagisaka threatening Kampei, behind whom stands Ōkaru.

Act IV. Yuranosukè showing Yenya's dirk to Rikiya.

Plate 3. Act V (above) : Sadakuro killing Yoichibei ; black sky indicating nightfall and rain.

Act VI. Ōkaru being helped to her *kago* by the tea-house proprietor, and turning to bid her mother farewell.

Plate 4. Act VII (above) : Heiyemon dragging the spy Kudayū from under the veranda, while Yuranosukè looks on.

Act VIII. Honzo on his journey to Yamashima, following in the wake of Tonasé and Konami, unknown to them. He carries a sword in his hand and is examining a stone direction-post. This is the most unusual treatment of this act that has hitherto come under observation.

Plate 5. Act IX (lower portion, the order being reversed in this plate) : Honzo reveals himself to Ō-ishi (right), and his wife Tonasé, at the same time stamping to pieces the wooden stool upon which the former had demanded his head of Tonasé.

Act X. Scene at Gihei's house at Sakai. Interview between Gihei and his father-in-law Ryochiku, just before the arrival of Yuranosukè and his party of *ronin*, disguised as police to search Gihei's house for arms. A very unusual treatment of this act.

(Ryochiku was a quack doctor, of a mean and parsimonious character, in the service of Moronao as a spy, and a friend of the spy Kudayū. Owing to Gihei's connection with Yuranosukè and his active help in furthering the latter's plans against Moronao, Ryochiku took a violent dislike to him, and endeavoured to annul the marriage of his daughter. Such was the purport of his visit as shown in this act by Toyokuni.

Gihei, however, had sent his wife back to her father's home in order to avoid the possibility of the *ronin's* secret leaking out to Ryochiku through her, and so eventually reaching the ears of Moronao. The divorce, however, was only intended to be of a temporary nature, until such time as the attack on Moronao had been successfully achieved.)

Plate 6. Act XI (above) : Moronao discovered in his hiding-place in the coal-cellar, and being dragged forth ; Yuranosukè showing him Yenya's dirk and inviting him to commit *seppuku* therewith, thus showing his enemy the courtesy proper to one of his rank.

Below, one of the *ronin* engaged in single combat with Kobayashi Heihachi, one of Moronao's bodyguard.

As a final example of *Chushingura* prints by an artist of the Katsukawa

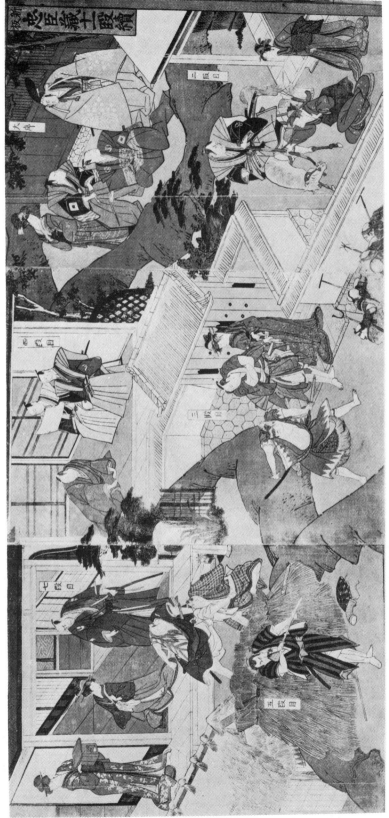

1. Acts 1 and 2.

2. Acts 3 and 4.

3. Acts 5 and 7.

TOYOKUNI : Pentaptych showing the eleven scenes of the *Chushingura* in one continuous picture ; signed (on last sheet) *Toyokuni*.
(A rare print.)

PLATE 45 (first part)

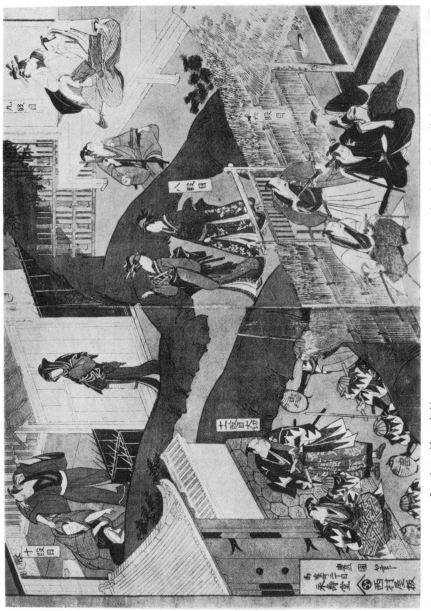

5. Acts 10 and 11. 4. Arts 6, 8 and 9.

TOYOKUNI : Pentaptych showing the eleven scenes of the *Chushingura* in one continuous picture ; signed (on last sheet) *Toyokuni*.

(A rare print.)

PLATE 45 (second part)

school, we will now describe a good set by Katsukawa SHUNSEN (c. 1790–1820), a pupil of Shunyei, who is better known for his book-illustrations than for his full-size, single-sheet prints, which are not common. This series, which is full size, oblong, has all the characteristics of *Ukiyè* pictures ; the band of pink cloud across the top of the design, and the narrow panel at the side with the title thereon, coupled with unusually deep perspective.

Title *Ukiyè Chushingura* (" Perspective Chushingura Pictures "), followed by the signature in full *Katsukawa Shunsen*, and the publisher's name, *Wakasa-ya Yoichi*. Complete in eleven scenes. Predominating colours of pink (*beni*), apple-green, and yellow.

Act I. Moronao detaining Lady Kawoyo as she turns to mount the temple steps, and offering her his love-verses ; Wakasa watching him from behind a tree.

Act II. Honzo cutting off a pine branch before Wakasa, and behind Konami making obeisance to Rikiya as she offers him tea, while he delivers his message for Wakasa who watches them from behind a screen in a room beyond.

The perspective of the various rooms opening out of one another is very good.

Act III. Scene on the bridge over the moat at the castle of Kamakura. Bannai and his men coming out of the castle and approaching Kampei to arrest him, behind whom stands Ōkaru getting her scarf ready with which to smother Bannai. In the background a long perspective of the moat and walls of the castle to green hills in the distance. (See Plate 46.)

Act V. Rain-storm near Yamazaki. Sadakuro seizing Yoichibei from behind by his coat ; in the background the meeting of Kampei and Yagoro.

Act VI. Arrival of the tea-house proprietor, Ichimonji-ya, from Kyoto at Yoichibei's house, to claim Ōkaru, at the same time showing Kampei his contract and demanding its fulfilment. Outside, on the left, Yagoro and Goyemon approach in disguise, along a winding path. (See Plate 46.)

Act VII. Yagoro and Goyemon, accompanied by Heiyemon, arrive at the Ichiriki tea-house while Yuranosukè is engaged in playing blindman's-buff with the tea-house girls ; in another part of the building he is shown with Lady Kawoyo's letter in his hand, looking up at Ōkaru in the balcony above, who has been reading it with the aid of a mirror, while Kudayū reads it from under the veranda.

Act VIII. The Bridal Journey. Tonasé and Konami, accompanied by a lady attendant, walking along the seashore, followed by their *kago* bearers. Behind them rises the wooded island of Enoshima and Fuji in the distance.

Act IX. Rikiya attacking Honzo with a long spear just as the latter had overcome Ō-ishi's assault and has her helpless on the floor ; on the right Tonasé and Konami look on at the struggle in dismay, not knowing what to do.

In another room, across the garden which is white with snow, Yurano-suké explains to Honzo his plan of attack on Moronao's castle from the drawing thereof which Honzo had brought with him, and which is spread out on the floor between them.

(The late Lord Redesdale in his *Tales* relates how he was able to have a private inspection of the relics of the Forty-seven *Ronin* preserved at Sengakuji Temple, and that amongst them was a plan of Kotsuké-no-Suké's house, which one of them had obtained by marrying the daughter of the builder who designed it.)

Act X. Gihei standing on the chest containing the *ronins'* arms and armour and defying them to make him reveal its contents. Outside, on a bridge over the canal, two other *ronin*, Ohowashi Bungo and Yazama Jiutaro, set on O-Sono and cut off her hair.

Act XI. The attack on Moronao's castle. Scene inside the building with a view of the grounds outside, through which flows a river. A general *mêlée* between the *ronin* and Moronao's retainers, one of whom has climbed up on to a rafter in the roof, but is shot down by a *ronin* armed with a bow and arrow. In the background, in another room, Moronao is being dragged out of his hiding-place.

At Plate 46, Illustration 3, we give a scene (Act IX) from another *Chushingura* series by Shunsen for the sake of comparison with the fore-going and for the purpose of identification of other scenes from it which may come under the notice of the reader. It is somewhat smaller than the above set, being medium size, instead of full size, oblong, and the edging of the pink cloud at the top of the picture is treated some-what differently, and affords the readiest method of distinguishing the two series.

The title is the same, namely *Ukiyè Chushingura*, is signed *Shunsen* only, and the publisher is *Senichi*.

Act IX. Tonasé about to take her daughter's life is interrupted by Ō-ishi, just as Honzo appears at the gate. In the background the departure of Yuranosuké watched by Rikiya and Honzo, who expires immediately afterwards from the effects of Rikiya's attack on him previously, and for which Yuranosuké reproaches him as being over-hasty.

(The big snow-ball in the fore-court, which at first sight appears to be only a fancy of the artist, and as of no more importance to the story than a snow-laden tree or garden ornament, actually has a connection with the scene illustrated, and serves to show, as has been noted before in other instances, how particular the artist was to portray faithfully in his picture even the smallest detail of each act.

Yuranosuké, on his return to Yamashima from the tea-house at Kyoto, where he

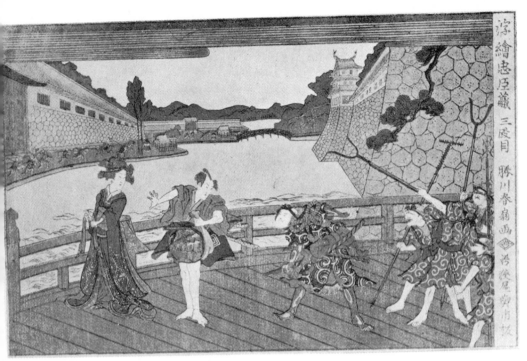

1. SHUNSEN: *Chushingura*, Act 3; signed *Katsukawa Shunsen*

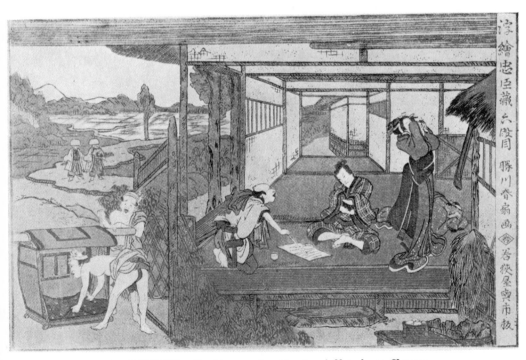

2. SHUNSEN: *Chushingura*, Act 6; signed *Katsukawa Shunsen*

PLATE 46 (first part)

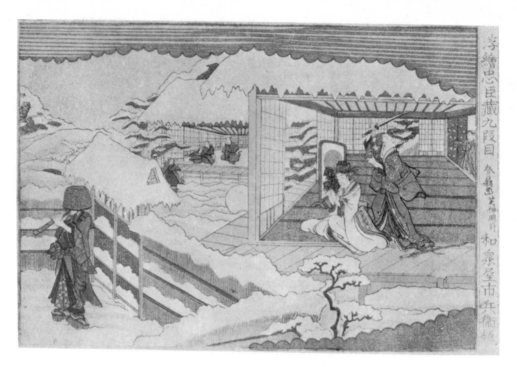

3. SHUNSEN : *Chushingura* : Act 9 ; signed *Shunsen.*

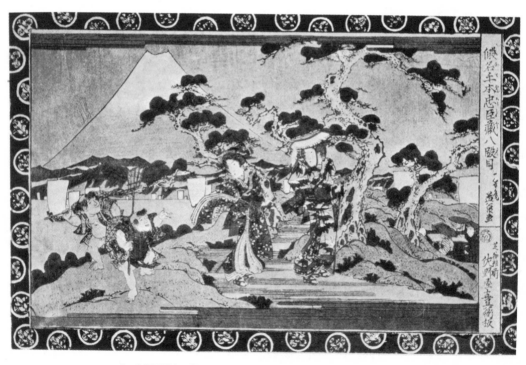

4. YEISEN : *Chushingura* : Act 8 ; signed *Ippitsuan Yeisen.*

PLATE 46 (second part)

had been detained all night by a heavy fall of snow, starts heaping up the freshly-fallen snow as soon as he gets inside the gate, in an apparently aimless and half-drunk manner.

After this he enters the house and, pretending to go asleep, dismisses his wife and the servants to their quarters.

When left alone with Rikiya, he draws his attention to the mass of snow with which he had been pretending to amuse himself by heaping up, and asks his son if he can guess its significance.

" I think I can," answers Rikiya. " Snow is so light that the least breeze blows it away in dust ; but when heaped up into a mass, it may roll down from some mountain-top and crush even rocks like a huge boulder. So is our strength in our united loyalty, in the weight of our affliction. But that mass of snow will soon melt away under the sun's rays, and . . ."

" Nay, not so," breaks in Yuranosukè. " We forty-seven plotters are in the sun of no man's favour. In the shade that mass of snow will take long enough to melt. As for us we must persevere like that philosopher Riuto " (a Chinese sage), " whose poetry compelled him, being unable to buy oil for his lamp, to supply his need with the dim light reflected from a heap of snow."

" Let yonder mass," adds he, " be taken into the inner court, where the sun's rays cannot beat upon it.")[1]

Though not an artist of either the Katsukawa or Utagawa schools, it will be convenient to mention here two series of *Chushingura* illustrations by Keisai YEISEN (1792–1848), both full size, oblong, one (the earlier of the two) of better merit as regards drawing than the other.

This earlier set may be recognized by having the title in very large white characters on a horizontal black label, round which is a *tomo-ye* border. This label is spread across a conventional cloud which comes half-way down the picture, the illustration of the scene occupying the lower half.

The Bridal Journey scene from this set is illustrated in Strange's *Japanese Illustration* (London, 1903). The colouring of this set is good, rose-red being much employed, while the figures stand out well from the background.

The scenes mostly follow the usual treatment for each act.

Act VI shows Kampei examining Ōkaru's contract with the tea-house proprietor, and Act VII is an unusual illustration : Heiyemon is threatening to kill his sister, Ōkaru, as a spy, while she baulks him by flinging a roll of paper in his face.

Act VIII, the Bridal Journey scene, is perhaps the best one of the set. Konami and Tonasé are shown walking by the seashore, and behind them a large Fuji, with snow-covered slopes, rises into a rose-red sky.

Act X is also an unusual treatment, though we have noted others of the same nature. Interior of Gihei's house, and his wife asking him to take her back ; on the floor lies his letter of divorce.

[1] Abbreviated from F. V. Dickins' translation of the *Chushingura*.

For the sake of comparison with Act VIII of the above series illustrated in Strange's *Japanese Illustration*, we here reproduce at Plate 46, Illustration 4, the same scene from Yeisen's other *Chushingura* set. This has the title *Kanadehon Chushingura* (" The Loyal League ; a copy for Imitation ") on a panel at the side, followed by a very rare form of Yeisen's signature, *Ippitsuan Yeisen*, hitherto only noted on an occasional *surimono* by him, and then in the form of a seal ; below is the publisher's name *Kikakudo* (or *Sanoki*).

This set has an unusual border in black upon which is repeated at intervals Yenya's crest of two crossed arrow-feathers instead of the *tomo-ye* crest of Yuranosukè.

The general colour-scheme is rose-red, blue, and apple-green. The best plate of the set is Act VIII, here illustrated. Unfortunately the beautiful contrasting colours of blue sea, green mountain, and rose-red sky are completely lost in a monochrome reproduction.

The figures in the other plates are rather awkwardly drawn, while the landscape setting is too crowded with detail, so that the figures appear mixed up in it, and the whole picture being strongly coloured, no contrast is afforded between background and foreground.

In this respect the design of the earlier set is much happier.

CHAPTER XXX

"CHUSHINGURA" ILLUSTRATIONS BY KUNISADA AND PUPILS

KUNISADA, like his master Toyokuni, appears to have been a fairly prolific designer of illustrations to the *Chushingura*, those of his early and middle period, that is previous to 1844, being the best.

These are generally signed *Kochoro Kunisada*. Over this signature he has designed a fine set of eleven triptychs, the only *complete* set in this form known to the writer, though single triptychs from a similar set by Kuniyoshi have been noted. Various artists have designed triptychs showing all the eleven acts on the one sheet (that is three sheets joined to form one complete whole), but this set by Kunisada and another by Kuniyoshi are the only series known giving a triptych to each act.

As this set is very rare, and may not be known to the reader, we will briefly describe each act.[1]

Title *Kanadehon Chushingura* ("The Loyal League; a copy for Imitation"); signed *Kochoro Kunisada ; c.* 1835.

Act I. The Hachiman Temple at Kamakura (Tsuruga-oka). Lady Kawoyo being summoned before the council of nobles to identify Yoshisada's helmet.

Act II. In the centre love-scene between Konami and Rikiya, and her mother Tonasé listening on the left; on the right Honzo and Wakasa.

Act III. Yenya's attack on Moronao ; and outside Kampei scattering Bannai's men, while Ōkaru trips one of them up with her scarf.

Act IV. In the centre the arrival of the two commissioners with sentence of death on Yenya ; Yuranosukè showing his retainers the sword of death, while Yakushiji hurls imprecations at them to take themselves off from the palace. Above, Lady Kawoyo with Goyemon and other retainers.

Act V. Scene in the hill country near Yamazaki during a rain-storm. In the centre Sadakuro pursuing Yoichibei, and on the right the meeting of Kampei and Yagoro.

Act VI. Scene at Yoichibei's cottage, Yamazaki. In the centre the

[1] Complete set by Kunisada in the Blow sale, July, 1912.

arrival of Yagoro and Goyemon ; on the right Kampei being accused by Ōkaru's mother of the murder of Yoichibei, and on the left Ōkaru being taken away in the *kago.*

Act VII. The tea-house Ichiriki. In the centre Ōkaru and Yuranosukè ; on the right the letter-reading scene, and on the left Heiyemon dragging out Kudayū from under the *engawa.*

Act VIII. The Bridal Journey. The best triptych of the series ; a very fine landscape scene with Fuji in the distance.

Act IX. Yuranosukè's house at Yamashima. In the centre Honzo arrives just in time to prevent Tonasé taking her daughter's life ; on the right (above) Yuranosukè and Rikiya examining Honzo's plan of Moronao's castle ; and on the left the snow which Yuranosukè had amused himself with in heaping up, being rolled into the inner court (*vide* last chapter).

Act X. The test of Gihei by the patrol of *ronin ;* and on the right, behind, interview between Gihei and his wife.

Act XI. Snow scene under moonlight. The *ronin* crossing the bridge on their way to the attack on Moronao.

At Plate 47 we illustrate four scenes from another early *Chushingura* series by Kunisada of about the same date as the above, of the ordinary full-size, oblong shape. This series is also uncommon and is the best one in this form by Kunisada that has come under notice. The colour-scheme is mainly red, yellow, blue, and green. The drawing of the figures is bold, and the colouring strong without being garish. Each scene has a small black and white indented border, after the pattern adopted by the *ronin* on their dress as a distinguishing mark, typifying day and night, a token of their unceasing vigilance upon their enemy.

Title : *Kanadehon Chushingura ;* signed *Kochoro Kunisada ;* publisher's sign of *Man-kichi.*

Act I. Scene at the foot of the steps leading to the shrine of the Hachiman Temple, looking out over the Bay of Yedo. Yenya (right) intervening in the quarrel between Wakasa (centre) and Moronao (left), behind whom stands Lady Kawoyo in an attitude of some alarm.

At the top of the steps appears Tadayoshi with his escort leaving the temple. (See Plate 47.)

Act II. On the right Honzo cutting off a pine branch in front of Wakasa who stands on the veranda behind ; on the left, on a balcony built out over the water, Konami receiving Rikiya.

Act III. Above, Yenya's attack on Moronao who reels and falls under the blow, while another *daimyo* rushes up and pushes Yenya back ; below, Kampei, who has been making love to Ōkaru, vainly endeavouring to gain admittance to the castle in order to go to his lord's assistance.

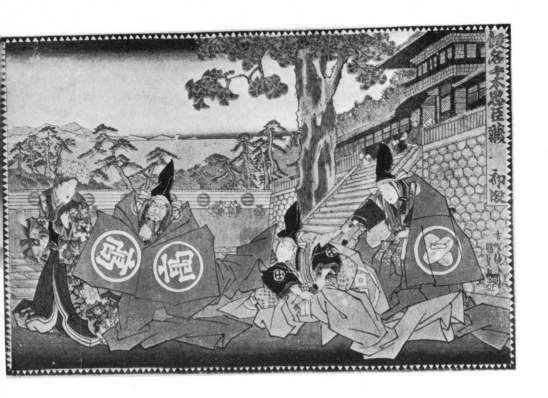

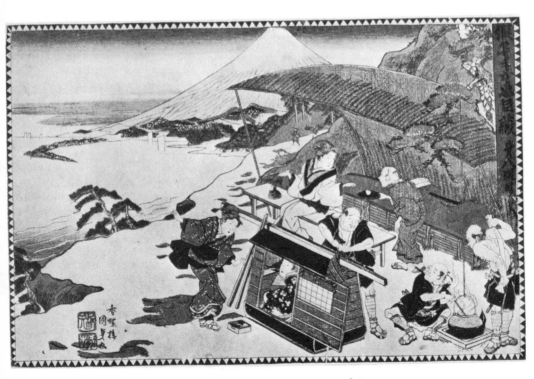

KUNISADA : *Chushingura*, Acts 1 and 8.

PLATE 47 (first part)

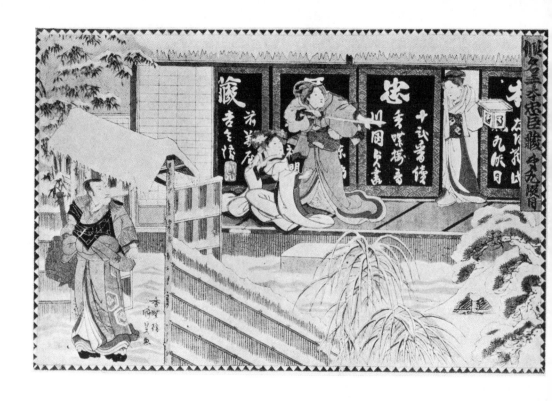

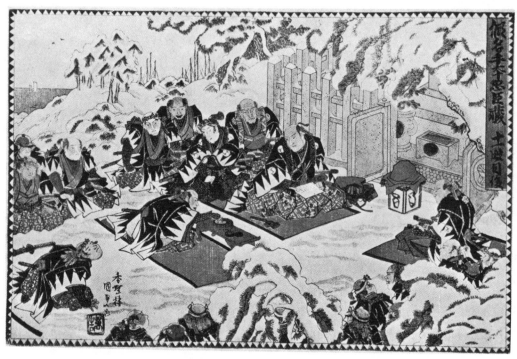

KUNISADA : *Chushingura*, Acts 9 and 11 (2nd episode).

PLATE 47 (second part)

Act IV. This illustrates the opening scene of the fourth book in the drama, and is an unusual treatment.

In the centre is seated Rikiya, who is in attendance on Lady Kawoyo, seated behind with her maids-of-honour, and on his left squats Goyemon and on his right Kudayū. They are engaged upon discussing the events which led up to their lord's confinement in his castle at Yedo, and the merits or demerits of his attack on Moronao. This discussion is abruptly terminated by the arrival of the two commissioners who are seen approaching along the veranda through an open shutter behind.

Act V. Sadakuro, who holds a large umbrella over himself, snatches at Yoichibei's purse, while the latter sprawls on the ground in his effort to save his money. Behind, further along the road, the meeting of Kampei and Yagoro.

Act VI. Kampei being reviled by Goyemon and Yagoro as the murderer of Yoichibei, whose wife joins in the accusation. Outside, Ōkaru being carried away to Kyoto in a *kago* followed by her new master.

Act VII. The tea-house Ichiriki, Kyoto. Yuranosukè discovered by Yazama Jiutaro, Senzaki Yagoro, and Takemori Kitahachi, playing blind-man's-buff with the tea-house girls, and disgusted with their chief's behaviour, are about to set on him with their swords, when Heiyemon implores them to restrain themselves for a while. Seeing the justice of his explanation of their chief's apparent careless behaviour, they yield to Heiyemon's entreaties and withdraw.

Behind, in a forecourt, Bannai Sagisaka discovering the large stone left in the *kago* by Kudayū, much to his surprise, while Ōkaru watches him from the balcony above.

Act VIII. The Bridal Journey. A somewhat unusual treatment of this scene. View of the seashore at Tago looking towards the Miho-no-Matsubara Peninsula, and a great white Fuji streaked with green rising up into a deep blue sky, coloured red on the horizon.

Konami and Tonasé stopping at a wayside refreshment place ; Konami points out the view to her mother still seated in the *kago* which the porters have just put down, one of them stirring a pot over a fire, while a third wipes himself with a towel.

On a bench behind, under a straw awning, sits their travelling companion to whom the tea-house proprietress beings a cup of *saké*. (See Plate 47.)

Act IX. The most beautifully coloured plate of the set. The dresses of Tonasé and Ō-ishi are delicate shades of pink and blue, in contrast to the black screen behind and the snow around them.

Honzo, holding in his hand his bamboo flute and basket hat, arrives at the gate just as Ō-ishi interrupts Tonasé from taking Konami's life, by

demanding Honzo's head as a bridal gift, ere she will consent to the marriage of Rikiya with Konami.

The large characters on each division of the screen, at the top, from right to left, form part of the title of the series (*Kanade*) *hon Chus-*(*shin* hidden by Tonasé's head)-*gura ;* while on the middle screen, which Ō-ishi is opening, is written *Twelve Scenes, Kochoro Utagawa Kunisada gwa.* (See Plate 47.)

Act X. Gihei standing on the chest defying the patrol of *ronin* to make him reveal the whereabouts of the arms and armour he is making for them, while one of them threatens to decapitate his son.

Outside, by the edge of the wharf, one of the *ronin* cuts off O-Sono's hair.

Act XI. First Episode. Moronao being dragged forth from his hiding-place, and Rikiya directing operations. In the background other *ronin* fighting Moronao's retainers and putting them to flight.

Act XI. Second Episode. Snow scene at Sengakuji Temple.

The *ronin* offering incense before Yenya's tomb, in front of which is placed Moronao's head on a white-wood stand, covered with a purple cloth.

Each comes forward as Yuranosukè reads out their names in turn from the roll, Yazama Jiutaro, in honour of having been the one to discover Moronao in his hiding-place when they had almost given up hope of finding him, being first, followed by Heiyemon on behalf of Kampei, who lays the fatal purse upon the censer and offers incense.

Behind Yuranosukè is seated his son Rikiya, and the *ronin* Kanamaru, seventy-eight years of age, the oldest of the forty-seven. (See Plate 47.)

In our last chapter we referred to a *Chushingura* series by Toyokuni as an example of treatment in the upright form of illustration ; we will now describe and illustrate a similar set by Kunisada, showing one or two episodes in an illustration.

The title of the series is *Kanadehon Chushingura*, as in the above oblong set ; signed *Kochoro Kunisada* ; publisher *Yezaki-ya.* Both Kunisada's signature and the publisher's name are written on labels, and each print is stamped with the *kiwamè* (" perfect ") seal. Date about 1835.

The chief colours used are blue, green, and a dull brick-red (*beni-gara*), which gives a more subdued tone to the composition than in the oblong set, in which yellow (*shio*) is much employed.

Act I. Scene on the steps leading up to the shrine of the Hachiman Temple. Yenya and Lady Kawoyo trying to pacify Wakasa in his quarrel

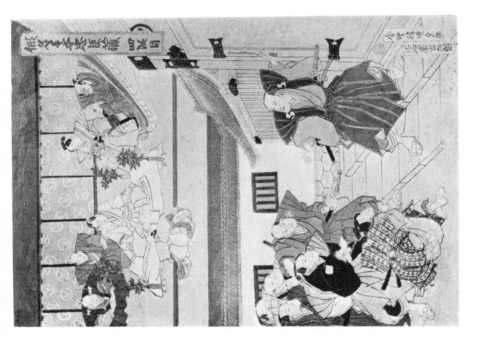

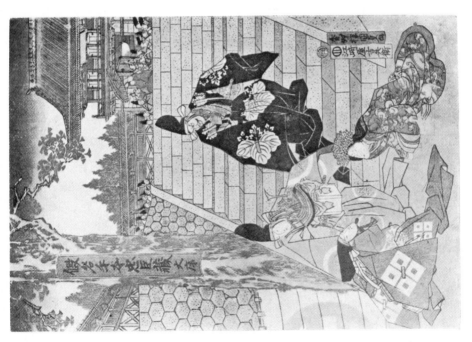

KUNISADA: *Chushingura*, Acts 1 and 4.

PLATE 48 (first part)

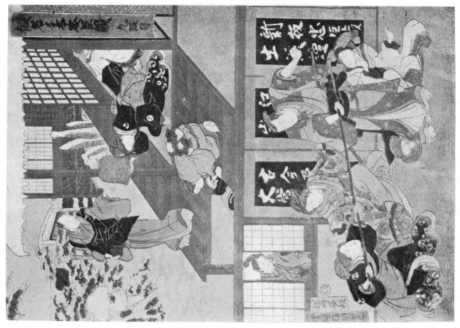

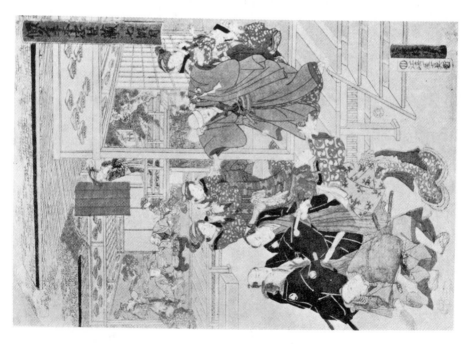

KUNISADA : *Chushingura*, Acts 7 and 9.

PLATE 48 (second part)

with Moronao who stands on one of the steps, scowling at him. On a white-wood stand Yenya carries Yoshisada's helmet to deposit it in the treasury of the shrine, the first illustration of this act in which we have noticed it thus introduced into the composition.

At the top of the steps Tadayoshi appears, followed by a retinue of nobles. (See Plate 48.)

Act II. Wakasa, squatting by the veranda, watches Honzo who has just cut off the pine branch, and is wiping the blade of his sword. Beside Wakasa is a box full of picture rolls, presumably in allusion to those which Honzo presents in the early morning of the following day to Moronao to buy off his hostility against Wakasa, as a gift from him and his household.

Below, Konami on bended knee offering refreshment to Rikiya, while her mother watches her from behind a screen.

Act III. Yenya's attack on Moronao, and Kajikawa Yosobei, a retainer to the *Shōgun*, Ashikaga, whose *rôle* in the drama is taken by Honzo, though the latter really represents Ogiwara the chief councillor to Wakasa, holding him back.

Below, Kampei putting Bannai and his men to rout outside the entrance to the castle, and Ōkaru standing by him.

Act IV. Yenya, prepared for *seppuku*, asks Rikiya if Yuranosukè has yet arrived, as he has much to say to him before the end comes. (See Chapter XXVI, page 247.)

On the right are the two commissioners Ishido and Yakushiji, and on the left, two other witnesses.

Below, outside the gate, Yuranosukè shows the sword of death to Yenya's retainers. (See Plate 48.)

(This plate is interesting because it indicates the procedure to be observed at the ceremony of *seppuku* (*hara-kiri*) of a person of rank.

The condemned man is dressed in white, short-sleeved garments; he has thrown off the *kamishimo*, or outer garment, on which in ordinary wear would appear his crest, like that worn by Yuranosukè in the illustration below, but which on this occasion is bare of device.

He is seated on a white cotton quilt, at each corner of which is a vase containing a sprig of green *shikimi*.

Before him is the dirk placed on a white cloth resting on a white-wood stand.

In the instance of Yenya he was allowed to disembowel himself ; but usually in

the case of a person of lower rank his second strikes off his head as he leans forward to take the dirk.

It will be noticed that only the two chief commissioners wear both long and short swords ; the other witnesses carry the dirk only, it being contrary to etiquette to wear the sword in a house. In the drama, Yenya is confined in his own castle at Yedo pending the delivery of sentence against him, and commits *seppuku* in its precincts. Actually, Asano Takumi-no-Kami (the original of Yenya) was given in charge of a *daimyo* called Tamura, and the ceremony of *seppuku* carried out in the garden of the latter's palace at Shirokané, in Yedo.)

Act V. Rain-scene at nightfall. Above, the meeting of Kampei and Yagoro ; below, Sadakuro's murder of Yoichibei.

Act VI. Above, scene at Yoichibei's cottage : Kampei having made his peace with Yagoro and Goyemon, now that the truth of his father-in-law's death had been discovered, is asked by the latter to sign the roll of the forty-seven *ronin*, before death overtakes him. On the floor lies the purse of money, the cause of all the trouble.

Below, Ōkaru being borne away in a *kago* to Kyoto, followed by Ichimoniya, who turns to speak to one of the hunters who had brought Yoichibei's dead body to his cottage.

Act VII. The Ichiriki tea-house, Kyoto. Yuranosukè discovered by Jiutaro, Yagoro, Kitahachi, and Heiyemon playing blindman's-buff with the tea-house girls ; above, in top left-hand corner, another room in the tea-house, in which he is discovered by Jiutaro and Yagoro supping with Kudayū, who is on the point of offering him a piece of fish, which Yuranosukè takes with the utmost unconcern. From a balcony above Ōkaru looks on at the proceedings. (See Plate 48.)

(As Yuranosukè is on the point of eating the fish, Kudayū reminds him that it is the anniversary of the death of Yenya, but the former takes no notice of this hint and eats it all the same, thus showing Kudayū that he apparently troubled himself little about his dead lord, adding, " As to fasting, I cannot see that we are in the least bound to mortify ourselves for his sake " [*vide* Chapter XXV respecting this allusion].)

Act VIII. The Bridal Journey. A woman stoops to tie Konami's sandal, while her mother stands close by admiring the view.

Approaching along the road over the top of a slight hill which overlooks the sea, is the head of a *daimyo's* procession ; in the background,

from a deep blue sea, rises a great Fuji, its slopes coloured green, its summit white with snow, the whole sky a beautiful rose-pink. A fine plate.

Act IX. Below, Ō-ishi's attack on Honzo, and behind, Rikiya, attracted by the noise of the scuffle, opens a shutter to see what is happening.

Above, Ō-ishi, on bended knee, hands Honzo's *komuso* hat to Yurano-sukè, who carries his flute, while a servant places his sandals ready for him on the step ; behind Ō-ishi is seated Konami. A variant to the usual treatment of this episode. (See Plate 48.)

Act X. Above, Gihei seated on the chest defying the party of *ronin* to dislodge him.

Below, interview between Gihei and his father-in-law, Ryochiku, a very common and uncouth fellow, squatting on the floor with his hands clasped across his knees and smoking a pipe, while Gihei is occupied in writing his letter of divorce, O-Sono standing outside a half-open screen listening to the interview.

Through an open screen at the back Igo, Gihei's servant-lad, carrying the latter's son on his back, peers in, grinning at the uncouth Ryochiku.

Act XI. Snow-scene at night under a large full moon. Moronao, dragged out of his hiding-place, lies sprawling in the snow before his captors, and Yuranosukè comes up to identify his enemy.

In the upper part of the picture, which is separated from the lower by a black wooden fence, two of Moronao's retainers who have sought refuge up a tree are being attacked, while others are pursued by the *ronin* across the snow-covered roofs.

At Plate 49, Illustrations 1 and 2, are two scenes from a set of *Chushingura* incidents by Kuniyoshi, showing Acts X and XI ; the attack on Gihei, and the death of Moronao, with Yuranosukè showing him the fatal dirk.

The title, *Kanadehon Chushingura*, followed by the number of the act and a sub-title, is in the bottom corner ; signed *Ichiyusai Kuniyoshi* ; no decorative border.

Illustration 3 is an example from another—and later—set, showing the ninth act ; Rikiya's attack on Honzo. Prevailing colours of green and rose-pink, with touches of mauve, blue, and black ; grey sky in back-ground ; green and white indented border. Title *Kanatehon Chushingura*

in variously-tinted square panel in top right-hand corner ; on long upright red panel below *aratamè* seal at top, followed by *Ichiyusai Kuniyoshi*, and name and address of publisher, *Sanoki ;* seal-dated Tiger 11 = 11th month, 1854.

Illustration 4 is Act X from a rare set (title *Kanadehon Chushingura*) by Kikumaro over the signature of *Kitagawa Tsukimaro ;* date about 1800 ; publisher *Yamaguchi-ya (Tō-bei) ;* medium size, oblong ; complete in eleven scenes.

Kuniyoshi also designed two series (full-size, upright), consisting of portraits of all the forty-seven *ronin*, with their biographies, one set, entitled *Seichu Gishiden*, " Biographies of the Ronin," being a single figure of each *ronin*. Belonging to this set, but with the title slightly altered to *Seichu Gishi hottan*, " Beginning of the Loyal Ronin," are four portraits of Yenya, Moronao, Wakasa and Honzo, with their biographies.

The other series shows each *ronin* engaged in combat with an enemy, and may be recognized from the previous set by having the title *Chushin Gishi Komyo Kurabè*, " A comparison of the Persons in the Loyal League," written on a *tsuba*, or sword-guard. Each plate is numbered.

As a final example of *Chushingura* illustrations we now take a very good set, full size, oblong, by Utagawa SADAHIDE (worked about 1840), perhaps the leading pupil of Kunisada.

In this series the figures are relatively small, landscape enters largely into the composition, while their treatment is, in many instances, very unusual and highly original.

The predominating colours are blue, green, brick-red (*beni-gara*), and, in some plates, a yellow tint known as *shio*, made from gamboge, which fades very readily if exposed to much light.

Title : *Kanadehon Chushingura ;* each plate signed *Sadahide ;* publisher *Fukusendo of Yedo ;* rare.

There is no decorative border to this set.

Act I. View of the large court of the Hachiman Temple looking out to sea ; on the left a corner of the principal gateway through which Nahò-yoshi is passing on his way out after the ceremony, followed by his umbrella bearer. Behind him, along the stone-flagged path, comes Moronao who turns his head and scowls at Yenya and Wakasa following with Ishido and other nobles in the procession, some descending the steps from the shrine above on their way out. On the right, by an opening in the screen which surrounds the whole of the courtyard, stands Lady Kawoyo, watch-

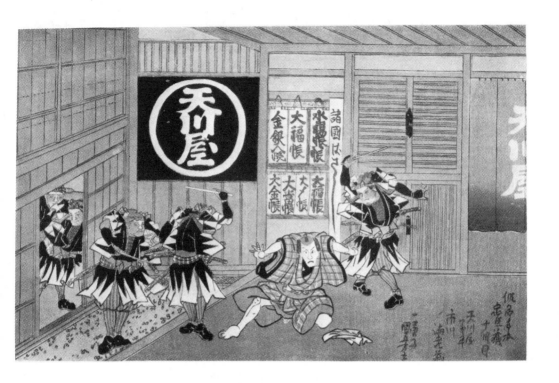

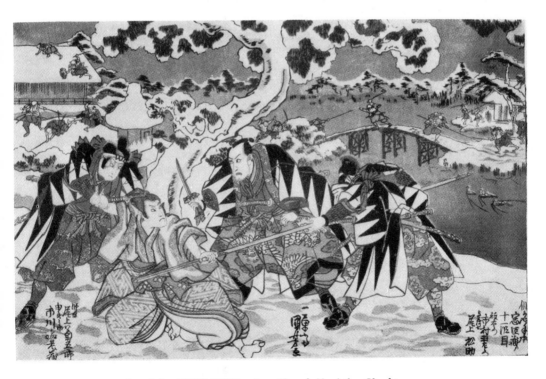

1 and 2. KUNIYOSHI : Acts 10 and 11 of the *Chushingura*.

PLATE 49 (first part)

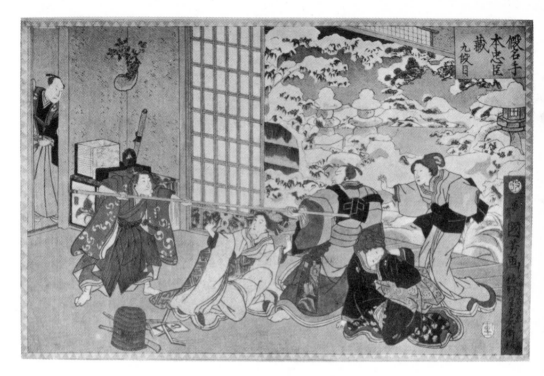

3. KUNIYOSHI : *Chushingura*, Act 9.

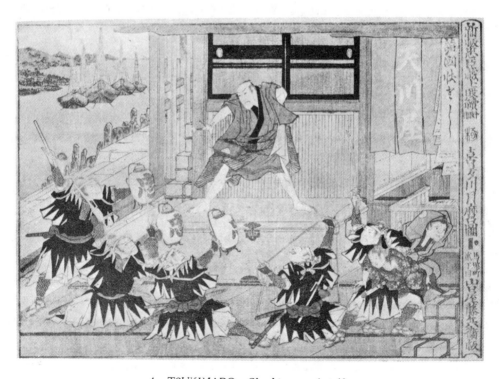

4. TSUKIMARO : *Chushingura*, Act 10.

PLATE 49 (second part)

ing the procession going out, and evidently uneasy at the remarks which Moronao throws behind him at her husband.

At the foot of the temple steps grows a giant pine tree.

A fine plate and an original rendering of this act, which does not follow the stereotyped treatment usually found.

Act II. A fine landscape view. The front of Wakasa's house overlooking a large lake. On the left Rikiya seated in a room waiting to deliver his message for Wakasa to Konami, who is on the veranda outside and carries a *saké* cup on a small stand, but is too shy to give it him, while a woman of the household endeavours to coax her over her shyness, Tonasé meanwhile watching her daughter round the corner of the *engawa*.

In another part of the building Wakasa sits in a room by the veranda watching Honzo as he cuts off the branch of a dwarf pine tree growing close to the water's edge.

The scene of the reception of Rikiya by Konami shows ingenuity in introducing the woman to take the part usually played by Tonasé in coaxing her daughter to act the part of hostess.

Act III. Extensive view of the moat and grounds of Kamakura Castle, from outside the entrance by a green mound which slopes down to the water.

The encounter between Bannai Sagisaka and Kampei, behind whom stands Ōkaru.

Act IV. Scene at nightfall in the large courtyard in front of the main entrance to Ogigayatsu Castle which is now closed and all the windows shuttered. Rikiya and the other retainers of Yenya making obeisance to their lord's sword of death, which Yuranosukè shows to them.

(An impressive scene ; the idea of death and impending disaster upon the family and clan of Asano is well indicated in the closed and deserted castle under the deepening shadows of night, while in the foreground the forty-seven solemnly pledge themselves to avenge their lord's untimely end.)

Act V. The masterpiece of the set, which can challenge comparison with any representation yet noted of this scene, and which in the writer's opinion is quite the equal of, if not superior to, Hiroshige's illustration of this act. (See Plate 50.)

Hiroshige's mountainous landscape and the rain is finely indicated, but the composition is spoilt, as is frequently the case with him, by his crude drawing of the two figures of Sadakuro and Yoichibei.

Sadakuro is snatching at the purse of the old man, who has fallen on the ground, and on the right, under a steep hill, the meeting of Kampei and Yagoro. Under the shelter of a pine tree, in the foreground, is a wayside stone figure of the god Jizo, the patron saint of travellers. He is represented holding in one hand the ringed staff and in the other the mystic jewel, his two attributes. He is generally shown bare-headed and with a shaven pate, though he is sometimes given, as here, a hat made from a lotus leaf.

Jizo is also the patron saint and protector of children, which accounts for the offerings of toys which lie on the ground by his statue. In this capacity he spends his time under the earth in the *Sai-no-kawara*, or " Dry Bed of the River of Souls," where all children go after death.

Across the rice-fields, under the shadow of three giant pines, stands a small shrine with a *torii* in front of it.

In the background a range of yellow mountains.

Act VI. Yoichibei's cottage behind a rough bamboo fence by the edge of a stream which irrigates the fields ; clumps of trees and bamboo growing round it. An almost purely landscape scene.

Kampei, as he approaches the cottage, stops the *kago* in which Ōkaru is being carried off, and demands explanations as to where his wife is going.

Act VII. (This act has not, unfortunately, come under observation, but is presumably the tea-house scene.)

Act VIII. The Bridal Journey scene. View at the mouth of the Okitsu River looking across the Miho Peninsula to the great mass of Fuji, its upper slopes white with snow, its base wreathed in mist ; the sky pink on the horizon changing to gold above.

Tonasé admiring the mountain which another traveller points out to her, while Konami has just got out of her *norimono* (not a *kago* as generally shown), and a woman fastens her sandal. On the other side Honzo, in disguise, sits on a bench smoking a pipe.

Sadahide again shows his originality here by introducing Honzo into the scene, as, unknown to his wife and daughter, he follows them on their journey to Yamashima.

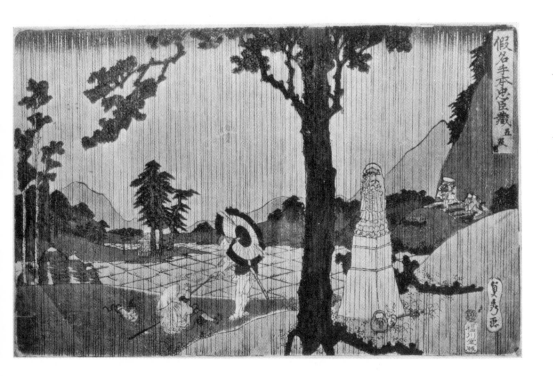

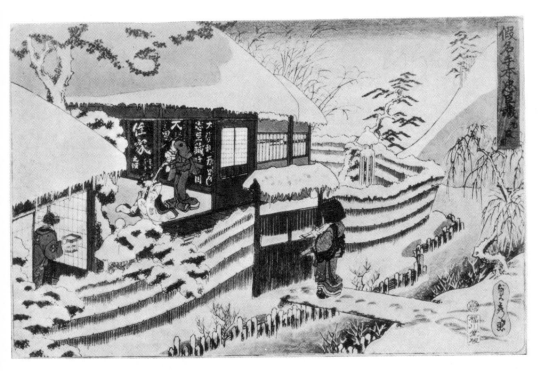

SADAHIDE : *Chushingura*, Acts 5 and 9 : signed *Sadahide*.

PLATE 50 (first part)

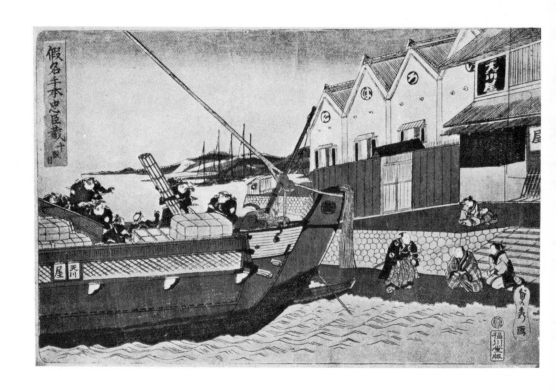

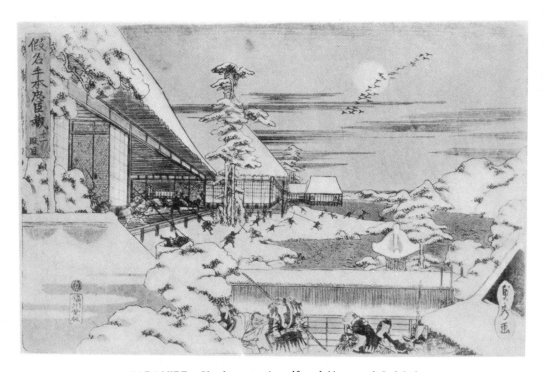

SADAHIDE : *Chushingura*, Acts 10 and 11; signed *Sadahide*.

PLATE 50 (second part)

Act IX. Snow scene ; another masterpiece ; very good colouring. (See Plate 50.)

Honzo arrives at Yuranosukè's house just in time to prevent Tonasé taking her daughter's life ; from behind a screen Ō-ishi, holding the wood stand in her hand, watches them.

Act X. Loading the *ronins'* arms on to the ship at the Port of Sakai, outside Gihei's warehouse. The most original treatment of this act that has come under notice. (See Plate 50.)

At the water's edge Yuranosukè takes his leave of Gihei and O-Sono, while above, on the quay, is Gihei's son in charge of a servant.

Act XI. Another excellent snow scene. Under the light of a full moon in a deep blue sky, the *ronin* make their attack, and drive their enemy from pillar to post.

In the foreground Moronao is led prisoner before Yuranosukè for identification. (See Plate 50.)

As a result of examining several *Chushingura* series by different artists, and even different series by the same artist, it will be noticed that, speaking generally, certain acts are nearly always better than others. Thus the Bridal Journey scene (Act VIII) and Honzo appearing at Yuranosukè's house (Act IX), are nearly always amongst the best, while the scene between Kampei and Bannai (Act III), and Act VI are often unsatisfactory, particularly in Hiroshige's sets.

CHAPTER XXXI

" CHUSHINGURA " " BROTHER-PICTURES "

BY " Brother-Pictures " are meant scenes from the play which are adapted or compared to everyday scenes in life, parodied by women or Yoshiwara beauties, or acted by children in play. The artist who turned his attention to illustrating the " Chushingura " in this form more than any other was Utamaro, doubtless because he declined to paint actors or theatrical scenes as such, yet designed these " brother-pictures " as a kind of compromise between his aversion to the theatre as a subject for his brush, and the public demand for dramatic prints.

His best-known set of this nature is one with the title *Chushingura*, in which scenes from the play are compared to various incidents in everyday life, one act of which we reproduce at Plate 51.

The scene parodied is given in an inset in the top corner, together with the title and number of the act on a narrow label. Large size, upright (15 × 10 in.) ; each signed *Utamaro ;* publisher *Yeijudo ;* date about 1795. Rare.

Act I. A girl from behind a screen watching another, who has brought a cup of tea to a *manzai* dancer, flirting with him ; compared to Moronao caught by Wakasa while making his advances to Lady Kawoyo.

Act II. A young man delivering a love-letter in a letter-box to a girl kneeling near the entrance to a house, whose mother stands by her ; compared to love-scene between Rikiya and Konami.

Act III. A man attacking a nagging wife with a *miso* pestle, while a woman arrests his arm and a man drags him back from behind, and another woman tries to soothe the angry wife, at whose feet lie the remains of the broken mortar (*suribachi*) ; compared to Yenya's attack on Moronao and Honzo restraining him. (See Plate 51, Illustration 1.)

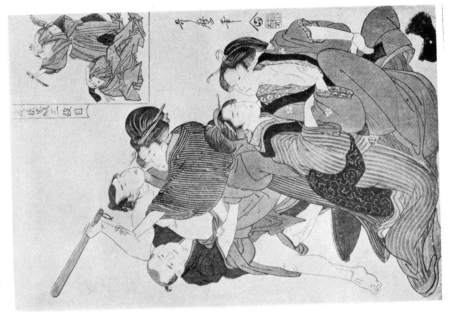

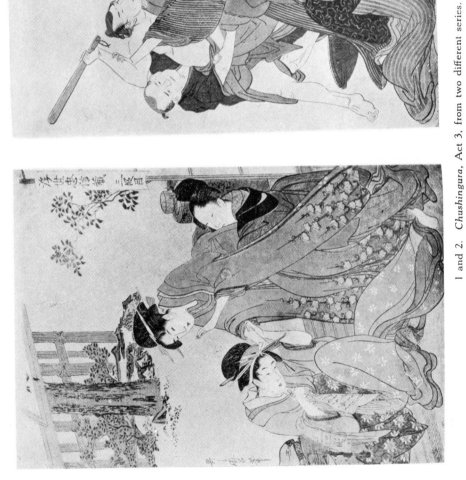

UTAMARO (Kitagawa).

1 and 2. Chushingura, Act 3, from two different series.

PLATE 51 (first part)

UTAMARO (Kitagawa).

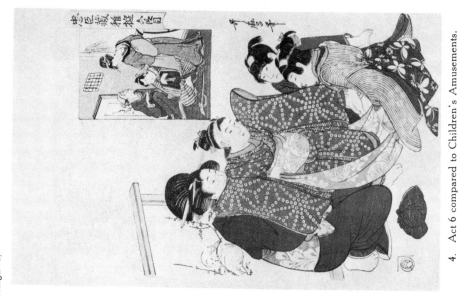

4. Act 6 compared to Children's Amusements.

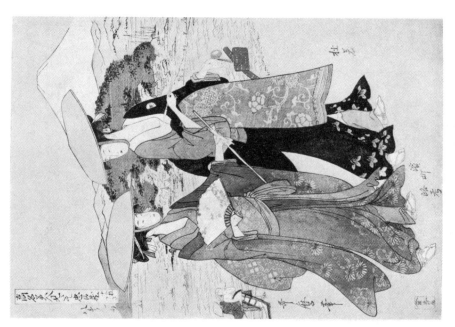

3. Act 8, The Bridal Journey.

PLATE 51 (second part)

Act IV. Two women and a man arranging flowers and bringing an offering of *saké* for the *Tsukimi* (" moon festival "), which is held twice a year, on the 15th day of the eighth month, and on the 13th of the ninth, when poems are composed to the moon, accompanied with *saké* drinking ; inset Rikiya bringing Lady Kawoyo a basket full of the rare eight and nine-fold cherry-blossom.

Act V. A Yoshiwara girl taking a bag of sweetmeats from another girl ; compared to Sadakuro's robbery of Yoichibei.

Act VI. A *geisha* preparing to go out to an engagement, while her manservant gets ready her *samisen*, and another servant holds a lantern ; compared to Ōkaru preparing to be taken away to the Ichiriki tea-house, to the grief of Kampei and her aged mother.

Act VII. The well-known " letter-reading " scene at the Ichiriki tea-house parodied by a nude man (as Yuranosukè) seated on the *engawa* of a bath-house, cooling himself, and anxiously perusing the long bill which his dissipation at the *joro-ya* has entailed, while a woman (as Ōkaru) seated on the balcony above fans herself, the fan being held like a mirror to reflect the contents of the bill the man is perusing, while the part of Kudayū is taken by a dog lying curled up under the *engawa*. Inset, Ōkaru reading Yuranosukè's letter by means of a mirror, and Kudayū scanning it from under the *engawa*. This act and that showing the man attacking the nagging wife are the two best-known plates of this series.

Act VIII. The Bridal Journey ; compared to two strolling players or *tori-oi* (women of the *eta* class).

Act IX. A woman at her toilet, seated before a mirror, while a servant dresses her hair, is interrupted by a street singer disguised in a basket hat bawling outside ; inset Honzo's appearance at Yuranosukè's house disguised as a *komuso*, interrupting Tonasé by the sounds of his flute just as she was about to take her daughter's life, and then her own.

Act X. A nude reveller, drunk with *saké*, in a Yoshiwara *joro-ya*, sits

upon the wine-tub (*sakadaru*), and prevents the servants from getting at it, notwithstanding the efforts of one man to shift him, while a woman endeavours to coax him off ; inset Gihei defying the *ronin*.

Act XI. The attack on Moronao ; compared to a scene in the kitchen of a *joro-ya*, the combatants being a *shinzo* with a standing floor candlestick, and two men armed with a mop and a broom.

At Plate 51, Illustration 2, we reproduce Act III of another *Chushingura* analogue series, in which all the characters are taken by women, for comparison with the same scene in the foregoing set.

This series is entitled *Ukiyo Chushingura* ("Passing World Chushingura") ; is small size, upright (12½ × 8½ in). ; publisher *Tsuru-ya ;* wash background.

The characters in the play which the women represent are indicated by the *mon* which they wear on their dress.

One woman, as Yenya, slaps another with her hand, who is trying to hide a letter from her in the bosom of her dress, while a third, in the character of Honzo, pulls the former back. In Act V, a woman as Sadakuro is shown taking another's purse from her, as Yoichibei.

Our next illustration (Plate 51, Illustration 3) is from a series, full size, upright, entitled *Komei Bijin Mitate Chushingura* ("A comparison of Celebrated Beauties and the Loyal League"), publisher *Omi-ya*. Rare.

The following acts from this series have come under observation :—

Act I. A lady in the character of Lady Kawoyo kneels before a stand on which *saké* cups are placed, and is examining one, behind her stands another as Moronao, while Tadayoshi is represented by a man seated in the background holding out a *saké* cup for inspection.

A comparison with Lady Kawoyo selecting Yoshisada's helmet. (See Plate 30, page 182.)

Act III. Three courtesans playing the attack on Moronao. Hishiya, a full-length figure, as Yenya, holds a rolled-up towel above her head in

both hands threatening Taka-shima as Moronao, while Fukujiu, as Honzo, kneels between them, and endeavours to draw off Hishiya.

Act VIII. The Bridal Journey. Iwai Hanshiro as Tonasé, and another actor, Ro-ko, as her daughter Konami, walking along the " seven *ri* " beach. Behind them is the island of Enoshima, and in the distance rises the cone of Fuji. (See Plate 51, Illustration 3.)

As Utamaro never drew actors as such on the stage, he here depicts two who took female parts, dressed as in private life, as women. He also, in addition, gives their personal names, and not those by which they were known in the theatre, Hanshiro being really To-jaku in private life. As the actor in the character of Konami has no crest on his dress, we cannot identify his stage name.

Act XII. A woman placing a box on a shelf above the *tokonoma*, in comparison to Yuranosukè laying Moronao's head before Yenya's tomb, while other women represent the priests with censers.

As an example of the " Chushingura " imitated by children we will quote scenes from a set also by Utamaro entitled *Chushingura Osana Asobi* (" The Loyal League. compared to Children's Amusements ") ; medium size, upright ; publisher *Tsuru-ya*. Rare. The scene parodied is given in an inset view in the top corner.

Act II. A boy cutting off a branch of bamboo, while his little sister (as Wakasa) watches him from the *engawa ;* inset Honzo cutting off the pine branch.

Act III. One boy holds back a baby brother, armed with a drum-stick, endeavouring to attack another boy who sprawls on the floor ; inset Yenya's attack on Moronao.

Act V. Sadakuro's attack on Yoichibei imitated by one boy trying to steal a charm-bag from another.

Act VII. A mother dressing her little girl for the girls' doll festival (third day of the third month), and putting on her *obi ;* inset Ōkaru, in

the presence of her mother and Kampei, changing round her *obi* to the front before being taken away to the *joro-ya* in Kyoto. (See Plate 51, Illustration 4.)

Act IX. A boy with a basket on his head playing the *Shakuhachi* (flute) as he passes the screen behind which his mother is dressing his sister's hair; inset, Honzo appearing at Yuranosuke's house.

Act XII. Three boys, armed with mops and brooms, finding a fourth crouching in the corner, trying to hide from them behind a *fusuma* (sliding door); inset, the *ronin* finding and dragging out Moronao.

Under the title *Chushingura*, Utamaro has designed several series of prints, various single sheets from which have come under observation at different times.

These are generally bust, half, or three-quarter length figure-studies, very similar to the scenes by Shunyei illustrated at Plate 44, but without any background. These, however, partake more of the nature of Utamaro's figure-studies and can hardly be called " brother-pictures " in the sense that the above are, yet they are quite different to the ordinary scenes from the play such as we have been describing. Sometimes, however, they assume the idea of an analogue where a male character in the play is taken by a woman, as, for example, in the eleventh act of a series which shows a bridesmaid supporting a bride, representing Rikiya followed by his affianced wife, Konami, on his way to the attack.

Other scenes, however, such as Yuranosuke helping Ōkaru down the ladder at the Ichiriki tea-house, are without any suggestion of an analogue.

At Plate 3, Illustration 3, we reproduce a fine and very uncommon *Chushingura* print from a series by Kikumaro (*w.* 1790–1820), in large *hoso-ye* form (14 in. by 6 in.), publisher *Tsuta-ya*, showing Rikiya on his way to the attack (Act XI) followed by Konami, for sake of comparison with the above analogue of this scene by Utamaro, of a bride and her bridesmaid, which is reproduced in colour in the late Dr. Anderson's *Portfolio* monograph *Japanese Wood Engraving*.

Kunisada has designed a set of *Chushingura* analogues, similar to those by Utamaro, in which the different acts are compared to women engaged in various occupations. Title, *Yekiodai Chushingura* ("Loyal League Brother-Pictures"); full size, upright; each signed *Kochoro Kunisada*; publisher, *Sanoki*; *c.* 1840; rare.

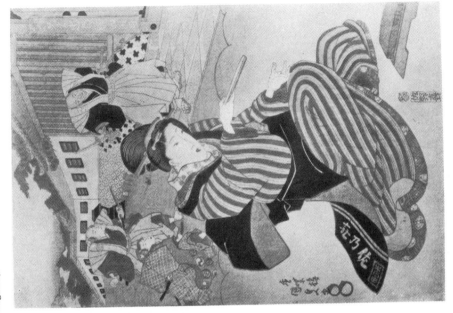

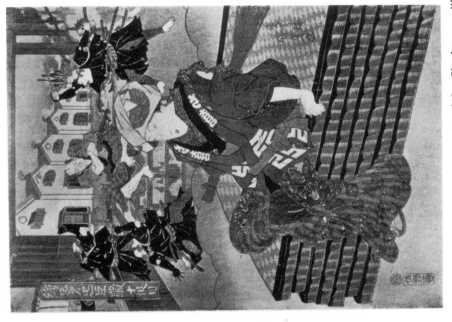

KUNISADA (Utagawa).

1 and 2. *Chushingura*, "Brother Pictures"; Acts 4 and 10.

PLATE 52 (first part)

KUNIYOSHI (Utagawa).

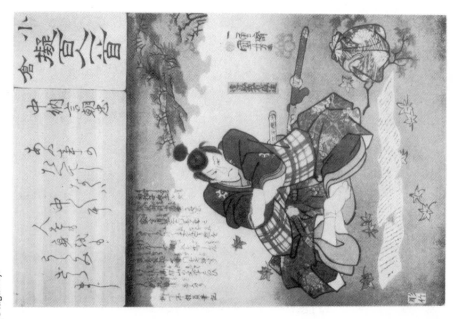

4. Endo Musho Mirito (*see page* 323).

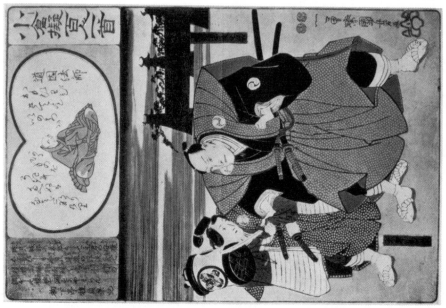

3. *Chushingura*, Act 4.

PLATE 52 (second part)

In the foreground is a large figure of a woman, and in the upper background, separated by conventional clouds, the different acts represented.

For purposes of identification of other scenes from this set we here reproduce, at Plate 52, Acts IV and X.

Act IV. A woman kneeling, dramatically holding out a closed razor, in front of her is a whetstone ; in the background, Yuranosukè showing the sword of death to Rikiya and Goyemon.

Act X. A woman resting while engaged in spring-cleaning, sitting on a pile of floor mats ; compared to Gihei sitting on the chest of armour, and defying the *ronin* to dislodge him.

Yeizan has also left a set of *Chushingura* prints with figure-studies of woman compared to the play, the scene shown above, separated by a cloud from the figure, like the above series.

Title, *Furyu Chushingura Gwa* (" Refined Chushingura Pictures ") ; each full size, upright ; signed *Yeizan*.

As a final example of a *Chushingura* analogue, we illustrate at Plate 52 (Illustration 3) a print from a series entitled " An Imitation of the Ogura Selection of the Hundred Poets," by Kuniyoshi, in which the fourth act, showing Rikiya and Yuranosukè leaving Akō Castle at nightfall after their lord's *seppuku*, the latter dramatically holding out the fatal dirk, is compared to the poem by the priest Do-in, No. 82 of the anthology.

Porter's translation of this poem runs as follows :—

> How sad and gloomy is the world,
> This world of sin and woe !
> Ah ! while I drift along Life's stream
> Tossed helpless to and fro,
> My tears will ever flow.

An apposite epilogue on the sorrows of humanity, which might be taken as the epitaph of the unfortunate Yenya.

CHUSHINGURA HAK'KEI

This is a very rare and interesting set, half-plate size, upright, by the artist CHŌKI, consisting of eight scenes from the *Chushingura* treated on a *Hak'kei* basis. Each scene is in a circle, and the margins outside are

gauffraged with an embossed brocade pattern ; both the colouring, soft tints of yellow, green, and violet, and the drawing are very delicate. As this set is very rare, in addition to its interest both by reason of its subject and as a work of art, we here reproduce each view from it. (See Plate 53.)

Act III. "Evening Bell; Quarrelling." Scene outside the Castle of Kamakura. Kampei protecting Ōkaru from Bannai Sagisaka who attempts to arrest him, but gets the worst of the encounter.

Act IV. "Clearing Weather at Ogigayatsu." Scene outside the Castle of Akō ; Yuranosukè showing the dirk with which Yenya committed *seppuku* to his retainers, by the edge of the castle moat.

Act V. "Evening Rain on the Mountains." The meeting of Kampei and Yagoro near Yamazaki ; behind, along a narrow winding path comes Yoichibei followed by Sadakuro.

Act VI. "Homing Geese at Yamazaki." Kampei, who has returned home, being denounced by Yagoro and Goyemon as the murderer of Yoichibei, while at the same time Yagoro indignantly throws down on the veranda before Kampei the purse of money which the latter had given him the evening before towards the purchase of the *ronins'* armour, adding that Yuranosukè does not want money obtained by murder.

Outside Ōkaru being taken away in a *kago*, and over the distant landscape a flock of geese flying to rest.

Act VII. "Autumn Moon at Gion Street." Yuranosukè, with the letter from Lady Kawoyo in his hand, looking up at Ōkaru in the balcony above, while Kudayū reads it from under the veranda. The moon, however, is not even indicated in *gauffrage*, though the letter-reading scene is generally represented to the accompaniment of a full moon. This plate alone of the set carries the signature of *Chōki*.

Act IX. "Evening Snow at Yamashima." Tonasé, about to take her daughter's life, is interrupted by the appearance of Honzo at the gate of Yuranosukè's house at Yamashima.

1. Act 3.

2. Act 4.

CHŌKI: *Chushingura* Scenes compared to the "Eight Famous Views."

PLATE 53 (first part)

4. Act 6.

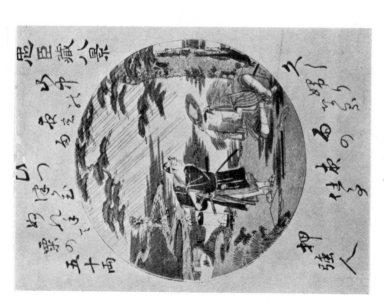

3. Act 5.

CHŌKI: *Chushingura* Scenes compared to the "Eight Famous Views."

PLATE 53 (second part)

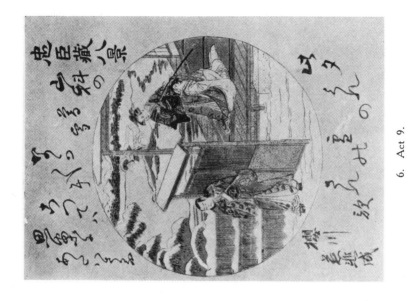

6. Act 9.

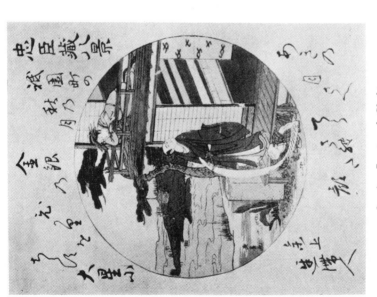

5. Act 7; signed Choki.

CHOKI: *Chushingura* Scenes compared to the "Eight Famous Views."

PLATE 53 (third part)

7. Act 10.　　　　8. Act 11.

CHOKI: *Chushingura Scenes compared to the* "Eight Famous Views."

PLATE 53 (fourth part)

Act X. " Returning Boats at Amakawa-ya " (i.e. the sign, or house, of the " Heaven-river," the Japanese term for the Milky Way, the name given by Gihei to his house at the harbour of Sakai). Boats sailing into the harbour of Sakai ; Gihei seated on the chest containing the arms of the *ronin* and defying them to open it.

Act XI. " Sunset : Night-killing." The *ronin* crossing the bridge on their way to Moronao's castle.

There is in the British Museum collection a *tanzaku* print ($11\frac{3}{4} \times 2\frac{3}{4}$ in.) by Toyonobu showing Gihei (represented by an actor) standing on the wharf, under a lantern, superintending the loading of a junk with the arms and armour for the *ronin*. Like the above Act X in the set by Chōki, this *tanzaku* is evidently one of a set of " Eight Views " compared to the *Chushingura*, this scene being " Returning Boats."

As Toyonobu died in 1785, and practically ceased designing prints about 1765, while the " Chushingura " play was not staged till 1748, this *tanzaku* print must not only be a very early one dealing with this play in any form, but a great rarity in treating it in the form of an analogue.

CHAPTER XXXII

THE SUGAWARA TRAGEDY

A DRAMA which was, and still is, as popular in the *kabuki-shibai* as the " Chushingura," is the *Sugawara Denju Tenarai Kagami* (" Penmanship as Taught by the Chancellor Sugawara," a somewhat fanciful title), written mainly by Takeda Izumo (1691–1756), who succeeded Chikamatsu as playwright for the Takemoto Theatre, Osaka, in collaboration with Miyoshi Shoraku, Namiki Senryu, and Koizumo, and was first performed in 1746.

This play is very long, and for this reason one single act, considered the masterpiece of the tragedy, is generally given alone, known as *Matsu* (" The Pine Tree "), or *Terakoya* (" The Village School-house ").

As a subject of illustration, however, there does not appear to have been the demand for it that its popularity as a play would have led one to expect, when one considers the numerous prints there are still in existence of the " Chushingura." Occasional prints are met with of actors in the part of characters from the play, or of some of the characters in the story upon which it is founded.

An almost complete set of scenes, similar to the scenes from the " Chushingura," and the only set of this nature of which the writer has been able to find any record, are described and illustrated in this chapter.

This is an excellent, and very rare, set by SADAHIDE, a good idea of which is given by the coloured reproduction of the best plate in the set at page 302.* Ten plates are here described, but it is presumed the set originally consisted of twelve, the number of acts in the play, though search has not revealed more than the ten, and the plates themselves not being numbered, as the " Chushingura " scenes always are, they afford no evidence on the point.

The play takes for its theme the story of the misfortunes of Sugawara-no-Michizane (A.D. 847–903), who became chancellor to the Emperor Daigo, was falsely accused of treason by the machinations of his rival, Fujiwara-no-Tokihira (Shihei in the drama), and banished to Tsukushi, where he died in poverty and exile in 903.

*Reproduced in black and white in this edition.

CHARACTERS IN THE PLAY

Sugawara-no-Michizane, " Minister of the Right " (*Udai-jin*) to Emperor Uda.
Fujiwara-no-Tokihira, " Minister of the Left" (*Sadai-jin*), enemy and rival of Michizane.
Kiyotsura, an accomplice of Tokihira's.
Matsuō (" Pine ") ⎫ Triplets, sons of *Shirata-yu*, a farmer and servant to
Umeō (" Plum ") ⎬ Michizane, who becomes their godfather; all faith-
Sakura-maru (" Cherry ") ⎭ ful retainers to Michizane.
O-Chiyo, wife of Matsuō, and *Kotarō*, his son, aged 8.
O-ya-ye, wife of Sakura-maru.
——(?), wife of Umeō.
Kanshusai, Michizane's son, and ⎫
Lady Sugawara ⎱ his mother. ⎬ both hiding from Tokihira in Matsuō's house.
(Minazuru-hime) ⎰ ⎭
Takebe Genzo, a vassal and former pupil of Michizane, who keeps a village school near Kyoto, at Seryu.
Tonami, his wife.
Shundo Gemba, emissary of Tokihira.
Village school children, their parents, and soldiers.

The play deals with the vengeance taken by the three brothers for the banishment and death of their lord, Michizane, and in particular the sacrifice by Matsuō, who, the better to carry out his plans, had nominally entered the service of Tokihira, of the life of his only son to save that of Kanshusai and prevent the extinction of the Sugawara clan.

" The memory of the unfortunate statesman, Sugawara-no-Michizane, is surrounded by a halo of romance which affords an insight into Japanese character. He belonged to an ancient family of professional *littérateurs*, and had none of the titles which in that age were commonly considered essential to official preferment. By extraordinary scholarship, singular sweetness of disposition, and unswerving fidelity to justice and truth, he won a high reputation, and had he been content with the fame his writings brought him, and with promoting the cause of scholarship, through the medium of a school which he endowed, he might have ended his days in peace. But, in an evil hour, he accepted office, and thus found himself required to discharge the duties of statesmanship at a time of extreme difficulty, when an immense interval separated rich and poor . . . when the nobles were crushing the people with merciless taxes, and when the finances of the Court were in extreme disorder. Michizane, a gentle conservative, was not fitted to cope with these difficulties, and his situation at Court was complicated by the favour of an ex-Emperor (Uda) who had abdicated, but still sought to take part in the administration, and by the jealousy of the Fujiwara representative, Tokihira, an impetuous, arrogant, but highly gifted nobleman. These two . . . became the central figures in a very unequal struggle. . . . The end was inevitable. Michizane, falsely accused of conspiring to obtain the throne for his grandson—an Imperial prince had married his (adopted) daughter—was banished, and his family and friends either killed or reduced to serfdom.

" The story is not remarkable. It contains no great crises nor dazzling incidents. Yet if Michizane had been the most brilliant statesman and the most successful general ever possessed by Japan, his name could not have been handed down through all generations of his countrymen with greater veneration and affection."—Brinkley, *Japan : its History, Arts, and Literature.*

Having said so much by way of introduction, we will now take up the story from the scenes illustrated in the set by Sadahide.

(Each plate has a variously coloured border—green, blue, or orange—on which appears the Sugawara crest at intervals. Title on a red narrow upright label, as title of play given above ; signed *Sadahide* on a yellow gourd-shaped label ; publisher's seal of *Senichi*, and *kiwamè* seal ; early work, *c.* 1840.)

1. Scene at the Palace of Shishiden, Kyoto. Tokihira seated at the top of a flight of steps receiving the Chinese Ambassador who prostrates himself before him ; on Tokihira's right is seated Michizane as " Minister of the Right," and behind, hidden by a partly rolled-up screen, is the Emperor. On each side of the pathway leading to the steps squat the imperial bodyguard of archers.

The Chinese Ambassador has been sent by the Chinese Emperor to request a portrait of the Emperor Daigo. As, however, Daigo is ill, Tokihira proposes to pose in his stead ; but Michizane objects that wearing the imperial insignia might be construed as an omen that Tokihira would one day become Emperor, and considers that the younger brother of Daigo, Tokyo Shinno, should impersonate him. Later on Tokyo Shinno meets the adopted daughter of Michizane, and marries her, thus giving Tokihira the chance of raising the accusation against him that he was plotting against Daigo, and endeavouring to secure the succession to his grandson. On the strength of this charge, Michizane is banished to exile.

2. Two episodes appear to be illustrated in this scene. Michizane's house in Kyoto, by the shores of a lake, before he became Chancellor. He is here shown in his capacity of tutor teaching Takebe Genzo, a loyal retainer, who afterwards became tutor of his son, Kanshusai. The uncouth youth sprawling on the veranda is not Kanshusai, nor is he Genzo's son, as the latter has no son ; whom he represents is uncertain.

Behind, Michizane is shown taking leave of his wife and adopted daughter, on departing for Court when appointed Minister to the Emperor.

3. Sakura-maru introducing Michizane's adopted daughter, accompanied by Minazuru-hime, to Tokyo Shinno, younger brother of the Emperor Daigo, who is seated in his travelling wagon.

Hilly landscape through which flows a deep blue stream ; the masterpiece of the set. (See Plate H, page 302.)

As explained above, it is the marriage of his daughter to Tokyo that

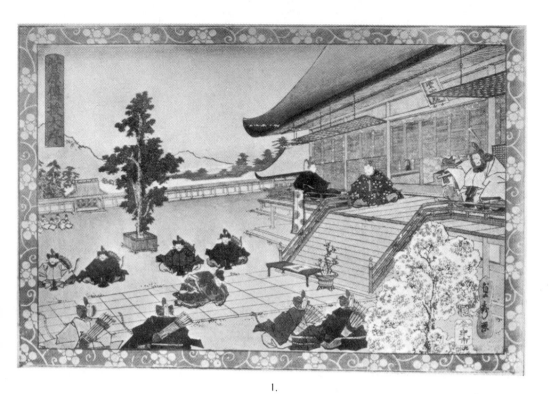

1.

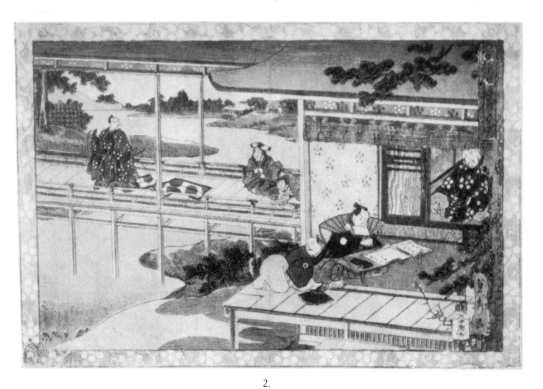

2.

SADAHIDE : Scenes from *Sugawara Denju*.

PLATE 54 (first part)

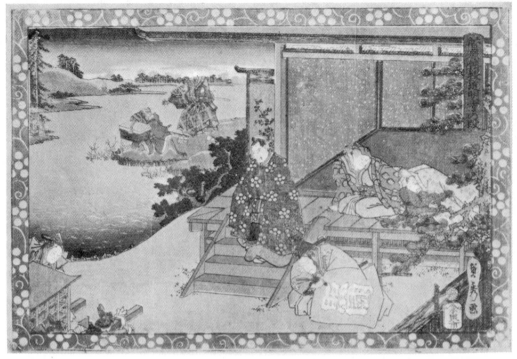

4.

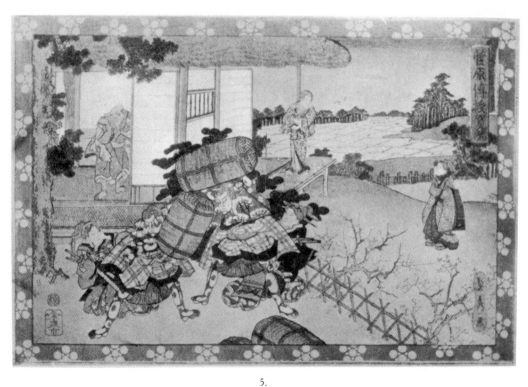

5.

SADAHIDE : Scenes from *Sugawara Denju*.

PLATE 54 (second part)

gives Tokihira the opportunity of denouncing Michizane, and which leads to his undoing.

4. Michizane going into exile, to the grief of his aged mother and his wife; at the foot of the steps kneels Terukuni, a faithful retainer.

The episode by the edge of the water, one man preparing to throw a large chest into the lake, and another restraining him, has not been identified.

5. Scene at the house of Shirata-yu, a farmer, and faithful servant to Michizane.

The three brothers, Matsuō, Sakura-maru, and Umeō, with their respective wives, have come to their father's house to congratulate him on the anniversary of his birthday.

Shirata-yu is a servant in the employ of Michizane, and possessed three trees, a plum, a cherry, and a pine, of which he was very fond. Triplets are born to him, and Michizane consents to be their godfather, and they are named after these three trees. When they grow up they are made *samurai* and enter the service of their godfather.

When Michizane is exiled, Matsuō, the better to serve his lord's cause, takes service with Tokihira, who is completely deceived and, enlisting his aid, reveals to Matsuō his plans for the murder of Michizane's son, Kan-shusai, and the complete overthrow of the Sugawara family.

So clever is Matsuō's dissimulation that even his own parents and brothers are deceived, and he is reviled by all and accused of disloyalty to his lord (an unpardonable offence) and disinherited by his family.

In this scene he is being set upon by Sakura-maru, the two fighting with their father's rice-bales.

In the end Matsuō proves the most loyal of the three, as, in devotion to the Sugawara clan, and to save its extinction, he willingly substitutes his own child, Kotarō, who is killed instead. Of the other two brothers Umeō follows his lord into exile, and kills the man sent by Tokihira to murder Michizane in the island of Tsukushi, while Sakura-maru is killed in defending his lord's cause.

6. Tokihira, a furious figure in white robes, standing on his dismantled chariot, casts a spell over Umeō and Sakura-maru, who have broken and trampled the shafts and the covering of the chariot and were on the point of killing him, but his spell renders them helpless. Matsuō makes as though to attack his brothers in defence of Tokihira. The scene is laid outside a temple, part of the *torii* before it appearing in the background in a grove of trees. (See Plate 55.)

This scene will also be found illustrated in a very fine four-sheet print by Toyokuni, a copy of which is in the British Museum.

7. We now come to what is the most famous act in the whole drama, and the one which is often given separately under the title of *Matsu* (The Pine Tree), Matsuō being the hero of it, or *Terakoya* (The School-house), from the principal scene being laid in Genzo's school at Seryu.

The act is divided into two scenes, the first being laid in Matsuō's home in Kyoto, where the wife of Michizane is in hiding from Tokihira.

Shundo Gemba, Tokihira's chief emissary, suddenly arrives after dark at Matsuō's house with a message to Matsuō to the effect that Kanshusai's hiding-place had been discovered at Genzo's school, who passed him off as his own son, and Tokihira's orders were that he (Matsuō), being the only one on their side who knew the boy, was to go to the school and identify him from amongst the other pupils, and bring his head as a trophy to Lord Tokihira.

" By way of reward for this service you will be created Lord of Harima. There is no time to be lost, so you must make preparations at once." Adding that they are to meet at Genzo's school-house the following morning to carry out the identification, Gemba takes his departure.

It is after this interview that Matsuō determines to sacrifice his own son, who is the same age as Kanshusai and very like him in appearance, by sending him to the school, and himself identifying him as Michizane's son. For this purpose he takes his wife and Lady Sugawara into his confidence, and the former immediately prepares to take Kotarō, to whom everything has been explained and who expresses a perfect willingness to die for his lord's son, to Genzo's school.

The scene now changes to Genzo's school, where Kanshusai is studying with other pupils, and excels them all, inheriting the ability of his father.

O-Chiyo arrives with her son while Genzo is absent, and is received instead by his wife Tonami. Just after O-Chiyo leaves, Genzo returns rather low in spirit, as he has just come from Gemba's house whither he had been invited as if to a feast given to the village mayor, and told that it was known he was secreting Michizane's son in his school and passing him off as his own child, and that unless he killed him at once and brought his head to Gemba, he would be attacked, his school raided and Kanshusai killed.

Genzo pretends to assent, and decides to sacrifice one of his pupils instead, but knowing the plebeian character of them all, he does not see how he could possibly palm any of them off as Kanshusai ; hence his state of mind on his return.

At this juncture, however, his eye lights upon the new pupil just arrived

(O-Chiyo does not reveal the identity of herself or of Kotarō to Tonami when she brings her son to the school), and struck with the resemblance between him and Kanshusai decides to take the former as a substitute, and risk Matsuō's noticing the change. In the event of Matsuō discovering the ruse, Genzo determines to kill him at once and then try and cut his way through Gemba's soldiers with Kanshusai, or both be killed in the attempt.

He therefore sends the two boys into an inner room to play together and gives the other pupils a holiday.

Shortly afterwards Matsuō and Gemba arrive at the school, followed by the parents of the pupils.

Matsuō takes his seat in front and Gemba behind, and each villager calls out his son, till all in turn have been searchingly inspected and allowed to go.

This is the episode here illustrated.

Gemba and Matsuō then demand Genzo to produce the head of Kanshusai at once.

" It shall be done ! " replied Genzo, and going into the inner room where Kanshusai and Kotarō had been playing together (on arrival of Gemba and Matsuō, Genzo hides Kanshusai in a cavity below the floor ; covering the place over with the thick floor mats), strikes off the latter's head, and brings it before Matsuō and Gemba on a white wooden tray under a cover.

While Matsuō deliberately examines the head of his own son, Genzo's eyes are riveted upon him, his hand on his sword-hilt, ready in an instant to cut down Matsuō the moment he realizes the deception that has been practised upon him.

At last Matsuō, after carefully and searchingly examining the head, pronounces the momentous verdict : " Undoubtedly this is the head of Kanshusai, son of the Lord Sugawara," at the same time replacing the cover over it.

Gemba, now delighted that the gruesome deed has been done, carries off the head in triumph to Tokihira, followed by Matsuō, who, however, presently returns (his wife meantime reappears on the scene, which causes complications to arise between her and Genzo), and explains the whole situation, how he himself had decided that Kotarō should impersonate Michizane's son, knowing what desperate straits Genzo would be in when ordered to deliver up Kanshusai's head and unable to find a substitute, yet equally unable to commit such a crime as the murder of his young lord.

The scene closes with the reunion of Lady Sugawara with her son and their flight to Kawachi, the stronghold of the Sugawara family.

From this point Matsuō disappears from the play.

8. Michizane is here shown in exile in the island of Tsukushi riding on a black ox and reading to his driver.

The two figures behind fighting on the seashore cannot be identified. Tokihira does send a man to murder Michizane while in exile, who is killed by Umeō, but they do not refer to this incident, as neither figure represents Umeō.

9. Michizane praying for a thunderstorm to destroy his enemies ; below Umeō, who follows him into banishment, overcoming three sailors, armed with oars, who had attacked him. Here again the allusion is not at all clear, and does not appear to fit in with the ascertained facts of the story, in which Umeō kills the man (not a sailor) sent to murder Michizane.

10. Tokihira and his accomplice, Kiyotsura, being killed by lightning, caused by the prayers of Michizane, in the Palace at Kyoto, while a priest endeavours, but in vain, to quell the storm.

Curtain.

On his death, Michizane received from the repentant Emperor, Daigo, the posthumous title of *Tenmangu*, the God of Caligraphy, under which title he became patron saint of schoolboys, while shrines were erected throughout the country in his honour.

He is said to have written twelve books of poetry and two hundred volumes of history.

Amongst his poems is one written during his exile, and which became one of his most celebrated :—

> *The plum tree follows me through the air,*
> (Umeō follows him in banishment)
> *Withered and dry is the cherry tree ;*
> (Sakura is killed defending his lord's cause)
> *Should then the pine tree so lofty and fair*
> *Alone be heartless and faithless to me ?*
> (In allusion to Matsuō taking service with his enemy Tokihira).

But the " pine tree " was not " heartless " nor "faithless," as subsequent events so amply proved.

The first line of the above poem is in allusion also to an event which took place on his departure into exile, when one of his favourite plum trees miraculously transported itself to Chikuzen, in the island of Tsukushi

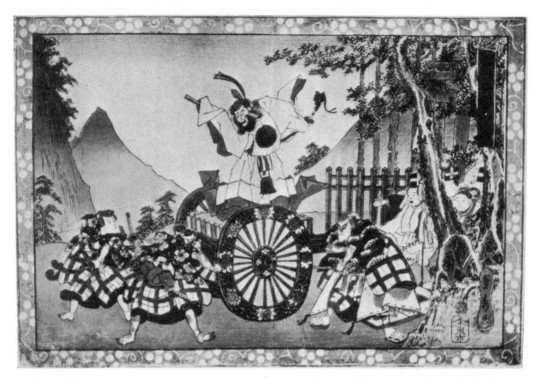

6.

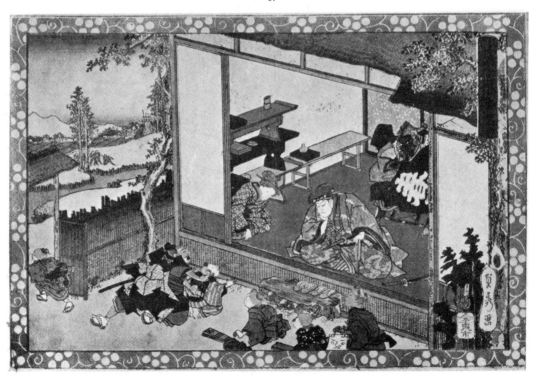

7.

SADAHIDE : Scenes from *Sugawara Denju*.

PLATE 55 (first part)

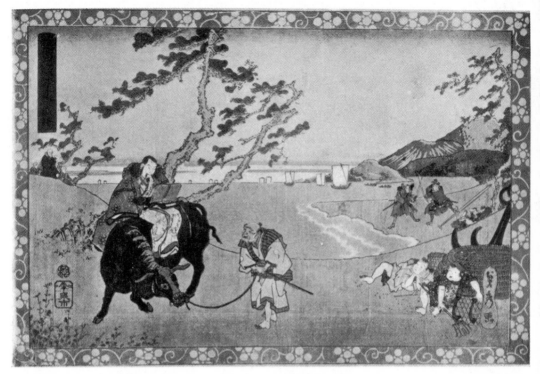

8.

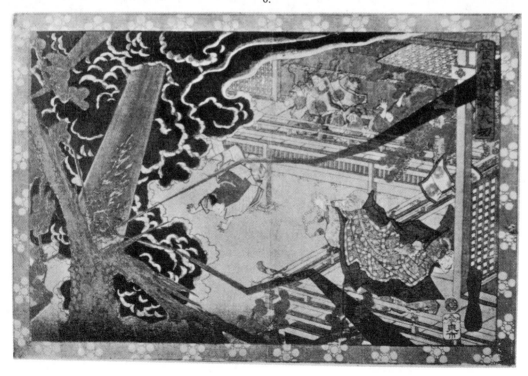

10.

SADAHIDE : Scenes from *Sugawara Denju.*

PLATE 55 (second part)

(hence in the play Umeō follows Michizane into exile), in response to his poem :—

> When the eastern breeze passes
> Load her with perfume, O blossoms of my plum trees.

This tree has since been known as *Tobi Ume*, the jumping plum tree.

PART V

HISTORICAL SUBJECTS, LEGENDS AND STORIES

CHAPTER XXXIII

HISTORICAL PRINTS BY HIROSHIGE

IN the various series to be described in the following pages we see Hiroshige's not unsuccessful attempts to rival Kuniyoshi in the domain of illustrations to history, legends, and drama, even as the latter tried his hand at landscape in compliment to Hiroshige. Although, as a rule, Hiroshige was not particularly successful outside the province of landscape, yet at times he exhibits unexpected dramatic powers.

The first series which we will pass in review is one dealing with incidents from ancient Chinese and Japanese history, of which only five plates are known. As these prints are highly interesting from the subjects illustrated and are, moreover, of a high order of merit both in drawing and colouring, we here illustrate each scene.

There is no series title, but the names of the characters in each scene are given ; each plate is full size, oblong, and has a white feathered border on a green ground ; publisher *Fuji-hiko*. *Very* rare. The drawing is particularly sharp and clear and the brilliant yet harmonious colouring compares very favourably with the best Tokaido views ; *c.* 1840.

1. Nitta Yoshisada, while besieging Kamakura, throwing his sword into the sea at Inamuraga Saki (5th month, 1333).

Yoshisada was a distinguished Minamoto general, and a follower of the Emperor Go-Daigo-Tenno, who was at war with the *Shōgun*, Takatoki, of the Hojo dynasty. The latter was beseiged at Kamakura by Yoshisada who, finding the sea too rough to cross over to the town, threw his sword into the water to propitiate the waves. At ebb tide the sea calmed, and Yoshisada was able to cross the inlet and capture Kamakura. (See Plate 56.)

2. Chohi defending Chohan Bridge, an incident from Chinese history. He is represented mounted on a coal-black charger, armed with a long lance, and scowling fiercely at the advancing enemy as they approach the bridge, a structure of stone spanning a waterfall, through a rocky defile,

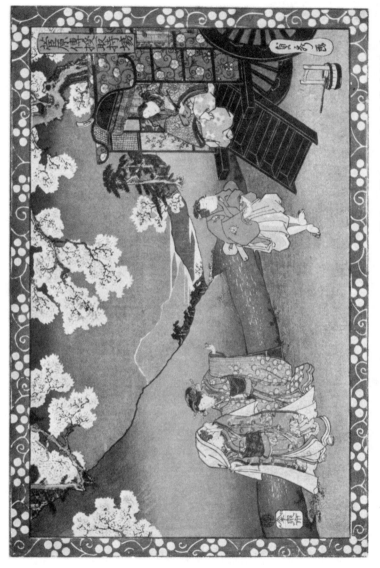

(1). SADAHIDE: Sakumaru introducing Michizane's daughter to Tokyo Shinno; signed *Sadahide* (*see page 294*).

PLATE H (first part)

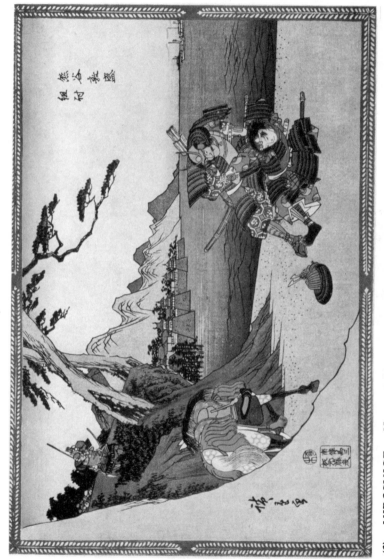

(2). HIROSHIGE: Kumagai Naozané and Taira no Atsumori at Ichi-no-Tani; signed *Hiroshige*.

PLATE H (second part)

with banners flying. In the distance a deep blue sea and a mountainous coast on the horizon, rising into a red sky.

Chohi was distinguished by his stature, long hair, fan-like beard, and a long, double-edged spear, characteristics with which Hiroshige has endowed him in this print. He was a celebrated Chinese warrior (Chang Fei, died A.D. 22) who joined forces with two other distinguished generals, Kwanyu and Gentoku (Liu Pei), his brothers-in-arms, and fought against the usurper Tsao-Tsao, in the wars known as the Wars of the Three Kingdoms (A.D. 184). Of these three Kwanyu was the most famous, being canonized as an immortal in 1128, deified as the Chinese God of War in 1594, under the name of Kwanti, and finally, in 1878, raised to the same level as Confucius as an object of national worship (Joly, *Legend in Japanese Art*).

Gentoku became Emperor of China on the fall of Tsao-Tsao in 220. All three generals began life in a very humble way. Gentoku was a maker of straw sandals and mats; Kwanyu a seller of bean curd, who spent his spare time in study (Kwanyu studying a book on strategy is the subject of illustration in a fine *surimono* reproduced at Plate 9 in our quarto edition); while Chohi was a " blue-eyed, red-haired butcher."

The incident in his career here illustrated depicts an episode in the story of the Undefended City, in which Chohi sends away all his army and defends the town single-handed against the forces of Tsao-Tsao which had just inflicted a defeat on Gentoku.

Meanwhile his own army makes a flanking movement, joins that of Kwanyu and Gentoku, and attacks Tsao-Tsao from the rear inflicting defeat on him.

3. Snow scene. Fight between Sato Tadanobu and Yokogawa Kakuhan at Yoshino.

Tadanobu was one of the chief retainers to Yoshitsune. When the latter was flying from the persecution of his half-brother, Yoritomo, he was attacked by the Yamabushis (warrior-monks) of Yoshino, who were adherents of Yoritomo. To allow Yoshitsune time to escape, Tadanobu donned the armour of his leader and fought, single-handed, the Yamabushis, led by Yokogawa Kakuhan.

4. Kajiwara Kagesuyè and Sasaki Takatsuna at Uji River.

Scene on the bank of the Uji River in flood. Takatsuna in mid-stream urging his horse through the flood, while Kagesuyè, holding his bow by the string in his mouth, halts on the bank to tighten the girth of his saddle ; his standard-bearer leans against a tree watching Takatsuna crossing.

On the further bank is situated the camp of Yoshinaka, and in the distance a range of blue mountains.

Kagesuyè was a retainer of Yoshitsune, whom he accompanied, in 1184, in his expedition to quell the revolt of Kiso Yoshinaka against Yoritomo. Coming to the Uji River which was in flood, a ford was found by Takatsuna, who was familiar with the locality. Yoshitsune gave Kagesuyè his own horse whereon to ride across, and he was the first to essay the passage. Takatsuna, however, who was mounted on one of Yoritomo's horses, plunging into the stream after Kagesuyè, called after him to tighten his girth, and as he stopped to do so, Takatsuna got across first.

5. Kumagai Naozane killing Taira-no-Atsumori after the battle of Ichi-no-Tani.

Scene on the beach at the foot of a green slope on which two pine trees are growing; beyond is the Castle of Ichi-no-Tani backed by precipitous mountains, and out in the bay lies the Taira Fleet. An incident in the wars of the Taira and Minamoto clans which were a counterpart of our own Wars of the Roses.

This is the best plate of the series, the colouring being particularly fine. Against a clear sky, a purple glow on the horizon changing to orange at the top, rise steep blue and grey mountains washed at the base by a deep blue sea. The green and purple armour of the two figures is contrasted with the grey sand of the beach, and the bright red trappings of the horse with the green slope behind it; on the extreme left, forming a frame as it were, is a cliff coloured a beautiful rose-pink. (Reproduced in colours at Plate H, page 302.)*

There are two versions to the incident here portrayed, the historical and the dramatic.

Atsumori was a youth of sixteen in command of the defenders of the Castle of Ichi-no-Tani, which was laid siege to by Yoshitsune, in 1184, Kumagai being one of the Minamoto generals taking part in it.

The castle was taken by Yoshitsune attacking it from the steep mountain side, from which an attack was considered impossible, and therefore left undefended, and all the defenders fled to their ships to escape. Atsumori, however, was too late and betrayed himself by playing on his flute, which Kumagai heard. He was on the point of killing Atsumori, renowned for his beauty, when he saw in him a resemblance to his own son, and would have spared his life, but for the taunts of Hirayama Suyeshigè (the figure standing on the top of the green slope) at his allowing a Taira to escape. Kumagai thereupon slew him, and sent his head and flute to Yoshitsune. Later, filled with remorse for his deed, he shaved his head and became a

*Reproduced in black and white in this edition.

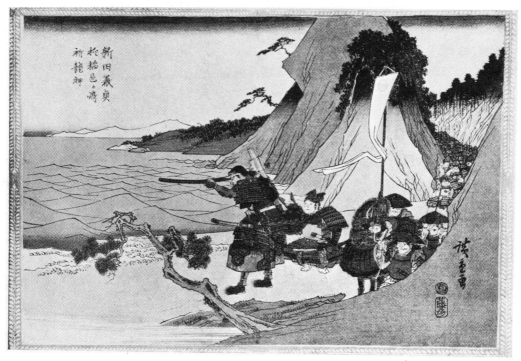

1. Nitta Yoshisada throwing his sword into the sea to propitiate the stormy waves.

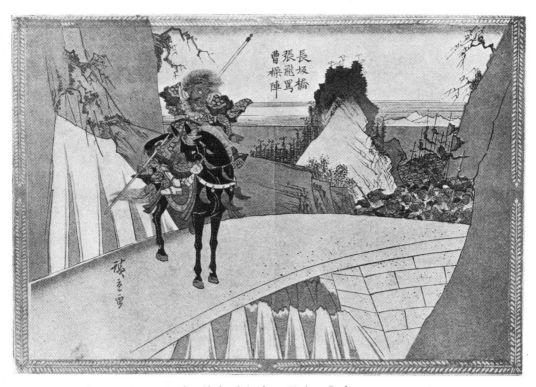

2. Chohi defending Chohan Bridge.

PLATE 56 (first part)

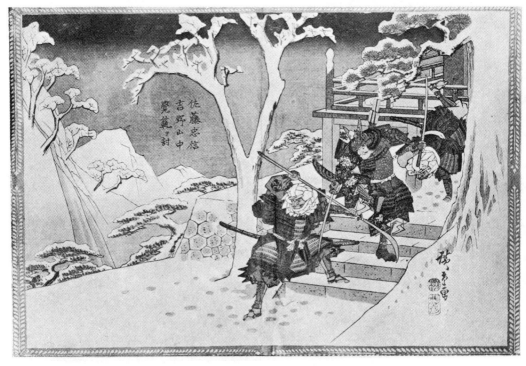

3. Fight between Sato Tadanobu and Yokogawa Kakuhan at Yoshino.

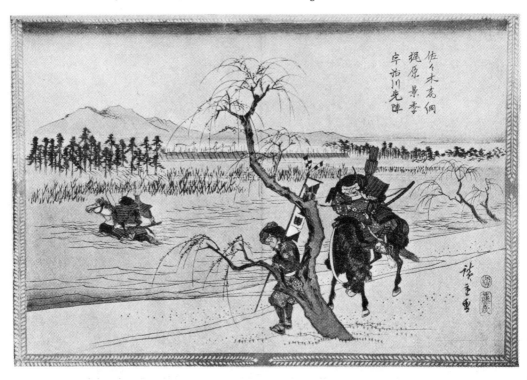

4. Kajiwara Kagesuyè and Sasaki Takatsuna at Uji River.

PLATE 56 (second part)

monk, retiring to the temple of Kurodani, at Kyoto, under the name of Renshobo.

The dramatic version is from the play *Ichi-no-tani Futaba Gunki*, written by Namiki Sosuké (" The Tale of the Sapling of Ichi-no-Tani "). This version, of course, is elaborated with improbable episodes in order to suit the public taste, and to convey the moral which is the dominant theme in all Japanese plays, that of loyalty to a chief at all costs. Accordingly Kumagai saves Atsumori's life by sacrificing that of his own son, in obedience to secret orders from Yoshitsune, which orders were conveyed to him by a notice set up on a board under the cherry trees before Atsumori's camp, which read : " It is strictly prohibited to injure the cherry blossoms " (an allusion to the youthfulness of Atsumori). " Anyone cutting off one branch shall be punished by having one finger cut off."

Kumagai, therefore, induces his son Kojiro to fight his way into the Castle of Ichi-no-Tani, change clothes with Atsumori so as to deceive both friend and foe, and finally to be killed by his father in order to convince everyone of Atsumori's death.

There was, however, a treacherous *samurai*, Hirayama Suyeshigè, who wished to see both Kumagai and his son Kojiro dead, so that he should have the distinction of attacking and capturing the Castle of Ichi-no-Tani, and of killing Atsumori.

When therefore Kumagai, in apparent desire to save his son, rushes up to the entrance and asks Suyeshigè (who had previously urged Kojiro to fight his way in first, pretending to yield this honour in his favour as an encouragement) if he has seen him, the latter exhorts him at once to go to his help, which he does.

Suyeshigè then congratulates himself that now both father and son are caught like mice in a trap and are sure to be killed.

Almost immediately afterwards Kumagai comes out supporting his son (really Atsumori in Kojiro's armour) as if wounded, and takes him to his camp.

Suyeshigè, seeing his plans frustrated, prepares to take to flight, but he is surrounded by Atsumori (really Kojiro) and other soldiers who were following Kumagai and forced to fight. All this is taking place at night.

He manages to beat a retreat, and the supposed Atsumori is the only one to follow him, but in the darkness he loses sight of him. He therefore rides back to camp to join the now defeated Tairas in the embarkation, but he is too late, as not a ship remains. He thereupon rides his horse into the waves in an attempt to reach the retreating ships.

At that moment he hears a voice hailing him from the beach and challenging him to fight. He turns his horse to the shore again and

accepts the challenge which comes from Kumagai himself. They fight, and (the supposed) Atsumori is defeated.

This is the incident portrayed by Hiroshige.

It was, therefore, the disguised Kojiro whom Kumagai killed on the beach at Ichi-no-tani, addressing him as Lord Atsumori in the most polite language, so that neither friend nor foe should see through the stratagem. Kumagai had thus fulfilled Yoshitsune's cryptic instructions to save Atsumori.

In the Happer sale catalogue mention is made of eleven full-size, oblong plates, belonging to an even rarer series than the above which we have just described, the total number of which is not known. It is entitled *Hon Cho Nen Reki dzuye*, " An illustrated Japanese Calendar (of events)." Each plate is numbered, and has text in the upper part ; publisher *Jo-Kin*. This is the only mention which the writer has noticed of this extremely rare series, and no prints from it have come under his observation ; he quotes it here as a matter of interest.

Amongst the legends illustrated in these eleven plates are the following :

1. Izanagi and Izanami descending from heaven. Izanagi was the creative divinity of Japan who was sent by the heavenly deities, accompanied by his wife Izanami, to consolidate the land, then floating about in a chaotic state.

2. The gods making music to allure Amaterasu, the sun goddess, born of the left eye of Izanagi, out of her hiding-place. She sulked in a cave, and thus cast darkness over the world, and was only lured out of it by the dancing of Ame-no-Uzume, a beautiful immortal. In memory of this legend the dance in Japan has been honoured as a religious ceremony and developed as a fine art, in grateful remembrance of the dance that was the means of bringing back the goddess of light to the land of the rising sun, a symbol which they have adopted as a national emblem.

To find, then, the origin of dancing in Japan, which in turn gave rise to the origin of the drama, we must go back to the remote period when history becomes fable and when the simple occurrence of a solar eclipse is attributed to supernatural causes.

3. Urashima and the Dragon King's Daughter. Urashima was a fisher-boy who one day caught a tortoise, but good-naturedly returned it to the water. In return for his kindness he is taken to the palace of the Dragon King of the sea under the waves, and given his daughter in mar-

riage, who was none other than the tortoise disguised as such. After three years of life in the depths of the sea, Urashima expresses a desire to return home to see his family and relations again. Unwilling to let him go, his wife however consents on condition he promises faithfully to return to her, at the same time giving him a box with strict injunctions not to open it. He returns home, only to find the place changed and his parents and their descendants long since dead. Then it suddenly occurs to Urashima that his three years under the waves in the palace of the sea King were in reality three hundred years, and that there was no use staying on earth any longer. So he hastened to return to his wife below the waves, but unable to find the way, forgot her strict injunctions and opened the fatal box in hopes that it would be able to direct him. As he did so a white cloud came out of it and floated away, and as the last traces of it disappeared, Urashima fell down dead on the beach.

CHAPTER XXXIV

DRAMATIC AND HISTORICAL SERIES—(*continued*)

THE next series by Hiroshige which we will describe is one entitled *Kokon Joruri Tsukushi*, " Ancient and Modern Dramas Illustrated " ; full size, upright. The number in a complete set is not known, but fourteen plates are here recorded, the largest number hitherto mentioned in any publication, as far as the writer is aware.

The title of the series is on a narrow yellow panel in the top right-hand corner, and the sub-title of the illustration on a red panel in the opposite corner, on each plate. Publisher, *Sanoki ;* below Hiroshige's signature is a red chrysanthemum seal, a device which has not hitherto been noted on any Hiroshige print ; and two censors' seals, which place the date of the series about 1846, during the Prohibition period. Very rare.

1. Sub-title : *Katsuragawa Renri-no-Shigarami* (the name of the drama), which concerns two lovers, Choyemon, a man forty years old, and O Han, aged fourteen, who, despairing of obtaining their parents' permission to marry, resolve to commit suicide together.

Choyemon is here shown carrying his youthful love on his back, to die together in the waters of the Katsura River, a full moon the only witness of their tragic end. One of the best plates in the series of those known. (Illustrated at Plate XVI of the catalogue of the Baker collection, Sotheby's, February, 1916.)

The subject of *shinju*, or double suicide, was first dramatized in 1703 by the playwright Chikamatsu Monzayemon, in a play called *Sonezaki Shinju*. Such dramas were called *Shinju-mono*, and became exceedingly popular, owing to the beautiful language in which Monzayemon described these tragedies, both with the public and other contemporary dramatists, and it is said their influence was such that the numbers of cases of double suicide increased to an alarming extent.

2. Sub-title : *Keisei Koi Bikyoku :* " A Courtesan, Love, and the Postman." Chubei, in order to buy out his love, Umegawa, from the Shinmachi of Osaka, steals money sent through the post, and seeks refuge in his father's house, where he hides at Nino Kuchimura. Umegawa

comes thither to seek him out, and is shown asking his father of her lover's whereabouts. To ingratiate herself with the old man, she mends his sandal for him. (See Plate 57.)

Censors' seals of Muramatsu and Yoshimura.

3. *O-Somé moyo Imose no Kadomatsu* : Hisamatsu and O-Somé are the Romeo and Juliet of Japanese drama. He was a clerk in the service of O-Somé's widowed mother, the owner of a prosperous business in Osaka, and fell in love with O-Somé ; he is here shown kneeling by the *torii* of a temple, persuading her to elope with him.

The scene is taken from the play *Shimpan Uta Zaimon*, written by Chikamatsu Hanji (lived 18th century), and was—and still is—one of the most popular plays in the repertoire of the Japanese stage.

The story is too long to give here even in an abbreviated form, but in the end, O-Somé, to save her mother from embarrassment of debts, promises to marry a young millionaire, who would pay them on condition that O-Somé became his bride.

Sooner, however, than betray her lover, she takes her own life, and Hisamatsu, unable to save her (he is held a prisoner by Kosuké, the villain of the play), immediately follows her example.

4. *Mei Boku Sendai Hagi* : The title of a play written by Chikamatsu Kwanshi (1785) and two other playwrights in collaboration.

Ashikaga Yorikane, Lord of Sendai, holding in his hand a few hairs of the head of Takao, whom he has just caused to fall into the water by hanging her by her hair over the side of the boat, and cutting through it with his sword.

(*Vide* Chapter XXIV, Part IV, for *résumé* of this play.)

5. *Chushingura, Act III* : Kampei and Ōkaru. Kampei, stricken with grief when he hears of his lord's frustrated attack on Moronao, and that he has in consequence been made a prisoner, and his absence from Yenya's side at such a crisis, ill-becoming a loyal retainer, resolves on suicide, but Ōkaru prevails on him to desist and flee with her to her father's home at Yamazaki, many miles away.

One of the best prints in the series. Kampei is shown kneeling, with one hand on the handle of his sword, about to draw it ; beside him stands Ōkaru. Behind them a tall pine tree, and in the background a large grey Fuji, its cone tinted green, rises up into a deep blue sky. (See Plate 57.)

Censors' seals of Kinugasa and Hama.

(This journey of Kampei and Ōkaru from Kamakura to Yamazaki is the dramatized version of the exploit of Kayano Sampei who, in company with another retainer

of Asano, had, at the beginning of the quarrel between their lord and Kira Kozukè, the results of which they dreaded, travelled the extraordinary distance of over 400 miles in 4¼ days—in those days usually a journey of 16 or 17 days—to find Kurano-sukè, the chief steward of Asano, who was at the time absent in the province of Harima. News of Asano's self-dispatch reached Kuranosukè the day after their arrival.

After this Sampei retires to his village and there finds his mother dead. His father, pleading age and loneliness, urges him to stay with him, but Sampei, distracted between his duty to his parent and loyalty to his lord whose death he has sworn to avenge, seeks escape from his dilemma in self-dispatch.)

6. *Chushingura, Act VIII.* The Bridal Journey of Konami and her mother Tonasé to find Rikiya, from Kamakura to Yamashima.

7. *Chushin Koshaku Yukifuri no dan :* " Meeting of the Loyal Ones in Snow." Snow scene. Yazama Jiutaro, one of the Forty-seven *Ronin*, meets his wife Orin in Yedo after a long separation. (See Plate 57.)

One of the best plates in the series.

Censors' seals of Kinugasa and Hama.

8. *Karukaya Doshin Tsukushi no Iyezuto :* the title of a play written by Namiki Sosuke (1694–1750). The priest Karukaya Doshin meeting his son Ishidomaru on Mount Koya, but refrains from revealing his identity to him.

(It was a popular belief at one time that jealous women had their hair transformed into writhing serpents, and Kato Sayemon Shige-uji, a *daimyo* of Tsukushi, a much-married man, suffered from the delusion that his wife was so afflicted. He fled to the mountains to escape her, and led the life of a hermit under the name of Karukaya Doshin.

One day, meeting a youth wandering in the mountains, he questions him, and elicits the information that he is seeking his lost father.

Karukaya then recognizes the boy as his own son, but firm in the resolve to remain lost to the world, he refrains from disclosing himself, and bids the youth return home.)

9. *Gompachi yume no dan:* " Gompachi dreaming." Gompachi standing by the river bank, reading a letter from Komurasaki by the aid of a lantern under a willow tree ; in the sky shines a crescent moon. A very fine plate. (See Plate 57.)

Censors' seals of Muramatsu and Yoshimura.

(The story of the two celebrated lovers, Gompachi and Komurasaki, is a famous one, as much so as that of O-Somé and Hisamatsu, and has likewise been dramatized in popular plays.

The two lovers first meet at what Gompachi supposes to be an inn, but which is really the abode of robbers, who had kidnapped Komurasaki. She warns him of his danger and advises him to escape.

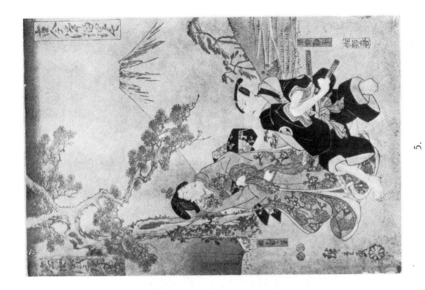

5.

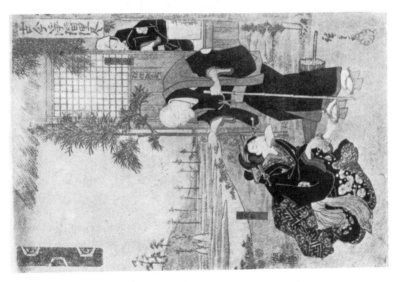

2.

HIROSHIGE : Six plates from the series *Kokon Joruri Tsukushi*, "Ancient and Modern Dramas Illustrated."

(Author's Collection.)

PLATE 57 (first part)

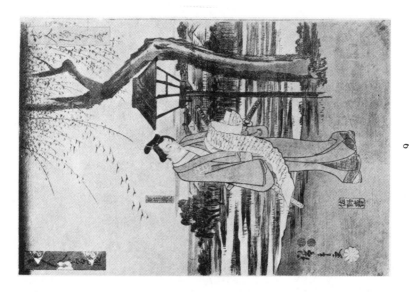

9.

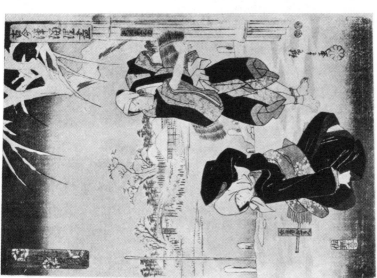

7.

HIROSHIGE : Six plates from the series *Kokon Joruri Tsukushi*, "Ancient and Modern Dramas Illustrated."

(Author's Collection.)

PLATE 57 (second part)

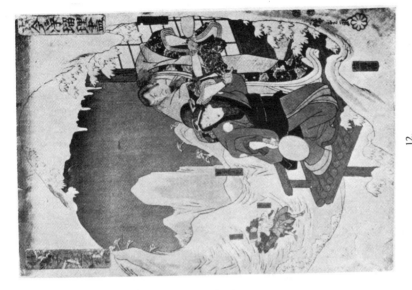

12.

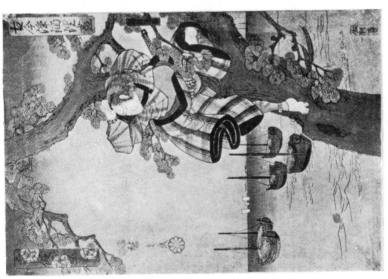

11.

HIROSHIGE : Six plates from the series *Kokon Joruri Tsukushi*, "Ancient and Modern Dramas Illustrated."

(Author's Collection.)

PLATE 57 (third part)

Gompachi, however, who was a skilful swordsman, decides to stay and fight them. He defeats them and escapes with Komurasaki whom he restores to her parents. Later, misfortune overtaking her parents, Komurasaki sells herself to the Yoshiwara to pay their debts ; Gompachi here meets her a second time and determines to redeem her, but the methods he adopts to attain this end, having no money himself, killing and robbing people to buy her out, finally land him in the hands of the public executioner.

A few days after his death, Komurasaki breaks out from her prison in the Yoshiwara and commits self-immolation on his grave. Their common tomb is known as the grave of the *hiyoku*, a fabulous bird embodying two souls in one body, the emblem of connubial love and fidelity.)

10. *Kagamiyama :* Iwa Fuji standing by a *torii* beating another lady, Onoye, with her straw sandal.

This is a scene from the play *Kagamiyama*, which relates how Ohatsu, maid to Onoye, the Lady of Kaga, avenges the insult heaped upon her in the palace by Iwa Fuji, who struck her in the face with her sandal. Onoye, to wipe out the insult she has received, commits suicide, and Ohatsu in revenge kills Iwa Fuji.

11. *Hirakana Seisukè* (i.e. History of the Taira and Minamoto clans). Higuchi-no-Jiro, in a tree, watches his lord whom he has rescued from arrest, sailing away. (See Plate 57.)

(Higuchi-no-Jiro is the same as Sendo (" sailor ") Matsuyemon, a retainer of Yoshinaka, a Minamoto warrior of the twelfth century, who was killed by Yoshitsune after the battle of Uji River (*vide* preceding chapter). Higuchi rescues Yoshinaka's son and, disguising himself as a sailor, gets him safely away in a ship.)

12. *Hime Komatsu Nenohi Asobi* (title of the play), by Chikamatsu Monzayemon.

Shunkwan dragging Oyasu into his house, while behind Ariomaru holds back Kameo-maru from coming to her rescue. Snow scene.

Considered the best plate of the series so far as they are known. (See Plate 57.)

The writer has been unable to identify the scene illustrated. Shunkwan was a priest, who, at the end of the twelfth century, was exiled for complicity with others in a plot against Taira no-Kiyomori.

Later his companions in exile were pardoned, but Shunkwan himself was left to die alone on the island to which he had been banished because, as a priest, his crime was the more unpardonable. Shunkwan in exile is the subject of a *Nō* drama, and is often the subject of illustration.

13. *Sekinoto :* Sekibei, armed with a huge axe, is about to cut down a cherry tree which is haunted by the ghost of a reformed *oiran*, Komachi Sakura (" cherry "), who became a nun. Sekibei was a gate-keeper (real

name Oto-no-Kuronoshi) who murdered her and buried her body by the cherry tree, which was thereafter haunted by her ghost until he cut it down. Snow scene ; in background a round-topped hill.

14. *Seishu Akogi no Ura :* Akogi no Heiji is being arrested for fishing in forbidden waters, his captor finding his name in his hat. Akogi had been watching the lightning and was fishing for the sword supposed to be dropped by it.

TOTO KYUSEKI TSUKUSHI : " Old Yedo Stories Illustrated."

A series of very rare, full-size, upright prints, issued through the publisher *Wakasa-ya*, with censors' seal of *Ta-naka*, which places the date at about 1845. The title of the series and the sub-title of the illustration are on two narrow labels in the top right-hand corner, while opposite on a large rectangular label is a short history of the scene depicted. Eight of the series have been noted by the writer, and this number is probably all that are known to-day. Four of them appeared in the Orange and Thornicraft sale (March, 1912), and are here illustrated at Plate 58.

1. *Azuma-no-Mori no Koji :* " The Old Story of Azuma." The prow of a ship in a heavy storm of wind and rain, and Tachibana Hime throwing herself over the side into the waves.

(She was one of the concubines of Yamato Také [*c.* A.D. 100], a son of the Emperor Keiko, and accompanied her lord on one of his expeditions, when boisterous weather was met with.

To appease the sea-god, who was offended at Yamato Také by reason of a jeering remark he had made to her previously when, jealous of his attentions to another woman, she ventured to remonstrate with him, only to receive the reply that her place was not in the wars, but " on the mats " [i.e. at home], she had her mats thrown into the water, and jumped on them, thus revenging herself upon her husband.

Azuma is the name given to the Eastern coast provinces of Japan, and this district received this designation [hence the name " Azuma " in the sub-title] from Yamato Také on his return home from this expedition, while gazing over the sea from the top of a mountain, exclaiming in remembrance of Tachibana Hime's self-sacrifice, " *Azuma ha ya !* " [Alas ! my wife.])

2. *Sumidagawa Miyakodori no Koji :* " History of the Miyako Birds of the Sumida River." (See Illustration 1, Plate 58.)

The Poet Narihira (A.D. 825–880) accompanied by a young page-boy carrying his sword, watching a flight of *chidori* on the Sumida River at Yedo. They so reminded him of his home at Kyoto (poetically called Miyakodori), that he called them " Miyako Birds."

3. *Takada Yama Yamabuki no sato Koji :* "Ancient Story of the Yamabuki at Takada Hill." Rain scene.

A girl picking a bloom of the *yamabuki* (*Kerria Japonica*), outside a hut.

This is an illustration of the story of Ota Dokwan, a *daimyo* (died, 1486), who, being caught in a rain-storm, made for the shelter of a house, which was of poor appearance, and asked for the loan of a raincoat (*mino*). The girl instead brought him a flower of the *yamabuki* (yellow rose), thereby signifying by a pun on the word *mino* (also = a seed) that she had no raincoat, the *yamabuki* having no seed. (See Plate 58.)

4. *Kanda Otama-ga ike no Koji :* " Old story of the Otama Pond at Kanda." (See Plate 58.)

Otama, a tea-house waitress, in a garden overlooking the lake, is lifting a pot out of a boiler. She drowned herself in the lake (not now in existence), because she was unable to choose between two lovers who both desired to make her wife.

(An exactly similar story concerns another maiden, known as the Maiden of Unai who, like Otama, was violently loved by two persistent admirers, Mubara and Chinu, and was also unable to choose between them. To solve the problem, her parents decided that he who should first shoot a water-fowl swimming in the water should have their daughter in marriage. Both shot their arrows at the same time, and both hit their mark, thus still failing to solve the problem.

In despair, the maid of Unai threw herself into the stream, and the two lovers sprang after her, all three perishing together.)

5. *Kasumi ga seki no Kozu :* " A former view *from* (not " of " as often given in catalogues) the Kasumi Barrier." (See Plate 58.)

View from the summit of a hill looking out across the Bay of Yedo, and a lady and her page-boy turning to admire the prospect, in the days before the hill was built over.

(The Kasumi Barrier was a hill in Yedo—now built over—where formerly a guard-house stood leading into another province [*vide* Plate 2 in Hiroshige's " Hundred Views of Yedo "].)

6. *Mukojima Umewaka no Yurai :* " The story of Umewaka at Mukojima."

Umewaka was a child of noble birth who was kidnapped in Kyoto. He died and was buried by a priest near the site of the Kameido Temple.

His mother searches all over the country for her lost son, and at last finds his grave under a willow tree. She goes mad after making this discovery, and is here depicted floating down the river in a boat and being jeered at by children.

This episode has been made the subject of a drama.

7. *Asakusa Kinryusan Kwanzeon Yurai :* " History of the Kwannon Temple, Asakusa, Kinryusan."

This illustrates the story of the founding of the Temple to the goddess Kwannon at Asakusa, and tells how a fisherman named Hamanari found an image of Kwannon entangled in his net, and enshrined it in his hut.

Another version is that the fisherman was a noble in exile, Hashi-no-Nakamoto, who fell into such poverty that he was obliged to take to fishing as a means of livelihood, accompanied by two faithful retainers. He is here depicted fishing up the sacred image, which is shown emitting rays of light as it is being brought to the surface, with his two retainers in the boat. In the background shines a deep red sun just above the horizon, behind a clump of trees.

8. *Asakusa ga hara Hitotsuya :* " The lonely house at Asakusa." This house was kept by a woman who murdered any wayfarers who put up there for the night by dropping a huge suspended stone on them when asleep, and then robbing them.

CHIUKO-ADAUCHI DZU-YE : " Illustrations to Fidelity in Revenge."

A very rare set of full-size, upright prints, probably complete in 14 plates. This number, in book form, appeared at a print sale at Sotheby's in August, 1919, the largest number hitherto recorded. Issued during the Prohibition period.

For purposes of identification of other plates in the set which may come under the notice of the reader, one of them is here reproduced at Plate 58 (Illustration 5).

Above, on a panel in the form of an open book is, on the right-hand label, *Ichiryusai Hiroshige gwa*, followed by his diamond seal, *Hiro*. (It was very unusual for Hiroshige to sign in full at this late date ; but his early work, before 1830, is often signed *Ichiyusai H*. The small difference of one letter (R) is important in distinguishing early and late work.)

On the centre panel is the title of the series, and on the left-hand one the name of the publisher, *Dansendo*, with his seal below, and that of the censor, *Murata*, above.

On the other page of the book is a synopsis of the incident illustrated in Japanese text by *Tanekazu*. In the bottom left-hand corner of the print is a small label of the engraver *Také*.

The incident portrayed is Shundo Jiroza-Yemon, disguised as a beggar,

HIROSHIGE.

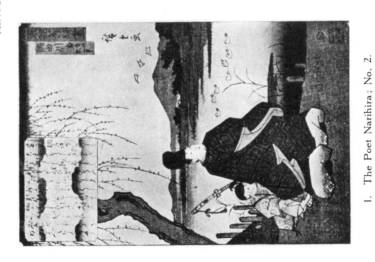

1. The Poet Narihira; No. 2. 2. Story of the "Yellow Rose"; No. 3.

Plates of the series *Toto Kyu-seki Tsu-kushi.*

(*By courtesy of Messrs. Sotheby.*)

PLATE 58 (first part)

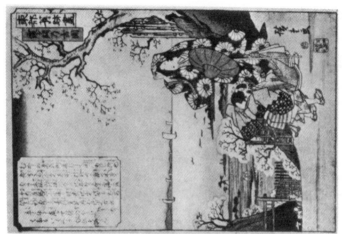

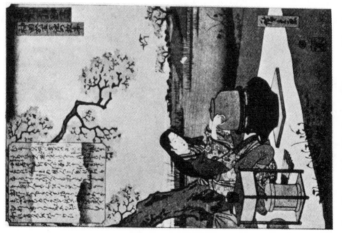

3. Otama, the Tea-house Waitress; No. 4. 4. The Kasumi Barrier, Yedo; No. 5.
Plates of the series *Toto Kyu-seki Tsu-kushi.*
(By courtesy of Messrs. Sotheby.)

PLATE 58 (second part)

HIROSHIGE.

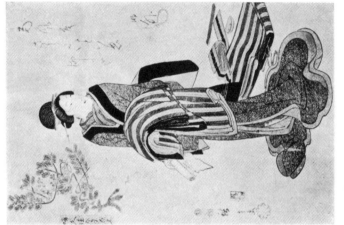

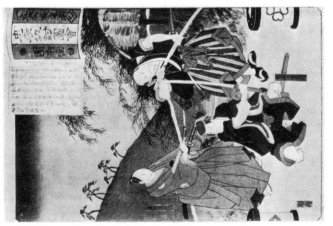

6. "The Careful Wife"; from the series "Money Bringing Trees."

5. Shundo and his enemy Kamura; "Fidelity in Revenge" series.

PLATE 58 (third part)

kneeling, preparing to fight his enemy Kamura Uta-yemon, who is drawing his sword. Behind Shundo stands Takaichi Buyemon holding a closed fan, acting as his second.

Shundo has sought out his enemy to avenge the murder of his father; having adopted the disguise of a beggar, he is thereby barred from openly carrying a sword, the handle and sheath of which are bamboo, so that when closed it appears to be only a stick. The scene is laid at night in a deserted country road.

Another incident illustrated in this series is Ohatsu's Revenge on Iwa Fuji, a scene from the play *Kagamiyama*, another episode from which we described above in the series " Ancient and Modern Dramas illustrated." Ohatsu is depicted attacking Iwa Fuji in a garden, while the latter tries to shield herself with her umbrella.

FUKU-TOKU KANE NO NARU KI : " Money-bringing Trees."

A very rare series of figure-studies, full size, upright, with the series-title on a narrow label, and the sub-title of the illustration written in characters forming the stalks to a cluster of leaves, composed of oblong-shaped gold coins. Publisher *Arita-ya*, also two censors' seals, and the red chrysanthemum seal, noted in the " Ancient and Modern Dramas " series at the beginning of this chapter.

The total number in the series is unknown, but the following have come under observation :—

1. *Tashinamiyoki :* " The Careful Wife." Full-length figure-study of a woman holding over her arm a garment, and on the floor behind her dressmaking materials. (See Plate 58.)

2. *Shuseki :* " The Tree of Good Writing." A woman on one knee writing on a scroll lying across her other knee.

3. *Utsukushiki :* " The Tree of Good Looks." A woman squatting before a mirror which reflects her face, and rubbing pomade in the palm of her hand preparatory to applying it to her face.

4. *Gyogi-yoki :* " The Tree of Good Behaviour." A woman carefully carrying a small cabinet, on which is a porcelain animal.

Other very rare series by Hiroshige are two sets of a comic nature, one entitled *Hiza Kurige Dochu Suzume*, " The Road Sparrow on ' Shanks'

Mare,' " being the travelling experiences of Yajirobei and his companion Kitahachi, consisting of seven full-size, oblong sheets ; the other a set of silhouette pictures, showing the performer and the shadow he makes, this latter signed " *Hiroshige, drawn for fun.*"

Prints of this nature, however, are somewhat outside the scope of this chapter, and are merely mentioned as possibly a matter of some interest to the reader.

CHAPTER XXXV

ILLUSTRATIONS TO BIOGRAPHY AND MISCELLANEOUS SUBJECTS

IN biography, scenes from the life of Yoshitsune, one of the most famous warriors of old Japan, are amongst the most popular.

The best-known, though rare, series of this subject, perhaps, is the set, complete in ten full-size, oblong plates, by Hiroshige, entitled *Yoshitsune Ichi dai Zu-ye*, " Biography of Yoshitsune, Illustrated." The titles to each plate are as follows :—

(Some of the plates in this series are numbered, that illustrated at Plate 59, Illustration 2, being No. 8, but the order given below, being chronological, is that generally accepted.)

1. Tokiwa's Flight through the Snow with her Children, in allusion to the flight of his mother, Tokiwa Gozen, the fairest woman in Japan, with her three children, Imawaka, Otowaka, and Ushiwaka (otherwise Yoshitsune), in the depth of winter, after the death of her husband, Minamoto no Yoshitomo, from the soldiers of his enemy, Taira no Kiyomori. (See Plate 59, Illustration 1.)

2. Learning to Fence from the King of the Tengus. This refers to his early (legendary) life, when he was taught fencing, wrestling, and other physical attainments by the Tengus, mythical creatures, half bird and half human.

3. Visiting Ise no Saburo, a hunter whose services Yoshitsune enlisted.

4. Yoshitsune and Joruri Hime, daughter of Ki-ichi Hogen, the great Taira strategist, whose books on war he induced her to let him see.

5. Combat with the Priest Shirakawa no Tankai at the Gojo Temple. A very good moonlight scene. (See Plate 59, Illustration 2.)

6. The Combat and Defeat of Benkei on Gojo Bridge, Kyoto. Another very fine moonlight scene ; perhaps the best-known print of the set. Benkei was a famous swordsman, a giant in strength and stature, who

allowed no one to pass over the Gojo Bridge without challenging him to fight. At last, after innumerable victims, he met in Yoshitsune, though a much smaller man, one who was more than a match for him, thanks to his thorough training as a swordsman under the Tengus. From that day to the end Yoshitsune had no more faithful adherent than Benkei.

7. Killing of Sanada-no-Yoichi. The allusion in this scene is apparently to the combat between Yoichi and the strong man Matano-no-goro, who overcomes him. On a previous occasion Matano had tried to kill Yoichi by hurling a great rock at him, but the latter caught it and threw it back. Nasu-no-Yoichi, a different character to the above, was a famous archer in the employ of Yoshitsune, and his great exploit was to shoot down the fan fixed on the mast of one of the ships of the Taira fleet at Yashima, a scene depicted in a triptych by Kuniyoshi.

8. Battle of Mikusayama, at which Yoshitsune defeated the Taira.

9. Climbing the Cliffs of Hiyodori Goye, in order to attack the Taira Castle, Ichi-no-Tani, from behind. These cliffs were so steep that it was said even monkeys could not descend them.

10. The Descent on the Castle of Ichi-no-Tani. While one party attacked the castle in front, Yoshitsune and his warriors descending the cliffs behind, from which no attack was considered possible, broke into the stronghold from the rear, and entirely defeated the Taira clan.

Illustration 3, Plate 59, is from another, extremely rare, series with same title, full size, upright, of which this is the only plate known; issued during the Prohibition period; engraver's seal of *Tako*. (Not mentioned by Happer.)

This plate (No. 2 of the series) shows the youthful Yoshitsune during his novitiate at the temple of Kurama-yama, in Kyoto (being originally intended for the priesthood), making his nightly journey to the waterfall, there to pray to the gods to give him strength and perseverance to avenge his father's death. In his mouth he carries his prayer-bell. In the year 1154 he makes his escape from the temple to carry out his plan of revenge.

Another biographical series is that depicting scenes from the life of the priest Nichiren, by Kuniyoshi, entitled *Koso go Ichidai Rya-ku-zu*, " An Abridged Biography of Koso, Illustrated," Koso being another name for Nichiren, the founder of a sect of Buddhists named after him in the thirteenth century (A.D.).

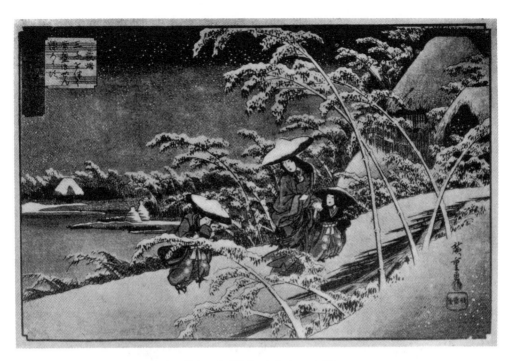

1. Tokiwa's Flight with her children.
(By courtesy of Messrs. Sotheby.)

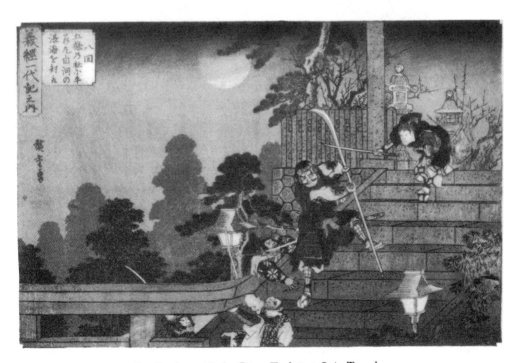

2. Combat with the Priest Tankai at Gojo Temple.

HIROSHIGE : Scenes from the Life of Yoshitsune (*two series*).

PLATE 59 (first part)

3. Yoshitsune going to pray at the waterfall.

HIROSHIGE : Scenes from the Life of Yoshitsune (*two series*).

PLATE 59 (second part)

This series which is very rare, consists of ten full-size, oblong plates ; publisher, ISE-YA RIHEI.

The following are the scenes comprising this series :—

1. Preaching to fishermen from the bank of the river. This plate is sometimes described as " exorcising the ghost of a fisherman." This hardly gives a correct meaning of the Japanese title, as the scene has nothing to do with the ghost of a deceased fisherman which haunted the place and required exorcising or " laying." A better translation is " converting the spirit of " a fisherman, that is to a better appreciation of his religion, which he was apt to neglect.

2. Buddha appearing to Nichiren, by moonlight, in the trunk of a tree.

3. Nichiren's defence with his rosary. Attacked at Koshigoye by a horseman and other soldiers on foot, sent by the *Shōgun* to arrest him for execution, at the instigation of his enemies, he invokes Buddha, and their arms are rendered powerless. This enmity was due to his attacks upon other sects.

4. The Averted Execution. As the sword of the executioner touched his neck it broke, and at the same time the *Shōgun's* palace at Kamakura was struck by lightning. Nichiren was then ordered to be exiled.

5. Quelling a storm raised by the demon Daimoku, while on his way to exile in the Isle of Sado. (See Plate 60, Illustration 1.)

6. Nichiren praying for rain after a long drought at Kamakura, whither he had returned from Sado in 1273. He is shown standing on a ledge of rock overhanging the sea under an umbrella held by a companion. A fine rain scene.

7. Attacked by a Yamabushi (a sect of " mountain-warriors," half monk, half warrior), who hurls a rock at Nichiren to crush him, but he keeps it suspended in the air by merely gazing at it. (See Plate 60, Illustration 2.)

8. While Nichiren was praying at Mount Minobu, whither he had gone from Kamakura, a beautiful woman appeared to him in the form of a huge snake.

9. Defeat of the Mongols in 1281, whose invasion Nichiren had predicted in a book written in 1260, in a great storm caused by his prayers.

10. Nichiren walking barefoot up a steep mountain-side in deep snow, while on a pilgrimage in the Tsukahara Mountains, in Sashiu. Considered the masterpiece of the series. A snow scene worthy to rank with any of Hiroshige's similar masterpieces. (Illustrated in colours in Joly's *Legend in Japanese Art*.)

Another well-known character, scenes from whose life are portrayed in colour-prints, is Kintoki (or Kintaro), the golden boy, wild child of the forest, and his foster-mother, Yama Uba. He is supposed to have been lost in the Ashigara Mountains by his mother, and to have been found eventually by Yama Uba, who adopted him and brought him up. Kintaro is the boy Hercules of Japanese mythology, who performed prodigious feats of strength, such as struggling with a gigantic carp, or vanquishing a bear and an eagle at the same time, uprooting a huge forest tree to make a bridge over a rushing torrent when overtaken by a storm on his way home.

His attributes are the deer, hare, monkey, and she-bear, while his weapon is an enormous axe. He is also frequently shown accompanied by *oni*, a generic term for devils, with horns growing out of their heads.

The three principal artists who portrayed scenes from the life of Kintoki are Kiyonaga, Utamaro, and Kuniyoshi.

Illustration 3, Plate 60, is taken from a series by Kiyonaga, showing Kintoki riding a wild boar and holding a small open fan ; on the far side is his bear carrying his axe, and on the near side two *oni*, one carrying his sword and the other a staff with a bunch of gourds at the top. It will be noticed that this series has no title ; it is signed *Kiyonaga*, and bears the publisher's sign of *Yeijudo of Yedo*.

It is uncertain how many prints are comprised in a complete set, but twelve different scenes have come under observation, and of these ten appeared in one collection (Anonymous sale, June, 1913). Out of some twenty-four different catalogues of sales of various dates since 1909, in only three was this series mentioned, one containing a set of ten plates (as quoted above). This series, therefore, must be very uncommon. The plate here reproduced was originally in the Hayashi collection.

In the collection of Sir Daniel Hall—sold at Sotheby's, July, 1918—there appeared a black and white proof of a print apparently intended for this series, showing Kintoki with his foot planted on the back of his bear. This proof bears no signature nor publisher's mark ; this print, therefore, probably never got beyond the outline proof stage.

1. Quelling a storm while on the way to the Isle of Sado.

2. Yamabushi hurling a rock at Nichiren

KUNIYOSHI : Scenes from the Life of Nichiren.

PLATE 60 (first part)

3. KIYONAGA : Kintoki riding a wild boar attended by two *oni* and a bear carrying his axe ; signed *Kiyonaga*.

PLATE 60 (second part)

Akin to the foregoing are the " Hundred and Eight Chinese Heroes," a popular subject with Kuniyoshi.

The " Hundred Poets " have been mentioned in an earlier chapter; also the " Six Famous Poets." Of these latter, the poetess Ono-no-Komachi has various incidents illustrated separately, sometimes in parody or transferred to scenes in everyday life, just as the " Chushingura " drama and other popular subjects are treated in various ways.

These seven incidents are as follows :—

1. *Soshi arai Komachi :* " Komachi Washing the Book," in allusion to a poetical contest at the Imperial Palace, when a rival poet accused her of having stolen from an old book of poems the verse she recited as her own composition, and in support of his claim produced a copy with the verse in it. Komachi, however, was equal to the occasion, and, calling for water, took the book and washed it, when the poem, being but freshly written, disappeared, leaving the original writing untouched. The accuser, thinking to get the better of Komachi, had hidden himself while she recited the poem to herself in her house, and had copied it into the book.

2. *Seki dera Komachi :* Komachi seated in a temple, or seated on a mat.

3. *Kiyomidzu Komachi :* Komachi at the Kiyomidzu Temple.

4. *Kayoi Komachi :* Komachi visiting.

5. *Amakoi Komachi :* Komachi praying for rain ; alluding to an incident when the country was suffering from a severe and prolonged drought, and the power of her magic alone broke the spell.

6. *Omu Komachi :* Parrot Komachi, so called because, when given a poem sent her by the Emperor, she repeated it with but one word altered.

7. *Sotoba Komachi :* Komachi (seated at) a grave post, in allusion to her penurious old age, when she was obliged to beg by the wayside.

In deities there are the Seven Gods of Good Fortune, who are generally treated humorously. Their names are : Fukuro-kuju, the god of wisdom and longevity, identified by his abnormal forehead. This abnormal development is due, so his votaries maintain, to his constantly racking his brains

to secure to his believers their happiness and long life. He is represented as a venerable old man with a beard, and sometimes he carries a fan in his hand.

Next to him comes Daikoku, the god of riches. He can be readily recognized by his mallet, a stroke with which confers wealth on its recipient, and his rice-bales, upon which he is sometimes shown seated. His familiar is the rat, the thief and destroyer of rice, emblematic of the care with which the wealth hidden in his bales must be guarded. The Festival of Daikoku is held on the day of the rat.

The third deity is Yebisu, the god of food and the patron of fishermen. He wears the black cap worn by persons of rank, and is always shown with a large *tai* fish, and often also with the rod and line by which he caught it. Yebisu's festival is on the twentieth day of the tenth month.

After Yebisu comes Hotei, the god of contentment, who corresponds to our Friar Tuck. He is portrayed as a fat, jovial person, often scantily attired, thus showing the ample proportions of his stomach. He carries a staff and a linen bag (*ho-tei*), from which he derives his name. He is a particular favourite of children, and when represented singly, as in *suri-mono*, is often shown carrying children in his bag.

The fifth deity is Juro-jin, the patron of learning. As a sign of his wisdom he is shown with a highly-developed forehead, though not to the exaggerated extent of Fukuro-kuju ; but as he wears a large cap, something like a bishop's mitre in shape, this physical peculiarity is less notice-able in his case. He is of a venerable aspect, with a white beard and of a more solemn mien than his companions ; he carries a long staff.

When all the seven deities are represented together on board their ship, Juro-jin is often shown in conversation with Benten, the lady of the group, and the goddess of fertility and music. In the latter capacity she is shown holding a *biwa*, a stringed musical instrument she is said to have invented.

Lastly we have Bishamon, a warrior in armour, the god of war and glory. He holds a lance in one hand and a small pagoda shrine in the other, emblematic of his patronage of the priestly caste.

A popular representation is to show these seven deities grouped to-gether on board their ship, the *Takarabunè*, which is supposed to sail into port every New Year's Eve bearing the *takaramono*, or treasures. Amongst these treasures are Daikoku's mallet and rice-bags ; the hat of invisibility ; the inexhaustible purse of money ; and the lucky raincoat, which protects its wearer against evil spirits.

Accompanying the *Takarabunè* are the crane and the tortoise, both emblems of long life. The tortoise is represented as a more or less super-natural creature ; while its body is natural, it is finished off with a broad,

hairy tail, said to grow when it is over five hundred years old ; hence the hairy-tailed tortoise as an emblem of longevity.

Other deities are Kwannon, the female Buddha, and Shoki, the demon-queller.

Ghost stories and legends was another popular subject, particularly with Kuniyoshi, who designed a large number of prints of this nature. Such is a series of Tokaido views, upright, the joint work of Kuniyoshi and Hiroshige, in which the title, *Tokaido Go ju San Tsugi*, is written in large white characters on a black label in the top right-hand corner, which with descriptive matter occupies the upper third of the print, the rest being an illustration of a ghost story or other legend connected with the station.

There is also a similar series by Kuniyoshi of the Kisokaido stations, each place being depicted in a small inset, leaf-shaped panel, while the principal illustration portrays a ghost story or legend.

Of the same nature as the foregoing is a series, also the joint work of Kuniyoshi and Hiroshige, entitled *Ogura Magai Hyak'unin Isshu*, " An Imitation of the Ogura Selection of the Hundred Poets," that is the anthology collected by Fujiwara-no-Sada-iye. Each print of the series carries the number of the poem and publisher's mark (*Ibasen*) in the margin, and some of them also have the seal of the engraver, *Takè*.

Like the above Tokaido series, the title and poem occupy the upper third of the print, and below an illustration to a story or of a character famous in history or legend, which is supposed to have a connection, real or imaginary, with the poem. Sometimes the poem only is given, and sometimes a portrait of the poet on a bean-shaped panel, with the poem written round the figure.

Illustrations 3 and 4, Plate 52, page 288, show the two forms, the former being referred to under the *Chushingura*.

Illustration No. 4 is the poem of the minister Yoshinobu, No. 49 of the anthology, and the principal subject is the *samurai*, Endo Musho Mirito. The poet compares the constancy of his love to the watchfulness of the palace guards at night, in allusion, no doubt, to Endo's fierce love for Kesa Gozen, the wife of another *samurai*, Watanabe Wataru. As she resisted Endo's entreaties, he vowed to kill her family unless she allowed him to make away with her husband and be his wife. She accordingly told him to come on a certain night, when he would find her husband asleep ; but she selected a time when the latter was absent, and Endo, coming to the room appointed, killed the sleeping individual he saw there, only to find afterwards it was Kesa herself. Overcome with grief, he repented, and became a priest under the name of Mongaku, inflicting penance on himself

by sitting under the icy-cold waterfall of Nachi, where he would have died, had not two Buddhist deities descended from heaven and rescued him.

The story of Endo and Kesa Gozen is made the subject of a drama entitled *Nachi-no-Taki Chikai No Mongaku*, " The Priest Mongaku at the Waterfall of Nachi," a famous play founded on actual events which took place in 1143 and forms part of the *Gempei Seisuké* (" History of the Taira and Minamoto Clans "). The title of the play is taken from the final scene, the penance of Endo for the murder of Kesa, an incident often found illustrated in prints and *surimono*.

When Endo realizes his ghastly error he rushes back to Kesa's dwelling and there confesses his crime to her husband and mother, asking the former to behead him to avenge his wife's death. Wataru, however, satisfied with his confession and repentance, refuses to take his life, but instead retires with Endo to a monastery and there spends the rest of his life in prayers for Kesa. Endo, however, having survived his long and austere penance, comes forth from the monastery, though still as the monk Mongaku, and becomes counsellor of the *Shōgun*, Yoritomo, whom he incites to attack the Taira. He is eventually exiled to Okishima for plotting against the Emperor Tamehito, and dies there in 1199.

In the room where Kesa is killed is found a letter addressed to her mother, setting forth the reasons which led her to sacrifice herself for her husband ; Kuniyoshi here represents Endo reading the fateful epistle.

Another well-known set of prints by Kuniyoshi, full size, oblong, is the series entitled *Ni-ju-shi-Ko Doji Kagami*, " The Twenty-four Examples of Filial Piety," which are remarkable for their curious application of European pictorial ideas to a Chinese subject, but which detracts from them as works of art. They represent scenes of children doing some pious work or sacrificing themselves for the benefit of their aged parents. The characters in them are Chinese, drawn in a semi-European manner. As an example of the subjects portrayed, we will quote two of the scenes : (i) Moso looking for bamboo sprouts in winter-time to make soup for his mother, and (ii) Yoko rushing in front of a tiger to enable her father to escape. These prints, which are uncommon, are interesting to the collector rather for the curious nature of the drawing than for their artistic merit.

In romance we have illustrations to the " Genji Monogatari," incidents in the life of Prince Genji, generally represented in the company of beautiful ladies, in allusion to his inveterate habit of love-making. These tales were written in the tenth century by a Court lady, Murasaki Shikibu, already alluded to as a poetess.

In some cases the title, Genji Monogatari, is merely a fanciful one, the picture being a portrait of a tea-house beauty.

In miscellaneous subjects we find representations of the twelve months with people at occupations suitable to each month, or taking part in a festival which occurs in that month. Or again, as in a set by Toyomasa, with whom children were a favourite subject of illustration, we have children playing at a different game for each month.

Similar to the twelve months are the *Go-sekku* or " Five Festivals " (to which we referred under the subject of " Figure-studies "), being the five chief festivals throughout the year. These are as follows :—

1. The first day of the first month (Shogatsu), that is, New Year's Day, when people wrote congratulatory poems to one another.

2. The third day of the third month, the girls' doll festival (Yayoi).

3. The fifth day of the fifth month, the boys' festival (Tango), which is to a Japanese boy what a birthday is to a European boy.

4. The seventh day of the seventh month (Tanabata), the weavers' festival.

5. The ninth day of the ninth month, chrysanthemum festival (Choyo).

These festivals have, unfortunately, practically fallen into disuse.

Evelyn Adam in *Behind the Shoji*, published in 1910 (though written some years previously), says that, " ten years ago (say c. 1900), the boys' festival, like the Tanabata, was still universally kept ; in another ten years both will have fallen into oblivion," like many an old custom in this country.

On the fifth day of the fifth month there floated above every house, where there was a son in the family, a large paper fish tied to a long bamboo pole. The fish represented was the carp, the emblem of perseverance, which the parents hoped their sons would emulate in their struggle through life against any obstacles they might encounter. A fish was displayed for every son in the family.

At the *Tanabata* festival a branch of freshly-cut bamboo, hung with strips of coloured paper on which short poems are written, is displayed over each dwelling.

There are different versions of the legend which the *Tanabata* festival celebrates. The story concerns the daughter, Shokujo, of the sun-god, and the herdsman, Kengiu, chosen by him to wed her. On the wedding day the bride became so frivolous that her father became angry with her,

and exiled Kengiu to the other side of the Milky Way (in Japan called the Celestial River), while Shokujo became the weaving princess. They were allowed, however, to see each other once a year, on the seventh night of the seventh moon (corresponding in our calendar to the latter part of August or the early part of September). On that night the Milky Way is spanned, if the sky is clear, by a bridge of magpies, by means of which the lovers may meet. If, however, it rains, the River of Heaven rises so that the bridge cannot be formed, and husband and wife must remain separated for another twelve months. The poems attached to the bamboos which float over every dwelling are prayers for fine weather, the bamboo being emblematic of the River of Heaven (in Chinese legend the " Bamboo Grove ").

In bird and flower (*Kwa-cho*) studies, the chief exponents were Masayoshi (very rare ; full size, oblong), Hokusai, Utamaro, Hiroshige and two independent artists, Sekkyo and Sugakudo, and (more recent) Bairei.

Hokusai designed a set of ten small upright prints of this subject, which are extremely rare, and are considered amongst his best work. They are on a deep blue background, which state probably denotes a first edition. A reproduction in colours from a copy of one of the set in the British Museum is illustrated in Von Seidlitz's book on *Japanese Prints*.

This set has been reproduced exceedingly well, and the writer has seen copies without the blue background of which it was difficult to say whether they were originals or reproductions.

There is also a well-known set of twelve, full-size, oblong bird and flower prints, designed for a book published in Ōsaka about 1848, by Katsushika Taito (*w.* 1816–1850), pupil of Hokusai, but bearing the forged signature of Zen Hokusai I-itsu (i.e. I-itsu, formerly Hokusai), one of Hokusai's well-known signatures. These prints have also been exceedingly well reproduced. Hiroshige has designed some excellent " Kwa-cho " prints in panels of various sizes, while Sugakudo (*c.* 1855) has left a very fine series of forty-eight prints, full size, upright, which are worthy to rank amongst the best illustrations of any artist in this subject, when first-edition copies. (See Plate 6.) They are divided into the four seasons, with twelve birds and flowers appropriate to each. The best print of the set is generally considered Plate 10, representing a large red parrot and a flowering plant. Another very fine plate is No. 17, a white heron half hidden behind a clump of iris in flower, while several others are excellent.

Utamaro's work in this subject chiefly takes the form of book-illustrations. Of this nature are two volumes, entitled *Raihin Zue*, " Exotic Birds," published in Yedo, 1793,[1] of which the first consists of ten full-size (that is double-page) plates of birds and flowers, and two plates of pictures

[1] Happer collection.

of Chinamen, these latter inserted, according to the preface, because they were the importers of the birds. The second volume consists of text only.[1]

In addition to the bird and flower series by Hiroshige mentioned above, he also designed a series of fishes, full size, oblong. This series is in two sets of ten prints each, one signed in full Ichiyusai Hiroshige, and the other Hiroshige only. This series is rather rare, and the collector should beware of late issues and reprints, which often show faults in printing, neither do they carry the publisher's seal (Yeijudo), nor, sometimes, the artist's signature.

In mythical creatures we find representations of the dragon, the *ho-ho* bird, and the *shishi*, either introduced as screen decorations or otherwise brought into a picture when showing, for example, the interior of a room. They also appear as subjects for *surimono*, particularly the dragon.

The *ho-ho* is represented as a gorgeously coloured bird with a superb tail of long waving feathers. It is something like a pheasant or a peacock, a fanciful combination of both.

The *shishi* is a highly imaginative lion of Chinese origin. Stone *shishi* are found in the gardens and grounds of Buddhist temples, like their stone lanterns. In pictorial art *shishi* are often depicted throwing their cubs from the top of a steep cliff, and watching them climb back, in order to test their strength. Should the cub survive this ordeal it was sure to have a long life. We have in mind a print by Hiroshige depicting a *shishi* watching the struggles of its cub to scale the steep cliff.

The semi-mythical hairy-tailed tortoise has already been alluded to as one of the attributes of the Gods of Good Fortune.

It is interesting to note that other Japanese art objects, such as *inro* and sword-fittings, were frequently decorated with designs taken, in some instances, almost line for line from those found in prints or book-illustrations.

[1] The first volume was subsequently issued in a second edition with the name of Utamaro omitted from the first plate on which it had first appeared, and that of Kitao Masayoshi substituted on all the plates which are signed *Keisai* and sealed *Kitao Masayoshi*. The pictures of Chinamen are also omitted, while the volume of text was not published a second time. No definite reason can be assigned for the substitution of Masayoshi's name for that of Utamaro; possibly the former had a greater reputation for this kind of subject in his day.

APPENDICES

APPENDIX I

THE DATING OF JAPANESE PRINTS

AS the dating of prints is a matter of interest and importance to the collector and student, it will not be out of place to preface the subject by a few words on Japanese chronology. The longest Japanese unit of time is a cycle of sixty years, which is subdivided into shorter cycles of twelve years ; to each year is assigned the name of an animal in regular sequence, similar to our twelve signs of the zodiac.

In addition to these regular divisions, there are also various periods (*Nengo*) which date from some particular event, such as a great earthquake, an epidemic, or other visitation, and are purely arbitrary in length, a change being often made because of ill-luck. To this is due their frequency previous to the *Meiji* (" enlightened ") period, which dates from 1868 down to the death of the late Emperor in 1911, the present period, *Taisho*, commencing in 1912. The *Meiji* period, therefore, was a comparatively long one, and in marked contrast to the *Manyen* and *Ganji* periods, which only lasted one year each, for 1860 and 1864 ; or the *Kiowa* period of two years, 1802–3.

Other long periods were the *Genroku*, 1688–1703, sixteen years, and the *Kiohō*, 1716–1735, twenty years.

The same animals which denote the years are also assigned to the hours of the day, which is divided into twelve periods of two hours each.

These twelve animals, the signs for which are reproduced at page 338, are :—Rat (1), Ox (2), Tiger (3), Hare or Rabbit (4), Dragon (5), Snake (6), Horse (7), Sheep, Ram, or Goat (8), Monkey (9), Cock (10), Dog (11), and Boar (12), the numbers in brackets being the years in the sixty-year cycle, which begins with the Rat, this order being repeated five times through each cycle.

When they represent the hours of the day the sequence begins with the Ox (1 a.m. to 3 a.m.) round to the Rat (11 p.m. to 1 a.m.).

In the date-seal on a print the month is denoted by a number, the year itself by one of the zodiacal signs. Sometimes a cypher for the particular

period within which the year falls is also added, which enables us to fix the exact date, unless the period is over twelve years in extent, in which case some of the signs will be repeated. Between 1800 and 1868, however (and date-seals earlier than 1800 are very rarely found), only two periods, *Bunkwa* (1804–1817, fourteen years) and *Tempo* (1830–1843, fourteen years), lasted sufficiently long to do this. Thus Tiger year, *Tempo* period, may be either the equivalent of 1830 or 1842 ; to decide which we must refer to other evidence, if it can be found, such as the years within which the artist worked, the style and quality of the print, form of the date-seal, and so forth.

When the activity of an artist extended over a long period, as was the case with Hokusai for example, the exact dating from the seal alone, apart from other evidence, becomes difficult, when only the year is indicated. Thus Hokusai's two well-known large *Chushingura* series are both seal-dated for the Tiger year, one issue for the 4th month and the other for the 6th, which is equivalent to 1806, 1818, and 1830, according to the period, *Bunkwa*, *Bunsei*, or *Tempo*, within which it fell. In this instance 1806 is the correct year, as, apart from other evidence, after 1814 the practice of seal-dating appears to have been dropped, not coming into use again till the last year or two of the Prohibition period, about 1850. After this it was practically universal in one form or another.

Many prints will be found dated between 1800 and 1810, such as examples by Utamaro and his pupils (thus helping to distinguish between work by Utamaro II and his master), by Yeizan, and by Toyokuni, and other artists of this period. Amongst prints illustrated in this volume are the following bearing date-seals between these years : Shunko, 1807 (Plate 2) ; Yeizan, 1808 (Plate 4, Illustration 2) ; Yeizan, 1806 (Plate C), and 1807 (Plate 33).

At the end of this appendix, on page 336, are reproduced on an enlarged scale three seals with their corresponding cyphers, two of which, Nos. 2 and 3, are often found on prints. Seal No. 1, which is the seal for the *Ansei* period, does not, however, occur on prints, but is given here to show the difference between it and the *aratamè* seal (No. 2) with which it may be confused, owing to their similarity.

This *aratamè* seal is an inspector's seal meaning " examined," and prints carrying this seal are sometimes wrongly described as being seal-dated for the *Ansei* period, whereas it only signifies they have passed the censor. Many of the upright prints by Hiroshige bear the *aratamè* seal, and it is only a coincidence that they are also sometimes dated for a year lying within the *Ansei* period (1854–59), such as those from the " Hundred Views in Yedo " series.

The *aratamè* seal, it should be noted, came into use in this form towards

the close of the year 1853, when the censors' seals began to be discontinued, and its appearance probably denoted that the duty of censoring prints devolved upon the publisher himself. (See Hiroshige's upright *Tokaido* series, which has the oval date-seal for the year 1855, and also the round *aratamè* seal.)

Sometimes, it will be noticed, the date-seal, such as that on the print illustrated at Plate 20 (No. 4), page 136, carries a small cypher in addition to the zodiacal sign and the numeral of the month. This is the *uru* cypher and denotes an intercalary or additional month, certain years having thirteen months. As no two years of the *same* sign in any *one* period have an intercalary month, a date-seal of this nature can be definitely determined. In the above instance the seal reads " Tiger *uru* seven," that is, " intercalary seventh month, Tiger year " = 1854 (*Ansei* period), as the previous Tiger year which had an intercalary month (the third) was 1830 (*Tempo* period), the Tiger year for 1842 (also *Tempo* period) having no intercalary month.

Also the evidence of the *aratamè* seal above the date-seal places the date as later than 1852, thus giving corroborative evidence as to correctness of date in this instance.

As another example of the *uru* cypher in a date-seal we will instance Plate 63 of Hiroshige's " Hundred Views in Yedo " series, showing a great paper carp flying from a bamboo pole on the boys' birthday festival. This plate is dated " Snake *uru* five " = " intercalary fifth month, Snake year (= 1857) ; no other Snake year has an intercalary month.

Plate 107, showing a great eagle hovering in the sky (illustrated at Plate 28A, page 174) also has this date-seal with the *uru* cypher in it.

In the table of Japanese dates on page 337, the years having intercalary months are marked by a †, followed by the number of the month in brackets.

Series of prints, such as Hiroshige's " Sixty Odd Provinces," which extended from the Prohibition period till after its close, will be found with certain plates bearing the censors' seals and others with only the *aratamè* seal, in conjunction with the date-seal.

After 1857 the *aratamè* seal disappears for a year (for what reason is not known), and only the date-seal is found, as is shown in Hiroshige's " Thirty-six Views of Fuji " series (upright), and his " Mountain and Sea as Wrestlers " series (oblong) ; both these have the seal for the Horse year (1858) only. (See Plates 16 and 21.) Kunisada's well-known memorial portrait of Hiroshige also confirms this. (See also print by Shigenobu [Hiroshige II] at Plate 7, Illustration 3.)

In the Ram (or Goat) year, 1859, and subsequently, the *aratamè* seal reappears, but is now incorporated with the date in a single round seal. (See prints by Hiroshige II at Plates 27 and 29.)

The Prohibition period, the nature of which we have already stated earlier in this volume, extended from the sixth month of 1842 to the close of 1853. Prints issued during these eleven and a half years had to carry a censor's seal before they could be issued to the public, and fines, including confiscation of the offending print, were levied for any infraction of this regulation.

These seals, of which twelve are known, are generally found in pairs, and less frequently singly. Hiroshige's two series (upright) of historical and dramatic subjects described and illustrated in Chapter XXXIV, show in one set, two seals, and in the other one only. They will be noticed in other prints herein illustrated.

As far as our investigations go, these censors' seals appeared alone without a date-seal till about the year 1850, after which the oval date-seal occurs alongside them, the earliest so far noted being for the Rat year (1852). After the last month or two of 1853, as mentioned above, the censors' seals disappear, their place being taken by the *aratamè* seal, while the date-seal is continued.

This transition can be seen in Hiroshige's extensive series of " Yedo Meisho " views (oblong), published by Yamadaya between 1853 and 1858, and known for distinction as the Yamadaya figure set. Prints in it dated Ox 11 (11th month, 1853) have two censors' seals, so apparently the censorship was not discontinued till either the very end of the 11th month or early in the twelfth. Prints dated 1854 and later have the *aratamè* seal instead.

As many censored prints have no date thereon, we may assume therefore that, lacking other evidence, these appeared between 1842 and 1850, and are earlier than the dated examples.

To sum up the foregoing remarks on date-seals we may set out the following facts respecting them.

A date-seal and a censor's seal occurring together enables us to fix the date exactly, as we know the years in which prints were censored.

Thus the date Ox 9 with a censor's seal gives the year 1853, ninth month, because the previous Ox year (1841) would require no censor's seal, and the following one, 1865, would also have no censor's seal, but would be incorporated with the *aratamè* seal.

If a seal has the *uru* (intercalary) cypher in it, this alone, apart from the presence or otherwise of any other seal, will fix the exact date. Thus,

" Snake *uru* five " must be 1857, as no other Snake year for the same period has an intercalary month ; no two years of the *same* zodiacal sign in any *one* period have an intercalary month. As, however, only two periods since 1800, *Bunkwa* and *Tempo*, down to 1868, duplicate any of the signs, the need for this distinction rarely occurs.

If a date-seal occurs in company with the *aratamè* seal, we know the date must lie between the end of 1853 and the end of 1857, this being the period for such combination.

In the same way when the two are found combined together in one round seal, we can fix the date as from the beginning of 1859 onwards.

Sometimes a date-seal may carry no zodiacal sign, but only the *uru* cypher and the number of the month ; we can determine the exact date by applying one of the above tests. To make this clear we will select two years within the above period, 1854 to 1868, in which the same month was intercalary, viz. 1857 and 1865 ; in both these years the fifth month was intercalary.

The date-seal for 5th month, 1857 (which falls in the *Ansei* period, zodiacal sign Snake), would be " *uru* five," *accompanied* by the *aratamè* seal; for the same month of 1865 (*Kei-ō* period, Ox sign) it would be *incorporated* with the *aratamè* seal.

The year 1846 also has the same month intercalary, in which case the date " *uru* five " would be accompanied by a censor's seal, but as date-seals do not appear to have been used so early in the censored period, this combination would not be met with.

Aratamè when written in characters may also be translated " changing to," as when an artist is on the point of adopting another name and signs himself (for example) *Kunisada aratamè ni sei Toyokuni*, " Kunisada changing (his name) to the second Toyokuni."

Seal No. 3 occurs frequently on prints and reads *kiwamè*, meaning " perfect." It has no connection with the censor, but was affixed by the publisher himself to prints only of a certain merit. It was, therefore, intended as a kind of hall-mark ; but as the art of the colour-printer fell into decay towards the middle of last century, it became customary to put it on every print issued, so that it eventually lost its significance as the mark of a good print.

On page 337 is given a comparative table of Japanese Chronology for the period during which date-seals were used on prints. As this method of dating prints does not go back earlier than the beginning of the nineteenth century (instances earlier than this are exceedingly rare, and only one, a print in the British Museum, previous to 1802 has come under the writer's notice, though the Yeizan print here illustrated at Plate 4 (1) may be

cypher-dated 1799, but is difficult to transcribe), it has not been thought necessary to give dates earlier than the year 1800. A full table of comparative dates from 1688 onwards is given in Strange's *Handbook* to the Collection in the Victoria and Albert Museum, and also in the *Catalogue* of the British Museum collection.

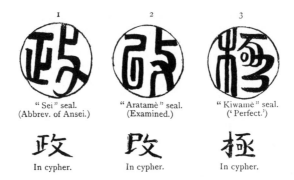

1	2	3
"Sei" seal. (Abbrev. of Ansei.)	"Aratamè" seal. (Examined.)	"Kiwamè" seal. ('Perfect.')
In cypher.	In cypher.	In cypher.

DATING OF JAPANESE PRINTS

COMPARATIVE TABLE OF JAPANESE CHRONOLOGY
FROM 1800 TO 1868

Years marked by a † are those which have intercalary months, the number of the month being given in brackets thus : (8).

Japanese Period.	No. of Year.	Zodiacal Sign.	A.D.	Japanese Period.	No. of Year.	Zodiacal Sign.	A.D.
Kwansei	12	Monkey	1800	Tempo	6	Goat	1835† (7)
Kiōwa	1	Cock	1801	,,	7	Monkey	1836
,,	2	Dog	1802	,,	8	Cock	1837
,,	3	Boar	1803¹	,,	9	Dog	1838† (4)
Bunkwa	1	Rat	1804	,,	10	Boar	1839
,,	2	Ox	1805† (8)	,,	11	Rat	1840
,,	3	Tiger	1806	,,	12	Ox	1841† (1)
,,	4	Hare	1807	,,	13	Tiger	1842
,,	5	Dragon	1808† (6)	,,	14	Hare	1843† (9)
,,	6	Snake	1809	Kōkwa	1	Dragon	1844
,,	7	Horse	1810	,,	2	Snake	1845
,,	8	Goat	1811† (2)	,,	3	Horse	1846† (5)
,,	9	Monkey	1812	,,	4	Goat	1847
,,	10	Cock	1813† (11)	Kayei	1	Monkey	1848
,,	11	Dog	1814	,,	2	Cock	1849† (4)
,,	12	Boar	1815	,,	3	Dog	1850
,,	13	Rat	1816† (8)	,,	4	Boar	1851
,,	14	Ox	1817	,,	5	Rat	1852† (2)
Bunsei	1	Tiger	1818	,,	6	Ox	1853
,,	2	Hare	1819† (4)	Ansei	1	Tiger	1854† (7)
,,	3	Dragon	1820	,,	2	Hare	1855
,,	4	Snake	1821	,,	3	Dragon	1856
,,	5	Horse	1822† (1)	,,	4	Snake	1857† (5)
,,	6	Goat	1823	,,	5	Horse	1858
,,	7	Monkey	1824† (8)	,,	6	Goat	1859
,,	8	Cock	1825	Mangen	1	Monkey	1860† (3)
,,	9	Dog	1826	Bunkin	1	Cock	1861
,,	10	Boar	1827† (6)	,,	2	Dog	1862† (8)
,,	11	Rat	1828	,,	3	Boar	1863¹
,,	12	Ox	1829	Ganji	1	Rat	1864
Tempo	1	Tiger	1830† (3)	Kei-ō	1	Ox	1865† (5)
,,	2	Hare	1831	,,	2	Tiger	1866
,,	3	Dragon	1832† (11)	,,	3	Hare	1867
,,	4	Snake	1833	Meiji	1	Dragon	1868† (4)
,,	5	Horse	1834				

¹ Denotes the last of a sixty-year cycle.

ZODIACAL SIGNS

ENGLISH	JAPANESE	SYMBOL		ENGLISH	JAPANESE	SYMBOL	
Tiger	Tora			Monkey	Saru		
Hare	Usagi			Cock	Tori		
Dragon	Tatsu			Dog	Inu		
Snake	Mi			Boar	I		
Horse	Uma			Rat	Nezumi		
Sheep, Goat, or Ram	Hitsuji			Ox or Cow	Ushi		

NUMERALS

NUMBER	SHORT FORM	COMMON FORM	JAPANESE
1	一	壹	Ichi
2	二	貳	Ni
3	三	参	San
4	四	四	Shi
5	五	五	Gō
6	六	六	Rōku
7	七	七	Shichi
8	八	八	Hachi
9	九	九	Ku
10	十	拾	Ju
12 (10+2)	十二		
20 (2×10)	二十		

APPENDIX II

NOTES

Page 43. Shunsen, pupil of Shunyei.

Besides this Shunsen, better known for purposes of distinction as *Kashōsai* Shunsen (though he also signed *Katsukawa*), there is another Katsukawa Shunsen, a direct pupil of Shunsho, whose work, however, is very rare ; less than half a dozen prints, all *hoso-ye*, by him are known to the writer, and consist of actor subjects like his master's. The "sen" of his signature is written in a different character to that used by Kashōsai Shunsen, and is the same as used by Yeisen ; for purposes of distinction it may be read *Izumi* as an alternative.

Page 65.

Hiroshige's *kakemono-ye*. While no *kakemono-ye* of "Cherry Blossoms" (generally the third subject in a *Settsu Gekka* series) has been found, there is in existence one of a peacock on a rock upon which peony flowers are growing below. This print may possibly be the missing flower-subject, with peony flowers instead of the usual cherry-blossom. It has no title nor publisher's mark, but bears a censor's seal (Tanaka), which dates it between 1842 and 1853. It is even rarer than the other two prints. (See No. 3, Plate 61.)

A fourth very fine *kakemono-ye* by Hiroshige, which forms a fit companion to the preceding, is one representing a falcon perched on the bough of a pine tree, with the half-disc of a large sun above ; two censor's seals and date-seal, 9th month, 1853 ; no publisher's seal.

Hokusai has designed a *kakemono-ye* (*very* rare) of the same subject, with a great red sun dimly seen through the mist above the bird, perched on a pine bough. This *kakemono ye* carries Hokusai's very rare signature of *Fusenkio* (usually found, and that rarely, only on *surimono*) in the form of a seal.

Another *kakemono-ye* by Hokusai represents a woman shell-diver coming up to the surface of the water, holding up an awabi shell in her left hand, and a chisel between her teeth ; below her is the rock from which she has just detached the shell and others still clinging to it ; signed *Gwakio Jin Hokusai*. The original of this, however, is a *painting*, the print being a very good reproduction of it, and it is only for this reason we mention it in case the reader should come across it.

Page 66.

Like Hiroshige's famous *kakemono-ye*, his three landscape triptychs, the Kiso Gorge under snow, Kanazawa Bay in moonlight, and the Awa no Naruto Rapids, themselves form a *Settsu Gekka* series, the sea-view of the rapids doing duty for the flower-scene, sea-water in Japanese being called poetically *nami-no-hana*, "waves of flowers."

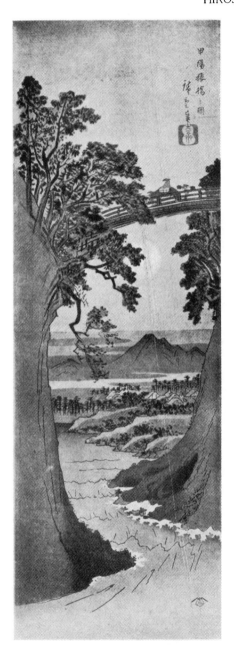 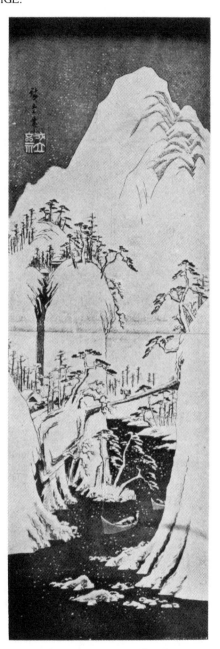

1. Monkey Bridge by Moonlight. 2. Snow Gorge of the Fuji River.

(By courtesy of Messrs. Sotheby.)

PLATE 61 (first part)

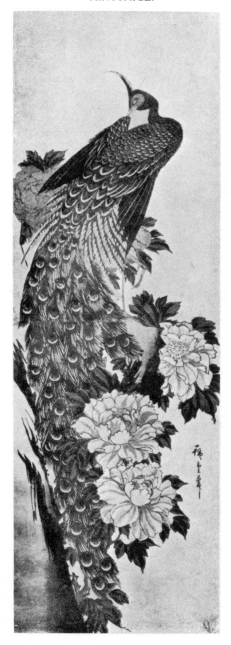

3. Peacock and Peony Flowers.

(By courtesy of Messrs. Sotheby.)

PLATE 61 (second part)

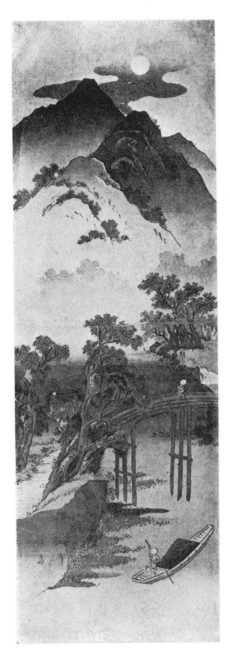

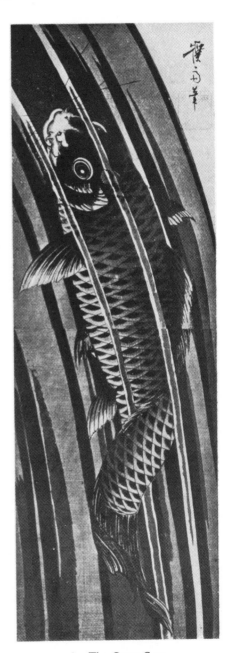

4. Mountain and River Scene
 by moonlight.

5. The Great Carp.

(By courtesy of Messrs. Sotheby.)

PLATE 61 (third part)

Other famous triptychs by Hiroshige are the following :—

Title : *Toto, Ryogoku Yusen no zue*, " A View of Pleasure Boats at the Ryogoku Bridge, Yedo." The great Ryogoku Bridge from mid-stream and another bridge seen in the distance through the arches ; fireworks bursting in the centre, overhead, in a shower of red stars ; publisher's seal of *Sano-ya Kihei*.

Very rare ; not mentioned in the Happer catalogue.

" Women-pilgrims to the Shrine of Benten at Enoshima." There are two triptychs of this subject forming companion-pictures to one another. Copies of both are in the B.M. Collection ; publisher *Sunimasa*.

In one four companies of women, each company in distinctive coloured dress and carrying umbrellas, are converging towards the isthmus leading to the island.

The other shows the further side of the island with groups of women on the rocky path round the cliffs, and boys diving. In both triptychs the title is on the centre sheet.

" Murasaki Shikibu, the poetess, contemplating Lake Biwa." She is shown seated on a balcony overlooking the moonlit lake, across which runs the long Seta Bridge.

In order to write her classic romance, *Genji Monogatari*, Murasaki (" Violet ") Shikibu retired to the Temple of Ishiyama, overlooking Lake Biwa, and spent the night of the August full moon in vigil in order to become inspired.

Both the blocks and a modern impression therefrom made for Mr. Happer were presented by him to the British Museum, where they now are, and another modern impression, presumably made at the same time, recently appeared at an auction sale at Messrs. Sotheby's. No contemporary impression of this print is known, these two modern examples being the only ones recorded.

Page 132.

HOKKEI'S *Shokoku Meisho* series. The following are the thirteen plates comprised in this rare series :—

1. *Shimotsuke no Nikko Urami gataki*, " The ' Seeing-from-Behind ' Waterfall, Nikko, Province of Shimotsuke." Men on a log bridge behind the fall trying to see round it.

2. *Joshu no Mikuni Goyei Fudo toge*, " Fudo, the protector of the Mikuni Pass, Yoshu Province." The god Fudo seated on a rock by a waterfall, and a red sun shining through a pass in the mountains ; a man and a woman at the waterfall.

3. *Musashi, Sumidagawa*, " The Sumida River, Musashi Province." A ferryboat with passengers caught in mid-stream in a torrent of rain.

4. *Nagato Nuno Kari Jinji*, " Nuno Kari Festival (Shinto), Province of Nagato." Two men, one carrying a burning torch, running along the seashore against which a great wave rolls in.

5. *Etchu, Tate-yama*, " Tatè Mountain, Etchu Province." People watching the burning sulphur and jets of steam rising up from the boiling mud.

6. *Sunshu, Omiya Kuchi Tozan*, " Climbing the mountain at Omiya, Province of Sunshu." A party of men climbing the slopes in the rays of a red sun at early morning.

7. *Izu, Chinuki no Hi*, " The Aqueduct of Chinuki, Izu Province." Travellers, one in a *kago*, passing under the aqueduct on which is perched a crane, and the mass of Fuji rising up in the background.

8. *Izu, Goseiki no Mida,* " The Amida (Buddha) of Goseiki, Izu Province." A boat putting out from shore in the trough of a great wave close to a big arched rock behind, and another rock projecting from the water in front. The second master-piece of the set.

9. *Soshu, Hakone no Seki,* " Hakone Barrier, Soshu." Snow-scene ; mountain pass overlooking Hakone Lake.

10. *Musashi no Sato,* " Musashi Village." A winding road across flat rice-fields leading to the huts of the village in the distance, and three horsemen wending their way thither ; a flock of wild geese fly across the half-disc of a huge moon resting on the horizon.

11. *Sesshu, Sumiyoshi,* " Sumiyoshi, Sesshu Province." View looking out to sea from behind the tower of a temple.

12. *Suruga, Satta-yama,* " Satta Mountain, Suruga Province." Snow-scene. An uphill road overlooking the sea on the right ; three men carrying a box toil up the hill followed by a traveller on horseback.

13. *Hizen, Inasa-yama,* " Inasayama, Hizen Province," near Nagasaki. A European ship saluting as she passes Mount Inasa, at entrance to Nagasaki Harbour. One of the masterpieces of the set. (See Plate 19, page 132.)

Page 186.

Utamaro's " silk-worm " print : First-edition copies of this print may be recognized by being printed in a beautiful but very uncommon colour-scheme of lilac, yellow, green, and blue ; publisher *Tsuru-ya.* Explanatory text as well as sub-titles is given on each sheet, except the last, which is without either ; on certain sheets, Nos. 1, 2, and 11, text only. A complete set, first edition, is in the British Museum and is described in detail in the catalogue thereto.

Page 186.

Utamaro's print of women making colour-prints. This series of six prints is designed to form two separate triptychs, both with the same title. Owing to this fact, and to the fact that they are very rarely found both complete, the two triptychs are confused, and sheets described as consecutive which, however, do not join as they belong to different triptychs. Five out of the six are in the British Museum collection, and are described in the catalogue under Utamaro, Nos. 99 and 109.

Page 187. Series signed " *Shomei* " *Utamaro.*

Further series with this rare signature are one of portraits of courtesans on a grey-wash background, without title, publisher *Yamamatsu* (*vide* B. M. Catalogue, Utamaro, No. 33) ; and another with title *Bijin Hana Awase* (" Beauties and Flowers Compared "), publisher *Omi-ya* (*vide* B. M. Catalogue, Utamaro, No. 35, for example).

" Ten Physiognomies of Women " series by Utamaro. This is one of the most beautiful series of figure-studies ever designed by Utamaro. The face and figure are drawn naturally, full and rounded, and well proportioned, very different to the drawn-out and attenuated figure with which he is generally associated. A beautiful example of this very rare series is illustrated in colours in Gookin's *Japanese Colour-*

Prints (New York, 1913). The title is on the right panel of a three-fold label, the centre panel blank, and the left-hand panel with signature *Somi Utamaro ko gwa*, followed by *kiwamè* seal and publisher's seal (*Tsuta-ya*); mica background.

A second series of figure-studies, also with a rare form of signature, with a very similar label to the foregoing, and with which it might at first sight be confused, is one entitled *Fujin so gaku jutei*, " Ten Types of Women's Physiognomies "; signed *Kwanso Utamaro*, " Utamaro the Physiognomist." In this set the label is a three-fold panel in *red* outline (in the preceding one it is black), with the series title in the right panel, an inscription setting forth the character of the woman portrayed in the centre one, and signature in the left panel. Though the titles in Japanese of these two series are slightly different, their meaning when translated is practically the same. The character *ju* (" ten ") in this series is written in the long or common form ; in the other (with label in black) it is in the short form.

The series signed *Kwanso Utamaro* appears to have been issued jointly by two publishers ; two examples from it catalogued in the B. M. Collection are from the publisher *Yamaguchi Tōbei*, while a copy of a print before us from which we have taken the above description bears the mark of *Tsuru-ya*.

Page 188. KORIUSAI.

A well-known, but rarely seen, series by Koriusai in the almost square, medium-size shape of Harunobu, is one entitled *Meisho Zashiki Hak'kei*, " Eight Views of Celebrated Indoor Birds," in which the scenes are indirectly connected with the theme of the " Eight Famous Views." They are really eight interior or boudoir scenes, a youth and a girl being the central figures in each, with a bird introduced into the picture. Seven out of the eight are known to the writer as follows :—

Omu (" Parrot," in this case a cockatoo) : A youth feeding a white cockatoo on a perch ; outside a pine tree covered in snow—Evening Snow.

Haitaka (" Falcon ") : The bird perched on a young man's hand ; outside shines a moon above mist—Autumn Moon.

Washi (" Eagle ") : A youth painting an eagle on a tree-trunk on a screen and a girl standing by listening to the sound of the Evening Bell.

Kyo Kwan-dori (" Raven ") : A youth and a girl looking at one in a cage—Clearing Weather (?).

Kinkei (" Pheasant ") : The bird in a cage and a youth lying on the floor by a seated woman looking at it ; outside rain is falling—Night Rain.

Tsuru (" Crane ") : A youth reclining on the floor and an *oiran* standing by watching two cranes fly past—Homing Geese.

Inko (" Parrot ") : A girl holding up a parrot on a perch and looking down at a youth reclining on the floor—Sunset (?). (This plate illustrated in B. M. Catalogue at page 52.) Title in narrow upright panel with name of bird below, and conventional cloud across top of picture ; signed *Koriu* only.

Koriusai has copied Harunobu, practically line for line, in a series of large, almost square prints (10 × 7½), illustrating the " Five Elements " (*Gogyo*), that is the five elementary principles in a girl's education, *Jin—Shin—Rei—Gi—Chi* (Love, Trust, Etiquette, Fidelity, Knowledge). Harunobu's set is each signed in full *Suzuki Harunobu*, while Koriusai's is signed with his full name, Koriusai ; a print from his set is illustrated at page 16 by Von Seidlitz.

JAPANESE COLOUR-PRINTS

Page 189. Kiyonaga's series *Fuzoku Adzuma no Nishiki.*

This is an extensive and important series by Kiyonaga, and is generally met with in the form of diptychs (*vide* Gookin's *Japanese Colour-Prints* [New York] for reproduction of one in colours), though each sheet is complete in itself, but as some certainly appear to be parts of triptychs to give correct balance to the whole composition, it is probable that the series was originally a magnificent set of triptychs. The series title generally appears on one sheet only, so that many single sheets without any inscription on them probably belong to the set.

Page 192. FURTHER NOTES ON THE DESIGNERS OF FIGURE-STUDIES.

At Plate 62, page 346, we are able, by the courtesy of Mrs. Norton Brown, of Kyoto, and of Mr. Kobayashi, of Tokyo, the owner of the original, to reproduce a very fine large head-study by Hokusai ; signed *Kako* (*c.* 1795). This print is believed to be the only one of this nature by Hokusai in existence ; it is a unique production. The writer has not been able to find any reference to figure-studies by Hokusai such as this in any book on the subject of Japanese Prints. Quite recently, however, a modern reproduction of this print, on mica ground, was noted in a sale catalogue. The inscription, alongside the signature of *Kako*, reads, *Furyu Nakute Nana Kuse*, " Refined (Presentation of) Seven Bad Habits (or Vanities) " ; one woman is so proud of her teeth that she is always cleaning them, and the other, who holds in her mouth a hollow dried kernel with a bean inside it, which makes a whistling sound when blown through, is an incessant chatterbox.

Some Famous Triptychs :—

By KIYONAGA : (i) *Pleasure Boats on the Sumida River.* Parties in two large pleasure boats passing underneath the great Ryogoku Bridge, the trestles of which appear behind as a background ; through them is seen the green landscape of the opposite shore. No title. (See Ficke catalogue, No. 205 ; £125.)

(ii) *The Ferry.* A ferry-boat on the Sumida River in mid-stream ; Fuji in the distance. The centre sheet, containing exquisitely drawn figures of two women, a man, and a child, is illustrated in the Ficke catalogue, No. 208. (£58).

(iii) *The Ferry.* Another triptych of the same subject, showing the forepart of the ferry-boat with six passengers (four seated) just reaching the shore on which stand two women awaiting it. Generally found with left-hand sheet missing. No title.

(iv) *Viewing Cherry Blossom at Dokan Yama.* (Reproduced at page 36 in Gookin's *Japanese Prints* [N. York, 1913], and another copy, in stronger and deeper colouring in B. M. collection, right-hand sheet illustrated in catalogue thereto.) Women and children strolling about the undulating country admiring the cherry blossom. No title.

(v) *An Actors' Boating Party.* The forepart of a great pleasure barge with roof overhead, crowded with actors and their friends watching a dressed-up monkey dancing to music of two *samisen* and a small drum ; round the barge press smaller boats crowded with people looking on. No title.

(vi) *Scene at a Tea-house* and two dancers, one with an umbrella, performing on a balcony overlooking Yedo Bay, before a man and woman, waitresses and *geisha* grouped in front, and a man beating the end of a floor candlestick like a drum ; on

the right-hand sheet a man and a woman in bed behind a mosquito curtain, and two women talking to one another outside. No title. A rare triptych.

Angiusai ENSHI (*c.* 1780–1790). A *very* rare artist, probably pupil of Shunsho but follower of Kiyonaga in style.

Triptych : Uyeno Temple and Grounds. A very beautiful print in soft and delicate colouring. The foreground filled with groups of men, women, and children, promenading about in the tree-lined avenue leading up to the Temple in background (centre sheet) ; in background of left-hand sheet appears, through the trees, the Shinobazu pond. This print has been noted both as a diptych (centre and left sheet), in which form it is more likely to be met with, and as a complete triptych, which is *very* rare. In the former both sheets are signed in full *Angiusai Enshi*, and in the latter each sheet *Enshi* only, but in a different script.

Triptychs by UTAMARO :—

(i) *The Awabi Shell Divers of Ise.* Considered Utamaro's most famous triptych and very rare ; it is said less than a dozen copies were ever printed. A group of five figures (large) on a rock amidst sea-waves. Too well known to need detailed description ; illustrated by Von Seidlitz and in B. M. Catalogue. Has been well reproduced.

(ii) *Awabi Shell Divers.* Another print of the same subject. On a long, narrow, projecting neck of land groups of women and children watch women diving for shells ; the left foreground of the triptych contains a boat with its bow run against the neck of land, with other divers in it. From the form of Utamaro's signature this triptych appears to be the earlier of the two. No title.

_ Not recorded by Kurth.

(iii) *Taiko with Five Yoshiwara Beauties.* In the centre sits Hideyoshi (Taiko), holding a *saké* cup in one hand and a fan in the other, surrounded by five frail beauties ; in the midst of his enjoyment there enters (on the left) his wife, Kita no Mandokoro, beneath an umbrella carried by a servant. Title, " A Picture of the Pleasures of Taiko with Five Women in the Happy Land."

_ Published in 1804 as a satire on the debauched life of Hideyoshi (1536–1598), the conqueror of Korea, this print gave great offence to the equally dissolute reigning Shogun, Iyenari, and Utamaro was thrown into prison, a punishment which hastened his death, his constitution already enfeebled by over-indulgence in the pleasures of the Yoshiwara.

(iv) *Picking Persimmon.* One of Utamaro's most magnificently coloured triptychs. Scene in a garden in centre of which grows a persimmon tree, and a man up it handing down a branch of fruit to three ladies below ; on the right a girl, lifted up on another woman's shoulder, picks the fruit, while a third, kneeling, fills a basket with it ; on the left two women pull down a branch with a long bamboo pole to within reach of a third who plucks off the fruit. Publisher *Wakasa.* No title. *_* Not recorded by Kurth.

(v) *A Young Prince's Dancing Lesson.* A very beautiful and graceful figure-study. In the centre sheet is the prince in courtly dress holding an open fan and dancing ; before him is seated his sword-bearer. On the left are the ladies of the orchestra in front of a screen decorated with cranes on the seashore ; on the right

stands his mother and two attendants seated in front of a screen, on which is Utamaro's signature, decorated with peonies. Publisher *Tsuruya*. No title.

<p align="center">*_** Unrecorded by Kurth.</p>

(vi) *Fishing by Night on the Sumida River*. Night scene under a crescent moon. A party of men and women on a covered-in pleasure barge alongside a fishing-boat, watching a man hauling up his net, which forms a screen right across the centre of the picture. No title.

(vii) *The " Seven Ri " Beach* stretching away in the background towards the island of Enoshima, and parties of women making their way thither, one on horse-back (centre), another in a *kago* (left), and others walking (right). In the distance (left) rises the peak of Fuji. Publisher *Tsuruya*. No title.

(viii) *" A Ladies' Stopping-place "* (*Inn*). Three ladies retiring to rest behind a large mosquito curtain, and three other women outside, two of them the inn servants. Title on narrow upright label on each sheet. Publisher *Tsuruya*. This triptych is notable for the unusually tall figures, a characteristic common to Utamaro's single prints of his later years, but not so as a rule to his triptychs.

(ix) *Carrying Salt Water*. A group of seven women in straw skirts on the sea-shore carrying salt water in buckets suspended from yokes over their shoulders, and in the centre sheet a man also engaged filling the buckets from a pail ; on extreme right a small boy looking on. Publisher *Wakasa*. No title.

(x) *Night Festival on Sumida River*. A famous and very fine print. On the left stretches away the great Ryogoku Bridge to the distant shore opposite, in the centre a firework is being let off from a boat in mid-stream. In the foreground promenade or rest groups of ladies and children on a deep black ground which shades off to grey on the river. Artist's signature and publisher's sign (*Yamaguchi-ya Chusukè*) in *white* characters on black ground. No title.

(xi) *Geisha Performance in a Daimyo's Palace*. In the centre of a large room looking out on to a garden a *geisha* posturing, the musicians seated on the left, and the lady of the house with her attendants watching on the right from behind a screen. In the distance, from another wing of the palace, watches her lord. In the fore-ground are numerous servants and other members of the household who appear to be amusing themselves on their own account with little heed to the dancing. Thus on the extreme left a girl whispers something to a man (said to be the artist Kitao Masanobu), kneeling on the floor heavy with *saké*, while another makes fun of him from behind a screen ; in the centre an introduction is taking place, and on the right two girls struggle for a letter. No title. Early work.

(xii) *A Summer Storm*. A famous triptych. People seeking shelter from a thunderstorm under a large tree, and a man and two women under an umbrella rushing for refuge to it. (See Plate 63.) A rare print, of which the right-hand sheet is more usually met with as a single print. No title.

<p align="center">*_** Not mentioned by Kurth.</p>

(xiii) *A Holiday at Enoshima*. View of the shore and rocky coast near Enoshima looking across the water to Fuji in the distance (left). In foreground groups of women and children ; on the left a woman seated, fishing with a rod and line, and flicking up a sprat she has just caught ; beside her a man smoking, and a woman in a large sun-hat waving her hand to a friend. In the centre stand two women looking at a

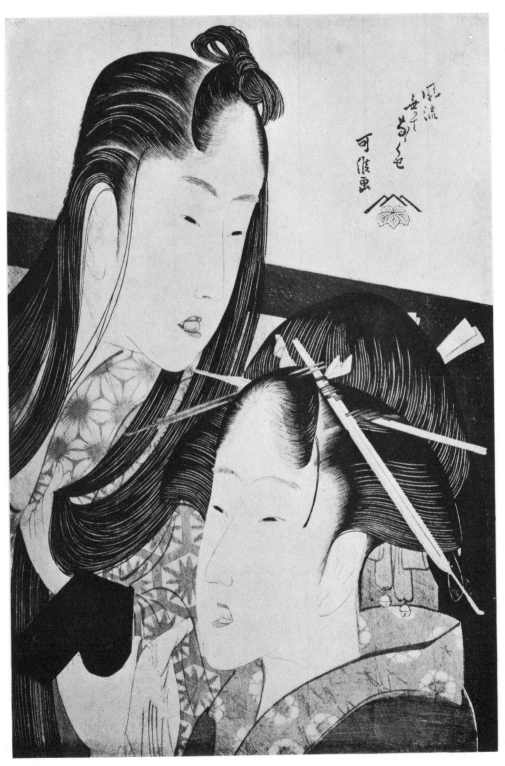

HOKUSAI : *Furyu Nakute Nana Kuse*; signed *Kako*; publisher *Tsutaya Juzaburo.*
(From the Collection of Mr. Kobayashi, Tokyo.)

PLATE 62

child who has fished up an old sandal ; on the right approach two other ladies and a boy carrying a mat. No title.

.*. Early work. Not recorded by Kurth.

(xiv) *A Princess's Hawking Party.* One of Utamaro's most beautiful figure-studies. In the centre a Princess, over whom an attendant holds an umbrella, has alighted from her *norimon*, which has just been landed from a ferry-boat on the top of a stone-walled embankment on the Sumida River ; on the right is the boat against the landing-place and attendants carrying boxes and spear-bearers waiting to disembark ; on the left a young *samurai* with hawk on wrist and three girls, two carrying boxes, wait to move off. Publisher *Wakasa*. No title. Later period.

.*. Not recorded by Kurth.

Pentaptych by UTAMARO.

House-cleaning at the end of the Year. A well-known but rare print by Utamaro, often described as a triptych owing to the two sheets on the right being generally missing. An interior scene with many figures, servants house-cleaning and playing jokes upon other (male) members of the household ; thus on the extreme right-hand sheet three of them trip up a chamberlain ; in another sheet a young man is being carried out by the legs and arms as if he was as much out of place as the two mice which a woman in the left sheet is chasing with her broom.

Triptychs by Kubo SHUNMAN :—

(i) *The Ichiriki Tea-House, Kyoto.* Yuranosukè playing blindman's buff with the tea-house girls, the 7th Act of the *Chushingura*. Yuranosukè, with eyes bandaged, is on the right-hand sheet ; in the centre are three *geisha*, two of them with *samisen*, one sitting on the *engawa* looking on ; in the background of the left sheet are two of Moronao's spies drinking *saké*. Considered one of his masterpieces. Very rare.

(ii) *Night Scene outside a Tea-house.* Scene outside a fence round a tea-house at the corner of two roads, and people going home. At the top of the picture (centre sheet), over the fence, appears an upper room, in candlelight, and two men and a woman seated, listening to a poetry-reader. On the right-hand sheet, by a gate in the fence, is a lady and her maid who carries a lantern, the rays from which brightly light up a part of her dress ; passing them is a woman carrying a basket of fish. Considered Shunman's chief masterpiece.

.*. This print is notable for its peculiar colouring, being mainly in sombre hues of grey and black, the brightly-coloured parts being only those whereon the light of candle or lamp falls. Yet there is no attempt to carry out the reality of darkness, as might be inferred, but this is implied by the usual conventional treatment common to the art of *Ukiyoye*.

(iii) *Temple Visitors.* A group of nine people in the portico of a temple, looking out over a vista of flat fields and the Sumida River in the distance (right). Publisher *Yeijudo*. No title.

Triptychs by SHUNZAN. In addition to the triptych illustrated at Plate 31, page 186, the following notable and rare prints by Shunzan should be mentioned :—

(i) *Village of Futami.* In foreground a large party of travellers, one (a woman) on horseback (centre sheet), with two children in panniers on either side ; on the right entrance to a tea-house, and three women coming out ; background of wooded hills and the sea, with the " Husband and Wife " rocks close to the beach. No title.

(ii) "*Morning Twilight.*" A group of six women and a man promenading in the early morning on high ground overlooking Yedo Bay ; title on a fanciful round panel on each sheet.

(iii) *Temple of Sen-so-ji, Asakusa.* On the right is the entrance guarded by the *Ni-ō-Kon-Go,* "Two Great Kings," two hideous demons in cages. In front of them are offerings of incense and votive offerings, and on the ground boxes containing the "hundred measures," and a woman kneeling in front of one depositing therein her measure. Foreground crowded with people. No title.

(iv) *Temple of Sen-so-ji.* The same subject as the foregoing with a full front view of the entrance with the two demons on either side, looking through to the grounds and buildings beyond ; foreground filled with people. No title.

*** These two triptychs constitute Shunzan's masterpieces.

(v) *River Festival.* Seated on low benches, or walking about, are groups of men and women on the bank overlooking the Sumida River crowded with gaily decorated pleasure barges and boats. Publisher *Yeijudo.*

Triptychs by SHUNCHO :—

(i) *Interior Scene in a Daimyo's Palace.* Twelve ladies grouped about in a large apartment opening on to a garden, some engaged in making preparations for the "Dolls' Festival," a girl in the centre sheet carrying a laden dish on a tray, followed by another bearing branches of peach-blossom.

(ii) *A Picnic.* Scene in undulating country with trees and flowering shrubs. In the centre a low platform covered with a red cloth, and on it five ladies, two of them standing ; others grouped round it, and on the left a girl and small boy catching insects off a shrub to put in a cage which stands at the corner of the table by them.

(iii) *The "Eight Parts" Bridge* over an iris pond, and *oirans* and their *kamuro* admiring the flowers. The names of the *oirans* are given as follows : right sheet, *Maiyu-zumi of Daimoni-ya ;* centre, *Shizuka of Tama-ya ;* and left, *Yuba-ye of Ogi-ya.*

Triptychs by YEISHI. In addition to the famous series of *Genji* triptychs and others already referred to in Chapter XX, the following are noteworthy examples :—

(i) *A Reception.* On the right kneels a gentleman between two kneeling ladies, bowing to a lady in the centre, who holds out a *saké* cup in one hand, and a *samisen* in the other, lying across her knees ; on the left a screen behind which kneels a man-servant, and two women standing by.

(ii) *The Pleasure Boat.* A noble lady seated under the awning of a large pleasure boat, on the Sumida River, surrounded by other ladies ; in the bow dances a woman to the music of a drum and a *tsuzumi* played by two other women, a little girl sitting by.

(iii) *A Garden Fête.* Under a trellis of wistaria hung with lanterns four tall women (two on each sheet) are walking ; behind them a bed of peonies in flower enclosed by a miniature bamboo railing, one woman on the right carrying a *samisen* case.

(iv) *The Good and Evil Influences.* Scene in one of the "Green-Houses" of the Yoshiwara, and guests being entertained by the women, while mingling with the assembled company are a number of tiny figures with bald heads and characters for faces, some urging on the guests to excesses, others restraining them. A very similar

print has been designed by Chōki, but the scene is laid outside instead of inside, and the little figures are larger in proportion to the figures of the men and women.

(v) *Garden of the Kanō-ō House.* Six women seated or standing on the *engawa* facing a garden wherein are placed two artificial figures of a tiger (left sheet) and a dragon (centre), the tail of which stretches away into the right-hand sheet. Behind it is a monument on an island in an iris pond, with an inscription upon it, and also a notice board, an advertisement of the maker of the artificial animals.

(vi) *The Treasure Ship.* Another triptych of this subject, different to that mentioned in Chapter XX. The forward end of a covered-in pleasure barge wherein are seven ladies as the Seven Gods of Good Fortune, and a single male guest. In the middle stands one as Daikoku holding a fan painted to represent his mallet, and pointing to another, seated, as Ebisu with rod and line, at end of which is a tiny fish ; the others have no special attributes.

(vii) *Scene in a Nobleman's Palace.* One of Yeishi's most beautiful compositions (reproduced in colour in Gookin's *Japanese Prints*). A large apartment with a view beyond of Yedo Bay ; eleven ladies and a girl seated or standing about, two of them writing poems on *tanjaku*. In the recess behind hang three *kakemono* with pictures of three of the *Rok'kasen*, Bunya-no-Yasuhidè, Ono-no-Komachi and Sojo Henjo. Publisher *Yeijudo*.

(viii) *Ryaku-Tsure-zure-Gusa* (title of a book dealing with refined occupations). On the right a lady seated at a table playing the *koto*, and by her another standing holding a *sho* (an instrument like miniature organ pipes) ; in the centre a lady feeding a crane and another standing by watching it ; on the left two ladies standing and talking together, one holding a court fan. Background of conventional cloud over-written with poems. Title as above on narrow panel on each sheet. Publisher *Yeijudo*.

Possibly complete as a pentaptych forming a companion to the following :—

(i) *Pentaptych : A Princess's Music Party :* Sheet 1 (right), a lady standing, holding a fan, talking to another, kneeling, by a large decorated gong ; (2) behind a reed screen, which extends across three-quarters of the picture, sits the princess, in front of her is a lady playing the *koto*, on her right sits another watching from behind the screen, in front a lady making obeisance ; (3) a lady playing the *sho*, and another standing behind her ; (4) Yoshitsune, with sword in bearskin scabbard, playing his flute, behind him a lady with a *shakuhachi* (bamboo flute), and another standing ; (5) two ladies playing *ken*, and a third, kneeling, performing on a *tsuzumi*. Publisher *Yeijudo*.

(ii) *Pentaptych : Pleasure Boats on the Sumida River.* On the right stretches in perspective the piles of the great Ryogoku Bridge ; in the centre, filling nearly the whole picture, is a great covered-in pleasure barge, crowded with people, and smaller boats round it.

Triptychs by YEISHO :—

(i) *Investiture of a Prince* on his attaining his majority by beautifully attired ladies with his sword, hat, robe, and other symbols of his coming of age.

(ii) *Interior of the " House of the Clove,"* with three of the *oirans* of *Choji-ya* seated in front of a panel decorated with a huge *ho-ho* bird which stretches right across the background. On the right is seated *Toyotsumi* writing a letter ; in the

centre *Michiyama* holding a pipe and talking to *Senzan* (left) who holds a fan. Publisher *Yamaguchi-ya Chusukè*.

(iii) " *Hana-ogi of Ogiya going into the Country.*" In the centre is *Hanaogi* with a *kamuro* and two *shinzo*, and groups of three women on each of the other two sheets, all under cherry-blossom.

(iv) *Yoshitsune serenading Jorurihimè*. On the right stands Yoshitsune outside the gate, playing his flute ; by him stands a youthful sword-bearer. Inside the gate is a lady holding up a lantern to see who the player might be ; on centre sheet are three other ladies, two sitting, looking at Yoshitsune ; on left sheet is seated Joruri-himè with a *koto* in front of her, listening to the strains of the flute, a child on her left, and a young lady on her right. The scene is laid on a veranda, looking on to hilly country and a mountain stream in background. Publisher *Yeijudo*.

Triptychs by TOYOKUNI. (Toyokuni has left such a large number of fine triptychs, the product of his earlier years, that we can only here mention a few of the best that have been noted.)

(i) *The Bath House.* A group of six women, two on each sheet, in the ante-room of a public bath house, one in the centre kneeling and dressing her little boy. (Reproduced in colour in Gookin's *Japanese Prints.*)

(ii) *Street Scene, Yoshiwara.* A long perspective view of the main street leading to the great gate in the distance, and the " green-houses " on either side ; the foreground filled with *oirans* and their guests, with attendant *kamuro ;* signed in very unusual *hira-kana* characters. A beautiful print in soft and subdued colours.

(iii) *Interior of Choji-ya.* A long perspective of a corridor on an upper floor, open on the left on to a balcony ; in foreground beautifully robed *oirans*, in the centre sheet one with a male guest, who is " making eyes " at another kneeling close by. On the left a waiter mounts the stairs from the floor below, and two women looking at him. A rare triptych.

(iv) *A River Party at Night.* Two boats fill the whole foreground of the picture ; overhead explodes a firework (see Plate 63, Illustration 3, page 350).

(v) " *Flower and Bird* " *Tea-House.* Garden scene, with an aviary stretching away behind on the right, and a portion of the tea-house on the left ; foreground filled with promenading figures. Publisher *Yeijudo*.

(vi) " *Deer* " *Tea-House.* Companion print to the foregoing. Garden scene with an aviary in the background, ladies seated on benches in foreground, and others standing talking.

(vii) *A Windy Day.* One of Toyokuni's most famous triptychs, notable for its rhythm. Two women, one standing on a bucket held by a companion, and the other held up on a man's shoulder, tie poem-slips to the branches of a cherry tree ; on the left, their mistress, embarrassed by the high wind, is helped along by two lady attendants ; all have their garments wildly blown about them. Publisher *Senichi*. (Illustrated in the B. M. Catalogue at page 268.)

(viii) *Procession of Ornaments.* Along a covered footbridge over a stream, leading from one part of a *daimyo's* palace to another, passes a procession of six ladies all carrying different decorations for a festival, followed behind by two children ; on the left two women make obeisance as the procession approaches, while in the background, behind a reed screen, the lady of the household looks on. Publisher *Senichi*.

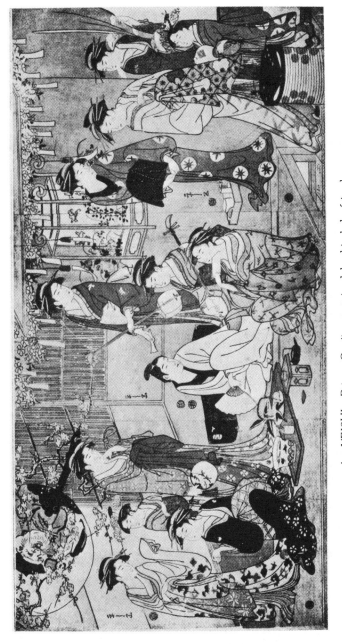

1. YEISHI : Prince Genji entertained by his lady friends.
(*By courtesy of Messrs. Sotheby.*)

PLATE 63 (first part)

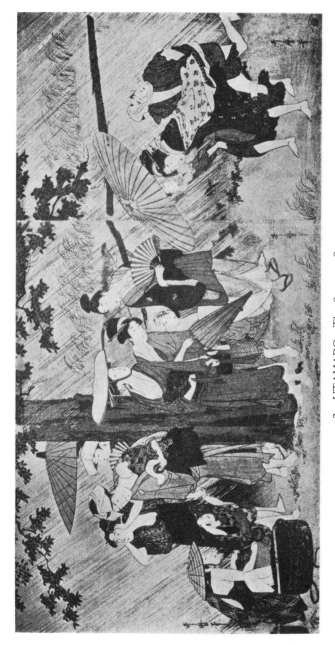

2. UTAMARO: The Summer Storm.
(By courtesy of Messrs. Sotheby.)

PLATE 63 (second part)

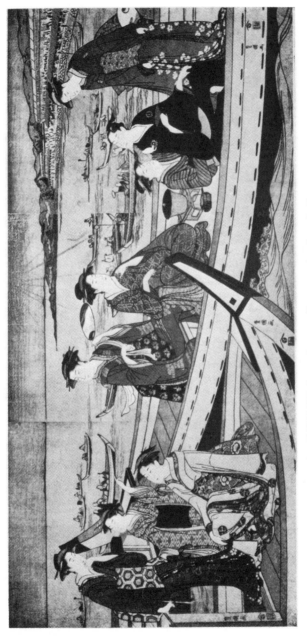

3. TOYOKUNI : A Boating Party on the Sumida River.
(By courtesy of Messrs. Sotheby.)

PLATE 63 (third part)

Notes

(ix) *A Noble Lady alighting from her Norimon*, richly lacquered in black and gold, which has been set down ; her ladies-in-waiting grouped round it, while one assists her ladyship over whom a young man holds an umbrella. One of Toyokuni's finest prints.

(x) *Floating Saké Cups down a Stream.* A group of nine ladies, three on each sheet, by a stream, engaged in racing *saké* cups ; background a beautiful landscape scene dotted about with cherry trees in blossom, dominated by the snow-capped peak of Fuji.

(xi) *The Dream.* One of Toyokuni's best known triptychs. Interior scene in a *daimyo's* palace ; in the centre a noble lady leaning on an arm-rest asleep, her dream represented above by a scene from the Mouse's Wedding, typifying marriage. Around her are women variously employed, those on the left playing *Uta-gar-uta*, the " Hundred Poets " game, which one of them checks from a copy of the *Hyakunin Isshu*.

Pentaptychs by TOYOKUNI :—

(i) *Viewing Fuji.* A Noble Lady (2nd sheet, R.) with an attendant on each side, and a man behind holding a large umbrella over her walking along the seashore at Tago ; in front of her is a procession of ten other women and girls, some carrying spears in their tufted coverings. In the background rises the great mass of Fuji, its upper part snow-covered. Publisher *Wakasa*.

(ii) *A Bridal Procession.* In the centre is the bride with three lady attendants, one of whom holds her hand ; behind, another holds an umbrella over her, and others follow in the procession. In front are three other women and two children, the procession being headed by a young *samurai*. In the background rise the high-pitched roofs of a temple, above low-lying mist and hilly country beyond. Publisher *Senichi*. Early work.

Triptych by TOYOKUNI and KUNIMITSU, a pupil, in collaboration :—

Ushiwaka (" Young Ox," i.e. Yoshitsune) fencing before a party of ladies, a parody of his fight with the *Tengu*. In the centre the hero leaps high in the air above the heads of two ladies, armed, like himself, with branches of plum blossom ; on the right sits a princess (in place of the *Tengu* king), surrounded by her ladies-in-waiting, holding up a large open court fan, and acting as umpire ; on the left three more ladies armed with plum-blossom branches ; landscape background, with a great Fuji (left) on horizon. Figures by Toyokuni, who signs only the left-hand sheet ; landscape by Kunimitsu, who signs the other two sheets. Publisher *Senichi*.

TOYOHIRO has left two very fine pentaptychs showing street scenes in Yedo, one in *Ōdemma chō*, with the large shop of *Dai Maruya*, and the other of *Ōwari chō* with the emporium of *Ebisuya ;* in both are groups of ladies and children passing to and fro in the foreground outside the building.

We have mentioned in Chapter XX two artists in connection with their picture-books, namely Kitao SHIGEMASA (1739–1820), and Kitao MASANOBU (1761–1816), his pupil ; Shigemasa himself being a pupil of the great Shigenaga. Both these are in the front rank of *Ukiyoye* artists, but are better known as such by their book-

illustrations, their full-size, single sheets being very uncommon. Masanobu, however, was, in his day, more celebrated as a writer and poet under the name of " Santo Kiōden " (*vide* triptych (xi) by Utamaro described above).

The draughtsmanship of both these artists in their magnificent full-size sheets is superb ; even the great Kiyonaga must bow to Shigemasa. A very fine example by Masanobu is illustrated in colours at our frontispiece, one of a set, unsigned, of " Beauties of the East, West, North, and South." Both these artists rarely signed their prints, with the result that it is very difficult at times to distinguish between them, though so marked is their individuality that they can be readily recognized from the other great figure-designers such as Koriusai or Kiyonaga. Five large-size prints are catalogued in the B. M. collection under Shigemasa, but all are unsigned.

As a testimony to Shigemasa's work during his lifetime we quote below a record[1] given by a contemporary engraver in the following words : " Though Shunsho was pre-eminent in his own special sphere of portraiture of stage-actors, yet he was less versed in the laws of general painting than Shigemasa, from whom he was ever willing to seek advice and receive instruction." A proud testimonial indeed, particularly when we remember that Shigemasa was over twelve years junior to Shunsho.

Besides the collaboration of these two in the two books already mentioned in Chapter XX, they, in conjunction with a third artist, Toyoharu, joined forces a third time in the production of a series of medium-size, almost square prints entitled *The Twelve Months*, each artist contributing four to the set, which is very rare. Each scene is divided diagonally into two, a device which enables anyone to recognize them readily, but which can only be described in Mr. Ficke's words as one of " unfortunate and ingenious ugliness." The design, however, is retrieved to some extent by the delicate figures which have a certain amount of charm about them. The series is divided as follows amongst the three artists :—

> Shigemasa : 1st, 5th, 9th, and 11th months.
> Shunsho : 2nd, 4th, 7th, and 12th „
> Toyoharu : 3rd, 6th, 8th, and 10th „

A well-known triptych showing Yoritomo on the seashore at Kamakura, by the large *torii* of the shrine, indulging in his favourite sport of flying cranes with poem-slips tied to their legs, is by Shigemasa, and is generally found unsigned, for which reason it is nearly always attributed to Toyokuni II (Gosotei), or sometimes to Utamaro, but a copy from the Ritchie collection has been noted signed in full *Kitao Shigemasa ;* publisher *Yeijudo.*

An unsigned copy is in the B. M. collection, and is there correctly catalogued under Shigemasa ; two sheets of it are reproduced in colours in the late Mr. Joly's *Legend in Japanese Art.*

What should increase our admiration for Shigemasa's talented pupil, Masanobu, is the fact that he ceased designing prints when he was only about twenty-five years old, and when he had already produced designs which would have brought fame to many an artist of maturer years. Had he not, after showing such great promise, abandoned art for literature, there is no doubt that he would have risen to greater heights than even Kiyonaga, whose equal he already was, and become *the* master of *Ukiyoye.*

[1] Quoted from Major Sexton's paper *Suzuki Harunobu and Some Others* in *Trans. of Japan Society* (Vol. XVII).

Kitao Masanobu, of course, must not be confused with the earlier Okumura Masanobu, one of the Primitives, and founder of the Okumura school, a confusion only likely to be made by the beginner ; both employ different characters for the second half of the name (*nobu*). (*Vide* reproduction in Appendix IV.)

Another pupil of Shigemasa was Kitao MASAYOSHI (1761–1824) whose single-sheet prints are also very uncommon ; his book-illustrations are less so. He is noted for his very large panoramic views, the first of their kind, like that illustrated in the Tuke catalogue at Plate XI, and for his sketches of flowers, animals and fish, such as his book of two volumes *Nami no Sachi* ("Pictures of Fishes and Shells," literally "Treasures of the Sea"), in colours (Yedo, 1775). The representations of fish are extraordinarily lifelike.

A third pupil is Enshutei SHIGEMITSU (*w. c.* 1800), whose biography is unknown, and who is only known to the writer by one print in his collection. He is mentioned here in case the reader should meet with an example by him.

In the domain of figure-studies as distinct from actor-portraits, Toyokuni's finest work is probably his series entitled *Jin, Gi, Rei, Chi, Shin*, that is the "Five Cardinal Virtues," title on upright panel ; publisher *Senichi*.

APPENDIX III

LIST OF *UKIYOYE* ARTISTS

NAME.	REMARKS.
ANCHI (Kwaigetsudo), *c.* 1715.	*See* KWAIGETSUDO.
BANKI (*c.* 1800).	A very rare follower of Utamaro ; work very refined.
BUNCHO (Ippitsūsai) *w.* 1764–1796.	A follower of Shunsho, but learnt painting from Ishikawa Takamoto ; date of birth and death unknown. Also a writer of comic poems.
BUNKYO (Sakuragawa), *c.* 1790.	A *very* rare artist, whose work is extraordinarily like that of Shuncho, whose pupil he may have been, though perhaps originally in the school of Buncho.
BUNRO (Tamagawa), *c.* 1800–1810.	A very rare imitator of Utamaro, though supposed to have been originally a pupil of Buncho.
CHIHARU (Takashima), 1776–1859.	An unknown artist ; book illustrator (*yoko-ye shape*).
CHIKANOBU (Kano), *c.* 1710.	Work very rare.
CHINCHO (Hanekawa), 1679–1754.	Pupil of Kiyonobu. By birth a *samurai*. Work exceedingly rare. Also signed *Hanekawa Motonobu*.
CHŌKI (Yeishōsai), *w.* 1785–1805.	Pupil of Toriyama Sekiyen ; also signed *Shiko* and *Yeishōsai*.
ENKIO (Kabukido), *w. c.* 1780–1790.	An unknown artist, follower of Sharaku. Large actor heads extraordinarily like those of Sharaku. Only known to the author by one print.
ENSHI (Angiusai), *c.* 1780.	Follower of Kiyonaga with style of Shuncho ; perhaps a pupil of Shunsho. Work *very* rare.
FUJINOBU (Yamaki), *c.* 1760.	A *very* rare pupil of Harunobu.
GAKUTEI (Yashima), *w.* 1800–1840.	Pupil of both Hokkei and Hokusai ; famous for his *surimono*. Worked at Ōsaka ; also signed *Gogaku* and *Gakutei Harunobu*.
GŌKYO (Hosoda), *c.* 1800.	Pupil of Yeishi ; signed *Yeishi's pupil, Gōkyo ;* rare.
GOSHICHI (Harukawa), *c.* 1810–1830.	Worked both in Yedo, Kyoto, and Ōsaka ; actor-prints and *surimono*. Rare.
HANZAN (Suiyeido), *c.* 1830.	An Ōsaka artist, designer of *surimono*.
HARUMASU (Kochoyen), *w.* 1830–1854.	As pupil of Kunisada signed *Kunimori* (later work) ; also signed *Hōrai*.
HARUNOBU (Suzuki), *c.* 1725–1770.	Pupil of Shigenaga. (See pages 39, 40.)

LIST OF *UKIYOYE* ARTISTS

NAME.	REMARKS.
HARUSHIGE (Suzuki), c. 1760.	Variously supposed to be :— 1. Son and pupil of Harunobu. 2. Same as Shiba KOKAN (*q.v.*). 3. Early name of KORIUSAI (*q.v.*).
HARUTSUGU (Suzuki), c. 1770.	Pupil (and perhaps son) of Harunobu. Work *very* rare.
HIDEMARO (Kitagawa), w. 1804–1817.	Pupil of Utamaro ; rather rare.
HIROKAGE (Ichiyusai) w. c. 1860.	Pupil of Hiroshige.
HIROSADA (Utagawa), 1800–1867.	Pupil of Kunisada who worked at Ōsaka.
HIROSHIGE (Ichiryusai), 1797–1858.	Pupil of Toyohiro ; noted for landscape. (*Vide* Chapter VII.)
HIROSHIGE II, w. 1840–1866.	Pupil of Hiroshige ; also known as ..chiyusai Shigenobu. (*Vide* Chapter VII.)
HISANOBU (Hyakusai), w. c. 1800–1810.	Follower of Utamaro, work rare.
HOKKEI (Totoya), 1780–1850.	Pupil of Hokusai, an Ōsaka artist, famous for his *surimono*.
HOKUBA (Teisai), 1770–1844.	Pupil of Hokusai ; designer of *surimono* and book-illustrations.
HOKUGA (Katsushika), w. c. 1830–1840.	Ōsaka artist, pupil of Hokusai, and designer of *surimono ;* signed also *Hōtei*.
HOKU-I (Hakusanjin), w. c. 1830–1840.	Pupil of Hokusai.
HOKU-ITSU (Katsushika), w. c. 1820–1830.	Pupil of Hokusai.
HOKUJIU (Shotei), w. c. 1800–1840.	Pupil of Hokusai ; noted for his landscapes in semi-European style.
HOKUSAI (Katsushika), 1760–1849.	At first studied in the school of Shunsho, but became an independent artist, famous for his landscape designs. (*Vide* Chapter VII.)
HOKUSHIU (Shunkōsai), w. c. 1810–1850.	Ōsaka artist, pupil of Hokusai.
HOKUTEI (Katsushika), w. c. 1790–1820.	Pupil of Hokusai ; also used names *Yeisai* and *Raito*, the latter given him by Hokusai when he discarded it.
HOKUYEI (Shumbaisai), w. c. 1810–1840.	Ōsaka artist, pupil of Hokusai ; also signed *Sek-warō*.
IKKU (Jippensha), 1775–1831.	An author of plays and romances, but only an occasional artist.
JAKUCHO-ō (Ito), w. c. 1865–1870.	Noted for his very fine *Kwa-cho* (" bird-flower ") prints on a black ground ; but very rare.
KANAMARO (Kitagawa), c. 1800.	A very rare pupil of Utamaro.
KATSUSHIGE (Utagawa), c. 1790.	Unknown artist ; work *very* rare.

[355]

NAME.	REMARKS.
KAZUMARO (Gakutei), c. 1830.	Ōsaka artist, designer of landscape in *yoko-ye* shape, probably a pupil of Gakutei ; but *very* rare. May possibly be a signature of Gakutei himself.
KIKUMARO (Kitagawa), w. c. 1789–1829.	The best of Utamaro's pupils ; also signed (after 1800) *Tsukimaro.*
KIŌSAI (Shojo), 1831–1889.	At first pupil of Kuniyoshi, afterwards of Kanō Tōhaku ; noted for his pictures of crows, but designed few colour-prints. Signed also *Chikamaro* (early), and *Kawanabe.*
KIYOHARU (Torii), c. 1720–1740.	Pupil of Kiyomitsu.
KIYOHIRO (Torii), c. 1708–1766.	Pupil of Kiyomasu.
KIYOMASA (Torii), w. c. 1790–1900.	Pupil and son of Kiyonaga ; work very rare.
KIYOMASU (Torii), 1679–1762.	Pupil of Kiyonobu.
KIYOMINE (Torii), 1786–1868.	Pupil of Kiyonaga ; work rare.
KIYOMITSU (Torii), 1735–1785.	Son and pupil of Kiyomasu.
KIYONAGA (Torii), 1752–1815.	Pupil of Kiyomitsu ; between 1780 and 1788 was the leading artist of *Ukiyoye*, influencing all his contemporaries.
KIYONOBU (Torii), 1664–1729.	Founder of the Torii school.
KIYOSHIGE (Torii), w. c. 1720–1760.	Third son and pupil of Kiyonobu ; very fine actor pillar-prints.
KIYOTADA (Torii), w. c. 1715–1740.	Pupil of Kiyonobu ; besides the prints usual to the Torii school, produced large prints of perspective views (*uki-ye*).
KIYOTOMO (Torii), w. 1717–1736.	Follower of Kiyonobu ; extremely rare.
KIYOTSUNE (Torii), 1735–1785.	Pupil of Kiyomitsu ; designed both *hoso-ye* and large-sized prints. Collaborated with Kiyomitsu ; influenced by Harunobu.
KOKAN (Shiba), 1747–1818.	Follower of Harunobu, who also forged many prints signed Harunobu ; also perhaps imitated him over the signature Harushige.
KORIUSAI (Isoda), w. c. 1760–1780.	Pupil first of Shigenaga and afterwards of Harunobu ; notable for his pillar-prints and studies of birds and flowers. Also signed *Haruhiro* as pupil of Harunobu, but *very* rare ; the signature *Harushige* may also be an early one of his ; also signed *Koriu* only. Uses sometimes the signature *Buko Yagenbori no Inshi Koriusai* ("Koriusai the retired old man of Yagenbori," i.e. Yedo) on his series "New Designs for Spring Grasses." (See Plate 31, page 186.)

LIST OF *UKIYOYE* ARTISTS

NAME.	REMARKS.
KUNICHIKA (Ichiōsai), w. c. 1860.	Pupil of Kunisada. Actor-prints and figure-studies; drew memorial portrait of his master.
KUNIHARU (Utagawa), c. 1800.	Pupil of Toyokuni. Was an actor, Arashi Tokusaburo, who turned artist. Signs *Arashi Tokusaburo aratame Kuniharu.*
KUNIHIRO (Utagawa), c. 1820.	Pupil of Toyokuni.
KUNIHISA (Ichiryūsai), w. c. 1860.	Pupil of Kunisada, with whom he sometimes collaborated; must not be confused with the other Kunihisa, female pupil of Gosotei Toyokuni; also signed *Ippōsai* and *Ichiyunsai.*
KUNIHISA (Utagawa), w. c. 1840–1860.	Said to be a female pupil of Gosotei Toyokuni; work very rare; signed *Kunihisa, pupil of Toyokuni.* Actor-prints.
KUNIMARO (Utagawa), w. c. 1840–1860.	Pupil of Kunisada; signed also *Ichiyensai;* also book-illustrator and writer of verse.
KUNIMARU (Utagawa), c. 1787–1817.	Pupil of Toyokuni; signed *Saikaro Kunimaru,* also *Ichiyensai.*
KUNIMASA (Utagawa), 1772–1810.	Pupil of Toyokuni; work very rare and of a high order.
KUNIMITSU (Ichiyōsai), w. c. 1805–1820.	Pupil of Toyokuni with whom he collaborated; also book-illustrator; work rare.
KUNIMORI (Utagawa), w. 1830–1854.	The later name of Horai Harumasu (*q.v.*), as pupil of Kunisada.
KUNINAGA (Utagawa), d. c. 1820.	Pupil of Toyokuni. Work rare.
KUNINAO (Utagawa), w. c. 1810–1840.	Pupil of Toyokuni; prolific book-illustrator; prints rare.
KUNINOBU (Suzuki), c. 1770.	An exceedingly rare artist; pupil first of Toyonobu and afterwards of Harunobu.
KUNISADA (Utagawa), 1786–1864.	Chief pupil of Toyokuni, and leader of the Utagawa school after the latter's death; also used the names *Gototei, Kochoro, Ichiyusai,* and *Ichiyōsai.* After 1844 he signed *Toyokuni,* as the second of the name, ignoring the prior claim of Gosotei Toyokuni, adopted son of Toyokuni.
KUNISADA II, 1823–1880.	Pupil of Kunisada; when his master assumed the name of Toyokuni, he took that of Kunisada, being previously known as Kunimasa II. Also used the names *Baido* and *Baichoro.*
KUNITERU (Utagawa), w. c. 1830–1850.	Pupil of Kunisada; previous to 1844 known as *Sadashige.* Also signed *Ichiyusai.*
KUNITORA (Utagawa), c. 1804–1830.	Pupil of Toyokuni; biography unknown.
KUNIYASU (Utagawa), c. 1800–1830.	Pupil of Toyokuni; work rather better than most of his contemporaries, and rather uncommon. Used also names *Ippōsai* and *Yasugoro.* Designed *surimono.*

NAME.	REMARKS.
KUNIYOSHI (Utagawa), 1797–1861.	With Kunisada the leading pupil of Toyokuni's studio and himself the master of several pupils. Also used names *Ichiyusai* and *Chō-ō-rō*.
KWAIGETSUDO (*c.* 1715).	The name of a group of artists who used this name together with their own.
KWANZAN (Ōkada), *w. c.* 1825–1846.	An Ōsaka artist, designer of *surimono*.
MASANOBU (Kitao), 1761–1816.	A highly-talented pupil of Shigemasa, better known in his day as a poet under the name of *Santō Kiōden*. His book-illustrations of "Yoshiwara Beauties and their Autographs" is famous ; his single-sheet prints are very fine and very rare; frequently no signature to them.
MASANOBU (Okumura), 1685–1764.	A Yedo bookseller, founder of the Okumura sub-school ; used the signatures *Yamato Gwako, Hōgetsudo, Bunkaku, Tanchōsai* (also in seal form).
MASAYOSHI (Kitao), 1761–1824.	Pupil of Shigemasa ; also used the names *Keisai* and *Shōshin*.
MASUNOBU (Tanaka), *w. c.* 1750–1770.	Very rare artist, who appears to have been a follower of Harunobu in style, judging from the only two *hashira-ye* that have been noted by him. Perhaps a pupil of Toyonobu.
MATORA (Ōishi), *w. c.* 1830.	Designer mainly of book-illustrations and Ōsaka *surimono*. Rare.
MINEMARO (Kitagawa), *c.* 1800.	A rare pupil of Utamaro.
MINKO (Tachibana), *w. c.* 1751–1771.	An extremely rare artist, known for his famous series of six oblong prints entitled *Kitsune-no-Yome-iri*, "The Fox's Wedding," done in collaboration with five other artists, probably his pupils, Chiryu, Banto, Kisen, Ryushi, and Suiyo.
MOROMASA (Furuyama), *c.* 1715–1740.	Pupil of Moronobu ; signed also *Tsukitsukido*.
MORONOBU (Hishikawa), 1625–1694.	His lifetime saw the real beginnings of the *Ukiyoye* school as designers for wood-engraving. Moronobu was the first to make it a real art.
NANAMARO (Kitagawa), *c.* 1800.	A very rare pupil of Utamaro.
NAOMASA (Utagawa), *c.* 1830.	An unknown artist, perhaps pupil of Kuninao.
NORISHIGE (Kwaigetsudo), *c.* 1715. NORITOKI (Kwaigetsudo).	See KWAIGETSUDO.
RENSHI, *c.* 1830–1840.	Pupil of Gakutei ; designed landscape book-illustrations, *yoko-ye* shape like Gakutei's "Views of Tempozan" series.
RYUKŌKU (Shunkyōsai), *c.* 1795–1810.	A rare follower of Utamaro, but nothing is known of his biography.

[358]

NAME.	REMARKS.
SADAHIDE (Utagawa), w. c. 1830–1850.	The best of Kunisada's pupils. Also used the names *Gōuntei, Gokuransei, Gokurantei, Gōfutei*, and *Giokuran*.
SADAHIRO (Utagawa), w. c. 1840.	An Ōsaka artist, pupil of Kunisada; did a good oblong series of Ōsaka views.
SADAKAGE (Utagawa), c. 1850.	Pupil of Kunisada; worked both in Yedo and Ōsaka; designed *surimono ;* signed *Gōkōtei.*
SADAMASA (Utagawa), c. 1840.	Pupil of Kunisada and Sadanobu; an Ōsaka artist.
SADAMASU (Utagawa), w. 1830–1850.	One of the best pupils of Kunisada, following Hiroshige in landscape designs. An Ōsaka artist.
SADANOBU (Tamura), c. 1730.	Pupil of Sukenobu; *very* rare.
SADANOBU (Hasegawa), w. c. 1850–1860.	Pupil of Kunisada and Sadamasa. Ōsaka artist; designed actor-prints and also copied Hiroshige's landscapes.
SADASHIGE (Utagawa), c. 1850 (d. 1874).	Pupil of Kunisada; also used name of *Kuniteru* (late), signed *Tōshirō.*
SADATORA (Utagawa), w. c. 1820–1845.	Pupil of Kunisada; also signed *Gōfutei.*
SANJIN (Suiho), c. 1850.	An Ōsaka artist; actor-prints.
SEKIJŌ (Toriyama), c. 1790.	Pupil of Toriyama Sekiyen, who followed Utamaro. Work rare.
SEKKYO (Sawa), c. 1790.	Pupil originally of Tsutsumi Torin, a painter of the Kano school, but became independent. He designed landscapes, bird and animal studies often in one colour of graded black or blue. Work rare.
SENCHŌ (Teisai), c. 1830–1850.	Pupil of Yeisen; designed studies of *oirans* closely after the style of his master.
SENKA (Toriyama), c. 1790–1800.	An unknown artist whose work is good and closely resembles that of Utamaro, much like Ryukōku. Very uncommon.
SHARAKU (Toshiusai), w. c. 1790–1795.	An independent artist, formerly an actor in the aristocratic " Nō " dance. Notable for his large bust-portraits of actors. Very rare.
SHIGEHARU (Riūsai), 1818–1844.	Pupil of Yanagawa Shigenobu; an Ōsaka artist, designed actor-prints.
SHIGEMASA (Kitao), 1739–1819.	Pupil of Shigenaga; prints rare, and often unsigned.
SHIGENAGA (Nishimura), 1697–1756.	Son and pupil of Nishimura Shigenobu.
SHIGENOBU (Nishimura), w. c. 1720–1740.	Biography unknown; work *very* rare.
SHIGENOBU (Ichiyūsai), w. c. 1840–1866.	Pupil and son-in-law of Hiroshige, better known as Hiroshige II (*q. v.*).
SHIGENOBU (Yanagawa), 1784–1832.	Pupil and son-in-law of Hokusai; an Ōsaka artist, noted for his fine *surimono.* Sometimes signed *Yanagawa* only.

NAME.	REMARKS.
SHIKIMARO (Kitagawa), *w. c.* 1790–1810.	Pupil of Utamaro. Designed figure-studies ; also some good bird-studies.
SHIKO. (See CHŌKI.)	
SHINKO (Toriyama), *c.* 1800.	A follower of Utamaro ; work very rare.
SHINSAI (Riuriukio), *w. c.* 1800–1830.	Pupil of Hokusai, whose name of Shinsai he took when the latter dropped it ; designed fine *surimono.*
SHUCHO (Tamagawa), *w. c.* 1790–1800.	A rare artist ; biography unknown, but probably a pupil of Ippitsūsai Buncho by the script of his signature. Designed figure-studies.
SHUNBENI (or Shunko), *c.* 1810.	A late pupil of Shunyei ; must not be confused with Shunkō the pupil of Shunsho.
SHUNCHO (Katsukawa), *w.* 1770–1800.	One of the chief artists of *Ukiyoye ;* pupil of Shunsho but follower of Kiyonaga in style.
SHUNDO (Katsukawa), *w. c.* 1770–1800.	Pupil of Shunsho ; work rare. Actor-prints.
SHUNJO (Katsukawa), *w. c.* 1780–1790.	Pupil of Shunsho. Actor-prints.
SHUNKIYO (Katsukawa), *c.* 1810.	A pupil of the Katsukawa school, probably of Shunyei, but designed figure-studies of Yoshiwara beauties *à la* Utamaro instead of actors, closely after the style of Yeizan. Rare.
SHUNKŌ (Katsukawa), *w. c.* 1770–1790.	A leading pupil of Shunsho ; also used a small jar-shaped seal (hence his nickname of " Little Jar "— *ko-tsubo*) in lieu of signature. *Hoso-ye* actor-prints.
SHUNKŌ (or Shunbeni), *c.* 1810.	Pupil of Shunyei ; writes the *kō* of his signature different to the above. (*Vide* SHUNBENI.)
SHUNKYOKU (Katsukawa), *c.* 1770.	An extremely rare artist, probably pupil of Shunsho ; the only recorded print by him being a figure-study *hashira-ye.* (Happer.)
SHUNMAN (Kubo), 1757–1820.	Pupil of Shigemasa ; followed Kiyonaga in style. Full-size prints very rare ; designed many *surimono.* Writer of verse.
SHUNSEI (Katsukawa), *c.* 1790.	A very rare pupil of Shunsho.
SHUNSEN (Kashōsai), *w. c.* 1790–1823.	Pupil at first of Torin, then of Shunyei ; also signed *Kashōsai,* and (after 1820) *Shunko,* but different script to either the foregoing of this name. Figure-studies and landscape. Book-illustrations more numerous than single prints.
SHUNSEN (Katsukawa), *w. c.* 1790.	A very rare pupil of Shunsho, not to be confused with the foregoing ; he designed *hoso-ye* actor-prints like his master and wrote the *sen* of his name different to the above Shunsen, and in the form Yeisen wrote it.
SHUNSHO (Katsukawa), 1729–1792.	Pupil of Shunsui, a painter, and founder of the Katsukawa school. One of the leading artists of *Ukiyoye,* particularly in actor-portraiture.

LIST OF *UKIYOYE* ARTISTS

NAME. REMARKS.

SHUNTEI (Katsukawa), 1770–1820. — Pupil of SHUNYEI; noted for his battle-scenes and prints of actors and wrestlers. Also book-illustrations.

SHUNTŌ (Katsukawa), *w. c.* 1790. — Pupil of Shunyei; work uncommon.

SHUNWAKU (Katsukawa), *c.* 1780–1790. — A pupil of the Katsukawa school, probably of Shunyei; work rare.

SHUNYEI (Katsukawa), 1768–1819. — The chief pupil of Shunsho, and himself master of a large school of pupils; noted for his prints of actors and wrestlers. A leading artist in his day. Designed many book-illustrations.

SHUNZAN (Katsukawa), *w. c.* 1780–1800. — Pupil of Shunsho and of Shunyei, but worked under the influence of Kiyonaga.

SŌGAKU (Rekisentei), *c.* 1810. — A *very* rare pupil of Rekisentei Yeiri.

SŌRAKŪ (? Toriyama), *c.* 1800. — A very rare artist, biography unknown; figure-studies *à la* Utamaro and Yeishi; may possibly have been a pupil of the latter.

SORI (Tawaraya), *w.* 1798–1840. — Pupil of Hokusai, who adopted the name of Sori on his master's discarding it in 1798; designed *surimono*. Rare.

SORIN (Rekisentei), *c.* 1800. — *Very* rare; presumably pupil of Rekisentei Yeiri.

SUGAKUDO, *w.* 1850–1860. — An independent artist, noted for his prints of birds and flowers.

SUKEI (Tsutsumi), *c.* 1800. — Pupil of Torin, a painter of the Chinese school.

SUKENOBU (Nishikawa), 1674–1754. — Single prints *very* rare; practically all his work being in the form of book-illustrations dealing with the occupations of women.

TAITO (Katsushika), *w. c.* 1800–1840. — Pupil of Hokusai; received the name *Taito* from him in 1810. Worked both in Yedo and Ōsaka; forged Hokusai's signature frequently.

TAKIMARO (Kitagawa), *c.* 1800. — Pupil of Utamaro whom he assisted in his "Book of the Green Houses." Work rare.

TERUNOBU (Katsumura), (18th cent.). — One of the Primitives, biography unknown.

TERUSHIGE (Katsukawa), (18th cent.). — Perhaps pupil of Kiyonobu; biography unknown. *Very* rare.

TORIN (Tsutsumi), *w. c.* 1780–1820. — Painter of the Kano school; founded a small school which produced mainly book-illustrations.

TOSHIMASA (Chōkōtei), *c.* 1800. — A *very* rare artist; biography unknown.

TOSHINOBU (Okumura), *w.* 1750. — Pupil and son of Masanobu.

TOYOHARU (Utagawa), 1733–1814. — Pupil of Shigenaga and probably also of Toyonobu; founder of the Utagawa school. Noted for his prints in perspective after the canons of European drawing.

JAPANESE COLOUR-PRINTS

NAME.	REMARKS.
TOYOHIDE (Kitagawa), c. 1830.	An Ōsaka artist, pupil of Gosotei Toyokuni.
TOYOHIDE (Utagawa), w. c. 1790–1820.	Pupil of Toyoharu, work rare.
TOYOHIRO (Utagawa), 1763–1828.	Pupil of Toyoharu ; distinguished as the teacher of Hiroshige.
TOYOHISA (Utagawa), w. c. 1790–1820.	Pupil of Toyoharu ; designed figure-studies ; work rare.
TOYOKUNI (Utagawa), 1769–1825.	Pupil of Toyoharu, and the most prominent artist of the *Utagawa* school ; his output of prints (actors and figure-studies) was enormous, and varies very much in quality. He had a large number of pupils.
TOYOKUNI (Gosotei), 1777–1835.	Pupil and adopted son of Toyokuni to whose name he succeeded in 1826 after the death of the latter, being the real Toyokuni II, a claim ignored by Kunisada who called himself the " second Toyokuni." Also used the name *Ichiryusai*.
TOYOMARU (Utagawa), w. c. 1785–1815.	Pupil of Toyoharu and also of Shunsho, under the name of *Kusamura Shunrō ;* also signed Kusamura Toyomaru. Actor-prints ; work rare.
TOYOMASA (Ishikawa), w. c. 1770–1790.	Pupil—and perhaps son—of Ishikawa TOYONOBU ; noted for his representation of children.
TOYONAGA (Amano), (mid-18th cent.).	An unknown and extremely rare artist ; probably pupil of Toyonobu.
TOYONOBU (Ishikawa), 1711–1785.	Pupil of Shigenaga ; noted for his very fine pillar-prints, and drawings of the nude, thus making an exception to the general practice of Japanese art. Also signed *Ishikawa Shuha*, either alone or in conjunction with *Toyonobu*. Other names used : *Meijōdō, Tanshindo,* and *Tanjōdō*.
TOYONOBU (Utagawa).	Said to be a pupil of the above. He died very young and his prints are exceedingly rare.
TOYOSHIGE (Utagawa), 1777–1835.	The name of Gosotei TOYOKUNI (*q.v.*) previous to 1826.
TSUKIMARO (Kitagawa).	See KIKUMARO.
UMPO (Tsutsumi), c. 1800.	Pupil of Torin.
UTAMARO (Kitagawa), 1753–1806.	Son and pupil of Toriyama Sekiyen ; one of the leading artists of *Ukiyoye*, and in his day the foremost painter of women. Had several pupils and innumerable imitators and forgers of his name ; amongst the latter were Toyokuni and more particularly Yeizan.
UTAMARO II, w. 1804–1817.	Pupil of Utamaro who married his widow and assumed his name and style.
YEI-ICHI (Teisai), c. 1840.	Pupil of Yeisen. Very rare.
YEIJU (Chōtensai), c. 1800.	Pupil of Yeishi. Work extremely rare.
YEIRI (Hōsoda), w. 1790–1800.	Pupil of Yeishi ; work very rare. Signed often *Yeiri, pupil of Yeishi.*

LIST OF *UKIYOYE* ARTISTS

NAME.	REMARKS.
YEIRI (Rekisentei), w. 1790–1800.	Pupil of Hasegawa Mitsunobu, but influenced by Yeishi, whose style he followed ; wrote the *Yei* of his name in different character to that used by Yeishi and his pupils. Signed also in full *Rekisentei Yeiri*.
YEISEN (Keisai), 1789–1851.	Pupil of Kano Hakukeisai, mostly designer of figure-studies of women, but also did some fine landscapes. Notable also for his blue prints.
YEISHI (Hosoda), w. 1780–1800.	An artist of *samurai* rank, notable for his very refined work ; one of the best figure-study artists of *Ukiyoye*. Founder of the Hōsōda school. Also used the name *Chōbunsai*.
YEISHIN (Choyensai), c. 1800–1810.	Pupil of Yeishi ; work very rare.
YEISHO (Hōsōda), w. c. 1790–1800.	The chief pupil of Yeishi ; work rare. Also signed *Chōkōsai*.
YEISUI (Ichirakūsei), w. c. 1790–1800.	Pupil of Yeishi ; work very rare.
YEIZAN (Kikugawa), w. 1800–1829.	Pupil of Kikugawa Yeiji ; imitator and rival of Utamaro, whose prints he sometimes forged.
YEKIGI (Tsutsumi), c. 1800.	Pupil of Torin.
YENKIO (Kabukido).	See ENKIO.
YENSHI (Angiūsai).	See ENSHI.
YOSHI-IKU (Ichiyeisai), 1824–1895.	Pupil of Kuniyoshi.
YOSHIKAZA (Ichijiusai), w. c. 1830–1865.	Pupil of Kuniyoshi ; also signed *Ichikawa*.
YOSHIKUNI (Utagawa), w. c. 1830–1860.	Pupil of Kuniyoshi ; also signed *Jukōdō* and *Toyokawa*.
YOSHINOBU (Kōmai), w. c. 1765–1770.	Very rare pupil of Harunobu ; also signed *Yamamoto*. By some supposed to be an early signature of Koriusai.
YOSHITORA (Utagawa), w. 1840–1870.	One of the most capable of Kuniyoshi's pupils ; also signed *Ichimōsai* and *Kinchōrō*.
YUMIAKI (Toriyama), c. 1800.	An unknown artist, whose only known work consists of three *hashira-ye*. Apparently a follower of Utamaro.

ARTISTS' SIGNATURES

NAME	SIGNATURE	NAME	SIGNATURE	NAME	SIGNATURE
BUNCHO	文調	HIROSHIGE (early period)	廣重	HOKUSAI	卍 為一
CHŌKI (See also SHIKO and YEISHŌSAI)	長喜			also signed :— I-ITSU (2 forms)	屬一 可侯
GAKUTEI	岳亭	(middle period)	廣重	KAKO (e.g. early "Chushingura" series, c. 1798)	宗理
GŌKYO	五郷	(late period)	廣重	SORI	戴斗
HARUNOBU	春信			TAITO	栗麿
HIROSHIGE	"Ichiryusai" seal — Diamond seal ("Hiro")	HOKKEI	北溪	KIKUMARO (early form) = Kiku-maro	喜久麿
		HOKUJIU	北壽	(late form) = Ki-ku-maro	

NAME	SIGNATURE	NAME	SIGNATURE	NAME	SIGNATURE
KIYOHIRO	清廣	KORIUSAI	湖龍齋	KUNIYOSHI	國芳
KIYOMASU	清倍	KUNIMASA	國政	MASANOBU (Kitao)	北尾政演
KIYOMINE	清峯	KUNINAGA	國長	MASANOBU (Okumura)	奥村政信
KIYOMITSU	清滿	KUNINAO	國直	MASAYOSHI	政美
KIYONAGA	清長	KUNISADA	國貞 豐國	MORONOBU	師宣
KIYONOBU	清信	(also signed TOYOKUNI after 1844)	國安	RYUKŌKU	柳谷
KIYOTADA	清忠	KUNIYASU		SADAHIDE	貞秀

JAPANESE COLOUR-PRINTS

NAME	SIGNATURE	NAME	SIGNATURE	NAME	SIGNATURE
SHARAKU	寫樂	SHUNCHO (Katsukawa)	勝川 春潮	SHUNTEI	春亭
SHIGEMASA	重政	SHUNKŌ (Pupil of Shunsho)	春好	SHUNYEI	春英
SHIGENAGA	重長	SHUNKŌ (=Shunbeni) (Pupil of Shunyei)	春紅	SHUNZAN	春山
SHIGENOBU (Yanagawa)	柳川 重信	SHUNMAN	後滿	SORI	宗理
SHIGENOBU (Hiroshige II)	重宜	SHUNSEN (Pupil of Shunyei)	春扇	SUGAKU	髙岳
SHIKIMARO	弍麿	SHUNSEN (=Shun-Izumi) (Pupil of Shunsho)	春泉	TOYOHARU	豊春
SHIKO (See also CHŌKI and YEISHŌSAI)	子興	SHUNSHO	春章	TOYOHIRO	豊廣

NAME	SIGNATURE	NAME	SIGNATURE	NAME	SIGNATURE
TOYONOBU (Ishikawa)	石川豊信	TSUKIMARO	月麿	YEISHO	栄昌 栄松斎
TOYOKUNI (early form)	豊信 豊國	UTAMARO (early form)	歌麿	YEISHŌSAI (= Choki or Shiko)	
(middle period)	豊國 國	(late form)	哥麿	YEIZAN (Kikugawa)	英山 菊川
(late period)	豊國	YEIRI (Hosoda)	栄里	YOSHINOBU	義信
				fudè (" with brush ") in kaisho (capital script)	筆
				fudè in semi-kaisho script (as written by Utamaro)	筆
TOYOKUNI (Gosotei) (Pupil of Toyokuni)	後素亭豊國	YEIRI (Rekisentei)	礫川亭永理	fudè in Sōsho script as written by Hiroshige (late)	筆
				gwa (" drew ")	画
		YEISEN (Keisai)	渓齊英泉	ōju (" to order ")	應需
TOYOMASA (Ishikawa)	石川豊雅	YEISHI (two forms)	栄之 栄し	utsusu (" copied ")	寫
				zu (" picture ")	圖

NAME	SEAL	EXAMPLES OF PRINTS WHEREON FOUND
AŌTO (of Yedo)	相ト	" Thirty-six Views of Toto " (Hiro-shige II).
ARITA-YA	真	Oblong " Yedo Views," and a " Chushin-gura " series by Hiroshige.
DAIHEI	本大平	Prints by Kuniyoshi.
DANSENDŌ	(See IBASEN.)	
ENHIKO (Enshu-ya Hikobei)	⊕遠彦	" Yedo Meisho " series (Hiroshige) ; prints by Kunisada.
FUJI-HIKO	藤彦 　松原堂	Various panel series by Hiroshige (e.g. " Six Tama Rivers ") ; fan prints ; " Celebrated Tea-Houses of Yedo " ; *Honcho Meisho* series (Hiroshige). Prints by Kuniyoshi.
FUJI-KEI (Fujio-kaya Kei-sukè)	今藤慶	Hiroshige's " Yedo Meisho," and other series.
HAYASHI (of Yedo)	(See ISEYA-RIHEI.)	
HEIKICHI	(See UWO-YEI.)	
HEISUKĒ	(See KOSHIMURA-YE.)	

NAME	SEAL	EXAMPLES OF PRINTS WHEREON FOUND
HOYEIDO (Takeuchi)	竹内 — *Takeuchi* 保永堂 — *Hoyeido seal.*	Early oblong " Tokaido Views " (1832) by Hiroshige, and certain " Kisokaido Views."
IBAKIU	久伊場久	
IBASEN (Dansendo)	伊塲仙	Prints by Kunisada and Kuniyoshi.
IDZUMI-YA ICHIBEI (See also Senichi)	和泉屋市兵衛	(See under SENICHI.)
ISEKANÈ	伊勢彙	" Genji Monogatari " series.
ISEYA-RIHEI (Ise-Iri)	林 森	" Kisokaido " series ; " Nichiren " series by Kuniyoshi ; early " Chushingura " set (c. 1796) by Hokusai ; prints by Kunisada, Toyokuni (Gosotei).
IWATO-YA	岩戸屋	Prints by Yeishi, Utamaro, Toyokuni, Hiroshige, Kunisada, Shunsen, Shunyei.

NAME	SEAL	EXAMPLES OF PRINTS WHEREON FOUND
JŌ-SHŪ-YA	笑	" Poems from China and Japan " series (Hiroshige) (*very* rare).
JZUTSU-YA	井筒屋　井彦	Prints by Yeizan.
KAWA-CHO	茸川長	Toto Meisho (Hiroshige).
KAWA-SHO (Yeisendo)	川正 *Kawa-sho* 榮川堂 *Yeisendo*	Early " Yedo Views," " Naniwa Meisho " and oblong " Omi Hakkei " series by Hiroshige.
KIKAKUDO	(See SANOKI.)	
KOSHIMURA-YE (Heisuké)	越平	" Sixty Odd Provinces " series and " Kanazawa Hakkei " series (Hiroshige).
KO-YEIDO (See also Tsuta-ya Kichizo)	紅英堂	" Bird and Flower " prints by Sugakudo.

NAME	SEAL	EXAMPLES OF PRINTS WHEREON FOUND
MARUJIN (Maru-ya Jinpachi)	甚 九 甚	" Settsu Gekka," " Yedo Meisho " series, etc., by Hiroshige. Prints by Shunsho, Utamaro, Kunisada.
MARU-KYU	九 久 全	" Six Tama Rivers " (Hiroshige), upright. Prints by Kuniyoshi, Utamaro.
MARUSEI	九 清	" Tokaido " series (1842), " Yedo Views " and " Chushingura " series by Hiroshige.
MASUGIN	増 銀	" Toto Meisho " series (Hiroshige).
MORI-JI (Jihei)	森 森治	Hokusai's " Imagery of the Poets " series ; prints by Utamaro and pupils ; also Kiyomitsu, Yeisen ; *Shinsen Yedo Meisho* series by Hiroshige.
OMI-YA (of Yedo)	喬	Prints by Utamaro.
SANOKI (Kikakudo)	佐の喜 喜鶴堂	*Yedo Kinko Hakkei* and " Yedo Views " series by Hiroshige ; prints by Kunisada.

Sanoki *Kikakudo*

NAME	SEAL	EXAMPLES OF PRINTS WHEREON FOUND
SEN-ICHI (Idzumi-ya Ichi-bei)	泉市	" Yedo Views " series by Hiroshige ; " Chushingura " (large issue) by Hokusai ; prints by Shunsen, Shuntei, Shuncho, Toyokuni, Utamaro, Yeishi, Yeisen, Kuniyoshi.
SOSHU-YA	總州屋　近	Prints by Ryukōku.
(Shiba) TAKASU	芝 高須	
TŌBEI	(See YAMAGUCHI-YA.)	
TSURU-YA		" Chushingura " set by Hokusai, 1st issue, 1806 ; prints by Kiyomine, Kunimasa, Kuniyoshi, Shuncho, Shunsho, Shunyei, Toyokuni, Utamaro, Utamaro II.
TSUTA-YA JUZABURO (Ko-sho-do)	蔦屋	Prints by Chōki (Shiko), Sharaku, Shunyei, Utamaro, Toyokuni.
TSUTA-YA KICHIZO [also known as KŌYEIDO (q.v.)]	蔦屋吉藏	" Tokaido " views (upright), " Thirty-six Views of Fuji "; " Monkey Bridge " kakemono, etc., by Hiroshige ; blue prints by Yeisen.

NAME	SEAL	EXAMPLES OF PRINTS WHEREON FOUND
UROKOGATA-YA		Prints by the Primitives, e.g. Kiyomitsu, Shigenaga, Toyonobu.
UWO-YEI (Heikichi)		" Hundred Views of Yedo " (Hiroshige) ; prints by Kunisada.
WAKASA-YA	*Waka-yo*	Prints by Kunisada, Shuncho, Shunman, Shunyei, Toyokuni, Utamaro, Yeisen, Yeizan.
YAMADA-YA		Large figure " Yedo Views " and " Mountain and Sea like Wrestlers " series (Hiroshige), prints by Toyohiro, Toyokuni, Utamaro ; *Harimaze* " Yedo Meisho " (Hiroshige).
YAMAGUCHI-YA (Tōbei)	*Tō*	Prints by Utamaro, Tsukimaro, Toyokuni, Yeisho, Kunisada, Yeizan.
YAMAGUCHI-YA CHŪSUKÈ		Prints by Yeisho, Utamaro, Shunyei.
YAMAMOTO-HEIKICHI (Yama-kiu or Yama-hei)		Prints by Hokujiu, Kuniyasu, Toyokuni (Gosotei), Yeisen (landscape), Kunisada, Kuniyoshi.

NAME	SEAL	EXAMPLES OF PRINTS WHEREON FOUND
YEBISU-YA		Prints by Kunisada amongst others.
YEISENDO	(See KAWA-SHO.)	
YETATSU		" Tokaido " series by Hiroshige.
YEIJUDO (of Yedo)		Prints by Chōki, Kiyonaga, Kiyomine, Kiyomitsu, Koriusai, Kuninao, Hokusai, Shikimaro, Shuncho, Shunyei, Shunzan, Toyoharu, Toyokuni, Toyokuni (Gosotei), Yeishi, Yeisho.
YEZAKIYA		Prints by Shunyei, Utamaro, Yeizan.

ACTORS' CRESTS (MON.)

NOTE:—Names marked thus (*) are those of actors who took female parts.

NAME	CREST	NAME	CREST	NAME	CREST
*ARASHI HINASUKÈ		*IWAI HANSHIRO		(early form)	
ARASHI OTOHACHI		KATAOKA NIZAYEMON		NAKAMURA NAKAZO	
*ARASHI SANYEMON				(later forms)	
BANDO HIKOSABURO		MATSUMOTO KŌSHIRO (2 forms)			
ICHIKAWA DANJURO		MIYAZAKI DENKICHI		NAKAMURA TOMIJURO	
*(early form) ICHIKAWA MONNOSUKÈ		NAKAJIMA MIOYEMON		NAKAMURA UTAYEMON	
(later form)		NAKAMURA DENGORO		*OGINO ISABURO (both male and female parts, latter when young)	
ICHIKAWA OMEZO					
ICHIKAWA YAOZO		*NAKAMURA MATSUE		ONINO SENJO	
ICHIMURA UZAYEMON		NAKAMURA SHICHISABURO		ONOYE KIKUGORO	

NAME	CREST	NAME	CREST	NAME	CREST
ONOYE MATSUSUKÈ		*SANNOGAWA ICHIMATSU		SODEÕKA SHÕTARO	
OTANI ONIJI		SAWAMURA SÕJURO		*TOMIZAWA MONTARO	
OTANI TOMOYEMON		*SEGAWA KIKUNOJO		YAMANAKA HEIKURO	
SAKATA HANGORO					
SANJO KANTARO		SEKI SANJURO		*YOSHIZAWA AYAMÈ	

APPENDIX V

BIBLIOGRAPHY

ANDERSON, W.—*Japanese Wood Engravings* (*Portfolio*). London, 1895.

AUDSLEY, GEORGE A.—*Gems of Japanese Art*. London, 1913.

BINYON, LAURENCE.—*Catalogue of Japanese and Chinese Woodcuts in the British Museum*. London, 1916.

DAVIS, FRED. HADLAND.—*Myths and Legends of Japan*. London, 1918.

DICKINS, F. VICTOR (trans. by).—*The Chushingura*. London, 1910.

EDWARDS, OSMAN.—*Japanese Plays and Playfellows*. London, 1901.

FICKE, A. DAVISON.—*Chats on Japanese Prints*. London, 1917.

JOLY, H. L.—*Legend in Japanese Art*. London, 1908.

MARCUS, M. C.—*The Pine Tree* (adapted from the Japanese). London, 1916.

MITFORD, A. B. (Lord Redesdale).—*Tales of Old Japan*. London, 2nd ed., 1874.

MIYAMORI, ASATARO.—*Tales from Old Japanese Dramas*. New York, 1915.

OZAKI, MADAME YUKIO.—*Romances of Old Japan*. London, 1919.

SEIDLITZ, W. VON.—*History of Japanese Colour-Prints*. London, 1910.

STRANGE, E. F.—*Japanese Illustration*. London, 2nd ed., 1904.

STRANGE, E. F.—*Japanese Colour-Prints*. London, 4th ed., 1913.

INDEX

Note.—To facilitate reference, artists' names are given in CAPITALS irrespective of their importance ; titles of prints, etc., in *italics*. Many other artists will be found listed in Appendix III.

A

Actors, 203–204, 221–222, 225
Actors' crests (*mon*) (reproductions of), 375
Advertisements (Pictorial), influence of Japanese Art on, 6
Amaterasu the sun-goddess, 306
Anchin (the monk) and Kiyohime (play), 208–209
Ancient and Modern Dramas Illustrated (Hiroshige), 308–312
Aratamè seal, 332
Artists (number of) in *Ukiyoye*, 37
— signatures (reproductions of), 364–367
— social status of, 203
Atsumori and Kumagai, 304–306
Azuma Mori no Koji, 312

B

Baiko (the actor) and Hokusai, 203
BANKI II, 46
" Bird and Flower " prints (*Kwa-cho*), 56, 326
" Bridges " series (Hokusai), 121–122
BUNCHO, 41, 214
BUNRO, 46

C

Censoring of prints and censors' seals, 334
Characteristics of Japanese Drawing, 71–74
" Chinese and Japanese History " series (Hiroshige), 302–307
Chinese Prints, 20
Chiuko-adauchi dzu-ye series (Hiroshige), 314
Chohi, Chinese General, 302–303
CHŌKI, 26, 47
Choyemon and O Han (story of), 308
Chronology (Japanese), Comparative Table of, 337
Chubei and Umegawa (story of), 308
Chushingura (drama), 230–234
— Illustrated by Hiroshige, 250–262, 309–310
— — Hiroshige II, 262
— — Hokusai, 234–244, 246–249
— — Kikumaro, 280, 288
— — Kunisada, 273–279
— — Kuniyoshi, 279–280
— — Masayoshi, 245–246
— — Sadahide, 280–283
— — Shunsen, 269–270
— — Shunyei, 263–265
— — Toyokuni, 265–268

Chushingura (drama) (Yeisen), 271–272
— " Brother-Pictures " (Kunisada), 288–289
— — (Kuniyoshi), 289
— — (Utamaro), 284–288
— — (Yeizan), 289
— *Hak'kei* (Chōki), 289–291
— — (Toyonobu), 291
Collection, care of a, 23
— cataloguing a, 29
Collections, Public and Private, 5, 6, 28
Colours used in old prints, 27, 276, 280
Courtesans, 182–184
Crêpe prints, 35

D

Date-seals on prints, 23, 25, 332–336
Dating (The) of prints, 331–336
Dengaku plays, 198
Dojoji (drama), 208–209

E

Eight Views of Celebrated Indoor Birds (Koriusai), 343
Eight Views of the Loo-choo Islands (Hokusai), 123
Endo Musho Mirito (Mongaku), 323–324
ENSHI (Angiusai), 345

F

Famous Resorts (Tea-houses) of Yedo (Hiroshige), 137–138
Famous Views in the Nikko Mountains (Yeisen), 121
Fan prints, 76
Festivals, The Five, 190, 325
Fifty-three Stations of the Tokaido (Hiroshige) :—
(Oblong) { *Hoyeido* issue, 78–87
{ *Marusei* issue, 88–89
{ *Yetatsu* issue, 89–90
— — — (upright series), 22, 90–95, 97 (footnote)
— — — (Hiroshige and Kunisada), 96
— — — (Hokusai, quarter-block), 97
— — — (Kunisada, half-plate), 96
— — — (Kuniyoshi), 95
Filial Piety series (Hiroshige), 314–315
— — — (Kuniyoshi), 324
" Fishes " series (Hiroshige), 327
" Five (The) Cardinal Virtues " series (Koriusai), 343
— — — (Toyokuni), 353
" Five Festivals (The)," 190, 325
Forgeries, 32

INDEX

INDEX

A CATALOGUE OF
SELECTED DOVER BOOKS
IN ALL FIELDS OF INTEREST

A CATALOGUE OF SELECTED DOVER
BOOKS IN ALL FIELDS OF INTEREST

RACKHAM'S COLOR ILLUSTRATIONS FOR WAGNER'S RING. Rackham's finest mature work—all 64 full-color watercolors in a faithful and lush interpretation of the *Ring*. Full-sized plates on coated stock of the paintings used by opera companies for authentic staging of Wagner. Captions aid in following complete Ring cycle. Introduction. 64 illustrations plus vignettes. 72pp. 8⅝ x 11¼. 23779-6 Pa. $6.00

CONTEMPORARY POLISH POSTERS IN FULL COLOR, edited by Joseph Czestochowski. 46 full-color examples of brilliant school of Polish graphic design, selected from world's first museum (near Warsaw) dedicated to poster art. Posters on circuses, films, plays, concerts all show cosmopolitan influences, free imagination. Introduction. 48pp. 9⅜ x 12¼.
23780-X Pa. $6.00

GRAPHIC WORKS OF EDVARD MUNCH, Edvard Munch. 90 haunting, evocative prints by first major Expressionist artist and one of the greatest graphic artists of his time: *The Scream, Anxiety, Death Chamber, The Kiss, Madonna*, etc. Introduction by Alfred Werner. 90pp. 9 x 12.
23765-6 Pa. $5.00

THE GOLDEN AGE OF THE POSTER, Hayward and Blanche Cirker. 70 extraordinary posters in full colors, from Maitres de l'Affiche, Mucha, Lautrec, Bradley, Cheret, Beardsley, many others. Total of 78pp. 9⅜ x 12¼. 22753-7 Pa. $5.95

THE NOTEBOOKS OF LEONARDO DA VINCI, edited by J. P. Richter. Extracts from manuscripts reveal great genius; on painting, sculpture, anatomy, sciences, geography, etc. Both Italian and English. 186 ms. pages reproduced, plus 500 additional drawings, including studies for *Last Supper*, Sforza monument, etc. 860pp. 7⅞ x 10¾. (Available in U.S. only)
22572-0, 22573-9 Pa., Two-vol. set $15.90

THE CODEX NUTTALL, as first edited by Zelia Nuttall. Only inexpensive edition, in full color, of a pre-Columbian Mexican (Mixtec) book. 88 color plates show kings, gods, heroes, temples, sacrifices. New explanatory, historical introduction by Arthur G. Miller. 96pp. 11⅜ x 8½. (Available in U.S. only) 23168-2 Pa. $7.95

UNE SEMAINE DE BONTÉ, A SURREALISTIC NOVEL IN COLLAGE, Max Ernst. Masterpiece created out of 19th-century periodical illustrations, explores worlds of terror and surprise. Some consider this Ernst's greatest work. 208pp. 8⅛ x 11. 23252-2 Pa. $6.00

UNCLE SILAS, J. Sheridan LeFanu. Victorian Gothic mystery novel, considered by many best of period, even better than Collins or Dickens. Wonderful psychological terror. Introduction by Frederick Shroyer. 436pp. 5⅜ x 8½. 21715-9 Pa. $6.00

JURGEN, James Branch Cabell. The great erotic fantasy of the 1920's that delighted thousands, shocked thousands more. Full final text, Lane edition with 13 plates by Frank Pape. 346pp. 5⅜ x 8½.
23507-6 Pa. $4.50

THE CLAVERINGS, Anthony Trollope. Major novel, chronicling aspects of British Victorian society, personalities. Reprint of Cornhill serialization, 16 plates by M. Edwards; first reprint of full text. Introduction by Norman Donaldson. 412pp. 5⅜ x 8½. 23464-9 Pa. $5.00

KEPT IN THE DARK, Anthony Trollope. Unusual short novel about Victorian morality and abnormal psychology by the great English author. Probably the first American publication. Frontispiece by Sir John Millais. 92pp. 6½ x 9¼. 23609-9 Pa. $2.50

RALPH THE HEIR, Anthony Trollope. Forgotten tale of illegitimacy, inheritance. Master novel of Trollope's later years. Victorian country estates, clubs, Parliament, fox hunting, world of fully realized characters. Reprint of 1871 edition. 12 illustrations by F. A. Faser. 434pp. of text. 5⅜ x 8½. 23642-0 Pa. $5.00

YEKL and THE IMPORTED BRIDEGROOM AND OTHER STORIES OF THE NEW YORK GHETTO, Abraham Cahan. Film *Hester Street* based on *Yekl* (1896). Novel, other stories among first about Jewish immigrants of N.Y.'s East Side. Highly praised by W. D. Howells—Cahan "a new star of realism." New introduction by Bernard G. Richards. 240pp. 5⅜ x 8½. 22427-9 Pa. $3.50

THE HIGH PLACE, James Branch Cabell. Great fantasy writer's enchanting comedy of disenchantment set in 18th-century France. Considered by some critics to be even better than his famous *Jurgen*. 10 illustrations and numerous vignettes by noted fantasy artist Frank C. Pape. 320pp. 5⅜ x 8½. 23670-6 Pa. $4.00

ALICE'S ADVENTURES UNDER GROUND, Lewis Carroll. Facsimile of ms. Carroll gave Alice Liddell in 1864. Different in many ways from final Alice. Handlettered, illustrated by Carroll. Introduction by Martin Gardner. 128pp. 5⅜ x 8½. 21482-6 Pa. $2.50

FAVORITE ANDREW LANG FAIRY TALE BOOKS IN MANY COLORS, Andrew Lang. The four Lang favorites in a boxed set—the complete *Red, Green, Yellow* and *Blue* Fairy Books. 164 stories; 439 illustrations by Lancelot Speed, Henry Ford and G. P. Jacomb Hood. Total of about 1500pp. 5⅜ x 8½. 23407-X Boxed set, Pa. $15.95

DRAWINGS OF WILLIAM BLAKE, William Blake. 92 plates from Book of Job, *Divine Comedy, Paradise Lost,* visionary heads, mythological figures, Laocoon, etc. Selection, introduction, commentary by Sir Geoffrey Keynes. 178pp. 8⅛ x 11. 22303-5 Pa. $4.00

ENGRAVINGS OF HOGARTH, William Hogarth. 101 of Hogarth's greatest works: *Rake's Progress, Harlot's Progress, Illustrations for Hudibras, Before and After, Beer Street and Gin Lane,* many more. Full commentary. 256pp. 11 x 13¾. 22479-1 Pa. $12.95

DAUMIER: 120 GREAT LITHOGRAPHS, Honore Daumier. Wide-ranging collection of lithographs by the greatest caricaturist of the 19th century. Concentrates on eternally popular series on lawyers, on married life, on liberated women, etc. Selection, introduction, and notes on plates by Charles F. Ramus. Total of 158pp. 9⅜ x 12¼. 23512-2 Pa. $6.00

DRAWINGS OF MUCHA, Alphonse Maria Mucha. Work reveals draftsman of highest caliber: studies for famous posters and paintings, renderings for book illustrations and ads, etc. 70 works, 9 in color; including 6 items not drawings. Introduction. List of illustrations. 72pp. 9⅜ x 12¼. (Available in U.S. only) 23672-2 Pa. $4.00

GIOVANNI BATTISTA PIRANESI: DRAWINGS IN THE PIERPONT MORGAN LIBRARY, Giovanni Battista Piranesi. For first time ever all of Morgan Library's collection, world's largest. 167 illustrations of rare Piranesi drawings—archeological, architectural, decorative and visionary. Essay, detailed list of drawings, chronology, captions. Edited by Felice Stampfle. 144pp. 9⅜ x 12¼. 23714-1 Pa. $7.50

NEW YORK ETCHINGS (1905-1949), John Sloan. All of important American artist's N.Y. life etchings. 67 works include some of his best art; also lively historical record—Greenwich Village, tenement scenes. Edited by Sloan's widow. Introduction and captions. 79pp. 8⅜ x 11¼. 23651-X Pa. $4.00

CHINESE PAINTING AND CALLIGRAPHY: A PICTORIAL SURVEY, Wan-go Weng. 69 fine examples from John M. Crawford's matchless private collection: landscapes, birds, flowers, human figures, etc., plus calligraphy. Every basic form included: hanging scrolls, handscrolls, album leaves, fans, etc. 109 illustrations. Introduction. Captions. 192pp. 8⅞ x 11¾. 23707-9 Pa. $7.95

DRAWINGS OF REMBRANDT, edited by Seymour Slive. Updated Lippmann, Hofstede de Groot edition, with definitive scholarly apparatus. All portraits, biblical sketches, landscapes, nudes, Oriental figures, classical studies, together with selection of work by followers. 550 illustrations. Total of 630pp. 9⅛ x 12¼. 21485-0, 21486-9 Pa., Two-vol. set $15.00

THE DISASTERS OF WAR, Francisco Goya. 83 etchings record horrors of Napoleonic wars in Spain and war in general Reprint of 1st edition, plus 3 additional plates. Introduction by Philip Hofer. 97pp. 9⅜ x 8¼. 21872-4 Pa. $4.00

THE COMPLETE BOOK OF DOLL MAKING AND COLLECTING, Catherine Christopher. Instructions, patterns for dozens of dolls, from rag doll on up to elaborate, historically accurate figures. Mould faces, sew clothing, make doll houses, etc. Also collecting information. Many illustrations. 288pp. 6 x 9. 22066-4 Pa. $4.50

THE DAGUERREOTYPE IN AMERICA, Beaumont Newhall. Wonderful portraits, 1850's townscapes landscapes; full text plus 104 photographs. The basic book. Enlarged 1976 edition. 272pp. 8¼ x 11¼.
23322-7 Pa. $7.95

CRAFTSMAN HOMES, Gustav Stickley. 296 architectural drawings, floor plans, and photographs illustrate 40 different kinds of "Mission-style" homes from *The Craftsman* (1901-16), voice of American style of simplicity and organic harmony. Thorough coverage of Craftsman idea in text and picture, now collector's item. 224pp. 8⅛ x 11. 23791-5 Pa. $6.00

PEWTER-WORKING: INSTRUCTIONS AND PROJECTS, Burl N. Osborn. & Gordon O. Wilber. Introduction to pewter-working for amateur craftsman. History and characteristics of pewter; tools, materials, step-by-step instructions. Photos, line drawings, diagrams. Total of 160pp. 7⅞ x 10¾. 23786-9 Pa. $3.50

THE GREAT CHICAGO FIRE, edited by David Lowe. 10 dramatic, eyewitness accounts of the 1871 disaster, including one of the aftermath and rebuilding, plus 70 contemporary photographs and illustrations of the ruins—courthouse, Palmer House, Great Central Depot, etc. Introduction by David Lowe. 87pp. 8¼ x 11. 23771-0 Pa. $4.00

SILHOUETTES: A PICTORIAL ARCHIVE OF VARIED ILLUSTRATIONS, edited by Carol Belanger Grafton. Over 600 silhouettes from the 18th to 20th centuries include profiles and full figures of men and women, children, birds and animals, groups and scenes, nature, ships, an alphabet. Dozens of uses for commercial artists and craftspeople. 144pp. 8⅜ x 11¼.
23781-8 Pa. $4.50

ANIMALS: 1,419 COPYRIGHT-FREE ILLUSTRATIONS OF MAMMALS, BIRDS, FISH, INSECTS, ETC., edited by Jim Harter. Clear wood engravings present, in extremely lifelike poses, over 1,000 species of animals. One of the most extensive copyright-free pictorial sourcebooks of its kind. Captions. Index. 284pp. 9 x 12. 23766-4 Pa. $8.95

INDIAN DESIGNS FROM ANCIENT ECUADOR, Frederick W. Shaffer. 282 original designs by pre-Columbian Indians of Ecuador (500-1500 A.D.). Designs include people, mammals, birds, reptiles, fish, plants, heads, geometric designs. Use as is or alter for advertising, textiles, leathercraft, etc. Introduction. 95pp. 8¾ x 11¼. 23764-8 Pa. $3.50

SZIGETI ON THE VIOLIN, Joseph Szigeti. Genial, loosely structured tour by premier violinist, featuring a pleasant mixture of reminiscenes, insights into great music and musicians, innumerable tips for practicing violinists. 385 musical passages. 256pp. 5⅝ x 8¼. 23763-X Pa. $4.00

TONE POEMS, SERIES II: TILL EULENSPIEGELS LUSTIGE STREICHE, ALSO SPRACH ZARATHUSTRA, AND EIN HELDENLEBEN, Richard Strauss. Three important orchestral works, including very popular *Till Eulenspiegel's Marry Pranks,* reproduced in full score from original editions. Study score. 315pp. 9⅜ x 12¼. (Available in U.S. only) 23755-9 Pa. $8.95

TONE POEMS, SERIES I: DON JUAN, TOD UND VERKLARUNG AND DON QUIXOTE, Richard Strauss. Three of the most often performed and recorded works in entire orchestral repertoire, reproduced in full score from original editions. Study score. 286pp. 9⅜ x 12¼. (Available in U.S. only) 23754-0 Pa. $7.50

11 LATE STRING QUARTETS, Franz Joseph Haydn. The form which Haydn defined and "brought to perfection." (*Grove's*). 11 string quartets in complete score, his last and his best. The first in a projected series of the complete Haydn string quartets. Reliable modern Eulenberg edition, otherwise difficult to obtain. 320pp. 8⅜ x 11¼. (Available in U.S. only) 23753-2 Pa. $7.50

FOURTH, FIFTH AND SIXTH SYMPHONIES IN FULL SCORE, Peter Ilyitch Tchaikovsky. Complete orchestral scores of Symphony No. 4 in F Minor, Op. 36; Symphony No. 5 in E Minor, Op. 64; Symphony No. 6 in B Minor, "Pathetique," Op. 74. Bretikopf & Hartel eds. Study score. 480pp. 9⅜ x 12¼. 23861-X Pa. $10.95

THE MARRIAGE OF FIGARO: COMPLETE SCORE, Wolfgang A. Mozart. Finest comic opera ever written. Full score, not to be confused with piano renderings. Peters edition. Study score. 448pp. 9⅜ x 12¼. (Available in U.S. only) 23751-6 Pa. $11.95

"IMAGE" ON THE ART AND EVOLUTION OF THE FILM, edited by Marshall Deutelbaum. Pioneering book brings together for first time 38 groundbreaking articles on early silent films from *Image* and 263 illustrations newly shot from rare prints in the collection of the International Museum of Photography. A landmark work. Index. 256pp. 8¼ x 11. 23777-X Pa. $8.95

AROUND-THE-WORLD COOKY BOOK, Lois Lintner Sumption and Marguerite Lintner Ashbrook. 373 cooky and frosting recipes from 28 countries (America, Austria, China, Russia, Italy, etc.) include Viennese kisses, rice wafers, London strips, lady fingers, hony, sugar spice, maple cookies, etc. Clear instructions. All tested. 38 drawings. 182pp. 5⅜ x 8. 23802-4 Pa. $2.50

THE ART NOUVEAU STYLE, edited by Roberta Waddell. 579 rare photographs, not available elsewhere, of works in jewelry, metalwork, glass, ceramics, textiles, architecture and furniture by 175 artists—Mucha, Seguy, Lalique, Tiffany, Gaudin, Hohlwein, Saarinen, and many others. 288pp. 8⅜ x 11¼. 23515-7 Pa. $6.95

THE AMERICAN SENATOR, Anthony Trollope. Little known, long un-available Trollope novel on a grand scale. Here are humorous comment on American vs. English culture, and stunning portrayal of a heroine/villainess. Superb evocation of Victorian village life. 561pp. 5⅜ x 8½.
23801-6 Pa. $6.00

WAS IT MURDER? James Hilton. The author of *Lost Horizon* and *Good-bye, Mr. Chips* wrote one detective novel (under a pen-name) which was quickly forgotten and virtually lost, even at the height of Hilton's fame. This edition brings it back—a finely crafted public school puzzle resplendent with Hilton's stylish atmosphere. A thoroughly English thriller by the creator of Shangri-la. 252pp. 5⅜ x 8. (Available in U.S. only)
23774-5 Pa. $3.00

CENTRAL PARK: A PHOTOGRAPHIC GUIDE, Victor Laredo and Henry Hope Reed. 121 superb photographs show dramatic views of Central Park: Bethesda Fountain, Cleopatra's Needle, Sheep Meadow, the Blockhouse, plus people engaged in many park activities: ice skating, bike riding, etc. Captions by former Curator of Central Park, Henry Hope Reed, provide historical view, changes, etc. Also photos of N.Y. landmarks on park's periphery. 96pp. 8½ x 11. 23750-8 Pa. $4.50

NANTUCKET IN THE NINETEENTH CENTURY, Clay Lancaster. 180 rare photographs, stereographs, maps, drawings and floor plans recreate unique American island society. Authentic scenes of shipwreck, lighthouses, streets, homes are arranged in geographic sequence to provide walking-tour guide to old Nantucket existing today. Introduction, captions. 160pp. 8⅞ x 11¾. 23747-8 Pa. $6.95

STONE AND MAN: A PHOTOGRAPHIC EXPLORATION, Andreas Feininger. 106 photographs by *Life* photographer Feininger portray man's deep passion for stone through the ages. Stonehenge-like megaliths, fortified towns, sculpted marble and crumbling tenements show textures, beauties, fascination. 128pp. 9¼ x 10¾. 23756-7 Pa. $5.95

CIRCLES, A MATHEMATICAL VIEW, D. Pedoe. Fundamental aspects of college geometry, non-Euclidean geometry, and other branches of mathematics: representing circle by point. Poincare model, isoperimetric property, etc. Stimulating recreational reading. 66 figures. 96pp. 5⅜ x 8¼.
63698-4 Pa. $2.75

THE DISCOVERY OF NEPTUNE, Morton Grosser. Dramatic scientific history of the investigations leading up to the actual discovery of the eighth planet of our solar system. Lucid, well-researched book by well-known historian of science. 172pp. 5⅜ x 8½. 23726-5 Pa. $3.50

"OSCAR" OF THE WALDORF'S COOKBOOK, Oscar Tschirky. Famous American chef reveals 3455 recipes that made Waldorf great; cream of French, German, American cooking, in all categories. Full instructions, easy home use. 1896 edition. 907pp. 6⅝ x 9⅜. 20790-0 Clothbd. $15.00

COOKING WITH BEER, Carole Fahy. Beer has as superb an effect on food as wine, and at fraction of cost. Over 250 recipes for appetizers, soups, main dishes, desserts, breads, etc. Index. 144pp. 5⅜ x 8½. (Available in U.S. only) 23661-7 Pa. $2.50

STEWS AND RAGOUTS, Kay Shaw Nelson. This international cookbook offers wide range of 108 recipes perfect for everyday, special occasions, meals-in-themselves, main dishes. Economical, nutritious, easy-to-prepare: goulash, Irish stew, boeuf bourguignon, etc. Index. 134pp. 5⅜ x 8½.
 23662-5 Pa. $2.50

DELICIOUS MAIN COURSE DISHES, Marian Tracy. Main courses are the most important part of any meal. These 200 nutritious, economical recipes from around the world make every meal a delight. "I . . . have found it so useful in my own household,"—*N.Y. Times.* Index. 219pp. 5⅜ x 8½. 23664-1 Pa. $3.00

FIVE ACRES AND INDEPENDENCE, Maurice G. Kains. Great back-to-the-land classic explains basics of self-sufficient farming: economics, plants, crops, animals, orchards, soils, land selection, host of other necessary things. Do not confuse with skimpy faddist literature; Kains was one of America's greatest agriculturalists. 95 illustrations. 397pp. 5⅜ x 8½.
 20974-1 Pa.$3.95

A PRACTICAL GUIDE FOR THE BEGINNING FARMER, Herbert Jacobs. Basic, extremely useful first book for anyone thinking about moving to the country and starting a farm. Simpler than Kains, with greater emphasis on country living in general. 246pp. 5⅜ x 8½.
 23675-7 Pa. $3.50

PAPERMAKING, Dard Hunter. Definitive book on the subject by the foremost authority in the field. Chapters dealing with every aspect of history of craft in every part of the world. Over 320 illustrations. 2nd, revised and enlarged (1947) edition. 672pp. 5⅜ x 8½. 23619-6 Pa. $7.95

THE ART DECO STYLE, edited by Theodore Menten. Furniture, jewelry, metalwork, ceramics, fabrics, lighting fixtures, interior decors, exteriors, graphics from pure French sources. Best sampling around. Over 400 photographs. 183pp. 8⅜ x 11¼. 22824-X Pa. $6.00

ACKERMANN'S COSTUME PLATES, Rudolph Ackermann. Selection of 96 plates from the *Repository of Arts,* best published source of costume for English fashion during the early 19th century. 12 plates also in color. Captions, glossary and introduction by editor Stella Blum. Total of 120pp. 8⅜ x 11¼. 23690-0 Pa. $4.50

THE CURVES OF LIFE, Theodore A. Cook. Examination of shells, leaves, horns, human body, art, etc., in "*the* classic reference on how the golden ratio applies to spirals and helices in nature"—Martin Gardner. 426 illustrations. Total of 512pp. 5⅜ x 8½. 23701-X Pa. $5.95

AN ILLUSTRATED FLORA OF THE NORTHERN UNITED STATES AND CANADA, Nathaniel L. Britton, Addison Brown. Encyclopedic work covers 4666 species, ferns on up. Everything. Full botanical information, illustration for each. This earlier edition is preferred by many to more recent revisions. 1913 edition. Over 4000 illustrations, total of 2087pp. 6⅛ x 9¼. 22642-5, 22643-3, 22644-1 Pa., Three-vol. set $25.50

MANUAL OF THE GRASSES OF THE UNITED STATES, A. S. Hitchcock, U.S. Dept. of Agriculture. The basic study of American grasses, both indigenous and escapes, cultivated and wild. Over 1400 species. Full descriptions, information. Over 1100 maps, illustrations. Total of 1051pp. 5⅜ x 8½. 22717-0, 22718-9 Pa., Two-vol. set $15.00

THE CACTACEAE,, Nathaniel L. Britton, John N. Rose. Exhaustive, definitive. Every cactus in the world. Full botanical descriptions. Thorough statement of nomenclatures, habitat, detailed finding keys. The one book needed by every cactus enthusiast. Over 1275 illustrations. Total of 1080pp. 8 x 10¼. 21191-6, 21192-4 Clothbd., Two-vol. set $35.00

AMERICAN MEDICINAL PLANTS, Charles F. Millspaugh. Full descriptions, 180 plants covered: history; physical description; methods of preparation with all chemical constituents extracted; all claimed curative or adverse effects. 180 full-page plates. Classification table. 804pp. 6½ x 9¼.
23034-1 Pa. $12.95

A MODERN HERBAL, Margaret Grieve. Much the fullest, most exact, most useful compilation of herbal material. Gigantic alphabetical encyclopedia, from aconite to zedoary, gives botanical information, medical properties, folklore, economic uses, and much else. Indispensable to serious reader. 161 illustrations. 888pp. 6½ x 9¼. (Available in U.S. only)
22798-7, 22799-5 Pa., Two-vol. set $13.00

THE HERBAL or GENERAL HISTORY OF PLANTS, John Gerard. The 1633 edition revised and enlarged by Thomas Johnson. Containing almost 2850 plant descriptions and 2705 superb illustrations, Gerard's *Herbal* is a monumental work, the book all modern English herbals are derived from, the one herbal every serious enthusiast should have in its entirety. Original editions are worth perhaps $750. 1678pp. 8½ x 12¼.
23147-X Clothbd. $50.00

MANUAL OF THE TREES OF NORTH AMERICA, Charles S. Sargent. The basic survey of every native tree and tree-like shrub, 717 species in all. Extremely full descriptions, information on habitat, growth, locales, economics, etc. Necessary to every serious tree lover. Over 100 finding keys. 783 illustrations. Total of 986pp. 5⅜ x 8½.
20277-1, 20278-X Pa., Two-vol. set $11.00

ART FORMS IN NATURE, Ernst Haeckel. Multitude of strangely beautiful natural forms: Radiolaria, Foraminifera, jellyfishes, fungi, turtles, bats, etc. All 100 plates of the 19th-century evolutionist's *Kunstformen der Natur* (1904). 100pp. 9⅜ x 12¼. 22987-4 Pa. $5.00

CHILDREN: A PICTORIAL ARCHIVE FROM NINETEENTH-CENTURY SOURCES, edited by Carol Belanger Grafton. 242 rare, copyright-free wood engravings for artists and designers. Widest such selection available. All illustrations in line. 119pp. 8⅜ x 11¼.
23694-3 Pa. $4.00

WOMEN: A PICTORIAL ARCHIVE FROM NINETEENTH-CENTURY SOURCES, edited by Jim Harter. 391 copyright-free wood engravings for artists and designers selected from rare periodicals. Most extensive such collection available. All illustrations in line. 128pp. 9 x 12.
23703-6 Pa. $4.50

ARABIC ART IN COLOR, Prisse d'Avennes. From the greatest ornamentalists of all time—50 plates in color, rarely seen outside the Near East, rich in suggestion and stimulus. Includes 4 plates on covers. 46pp. 9⅜ x 12¼. 23658-7 Pa. $6.00

AUTHENTIC ALGERIAN CARPET DESIGNS AND MOTIFS, edited by June Beveridge. Algerian carpets are world famous. Dozens of geometrical motifs are charted on grids, color-coded, for weavers, needleworkers, craftsmen, designers. 53 illustrations plus 4 in color. 48pp. 8¼ x 11. (Available in U.S. only) 23650-1 Pa. $1.75

DICTIONARY OF AMERICAN PORTRAITS, edited by Hayward and Blanche Cirker. 4000 important Americans, earliest times to 1905, mostly in clear line. Politicians, writers, soldiers, scientists, inventors, industrialists, Indians, Blacks, women, outlaws, etc. Identificatory information. 756pp. 9¼ x 12¾. 21823-6 Clothbd. $40.00

HOW THE OTHER HALF LIVES, Jacob A. Riis. Journalistic record of filth, degradation, upward drive in New York immigrant slums, shops, around 1900. New edition includes 100 original Riis photos, monuments of early photography. 233pp. 10 x 7⅞. 22012-5 Pa. $7.00

NEW YORK IN THE THIRTIES, Berenice Abbott. Noted photographer's fascinating study of city shows new buildings that have become famous and old sights that have disappeared forever. Insightful commentary. 97 photographs. 97pp. 11⅜ x 10. 22967-X Pa. $5.00

MEN AT WORK, Lewis W. Hine. Famous photographic studies of construction workers, railroad men, factory workers and coal miners. New supplement of 18 photos on Empire State building construction. New introduction by Jonathan L. Doherty. Total of 69 photos. 63pp. 8 x 10¾.
23475-4 Pa. $3.00

HOLLYWOOD GLAMOUR PORTRAITS, edited by John Kobal. 145 photos capture the stars from 1926-49, the high point in portrait photography. Gable, Harlow, Bogart, Bacall, Hedy Lamarr, Marlene Dietrich, Robert Montgomery, Marlon Brando, Veronica Lake; 94 stars in all. Full background on photographers, technical aspects, much more. Total of 160pp. 8⅜ x 11¼. 23352-9 Pa. $6.00

THE NEW YORK STAGE: FAMOUS PRODUCTIONS IN PHOTO-GRAPHS, edited by Stanley Appelbaum. 148 photographs from Museum of City of New York show 142 plays, 1883-1939. *Peter Pan, The Front Page, Dead End, Our Town,* O'Neill, hundreds of actors and actresses, etc. Full indexes. 154pp. 9½ x 10. 23241-7 Pa. $6.00

DIALOGUES CONCERNING TWO NEW SCIENCES, Galileo Galilei. Encompassing 30 years of experiment and thought, these dialogues deal with geometric demonstrations of fracture of solid bodies, cohesion, leverage, speed of light and sound, pendulums, falling bodies, accelerated motion, etc. 300pp. 5⅜ x 8½. 60099-8 Pa. $4.00

THE GREAT OPERA STARS IN HISTORIC PHOTOGRAPHS, edited by James Camner. 343 portraits from the 1850s to the 1940s: Tamburini, Mario, Caliapin, Jeritza, Melchior, Melba, Patti, Pinza, Schipa, Caruso, Farrar, Steber, Gobbi, and many more—270 performers in all. Index. 199pp. 8⅜ x 11¼. 23575-0 Pa. $7.50

J. S. BACH, Albert Schweitzer. Great full-length study of Bach, life, background to music, music, by foremost modern scholar. Ernest Newman translation. 650 musical examples. Total of 928pp. 5⅜ x 8½. (Available in U.S. only) 21631-4, 21632-2 Pa., Two-vol. set $11.00

COMPLETE PIANO SONATAS, Ludwig van Beethoven. All sonatas in the fine Schenker edition, with fingering, analytical material. One of best modern editions. Total of 615pp. 9 x 12. (Available in U.S. only)
 23134-8, 23135-6 Pa., Two-vol. set $15.50

KEYBOARD MUSIC, J. S. Bach. Bach-Gesellschaft edition. For harpsichord, piano, other keyboard instruments. English Suites, French Suites, Six Partitas, Goldberg Variations, Two-Part Inventions, Three-Part Sinfonias. 312pp. 8⅛ x 11. (Available in U.S. only) 22360-4 Pa. $6.95

FOUR SYMPHONIES IN FULL SCORE, Franz Schubert. Schubert's four most popular symphonies: No. 4 in C Minor ("Tragic"); No. 5 in B-flat Major; No. 8 in B Minor ("Unfinished"); No. 9 in C Major ("Great"). Breitkopf & Hartel edition. Study score. 261pp. 9⅜ x 12¼.
 23681-1 Pa. $6.50

THE AUTHENTIC GILBERT & SULLIVAN SONGBOOK, W. S. Gilbert, A. S. Sullivan. Largest selection available; 92 songs, uncut, original keys, in piano rendering approved by Sullivan. Favorites and lesser-known fine numbers. Edited with plot synopses by James Spero. 3 illustrations. 399pp. 9 x 12. 23482-7 Pa. $9.95

PRINCIPLES OF ORCHESTRATION, Nikolay Rimsky-Korsakov. Great classical orchestrator provides fundamentals of tonal resonance, progression of parts, voice and orchestra, tutti effects, much else in major document. 330pp. of musical excerpts. 489pp. 6½ x 9¼. 21266-1 Pa. **$7.50**

TRISTAN UND ISOLDE, Richard Wagner. Full orchestral score with complete instrumentation. Do not confuse with piano reduction. Commentary by Felix Mottl, great Wagnerian conductor and scholar. Study score. 655pp. 8⅛ x 11. 22915-7 Pa. **$13.95**

REQUIEM IN FULL SCORE, Giuseppe Verdi. Immensely popular with choral groups and music lovers. Republication of edition published by C. F. Peters, Leipzig, n. d. German frontmaker in English translation. Glossary. Text in Latin. Study score. 204pp. 9⅜ x 12¼.

23682-X Pa. **$6.00**

COMPLETE CHAMBER MUSIC FOR STRINGS, Felix Mendelssohn. All of Mendelssohn's chamber music: Octet, 2 Quintets, 6 Quartets, and Four Pieces for String Quartet. (Nothing with piano is included). Complete works edition (1874-7). Study score. 283 pp. 9⅜ x 12¼.

23679-X Pa. **$7.50**

POPULAR SONGS OF NINETEENTH-CENTURY AMERICA, edited by Richard Jackson. 64 most important songs: "Old Oaken Bucket," "Arkansas Traveler," "Yellow Rose of Texas," etc. Authentic original sheet music, full introduction and commentaries. 290pp. 9 x 12. 23270-0 Pa. **$7.95**

COLLECTED PIANO WORKS, Scott Joplin. Edited by Vera Brodsky Lawrence. Practically all of Joplin's piano works—rags, two-steps, marches, waltzes, etc., 51 works in all. Extensive introduction by Rudi Blesh. Total of 345pp. 9 x 12. 23106-2 Pa. **$14.95**

BASIC PRINCIPLES OF CLASSICAL BALLET, Agrippina Vaganova. Great Russian theoretician, teacher explains methods for teaching classical ballet; incorporates best from French, Italian, Russian schools. 118 illustrations. 175pp. 5⅜ x 8½. 22036-2 Pa. **$2.50**

CHINESE CHARACTERS, L. Wieger. Rich analysis of 2300 characters according to traditional systems into primitives. Historical-semantic analysis to phonetics (Classical Mandarin) and radicals. 820pp. 6⅛ x 9¼.

21321-8 Pa. **$10.00**

EGYPTIAN LANGUAGE: EASY LESSONS IN EGYPTIAN HIERO-GLYPHICS, E. A. Wallis Budge. Foremost Egyptologist offers Egyptian grammar, explanation of hieroglyphics, many reading texts, dictionary of symbols. 246pp. 5 x 7½. (Available in U.S. only)

21394-3 Clothbd. **$7.50**

AN ETYMOLOGICAL DICTIONARY OF MODERN ENGLISH, Ernest Weekley. Richest, fullest work, by foremost British lexicographer. Detailed word histories. Inexhaustible. Do not confuse this with *Concise Etymological Dictionary*, which is abridged. Total of 856pp. 6½ x 9¼.

21873-2, 21874-0 Pa., Two-vol. set **$12.00**

A MAYA GRAMMAR, Alfred M. Tozzer. Practical, useful English-language grammar by the Harvard anthropologist who was one of the three greatest American scholars in the area of Maya culture. Phonetics, grammatical processes, syntax, more. 301pp. 5⅜ x 8½. 23465-7 Pa. $4.00

THE JOURNAL OF HENRY D. THOREAU, edited by Bradford Torrey, F. H. Allen. Complete reprinting of 14 volumes, 1837-61, over two million words; the sourcebooks for *Walden*, etc. Definitive. All original sketches, plus 75 photographs. Introduction by Walter Harding. Total of 1804pp. 8½ x 12¼. 20312-3, 20313-1 Clothbd., Two-vol. set $70.00

CLASSIC GHOST STORIES, Charles Dickens and others. 18 wonderful stories you've wanted to reread: "The Monkey's Paw," "The House and the Brain," "The Upper Berth," "The Signalman," "Dracula's Guest," "The Tapestried Chamber," etc. Dickens, Scott, Mary Shelley, Stoker, etc. 330pp. 5⅜ x 8½. 20735-8 Pa. $4.50

SEVEN SCIENCE FICTION NOVELS, H. G. Wells. Full novels. *First Men in the Moon, Island of Dr. Moreau, War of the Worlds, Food of the Gods, Invisible Man, Time Machine, In the Days of the Comet.* A basic science-fiction library. 1015pp. 5⅜ x 8½. (Available in U.S. only) 20264-X Clothbd. $8.95

ARMADALE, Wilkie Collins. Third great mystery novel by the author of *The Woman in White* and *The Moonstone.* Ingeniously plotted narrative shows an exceptional command of character, incident and mood. Original magazine version with 40 illustrations. 597pp. 5⅜ x 8½. 23429-0 Pa. $6.00

MASTERS OF MYSTERY, H. Douglas Thomson. The first book in English (1931) devoted to history and aesthetics of detective story. Poe, Doyle, LeFanu, Dickens, many others, up to 1930. New introduction and notes by E. F. Bleiler. 288pp. 5⅜ x 8½. (Available in U.S. only) 23606-4 Pa. $4.00

FLATLAND, E. A. Abbott. Science-fiction classic explores life of 2-D being in 3-D world. Read also as introduction to thought about hyperspace. Introduction by Banesh Hoffmann 16 illustrations. 103pp. 5⅜ x 8½. 20001-9 Pa. $2.00

THREE SUPERNATURAL NOVELS OF THE VICTORIAN PERIOD, edited, with an introduction, by E. F. Bleiler. Reprinted complete and unabridged, three great classics of the supernatural: *The Haunted Hotel* by Wilkie Collins, *The Haunted House at Latchford* by Mrs. J. H. Riddell, and *The Lost Stradivarious* by J. Meade Falkner. 325pp. 5⅜ x 8½. 22571-2 Pa. $4.00

AYESHA: THE RETURN OF "SHE," H. Rider Haggard. Virtuoso sequel featuring the great mythic creation, Ayesha, in an adventure that is fully as good as the first book, *She.* Original magazine version, with 47 original illustrations by Maurice Greiffenhagen. 189pp. 6½ x 9¼. 23649-8 Pa. $3.50

HOUSEHOLD STORIES BY THE BROTHERS GRIMM. All the great Grimm stories: "Rumpelstiltskin," "Snow White," "Hansel and Gretel," etc., with 114 illustrations by Walter Crane. 269pp. 5⅜ x 8½.
21080-4 Pa. $3.50

SLEEPING BEAUTY, illustrated by Arthur Rackham. Perhaps the fullest, most delightful version ever, told by C. S. Evans. Rackham's best work. 49 illustrations. 110pp. 7⅞ x 10¾. 22756-1 Pa. $2.50

AMERICAN FAIRY TALES, L. Frank Baum. Young cowboy lassoes Father Time; dummy in Mr. Floman's department store window comes to life; and 10 other fairy tales. 41 illustrations by N. P. Hall, Harry Kennedy, Ike Morgan, and Ralph Gardner. 209pp. 5⅜ x 8½. 23643-9 Pa. $3.00

THE WONDERFUL WIZARD OF OZ, L. Frank Baum. Facsimile in full color of America's finest children's classic. Introduction by Martin Gardner. 143 illustrations by W. W. Denslow. 267pp. 5⅜ x 8½.
20691-2 Pa. $3.50

THE TALE OF PETER RABBIT, Beatrix Potter. The inimitable Peter's terrifying adventure in Mr. McGregor's garden, with all 27 wonderful, full-color Potter illustrations. 55pp. 4¼ x 5½. (Available in U.S. only)
22827-4 Pa. $1.25

THE STORY OF KING ARTHUR AND HIS KNIGHTS, Howard Pyle. Finest children's version of life of King Arthur. 48 illustrations by Pyle. 131pp. 6⅛ x 9¼. 21445-1 Pa. $4.95

CARUSO'S CARICATURES, Enrico Caruso. Great tenor's remarkable caricatures of self, fellow musicians, composers, others. Toscanini, Puccini, Farrar, etc. Impish, cutting, insightful. 473 illustrations. Preface by M. Sisca. 217pp. 8⅜ x 11¼. 23528-9 Pa. $6.95

PERSONAL NARRATIVE OF A PILGRIMAGE TO ALMADINAH AND MECCAH, Richard Burton. Great travel classic by remarkably colorful personality. Burton, disguised as a Moroccan, visited sacred shrines of Islam, narrowly escaping death. Wonderful observations of Islamic life, customs, personalities. 47 illustrations. Total of 959pp. 5⅜ x 8½.
21217-3, 21218-1 Pa., Two-vol. set $12.00

INCIDENTS OF TRAVEL IN YUCATAN, John L. Stephens. Classic (1843) exploration of jungles of Yucatan, looking for evidences of Maya civilization. Travel adventures, Mexican and Indian culture, etc. Total of 669pp. 5⅜ x 8½. 20926-1, 20927-X Pa., Two-vol. set $7.90

AMERICAN LITERARY AUTOGRAPHS FROM WASHINGTON IRVING TO HENRY JAMES, Herbert Cahoon, et al. Letters, poems, manuscripts of Hawthorne, Thoreau, Twain, Alcott, Whitman, 67 other prominent American authors. Reproductions, full transcripts and commentary. Plus checklist of all American Literary Autographs in The Pierpont Morgan Library. Printed on exceptionally high-quality paper. 136 illustrations. 212pp. 9⅛ x 12¼. 23548-3 Pa. $12.50

AMERICAN ANTIQUE FURNITURE, Edgar G. Miller, Jr. The basic coverage of all American furniture before 1840: chapters per item chronologically cover all types of furniture, with more than 2100 photos. Total of 1106pp. 7⅞ x 10¾. 21599-7, 21600-4 Pa., Two-vol. set $17.90

ILLUSTRATED GUIDE TO SHAKER FURNITURE, Robert Meader. Director, Shaker Museum, Old Chatham, presents up-to-date coverage of all furniture and appurtenances, with much on local styles not available elsewhere. 235 photos. 146pp. 9 x 12. 22819-3 Pa. $6.00

ORIENTAL RUGS, ANTIQUE AND MODERN, Walter A. Hawley. Persia, Turkey, Caucasus, Central Asia, China, other traditions. Best general survey of all aspects: styles and periods, manufacture, uses, symbols and their interpretation, and identification. 96 illustrations, 11 in color. 320pp. 6⅛ x 9¼. 22366-3 Pa. $6.95

CHINESE POTTERY AND PORCELAIN, R. L. Hobson. Detailed descriptions and analyses by former Keeper of the Department of Oriental Antiquities and Ethnography at the British Museum. Covers hundreds of pieces from primitive times to 1915. Still the standard text for most periods. 136 plates, 40 in full color. Total of 750pp. 5⅜ x 8½.
23253-0 Pa. $10.00

THE WARES OF THE MING DYNASTY, R. L. Hobson. Foremost scholar examines and illustrates many varieties of Ming (1368-1644). Famous blue and white, polychrome, lesser-known styles and shapes. 117 illustrations, 9 full color, of outstanding pieces. Total of 263pp. 6⅛ x 9¼. (Available in U.S. only) 23652-8 Pa. $6.00

Prices subject to change without notice.

Available at your book dealer or write for free catalogue to Dept. GI, Dover Publications, Inc., 180 Varick St., N.Y., N.Y. 10014. Dover publishes more than 175 books each year on science, elementary and advanced mathematics, biology, music, art, literary history, social sciences and other areas.